THE AGE OF BRUEGEL

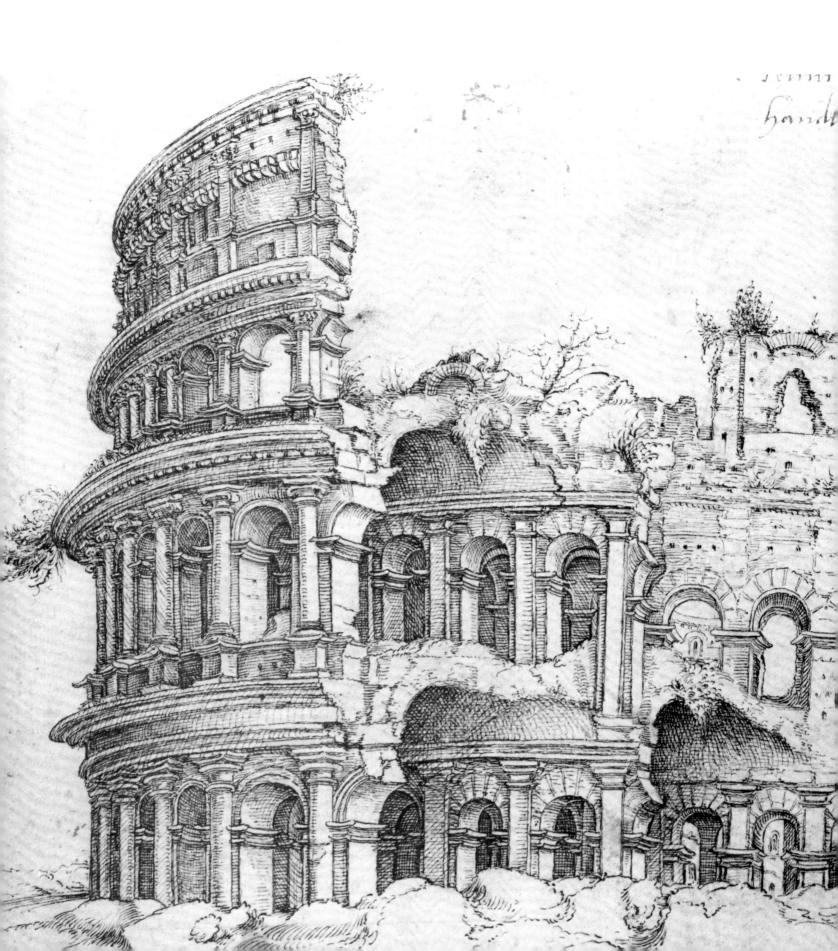

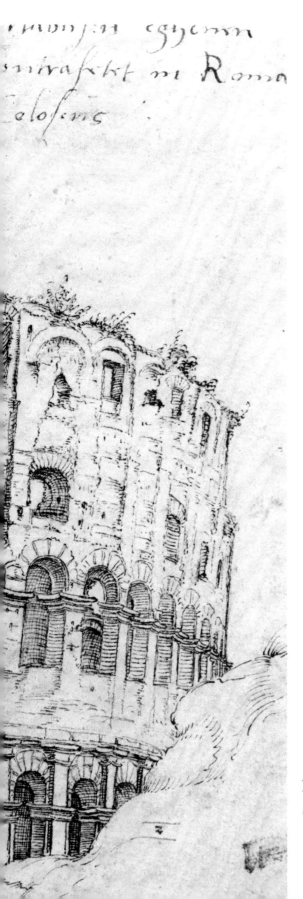

The Age of Bruegel:
Netherlandish Drawings in the Sixteenth Century

JOHN OLIVER HAND
J. RICHARD JUDSON
WILLIAM W. ROBINSON
MARTHA WOLFF

National Gallery of Art, Washington

Cambridge University Press

The exhibition is supported by Shell Companies Foundation, Incorporated, and Unilever United States, Inc.

The exhibition is supported by an indemnity from the Federal Council on the Arts and Humanities.

Edited by Mary Yakush, with Sara Day.
Typeset in Trump by VIP Systems, Inc.
Printed in New Haven by Eastern Press.
Designed by Susan Lehmann, Washington, D.C.

Cloth edition published by the Press Syndicate of the University of Cambridge
The Pitt Building, Trumpington Street, Cambridge, CB2 1RP, England
32 East 57th Street, New York, New York 10022
296 Beaconsfield Parade, Middle Park, Melbourne 3206, Australia

Library of Congress Cataloging-in-Publication Data
The Age of Bruegel.
"Exhibition dates: National Gallery of Art, Washington, 7 November, 1986-18 January, 1987; Pierpont Morgan Library, New York, 30 January-5 April, 1987"—T.p. verso.
 Bibliography: p.
 1. Drawing, Flemish—Exhibitions. 2. Drawing, Dutch—Exhibitions. 3. Drawing—16th century—Flanders—Exhibitions. I. Hand, John Oliver, 1941- II. National Gallery of Art (U.S.) III. Pierpont Morgan Library.
NC258.A34 1986 741.9492'074'01471
86-19144
ISBN 0-89468-095-1 (paper)
ISBN 0-521341965 (cloth)

Exhibition dates:
National Gallery of Art, Washington
7 November 1986-18 January 1987
The Pierpont Morgan Library, New York
30 January-5 April 1987

Frontispiece: Detail, cat. 63
Cover illustration: Detail, cat. 27

Contents

Detail, cat. 25

Directors' foreword

The Age of Bruegel: Netherlandish Drawings in the Sixteenth Century is the first major exhibition in the United States devoted solely to the achievement of sixteenth-century draftsmen of the Low Countries. It provides for the layman and specialist alike an unparalleled opportunity to explore the richness and variety of style, subject, and function found in the drawings of this period. The drawings by Pieter Bruegel, the focus of the exhibition, show the range of his work and his significance as a draftsman. We are delighted that once again the National Gallery of Art and the Pierpont Morgan Library have joined in presenting a most important exhibition of master drawings.

We should like to extend our thanks to the museums and private lenders for their willingness to part with the rare and precious drawings in their care. We are particularly indebted to John Oliver Hand, J. Richard Judson, William W. Robinson, and Martha Wolff who brought their combined expertise to bear on the conception and organization of *The Age of Bruegel.*

We are deeply grateful to Shell Companies Foundation, Incorporated, and Unilever United States, Inc. for their generous support of the exhibition, and to the United States Federal Council on the Arts and Humanities for providing an indemnity. At the Morgan Library the presentation has been funded in part by a grant from the National Endowment for the Arts.

We expect this exhibition of drawings will be a revelation to many viewers, and are confident that the catalogue will take its well-earned place in the scholarly literature of a fascinating period in the history of Western draftsmanship.

J. CARTER BROWN
Director
National Gallery of Art,
Washington

CHARLES A. RYSKAMP
Director
The Pierpont Morgan
Library, New York

Joris Hoefnagel, vol. 4, *Animalia Volatilia et Amphibia (Aier),* cat. 73, Promised gift on deposit at the National Gallery of Art by Mrs. Lessing J. Rosenwald

Lenders to the exhibition

Maida and George Abrams Collection, Boston, Massachusetts

Graphische Sammlung Albertina, Vienna

The Art Institute of Chicago

The Visitors of the Ashmolean Museum, Oxford

The Trustees of the British Museum, London

The Governing Body, Christ Church, Oxford

Courtauld Institute Galleries, London

The Duke of Devonshire and the Chatsworth Settlement Trustees

The Syndics of the Fitzwilliam Museum, Cambridge

Fondation Custodia (coll. F. Lugt), Institut Néerlandais, Paris

Foundation P. & N. de Boer, Amsterdam

Galleria dell'Accademia, Venice

The J. Paul Getty Museum, Malibu

Hamburger Kunsthalle, Kupferstichkabinett, Hamburg

Harvard University Art Museums (Fogg Art Museum), Cambridge

Hessisches Landesmuseum, Darmstadt

Historisches Museum, Frankfurt

Kunsthalle Bremen

Kunstmuseum Düsseldorf

The Metropolitan Museum of Art, New York

The Pierpont Morgan Library, New York

Musée du Louvre, Cabinet des Dessins, Paris

Musées des Beaux-Arts et d'Archéologie, Besançon

Musées Royaux des Beaux-Arts de Belgique, Brussels

Museum Boymans-van Beuningen, Rotterdam

Museum of Fine Arts, Boston

National Gallery of Art, Washington

National Gallery of Canada, Ottawa/Musée des beaux-arts du Canada, Ottawa

National Galleries of Scotland, Edinburgh

Stiftung Ratjen, Vaduz/Ratjen Foundation, Vaduz

Collection I.Q. Van Regteren Altena Heirs, Amsterdam

Rijksprentenkabinet, Rijksmuseum, Amsterdam

Prentenkabinet der Rijksuniversiteit te Leiden

Private Collections
Mrs. Lessing J. Rosenwald
Staatliche Graphische Sammlung, Munich
Staatliche Kunstsammlungen Dresden, Kupferstich-Kabinett, German Democratic Republic
Staatliche Museen Preussischer Kulturbesitz, Kupferstichkabinett, Berlin
Stedelijk Museum "De Lakenhal," Leiden
Szépmüvészeti Múzeum, Budapest
Teylers Museum, Haarlem
Herzog Anton Ulrich-Museum, Braunschweig
The Victoria and Albert Museum, London
Yale University Art Gallery, New Haven

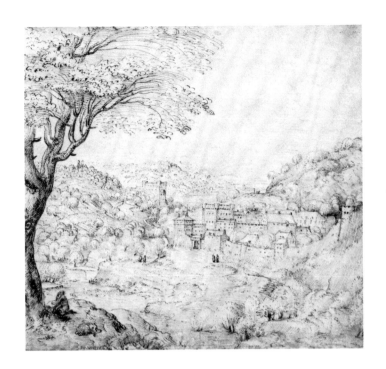

Introduction and acknowledgments

Over the past fifteen years our knowledge of Netherlandish drawings has benefited greatly from numerous scholarly publications, catalogues of the Netherlandish holdings of individual museums, such as those of the Staatliche Graphische Sammlung, Munich, or the Rijksprentenkabinet, Amsterdam; or from exhibitions such as the one held in Berlin in 1975, or from Karel Boon's catalogue of the sixteenth-century Netherlandish drawings in the Frits Lugt collection exhibited in Paris and Florence in 1980-1981. In the United States, however, *The Age of Bruegel* is the first major loan exhibition devoted solely to sixteenth-century Netherlandish drawings.

Our aim was to provide a survey of this fascinating and difficult century by bringing together the finest and best preserved drawings by the greatest Netherlandish draftsmen of the period. The opportunity to consider the varied functions of drawings was another factor in making the selection. Although the attribution of drawings was not our primary concern, questions of style, date, and authorship emerged in the course of the project. We take a certain pride in the fact that most of the drawings have not been shown in America and that several are exhibited for the first time ever. In presenting *The Age of Bruegel* we believe that we have prepared a feast for both the mind and the eye and hope that it will lead to an increased interest in and appreciation for the splendid accomplishments of these artists.

An exhibition of this scope and magnitude cannot come into existence without the cooperation and special skills of a great number of people and it is a pleasure to acknowledge their assistance. We are particularly grateful to Jan Piet Filedt Kok and Wouter Kloek who have been involved in our project almost from its inception and who have been model colleagues. Their exhibition *Art before the Icono-*

clasm—*North Netherlandish Art 1525-1580,* which opened in September 1986 at the Rijksmuseum, has a different focus, but covered similar territory. The following colleagues have also provided encouragement, advice, and assistance in numerous ways: Clifford Ackley, Keith Andrews, Roseline Bacou, Jacob Bean, Mària van Berge-Gerbaud, Holm Bevers, Jaap Bolten, William Bradford, David Alan Brown, David Blayney Brown, Mimi Cazort, Peter Day, Cara Denison, Christian Dittrich, Peter Dreyer, Douglas Druick, Alexander Duckers, Richard Field, Glaubrecht Friedrich, Teréz Gerszi, Walter Gibson, George Goldner, George Gordon, Richard Harprath, Carlos van Hasselt, Egbert Haverkamp-Begemann, Friedrich Heckmanns, Carl Benno Heller, Christian von Heusinger, Michael Kauffmann, Martin Royalton Kisch, Ellen Konowitz, Fritz Koreny, Thomas Kren, Dieter Kuhrmann, Catherine Legrand, Christopher Lloyd, Ann W. Lowenthal, Suzanne McCullagh, A.W.F. Meij, Hans Mielke, J.R. ter Molen, Helen Mules, John Murdoch, Mary Myers, Giovanna Nepi Sciré, Lawrence Nicols, Konrad Oberhuber, Roy Perkinson, Jurriaen Poot, Anne Röver, John Rowlands, Eckhard Schaar, Peter Schatborn, David Scrase, Mary Schmidt, Werner Schmidt, Viktoria Schmidt-Linsenhoff, René Schreuder, Jürgen Schultze, Nina Serebrennikov, Joaneath Spicer, Miriam Stewart, Julian Stock, Walter L. Strauss, Margret Stuffmann, Janno van Tatenhove, Carel van Tuyll, Carl van de Velde, Mia Weiner, Eliane de Wilde, Klaus Wolbert, Joanna Woodall, and M.L. Wurfbain.

We are particularly grateful to Walter Gibson for his careful reading of the catalogue in typescript and for his valuable suggestions and comments.

At the National Gallery of Art, Diane De Grazia, Andrew Robison, and H. Diane Russell of the department of graphic arts generously shared their expertise and experience. Mary Suzor and other staff in the registrar's office capably handled transporation arrangements. We thank matter-framers Hugh Phibbs and Virginia Ritchie, and Gaillard Ravenel and his staff in the department of design and installation for the handsome presentation. Ted Dalziel, Thomas McGill, and Julia Wisniewski were unfailingly attentive to our requests for inter-library loans. We thank the department of photographic services and the photographic laboratory headed respectively by Ira Bartfield and Richard Amt for their response to our requests. Ann Bigley, Cameran Castiel, Cheryl Hauser, and Deborah Shepherd of the department of exhibitions and loans headed by D. Dodge Thompson provided vital support and coordination. Sydney J. Freedberg read the catalogue and offered helpful comments. We are especially grateful to our editor, Mary Yakush, who has brought order and consistency to our often disparate modes of expression, and also to Frances Smyth, head of the editors office. Our thanks go to Susan Lehmann for the splendid design of the catalogue. Susan Holmberg Currie, secretary in the department of Renaissance painting, not only cheerfully coped with collating numerous revisions to the manuscript, but brought her fine organizational skills to bear on assembling the list of references cited and coordinating photographic orders.

At the Pierpont Morgan Library, Charles Ryskamp has been an enthusiastic and helpful supporter of the exhibition from the beginning. Francis Mason and Lynn Thommen worked hard to secure financial support for the project. Miss Felice Stampfle, curator emeritus, has generously shared her knowledge of northern drawings throughout the preparations of this catalogue. David Wright organized the transport and the complex return shipment of the drawings. The library's drawings were photographed by David Loggie, who also provided other photographs required for publication and research. Patricia Reyes, Nancy Seaton, and Timothy Herstein were responsible for the handsome installation as well as for packing and unpacking the works. Elizabeth Wilson handled publicity and Priscilla Barker edited the library's brochure. Special thanks to Cara Denison, Stephanie Wiles, and Elizabeth Allen who, for many months, generously took over Mr. Robinson's duties in the department of drawings and prints, and also helped in various ways with the installation of the exhibition. We are most grateful to Anja Becker, volunteer in the department of drawings and prints, who graciously typed and retyped catalogue entries on the word processor, kept track of photographic orders, and organized the mounds of paper that inevitably accumulate during a project such as this. Kathryn Robinson, who has been related by marriage to this project since its inception, provided steadfast support and cheerfully endured the anxieties and disappointments engendered by several years of preparations.

Special thanks are due to those private collectors who welcomed us into their homes and allowed us to borrow their treasured drawings, and to our professional colleagues whose personal encouragement and hospitality matched the generosity of their institutions in making loans.

JOHN OLIVER HAND
J. RICHARD JUDSON
WILLIAM W. ROBINSON
MARTHA WOLFF

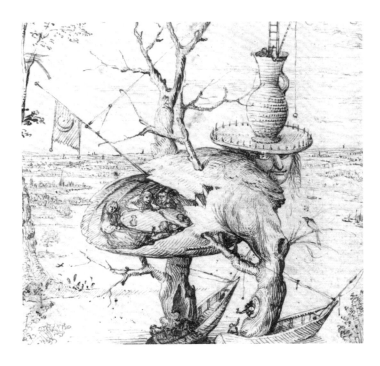

The Sixteenth Century

JOHN OLIVER HAND

The Sixteenth Century: The Historical Situation

The sixteenth century stands apart from all that preceded it. It was a period of religious and political upheaval and of remarkable economic, cultural, and scientific achievement. In the north of Europe particularly, the sixteenth century marks the transition from the late Middle Ages to what is essentially the modern era. Nowhere is this process more apparent than in the Netherlands, the region corresponding approximately to present-day Holland, Belgium, Luxembourg, and parts of northern France. Ruled by the Dukes of Burgundy, the area came under Habsburg influence through the marriage of Mary of Burgundy to Maximilian I in 1477. Their son Philip the Fair married Juana of Aragon and Castile in 1496, thus extending the Habsburg dynasty into Spain, while retaining title to much of the Netherlands. Several marriages were arranged for their daughter, Margaret of Austria, but each ended badly. Following Philip's death in 1506, Maximilian appointed Margaret to govern the Netherlands, giving her full power by 1509. She was responsible for raising the children of Philip and Juana, including Charles, the future emperor Charles V.

Born in Ghent in 1500, Charles was raised at Margaret of Austria's court in Mechelen along with his sisters Eleonore, Isabella, and Mary (his brother Ferdinand and his sister Katherine grew up in Spain). Facets of his education reflecting several of the main currents of thought in the Netherlands helped form his character and outlook. One of his tutors was Adriaen of Utrecht, deacon of Saint Peter's in Louvain, and later Pope Adriaen VI. Adriaen impressed on Charles the simple piety and devotion that had its roots in the *Devotio moderna* of Thomas à Kempis,

an integral part of religion in the Netherlands. Charles was instructed in statecraft, politics, and court etiquette by Spaniards and by members of the old Burgundian nobility. Charles' encounter with one of the latter, Guillaume de Croy, Lord of Chièvres, probably helped to engender a mistrust of France and the house of Valois. The young prince was also exposed to northern humanism through no less a person than Erasmus of Rotterdam, who resided at the court for about a year and composed for Charles the *Institutio principis Christiani (The Education of a Christian Prince)* in 1516. In accord with Erasmus' Christian humanism, the *Institutio* was an exhortation to moral behavior and sound judgment based on the precepts found both in the Bible and in the writings of classical authors such as Plato and Aristotle.

Following the death of Maximilian I in 1519, Charles was elected Holy Roman Emperor. He quickly reappointed Margaret of Austria Regent and Governess of the Netherlands; she ruled with industry and intelligence until her death in 1530. Margaret was succeeded by Charles' sister, Mary of Hungary, who governed from Brussels until 1558, the year of her death. Charles was always in need of able, trustworthy administrators, for from the very outset he traveled constantly, attempting to rule a far-flung empire that included Spain, the Netherlands, Germany, Austria, and, at times, the Franche-Comté, Milan, Naples, and Sicily as well as dominions in the West Indies, Mexico, Venezuela, and Peru.

In 1534 Charles wrote to Count Henry III of Nassau regarding the Netherlands, "These lands are rooted above all in commerce. We must not lose sight of this."[1] In the first half of the century the Netherlands was the economic hub of Europe and, as now, the most densely populated region of Europe. Commercial activity centered on Antwerp, a focal point for the import and export of goods from Europe, the Americas, and the Far East, and also the seat of the Bourse, or financial exchange.

At the same time the Netherlands was involved in the religious turmoil of the times. In the wake of Martin Luther's initial protest of 1517 and the 1521 Diet of Worms at which Charles V condemned Luther as a notorious heretic, various forms of Protestantism spread rapidly through the Lowlands. Officially the Netherlands was Catholic, and different Protestant sects were treated with varying degrees of severity. In Antwerp, for example, where there was a sizable community of Germans, the Lutherans were tolerated by the magistrates while the Anabaptists were considered dangerous and dealt with harshly. On the whole Charles V's edicts against heresy were enforced, until the Peace of Augsburg (1555), which in effect sanctioned the existence of Protestantism.

In the end, Charles V's dynastic aspirations and visions of a unified empire failed. In 1556 he abdicated; his brother Ferdinand I became Holy Roman Emperor, and his son Philip II became ruler of the Netherlands as well as Spain and portions of Italy, including Naples and Sicily. In 1558 Margaret of Parma, illegitimate daughter of Charles V, became Regent and Governess of the Netherlands, succeeding Emmanuel Philibert of Savoy, who ruled briefly following the abdication in 1555 of Mary of Hungary.

The second half of the sixteenth century was a period of almost continuous revolt, although it occurred in distinct phases.[2] There was increasing dissent on the part of the nobility against the economic policies of Philip, which were viewed as illegal encroachments on local privileges. The spread of Protestantism into the Lowlands, Calvinism in particular, and the ensuing attempts to eradicate it contributed to the unrest. In 1566 economic malaise and a severe food shortage coupled with the spread of organized Calvinist worship led to a collapse of governmental authority. Beginning in the late summer of 1566, and incited by the outdoor sermons of Calvinist preachers who regarded the worship of images as an idolatrous transgression of the Second Commandment, gangs of Calvinists and their supporters sacked churches, destroying paintings, sculpture, and any other images associated with Catholic worship. The iconoclasm moved northward with terrible swiftness. Antwerp was hit on 20 and 21 August, Amsterdam's churches, which suffered greatly, were attacked on 23 August, and those of Leiden on 25 August. In some instances works of art were saved, but in the northern Netherlands particularly many paintings were destroyed. Philip II sent the Duke of Alva and ten thousand Spanish troops to the Netherlands to drive out the Calvinists and replace the powerless Margaret of Parma. A second wave of revolt occurred in 1572 when fighting broke out in the provinces between the government and the exiles, many of them Calvinists.

The final phase of late-sixteenth-century revolt saw the increasing separation of northern and southern provinces. Led by William of Orange, the 1579 Union of Utrecht was an alliance of six northern provinces against Philip II's authority, and the Spanish sovereign was again repudiated by the States General in 1581. The surrender of Antwerp to Spanish forces in 1585 essentially divided the Netherlands into a Catholic south and a Protestant north, and the defeat of the Spanish Armada in 1588 crushed any Spanish/Catholic hopes of recapturing the north. During this period many people, including artists, migrated northward to escape religious persecution or to earn a better living. In what might be viewed as the eco-

nomic triumph of Calvinism, Amsterdam replaced Antwerp as a mercantile and financial center. De facto independence for the north was achieved with the Truce of Antwerp, signed on 9 April 1609.

The Sixteenth Century: The Artistic Situation

Any attempt at a coherent, unified explanation of sixteenth-century Netherlandish art immediately runs into something like the Heisenberg Principle. Many diverse strands of influence occurred simultaneously. The analysis of any one strand would exclude others that are equally important. This magnificent complexity and variety endows the century with a special dynamism that resists all efforts at neat or easy organization.[3] Only a brief chronological discussion of the major personalities and tendencies of the period can be attempted here.

Karel van Mander's *Schilder-boek*, first published in 1604, is frequently mentioned as the primary source of information on Netherlandish art and artists. Artist and theorist as well as biographer, Van Mander is not always totally accurate, especially for earlier artists, but he remains the point of departure for the study of art in the Low Countries. Other contemporary writings that contain valuable information are Ludovico Guicciardini's *Descrittione di tutti i paesi bassi, altrimenti detti Germania inferiore* (Antwerp, 1567), and Dominicus Lampsonius' *Pictorum aliquot celebrium Germaniae inferioris effigies* (Antwerp, 1572).

The art produced in the Netherlands at the end of the fifteenth century is essentially late medieval in style. Even while a new conception of the figure and its relationship to the space surrounding it was taking place, figural proportions were still Gothic and perspective was arrived at on an empirical rather than rational basis.[4] It is something of a shock to realize that Hieronymous Bosch died only four years before Raphael, so different are the worlds they represent. Nevertheless, Bosch's art is of great importance for the sixteenth century on several accounts. It was in the sixteenth century that drawing attained independent status, and as far as we know Bosch was the first major artist to make drawings that are complete in themselves, that are neither quick sketches nor compositions preparatory to work in another medium such as painting. The purpose of such drawings as *The Tree-Man* (Albertina, Vienna, fig. 1) is unknown. While we know almost nothing about the collecting of drawings at this early date, the possibility that they were made for connoisseurs, either as gifts or for sale, should not be excluded. That Hieronymous Bosch was one of the greatest landscapists in the Netherlands is evident as much from the drawing *The Tree-Man* as from his paintings. His landscapes display a sensitivity to subtle atmospheric effects as well as to the depiction of dramatic, fiery skies and bizarre vegetation; space is fluid and infinite, defined and enveloped in tonal gradations. The representation of nature and the increasing independence of landscape as a genre is one of the main threads woven into the complex fabric of sixteenth-century Netherlandish art.

Another strand at the beginning of the century important to an understanding of Netherlandish art is the conscious quotation from great masters of the past that is evident in the paintings of Quentin Massys and Gerard David (also seen in David's drawing after Jan van Eyck, cat. 44). The admiration for the achievements of an earlier generation doubtless affected artist and patron alike.

The patronage of works of art in the Netherlands was not confined to one group or social class, but included the nobility and aristocracy, who demanded not only paintings, but large decorative ensembles such as tapestries; the various guilds, who commissioned altarpieces often destined for the chapel of their patron saints; and the merchant and middle classes, who requested portraits, devotional pictures, and paintings of secular subjects. The general level of prosperity and interest in art enabled sixteenth-century Netherlandish artists to produce not just on commission but on speculation—for sale in the marketplace—as well.

At the turn of the century the thriving new commercial center of Antwerp, previously undistinguished artistically, began to attract artists from many different localities. In this city particularly, diverse elements came together to produce a new style. Max J. Friedländer, one of the first to analyze the style, coined the term "Antwerp Mannerism" to describe the exaggerated postures, extravagant costumes, and fanciful, spatially ambiguous architecture that are its components. Baldass' appellation "painting of the late Gothic style" is perhaps less pejorative and more descriptive, but is less used.[5] Most of the Antwerp mannerists have resisted identification and their origins remain obscure; altarpieces documented to 1513 and 1514 are among the earliest manifestations of the style.[6] Standing apart from the general run of anonymous artists, who are often content merely to repeat formulas, are the two most talented practitioners of Antwerp mannerism, Jan Gossaert and Jan de Beer.

The two most important figures active in the first third of the sixteenth century are Jan Gossaert and Lucas van Leyden (cats. 63–68 and 78–81). Of different artistic temperaments, both were virtuosi who

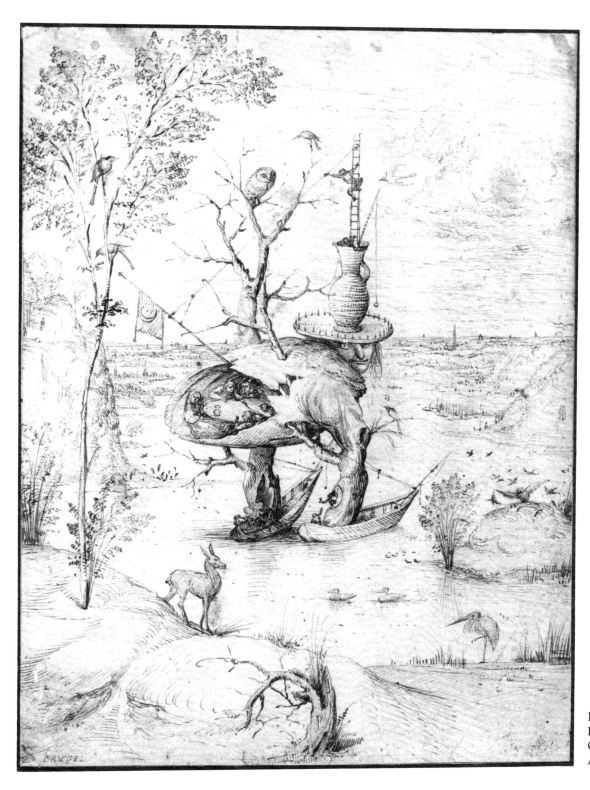

Fig. 1. Hieronymus Bosch, *The Tree-Man*, Graphische Sammlung Albertina (Fonds Albertina)

enriched and expanded the vocabulary of Netherlandish art. First mentioned in Antwerp in 1503, Jan Gossaert's earliest works are intimately connected with Antwerp mannerism—he may have been one of the pioneers in formulating the style. In 1508/1509 Gossaert accompanied his patron Philip of Burgundy to Rome where he recorded antique statuary and architectural monuments. The importance of this trip is twofold: Gossaert was the first Netherlander to unite classical, archeologically correct style and details with classical subject matter, and his journey opened the door for an ever-increasing number of Netherlandish artists who went to Italy to study antique and contemporary art firsthand. The antiquarian interest of Gossaert's patrons was not an isolated phenomenon; the increased desire to have direct access to classical texts and images was an important facet of northern humanism.

Although he was an excellent painter, Lucas van Leyden's fame rests more on his engravings, woodcuts, and drawings. Technical mastery was combined with a vigorous realism to produce works that are characterized by unusual narratives, often involving a moment of choice, or an inversion that places the main action in the background. Lucas inserted genre elements into religious scenes also depicting purely secular themes, such as card playing, that have moralizing overtones. Lucas apparently never went to Italy; his knowledge of Italian art came from prints. Marcantonio Raimondi's engravings provided Lucas with Italianate figures and influenced his technique in the 1530s. Italian artists, including Raimondi, were influenced, in turn, by Lucas' prints. Lucas was also strongly affected by the graphic art of Albrecht Dürer and in 1521 traveled to Antwerp specifically to meet the German master, who journeyed to the Netherlands in 1520–1521. Lucas probably met Gossaert in the 1520s as well, for his late works reflect both the style of Antwerp mannerism and of Gossaert's massive figures.

The meticulous diary that Dürer kept of his journey is an important primary source of information about Netherlandish art and artists. From it we learn that Dürer met with artists such as Joachim Patinir and Dirk Vellert and that quantities of Dürer's prints came into the hands of artists and collectors through gift, sale, or trade. Dürer's prints and the paintings that he executed in Antwerp, such as the *Saint Jerome* (Museu Nacional de Arte Antiga, Lisbon) had a profound and lasting effect on art in the Netherlands.[7]

The art of Italy was an even more significant factor than the example of Albrecht Dürer in determining the character of Netherlandish art in the sixteenth century. Flemish artists were quick to explore the formal and expressive possibilities of Italian High Renaissance and mannerist works, but both the Netherlanders' choice of models and their manner of response varied greatly. It is fascinating to observe the permutations that result from the interaction of individual temperaments, indigenous Netherlandish styles and traditions, and differing Italian sources during this period. The term "Romanism" is often used to describe this trend, which gained momentum in the 1520s and particularly in the 1530s to the 1550s. Like many labels it is not wholly accurate, but it does indicate a change of emphasis and interest from the preceding late Gothic style.

Bernard van Orley is usually called a Romanist, and while there is no evidence that he ever went to Italy, Italy came to him in the form of Raphael's cartoons for the tapestry series of *The Acts of the Apostles*, which were in Brussels, where the series was woven, from 1516 onward. In Raphael's tapestry cartoons Van Orley found not only the Renaissance concern for harmonious figural groupings, but also the expressive qualities of the human figure as it twists and turns in space. The primary example of Van Orley's Romanism is the *Vertu de Patience*, or *Job*, altarpiece of 1521, which achieves an unprecedented level of emotional power by means of muscular, energetic figures, recalling both Raphael and Michelangelo, which seem to explode out of the confines of the lavishly ornamented, Italianate architectural setting.

In his later years Van Orley was less involved in the actual production of art than in the creation of designs for stained glass and tapestries executed by other craftsmen. It was in this activity that Van Orley came closest to the Renaissance conception of the artist as creator of ideas, a conception in which imagination was as important as execution. In the paintings, drawings, and tapestry designs of Pieter Coecke van Aelst, who presumably studied with Van Orley and traveled to Italy and the Levant, we find greater fluency, but a basically similar style in which motifs from Raphael and Leonardo are sometimes uneasily joined to exaggerated contrapposto postures that often owe more to Antwerp than to Italian mannerism.

There is something noble about both the art and life of Jan van Scorel, who was an ecclesiastic and linguist welcome in humanist circles. He was well traveled and was acquainted with the soft, atmospheric effects and the emphasis on landscape of Venetian art. Thanks largely to an appointment in 1523 as curator of the Vatican art collections, he had direct contact with antique statuary and Renaissance and early mannerist painting in Rome. These varied influences were integrated into a unified personal style of great breadth and majesty, without the sense of disjunction between northern and southern components sometimes seen in Gossaert or Van Orley.

Van Mander praised Scorel for being the first to enlighten the Netherlanders about Italian art and working methods, and in this regard Scorel's importance as a teacher needs to be stressed. His most famous disciple was not a member of the atelier, but a slightly younger artist, Maerten van Heemskerck, who studied with him from 1527 to 1530 while both were in Haarlem. According to Van Mander, Heemskerck became so adept at emulating Scorel's new Italian-inspired manner that it was difficult to tell the paintings of the two men apart. Heemskerck was in Italy from 1532 to 1537 and, thus, in comparison to Scorel, he was exposed to a greater degree of mannerism as seen in the works of Salviati, Michelangelo, and Giulio Romano. Heemskerck's own style is nervous, eccentric, and muscular, with extreme foreshortenings and contortions of the human figure.

Heemskerck was an inventive and prolific artist and,

in numerous designs for prints as well as in paintings, he treated a wide range of religious subjects, including series on Old Testament heroes and allegories of the virtues (cats. 70 and 71) as well as classical themes in which the sketches of ruins and sculpture made in Rome were re-used. Unusual subjects, such as the 1561 painting *Momus Criticizing the Creations of the Gods* (Staatliche Museen, East Berlin), reflect the increasing sophistication and taste of Netherlandish patrons for antique subjects. At the same time Heemskerck's mythological scenes often have an allegorical or emblematic character that is derived from the artist's close association with scholars and humanists such as Hadrianus Junius and Dirck Volkertsz. Coornhert, the latter a religious philosopher and artist who made engravings after Heemskerck's drawings.[8]

It is impossible to overestimate the impact that prints had on the culture—intellectual and popular, visual and literary—of the Netherlands in the sixteenth century (we have already seen how prints by the Italians and Dürer were a major source of inspiration for Netherlandish artists in the first third of the century). At mid-century, Antwerp was a center for both book and print publishing. From 1555 onward Christoph Plantin's *Officina Plantiniana* produced humanistic and religious publications in a variety of languages,[9] while the most important source of prints was Hieronymus Cock's firm, *Aux Quatre Vents*.[10] Beginning in 1551 a steady stream of etchings and engravings issued from Cock's establishment. Paintings and drawings by a great variety of Italian artists were reproduced, including works by Andrea del Sarto, Raphael, Bronzino, Luca Penni, Giorgio Vasari, and Leonardo da Vinci. Antique art was well represented; of particular interest is the series of Roman ruins published in 1551 and etched by Cock after designs of Heemskerck and others[11] (see cat. 32, a drawing preparatory to an etching). Of equal importance is the fact that a large number of the major Netherlandish artists of the period around 1550–1570 were represented either by prints after existing works or by original designs to be reproduced by the etchers and engravers in Cock's employ. Among these artists were Pieter Bruegel the Elder, Maerten van Heemskerck, and Lambert Lombard (see cats. 28, 29, 69, 71, 76) as well as Michiel Coxcie, Frans Floris, and Marten de Vos.

In the southern Netherlands at mid-century Romanism remained a dominant force. A major figure in this movement was Lambert Lombard who worked in Liège, as both painter and architect. Lombard's antiquarian and archeological interests are manifested in his drawings after antique sculpture and in the quotation of ancient and Italian Renaissance architecture in his paintings. Probably after his return from Italy in 1538 he created an "Academy" for the instruction of young artists (about which we know very little). Of Lambert Lombard's numerous pupils, the most important and influential was Frans Floris.

The art of Frans Floris integrated Italian mannerism into a personal, internally coherent style that gave new direction and impetus to Netherlandish mannerism. Michelangelo's *Last Judgment*, which Floris saw during his trip to Italy after 1541, was a seminal influence on him. He was also impressed by other mannerists of the 1540s such as Vasari, Salviati, and Bronzino as well as by the softer tonalities of Venetian and northern Italian art. It is, however, the influence of Michelangelo that is most apparent in Floris' most famous painting, *The Fall of the Rebel Angels* of 1554 (Koninklijk Museum, Antwerp; fig. 2), with its twisting, foreshortened bodies, expressive gestures, and robust brushwork. In drawing, Floris sometimes abandoned fine pen lines for the more tonal effects of chalk and brush (often combined with white heightening on colored grounds). He was also a superb portraitist, who joined a broad handling of the brush to an essentially Northern delight in the individual and in the description of the particular. Floris became the dominant figure in Antwerp through the force of his artistic personality and through the great number of students that he trained. Van Mander cites the estimate of a former pupil of Floris that one hundred and twenty pupils had passed through the artist's atelier.

Maerten de Vos was a pupil of Floris who was trained in Rome and Florence. He also studied with Tintoretto, and his paintings show the influence of the smoldering colors and loose brushwork of Venetian art. De Vos was affected by the Antwerp iconoclasm of 1566, and a significant part of his career was spent replacing altarpieces or portions of altarpieces that had been lost, either in the 1566 wave or the second, more peaceful, wave of iconoclasm that occurred in Antwerp in 1581 with the election of a Calvinist town council. Following the iconoclasm of 1566, several works were published in defense of images—partly in response to the criticism of Protestants and partly in response to the decrees of the Council of Trent. The Catholic Church, in an attempt at self-reform, set up guidelines to ensure decorum and doctrinal and scriptural accuracy.[12] For De Vos and others this often meant closer scrutiny and control of the content of their work by church officials.

In addition to the response to classical antiquity and the experience of Italy manifested in the depiction of the human figure, there is another strand, perhaps more typically northern, woven into sixteenth-century Netherlandish art that is concerned with the representation of nature. The panoramic world land-

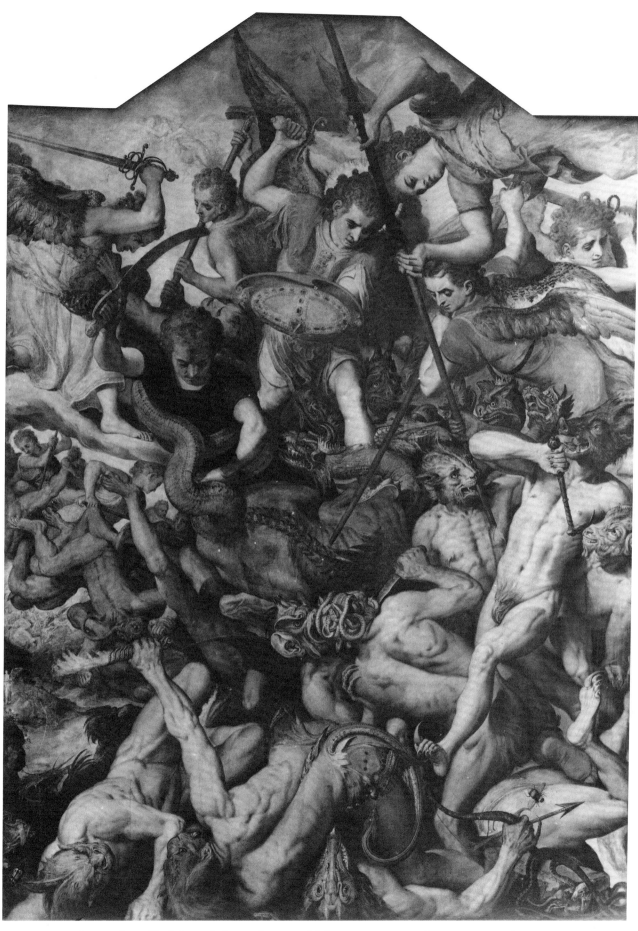

Fig. 2. Frans Floris, *The Fall of the Rebel Angels*, Koninklijk Museum voor Schone Kunsten, Antwerp
(Copyright A.C.L. Brussels)

scapes of Joachim Patinir, created in Antwerp in the first quarter of the century, although influenced by the landscapes of Hieronymus Bosch, were innovative in their manner of depicting and organizing the external world. In Patinir's work the human figure takes second place to the representation of vast spaces and of seemingly bizarre rock formations that, nonetheless, have their origins in the observation of the outcroppings that occur along the river Meuse. Patinir's vocabulary of forms, his high vantage point, and his three-distances schema were continued throughout the sixteenth century. The Patinir tradition is carried on in the drawings of Matthijs Cock, Cornelis Massys, and the Antwerp artist who was close to the Master of the Errera Sketchbook (cats. 34, 84, 8).

Pieter Bruegel the Elder, the greatest Netherlandish artist of the sixteenth century, was a genius who was at once part of his time and an exception to it. He synthesized the various tendencies operating in the first half of the century in a unique style. He was nearly an exact contemporary of Frans Floris and died a year before him. Floris enjoyed municipal and ecclesiastical patronage, lived in a splendid home, and employed many assistants and students. With one exception,[13] Bruegel never received a public commission for a painting, and no portraits from his hand survive. He painted, and perhaps made drawings, for private collectors; the public knew him through the engravings made from his designs and published by Hieronymus Cock and others.

In both painting and drawing Bruegel first appeared as a landscapist who had totally mastered the Patinir tradition, but transformed the Patinir panoramic world-view by the addition of an unprecedented power and grandeur, a new sense of observed reality—in part a result of his trip through the Alps to Italy. A complex system of parallel hatchings, short curved strokes, and dots and dashes convey atmospheric and textural effects with extraordinary delicacy. Bruegel's depictions of the natural world such as the 1565 *Return of the Herd* (Kunsthistorisches Museum, Vienna; fig. 3) are absolutely convincing as observation yet they surpass what might be called ordinary reality.

In other areas Bruegel managed to be both archaistic and progressive. On the one hand, he was able to re-create the grotesque, demonic world of Bosch; his interest in peasant folklore, proverbs, and activities was embedded in Netherlandish tradition, and his religious images often had their source in fifteenth-century Netherlandish and German art.[14] On the other hand, that Bruegel was aware of and used motifs and compositional devices from Raphael and his followers is less immediately evident, but still demonstrable, and in Bruegel's late works there is a definite Michelangelesque quality to the massive figures and

foreshortened, contrapposto poses.[15] There seems to be little doubt that Bruegel was a learned man, aware of contemporary religious and political events, acquainted with scholars and humanists (such as the geographer Abraham Ortelius), and patronized by men of wealth and prestige.

In spite of a great deal of learned historical and iconographical investigation, Bruegel's true intentions often remain hidden from us; many of his paintings and drawings hint at deeper meanings and resist precise interpretation. This quality partly derives from the fact that, even though acutely observed, Bruegel's figures are somehow abstracted and made universal. In the same way, attempts to explain Bruegel's art in terms of the philosophical or religious systems of such men as Sebastian Franck or Dirck Coornhert are too limiting.[16] Bruegel was a moralist, a satirist at times, who found in nature a grandeur lacking in man. His innovations in landscape were quickly taken up by the Master of Small Landscapes, Hans Bol (cats. 87, 14, and 15), and other, often anonymous, followers. His figure style was carried on by his son Pieter the Younger and by Marten van Cleve and Roelandt Savery, but in terms of the power and inventiveness of his compositions and the monumentality of his cooks and peasants, only Pieter Aertsen, working around mid-century, can stand comparison to Bruegel.

The last decades of the sixteenth century were a time of upheaval, division, and migration. In the southern Netherlands, the threat of religious persecution, the presence of Spanish troops who were often unruly and destructive, and the gloomy economic situation brought about the northward emigration of thousands of people. Antwerp, for example, which remained a major art metropolis, suffered in the "Spanish Fury" of 1576 and, after having sided with the Calvinists, fell to the Spanish and was sacked in 1585. Artists were among those who moved north or traveled elsewhere, to Italy or central Europe.

Netherlandish artists in Italy in the 1560s and 1570s were often strongly influenced by the developing *maniera* or late mannerist style practiced in Rome, Florence, and elsewhere by such artists as Jacopo Bertoia, Raffaellino da Reggio, Jacopo Zucchi, and Taddeo and Federico Zuccaro.[17] (Federico Zuccaro, whose extensive journeys in the early 1570s included travels in the Netherlands and England, was a dominant figure in Rome from 1575 onward). The drawings of Hans Speckaert, Anthonis Blocklandt, Joos van Winghe, and Bartholomeus Spranger (see cats. 12, 106, 107–109, 121, and 122), whatever their individual differences, all manifest the absorption of this late mannerist style. By far the most influential of this group was Spranger, who was widely traveled and had worked in Rome for Cardinal Alessandro Farnese and Pope Pius V, in Vi-

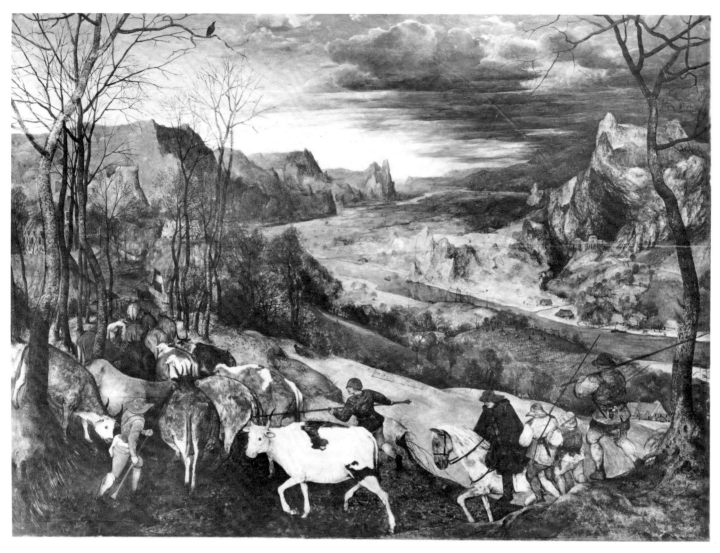

Fig. 3. Pieter Bruegel the Elder, *The Return of the Herd*, Kunsthistorisches Museum, Vienna

enna from 1575 for Maximilian II, and by 1580 in Prague for Rudolf II. Out of a variety of influences, that of Parmigianino in particular, Spranger fashioned a courtly, often erotically charged mannerism composed of elegantly contorted yet powerful figures. Although it is likely that the two could have met previously in Italy, it is known that Karel van Mander worked with Spranger in Vienna for Rudolf II in 1577 and upon his return to the Netherlands championed the Spranger style. The engravings made after Spranger's drawings, some doubtless brought to Haarlem by Van Mander, Goltzius, and others, had a tremendous impact on mannerism in the Netherlands.

At the end of the century revitalized centers of art appeared in the north. One was Haarlem where in 1583 Karel van Mander and Cornelis van Haarlem joined the virtuoso draftsman and engraver Hendrick Goltzius, who had lived there since 1577.[18] In Utrecht, where Anthonis Blocklandt lived from 1577, we also find Abraham Bloemaert from 1583 as well as Joachim

Wtewael, who was born and trained in the city and returned there in 1592 after a stay in Italy and France. Amsterdam was home to Dirck Barendsz. from 1562 onward, Cornelis Ketel from 1581, and Jacques de Gheyn II, who arrived in 1590 after studying with Goltzius. The complex and lively interchange that took place among these artists at times confounds the historian's attempt to determine precisely the source and direction of influence.

The turn of the century witnessed a resurgent interest in landscape. A major factor in this florescence was the revival in the 1590s of the landscapes of Pieter Bruegel the Elder as a model for artists. His influence lies behind the outdoor village fêtes (kermises) of David Vinckboons, the panoramic views of Hendrick Goltzius and Jacques de Gheyn II, and the forest landscapes of Paulus van Vianen (cats. 50, 59, 116, 118, and 119) as well as the early work of his son Jan Brueghel the Elder. Another key figure was Gillis van Coninxloo, who fled Antwerp around 1585 and, after

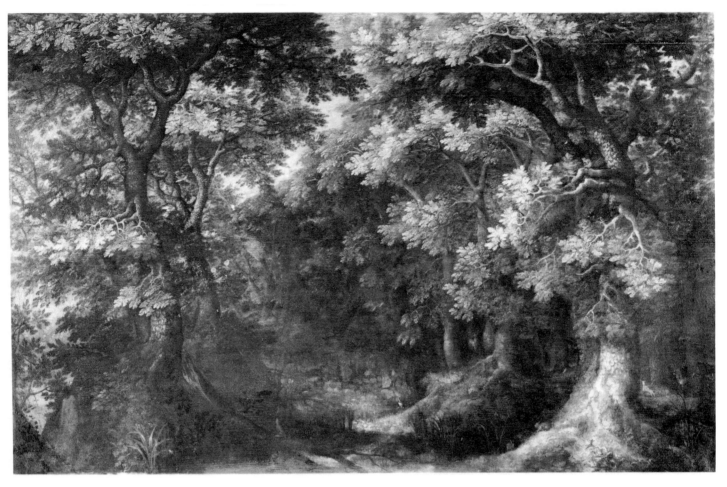

Fig. 4. Gillis van Coninxloo, *Forest Landscape*, Kunsthistorisches Museum, Vienna

joining other immigrants in Frankenthal, Germany, in 1587, settled in Amsterdam in 1595. His landscapes of dense, leafy forests (fig. 4), which are mannerist in composition but realistic in effect, were a new specialty and quite influential in both southern and northern Netherlands.

In discussing landscape, the extent to which artists traveled, whether out of desire or necessity should be underscored. While the Netherlands imported Italianate ideals of figural beauty, it also exported a particularly northern love of and approach to depicting nature. The brothers Matthijs and Paul Bril worked in Rome from the mid- or late 1570s, and collaborated as landscape specialists on fresco decorations that influenced Italian artists. Paul, especially, was a major point of contact for the stream of northern artists who came to Rome. Jan Brueghel, too, was in Rome by 1592 (see cat. 23). From the pen of Roelandt Savery there exist not only townscapes of Prague, but also depictions of the rugged, picturesque scenery in the Tyrolean Alps, where, according to Sandrart, Savery was sent by Rudolf II to make drawings of the wonders of nature. The peripatetic Joris Hoefnagel, in ad-

dition to exquisitely detailed miniatures, also made topographic views of cities. Hoefnagel's devotion to the accurate description of nature reflects more than just the scientific naturalism of the day, for the artist saw himself as an exponent of the tradition of Pieter Bruegel, and perhaps even as his successor.[19]

A discussion of the late sixteenth century would not be complete without brief mention of two interesting phenomena. One was the ability of artists to work simultaneously in seemingly contradictory styles. Karel van Mander, Paulus van Vianen, Hendrick Goltzius, and Jacques de Gheyn II are represented in the exhibition by both mannered and realistic drawings. This ability to create in varying styles is seen by Kaufmann and others as related to a theory of modes—that is, different types of representation were appropriate to different subjects.[20] Some critics and historians have suggested that there are hierarchies in the visual arts that correspond to those found in the literary genres of rhetoric or poetry.

A second phenomenon was the revival of earlier styles at the turn of the century. Perhaps the most striking examples are those drawings by Jacques Sav-

ery that so skillfully copy Pieter Bruegel that, until very recently, they were considered original (cats. 97-99). Another instance of the revivalist attitude is Goltzius' creation of engravings in the style of Lucas van Leyden and Albrecht Dürer (perhaps related to the more general "Dürer Renaissance" that occurred in both Germany and the Netherlands).[21] Although not fully understood, this archaism, like that at the beginning of the century, doubtless stemmed in part from a desire to preserve continuity and from a genuine admiration for past achievements. A patriotic element may also have been involved; the implication being that the older Netherlandish artists were as worthy of copy and study as the Italians. The ability to work in an earlier style may also have been related to the concept of modes and served as an expression of the artist's virtuosity.

By 1609/1610, the terminus for this exhibition, new forms of art and new energies were making themselves felt; both realism and mannerism were in a process of transformation into the style we call baroque. Differences between northern Holland and southern Flanders became more apparent. Art in Flanders was essentially conservative; the Floris style continued to be practiced until the end of the century and the mannerism of an artist like Otto van Veen, who was trained by Federico Zuccaro, moved increasingly toward classicism. With the exception of Joos de Momper, on the other hand, Holland was the center of innovative landscape. It is perhaps not too much of an overgeneralization to say that realism became simpler and more direct, as can be seen at times in the work of Goltzius and de Gheyn. Netherlandish artists in Italy now looked not to the late mannerists, but to the Carracci and the extraordinary naturalism of Caravaggio. That a new era had begun in 1609/1610 is immediately evident in Peter Paul Rubens' *The Raising of the Cross* (Antwerp, Cathedral of Our Lady) and Frans Hals' early portraits, works created in these years.

1. Brandi 1980, 346–347.
2. An excellent history of the period is Parker 1985.
3. A comprehensive analysis of Netherlandish art for the entire century remains to be written. Von der Osten and Vey 1969 is chronologically complete, but is restricted by the necessity of covering painting and sculpture in Germany as well. Surveys of northern Renaissance art such as Cuttler 1968 and Snyder 1985 end before the last quarter of the century. Van Puyvelde 1962 is more complete, but curiously organized.
4. See the perceptive essay by Philippot 1962.
5. Friedländer 1915; Baldass 1937b. Apart from the excellent study of Jan de Beer by Ewing 1978, Antwerp mannerism has been studied only sporadically.
6. Adriaen van Overbeke's altarpiece for the church in Kempen, West Germany, is documented to 1513 (Von der Osten and Vey 1969, 155), and the painted shutters that accompany Jacob van Cothem's carved *Lamentation*, done in 1514 for the high altar of the Abbey at Averbode, are mannerist in style (Oudheidkundige Musea, Antwerp, reproduced in Voet 1973, 365). See the essay Jan Gossaert and the New Aesthetic, page 14.
7. Dürer's influence on Netherlandish art is extensively discussed by Held 1931.
8. Veldman 1977a, 55–93.
9. See Voet 1969–1972 and Voet 1980–1983.
10. See the comprehensive study by Riggs 1977.
11. Riggs 1977, 256–266, nos. 1–25.
12. The relation of paintings to the iconoclasm and to the criticism and the defense of imagemaking is discussed in Freedberg 1976a and 1976b.
13. Van Mander, *Schilder-boek* 1: 260–261, reported that at the end of his life Bruegel was commissioned by the magistrates of Brussels to depict the digging of a canal between Brussels and Antwerp, but died before the project was completed.
14. Bruegel's archaism is discussed in the context of his painting of *The Death of the Virgin* (Upton House, Banbury) by Urbach 1978; see also Grossmann 1973.
15. Grossmann 1961; Vanbeselaere 1944. As noted by Grossmann 1973, 147, Bruegel's borrowings are so subtly and completely integrated into his vocabulary that they are often hard to detect.
16. A perhaps extreme example of this approach is Stridbeck 1956. I find Boon's suggestion more appealing, in Florence 1980–1981, xx, that the Erasmian ideal of self-knowledge is a leitmotif in Bruegel's work.
17. A great deal has been written on mannerism, but for definitions and discussions of mannerism and *maniera* see Freedberg 1965, Shearman 1967, and Miedema 1978–1979.
18. The notion that these three artists formed an "Academy" in Haarlem, which was based on Italian models and where they drew from the model, is often discussed, but is mentioned only in the anonymous biography that accompanied the 1618 edition of Van Mander's *Schilder-boek*; see Miedema 1973, 2: 303.
19. Kris 1927, 243–244; Hendrix 1984, 22 and 28–29.
20. Kaufmann in Princeton 1982–1983, 19–25; the phenomenon is not confined to northern European artists, as is evident from the work of Jacopo Ligozzi (1547–1626), who produced both mannerist religious paintings and painstakingly detailed, naturalistic plant and animal studies.
21. Reznicek 1961, 98–99.

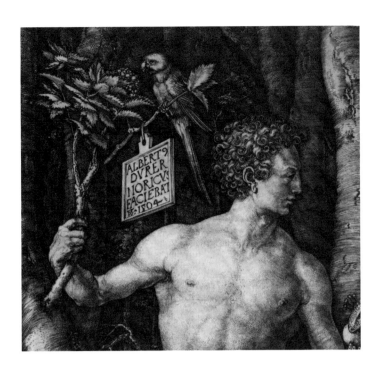

Jan Gossaert and the New Aesthetic

J. RICHARD JUDSON

The art of the sixteenth century in the Netherlands was characterized by several important stylistic trends; the most important of these was mannerism. In the Netherlands, the term mannerism generally has been applied to the art created around 1580.[1] This date seems too restrictive, however, and should be moved back to the end of the first decade of the sixteenth century when mannerism first appeared in the work of Jan Gossaert shortly after he left Antwerp to join the court of Philip of Burgundy in Middelburg. Gossaert's early influence was of exceptional significance for the development of mannerist art in the Netherlands.

There had been no strong artistic tradition in Antwerp in the fifteenth century, but, because of its extraordinary rise in the sixteenth century as the main trading center of northern Europe, Antwerp became a mecca for artists, surpassing the former artistic centers of Bruges and Brussels. Practically every artist of any importance in the Netherlands in the early sixteenth century spent some time there.[2] The influx of artists from many regions resulted in an exceptionally varied and complex artistic milieu from which emerged the aesthetic that dominated the Netherlands for the remainder of the century.

The main styles present around 1500 have been defined broadly. The most conservative group of artists continued the ideals of Rogier van der Weyden, who placed graceful, elongated, curving, and emotional figures in a shallow space close to the foreground. Rogier's *Deposition* (Prado, Madrid; fig. 1), originally executed for Louvain's Corporation of Crossbowmen in the early 1430s, was copied continuously throughout the fifteenth and early sixteenth centuries.[3] A second group of artists studied the works of Robert Campin and Jan van Eyck in their effort to break away from Rogier van der Weyden's dominance. Among them were Gerard David and Jan Gossaert, who were

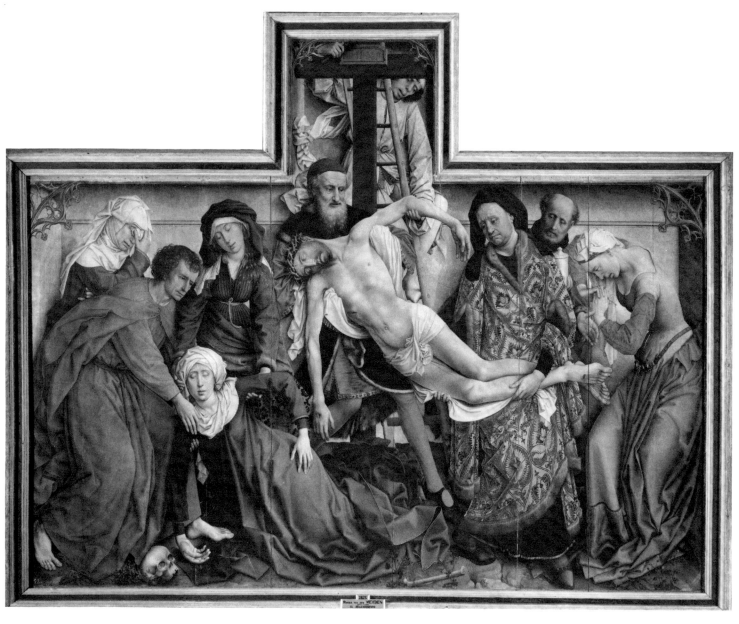

Fig. 1. Rogier van der Weyden, *The Deposition*, Museo del Prado, Madrid

searching for ways to paint rounded and monumental forms placed in a readable space.[4]

The third, and perhaps most important, group continued and elaborated upon an existing Gothic style that emphasized decorative expression. This style began to be evident late in the fifteenth century outside of Antwerp in the works of such artists as the Master of Saint Gudule, the Virgo Inter Virgines Master, the Master of the Saint Lucy legend, and Geertgen tot Sint Jans.[5] These painters emphasized expressionistic elements, and by the second decade of the sixteenth century the style referred to by Max Friedländer as "Antwerp Mannerism" came into being.[6] The mannerist artists produced distorted, thin, elongated forms in exaggerated, decorative poses and placed them in ambiguous spaces, surrounded by inventive com-

binations of medieval and antique architectural forms. The sole aim was to create a novel effect. The vocabulary of this style, while continuing certain Gothic principles, produced extreme and artificially expressive images, a tendency that led Baldass to define it as the "Late Gothic Style"—a definition that seems more appropriate than Friedländer's "Antwerp Mannerism."[7]

Although the late Gothic style first appeared outside of Antwerp, its fantastic possibilities were further exploited and developed by a number of emigré artists working in the city. Because of the dearth of dated works, it is difficult to pinpoint its earliest appearance. Max Friedländer believed that the Antwerp mannerist movement began around 1503–1504, when Jan Gossaert and Jan de Beer began working as mas-

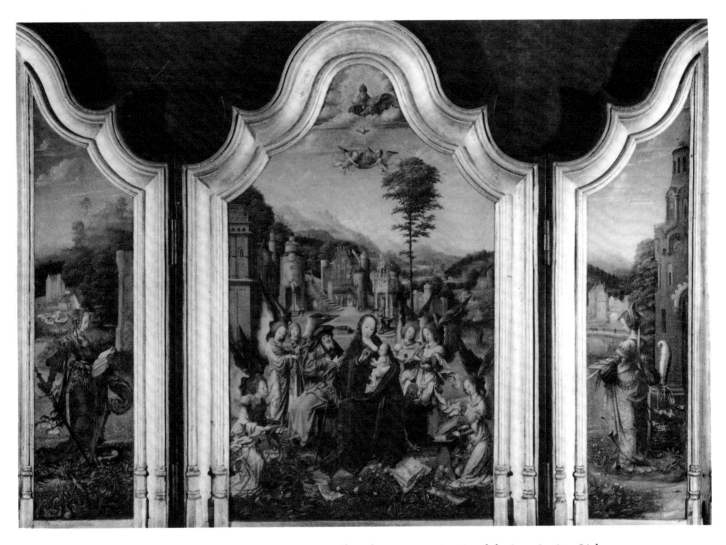

Fig. 2. Jan Gossaert, *Holy Family with Saints Catherine and Barbara*, Museu Nacional de Arte Antiga, Lisbon

ters in Antwerp,[8] but the first fully documented picture in this style, by Adriaen van Overbeke for the Church at Kempen, Westphalia, could not have been painted prior to 1513, the year of the contract for the commission.[9] The 1513 date for the earliest documented work in this style does not, however, negate Friedländer's contention that Antwerp mannerism began earlier, around the time that Jan Gossaert (1503), Jan de Beer (1504), and Adriaen van Overbeke (1508) became masters in Antwerp's Guild of Saint Luke.[10]

Gossaert's *Holy Family with Saints Catherine and Barbara* (Museu Nacional de Arte Antiga, Lisbon; fig. 2), for example, contains all of the characteristics associated with the late Gothic style, but its date has been the subject of considerable discussion. Friedländer believed it to have been executed around 1505,[11]

and compared it favorably with Gossaert's drawing of the *Mystic Marriage of Saint Catherine* (Statens Museum for Kunst,Copenhagen; fig. 3), which Winkler had dated from the same time.[12] Von der Osten, on the other hand, dated the work c. 1510–1515.[13] The elegant, decorative figures with flowing drapery, however, are very different from the more substantial forms used by Gossaert in works executed after 1509.[14] Friedländer's date, therefore, seems to be more accurate.

The same accentuation on the excessively ornamental is also characteristic of Jan Gossaert's Antwerp contemporary, Jan de Beer. As in the case of Gossaert, De Beer's works are not dated. From his preserved oeuvre, however, it appears that Jan de Beer worked exclusively in the late Gothic style from the

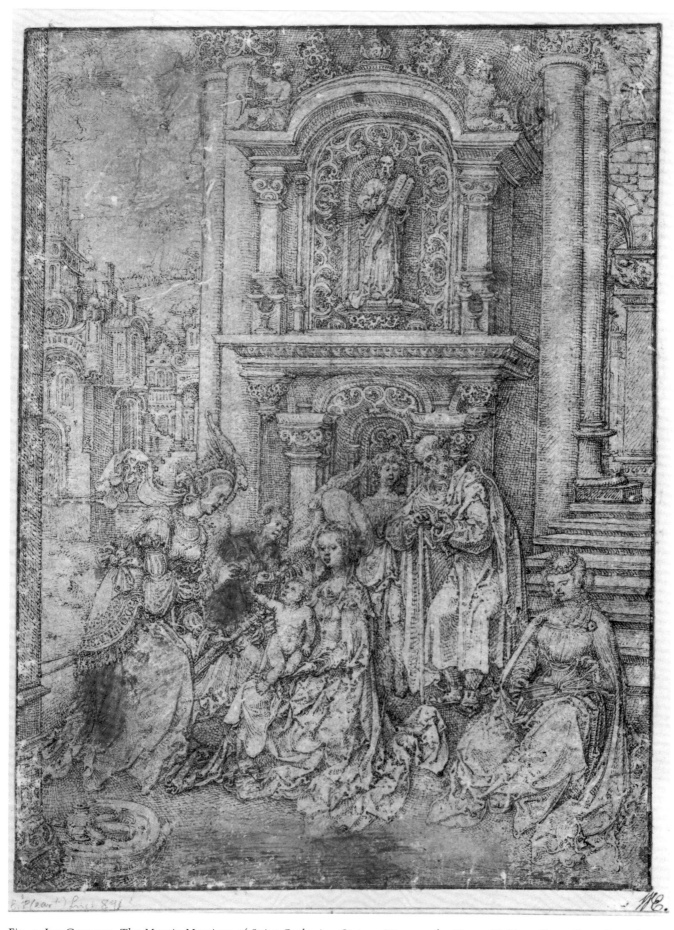

Fig. 3. Jan Gossaert, *The Mystic Marriage of Saint Catherine*, Statens Museum for Kunst, Kobberstiksamling, Copenhagen
(Copyright Hans Petersen)

very beginning.[15] This artistic style, which seems to have started in Antwerp during the first decade of the sixteenth century, did not reach Leiden, the main art center of the northern Netherlands, until shortly after 1510, when it became more and more evident in the oeuvre of Cornelis Engebrechtsz.[16]

The late Gothic style was predominant in the Netherlands until the last years of the second decade of the sixteenth century, when a new style, mannerism, suddenly emerged. This innovative aesthetic became the governing force of the later sixteenth century. The use of the word "mannerism" and its meaning have been hotly debated during the last twenty-five years.[17] The term is defined by modern writers such as Smyth as a "subjective art expressing a spiritual situation through anti-classical forms, deformation and abstraction,"[18] and by Shearman as the "stylish style" or a "style of excess."[19] Miedema, on the other hand, rejects the notion that mannerism should be interpreted as "style" and prefers to describe it as a "working method."[20] However it is defined, the art produced by the northern mannerists is very different from that of the Antwerp mannerists. Although a similar vocabulary can be used to describe them—words such as grace, complexity, and preciousness[21]—the northern mannerist images contain a most important element not present in the late Gothic or Antwerp mannerist works—the incorporation of the antique. Mannerist figure drawing in the Netherlands, beginning with Gossaert's 1509 drawings after ancient sculptures in Rome (cat. 64) and his 1516 painting of *Neptune and Amphitrite* (fig. 4), is based on a study of antique figures and architecture that imparts a sense of the substantial not present earlier.

By the beginning of the sixteenth century in Italy, artists were already involved in the study of antiquities and were especially attracted by the variety of styles in the newly discovered figure sculptures and reliefs from the ancient world. These works contained graceful, refined, and elegant forms, sometimes rendered ideally, in a straightforward way, and at other times oddly rendered, in an exaggerated manner.[22] According to Giovanni Battista Armenini's treatise on painting published in 1586, the study of the antique was of the utmost importance, and the student learned more from copying "statues, [reliefs on] arches and sarcophagi" than from anything else because they "impress themselves on the mind by being more certain and true."[23] Armenini writes elsewhere that the best examples of the antique are the *Laocoön, Hercules, Apollo,* "the great Torso" (*Belvedere Torso*), *Cleopatra, Venus,* and the *Nile,* all of which are found in the Belvedere of the Papal Palace in the Vatican.[24] Giorgio Vasari, the Italian sixteenth-

century painter and biographer, praised the "antiquely modern and the modern antique in painting."[25]

The new interest in using as models recently unearthed antique Roman sculptures played an equally important role in the stylistic changes in the Netherlands. The introduction of this new trend to early sixteenth-century Netherlandish art helped transform late Gothic ideals into a mannerist style. Although the classical concept of ideal form appears to have been the starting point for the new art of the Netherlands, the study of it was responsible for an aesthetic that stressed exaggeration and ornament. The new Northern mannerist style first appeared in the Netherlands in the work of Jan Gossaert, who also played such an important role in the development of the late Gothic or Antwerp mannerist trend.

In the fall of 1508, Gossaert traveled to Italy with his patron, the early sixteenth-century humanist, Philip of Burgundy. They visited Verona, Mantua, and Florence, and arrived in Rome on 14 January 1509. There Gossaert made for his patron drawings of the famous antique monuments,[26] among which four are extant: the *Spinario* (Prentenkabinet der Rijksuniversiteit, Leiden; cat. 63, fig. 1), the *Apollo* (Accademia, Venice; cat. 64), the *Hercules* (heirs of Lord Wharton; cat. 67, fig. 2), and the *Colosseum* (Kupferstichkabinett, Berlin, cat. 63). In all of these drawings based on sculpture, the figures are rendered in exaggerated and ornamental poses, the anatomy is consciously distorted, and the musculature is separated into lumpy segments, accentuated by sharp contrasts of light and shadow that create decorative patterns on the surface. The drawings are clearly antithetical to the ancient ideals expressed in the works that Gossaert copied. The *Hercules* (cat. 67, fig. 2) most obviously displays these anticlassical characteristics. Gossaert drew this study after the *Hercules* originally in the Forum Boarium in Rome (now in the Palazzo Conservatori, Rome)[27] from an exceedingly dramatic angle. In doing this, Gossaert translated this Roman copy of a Hellenistic sculpture into a mannerist image and introduced the *Knollenstil* (bulbous style) into the vocabulary of Netherlandish art. The exaggerated representation of musculature in distinct, lumpy forms was likely adopted by Gossaert from earlier Italian artists such as Luca Signorelli[28] and it later became an important part of the sixteenth-century northern mannerist vocabulary.[29]

Although Gossaert's single-figure drawings after the antique were done as early as 1509, his earliest documented painting of a mythological subject was not executed until seven years later, in 1516. This painting, *Neptune and Amphitrite* (Staatliche Museen, East Berlin; fig. 4), was originally part of a large decorative scheme for Philip of Burgundy's castle at Souberg and

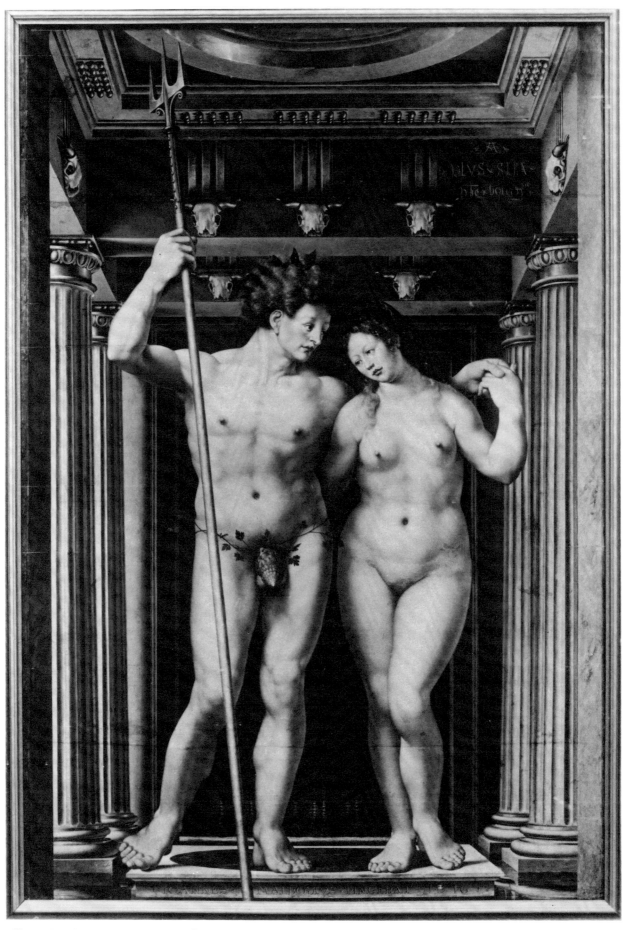

Fig. 4. Jan Gossaert, *Neptune and Amphitrite*, Staatliche Museen zu Berlin (Gemäldegalerie), Berlin, The German Democratic Republic

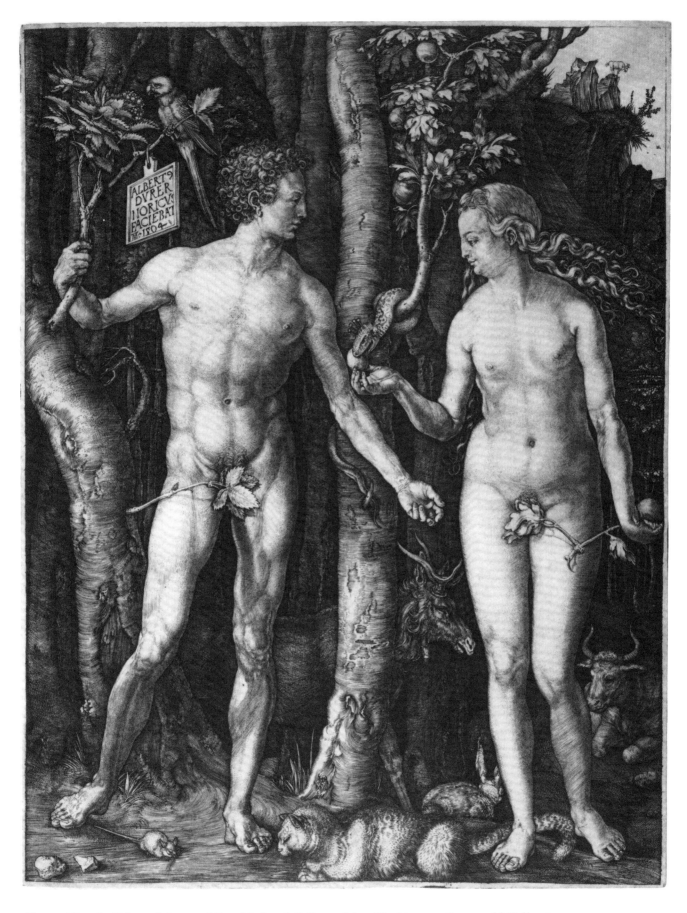

Fig. 5. Albrecht Dürer, *Adam and Eve*, National Gallery of Art, Washington, Rosenwald Collection

shows Gossaert rendering an ancient theme in a completely new way for the Netherlands. He combined the compositional arrangement of Albrecht Dürer's 1504 engraving of *Adam and Eve* (fig. 5)[30] with a grand, stonelike figure sculpture. Amphitrite is an exaggerated interpretation of Gossaert's Roman drawing made after *Apollo* (cat. 64), while Neptune is a similar adaptation of Dürer's Adam. The painting combines two elegant forms placed in an illogical space with the clashing and decorative colors of the late Gothic style. To this, Gossaert added a clear reference to the antique, but portrayed with hard shapes and strongly erotic overtones, all set in a fantastic and imaginative reconstruction of an antique cella.

The *Neptune and Amphitrite* marked the beginning of the northern mannerist aesthetic in the Netherlands. No longer based on medieval concepts, the new aesthetic used the antique as a starting point for an ingenious combination and rendering of figures, architecture, and space. Gossaert's interpretation of antique sculpture, beginning as early as 1509, preceded Italian mannerist examples,[31] and his innovations were praised by sixteenth-century writers, among whom was Lodovico Guicciardini, who wrote in his *Descrittione di tutti i paesi Bassi* (Antwerp, 1567, page 98) that Gossaert was "the first Netherlander to bring the art of history and poetry painting with nude figures to his land."

According to the late sixteenth-century art theorist and biographer Karel van Mander, Gossaert met Jan van Scorel in 1517 while working in Utrecht.[32] Scorel, following Gossaert's example, went to Italy on a study trip that began in 1518/1520 and ended late in 1523. Van Mander recorded the importance of this journey for Scorel and the Netherlands, stating that until Scorel brought his insight to the study of the best painting from Italy, the Netherlanders had worked in the dark. He goes on to say that while in Rome, Scorel studied and copied antique sculpture as well as "the excellent paintings of Raphael, Michelangelo and others."[33] Unfortunately, these copies, which were most likely drawings, have not survived. The only preserved and documented preparatory designs by Scorel are from late in his career and were drawn in pen and wash (cat. 105).[34]

There are, however, a number of paintings that date from Scorel's early post-Italian years. One of them, the *Adam and Eve* (The Marquess of Salisbury, Hatfield House; fig. 6),[35] illustrates his continued interest in Jan Gossaert, while others from this period clearly demonstrate Scorel's Italian orientation. The c. 1527/1529 *Baptism of Christ* (Frans Hals Museum, Haarlem) is a good example of the artist's debt to Italy. Van Mander described this work (then in the collection of Symon Saen, Haarlem) as containing "two very pretty female figures with very fine Raphaelesque faces."[36] There is a striking resemblance—although in reverse—in the underdrawing of the seminude woman behind Saint John to the *Apollo* in the Casa Sassi, also drawn by Gossaert.[37] A connection with Raphael is also seen in the figure on the right who bends down and grasps a piece of drapery on the ground (a direct borrowing from Raphael's *Miraculous Draught of the Fishes* in the Victoria and Albert Museum, London).[38] The complicated poses of the small figures in the distant landscape, on the other hand, recall the turning and twisting sculpturesque forms of Michelangelo, although specific quotations are not to be found.[39] In any case, Scorel's nudes are variations on those executed by Raphael and Michelangelo (themselves ultimately based on antique sculpture) but placed in exaggerated and elegant positions and characterized by overstated and brittle musculature, following the mannerist aesthetic first introduced to the Netherlands by Gossaert.[40] This style, with its even greater attention to the antique, was continued by Scorel's famous pupil and assistant Maerten van Heemskerck well beyond the middle of the sixteenth century.[41]

Jan Gossaert's importance for the spread of mannerism north of the Maas River was not just limited to artists in Utrecht and Haarlem but also appears to have reached Lucas van Leyden, the most important draftsman in the northern Netherlands. According to Van Mander, at about the age of thirty-three, Lucas van Leyden met Jan Gossaert in Middelburg.[42] Shortly after this encounter around 1527, Lucas' treatment of human forms in his engravings changed decidedly. He began to create considerably more elongated bodies, to exaggerate the muscles and distort the poses, and to make the erotic element more pronounced. These developments can be seen in the 1528 engraving *Venus and Cupid* (Bartsch 138); they reach culmination in the 1530 *Lot and His Daughters* (Bartsch 16) and *Mars, Venus, and Cupid* (Bartsch 137).[43]

While Gossaert's mannerist concepts were being further developed in the northern Netherlands in the 1520s, they were also continued in the southern Netherlands by Bernard van Orley. Although it is most likely that Van Orley came into contact with Gossaert as early as 1516 in Brussels—when they were working on the funeral decorations for Ferdinand the Catholic and painting portraits of Charles V's sister, Eleanor of Austria[44]—Van Orley does not show Gossaert's influence until 1521 in the *Vertu de Patience* altarpiece (Musées Royaux des Beaux-Arts, Brussels; fig. 7). In this altarpiece, Van Orley introduced new figure types that combined elements from Gossaert, Raphael, and Marcantonio Raimondi. Here Van Orley used large forms in contorted and exaggerated

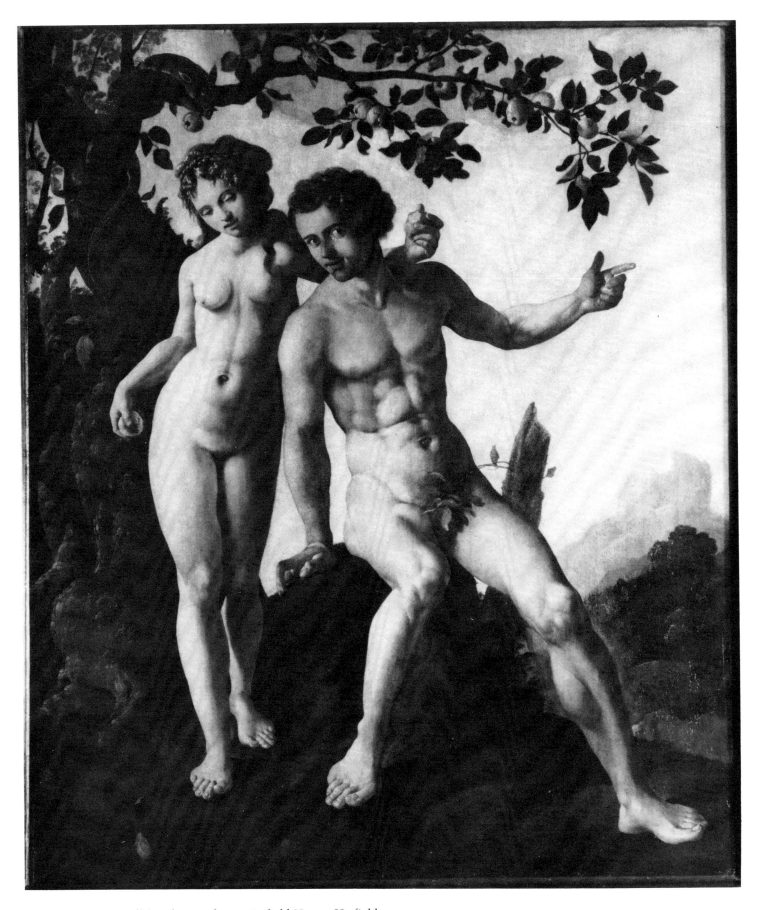

Fig. 6. Jan van Scorel(?), *Adam and Eve*, Hatfield House, Hatfield (Courtesy of The Marquess of Salisbury. Photo: Courtauld Institute of Art)

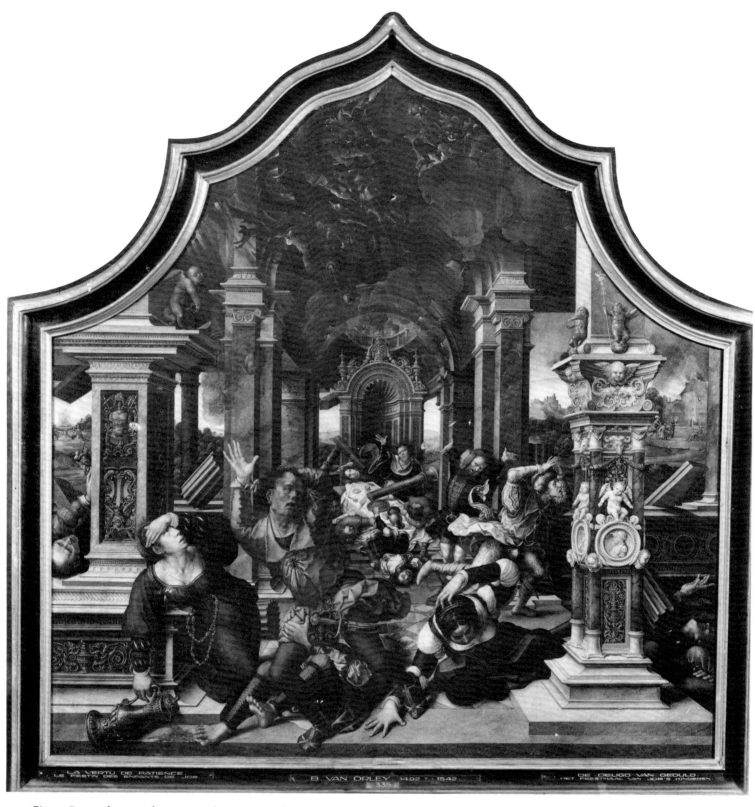

Fig. 7. Bernard van Orley, *Vertu de Patience* altarpiece, center panel, Musées Royaux de Beaux-Arts de Belgique, Brussels
(Copyright A.C.L. Brussels)

poses, placed in an illogical space, within a bizarre architectural setting decorated with strange combinations of antique ornamentation. Although it is possible to see something of Gossaert in the strong contrasts of light and shadow that create a sculptural quality in the figures, the strong movement, especially in the central panel from the center out to the sides, suggests that Van Orley also studied the Raphael tapestry cartoons that were in Brussels from 1516 onward as well as the prints by Marcantonio.[45] Van Orley's mannerist technique remained throughout his career and influenced, among others, his well-known pupil Pieter Coecke van Aelst.

Gossaert's importance for the spread of mannerism in the Netherlands and for the adaptation of the antique to enrich its vocabulary cannot be underestimated. Almost every important artist working in the Netherlands during the first three decades of the sixteenth century came into contact with him either in Middelburg or in Wijk bij Duurstede near Utrecht. He was in touch not only with Bernard van Orley, Jan van Scorel, and Lucas van Leyden, but also with Lambert Lombard, who came to work with him in Middelburg around 1525.[46] Lombard used his numerous drawings after ancient monuments as preparatory studies for his mannerist paintings and as designs for his students to copy.[47] In turn Lombard had many students who became famous and continued their master's mannerist style, with its emphasis upon the use of ancient monuments as the source for its vocabulary.[48]

Jan Gossaert and his humanist colleagues at the court of Philip of Burgundy in Middelburg, and later in Wijk bij Duurstede, had a profound influence upon the change of style in the Netherlands during the early years of the sixteenth century. The mannerist style, which began in a courtly ambience, dominated the major art centers of the Netherlands until the early seventeenth century. At that time a renewed interest in the natural world contributed to the demise of mannerism. This interest was responsible, in part, for the start of the study of natural science and the importation of the fresh artistic ideas of the Italian masters Caravaggio and the Carracci.

1. For a summary of the literature see Reznicek 1963, 247–253, who rightly states that it is not correct to call the art produced between 1580 and 1600 mannerism. Shearman 1967, 26, 28, believes that the ground for mannerism was prepared around 1540 by the Romanists, especially Maerten van Heemskerck.
2. Freidländer, *ENP*, 7 (1971): 49; Silver 1984, 6.
3. One of the earliest copies, the Edelheer altarpiece, Saint Peter's Church, Louvain, is dated 1443—see Panofsky 1953, 1: 257. One of the latest, on the other hand, was Joos van Cleve's c. 1518 *Deposition*, Philadelphia Museum of Art, Johnson Collection. For a more detailed list of copies see Friedländer, *ENP*, 2 (1967): 60 and 61.
4. For details see Panofsky 1953: 351.
5. Gibson 1977b, 82 and 223.
6. Friedländer 1915, 65–91.
7. Baldass 1937b, 117–138.
8. Friedländer, *ENP*, 11 (1974): 14.
9. Gibson 1977b, 85 and 86. A second altarpiece was purchased by the Abbey at Averbode in December 1514 and is now in the Vleeshuis, Antwerp (see Gibson 1977, 86; and Silver 1984, 54 n. 44). A third, Joos van Cleve's Saint Rheinhold Altar, was shipped to the Marienkirche at Gdansk in 1516, but was surely started earlier (see Gibson 1977, 86; and Silver 1984, 178 and 179).
10. Friedländer, *ENP*, 11 (1974): 14.
11. Friedländer, *ENP*, 8 (1972): 22, 90, no. 1, pls. 1–3.
12. Winkler 1921, 6, 11, and ill. opposite 5.
13. Von der Osten 1961, 460.
14. Compare, for example, *Saint Luke Painting the Virgin*, Národní Galerie, Prague.
15. For examples see Friedländer, *ENP*, 11 (1974): pls. 8–25.
16. For details see Gibson 1977b, 86.
17. For various points of view concerning mannerism see the following: Friedländer 1957; Smyth 1962; Shearman 1967; Freedberg 1965; Bialostocki 1970, 105–109; Miedema 1978–1979, 10: 19–45; Boschloo 1982, 35–43; Kaufmann 1982, 119–148.
18. Smyth 1962, 28.
19. Shearman 1967, 19 and 171.
20. Miedema 1978–1979, 19 and 20.
21. Shearman 1967, 25.
22. For details see Smyth 1962, 8, 15, and 17, and Shearman 1967, 177.
23. Smyth 1962, 15.
24. G.B. Armenini, *De' veri precetti della pittura*, 1586. For an English edition, see Olszewski 1977, 131.
25. Smyth 1962, 15.
26. Sanuto 1882, 7: col. 716.
27. Dacos 1964, 18.
28. Judson 1981, 338.
29. Judson 1981, 338 and 339.
30. Friedländer, *ENP*, 8 (1972): 32.
31. Judson 1985a, 18.
32. Van Mander, *Schilder-boek*, 1: 266–277.
33. Van Mander, *Schilder-boek*, 1: 262–267. In stating that Scorel was the first to study Italian painting he probably meant the first northern Netherlander (earlier in the *Schilder-boek*, 1: 200–201, he speaks of Gossaert as one of the first Netherlanders to have brought Italian ideas back to Flanders—Gossaert's trip occurred in 1508–1509).
34. For examples see Utrecht 1977, 33, 102–104, 121, nos. 31, 37, 38, and 47, and figs. 56, 69, 70, and 94.
35. Bruyn 1954, 55, 56, and fig. 3.
36. Van Mander, *Schilder-boek*, 1: 274–275. For the prove-

nance of the Haarlem painting see Utrecht 1955, 39, 40 n. 19, fig. 26.

37. For an illustration of the underdrawing, see Faries 1975, 107, fig. 13b.

38. Grosshans 1980, 99 n. 2.

39. The Michelangelo figures that most approximate those in the Scorel are present in the 1542 copy of the lost cartoon for the *Battle of Cascina*, preserved on the grisaille panel in the collection of Lord Leicester, Holkham Hall. Unfortunately, Scorel could never have seen the complete cartoon, which was cut up into parts in 1515–1516 and dispersed to various places including Mantua and Turin. For documentation see De Tolnay 1943, 211–213, and fig. 232.

40. For similarities in the anatomy of Scorel's later work and Gossaert's, see the infrared photographs and reflectogram of the executioner's legs in the bottom half of the *Burial of Saint Stephen*, Musée de La Chartreuse, Douai, illustrated in Faries 1975, figs. 23 a–c.

41. See for example Heemskerck's *Man of Sorrows*, Veldman 1977a, fig. 7. For others see Veldman 1977a, figs. 1, 2, 4, and 64, and Friedländer, *ENP*, 13 (1975): pls. 90, 91, 98, and 100–104.

42. Van Mander, *Schilder-boek*, 1: 126–127.

43. See Lavelleye 1966, pls. 163, and 173–181.

44. Friedländer, *ENP*, 8 (1972): 14, 27, 52, 63, 100, and 111, ns. 74 and 143, and pls. 61 and 120.

45. For a possible connection with Raphael, see Van Orley's twisted figure of the rich man in Hell, which compares favorably with the *Death of Ananias* tapestry cartoon in the Victoria and Albert Museum, London, in Friedländer, *ENP*, 8 (1972): 67. For a general impression of the figures in contorted poses radiating out from the center to the sides and back, see Marcantonio's c. 1513–1515 *Massacre of the Innocents*, Bartsch 21–24. The pose of the man rushing out of the scene in the left foreground with head turned back, torso moving forward, right leg bent at the knee and left leg extended back in space, appears to be an early adaptation of the *Laocoön*, which Marcantonio had engraved c. 1520 (Bartsch 268 and 353).

46. Hubaux and Puraye 1949, 65.

47. For details and bibliography see Judson 1985b, 52 and 53.

48. For details see Judson 1985b, 54 and 55.

The Function of Drawings in the Netherlands in the Sixteenth Century.

WILLIAM W. ROBINSON and **MARTHA WOLFF**

The period from 1500 to about 1610 saw far-reaching changes in the artist's view of his own role, in his relation to tradition, and in the way he prepared and sold his work. An important index of the emergence of Netherlandish artists from the medieval craft tradition is the survival of drawings in greater numbers. Another is the development of different types of drawings whose function can be tied to the more personal invention of a specific work of art. In Italy this development took place in the course of the fifteenth century,[1] and the achievements of the High Renaissance, particularly in Florence and Rome, were built on a working process involving compositional sketches, detailed figure studies, and full-scale cartoons. In the Netherlands the broad change in the function of drawings, the shift to a greater emphasis on invention and observation, took place in the sixteenth century.

The little we know about the appreciation of drawings in the sixteenth century suggests that the earliest collectors preferred finished sheets to sketches or working studies. In a letter written in 1579 to the Florentine collector Niccolò Gaddi, Joris Hoefnagel offered sheets by Dürer, Holbein, Lucas van Leyden, Joachim Patinir, Maerten van Heemskerck, Quentin Massys, and Jan Gossaert, which he praised as "tutti disegni d'Importancia et finiti."[2] The survival of a disproportionately large number of finished works, modelli, or independent drawings, as opposed to working studies—a survival inevitably reflected in this exhibition—means that the profound changes in the function of drawings during this period may not be immediately apparent. Hence, the evidence of the surviving works must be taken together with what can be deduced about artistic practice. It is appropriate, therefore, to try to sketch these changes through the varied uses of drawings in the preparation of works in different media.

Painting

At the beginning of the sixteenth century, painters' practices remained rooted in fifteenth-century traditions. The types of drawings on paper that remain from fifteenth-century Netherlandish artists are rather limited. Most appear to be excerpts or copies of authoritative compositions, forming a repertory of material to be used by the painter. As a drawn preparation for a known painting, Jan van Eyck's silverpoint portrait of Cardinal Niccolò Albergati remains isolated among surviving fifteenth-century Netherlandish drawings, and a type that is rare in the early sixteenth century as well.[3] On the other hand, the practice of making a repertory of useful material continued into the sixteenth century. An example is Gerard David's silverpoint drawing (cat. 44) showing four heads from the Ghent altarpiece. The silverpoint technique and the orderly arrangement of the elements on the page are reminiscent of earlier model books and suggest that the sheet was part of a collection of such studies. The practice of assembling material from paintings and other sources is still evident in the second quarter of the sixteenth century in the landscapes of the Berlin sketchbook.[4] Though the few surviving studies of monsters and other figures that can be attributed to Hieronymus Bosch are highly inventive, and drawn with a fluid pen line that also endows them with a three-dimensional quality, the figures are loosely grouped on the sheet and seem to be notations of ideas rather than preparations for specific paintings.[5]

Another kind of survival from the late medieval craft tradition that lasted well into the sixteenth century is the contract drawing, which served as a legal document between artist and patron.[6] These drawings were usually executed in pen with clear outlines and minimal hatching to set forth the composition and accessories of an altarpiece for the patron's approval. Pieter Coecke van Aelst's design for a triptych (cat. 37) is an example. Pieter Pourbus' 1555 contract drawing for the Van Belle triptych (fig. 1) is signed by both Pourbus and Van Belle and is inscribed with the stipulation that the Virgin's arms be crossed, an adjustment that was made in the final painting, along with other variations apparently left to Pourbus' discretion.[7]

The kinds of drawings related to paintings discussed so far do not include compositional sketches in which the artist worked out the placement and interaction of figures. The extreme rarity of such drawings in the work of fifteenth- and early sixteenth-century Netherlandish artists may result not only from accidents of survival but from the fact that the traditional narrative and devotional formulas of their paintings did not put a premium on experiments in composition. Furthermore, the underdrawing that customarily preceded the application of the paint layers of earlier Netherlandish paintings may have been one stage at which compositions were worked out and variations made on established types. Some scholars have even questioned whether fifteenth- and early sixteenth-century Netherlandish painters made preparatory drawings on paper to any great extent.[8] Thus, though Bosch has been considered the first Netherlandish artist to make compositional studies,[9] the brush drawings, heightened in white, of *The Ship of Fools* and *Death and the Miser* in the Louvre, formerly thought to be preparations for the paintings of these subjects in Paris and Washington, have recently been shown to be copies after the paintings.[10] Comparison with the fully worked-up underdrawn designs shows that the brush drawings reflect the changes Bosch introduced at the paint stage (figs. 2 and 3).[11]

The known drawn oeuvre of another of the most original painters of the early sixteenth century, Lucas van Leyden, includes only one preparation for a surviving painting, the black chalk half-length *Madonna and Child* in the British Museum, from the late 1520s, for the painting in Oslo.[12] The drawing seems to have served both as a compositional sketch and as a figure study, since Lucas worked out the placement of the figures with loose, curving strokes, then studied the effect of light on the hands, breast, and face of the Virgin through massed soft hatching lines.

The body of underdrawing only now emerging for study will yield much information about the way paintings were prepared.[13] Some observations with implications for drawings on paper can be made on the basis of studies undertaken so far, though it is essential to remember that the character of the underdrawn preparations varies greatly depending on the painter and the scale and function of the work. During the painting process artists frequently made changes in relation to the underdrawn design. The underdrawing itself might be corrected, a notable example of which is the brush and wash underdrawing of Lucas van Leyden's *Last Judgment* in Leyden, which seems to have been corrected in chalk after a preliminary underpainted layer had been applied.[14] Though underdrawings were commonly executed freehand on the smooth chalk ground of the panel, in some instances the design was transferred by pouncing fine powder through a pricked pattern. This procedure can be demonstrated for paintings associated with Gerard David, Adriaen Isenbrant, Joos van Cleve, and others, and is linked to the production of workshop replicas or copies after authoritative originals.[15] The full-scale drawn cartoons that must have been the basis for this process do not survive.

Fig. 1. Pieter Pourbus, *Notre-Dame-des-Sept-Douleurs*, Ecole Nationale Supérieure des Beaux-Arts, Paris

Independent portraits were, for the most part, not underdrawn, or at least not in techniques that can be revealed by examination under infrared light.[16] What this means about the way painters prepared their portraits is still unclear, especially since surviving portrait drawings cannot be paired with paintings apart from the isolated silverpoint of Niccolò Albergati. Yet it may be significant that in Gossaert's two versions of Saint Luke painting the Virgin, in Prague and Vienna, the saint is actually making a precise silverpoint drawing of his model, using the same procedure as in Rogier van der Weyden's painting of the same subject.[17] In contrast, Maerten van Heemskerck's later treatment of the same subject, the painting of about 1550 in Rennes, shows the artist saint employing a neutral underpainted sketch directly on the panel (cat. 69, fig. 2).[18]

In his biography of Ouwater, Karel van Mander notes Heemskerck's amazement at the painstaking and time-consuming painting technique, presumably including the layered transparent glazes, of the foun-

ders of Netherlandish painting.[19] (The implication is that Heemskerck worked more economically.) Indeed, by mid-century, changes in the way Netherlandish artists prepared their paintings had accelerated. Many painters began to employ more visible brushstrokes, modeling form by the play of areas of thicker impasto against transparent glazes through which the light ground showed. Chiaroscuro effects took on a greater importance.[20] At the same time, a stay in Italy became increasingly common and painters were inspired to copy not only the monuments of antiquity and the Renaissance, but also Italian drawing types and styles. There are indications that Netherlandish artists of this period, notably Scorel, Heemskerck, Lombard, and Floris, began to systematize their production of drawings to study poses, light, or composition, to a certain extent following Italian precedents.

Figure studies, almost wholly lacking in relation to early sixteenth-century painting, can be traced in greater number at mid-century, though surviving examples are still very rare and connections between

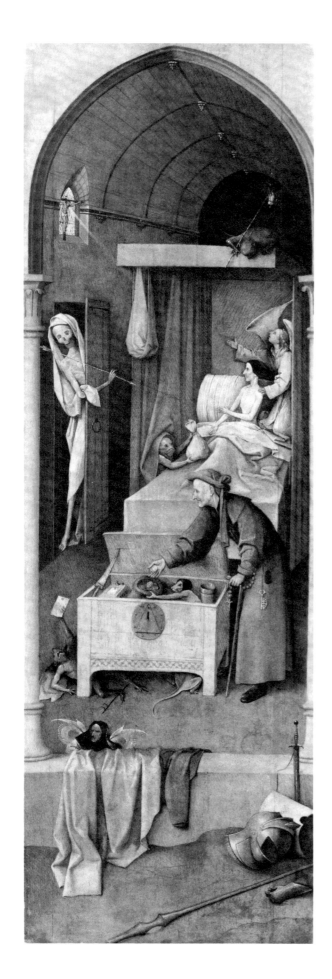

Fig. 2. Hieronymous Bosch, *Death and the Miser*, National Gallery of Art, Washington, Samuel H. Kress Collection.

Fig. 3. Hieronymous Bosch, *Death and the Miser*, infrared reflectogram, National Gallery of Art, Washington, Samuel H. Kress Collection

surviving drawings and paintings are infrequent. The existence of figure studies in red chalk by Frans Floris can be deduced from Van Mander's biography and from copies in red chalk in an album of Floris material formerly belonging to Georges Dansaert that includes figures appearing in paintings of different periods together with drawings from the antique.[21] The use of red chalk for figure studies in the circle of Romanist artists close to Frans Floris is confirmed by surviving examples by Lambert van Noort in the Lugt collection and the Louvre (cat. 89). The repetition and variation of the nude figure on the Lugt sheet, dated 1553, suggest that Van Noort was working from a live model, while the use of the figure in a later stained glass design indicates that he returned to such sheets as a source of poses. In his red and black chalk copies of Roman monuments Heemskerck seems to have been influenced by the modeling system of Michelangelo's red chalk figure studies, and a precise copy of one of Michelangelo's sheets of studies for the *ignudi* has been attributed to Heemskerck. Heemskerck also used red chalk for a head study of an old man in Berlin, though no independent figure drawings by him survive.[22]

While this type of chalk figure study probably carries Italian associations, the very few known figure studies by Pieter Bruegel (cat. 30) are all in pen and seem to relate to a northern tradition. With the exception of these and a few landscape studies (cat. 24), all the other surviving drawings by Bruegel are modelli or independent works rather than working drawings. It is, therefore, all the more necessary to compare these figure studies to the as yet barely studied body of Bruegel underdrawings.[23] That the carefully gauged interrelationship of Bruegel's weighty figures should have been worked out in successive studies and compositional drawings is most likely, but the way he adjusted his designs on the panel at the underdrawn stage and the relationship of his working method to earlier Netherlandish precedents need to be examined.

There is evidence too that at mid-century some Netherlandish painters began to make drawings to study the effect of light and shade in their paintings. Molly Faries' recent work on the paintings and drawings of Scorel and his workshop points to the probability of such a preparatory stage. In particular, she notes that the pen and wash drawing from Scorel's workshop of *Christ Blessing a Child* in Budapest is neither a copy after the painting of the same subject nor an immediate preparation for or copy after the underdrawn stage. Rather the areas of wash may be a separate guide to the laying in of light and shadow.[24] Scorel's wash drawing of *The Stoning of Saint Stephen* in the Lugt collection may have served a related

purpose in connection with the central panel of the altarpiece of Saint Stephen in Douai, probably executed shortly after 1540.[25] Another type of preparatory study that emphasizes effects of light and shade is Frans Floris' oil sketch of *Diana and Actaeon* (fig. 4) at Christ Church, which is preparatory to the painting formerly in the Middleton collection.[26] This drawing differs markedly from the rough sketches in pen and wash that can be associated with Floris' paintings (see cat. 47). It is unclear whether this tonal study of the relief of the figures reflects a conventional stage in Floris' preparatory process or is an isolated example. The monochrome oil sketch as a preparation for painting was carried further in Antwerp by Otto van Veen at the end of the century, providing a precedent for his student Rubens.[27]

Toward the end of the sixteenth century the practice of preparing a work through different stages became more widespread. In Haarlem the drawings from life made by the "Academie," consisting of Hendrick Goltzius, Cornelis van Haarlem, and Van Mander, must have been something of an innovation, judging from the account in the anonymous biography of Van Mander. Despite the intensive exchange of influences between these three artists in the late 1580s, there is general agreement that their studies did not include drawings from the live model until the early 1590s, after Goltzius returned from Italy.[28] Presumably, these were done in preparation for particular paintings and other works, as well as for practice. Though the body of Cornelis van Haarlem's chalk figure studies is lost, a surviving example in Darmstadt must have determined the contours and musculature of a figure in at least three paintings of the baptism of Christ.[29] Spranger's sheet with studies for *Fame Conducting the Gods to Olympus*, with its repeated, obsessive working out of limbs and poses and its first compositional sketch apparently for a wall decoration, is exceptional even in the surviving oeuvre of Spranger, an artist steeped in Italian practice as well as style (cat. 108).

Prints

Painters were frequently also designers of prints, and, to a degree, their drawings in preparation for paintings and prints reflect the same trends. Yet the differing requirements of the woodcut and engraving techniques and the changing ways in which they were produced also conditioned the types of drawings artists made. The making of woodcuts typically involved a division of labor between the designer and the craftsman-blockcutter, whereas, from its begin-

Fig. 4. Frans Floris, *Diana and Actaeon*, Christ Church, Oxford

nings in the second quarter of the fifteenth century, the engraving medium was the province of artist-engravers. The designer of a woodcut made a careful, finished drawing as a guide for the cutter. The few surviving uncut blocks, including the early Dürer blocks for an illustrated Terence and the partially cut *Dirty Bride* by Pieter Bruegel (fig. 5), are drawn in pen and ink on blocks prepared with a white ground. The effect of the clear black line on the smooth white ground of these blocks may have resembled some underdrawn preparations for paintings. Yet such guides may not always have been autograph. Philibert de l'Orme's 1567 treatise on architecture described the procedure whereby the designer provided the cutter with a drawing on paper to be transferred to the block.[30]

The division of labor characteristic of woodcut production came to be applied to engravings, too, at mid-century, with the advent of the print publishing house. While Netherlandish practitioners of engraving and etching such as Lucas van Leyden or Dirk Vellert made and issued their own prints, in the 1540s printmakers

like Cornelis Bos and Dirck Coornhert began to concentrate on reproductions of other artists' work, a development that culminated in Hieronymus Cock's highly productive Antwerp publishing house *Aux Quatre Vents*, which probably began operation in 1548.[31] The modelli, which were the basis for the reproductive engraver's work, form the main body of surviving drawings in preparation for prints. This may be both because of their finished character and because they were preserved as a valuable working part of the publishing enterprise. The drawings by Maerten van Heemskerck, Pieter Bruegel, and Lambert Lombard that served as models for prints issued by Cock were executed in pen and ink to provide a clear guide for the hatching strokes of the engraver or etcher. In the case of some of Frans Floris' designs for prints, such as his series of the virtues engraved by Cornelis Cort, Floris apparently made a rather fluid drawing in pen, wash, and white heightening, on the basis of which a pen and ink modello was then made by an assistant.[32]

Fig. 5. Pieter Bruegel, *Dirty Bride*, The Metropolitan Museum of Art, New York

In the last decades of the sixteenth century, as the virtuoso swelling and tapering burinwork of Goltzius and engravers influenced by him stretched the capacity of the medium to render form and light, modelli for prints were increasingly executed in techniques that stressed coloristic and chiaroscuro effects. These techniques included various tones of wash with white heightening, red chalk, which Goltzius began to use with *The Three Graces* and *Apollo and Minerva* from the Mythological and Allegorical Scenes of 1588,[33] and the monochrome oil sketch. The latter technique, while sometimes used in preparation for painting, was more frequently used for finished models for engravings. Blocklandt, Bloemaert, Spranger, Barendsz., Goltzius, and Cornelis van Haarlem all made this type of preparation (see cats. 9 and 61).

While most of the surviving drawings made in preparation for prints reflect the separation between the designer and the maker of the print, in the case of engravings the exacting technique and the original subject matter characteristic of the medium may have meant that even the artist-engravers of the first part of the century prepared their plates through a sequence of drawings. It is now impossible to determine whether and how Lucas van Leyden's process of making drawings in preparation for engravings differed from that for his paintings, with their underdrawn design. But it is noteworthy that his small oeuvre of drawings includes a highly finished preparation for the *Portrait of Maximilian* in which the use of pen and the point of the brush may have been determined by the combination of engraving and etching in the print (cat. 68, fig. 3), as well as studies for figures, and a rapid chalk compositional sketch for the placement of figures.[34] Similarly, Dirk Vellert's chiaroscuro drawing *Saint Peter Walking on Water*, on dark-gray prepared paper, is evidently a modello that studies the distribution of light and shade as well as the arrangement of the figures in the related etching.[35]

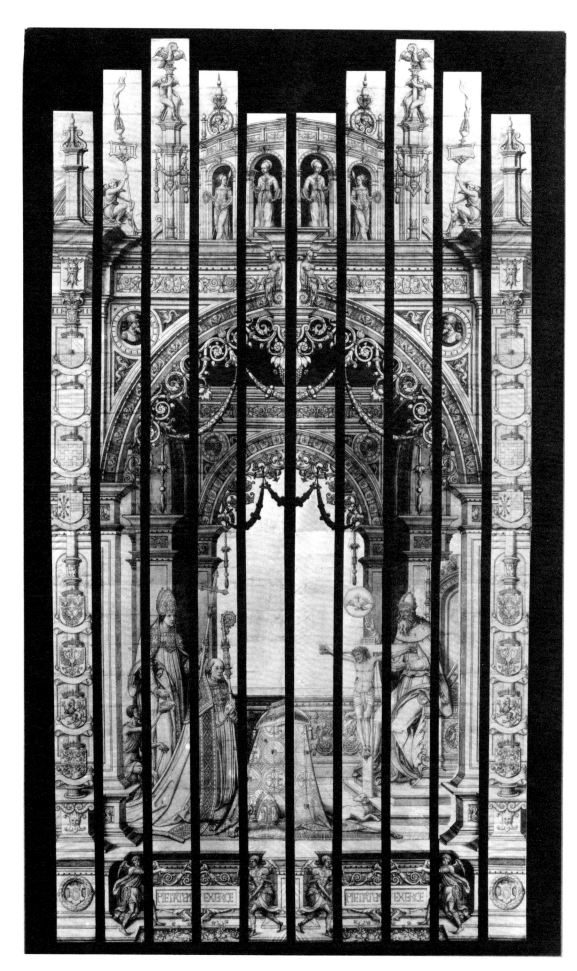

Fig. 6.
Saint Bavo, cartoon,
Rijksprentenkabinet,
Amsterdam

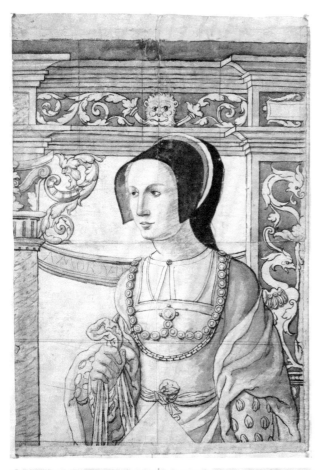

Fig. 7. Saint Bavo, cartoon, detail, Rijksprentenkabinet, Amsterdam

Glass Painting

The impact of Italian art precipitated radical changes in the decoration of monumental church windows in the Netherlands. Rejecting the medieval glass painter's flat forms and shallow settings, sixteenth-century masters projected their compositions in a deep pictorial space defined by Italianate architectural elements.[36] The autonomy and complexity of these works, as well as the fact that designer and glass painter were not invariably the same, demanded systematic procedures whose successive stages reflect the conservative craft tradition of the medium.

The design of a window culminated in a full-scale cartoon (*patroon*) that served as the glass painter's direct model. Cartoons have survived for the most ambitious glazing projects undertaken in the northern Netherlands during this period, the west window of Saint Bavo's in Haarlem (figs. 6–7) and the great windows of the Sint-Janskerk at Gouda (cat. 89, figs. 1–2).[37] Because of their enormous size and utilitarian function, the execution of large cartoons was generally entrusted to workshop assistants. Cartoons on a smaller scale might have been carried out by a skilled hand (cat. 92).[38]

The cartoon was an enlargement of the designer's modello, or *vidimus*, which, like the contract drawing for a painting, also functioned as a legal document for the project (the Latin term *vidimus*—"we have seen"—signifying that both patron and glass painter examined the drawing). On the verso of a design by Michiel Coxcie is the text of a contract stipulating that the glazier Melsen van Vianen agreed to execute a window in Malines Cathedral "following this *vidimus*."[39] A *vidimus* depicted, on a small scale, all the salient details of the composition as well as the configuration and exact intervals of the horizontal and vertical bars to which the glass panels would be secured (cat. 4).[40] Minor adjustments could be introduced between the *vidimus* and cartoon.[41] Numerous *vidimi* have survived, but this is not true of the early compositional sketches that must have preceded them. Without these, the initial stages in the design of a monumental window will remain obscure.

Lambert van Noort's red chalk drawing of 1553 showing a male nude in two positions is a rare example of a figure study associable with stained glass (cat. 89). Van Noort adapted the pose of the man at the right of the sheet, in reverse, for a soldier wearing armor in a window of 1561 in the Sint-Janskerk, Gouda (cat. 89, fig. 1).

The design of the small glass panels that decorated the walls of cloisters, sacristies, chapels, and private homes also terminated in a full-scale drawing that

the glazier reproduced faithfully.[42] These little cartoons were prepared by inventive masters who did not practice glass painting themselves, such as Jan Gossaert (cat. 65), as well as by professional glaziers such as Dirk Vellert (cat. 114). The chiaroscuro technique of black ink heightened with white on a colored ground, favored during the late fifteenth and early sixteenth centuries (cat. 65), gradually yielded around 1520 to a preference for pen or pen and wash (cat. 114). Although common during the first half of the century, studies for small glass panels disappeared by the late sixteenth and early seventeenth centuries.

Here, too, we have much to learn about the process that led up to the definitive design. Exceptionally, in Vellert's known oeuvre there are a variety of studies that offer some insight into the evolution of his compositions. In at least a few instances his method involved tracing the satisfactory parts of a drawing onto a fresh sheet, and using the traced lines as the basis for further improvement of the design. *Abraham and Pharaoh (?)* (cat. 115), a tracing considerably reworked in some passages, was certainly preceded by one preliminary study and perhaps succeeded by another. In addition to several finished designs that are presumably cartoons (cat. 114), and the moderately revised tracing *Abraham and Pharaoh (?)*, there exist instances of radically reworked tracing, pure tracing, and tracing partially shaded with wash, each possibly representing a different stage in Vellert's method of composition.[43]

Tapestry

In sixteenth-century Netherlandish tapestry design, as in glass painting, contact with Italian art—particularly with Raphael's cartoons for The Acts of the Apostles series that arrived in Brussels in 1516—stimulated fundamental stylistic changes. About 1520 Netherlandish designers, led by Bernard van Orley and, after his death, by Pieter Coecke van Aelst, began to transform the essentially two-dimensional compositions of earlier tapestries into illusionistic pictorial spaces inhabited by massive figures set in a classicizing architecture and enframed by antique ornamental motifs.

The weavers worked from a detailed, full-scale cartoon on paper, which they followed precisely, reproducing the design in reverse. Cartoons were customarily executed by specialist *cartonniers* (*patroonschilders*), although in a contract of 1546 Jan Vermeyen explicitly agreed to provide cartoons from his own hand for the cycle depicting Charles V's conquest of Tunis. Ten of Vermeyen's original cartoons, executed in watercolor over charcoal, still exist (fig. 8).[44]

Before the preparation of cartoons the designer produced modelli for the patron's approval. In the contract for The Conquest of Tunis Vermeyen promised to execute the *grans patrons* (full-scale cartoons) according to the modelli he submitted to the patron, Mary of Hungary, and he further agreed to introduce into the cartoons certain changes she requested.[45] Most designers, who did not make their own cartoons, would have to provide the *cartonnier* with a detailed modello of the definitive composition. Van Orley's drawings of 1524 for the Romulus and Remus series—monogrammed, dated, annotated with the names of several figures and sites represented, and finished in pen, watercolor, and bodycolor over chalk—must have served as models for the cartoons.[46] The later set of drawings for The Hunts of Maximilian (see cat. 90, fig. 1) may also belong to this category.

A design naturally went through various modifications before reaching the modello stage. The silhouetted principal figures in most of the known drawings for Van Orley's Nassau Genealogy series were excised from earlier studies, pasted onto a fresh sheet, and worked up into these nearly definitive versions (see cat. 91). Too few of Pieter Coecke's preparatory studies survive to permit a complete reconstruction of his working method. Since some within a single series are more summarily drawn and further removed from the tapestries than others, however, it is clear that the process involved a number of increasingly detailed designs (fig. 9 and cat. 36).[47]

As in the case of other media, the *primi pensieri* in which the artists initially jotted down the basic lines of a composition have not come to light. It seems certain, however, that the novelty of the subjects depicted by Orley and Coecke and the complexity of their designs must have demanded numerous experimental sketches. Nor do we have the auxiliary studies of heads or entire figures that some of these projects must have entailed.

Finished Drawings

Finished drawings are autonomous works of art. Most depict integrated and painstakingly rendered compositions, although even a summarily sketched single figure may qualify (cat. 95). Also known as presentation drawings, these sheets were usually given away or sold. They often bear the artist's signature or monogram, occasionally a date, and, in some instances, a verse or salutation. Their subject matter ranges widely, from historical, allegorical, and genre scenes to portraits and landscapes. The efflorescence of the presentation sheet is yet another index of the autonomy and stature attained by the art of drawing

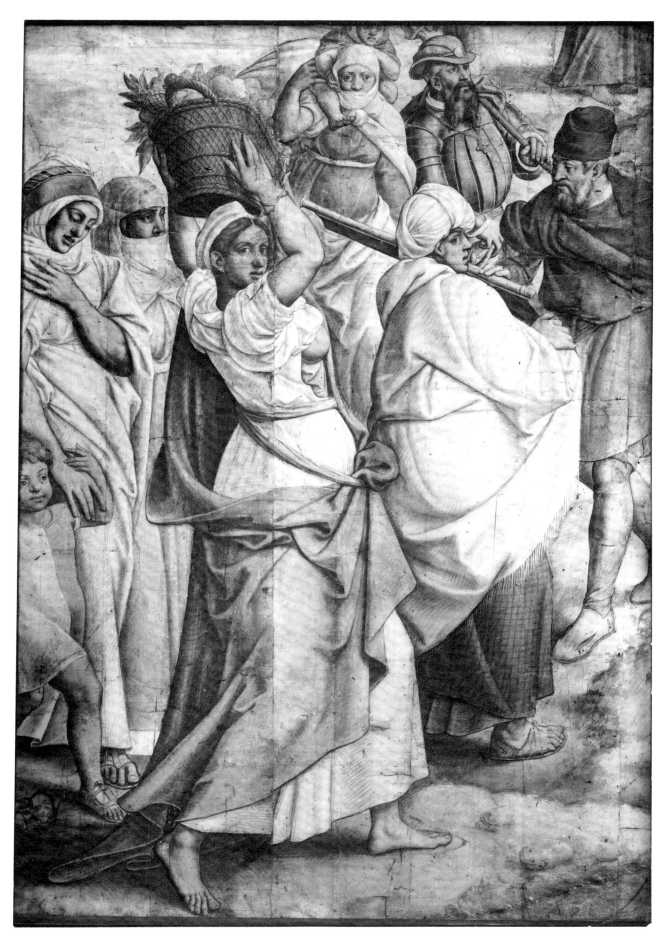

Fig. 8. Jan Vermeyen, *Withdrawal of the Army from Tunis*, detail, Kunsthistorisches Museum, Vienna

Fig. 9. Pieter Coecke, *The Stoning of Stephen*, Hessisches Landesmuseum, Darmstadt

during the sixteenth century, and implies some acceptance by artists and connoisseurs of Italian Renaissance ideas about the original design as the truest manifestation of artistic individuality. Although cultivated throughout the century, the finished drawing reached its apogee between 1580 and 1610 in the works of Hendrick Goltzius and his followers, who became its most inventive and prolific exponents.[48]

Finished compositions representing landscapes and biblical, mythological, allegorical, and genre subjects were produced by sixteenth-century draftsmen in a wide variety of styles, media, and formats. Few from the first half of the century have come down to us, though Bosch's *The Field Has Eyes, the Forest Has Ears* (cat. 17) appears to be an early example of a presentation sheet because of its autonomous character. The same holds true for his *Owl's Nest* (cat. 16) and The *Tree-Man* in the Albertina (see the essay, The Sixteenth Century, fig. 1).[49] Landscape was a popular subject for presentation drawings throughout this period. The small group of harmoniously designed and carefully drawn panoramic views in the style of Joachim Patinir by Cornelis Massys are mostly dated and signed with the monogram Massys often added to his prints (cat. 84).[50] The tradition of independent

pen drawing founded by Bosch and Massys was inherited at mid-century by Pieter Bruegel. His finished landscapes, such as the 1553 *Landscape with Saint Jerome* (cat. 27) and other drawings executed during his *Wanderjahre,* while more inventive and naturalistic, not only depict the kind of composite view favored by Massys, but also follow his practice of making large presentation sheets with the pen in a regular, linear manner reminiscent of engraving.[51] By contrast, among Bruegel's figural compositions, only *The Calumny of Apelles* of 1565 and the so-called *Painter and Connoisseur* are likely to be autonomous drawings.[52] The penwork as well as the motifs of Bruegel's autonomous landscape drawings were overtly imitated or respectfully acknowledged by authors of presentation sheets at the end of the century, including Jacques and Roelandt Savery (cat. 100 and cat. 101, fig. 1), Jan Brueghel, and Goltzius.[53]

At the end of the century, too, the taste for neatly rendered pen drawing in the style of engraving was frankly acknowledged in the virtuoso performances of the *Federkunststücke.* First cultivated in Italy by draftsmen like Bartolomeo Passerotti, the *Federkunststücke* were introduced in the Netherlands by the Wierix brothers, who drew them on vellum in the

fine, minute technique of their prints, and by Goltzius, whose later works of this type were on a huge scale and used the dramatically swelling and tapering crosshatched strokes he devised for engraving in the 1580s (cat. 54).[54] The grandest collectors of the age avidly sought these curiosities, perhaps confirming the opinion of the German connoisseur Philip Hainhofer, who noted that a pure pen drawing enjoyed greater esteem than an oil painting, especially in the Netherlands, because the pen line could not be erased or corrected, and therefore demanded more "diligence, effort, and work."[55] Van Mander considered Goltzius' *Federkunststücke* as the best proof of the artist's unparalleled invention and technical ability, reporting that he executed these works, one of which exceeds six feet in height, directly from his imagination and without benefit of preparatory studies.[56] The conspicuous display of skill that redefined the limits of a difficult medium, combined with the novelty of a life-sized drawing emulating engraving, made the *Federkunststücke* a sensation of the late mannerist period, when virtuosity, caprice, and bold invention

were treasured aesthetic qualities. It should be noted that, in addition to pen drawings, presentation sheets depicting landscapes and figural subjects were produced by sixteenth-century draftsmen in a variety of other media (cats. 13, 33, 39, and 82).

A type of drawing that vies with painting as a finished product is the autonomous miniature, usually executed in gouache on parchment. Made as collectors' items, independent of their traditional function as illustrations in manuscripts, these appeared in the second half of the century in the works of Joris Hoefnagel, Hans Bol, Jacques Savery, and others.[57] Like Hoefnagel's manuscripts (cat. 73), they were especially prized at central European courts; works by Bol entered the Electoral *Kunstkammer* at Dresden by 1587.[58] Bol, a prolific miniaturist, treated religious and mythological subjects as well as various types of landscapes (fig. 10, and cat. 15, fig. 2).[59] The miniatures Hoefnagel presented to his humanist friends usually depicted allegorical or literary themes and were often provided with edifying verses or witty dedications.[60]

Fig. 10. Hans Bol, *The Rape of Europa*, Rijksmuseum, Amsterdam

Fig. 11. Hendrick Goltzius, *Portrait of a Military Leader*, Rijksprentenkabinet, Amsterdam

Fig. 12. Hendrick Goltzius, *Portrait of a Distinguished Lady*, Rijksprentenkabinet, Amsterdam

Poems or dedicatory inscriptions accompanied many of the sketches entered into autograph albums, which also typically represented allegorical and historical subjects. Although the practice of keeping an autograph album (*album amicorum*) was less widespread in the Low Countries than in Germany, some interesting Netherlandish examples survive. The volume that belonged to Emmanuel van Meteren, the Dutch merchant residing in London, contained entries dating from 1575 to 1609, including drawings by Hoefnagel, the geographer Ortelius, Abraham Bloemaert, Lucas d'Heere, Hubert Goltzius, Marcus Gheeraerts, and Philip Galle.[61]

The quality of a presentation work made with a particular patron in mind also appears to be inherent in the few surviving independent portrait drawings from the period. These were presumably given or sold to the sitter or his family. The small number of surviving portrait drawings of any type is surprising given the importance of the portrait in sixteenth-century Netherlandish art and the probable role of

drawings as preparations for painted portraits. Among the earliest autonomous examples are the imposing black chalk portraits from 1521 by Lucas van Leyden (see cat. 80). It must be significant that these were executed in the year Lucas met Dürer in Antwerp and in format and technique emulate the portraits drawn by the German master during his visit in the Netherlands. Dürer made many such works, most in chalk or charcoal, on his 1520–1521 journey and gave them away in exchange for goods and services or in expectation of monetary reward.[62] Lucas' monogrammed and dated portraits, which cannot be related to his surviving paintings, were probably also given or sold to the sitters.

Few draftsmen after Lucas seem to have executed independent portraits until about 1580, when Hendrick Goltzius started to make miniaturelike works of unprecedented refinement. These autonomous portraits, for which the young virtuoso chose the outmoded and painstaking metalpoint technique, evidently derived from the modelli, also in metalpoint,

that he designed at the same period for engraved medallions and small prints. The small prints, in turn, recall the little portrait engravings published in the 1570s by the Wierix brothers. The exquisite pair of portraits from c. 1586 in Amsterdam (figs. 11 and 12) adapt the type of half-length, lifesize court portrait painted by Anthonis Mor to the scale of a miniature. Each drawing measures 89 x 64 mm.[63] Beginning in 1588 Goltzius chose colored chalk for a series of larger portrait heads. Significantly, shortly before his Italian journey, Goltzius returned to this medium utilized for independent portraits by the Clouets and their followers in France and by Italian draftsmen such as Federico Zuccaro.[64] Of the several lifesize chalk portraits executed during his trip, most represent artists (see cat. 57). The monogram and date on some of these sheets may indicate that he presented them to the sitters, but it is also possible that he made them with the intention of engraving a series of artists' portraits.[65]

1. For this development, see, most recently, Ames-Lewis 1981.
2. Held 1963, 79.
3. Panofsky 1953, 200, pls. 263 and 264.
4. Kupferstichkabinett, Berlin, 79C2; see Berlin 1975, no. 180, figs. 20–22.
5. According to Filedt Kok 1972-1973, 159–162. The formal characteristics of early sketchbooks as opposed to model books—fragmentary and repeated motifs, broken contours, irregular arrangement on the page, and so on—are discussed by Jenni 1976, 77–87.
6. See Huth 1967, 26–42, for the legal role and appearance of contract drawings, based largely on German late Gothic sources; see also Faries 1976, 146 and 213 n. 86.
7. See Bruges 1984, no. 5.
8. Taubert 1956, 21–23; Arndt 1961, 161–162; and Filedt Kok 1978, 1–2.
9. Baldass 1943, 74.
10. This is demonstrated by Filedt Kok 1972-1973, 159–162; see also Hand and Wolff 1986, 17–21.
11. For the Louvre drawing of *Death and the Miser*, see Lugt 1968, 25–26, no. 70.
12. Kloek 1978, 426, 433, 454–455, figs. 1 and 2. See also Filedt Kok 1978, 60–62. Kloek 1978, 455, also suggests that the black chalk drawing of *The Fall of Man* in Hamburg, which is squared for transfer, may be a preparation for a lost painting.
13. Underdrawings can be made visible through infrared photography and, more particularly, infrared reflectography; see Van Asperen de Boer 1975, 8–12. To date the most conclusive studies have been surveys of a range of a single artist's work, such as Filedt Kok 1972-1973 and 1978, Faries 1975, and surveys now in progress for Rogier van der Weyden by Van Asperen de Boer and others and for Gerard David by Maryan Ainsworth.
14. Filedt Kok 1978, 65–99.
15. See, for example, Arndt 1961, 153–175 and Ainsworth 1982b, 164–165.
16. See Faries 1975, 97, 203–204, nos. 16 and 18.
17. Friedländer, *ENP*, 8 (1972): no. 24, pl. 28, and no. 23, pl. 27, respectively. For Rogier's painting, see Friedländer, *ENP*, 2 (1967): no. 75, pl. 6.
18. Grosshans 1980, no. 75, pl. VI.
19. Van Mander, *Schilder-boek*, 1: 68–69.
20. To date the most important investigation of this trend in painting is Miedema and Meijer 1979, 79–98.
21. See Van de Velde 1969, 255–256, and 1975, 86.
22. Bock and Rosenberg 1930, 37, KdZ 8485, pl. 29. Floris' painted head studies may have served a similar function.
23. For Bruegel underdrawing see Van Schoute and Marcq-Verougstraete 1975, 259–267.
24. Faries 1982, 123–125 and 129.
25. Faries 1975, 142–146, figs. 32 and 33.
26. Van de Velde 1975, 383–384, no. T 51; the painting is S 164, fig. 88. For the use of this type of oil sketch by Italian, particularly Venetian, painters, see Bauer 1978, 45–57.
27. For Van Veen's oil sketches, see Müller Hofstede 1957, 142–147.
28. Reznicek 1961, 216–220; Van Thiel 1965, 128–130 and 134–135; and Miedema 1973, 2: 303–304.
29. In a painting in Mainz, Van Thiel 1965, fig. 7, another in Dessau, Marburg photo no. 77624, and another (of the Baptism or Mankind before the Flood) exhibited in Los Angeles in 1937, D.I.A.L. 71 B31.2.

30. Quoted by Delen 1924–1935, pt. 2, 2: 71. See also Hans Mielke in Berlin 1975, no. 99.

31. For a summary of publishing activity in the Netherlands before Cock, see Riggs 1977, 6–21.

32. Van de Velde 1975, 94–96.

33. Reznicek 1961, nos. 133 and 134, pls. 79 and 80.

34. Kloek 1978, no. 5, 9, 21, and 23, repro.

35. Boon 1978, 168, no. 458, and *The Illustrated Bartsch*, 14: 4(28).

36. Boon 1983, 437.

37. Boon 1983, 437–440; Van der Boom 1940, 164–206. On the Gouda windows, see also Rijksen 1945.

38. For all other small cartoons, see Boon 1983, 440–441, and Friedländer *ENP*, 11 (1974): pl. 206D.

39. On Coxcie's drawing and the term *vidimus*, see Wayment 1972, 30; Wayment 1979, 356–376; Wayment 1984, 44.

40. For the requirements of a *vidimus*, see Wayment 1972, 20, 30. Wayment concluded that a *vidimus*, strictly defined, originally designated a workshop copy after the designer's modello. This workshop copy would have been retained by the patron as an *aide-memoire* and a legal document recording the design to be executed. Eventually, *vidimus* came to denote the modello itself as well as the copy after it.

41. Schapelhouman 1979, no. 12; Wayment 1984, 44–45.

42. For a discussion of small glass roundels, see Popham 1928; Popham 1929; and Gibson 1970.

43. The drawings signed with Vellert's monogram and the date, often including the day (cat. 114), seem to be the final designs. Other examples include: Glück 1901, figs. 5–10, 12, and pls. II and V; Popham 1932, 50, nos. 2, 3, 4, 5. A radically reworked tracing is Popham 1932, 52, no. 9; a pure tracing is Popham 1932, 51, no. 7 (squared in black chalk); and tracings partially worked up with wash are Glück 1901, pls. III and IV (both squared in black chalk), and Popham 1932, 51, no. 6.

44. Kunsthistorisches Museum, Vienna, Demus 1972, 98–102. The detail reproduced in fig. 8 is from *The Withdrawal of the Army from Tunis*, inv. no. 2046, Demus 1972, 101, and pl. 14. See Horn 1984, 19–20, and 23 n. 13 for the contract between Vermeyen and Charles V's sister, Mary of Hungary.

45. Horn 1984, 19–20, and 23 n. 13.

46. Munich 1983–1984, no. 66; Wegner 1973, nos. 24–25.

47. Van Orley's *Crucifixion* in Stuttgart is another study that belongs to a relatively early stage in the design of the related tapestry; Stuttgart 1984, no. 93. For Coecke's drawings for tapestry, see Marlier 1966, 311–342, and Halbturn 1981, 19–75. Another drawing by Coecke representing the same stage in the design of a different tapestry in the series as the Darmstadt drawing (fig. 9) Marlier 1966, fig. 250.

48. On the finished drawing, see De Tolnay 1943, 25–26; Hutter 1966, 97–110; Princeton 1982–1983, 15–16. On Goltzius' role in this development, see Reznicek 1961, 1: 10–12, 77–79, 101–112, 128–130.

49. Benesch 1928, no. 26.

50. For other finished drawings by Massys, see Zwollo 1965, figs. 4–6, and the unnumbered reproduction on page 65.

51. On Bruegel's landscapes as presentation drawings, see cat. 27, and Müller Hofstede 1979, 108–109.

52. Münz 1961, nos. 126 and App. 8.

53. Berlin 1975, no. 50 (Jan Brueghel); Reznicek 1961, 108–110.

54. Reznicek 1961, 77–79. On Jan Wierix, see New York 1986, nos. 26 and 27.

55. Hainhofer's remarks appear in a letter of 1610 to his patron, Duke Philip II von Pommern-Stettin; Reznicek 1961, 27. See also Held 1963, 82–83.

56. Reznicek 1961, 10–11.

57. On Hoefnagel's miniatures, see Kaufmann 1985, 244–251, with earlier literature. On Bol's miniatures see Franz 1965, 21 and 44, and pls. 179–188; and Franz 1979/1980, pls. 36, 37, 41, 51, 52, 54, 56, and 58. On Savery, see Zwollo 1979, 204–205.

58. Washington 1978–1979, no. 115; Mayer-Meintschel, Walther, Marx, and Göpfert 1979, 112–114.

59. See nn. 57 and 58 above for Bol's miniatures.

60. See, for example, Kaufmann 1985, 246–247, nos. 9-4 and 9-6.

61. Rogge 1897, 199–210.

62. Panofsky 1948, 1: 214. Panofsky notes that Dürer gave many of these large chalk or charcoal portraits away together with a wooden panel on which they could be mounted. See also Held 1963, 76.

63. Reznicek 1961, nos. 297 and 354. For Goltzius' portraits in metalpoint, see Reznicek 1961, 64–65, 95–96.

64. See cat. 57 and Reznicek 1961, 84–89.

65. See cat. 57 and Reznicek 1961, 203–204, for the suggestion that Goltzius may have planned a series of engraved portraits of artists.

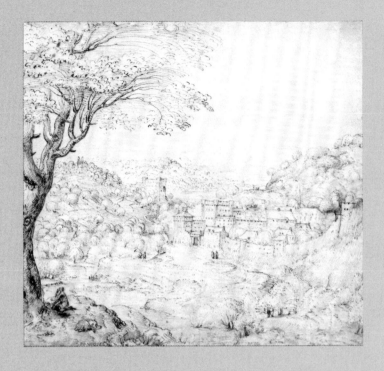

Catalogue

NOTE TO THE READER

The drawings are catalogued alphabetically by artist. Artists such as Master of the Good Samaritan are found under "M." Measurements are given in millimeters, height preceding width, followed by inches within parentheses. Where a Lugt number is given, a collector's stamp appears on the drawing. Shortened references are fully explained in the list of references cited, which is divided into books and articles, cited by author and date, and exhibition catalogues, cited by city and date.

Aertgen van Leyden

1498-1564

The most important source of information for Aertgen van Leyden (Aert Claesz.) is Van Mander's Schilder-boek, which states that Aertgen was born in 1498 in Leiden and was the son of a fuller, for whom he worked until he reached the age of eighteen in 1516. In that year, he entered Cornelis Engebrechtsz.' studio in Leiden. According to Van Mander, Aertgen worked in his master's style during his early years. However, after having seen the works of Jan van Scorel and Maerten van Heemskerck, he fell under their influence, which is especially evident in his borrowings from their architectural motifs. Van Mander notes that Aertgen made numerous designs for glassmakers, "and others"—very likely a reference to his drawings for woodcuts—and further asserts that Aertgen became so well known that Frans Floris visited him in 1553 in Leiden. Aertgen died at the age of sixty-six in 1564.

Aertgen's early drawing style is closely connected with the work being done in Cornelis Engebrechtsz.' studio. Aertgen was especially touched by Lucas van Leyden and Jan de Cock, and his designs have often been confused with those executed by Cornelis Engebrechtsz.' sons, especially Pieter Cornelisz. Kunst. Aertgen's early style from the 1520s and early 1530s is characterized by short, hooked pen lines that quickly outline the forms, which are enclosed by rounded contours. Aertgen's fine perception for delicate nuances of light and shadow is suggested through sensitive pen hatchings, which run horizontally and vertically. Around 1535, Jan van Scorel's influence became evident in Aertgen's more colorful surfaces. He combined pen and ink with colored washes brushed on with long, parallel strokes. Also in the mid-1530s, Aertgen's figures became thin and elongated and the heads small; their pseudo-antique settings are also highly reminiscent of Scorel. It is clear that around 1535, Aertgen moved away from the late Gothic style of Cornelis Engebrechtsz. and his associates to the mannerist style, which was based upon Italian ideas that were introduced into the northern Netherlands by Scorel.

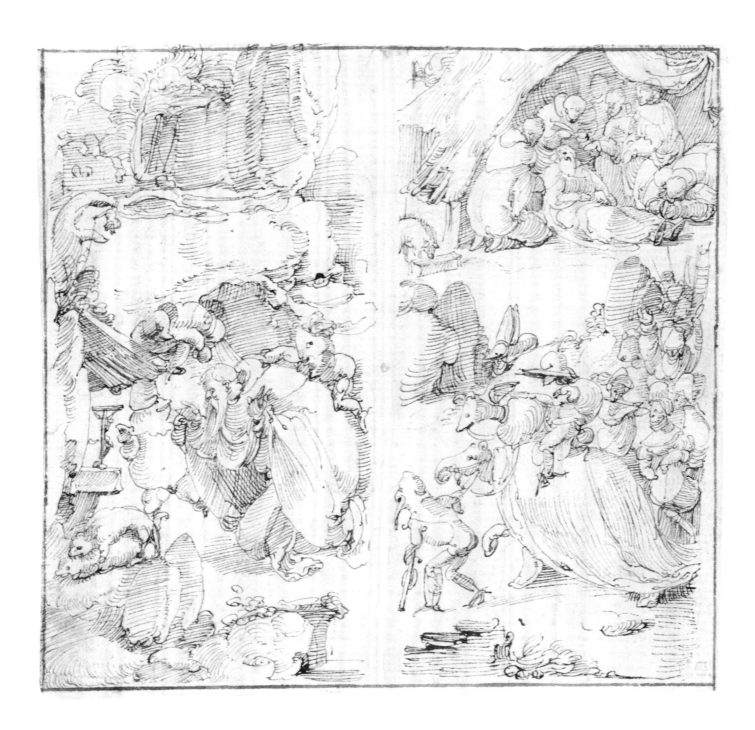

I *The Temptation and Death of Saint Anthony*

Pen and ink
155 x 169 (6⅛ x 6⅝)
Signed on the verso in sixteenth- or early seventeenth-century hand, *Aertie v. Leyden*

Provenance: N.C. de Gyselaar, Leiden, by whom given to the Prentenkabinet c. 1851

Literature: Wescher 1925-1926, 153; Van Gelder 1928, 241, 244; Winkler 1929-1930, 28; Held 1933, 283, 284; Beets 1935, 170, 171; Beets 1936, 66; Hoogewerff, *NNS*, 3: 356; Bruyn 1960, 70-74, 82-84, 88, 90, 91; Friedländer, *ENP*, 11 (1933): 69 (11 [1974]: 41, no. B)

Exhibitions: Ghent 1955, no. 163

Prentenkabinet der Rijksuniversiteit te Leiden, inv. no. 2160

Because of its Bosch-like figures, this drawing has been attributed to several artists closely connected with Leiden and especially the followers of Cornelis Engebrechtsz., Jan de Cock,[1] and the former's two sons, Pieter Cornelisz. Kunst[2] and Lucas Cornelisz. de Cock.[3] It was not until 1960 that Aertgen van Leyden, yet another follower of Cornelis Engebrechtsz., was convincingly assigned this *Temptation and Death of Saint Anthony*.[4] The sheet had always been closely associated with the painted fragment of the *Temptation of Saint Anthony* (Musées Royaux des Beaux-Arts, Brussels; fig. 1), while Jan de Cock's woodcut with scenes from *The Life of Saint Anthony* (fig. 2) had been the basis for the attribution. The woodcut has several motifs that are also present in the drawing, such as the figure seated on the roof just above the saint, the type of shed upon which the former sits, the procession of fantastic creatures moving into the scene from the right, and the division of the composition into isolated episodes from the life of the saint. However, as Bruyn points out,[5] even closer parallels exist between the drawing and the painting, in the altar upon which the crucifix stands and the shape of the struc-

ture in which it is housed, and in the procession moving from right to left where a small monster holds the reins and leads a fantastic pig with a strange rider. Although the drawing and painting with their more substantial forms are closer stylistically than the woodcut with its thin and elongated shapes, the 1522 De Cock woodcut was very likely the starting point for Aertgen's drawing.

Aertgen's design contains an empty vertical strip that runs down the middle and divides the sheet into two equal parts. Bruyn has suggested that the drawing might have been a preliminary study for a large altarpiece with two movable sets of wings. He goes on to postulate that perhaps these two episodes were meant to adorn the front and back of one of the innermost wings. This arrangement was later changed and elements from the drawing were incorporated into the Brussels fragment, which may have been part of the central panel of a lost triptych.[6]

Because of the close relationship between the Leiden design and the Brussels fragment, Bruyn has proposed a convincing reconstruction of the whole to which the latter belonged. It is clear that the details in the foreground of the drawing were repeated, with slight changes, in the painting. Moreover, given the fragmentary state of the panel and the fact that the drawing, also cut down at the top, contains at least two scenes from the life of the saint, it is most likely that originally the Brussels picture depicted more than one episode from Saint Anthony's life. This becomes even more probable if one recalls the woodcut of Jan de Cock and the panel attributed to him in the collection of Van der Feer Ladèr, Baarn.[7]

A new solidity and roundness of form have been created in the Leiden drawing by the artist's rapidly moving pen. The lines set against the white paper represent a marked departure from the attenuated, elegant, late Gothic shapes of Jan de Cock's woodcut. Based on this new style, Bruyn has justly added several drawings around 1530 to Aertgen's oeuvre.[8] These fit in well with the linear style that is associated with Leiden, but carry it a step further. However, in the case of Aertgen, his pen produced freer contours, which contain a greater variety of shapes and interact with the paper to establish more convincing chiaroscuro patterns. For example, Aertgen's *Saint Anthony* is more advanced than other drawings executed in Leiden at the same time, such as the *Burial* (cat. 40) or the *Landscape* in the Abrams collection (cat. 41). JRJ

Fig. 1. Aertgen van Leyden, *The Temptation of Saint Anthony*, Musées Royaux des Beaux-Arts de Belgique, Brussels (Copyright A.C.L. Brussels)

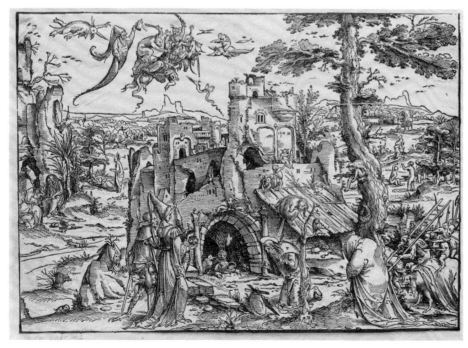

Fig. 2. Jan de Cock, *Scenes from the Life of Saint Anthony*, Rijksprentenkabinet, Amsterdam

1. Wescher 1925-1926, 153; Van Gelder 1928, 242; Baldass 1929, 72; Friedländer, *ENP*, 11 (1933): 69 (11 [1974]: 41, no. B, pl. 100).
2. Winkler 1929-1930, 28.
3. Beets 1935, 170, 171; Beets 1936, 66; Hoogewerff, *NNS*, 3:356.
4. Bruyn 1960, 70, 71.
5. Bruyn 1960, 70.
6. For details see Bruyn 1960, 71, 72.
7. Bruyn 1960, 74, 75, fig. 21.
8. For these new attributions see Bruyn 1960, figs. 25-27, 29-30.

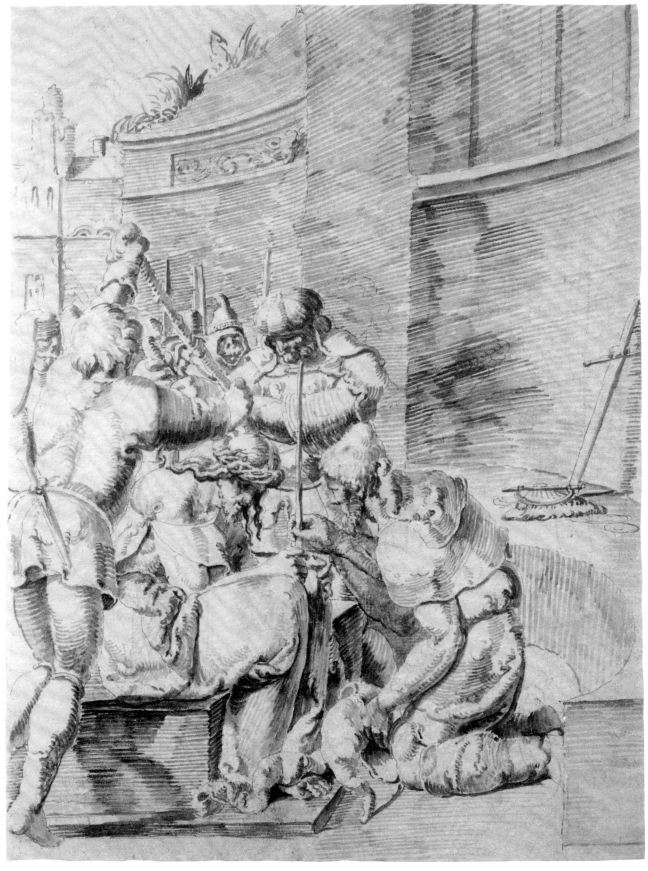

2

2 *The Mocking of Christ*

Pen, brown ink, brush, and gray ink over preliminary sketch in black chalk
260 x 198 (10¼ x 7¹³⁄₁₆)

Provenance: (H.M. Calmann, London, 1963)

Literature: Bruyn 1960, 113, no. 7*; New Haven 1964, 13; Haverkamp-Begemann and Logan 1970, 180, 181, no. 330.

Exhibitions: London (H.M. Calmann) 1960, no. 18

Yale University Art Gallery, New Haven. Everett V. Meeks, B.A. 1901, Fund, inv. no. 1963.9.29

The oddly proportioned figures on this sheet place it among a group of drawings that were brought together by Paul Wescher in 1928.[1] Because one of those drawings, *Christ among the Children* (Cabinet des Dessins, Louvre, Paris) carries the date of 1527, Wescher called this unknown artist the Master of 1527. The style of the Louvre design is the same as that seen in this *Mocking of Christ*. The forms in both drawings are created by thick, heavy brushstrokes. The heads are far too small for the torsos. The hair appears to sit on the skulls like a mop, and the figures are grouped extremely close together and appear unable to turn freely in the space allotted them. The architecture is also similarly constructed in both sheets.

In 1939, the late Prof. J.Q. van Regteren Altena attributed all of the drawings given to the Master of 1527 to Aertgen van Leyden. This was done on the basis of stylistic similarities between the aforementioned 1527 *Christ among the Children* in Paris, and a painting of the *Nativity* (Wallraf-Richartz Museum, Cologne) which he had identified as a lost work by Aertgen van Leyden.[2] Van Regteren Altena pointed out similarities between these two works, such as the type of architecture, with its delicate moldings and sculptured arches, the shadow patterns of light from below, the children's caplike hair styles and awkwardly constructed arms, and especially Christ's right arm in the drawing, which is the counterpart of the Virgin's in the painting.[3]

The Yale drawing presents us with figures that are different from those used by Aertgen's teacher, Cornelis Engebrechtsz., and his shop. In the *Mocking of Christ*, large, exaggerated forms are placed in contorted and cramped positions. These types suggest a new aesthetic that moves away from the late Gothic ideals characteristic of Engebrechtsz. and his followers to more imaginative mannerist figures. This is particularly evident in the foreground and suggests a possible contact

between Leiden and the work of Jan van Scorel and Maerten van Heemskerck during the years around 1530. If this is true, then an attribution of these drawings to Aertgen van Leyden becomes even more likely. Van Mander's statement that Aertgen, after working in the manner of Cornelis Engebrechtsz., later worked in the style of Jan van Scorel and Maerten van Heemskerck,[4] would accord with this attribution.

Although the Yale drawing and the other sheet exhibited here and attributed to Aertgen, *The Temptation and Death of Saint Anthony* (cat. 1), have little in common stylistically, the attribution of both works to the same master illlustrates a change from a late medieval style to the more modern mannerist ideal in Leiden, which would coincide, in part, to Lucas van Leyden's work around the same time.[5] The *Mocking of Christ*, because of its stylistic affinities with the 1527 *Christ among the Children* and the possible contacts with Jan van Scorel and Maerten van Heemskerck, might very well date from the years around 1530.
JRJ

1. Wescher 1928b, 251-254, figs. 6, 7.
2. For details see Van Regteren Altena 1939, 24, 25, 75, 76. For a negative point of view concerning the attribution of the *Nativity* to Aertgen see Bangs 1979, 135, 136.
3. Van Regteren Altena 1939, 75, 76.
4. Van Mander, *Schilder-boek*, 1:280-283. The validity of Van Mander's statement is partially borne out by the existence of the only certain work by Aertgen, the Van Montfoort *Last Judgment* (Musée des Beaux-Arts, Valenciennes), which is closely connected with Maerten van Heemskerck. For details see Bangs 1979, 128. I am thankful to E. Haverkamp-Begemann for reminding me of this *Last Judgment* and the Bangs citation.
5. See, for example, Lucas van Leyden's 1530 engraving of *Mars, Venus, and Cupid* (Bartsch 137).

Pieter Aertsen

1508/1509-1575

The son of a stocking maker, Pieter Aertsen was born in Amsterdam. After 1530 Aertsen may have moved to Antwerp where, according to Van Mander, he lived with Jan Mandyn, and in 1535 became a master in the guild of Saint Luke. In 1542 he registered as a citizen in Antwerp and married Kathelijne Beuckelaer; her nephew Joachim Beuckelaer (c. 1535-1574) became Aertsen's apprentice and the inheritor of his style. Sometime around 1557 Aertsen returned to Amsterdam where he lived until his death in 1575. Two of his seven children, Pieter Pietersz. (1541-1603) and Aert Pietersz. (1550-1612), were painters.

Little is known about Pieter Aertsen's early years in Amsterdam or his first decade in Antwerp. The earliest documented work is the Crucifixion altarpiece of 1546 (Koninklijk Museum, Ant-

werp). The influence of Pieter Coecke and Jan van Hemessen is discernible in the early works. Aertsen received several commissions from churches and other religious institutions, but many altarpieces were destroyed in the iconoclasm of 1566. Aertsen was an important innovator. Most astonishing for their time are the "inverted" compositions such as the Butcher's Stall with Flight into Egypt of 1551 (University, Uppsala) where a realistic still life dominates the foreground and is juxtaposed with a religious scene in the background. His representations of peasants are free from overt satire and his depictions of cooks, as in the 1559 panel in Brussels, are monumental and dignified. The religious works of his last years are serious in feeling and influenced by Venetian art.

3 Christ and the Apostles in the Garden of Gethsemane

Pen and brown ink with gray wash
(verso: *study of two kneeling female donors*, fig. 1, pen and black ink, squared in red chalk)
181 x 304 (7⅛ x 11¹⁵⁄₁₆)

Inscribed at top right, in graphite; *aertgen Van Leijen fecet 1560*

(fig. 1), pen and black ink, squared in red chalk

Provenance: Lord Milford (Lugt 2687); Dr. and Mrs. Francis Springell, Portinscale; (sale, Sotheby's, London, 22 November 1974, no. 26); (Drey Gallery, New York)

Literature: Bruyn 1965b, 356, 358

Exhibitions: Manchester 1965, no. 249; Edinburgh 1965, no. 13; Munich 1982, no. 1

Staatliche Graphische Sammlung, Munich, inv. no. 1980:2

As the inscription at the top indicates, this drawing was once attributed to Aertgen van Leyden. Since Bruyn's magisterial study of Pieter Aertsen's drawings, however, it is evident that this is a superb and characteristic early work by Aertsen. Although it cannot be connected with an extant work, the Munich drawing is probably a preparatory sketch for a painting.

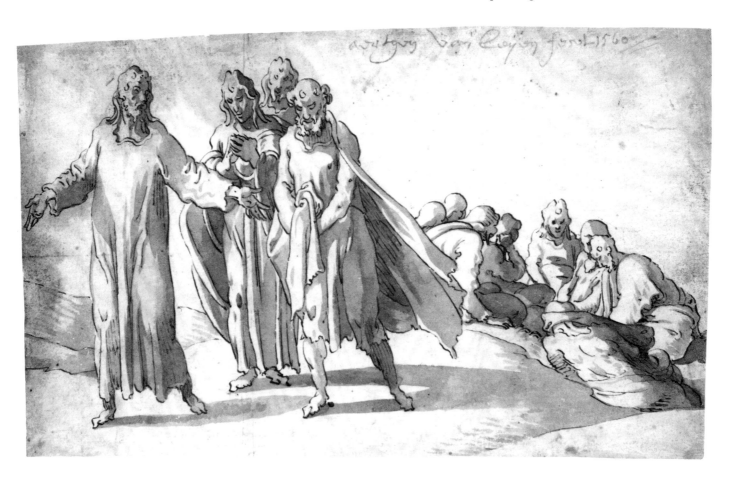

Fig. 1. Cat. 3, verso

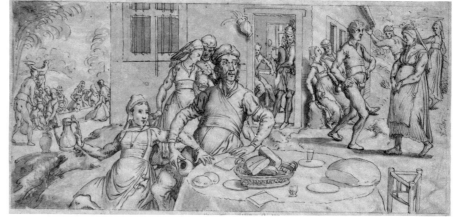

Fig. 2. Pieter Aertsen, *The Peasant Feast*, Staatliche Kunstsammlungen Dresden, Kupferstich-Kabinett

The Munich sheet belongs to a group of drawings produced in Aertsen's first decade of activity, c.1540/1555. Bruyn proposed a date of c.1546 on the basis of its similarity to the exterior wing depicting *Saint Francis and the Six Alms Women* on Aertsen's earliest documented painting, the *Crucifixion* altarpiece of 1546 (Koninklijk Museum, Antwerp).[1] Earlier drawings, such as *The Arrest of Christ* (Biblioteca Nacional, Madrid),[2] drawn in pen alone, display cramped compositions and jerky rhythms. In the Munich drawing Aertsen at once simplified and intensified his expressive and technical means. Line and wash are used with great economy and boldness to define the setting, the figures, and the light source. Aertsen's pen work, characterized by a nervous energy most evident in the jagged edges of garments, captures Christ's eloquent gesture of acceptance and departure as well as the downcast, resigned expressions and postures of John, Peter, and possibly James, who all stand next to Christ. The figures are elongated, graceful, and flowing.

The identity of Pieter Aertsen's first teacher, whether he went to Italy, and the precise sources for his early mannerist style are all unknown to us. The early religious paintings owe something to the Braunschweig Monogrammist and Jan van Hemessen,[3] while it is possible to see the influence of Pieter Coecke van Aelst in the drawings.[4] Aertsen seems to have reserved a different manner for drawings of genre scenes. The drawing in the Kupferstich-Kabinett, Staatliche Kunstsammlungen, Dresden (fig. 2), which is preparatory to *The Peasant Feast*, dated 1550 (Kunsthistorisches Museum, Vienna)[5] is more realistic and less elegant than the Munich sheet, though certainly by the same hand. That different subjects required different styles of draftsmanship is fascinating and important, for it implies that a theory of modes was operating in the Netherlands in the mid-sixteenth century.

From the way in which the chalk lines are ruled, it is evident that the sketches on the verso are for a stained-glass window. JOH

1. Bruyn 1965b, 356; for the painting see Friedländer, *ENP*, 13 (1975): no. 293, pl. 144. Bruyn 1965b, 358, found the drawing of *Christ Washing the Feet of the Apostles* (Musée Municipal, Bergues) to be similar in style and date to the Munich sheet.
2. Bruyn 1965b, pl. 1.
3. Kreidl 1972, 46-64, who also saw the influence of Jan van Scorel's Lockhorst altar on the *Crucifixion* altarpiece in Antwerp.
4. Bruyn 1965b, 355, describes Aertsen's mannerism as "based on the style of Parmigianino as seen through the eyes of one trained in the circle of Pieter Coecke van Aelst."
5. Friedländer, *ENP*, 13 (1975): no. 334, pl. 165.

PIETER AERTSEN
4 *The Feast of Herod*

Pen, brown ink, gray-brown wash, and white
heightening, over black chalk; laid down;
compass holes where crossbar lines intersect
left and right vertical borders
422 X 211 (16⅝ x 8⁵⁄₁₆)

Inscribed at left on base of the caryatid, *1562*

Provenance: John Thane (Lugt 1544); Sir
Thomas Lawrence (Lugt 2445); Burki (sale,
Berlin, Amsler & Ruthardt, 3 May 1895)

Literature: Bruyn 1965b, 363

Exhibitions: Frankfurt 1956, no. 77

Historisches Museum Frankfurt, Frankfurt,
inv. no. C9278

Exhibited in New York only

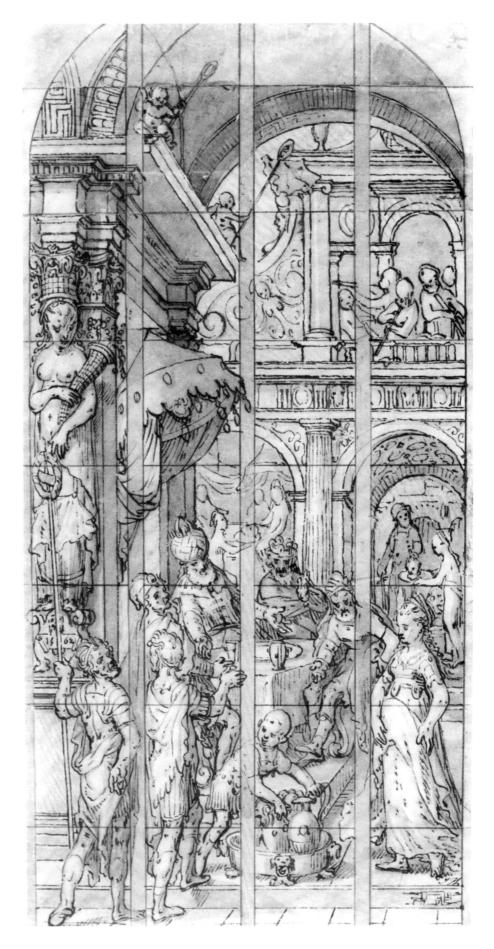

As is evident from the indications of tra-
cery and horizontal iron bars (*ferramenta*)
that secure the glass panels, this is a de-
sign for a large stained glass window. The
brief accounts in the gospels of Matthew
(14:1-12) and Mark (6:14-29) inform us
that because John the Baptist had cen-
sured the tetrarch Herod for marrying his
brother's wife, Herodias, Herod had John
imprisoned. At a birthday party for Her-
od, a daughter of Herodias danced for the
ruler and was granted a request in return.
At the urging of her mother, she asked for
the head of John the Baptist on a platter.
This drawing depicts the moment when
Herodias' daughter, named Salome in
apocryphal accounts, announces her
gruesome request to Herod who draws
back in shock. At the right in the back-
ground, an executioner places the Bap-
tist's head on a tray and at the left the
head is presented to Herodias by her
daughter.

This drawing remained anonymous un-
til 1965 when Bruyn attributed it to Pie-
ter Aertsen and associated it with other
of Aertsen's designs for stained glass from
the early 1560s.[1] The group comprises
two curiously shaped drawings, the *De-
parture of the Prodigal Son*[2] (fig. 1; Staa-
tliche Museen, Kupferstichkabinett, Ber-
lin) and the *Continence of Scipio*[3] (British
Museum, London), both dated 1562, and
The Adoration of Shepherds[4] (Kunsthalle,
Kupferstichkabinett, Hamburg), dated
1563. The composition and elaborate ar-
chitecture of the Berlin and Frankfurt
drawings are closely related, as are the
figures of Herod and the Prodigal's father.
As suggested by Bruyn, the Berlin sheet
may derive from the Frankfurt one.[5] To
this may be added a drawing of the *Res-
urrection*, dated 1562 (present location
unknown, formerly Otto Feldmann col-
lection, Brno),[6] and a *Last Judgment*, also
dated 1562, recently acquired by the Staa-
tliche Museen, Kupferstichkabinett, Ber-

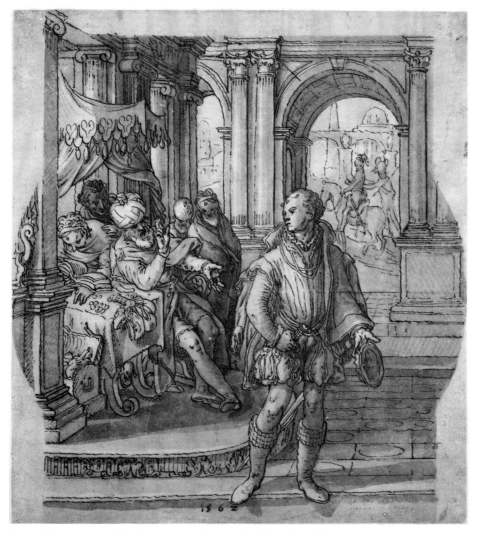

Fig. 1. Pieter Aertsen, *The Departure of the Prodigal Son*, Staatliche Museen Preussischer Kulturbesitz, Kupferstichkabinett, KdZ 11655, Berlin (Jörg P. Anders)

lin.[7] That no corresponding windows survive may be a result of the iconoclasm of 1566 or the awarding of the commission to someone else. Bruyn suggested that *The Feast of Herod* was a design for one of a series of windows in the church of Saint John in Gouda depicting scenes from the life of Saint John the Baptist; that window was ultimately executed by another artist.[8]

In discussing this group of drawings Bruyn felt compelled to defend his attribution to Aersten, for Lugt had raised doubts about the authorship of the Berlin sheet, based on style and on the belief that in the 1560s Aertsen was more involved in depicting peasants than religious subjects. Wescher was also cited as proposing that the Berlin and Hamburg drawings were by Joachim Beuckelaer.[9] Beuckelaer (c.1535-1574) was Aertsen's apprentice; after entering the Antwerp guild in 1560 he continued to paint in the style of his master. There are no surviving altarpieces by him and he treats nar-

rative religious subjects less frequently than Aertsen.

Recently, Hans Buys has suggested that Aertsen's style is not present in the Frankfurt, Berlin, London, and Hamburg drawings, and that they should probably be given to another artist, namely Beuckelaer.[10] Consideration must be given to this possibility, but the change in manner between the Frankfurt sheet and works such as the Munich *Christ and the Apostles in the Garden of Gethsemane* (cat. 3) can also be explained as resulting from differences of date or function, for as noted by Bruyn, the steadier line and greater detail found in *The Feast of Herod* and related drawings may be due to the requirements of stained glass design. In this regard there is a degree of comparison with *The Resurrection* from the workshop of Bernard van Orley (cat. 92). Further, there are no certain drawings from Beuckelaer's hand; a series of market scenes and kitchen interiors (Museum Boymans-van Beuningen, Rotter-

dam) attributed to him are in a much looser and more realistic style.[11] If *The Feast of Herod* is not by Aertsen, then Beuckelaer is the next logical choice, but with our present knowledge the question must remain open. JOH

1. Bruyn 1965b, 363.
2. Bock and Rosenberg 1930, 9, no. 11655.
3. Popham 1932, 89, no. 1, pl. 38; who observed that shape allows the design to function either for a rectangular or a round window.
4. No. 21626; Van Gelder 1959, pl. 16.
5. Bruyn 1965b, 367 n. 23, pointed to the ornamental scroll at the extreme left of the Berlin sheet, which is taken from the Frankfurt drawing but appears out of context. On page 363, he notes that the prominence of the architectural setting in both drawings was stimulated by the publication of Hans Vredeman de Vries' *Variae architecturae formae* (Antwerp, 1560).
6. Benesch 1937b, 146, fig. 4. Although it is not a design for glass, an *Adoration of the Shepherds*, dated 1560 (Metropolitan Museum of Art, New York), Haverkamp-Begemann 1974, 36, fig. 2, is from the period under discussion.
7. No. 26544, pen and brown ink, gray wash, squared for transfer in red chalk, 366 x 259 mm.
8. Bruyn 1965b, 367 n. 23.
9. Lugt 1931, 37.
10. I am grateful to Wouter Kloek, letter of 3 April 1986, for bringing Buys' comments to my attention.
11. Nos. N93, N166-169.

ANONYMOUS DUTCH

5 *Draftsman among Ruins*

Pen and brown ink; verso, black chalk (with rubbing of red chalk from another sheet) (verso: *Donkeys*)
202 X 127 (7^{15}⁄$_{16}$ X 5)

Inscribed in hand of Carlo Ridolfi on a label attached below, *Vincenzo Catena Veneziano no 1*

Provenance: Carlo Ridolfi, Venice, d. 1658; heirs of Carlo Ridolfi (Lugt 2176);[1] General John Guise, d. 1765

Literature: Byam Shaw 1976, 320-321, no. 1311

Exhibitions: Washington 1972-1973, no. 95; London 1981, no. 51

The Governing Body, Christ Church, Oxford, inv. no. 0297

This drawing, which can be linked to the graphic vocabulary of Jan van Scorel and his circle, is a rare early example of a figure studied from life. It is unusual too as an early representation of a draftsman seated in a landscape. Though no drawing materials are visible, the implied concentration of the figure on the ruins immediately before him evokes this activity. Furthermore, the type of a draftsman in a landscape is frequently represented from the back, as an expression of involvement in the landscape or of the role of witness to a particular view.[2] The ruins being

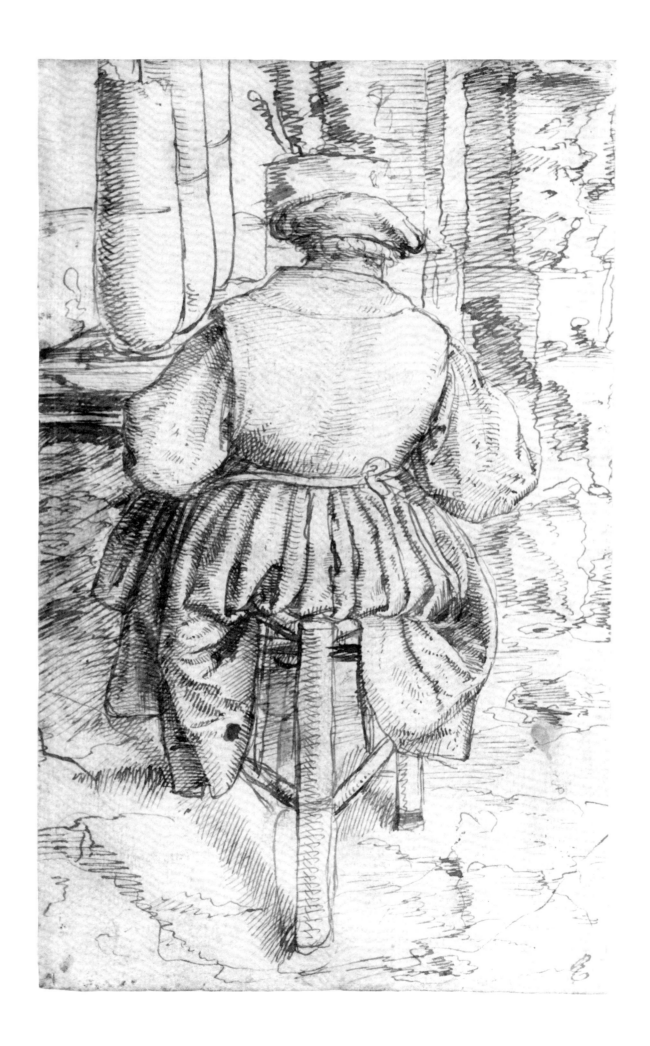

Fig. 1. Cat. 5, verso

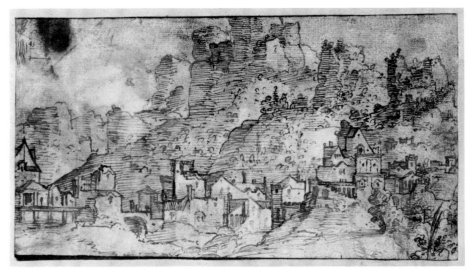

Fig. 2. Workshop of Jan van Scorel, *Landscape*, The British Museum, London (Courtesy of the Trustees of the British Museum)

studied suggest that this drawing was made in Italy.

Jörg Oberhaidacher first associated this sheet with Scorel.[3] The use of loose, zigzag lines and rather hesitant, wavy contours to suggest rocky forms does indeed connect the sheet to other landscapes in the Scorel group. Particularly close is a drawing in the British Museum, apparently from Scorel's workshop, showing an Italian landscape and also including a group of three swelling columns (fig. 2).[4] However, the scarcity of comparable material prevents the attribution of the drawing to a distinct hand, either that of Scorel or a member of his workshop. The Christ Church sheet is above all a figure drawing. The draftsman's foursquare pose and the bulk of the figure, rendered

through stubby hatching strokes and short, zigzag lines, provide the focus of the study. The shadows cast by the stool, made up of long, evenly spaced hatching lines, appear to be part of the system that describes the figure, whereas the scribbled lines filled in around the figure relate to the landscape convention. The surviving drawings associated with Scorel, on the other hand, are either landscapes executed in pen, or pen and wash compositional drawings apparently made in preparation for paintings.[5]

The possibility that the drawing is by Scorel himself can be excluded in part because the costume, with its extended shoulders and full skirt, was current about fifteen years later than the period of Scorel's travels in Italy and the Holy

Land c. 1519-1524.[6] Moreover, the landscape portions lack the sequence of pronounced decorative contours found in the few early landscape drawings securely attributable to Scorel (see cat. 104). While the landscape conventions are closest to those of the British Museum sheet cited above (fig. 2), the nearest analogy for the modeling of the figure is the underdrawing in the 1537 painting of the *Good Samaritan* in the Rijksmuseum by the Master of the Good Samaritan.[7] In both, the crosshatching, itself rare in the Scorel group, is stubby and is laid over the areas of transition between forms, particularly the foreshortened chin of the victim in the *Good Samaritan* or the bunched pleats of the draftsman's skirt. Both employ loose, zigzag lines. However, these general affinities are probably due to the paucity of surviving drawings of different types.[8]

Apart from the question of authorship by a member of Scorel's circle, the drawing indicates the way in which northern artists appropriated the classical past. At mid-century the motif of an artist at work among the ruins of antiquity occurs in works by Heemskerck, Hermannus Posthumus, and Hieronymous Cock.[9] That the anonymous Dutch artist has taken a fellow draftsman at work as his model is also testimony to the practice of shared exploration of antiquity. This practice is evident from the inscribed names of Heemskerck, Hermannus Posthumus, and Lambert Sustris, providing a record of their joint visit to the grotto of the Domus Aurea, presumably in the mid-1530s.[10] At the same time, the Christ Church drawing suggests a kind of disjunction between the observing artist and the world of nature at this period. The draftsman is described in terms of mass and broad areas of light and dark, while the landscape forms are relatively conventionalized and flat. In the other Netherlandish works cited above, the artists at work are, by contrast, treated as conventionalized motifs in a landscape. Only later, around 1600, did Netherlandish artists such as Lucas van Valckenborch, Paulus van Vianen, and others treat the observing artist and the landscape with equal degrees of objectivity.[11]
MW

1. Byam Shaw 1968, 240 n. 14, suggests that this mark was added by Ridolfi's heirs.
2. See Weber 1977, 44-82, for the different variations on the draftsman in a landscape.
3. Byam Shaw 1976, 321.
4. 1946-7-13-173; this is the verso of the sheet, the recto being another landscape with a town in a rocky valley treated with more emphasis on thin, overlapping planes (photo Gernsheim 13413). The sheet has

been cut on all sides, but especially at the top, as is evident from comparison with another version of the view with ruins in Cologne; Steinbart 1932, 283-284, fig. 3. Both may copy a drawing by Scorel. Similar landscape conventions occur in a drawing sold at Sotheby Mak van Waay, Amsterdam, on 3 April 1978, no. 3, 70 (repro.), and cover, as by Scorel.

5. Underdrawing in paintings produced by Scorel and his workshop, as revealed by infrared reflectography, provides an additional body of material, which, however, has a specialized function in the process of preparation of a painting. See Faries 1975, 73-228, esp. 97-105, for these underdrawings and their character as preparations.

6. For example, in works of the so-called Braunschweig Monogrammist such as the *Tavern Scene* of c. 1540 in Berlin, Friedländer, *ENP*, 12 (1975): no. 235, pl. 126.

7. Faries 1975, 161-176, and 217 n. 116, with previous literature on this artist; figs. 44, 45a-b, 46, 47, and 50.

8. Molly Faries suggests (letter 6 December 1985) that any general tendencies toward a looser, bolder drawing style in the Good Samaritan Master's work and the Oxford drawings may indicate a later date, after Scorel's or Heemskerck's Italian trip.

9. Compare the drawing of the Forum by Heemskerck, Egger 1918-1931, 2: pl. 10; the *Archeological Fantasy*, dated 1536 by Hermannus Posthumus in the Liechtenstein collection, Dacos 1985, 433-438, figs. 2 and 7, showing an architect measuring ruins, and the second and third views of the colosseum in Hieronymous Cock's etched series published in 1551; Riggs 1977, nos. A 3 and A 8, figs. 6 and 11.

10. Dacos 1985, 434.

11. Compare Lucas van Valckenborch's 1593 *View of Linz* in the Ecole des Beaux-Arts, Paris (cat. 74, fig. 1) and Paulus van Vianen's *Two Draftsmen in a Forest*, dated 1603, in the Kupferstichkabinett, Berlin, Winner 1985, fig. 7. Despite the small draftsman in the landscape, Heemskerck's 1553 *Self-Portrait* in the Fitzwilliam Museum, Cambridge, reveals a pronounced disjunction between artist and landscape; Veldman 1977a, fig. 99.

ANTWERP ARTIST
6 *The Tree of Jesse*

Pen and light brown ink, black ink, and white heightening, on gray prepared paper
404 x 268 (15⅞ x 10⁹⁄₁₆)

Provenance: Mr. G. Bellingham-Smith, London; acquired by the present owner in 1927

Literature: Popham 1926b, 39-40; Benesch 1928, 6, under no. 31; Bock and Rosenberg 1930, 61, no. 12492; Friedländer, *ENP*, 11 (1933): 28-29 (11 [1974]: 20); Winkler 1948, 12; Ewing 1978, 2:325, no. 35

Staatliche Museen Preussischer Kulturbesitz, Kupferstichkabinett, Berlin, inv. no. KdZ 12492

Elegant virtuosity, anonymity, and shared motifs and style—those qualities that make the Antwerp mannerists so intriguing and so difficult to disentangle—are present in this accomplished and graceful drawing. It was first attributed by Popham to the Master of the Milan Adoration, identified with increasing confidence by Friedländer as Jan de Beer.[1] Popham also linked the Berlin drawing with a sheet in the British Museum.[2] In 1933 Friedländer attributed *The Tree of Jesse* to the master known as Pseudo-Bles on the basis of its resemblance to the *Saint John the Baptist* altarpiece (Museo Nazionale, Messina).[3] This association is not wholly convincing. Friedländer also gave to Pseudo-Bles a second drawing in Berlin, *The Martyrdom of Saint John the Baptist* that, upon comparison, does not seem to be by the same hand as *The Tree of Jesse*.[4] Most recently, Ewing excluded this drawing from the works he accepted as by Jan de Beer and his workshop.[5] In sum, *The Tree of Jesse* is neither by Jan de Beer nor Pseudo-Bles, but is the work of a discrete, anonymous artist working in Antwerp around 1520.[6]

There are, however, certain elements in this drawing that are shared by both Jan de Beer and Pseudo-Bles. The standing figure at the far right is a stock type; his angular features, pointed beard, and pointed hat with long brim and ear flaps correspond to the type found in the panel depicting the beheading of John the Baptist in the Messina altarpiece, in the center panel of Jan de Beer's *Adoration of the Magi* in Milan (cat. 11, fig. 1), and in modified form in his drawing of *The Marriage of the Virgin* in the Albertina, Vienna.[7] Like other Antwerp mannerists, this artist too was influenced by Dürer; the oval, double-chinned face of the prophet second from the right may be compared to the face of the fat merchant selling doves in Dürer's woodcut of *The Presentation of the Virgin* from the series of the Life of the Virgin.[8]

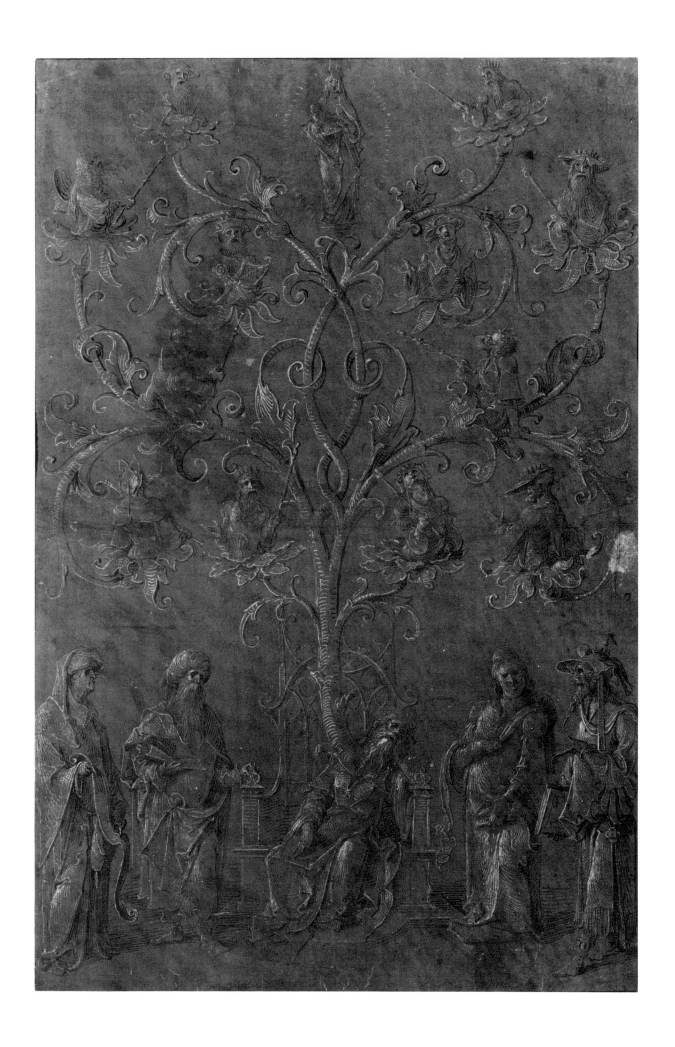

The artist who drew *The Tree of Jesse* was endowed with great technical skill and a fine sense of design. A pleasingly symmetrical and ornamental surface pattern is formed by the Gothic ornament of Jesse's throne and the flowing arabesques of the genealogical tree. These curves are echoed in the scrolls and garment folds of the tall, palpably rendered prophets.

The iconography of the Tree of Jesse is based on the prophecy of Isaiah 11: 1-3, "There shall come forth a shoot from the stump of Jesse, and a branch shall grow out of his roots." The genealogy of Christ given in the Gospels of Matthew and Luke includes Jesse, the father of David, as one of Christ's forebears. The Berlin drawing follows the traditional form: a tree grows out of the chest of the sleeping Jesse, and in its branches are the ancestors of Christ, the Kings of Judah; their number can vary considerably, but here there are twelve. At the top of the tree is its "flower," the Virgin and Child. On either side of Jesse are Christ's spiritual ancestors, the Old Testament prophets who foretell his coming.[9] They are not identifiable, but doubtless include Isaiah, Ezekiel, and Jeremiah.

Although represented in other media, the theme of the Tree of Jesse finds its highest and most frequent expression in stained glass. It has been suggested that the Berlin drawing is a design for stained glass; this is quite possible but cannot be proved from the drawing itself.[10] Paintings by the Antwerp mannerists were exported throughout Europe and their compositions found their way into stained glass and manuscripts in France.[11] Perhaps a thorough investigation of sixteenth-century French glass will reveal a counterpart to this fine drawing. JOH

1. Popham 1926b, 39-40; the sheet is in poor condition and its subject is uncertain. For the paintings and drawings gathered together under the name of the Master of the Milan Adoration, see Friedländer 1915, 69-78.
2. Popham 1932, 4-5, no. 2, as by Jan de Beer and of an unknown subject. Friedländer 1915, 75, and others identified it as the Judgment of Solomon, but Ewing 1978, 2:324, recognized the subject as the *Trial by Coals of the Young Moses*. Both Benesch 1928, 6, and Winkler 1948, 12, accept the Berlin drawing as Jan de Beer; the latter author suggests that it might also be by a close colleague.
3. Friedländer, *ENP*, 11 (1933): 28-29. The painting, which appears to be in poor condition, is reproduced in Friedländer, *ENP*, 11 (1974): no. 8, pl. 7. It should be kept in mind that at this time Friedländer considered it possible that the Pseudo-Bles was the youthful Master of the Milan Adoration (Jan de Beer). I am not convinced that the Messina panel is by the same hand as others in the group. Pseudo-Bles is so named for *The Adoration of the Magi* (Alte Pinakothek, Munich) that once bore a false signature, *Henricus Blesius*. See Friedländer 1915, 66-69, and Friedländer, *ENP*, 11 (1974): nos. 1-8, pls. 1-7.
4. Bock and Rosenberg 1930, 60, no. 4350, pl. 50, as Antwerp school, c. 1520. The rhythms of this drawing are more irregular and jerky and the facial types different than those found in *The Tree of Jesse*.
5. Ewing 1978, 2: 325, no. 35.
6. Bock and Rosenberg 1930, 61.
7. Benesch 1928, 6, no. 31, pl. 9.
8. Kurth 1963, pl. 179 (Bartsch 81); the woodcut is usually dated c. 1503/1505. The series appeared in book form in 1511. That the face is inspired by Dürer is no guarantee that the artist had first-hand knowledge of the woodcut, for motifs from Dürer's art were widely quoted.
9. Réau, *Iconographie*, 2, part 2 (1957): 129-140.
10. Popham 1926b, 39-40; Winkler 1948, 12.
11. In the case of the British Museum drawing cited in n. 2 above, Popham 1932, 4-5, observed that portions of the drawing were copied in a stained glass window of 1531, depicting the Judgment of Solomon, in the church of Saint-Gervais, Paris. The influence of Dürer's woodcut of *The Presentation in the Temple* (Bartsch 88) from the Life of the Virgin series is evident in both. Both the window and the drawing are reproduced in Krönig 1974, 132-133, figs. 16-17. Orth 1980, 44, and 1983, 219-221, discusses several instances in which elements from Antwerp mannerist drawings were used in French manuscript illuminations of the 1520s. The means of transmission and reasons for the popularity of these models in France remain unclear. I am also grateful to Dr. Orth for making available to me portions of her dissertation, *Progressive Tendencies in French Manuscript Illumination, 1515-1530: Godefroy le Batave and the 1520s Hours Workshop*, Institute of Fine Arts, New York University, 1976.

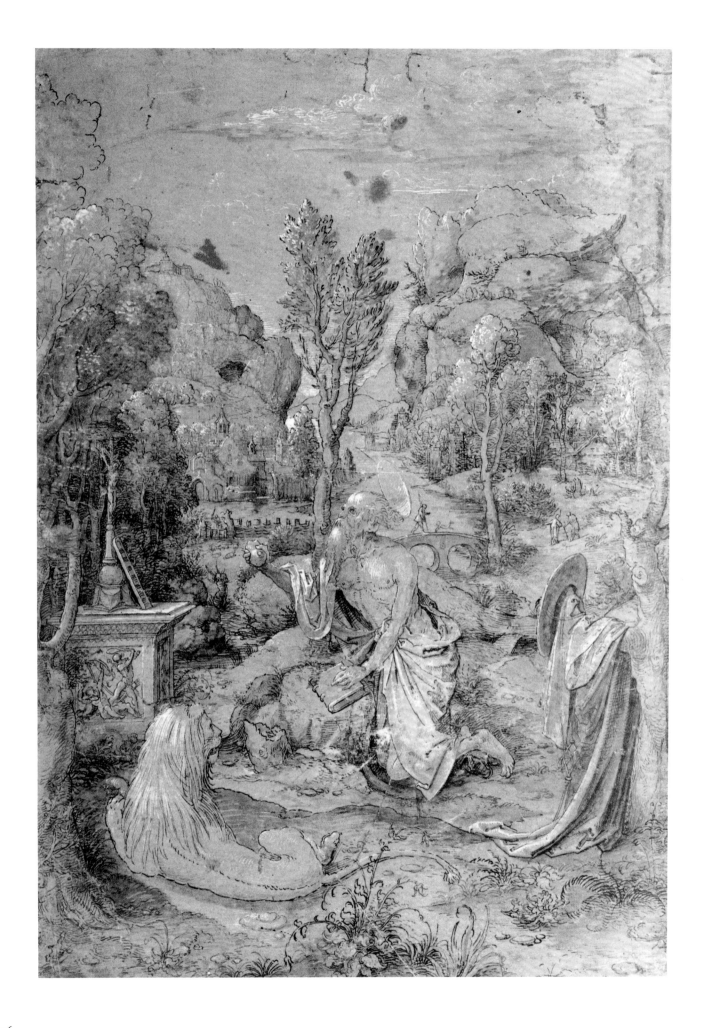

ANTWERP ARTIST

7 Saint Jerome in Penitence

Point of brush and black ink, gray wash, and white heightening, on gray prepared paper
372 x 262 (14⅝ x 10⁵/₁₆)

Provenance: Leopold Hirsch

Literature: Popham 1926a, 32, no. 54; Popham 1932, 70, no. 70; Baldass 1944, 148

Trustees of the British Museum, London, inv. no. 1912.12.14.6

Exhibited in Washington only

Of the four Latin Church Fathers, Saint Jerome is perhaps the most visually interesting and complex, and a touchstone for many aspects of Renaissance thought. The patron saint of scholars and humanists—the favorite of Erasmus—he also, as seen in this fine drawing, represents self-denial and asceticism. As recounted in one of his letters, Jerome retired to the desert of Chalcis where he often mortified himself day and night in an effort to overcome his passionate visions of the pleasures of Rome.[1]

In the British Museum drawing, Jerome is shown half-naked, kneeling in front of a crucifix, a rock in one hand, the other resting on a book, probably a Bible. Leaning against the crucifix is a tablet in the shape of the tablets of the Law given to Moses; as a symbol of the Old Testament this may allude to the prophecies of Christ as Messiah or to Jerome's knowledge of Hebrew, which along with Greek, was required for his translation of the Bible into Latin.[2] On the side of the base of the crucifix is a scene of battling warriors, a possible reference to the classical, pagan world that Jerome was renouncing.

Other attributes of the saint are the cardinal's hat and cloak hanging from a tree limb and the lion who, according to legend, became his faithful companion after Jerome removed a thorn from his paw. In the mountains at the upper right one can discern two camels and a third animal; these probably refer to another episode involving Jerome's lion.[3]

Depictions of the penitent Jerome flourished first in Italy in the fifteenth century and spread to Germany and the Netherlands in the late fifteenth and early sixteenth centuries,[4] appearing in prints, drawings, and paintings. The theme seems to have been especially popular among Antwerp artists, and part of its appeal may have been that it provided an opportunity to include a landscape. For example, five of Patinir's nineteen autograph paintings represent Saint Jerome.

The artist who drew the British Museum sheet remains anonymous, and no other paintings or drawings by his hand have been identified. Executed in the chiaroscuro technique favored by the Antwerp mannerists, the drawing rises well above their usual level of quality, and perhaps for this reason was once attributed to the youthful Bernard van Orley by Baldass.[5] The drawing is distinguished by a delicacy and sureness of line and a carefully composed, rhythmically animated composition. Note how the S-curve of the lion's body and tail is echoed in the lines of the foreground and in the cardinal's cape, and set off against the more lively curves of the plants in the foreground.

The drawing may be dated c. 1515/1525. The massive, bizarre rock formations derive from Patinir's example, although the rocks themselves are not as eccentric.[6] The landscape elements are built up vertically, but in smoothly receding layers. The drawing's function is unknown, though it may have been preparatory to a painting. JOH

1. Wright 1953, 66-69.
2. A tablet resting against a crucifix also appears in a painting of *Saint Jerome Penitent* (Kunstgewerbemuseum, Cologne) by an Antwerp artist working around 1525; Franz 1969, fig. 27.
3. This refers to the story, found in *The Golden Legend*, of how the lion, falsely accused of having eaten a donkey belonging to the Hieronymite monastery, rescued the donkey from merchants and exonerated himself. See Ryan and Ripperger 1941, 2: 589-591. This episode occurs with some frequency in the background of depictions of Jerome's penitence.
4. Réau, *Iconographie*, 3, part 2 (1958): 742-744.
5. Baldass 1944, 148.
6. The closest parallels are the somewhat subdued rock formations in Patinir's *Saint Jerome* (Metropolitan Museum of Art, New York); Friedländer, *ENP*, 9, part 2 (1973): supp. 266, pls. 250-251. Popham 1932, 70, saw similarities with the landscapes in Vellert's engravings and drawings of 1523.

ANTWERP ARTIST

8 Landscape with a River and a Mill

Pen and brown ink
188 x 283 (7⅜ x 11⅛)

Watermark: Arms of Paris, Bofarull 1956, no. 58 (Paris, 1488-1499)

Inscribed at lower right, in brown ink, *195*

Inscribed on verso, in red ink, *Lot 1766*; in black ink, *156*, in brown ink, *31:*

Provenance: Sir Joshua Reynolds, London (Lugt 2364); A.M. Champernowne, South Devon (Lugt 153); Leonora Hall Gurley, Chicago (Lugt Supp. 1230b, on verso); William F. E. Gurley, Chicago (recto, stamp not in Lugt)

Literature: Gudlaugsson 1959, 138; Dunbar 1972, 59 n. 14

The Art Institute of Chicago, The Leonora Hall Gurley Memorial Collection, inv. no. 1922.2977

This delicate depiction of a placid village nestled among trees is possibly a leaf from a sketchbook. In the foreground, four figures stand on a narrow neck of land in front of a river that powers the mill at the right. A cleared, semicircular field occupies much of the middle ground and in the distance are the crenellated walls, roofs, and church spires of a small town.

The Chicago sheet was discussed only by Gudlaugsson who compared it to drawings in the Errera Sketchbook (Musées Royaux des Beaux-Arts, Brussels) and asserted that both the Chicago and Errera drawings were youthful works by Lucas van Valckenborch.[1] Gudlaugsson's attribution has not found acceptance, but with it we are plunged into the difficult, complex, and as yet unresolved problem of the authorship of the Errera Sketchbook. Franz discerned three different hands among the drawings; this approach was carried even further by Dunbar.[2] Mielke, however, found the distinctions between the hands blurred, and argued that the sketchbook was the work of one artist.[3] The artist of Errera Sketchbook remains unknown, but there is general agreement that it was produced in Antwerp.[4]

Despite similarities in the choice of subject, manner of composition, and period style, the Chicago drawing cannot be by the same hand as any of the sheets in the Errera Sketchbook. In their delicacy and lightness of touch, certain pages of the Errera Sketchbook[5] are close to *Landscape with a River and a Mill*, but the dry and somewhat feathery strokes and manner of depicting trees in the Chicago sheet is distinctive. I am not aware of any other drawings by this artist.

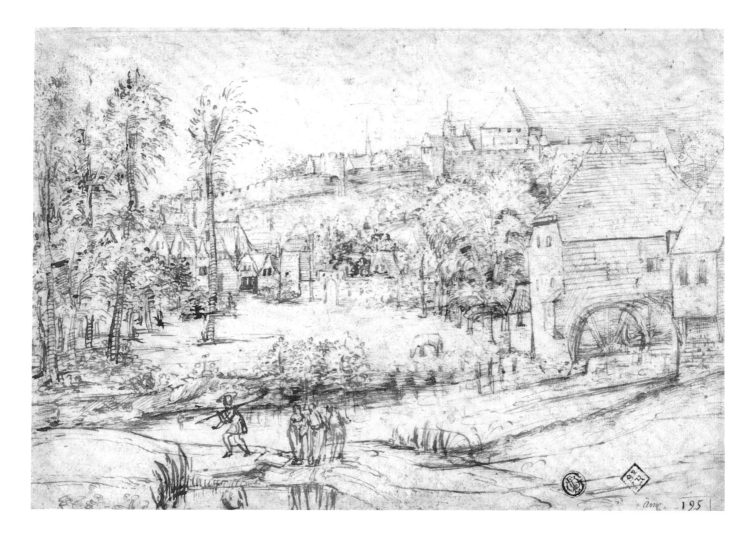

Landscape with a River and a Mill should be placed in the period around 1540. The earliest dated landscape of this type is a sheet from 1530 in the P. de Boer collection, Amsterdam, while the Errera Sketchbook contains a page that copies a painting dated 1546.[6] The elaborate, dated landscapes of the 1540s by Cornelis Massys offer some points of comparison, but the Chicago drawing is closer in spirit to the more modest, undated attributions to Cornelis.[7] Further landscapes of a similar type are found in the first part of an album (Staatliche Museen, Kupferstichkabinett, Berlin) that is attributed to an Antwerp artist and dated c. 1530/1543.[8]

The artist's sketchbook did not necessarily contain only firsthand impressions of nature, but functioned as a repository for motifs and compositions that were admired in the work of other artists.[9] It is possible that *Landscape with a River and a Mill* copies another work of art, most likely a drawing. Evidence for this may be seen in the group of trees at the left, for the leaves seem disconnected from their branches and float in mid-air, as if one step removed from direct observation. JOH

1. Gudlaugsson 1959, 138.
2. Franz 1969, 70-73; Dunbar 1972.
3. Berlin 1975, 136, no. 181.
4. Boon 1955b, 219, refuting Benesch's earlier suggestion that the artist was Hans Vereycken who was active in Bruges. See Berlin 1975, 135-137, no. 181, and Dunbar 1972, 53-58, for previous attributions of the sketchbook to Joachim Patinir, Lucas Gassel, Matt-

hijs Cock, Cornelis Massys, and others.
5. In particular, the landscapes on pages 113 and 131, Franz 1969, figs. 70,73.
6. The De Boer collection drawing is reproduced in Franz 1969, fig. 50, erroneously labeled as part of the Errera Sketchbook. The drawing on page 112 of the sketchbook copies a painting of a farmhouse with a square tower (formerly Kappel collection, Berlin) dated 1546; a second painted version is in the Musées Royaux des Beaux-Arts, Brussels. Neither are attributable to a known artist. Gudlaugsson 1959, 120-121, figs. 3-5.
7. Specifically, the *Landscape with Watermill* (Museum Boymans-van Beuningen, Rotterdam) and the *Landscape with a Church* (P. de Boer collection, Amsterdam); Zwollo 1965, figs. 11, 16, and attributed by her to Cornelis Massys.
8. Berlin 1975, 134-135, no. 180.
9. Mielke made this observation in Berlin 1975, 134-137, nos. 180-181, and also noted that certain landscape and building motifs appear in both sketchbooks and are also found in paintings and individual drawings.

Dirck Barendsz.

1534-1592

Barendsz. was born in Amsterdam, the son of the painter Doove Barend, from whom he presumably received his early training. At the age of about twenty-one, he left for Italy, where he lived in Venice as part of Titian's household, according to Van Mander. He remained in Italy seven years, at some point visiting Rome where he inscribed his name on the wall of the Domus Aureus. He must have been back in Amsterdam by 1562, because he married a woman from a prominent Amsterdam family at the age of twenty-eight, and his earliest known work, the Portrait of Company G in the Rijksmuseum, is dated in that year. He seems to have remained in Amsterdam for the rest of his life, as Van Mander's account implies that he found it difficult to travel even to nearby Haarlem. Barendsz. was well versed in languages, music, and mathematics, and he enjoyed the friendship of statesmen and humanists.

Among the very few works by Barendsz. that survive, the triptych of the Nativity in Gouda provides the clearest testimony to the harmony of form and rich handling of paint that he brought back from Italy. An altarpiece of the fall of the rebel angels, painted for the Amsterdam Guild of Marksmen, was de-stroyed in the iconoclastic outbreak of 1566, according to Van Mander, though a drawing at Windsor may be a preparation for it. Several group and individual portraits by him survive. About thirty drawings by Barendsz. are known, and almost all of them are preparations for prints. These include twenty-four recently discovered chiaroscuro sketches in oil, from a series of forty preparations for an incomplete series of engravings of the life of Christ by Jan Sadeler I, and hence a major addition to our knowledge of his oeuvre. It is difficult to trace a clear chronological development in his surviving work, in part because no dated works are known between the 1567 Portrait of Dirck Jan Hendricksz. in the Occo Hofje, Amsterdam, and the 1581 modello for the engraving of Mankind Awaiting the Last Judgment (cat. 10).

Van Mander accorded Barendsz. special praise as the most important transmitter of the "right Italian manner [de rechte manier van Italien], pure and unalloyed," to the Netherlands. While the precise meaning of Van Mander's phrase may be debated, it is clear that Barendsz. introduced important innovations into northern Netherlandish art, both in terms of fluid technique and spatial arrangement.

9 Saint Peter Walking on the Water

Dark brown, gray, and cream oil paint on paper prepared with lighter brown oil paint, laid down and varnished
249 x 209 (9¹³/₁₆ x 8³/₁₆)

Inscribed on boat at lower right in brown oil paint, *Theo*; on old mount above drawing in black ink surrounded by ruled border, *37.*; at bottom below drawing surrounded by ruled border, *Jesus apparoit a ses Disciples*; on verso of mount in graphite in center, *126* encircled

Provenance: Private collection, France; (P. & D. Colnaghi, Ltd., London, 1985)

Literature: Mariette, *Abecedario*, 1: 65-68; Bull 1985, 471

Exhibitions: London 1985, no. 12

The Pierpont Morgan Library, New York. Gift of the Fellows with the assistance of the Herzog Fund, inv. no. 1985.52

The subject of this rapid sketch is the incident recounted in Matthew 14: 22-33, when the disciples were in a small boat on a stormy sea and Christ came out to them, walking on the water. Barendsz. depicts the moment when Saint Peter, at Christ's command, walks out to join him, but begins to sink as he loses faith amid the wind and tossing waves.[1] The scene is rendered economically with a few broken and flickering strokes accentuating the straining figures in the boat, waves, and clouds. The warm middle tone, which is brushed in with visible strokes to prepare the paper, suggests a night scene and hints at a veil of falling rain in the distance.

This is one of a group of recently discovered sketches, all the same size, from a series of forty chiaroscuros of episodes from the Life of Christ, which Mariette saw in Paris in 1759 and at an earlier date. This sheet and sketches of *The Ascension*, *The Incredulity of Thomas* (acquired by the British Museum), and *Joseph of Arimathea Requesting Jesus' Body from Pilate*, have only recently appeared and were exhibited together at Colnaghi.[2] More recently, twelve sketches from the series appeared on the Paris art market and one more can be identified in the Kupferstichkabinett, Berlin.[3] They join seven sketches from the series published by Pierre Rosenberg and Jacques Foucart, who attribute them to Barendsz. and identify them with Mariette's notice.[3] Mariette mentions that Jan Sadeler I engraved several Passion scenes after Barendsz. and that he had seen forty preparatory drawings in black and white for these, not all of which were

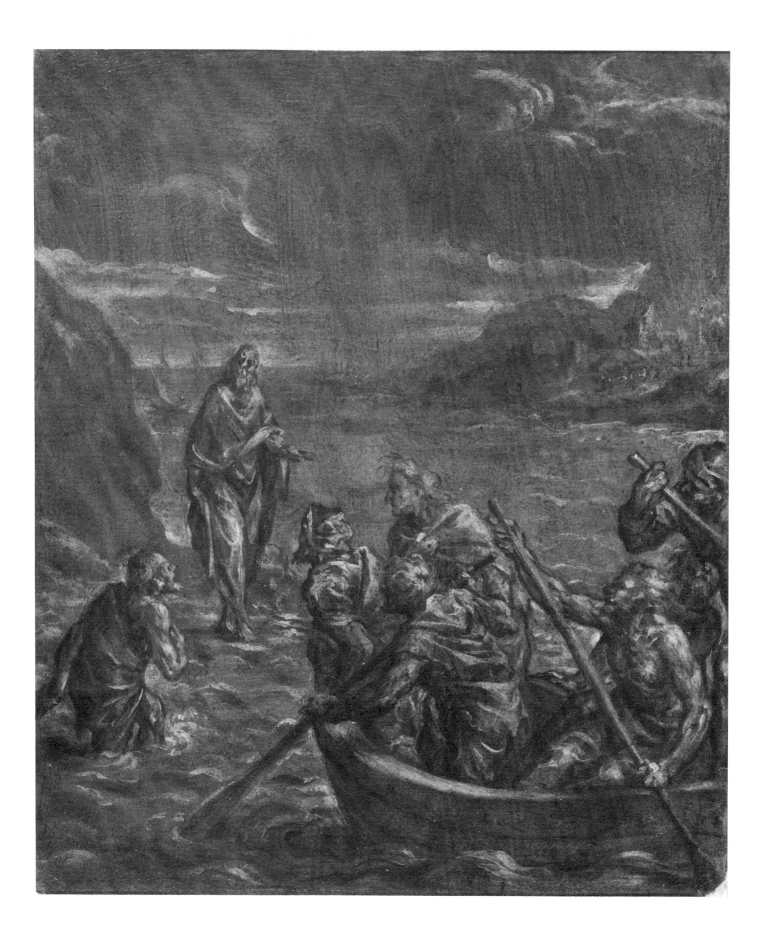

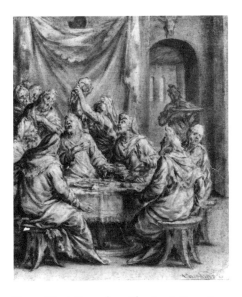

Fig. 1. Dirck Barendsz., *The Anointing at Bethany*, Musée du Louvre, Cabinet des Dessins, Paris (Cliché des Musées Nationaux)

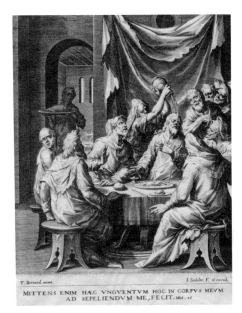

Fig. 2. Jan Sadeler I after Dirck Barendsz., *The Anointing at Bethany*, Rijksprentenkabinet, Amsterdam

engraved. Later Mariette recorded that he had the opportunity to examine the group more closely in 1759, at which point he observed that some were inscribed *Joes Sadeler f.*, *Jan. Sad.*, and *Joan Sad* in addition to *Theodorus in.*.[5] He therefore concluded that the whole series must be by Sadeler after Barendsz.' designs. The four sketches exhibited together in London are on old mats with inscriptions in French and a numbering system corresponding to that mentioned by Mariette. A sketch of *The Resurrection of the Dead* in the Musée des Beaux-Arts, Lille, was formerly on an identical mat.[6]

To date only five engravings by Sadeler after the series have been identified: *The Entry into Jerusalem, Christ Driving the Moneychangers from the Temple, Father, Glorify Thy Name* (John 12: 28), *The Anointing at Bethany* (figs. 1 and 2), and *The Mocking of Christ.* The sketches published by Rosenberg and Foucart do include one, *The Crowning with Thorns* in Rouen, inscribed *Theodo . . . IN* and *JAN SAD(?).*[7] However, the authors are undoubtedly correct in discounting the possibility of Sadeler's authorship. No drawings by him are known, and the angular poses, broken contours, and above all the lively application of flickering strokes of shadow and highlight are in complete accord with other drawings by Barendsz. (cat. 10).

The date of this series is more difficult to determine. Rosenberg and Foucart place the sketches in the 1580s, comparing them to the 1582 *Jonah Spat up by*

the Whale in the Albertina and *The Entombment* in the Rijksprentenkabinet.[8] However, it should be noted that the technique of these monochrome sketches is strikingly similar to the figure of Death inserted in the background of the *Portrait of Dirck Jan Hendricksz.*, dated 1567.[9] In their elongated proportions, the figures of the chiaroscuro series are comparable to the shepherds in the background of the Gouda triptych, usually dated c. 1565.[10] These similarities do not necessarily indicate an early date, but rather that Barendsz.' work does not show a marked chronological development.

J.R. Judson compares Barendsz.' fluid brushwork in the monochrome figure of Death to Schiavone's drawing style,[11] and this is valid for the sketches as well. They evoke other parallels with Venetian art, notably with El Greco's small, early paintings[12] and the oil sketches of Palma Giovane and Domenico Tintoretto.[13] However, since these works are later than c. 1555-1562, Barendsz.' years in Venice, the free oil sketch may be the Amsterdam artist's own development from the Venetian tradition. Like most of Barendsz.' surviving works, the sketches show an innovative adaptation of Italian style to northern requirements. Yet, it should not be foregotten that some of his Flemish contemporaries, including Floris. Beuckelaer, and Spranger, also used the monochrome oil sketch to study subtle or dramatic effects of light for figural compositions.[14] MW

1. The title on the old mount, as well as the designation as no. 37 in the series of forty, suggests that the sketch was interpreted as the later incident of Christ appearing to his disciples on the Sea of Tiberias after the Resurrection (John 21: 1-14), an interpretation retained in London 1985, no. 12. The stormy sea, Peter sinking up to his knees, and the fact that the six disciples in the boat are not shown fishing all point to the episode that precedes the Passion.
2. London 1985, nos. 11-14, repro.; nos. 11 and 14 were acquired by an English collector.
3. Hôtel Drouot, Paris, 29 April 1986, nos. 82-93. The modello in Berlin represents the Descent from the Cross. It is KdZ 24860, from the Pacetti collection, unpublished. I am grateful to William W. Robinson for bringing this sheet to my attention.
4. Rosenberg and Foucart 1978, 198-204, figs. 2-8. These seven are: *The Calling of Saint Matthew* (Louvre, Paris, Département des peintures with life interest]); *Christ in the House of Simon* (Louvre, Paris, Département des peintures); *The Crowning with Thorns* (Musée des Beaux-Arts, Rouen); *The Crucifixion* (private collection, Paris); *The Resurrection of the Dead* (Musée des Beaux-Arts, Lille); *Saints Peter and John at the Tomb* (Musée des Beaux-Arts, Rouen); and *Christ Appearing to the Three Marys* (Musée Lambinet, Versailles).
5. Mariette, *Abecedario*, 1: 65-67; the editors Chennevières and Montaiglon add that they had seen the series of drawings, which were offered to the Louvre, at some time before 1853. In none of these instances is the owner mentioned.
6. See London 1985, nos. 11-14, and Rosenberg and Foucart 1978, fig. 8. Mariette, *Abecedario*, 1: 66-67, mentions sketches numbered 14, 19, 23, and 28.
7. Rosenberg and Foucart 1978, 203, not in the same hand as the *Theodorus.*
8. Rosenberg and Foucart 1978, 201-202; Judson 1970, figs. 28 and 26A respectively. They are correct in calling attention to the reference to the two Jonah scenes and the Entombment as a series in Heinecken 1778-1790, 2: 554. Jan Sadeler's engravings after these scenes bear arabic numbers 1-3 and Custos' copies Roman numbers I-III.
9. Judson 1970, no. 34, figs. 20-21.
10. Judson 1970, no. 6, figs, 7-13, esp. fig. 10.
11. Judson 1970, 58.
12. Compare especially the small portable altarpiece in Modena; Venice 1981, no. 95. Foucart 1985, 41, also compares the sketches to El Greco. For Palma Giovane, see London 1983b, no. D30.
13. For the album of Tintoretto sketches in the British Museum, see Tietze and Tietze-Conrat 1944, 263-266, no. 1526, pls. CXVII-CXVIII and CXX-CXXI.
14. Compare Floris' delicate *Diana and Actaeon* (see The Functions of Drawings, fig. 4), two sketches of Calvary by Beuckelaer in the Louvre (Lugt 1968, 124-125, nos. 603-604, pl. 171); and Spranger's 1582 *Saint Luke Painting the Virgin* in Munich (cat. 107, fig. 2), apparently a modello for Raphael Sadeler's engraving.

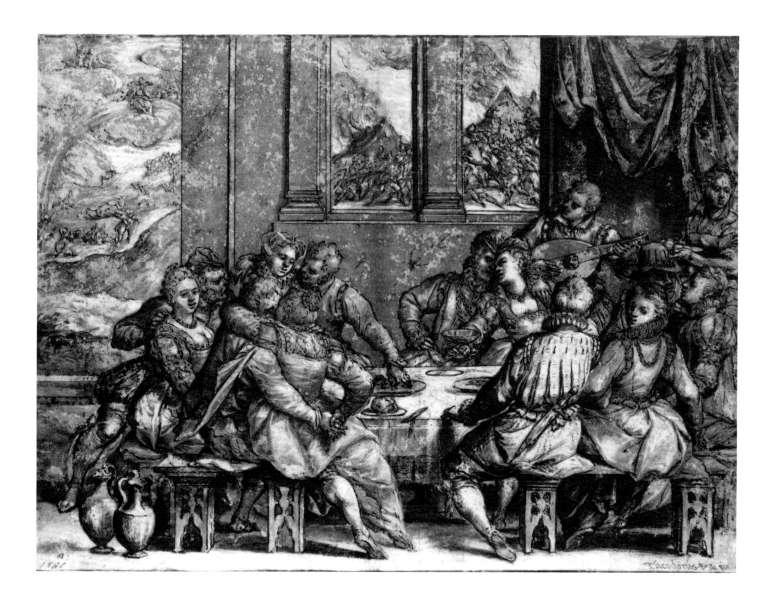

DIRCK BARENDSZ.

10 *Mankind Awaiting the Last Judgment*

Pen and brown ink, brown wash, and white body color
337 x 461 (13¼ x 18⅛)

Inscribed in brown ink at lower right, *Theodorus:* [bar?] *in;* in brown ink at lower left, *1581*

Provenance: Dyce bequest, d. 1869

Literature: Steinbart 1940, 71-72; Reznicek 1961, 146; Judson 1962, 98-101, 105, 116-117; Judson 1970, 25, 32-35, 78, 93-98, 118-119; Stechow 1972, 166, 171, 174-175; Harbison 1976, 81-83, 86

The Victoria and Albert Museum, London, inv. no. Dyce 442

This sheet is the modello for one of an influential pair of engravings by Jan Sadeler I after Barendsz., illustrating Christ's admonition in Matthew 24: 37-39, "As were the days of Noah, so will be the coming of the Son of man. For as in those days before the flood they were eating and drinking, marrying and giving in marriage, until the day when Noah entered the ark, and they did not know until the flood came and swept them all away, so will be the coming of the Son of man.'"[1] The first plate (fig. 1), for which the modello does not survive, shows an outdoor banquet of seminude figures who feast, sing, and make love even as the torrential rains of the flood fall on the ark in the distance. In this drawing and the second plate that copies it (fig. 2) the activities and elegantly alternating poses of the seated couples are similar, but the background vignettes of a battle scene and the Last Judgment refer to Christ's description of the signs of the last days in the immediately preceding text of Matthew's gospel.

Scenes of merrymaking that taught the vanity or folly of earthly pleasures were produced throughout the sixteenth century. Barendsz.' own painting of a "modern banquet," known from copies and from Van Mander's description, included a fool as a gentle warning to his viewers.[2] However, the explicit references to the flood and the Last Judgment give a more pointed moralizing message to these paired prints.[3] The clarity of the complementary arrangement of the two scenes, with their banqueting tables placed parallel to the front plane, reinforces this message. Barendsz. contrasts the generalized seminudity of the revelers from the days of Noah with the fashionably dressed contemporary figures, thus underscoring the warning to his audience. The concise, didactic character of his pair is evident from a comparison to Marten de Vos' more abstract treatment of a very similar concept in the six-part series of The Second Coming of Christ.[4]

The large number of copies, both prints and paintings, after Sadeler's paired en-

62

gravings demonstrates the wide influence of Barendsz.' designs.[5] Further, numerous representations of mankind before the flood, notably in paintings by Cornelis van Haarlem and other Haarlem artists, may have been inspired by the engraving.[6] Moreover, Judson has shown that Barendsz.' compositions, and particularly his fasionably dressed merrymakers, were influential for early seventeenth-century high life genre scenes, in which the moralizing component was increasingly diluted.[7]

This is Barendsz.' first dated work after the *Portrait of Dirck Jan Hendricksz.* of 1567 in the Occo Hofje,[8] and hence is important for an understanding of his chronological development. J.R. Judson suggests that it and the pendant design signal a classicizing tendency in Barendsz.' work of the 1580s.[9] However, it is possible that their clarity of structure is a function of subject and scale rather than a new stylistic phase, particularly since the Amsterdam drawing of the *Entombment* must now be dated 1582.[10] Further, Barendsz.' surviving oeuvre does not include enough works of a single type and medium from different periods of his career to make generalization possible.
MW

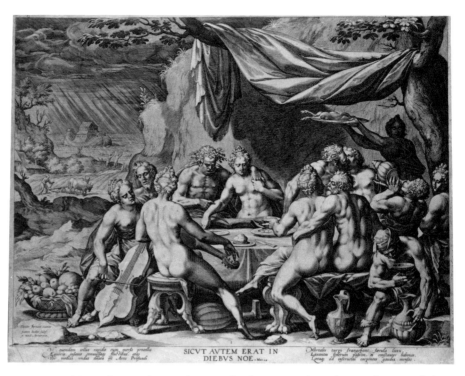

Fig. 1. Jan Sadeler I after Dirck Barendsz., *Mankind Awaiting the Deluge*, Rijksprentenkabinet, Amsterdam

1. Hollstein 1951, 264 and 265; 348 x 455 mm and 348 x 454 mm (size of image 332 x 451 mm), with the text of Matthew 24: 37 divided as a title for the two plates: SICVT AVTEM ERAT IN DIEBVS NOE Matt. 24 and ITA ERIT ET ADVENTVS FILII HOMINIS. Matt. 24. For the additional inscriptions and editions, see Judson 1970, 126-131, nos. 71-72.
2. Van Mander describes a copy by the young Bloemart, *Schilder-boek*, 2: 352. For other copies, including one dated 1578, see Judson 1970, 113, no. 30, fig. 22.
3. The pairing of illustrations of these two parts of the text seems to be original to Barendsz. A lost painting by Bosch was described in 1595 as "a history with naked people, sicut erat in diebus Noe," and Gombrich has interpreted Bosch's *Garden of Earthly Delights* as mankind before the flood: see Gombrich 1969, 162-170, esp. 166.
4. See Mauquoy-Hendrickx 1978-1979, 2: 274-275, nos. 1506-1511, pl. 205, for this undated series illustrating the second coming of Christ, with each plate accompanying paired warning texts from the Old and New Testaments.
5. See Judson 1970, 126-131, nos. 71 and 72 for these.
6. Stechow 1972, 165-175.
7. Judson 1962, 98-105 and 1970, 93-98.
8. Judson 1970, 114, no. 34, fig. 20.
9. Judson 1970, 35.
10. Rosenberg and Foucart 1978, 201-202, and cat. 9.

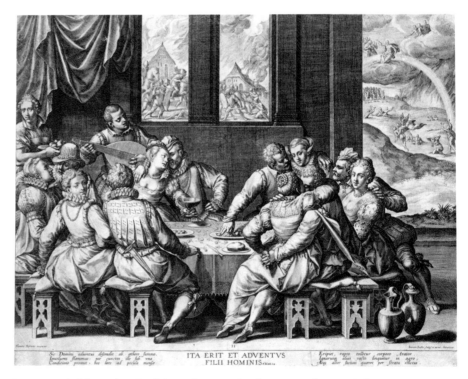

Fig. 2. Jan Sadeler I after Dirck Barendsz., *Mankind Awaiting the Last Judgment*, Rijksprentenkabinet, Amsterdam

Jan de Beer

c. 1475-before 1528

Probably born around 1475, Jan de Beer is first mentioned in 1490 as an apprentice to the Antwerp painter Gillis van Everen. In 1504 Jan de Beer became a master in the Antwerp painters' guild and held positions of authority in the guild; he was alderman in 1506 and dean in 1515. He enrolled apprentices in the guild in 1510 and 1513. His son Aert de Beer (c. 1509-before 1540) became an artist noted for stained glass cartoons, but no examples of his work survive. Jan de Beer is mentioned in several documents from 1519, including a lawsuit against a former colleague. It was thought that the artist lived until c. 1536, but Dan Ewing has recently published a document that indicates that Jan de Beer died before 10 November 1528.

The only signed work by Jan de Beer is the drawing of Nine Heads *in the British Museum, also dated, and usually read as 1520. The drawing can be associated with a group of paintings brought together by Friedländer. Chief among these is the* Adoration of the Magi *(Pinacoteca di Brera; Milan). Several drawings have been attributed to Jan de Beer, including designs for stained glass windows and roundels. Jan de Beer was one of the outstanding practitioners of the Antwerp mannerist style; he shares their coloristic and compositional exuberance and inventiveness, but stands apart by virtue of the superior technique and quality of his work.*

11 Nine Heads

Brush and black ink, black chalk, and white heightening on reddish-tan prepared paper, 200 x 259 (7⅞ x 10³⁄₁₆)

Inscribed at upper left, *Jan de Beer 15 0*; on verso; *Jochem de patinir* (an outline drawing of a squatting figure), ↕

Provenance: Cremer collection (sale, Amsterdam, 15 June 1886, no. 227)

Literature: Rooses 1903, 93; Hulin de Loo 1913, 71; Friedländer 1915, 89-90; Friedländer 1921b, 7-8; Conway 1921, 387; Popham 1926a, 15-16, 31-32, no. 52; Popham 1932, 4, no. 1; Friedländer, *ENP*; 11 (1933): 22-23 (11 [1974]: 17-18); Baldass 1937b, 131-132; Delen 1944, 55-56; Thieme-Becker, 37 (1950): 212; Croft-Murray 1952, 9; Puyvelde 1960, 65; Vervaet 1977, 169; Ewing 1978, 1: 40-55, and 2: 246-249, no. 10; Ewing 1980, 48, 50; Starcky 1981, 97-98; Boon 1985, 9-16

Trustees of The British Museum, London, inv. no. 1886.7.6.7

Exhibited in Washington only

The drawing of *Nine Heads* is the only fully signed work by Jan de Beer and therefore the basis for attributions to him.[1] Although the third digit is unclear, Hulin de Loo's reading of the date as 1520 is generally accepted.[2] This is almost certainly a leaf from a sketchbook, executed in the chiaroscuro technique favored by the Antwerp mannerists. The nine male heads, depicted in a variety of sizes and poses, are arranged randomly over the page. Different personalities are shown as well, but as noted by Ewing, downcast eyes and a mood of quiet introspection are common to many of the faces.[3] While the heads do not have exact counterparts in extant works, it is clear that some are "types" created and used repeatedly by the artist; others may have their origin in studies from nature.[4]

Nine Heads displays De Beer's great vitality and skill with the brush; the faces are built up with short, energetic strokes applied without hesitation. The combination of heavier strokes (in eyelids and noses, for example) with crosshatching and delicately applied white heightening endows these heads with both solidity and textural variety. In some of the smaller heads the initial chalk sketch alone is retained.

In 1915, two years after Hulin de Loo published his discovery of the signature and date, Friedländer connected the *Nine Heads* with those paintings and drawings he grouped under the sobriquet Master of the Milan Adoration.[5] The recurrence, in modified form, of the heads in many of the paintings and drawings attributed to

the master helps to confirm his identity as Jan de Beer. To take one instance, Ewing notes that the large head with a forked beard, just right of the center, is unique to Jan de Beer, and variations on this type can be found in the large cartoon of *The Tree of Jesse* (Albertina, Vienna), *The Adoration of the Magi* (fig. 1; Pinacoteca di Brera, Milan), and *Joseph with the Flowering Rod* (Barber Institute of Fine Arts, Birmingham) as well as other works.[6] The importance of the British Museum sheet is further underscored by the realization that the overwhelming majority of the Antwerp mannerists have remained anonymous.

For Popham the appearance of Patinir's name on the verso suggested that the drawing once belonged to him.[7] Ewing took this idea a step further and hypothesized that the *Nine Heads* was a gift to Patinir and that what appears to be an inscription above the signature and date is the remains of a dedication.[8] This is an intriguing thought and is one explanation of why De Beer's signature appears on this sketch but not on any other paintings and drawings. JOH

Fig. 1. Jan de Beer, *The Adoration of the Magi*, Pinacoteca di Brera, Milan (Alinari/Art Resource, N.Y. 31811)

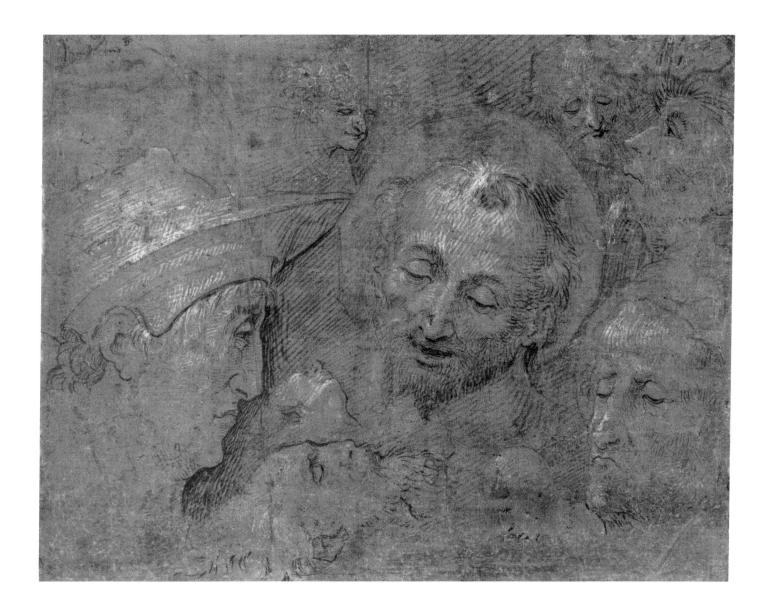

1. Ewing 1978, 1: 43, notes that the name "HENIN" that appears on the hem of Longinus' robe in the *Crucifixion* (Alte Pinakothek, Munich; Friedländer, ENP, 11 (1974); no. 13, pl. 13) might be a partial signature. Henin is a form of Henneken or Jan.

2. Hulin de Loo 1913, 71, where he notes that he first observed the signature and date in 1902. Ewing 1978, 1: 45, found this the most plausible reading of the date. Prior to Hulin de Loo's publication, the drawing was attributed to Patinir, probably because of the inscription on the verso.

3. Ewing 1978, 1: 48-49.

4. Ewing 1978, 1: 46, cites the head seen in extreme foreshortening at the lower left of center as deriving ultimately from a life study.

5. Friedländer 1915, 69-78, 89-90; this association is first expressed rather cautiously, but in Friedländer, *ENP*, 11 (1933): 17-18, the identification is made with more confidence. The most recent study and cata-

logue of the paintings and drawings of Jan de Beer is Ewing 1978, which reduces the number of works to about twenty-one.

6. Ewing 1978, 1: 52-55, and 2: 249, where counterparts to the other heads in the drawing are cited as well.

7. Popham 1932, 4, cites as a corollary example Dürer's presentation of his drawings of Saint Christopher to Patinir. The inscription and accompanying figures are in pen and black ink in what appears to be a sixteenth-century hand.

8. Ewing 1978, 1: 42-43. While Friedländer, *ENP*, 11 (1933): 21, notes the influence of Patinir's landscape style in De Beer's *Nativity* triptych (Wallraf-Richartz-Museum, Cologne), Ewing 1978, 1: 59-60, believes that Patinir borrowed the motif of shepherds dancing around a bonfire from Jan de Beer who used it in three of the Nativities.

Anthonis Blocklandt

1533/1534-1583

Anthonis Blocklandt, whose family name was Sweersz., was born in Montfoort to a family proud of its ancient lineage. He began his study of painting in Delft with his uncle Hendrick Sweersz. and then studied in Antwerp for two years with Frans Floris, who had lately returned from Italy. According to Van Mander, Blocklandt returned to Montfoort in 1552 and married there at the age of nineteen, later settling in Delft. In 1572 he traveled to Italy, where he visited Rome and probably returned home by way of Milan. By 1577 he was registered as a master in the saddlemakers' guild in Utrecht, to which the painters also belonged. He died in Utrecht, probably shortly before 18 October 1583.

Blocklandt painted numerous altarpieces and other religious pictures, many of which were destroyed by the iconoclasts. The few works that can be confidently dated to the long period of activity before his Italian trip, including The Beheading of Saint James in Gouda and a 1571 engraving of the Last Supper by Philip Galle, show Floris' influence, with powerful figures arrayed on a steeply raked, stagelike space. No drawings from this period have been identified. Blocklandt's surviving later works, chief among them the 1579 altarpiece of the Virgin painted for a church in Utrecht and now in Bingen, and numerous designs for prints, confirm Van Mander's testimony that he imitated Parmigianino. The informal massing of the figures, the suave contours, and small, elegant heads of his late period reflect his absorption of the style of the group of contemporary Roman painters dominated by Federico Zuccaro, as well as of Parmigianino and his followers. These characteristics are particularly evident in the fewer than twenty-five known drawings by Blocklandt, executed in a sure and flowing pen, in pen and wash or in a grisaille oil technique.

Along with Dirck Barendsz., Blocklandt was an important transmitter of the most recent Italian style to the northern Netherlands, preparing the way for the decisive influence of Spranger in the mid-1580s. Among his pupils were Cornelis Ketel and Michiel Miereveldt; the young Hendrick Goltzius, who engraved several of his designs, was strongly influenced by him.

12 Christ Blessing the Children

Pen and brown ink over black chalk; verso, graphite
(verso: *sketches*)
196 x 296 (7¹¹/₁₆ x 11⅝)

Inscribed, at lower left, in dark brown ink, *A·Blocklant*; at center, in brown ink over traces of black chalk, *mar: 10/[cap?]:* ; before this in pencil, *278*; at lower right in pencil; *L.K.*

Provenance: Dukes of Braunschweig, seventeenth century

Literature: Vuyk 1928, 174; Wescher 1928c, 273-274; Jost 1960, 73-74, 100, 109-110, 115-116, 150-151, no. II.3; Jost 1967, 119; Jost 1968, 141-142

Herzog Anton Ulrich-Museum, Braunschweig, inv. no. Z. 981

The inscription, apparently in the same ink as the drawing, refers to Mark 10: 13-16, "And they were bringing children to him, that he might touch them; and the disciples rebuked them. But when Jesus saw it he was indignant, and said to them, 'let the children come to me, do not hinder them, for to such belongs the kingdom of heaven. Truly, I say to you, whoever does not receive the kingdom of God like a child shall not enter it.' And he took them in his arms and blessed them, laying his hands upon them." The disciples, in a porch and in the left foreground, look on while mothers and children press toward the central figure of Christ.

This harmonious episode from the teaching of Christ was popular as a subject in painting from shortly before the middle of the sixteenth century. Although paintings of this episode by Lucas Cranach and his workshop have been interpreted as Lutheran polemics against the Anabaptists' denial of infant baptism,[1] the subject did not have exclusively Catholic or Protestant connotations.[2] With the Protestant consolidation of the northern Netherlands in the last decades of the sixteenth century, religious art was in disfavor. Utrecht, where Blocklandt worked for the last years of his life, joined the party of William of Orange in 1577, though the city was a center for the Catholic minority. In June 1579 Utrecht suffered an outbreak of iconoclasm, and Blocklandt would not have produced a public altarpiece after that point.[3] However, a private, didactic painting of Christ blessing the children might have been exempt from such restrictions.[4] The Braunschweig sheet may have been made in

preparation for either a painting or a print, though the fact that Christ is shown blessing a child with his right hand argues for a painting.

The arrangement of a stagelike space with an open center and a row of figures closing off the back is typical of Blocklandt.[5] That the drawing belongs to Blocklandt's later period, after his Italian trip in 1572, is indicated by the fluid interaction within the figural groups, the poses that break out of a single plane, and the transition made between the foreground and middle ground through the women standing at the extreme right. It was just these areas of transition that occupied Blocklandt in his first black chalk sketch. The pose of the pointing disciple at the right was thoroughly worked out in black chalk, counterbalancing standing figures were lightly sketched at the left, and the poses of the framing foreground figures adjusted in black chalk.[6]

On the basis of the more relaxed spatial transitions, Jost placed the drawing c. 1579/1580, in close proximity to the Bingen altarpiece, traditionally dated 1579.[7] However, the scarcity of dated works by

Blocklandt and the short period of time remaining to him after his Italian trip caution against assigning a precise date. As a compositional sketch working out the placement of the figures and fixing broad areas of light and shadow, the Braunschweig sheet is freer than most of Blocklandt's known drawings. The extremely sure contour lines and airy hatching nevertheless resemble the *Female Nude* in the Fondation Custodia,[8] which must be close in date. MW

1. See Kibish 1955, 196-203 and Basel 1974, 2: 516-518, under no. 366. The earliest treatments of the theme by Cranach and his workshop date from 1538; a painting by Vincent Sellaer in the Alte Pinakothek, Munich, signed and dated 1538, is the earliest Netherlandish painting of the subject: see Wescher and Steinbart 1927, fig. 1.

2. Knipping 1974, 1: 206-209. Examples include early works by Frans Floris (Van de Velde 1975, nos. S 41 and 42 and T 35, figs. 11, 13, and 134), a painting by Marten de Vos, part of the decoration of the Lutheran Schlosskapelle, Celle (Zweite 1980, 85-90, 97-98, 277-278, no. 37, fig. 47); and a drawing by Karel van Mander dated 1591 in Düsseldorf (Düsseldorf 1969/1970, no. 137, fig. 102).

3. For the unsettled situation in Utrecht and its probable effect on Blocklandt, see Jost 1960, 79-80, 141-142.

4. For a discussion of the relation between theory and practice in the restriction of religious images in the second half of the sixteenth century, see Freedberg 1982, 133-153.

5. Jost 1960, 25-26 and 32-35, tracing these characteristics in the few works datable before his Italian trip as well.

6. The gesture and serpentine pose of the pointing disciple appear more fully developed in *The Flight of Lot from Sodom* engraved by Goltzius after Blocklandt's design in 1582; Strauss 1977, 1: 276-277, no. 162, repro. The framing figures on the left of the Braunschweig drawing resemble those in Philip Galle's engraving of *Christ and the Adultress* after Blocklandt, Hollstein 102.

7. See n. 3 above. Repro. Michel 1929, 41.

8. Florence 1980-1981, no. 23, pl. 64.

Abraham Bloemaert

1564-1651

Bloemaert, born in Gorinchem in 1564, moved as a young man with his family to Utrecht. After receiving some basic instruction from his father, an architect, sculptor, and engineer, he studied with a succession of unsatisfactory teachers. One of them was the elusive Joos de Beer who, according to Van Mander, was a mediocre painter but the owner of beautiful pictures by Anthonis Blocklandt and Dirck Barendsz. Van Mander describes a copy in oils made by Bloemaert after a modern banquet scene by Barendsz. At about the age of sixteen Bloemaert traveled to Paris where he studied with three different masters, including Hieronymus Francken. From 1591 to 1593 Bloemaert resided in Amsterdam, where he executed his earliest surviving paintings and drawings. He married in 1592 in Amsterdam, but settled in Utrecht the following year. A second marriage around 1600 produced six children. Four of his sons, Adriaen, Hendrick, Cornelis, and Frederick, became artists. Bloemaert died in Utrecht in 1651 at the age of eighty-six or eighty-seven.

Like Joachim Wtewael, yet another Utrecht painter who studied with Joos de Beer, Bloemaert cultivated the mannerist style propagated by Spranger and the Haarlem School until well into the seventeenth century. He later developed an eclectic classicism based on Rubens, the Bolognese painters, and the Utrecht Caravaggists, such as Hendrick Terbrugghen and Gerritt van Honthorst, who were his pupils. Bloemaert, who endured so many inadequate masters during his youth, was a magnetic teacher. In addition to the history painters Terbrugghen and Honthorst, he trained the landscapists Cornelis van Poelenburgh, Jan Both, and Jan Baptist Weenix.

Bloemaert's career spans a period of some sixty years: dated works are known from 1592 to 1650. More than 200 landscape, genre, and history paintings have survived, and over 600 prints were executed after his designs. His innumerable drawings range from finished works and elaborate designs for engravings, to composition studies for pictures, to various detail studies, including landscape motifs, animals, figures, nudes, hands, feet, arms, and heads. Some of these were engraved and published c. 1650 in a drawing book that provided models for student draftsmen.

13 Christ and the Canaanite Woman

Pen and brown ink and brown wash, over black chalk, some heightening in white body color, partially squared in black chalk
343 x 483 (13½ x 19)

Signed and dated at lower left in pen and brown ink, *A Bloemaert fe/ 1595*

Provenance: Thédore-Charles-Louis Hippert, Brussels

Literature: Bean 1964, no. 84; Washington 1978-1979, under no. 589; Mules 1985, 9

Exhibitions: Poughkeepsie 1970, no. 8; New York 1973, no. 31

The Metropolitan Museum of Art, New York, Rogers Fund, 1962, inv. no. 62.44

Although previously identified as Christ and the Woman Taken in Adultery, the subject of this drawing is certainly Christ and the Canaanite Woman (Matthew 15: 21-28; Mark 7: 24-30). The story concerns the spread of Jesus' ministry beyond Israel. A Canaanite (Syrophoenician) woman approached Jesus and begged him to heal her daughter, who was beset with a demon. To the Jews she was a foreigner and a heathen, and the disciples urged Jesus to send her away, but she worshiped him and pleaded with him. Finally, he addressed her provocatively, "It is not right to take the children's bread, and cast it to the dogs," meaning that his healing and teaching should be confined to his own people. She replied: "Truth, Lord; yet the dogs eat of the crumbs which fall from their master's table." To this he answered, "O, woman, great is thy faith; be it unto thee even as thou wilt," and her daughter was cured. In the drawing, even as Jesus blesses the petitioner, one of the disciples seems to entreat him to get rid of her. Several agitated bystanders respond to the event, and two dogs, visible beneath the woman's arms, recall Christ's words.

During the course of his sixty-year career Abraham Bloemaert created a vast and diverse body of drawings; the great majority of them in the seventeenth century. However, a group of elaborate works on historical themes, such as *Christ and the Canaanite Woman* and the somewhat later *Raising of Lazarus* (fig. 1), rank among the finest Dutch mannerist drawings of the 1590s.[1]

To judge from its complex design and execution, as well as from its elegant signature and date, *Christ and the Canaanite Woman* may be a finished work of art. On the other hand, the partial squaring

Fig. 1. Abraham Bloemaert, *The Raising of Lazarus*, Museum der bildenden Künste, Leipzig

visible at the left suggests that Bloemaert may have intended to transfer the composition to the larger surface of a canvas or panel. The principles that govern the design inform several of the artist's early works. The shadowed front plane occupied by two oversized onlookers makes a startling contrast against the brightly lit middle ground, where the relatively small figures enact the main narrative.[2] One of the sharply silhouetted spectators gesticulates excitedly toward the protagonists, contributing to the exaggerated effect of space. Similar pointing figures, derived from Goltzius,[3] appear in the foregrounds of other drawings and paintings by Bloemaert of the early 1590s.[4] In *The Preaching of John the Baptist*, a canvas of 1602, Bloemaert depicted, in reverse, the same draped man who looms in the left foreground of the drawing (fig. 2).[5] The correspondence is so close that one wonders whether he used a chalk study and a counterproof of it—neither is known—to prepare these figures. If so, it would be an

Fig. 2. Abraham Bloemaert, *The Preaching of John the Baptist*, The National Gallery of Canada, Ottawa

exceptionally early instance of this practice.

Christ and the Canaanite Woman registers the impact of the Haarlem School on Bloemaert's early development. The doughy faces and huge hands with splayed fingers, and the flatly modeled bodies striking elegant poses and clothed in loose draperies with deep, taut folds, epitomize the figure style he evolved from the example of Bartholomeus Spranger and from the interpretations of Spranger's manner by Goltzius and Cornelis van Haarlem. Certain peculiarities of the draftsmanship, namely the use of long, parallel lines and concentric arcs to model the forms, recall the drawings of the Utrecht master Anthonis Blocklandt (cat. 12). Van Mander reported that one of Bloemaert's teachers, Joos de Beer, owned many works by Blocklandt, and a drawing, attributed by some scholars to Bloemaert, after a Blocklandt painting has survived.[6] WWR

1. *The Raising of Lazarus* (fig. 1), datable on the basis of style to the second half of the 1590s, Museum der bildenden Künste, Leipzig, inv. no. N.I. 392; Delbanco 1928, pl. 3. It was engraved by Jan Muller, Hollstein 18. Other elaborate drawings of historical subjects of the 1590s by Bloemaert include *The Annunciation* (known in two versions, one in Weimar dated 1593, Reznicek 1961, 1: pl. XXIV, and the other in the Museum Boymans-van Beuningen, Rotterdam); *Rest on the Flight into Egypt*, Albertina, Vienna, Benesch 1928, no. 419; *The Annunciation to the Shepherds*, Staatliche Kunstsammlungen, Kupferstich-Kabinett, Dresden, Dittrich 1976-1977, 100 and fig. 8. *The Mystic Marriage of Saint Catherine*, National Gallery of Canada, Ottawa, Poughkeepsie 1970, no. 9; *The Judgment of Paris*, now Art Gallery of Ontario, Poughkeepsie 1970, no. 10; *The Holy Family*, Bibliotèque Nationale, Paris, Lugt 1936, no. 195, attributed to Bloemaert by Reznicek 1961, 168; *Mars and Venus*, sale, New York, Sotheby's, 16 January 1986, lot 86; *Venus and Amor*, National Gallery of Scotland, Edinburgh, Andrews 1985, 7, no. RSA 408.
2. This compositional device was also employed by Bloemaert in *Apollo and Daphne* of 1592, Delbanco 1928, pl. 1, and in the related drawing in the Albertina, Benesch 1928, no. 420, and in *Judith Displays the Head of Holofernes*, 1593, Washington 1980-1981, no. 4.
3. Such as *The Judgment of Midas* (cat. 56) and the engraving reproduced by Delbanco 1928, pl. 2.
4. *Judith Displays the Head of Holofernes* (see n. 2 above); *Apollo and Daphne* (see n. 2); *Acis and Galathea*, Vienna 1986, no. 58.
5. National Gallery of Canada, Ottawa, inv. no. 3340, signed and dated 1602.
6. The influence of Blocklandt's drawing style on Bloemaert's, and the possibility that Bloemaert saw Blocklandt drawings in the collection of Joos de Beer, were noted by Reznicek 1961, 1: 168-169. For the copy of a concert of angels from Blocklandt's Bingen altarpiece, see Reznicek 1961, 1: 149, where the copy is ascribed to Bloemaert, and Lugt 1968, no. 472, where it is listed under Blocklandt's name.

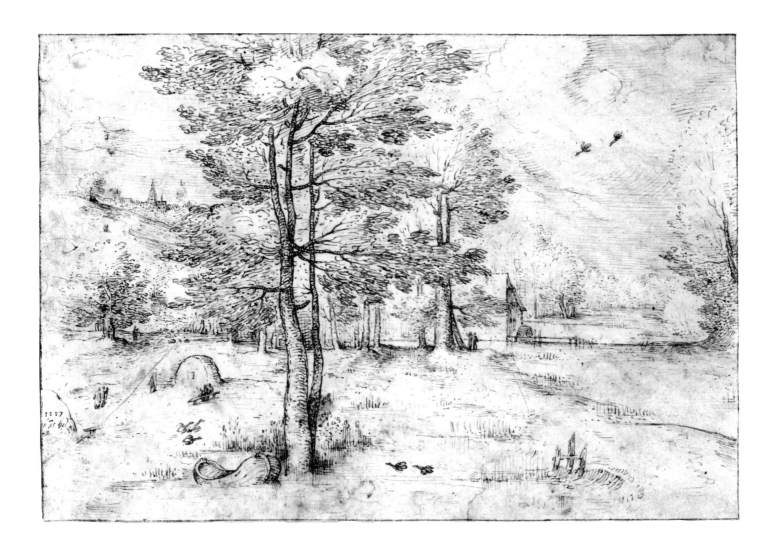

Hans Bol

1534-1593

Hans Bol was born 16 December 1534 at
Malines (Mechelen) where he was
trained in the local specialty of painting
in watercolors on canvas. After a sojourn
in Germany, including two years in Hei-
delberg, he settled in his native town,
where he joined the painters' guild in
1560. In 1572, after the Spaniards occu-
pied Malines, he moved to Antwerp, en-
tered the guild there in 1574, and ob-
tained citizenship the following year.
War and religious unrest drove Bol from
Antwerp to the northern Netherlands in
1584. After residing at Bergen op Zoom,
Dordrecht, and Delft, he settled in 1591
in Amsterdam, where he was buried 30
November 1593.

Little of his work in the perishable me-
dium of watercolor on canvas has come
to light (Franz 1979, 199-200). According

to Van Mander, Bol's large watercolor
paintings were so widely copied by other
Malines artists that he turned instead to
the production of miniatures in gouache
on parchment. Many of these have sur-
vived, and they rank among the finest
miniatures of the period. They earned
him enthusiastic praise from Van Man-
der, a good income, and an international
clientele that included the Elector of
Saxony. A few oil paintings and a brevi-
ary illuminated for a French duke have
also come down to us. However, Bol's
work is best documented in his draw-
ings, which number in the hundreds, and
by some 350 prints by and after him.
Bol's stepson, the miniaturist Frans
Boels, was his pupil, as were Jacques
Savery and Joris Hoefnagel.

14 Landscape with Trees and a Mill

Pen and brown ink
195 x 286 (7⅔ x 11¼)

Signed at lower left in pen and brown ink, *hās
bol*, and dated, *1557*

Provenance: E. Rodrigues, Paris; his sale, Am-
sterdam (Muller, 12-13 July 1921, lot 12);
Franz Koenigs, Haarlem

Literature: Dodgson 1926-1927, 55; Franz
1965, 22-26; Franz, 1969, 1: 183-184; Zwollo
1979, 301; Boon 1978, 1: 31-32, under no. 85;
Zwollo 1969, 210; Franz 1979-1980, 153-154;
Mielke 1980, 43

Exhibitions: London 1927, no. 536; Paris 1949,
no. 64

Museum Boymans-van Beuningen, Rotterdam,
inv. no. 35

Hans Bol's spirited drawing of 1557 her-
alds the birth of a new naturalism in
Netherlandish art, which was precipitat-
ed by Bruegel's return from Italy. It is the
earliest dated work produced in the

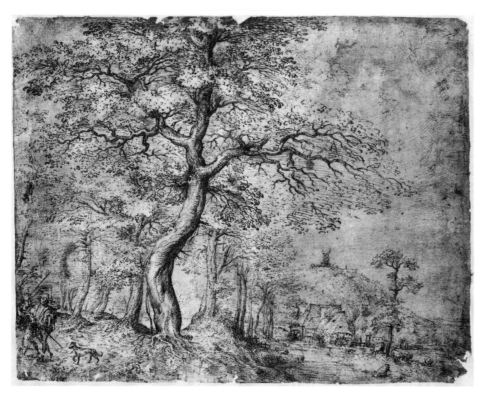

Fig. 1. Pieter Bruegel the Elder, *Landscape with Trees and a Mill*, The Ambrosiana, Milan

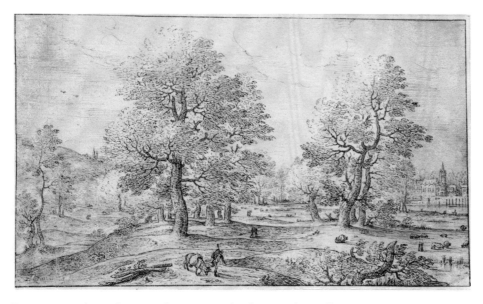

Fig. 2. Hans Bol, *Landscape with Town*, Graphische Sammlung Albertina, Vienna (Fonds Albertina)

Netherlands that reflects Bruegel's innovations.

Bol adopted the style and pen technique Bruegel formulated in Italy in such forest scenes as *Landscape with Trees and a Mill* of 1552 (fig. 1) and *Landscape with Bears* of 1554 (cat. 27, fig. 1). His low vantage point and compositional scheme dominated by a tall, leafy tree in the foreground clearly derive from these or similar drawings by the older master. The close view of the motif from eye lev-

el yields a more immediate visual impression than the ideal panoramas drawn c. 1540 by Cornelis Massys and Matthijs Cock (cats. 84, 34). As in Bruegel's drawings—which were inspired, in turn, by the dynamically structured landscapes of Venetian draftsmen[1]—Bol lined up a suite of trees of diminishing height that runs diagonally from the foreground into the far distance, creating the illusion of a deep, rapidly receding space. In the lively description of the sky, water, and

grasses and plants, Bol's penwork realizes a specificity of texture that is as different from Massys' uniform, generalizing touch as it is unthinkable without Bruegel's example. To be sure, Bol's stiff, straight trees miss the sinuous grace and sense of organic growth of his model's magnificent specimens, and the foliage is delineated with a stylization typical of his hand.

The sheet of 1557 exhibited here, Bol's earliest known work, precedes his next securely datable drawings by five years.[2] Its style differs from the more artificial manner of the innumerable landscape compositions he produced from 1562 until his death (see cat. 15, fig. 1). Four woodland scenes, none of them signed or dated, almost certainly belong to the period 1557-1560 (fig. 2) and link this drawing to Bol's work of the 1560s.[3] *Landscape with Pyramus and Thisbe*, neither signed nor dated but plausibly assigned by Franz to 1560-1562, very likely documents the stage of his development immediately prior to the mature style first exhibited in the designs for a series of prints published by Hieronymus Cock in 1562.[4] Finally, a drawing very similar in style and motif to the work of 1557, and preserved with it in the Museum Boymans-van Beuningen, is probably not by Bol, but by a close follower.[5]

The balanced design, replete with picturesque details, the absence of any preliminary sketch, and the autograph signature and date, affirm that Bol's *Landscape with Trees and a Mill*, despite its apparently spontaneous execution, was composed in the studio. It is either a finished work of art, made for sale or gift, or, like the great majority of his drawings, a modello for a projected engraving. However, no print after his composition has been identified. WWR

1. See cat. 27.

2. The next securely datable drawings are the four known modelli for a series of twelve landscape prints published in 1562; Franz 1979-1980, 154.

3. Two of these drawings are in the Rijksprentenkabinet, Amsterdam. They are inscribed, *H. Bol Fecit*, probably in the hand of Gerard Terborch the Elder (1583-1662), who owned them; Boon 1978, nos. 85, 86. A third drawing was in the Perman collection, Stockholm; Zwollo 1969, 300 pl. 6. It is inscribed, perhaps by the same hand, presumably Terborch's, *Hans Bol fecit. binnen mens ouer 26 Jaren*, which Boon interprets as, "Hans Bol made it in Mechelen age [ou(d)er] 26 years." If Boon is correct, whoever inscribed the drawing placed it accurately in Bol's twenty-sixth year, that is, 1560. The fourth drawing is in the Albertina (fig. 2), where it was attributed as early as the eighteenth century to Bol's contemporary Gillis Mostaert. Franz 1965, 31-32, cautiously ascribed the Albertina and Rijksprentenkabinet works to Bol. Franz 1969, 2: pl. 326, lists the Albertina sheet as "Hans Bol or Gillis Mostaert?." Zwollo 1969, 301,

and 1979, 210, assigns the whole group, including even the signed and dated Rotterdam drawing exhibited here, to Jacques Savery. Boon 1978, 1: no. 85, correctly restored this group to Bol. He was seconded by Mielke 1980, 43, who provides sound stylistic arguments for retaining these works in Bol's oeuvre. Franz 1979-1980, 154-155, figs. 28-30, accepts the Albertina and Rijksprentenkabinet drawings without reservation as Bol's work. Franz 1965, 24 and 31, had already dated these three sheets to the years 1557-1560.

4. Franz 1965, 31, pl. 11. See n. 2 above for reference to the drawings related to the print series of 1562.

5. Franz 1965, 23, pl. 4. According to Franz, the attribution to Bol is "not certain, but not to be ruled out."

HANS BOL

15 *Winter Landscape with Skaters*

Pen and brown ink, brown wash
192 x 258 (7⁹⁄₁₆ x 10⅛)

Inscribed in brown ink at lower left, *Hans Bol*; at upper left, *8*

Provenance: H.W. Campe (Lugt 1391); Dr. C. Gaa; his sale, Leipzig (Boerner, 9-10 May 1930, lot 56, repr.); Koutuzow collection; (Schaeffer Galleries, New York); J. Theodore Cremer, New York; his sale, Amsterdam (Sotheby Mak van Waay, 17 November 1980, lot 96, repr.)

Private collection, U.S.A.

From the 1560s until his death in 1593 Bol was one of the most productive landscapists in the Netherlands. His development can be followed in dozens of dated drawings that display his great facility of invention and a wide variety of types, ranging from extensive panoramas to intimate views of the Flemish countryside. Most include small figures who enact a biblical or mythological scene, an allegory of the months or seasons, or a genre scene. All are animated by the nervous,

fluid touch of his pen and composed with a tasteful combination of naturalism and artifice that endows them with considerable charm. The majority of these drawings relates to Bol's activity as a designer of prints or to the production of his miniatures.[1]

The realism of the Rotterdam *Landscape with Trees and a Mill* (cat. 14), which derived from the work of Pieter Bruegel, was transformed in the 1560s and 1570s into a vigorous, brilliantly mannered style characterized by lively penwork, elegant trees with small crowns and serpentine trunks, undulating groundlines, and bizarre disjunctions between the high bulge of the foreground and the vast *Weltlandschaft* in the distance (fig. 1). This phase of Bol's development owed less to Bruegel than to the landscapes etched in the 1550s by Hieronymous Cock (cat. 32).[2]

Winter Landscape with Skaters dates

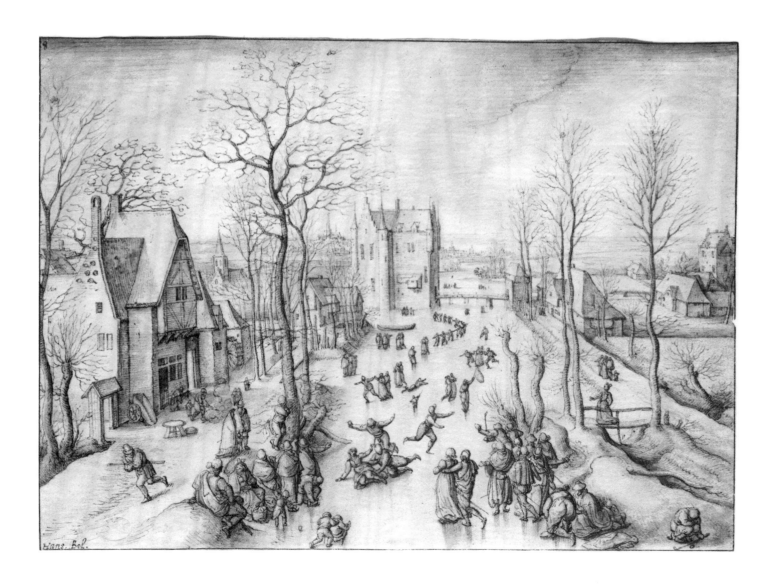

from the mid-1580s and exemplifies the restrained approach to composition that succeeded the capricious manner of the previous two decades. Instead of the heaving earth and the abrupt transitions from foreground to distance, a flat, Flemish landscape recedes smoothly into space. The more extensive use of wash and the refinement of atmosphere and tonal values are also characteristic of this period, as are the straight, slender trees.[3]

The drawing bears a general, but unmistakable, resemblance to a miniature that represents winter in a series devoted to the Four Seasons (fig. 2).[4] To be sure, major differences in composition and detail separate the two works. In order to accommodate the wider format of the miniature Bol added many prominent features—including a second canal and house at the left, the snow-covered avenue at the center and a mountainous vista in the distance—and enlarged others, most conspicuously the castle and church in the left background. Nevertheless, there is sufficient correspondence, both in the overall design and in several details, to assume a relationship between the two landscapes. While the drawing should not be characterized as a preparatory study for the miniature, it must have played a role in the evolution of the design. Perhaps Bol made a second study, as yet unidentified, that more nearly approaches the final composition.[5] On the other hand, we can cite additional instances where Bol evidently based a miniature or painting on a drawing that differs quite significantly from the completed work.[6] The *Winter* miniature is dated 1586, and the drawing probably belongs to the period c. 1584-1586.[7]

Skating scenes occur frequently in Netherlandish art of the second half of the sixteenth century, both as independent subjects and in the context of allegories of winter. Pieter Bruegel and Pieter van der Borcht designed prints with skaters, as did Bol himself, and paintings by Jacob Grimmer, Gillis Mostaert, and others have survived.[8] WWR

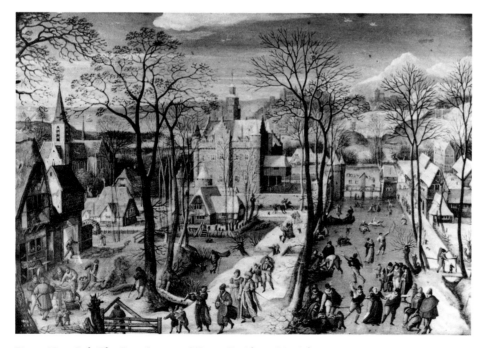

Fig. 1. Hans Bol, *The Four Seasons: Summer*, Staatliche Kunstsammlungen Dresden, Kupferstich-Kabinett

Fig. 2. Hans Bol, *The Four Seasons: Winter*, Residenz, Munich (Verwaltung der Staatlicher Schlösser, Gärten und Seen)

1. See Franz 1965 for the most complete study of Bol's career.
2. Franz 1965, 38-39, and 1969, 1: 190-191.
3. Franz 1965, 46-49.
4. Residenzmuseum, Miniaturenkabinett, Munich, inv. no. 227; Buchheit and Oldenbourg 1921, 11, no. 8, pl. 5, 115 x 175 mm, signed and dated *HBOL/1586*. All four miniatures in the series are reproduced by Franz 1979-1980, pls. 51, 54, 56, 58.
5. For examples of preliminary studies that preceded the final drawings for prints, see Franz 1965, pls. 72, 73, and Hamburg 1985, no. 9.
6. See my entry in Providence 1983, no. 74; and Franz 1965, pls. 104, 187.
7. For drawings comparable in style, see Franz 1965, pls. 116, 187.
8. See Münz 1961, pl. 137; Franz 1969, 2: pls. 272, 330, 331, 346; Hollstein 22, and vol. 26, fig. 7.

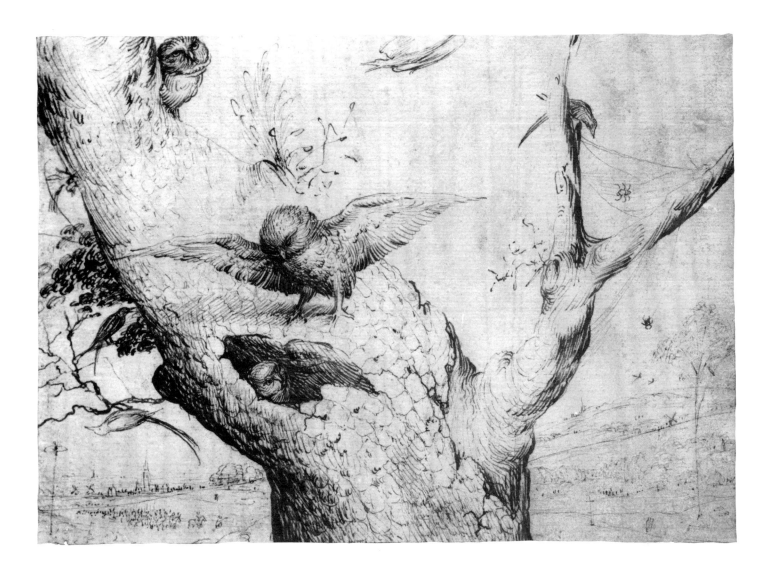

Hieronymus Bosch

c.1450-1516

Hieronymus Bosch was born in the town of 's-Hertogenbosch (Bois-le-Duc) in northern Brabant and he died there in 1516. His true name was Joen or Jeroen van Aken. His father and grandfather were painters and it is likely that he was first trained by his father, Anthonius van Aken. In 1486/1487 Bosch is listed for the first time as a member of a religious confraternity, the Brotherhood of Our Lady, for whom he executed paintings as well as designs for a stained glass window for a chapel in the Cathedral of Saint John in 's-Hertogenbosch. Bosch was known outside the confines of 's-Hertogenbosch. In 1504 Philip the Fair, Duke of Burgundy, commissioned a large altarpiece of the Last Judgment *(now lost), and by 1517 the* Garden of Earthly Delights *(Prado, Madrid) hung in the Brussels palace of Henry III of Nassau and was probably commissioned by him.*

None of Bosch's paintings is dated, but several pictures are signed Jheronimus Bosch, *which combines a Latinized first name with a shortened form of his home town. Although a precise chronology is impossible scholars generally agree on the division of his oeuvre into early, middle, and later works. Bosch occupies a singular position in the history of Netherlandish drawing, for he is considered the first to produce sketches that explore ideas for motifs as well as independent compositions. About fifteen drawings are generally accepted as autograph and are often categorized by function.*

Despite the ingenuity and diversity of approaches brought to bear on his art, Hieronymus Bosch remains a mystery and his works resist any one explanation. Bosch was enormously popular throughout the sixteenth century and was extensively copied and paraphrased in paintings, prints, and drawings.

16 *The Owls' Nest*

Pen and brown ink
140 x 196 (5½ x 7¹¹/₁₆)

Provenance: F. Koenigs (Lugt Suppl. 1023a on verso); D.G. van Beuningen, gift to museum 1941

Literature: Beets 1935, 226; Baldass 1937a, 22; Benesch 1937a, 260-261; De Tolnay 1937, 49, 111, no. 8; Baldass 1943, 84-85, 255; De Tolnay 1943, 58, 131, no. 156; Combe 1946, 97; Bax 1949, 159 (Bax 1979, 209); Beets 1952, 29; Baldass 1960, 66, 68, 239; Rosenberg 1961, 422-426; De Tolnay 1966, 389, no. 8; Reuterswärd 1970, 274, no. 36; Filedt Kok 1972-1973, 155, 159; Beuningen 1973, 30

Exhibitions: Rotterdam 1934, no. 2; Rotterdam 1936, no. 13; Rotterdam 1938, no. 233; Rotterdam 1948-1949, no. 6; Paris 1949, no. 28; Rotterdam 1952, no. 6; Paris 1952, no. 40; Rotterdam 1957, no. 4; Prague 1966, no. 9; Rome 1972-1973, no. 27; Berlin 1975, no. 16

Museum Boymans-van Beuningen, Rotterdam, inv. no. N-175

The Owls' Nest is one of the most beautiful of Bosch's drawings and one that amply displays both the power and the delicacy of his draftsmanship. Along with *The Field Has Eyes, the Forest Has Ears* in Berlin (cat. 17) and the *Tree-Man* in the Albertina (see The Sixteenth Century, fig. 1), it occupies a special position in his oeuvre. All three are independent drawings of outstanding quality, dating from his late period, c. 1505-1516, and works that are considered touchstones for other drawing attributions to Bosch. Baldass was the first to observe that the Rotterdam sheet was incomplete and Rosenberg's reconstruction assumes a great deal of loss at the bottom and smaller losses on the other three sides.[1] The original format was probably similar to that of the Berlin and Vienna drawings.

Two owls are shown perched on a tree trunk while a third occupies a hole in the tree. Four smaller birds are present, one of whom appears to attack or scold the topmost owl. On either side of the tree is a landscape remarkable for its light touch and atmospheric quality. The gibbet and procession of riders at the left and the cross at the foot of the hills at the right mark this as a place of execution.[2]

In northern Europe the owl was generally interpreted as an emblem of sin. The moralizing natural histories of the late Middle Ages portray the owl as an evil creature who shuns the light, desecrates churches, and preys upon other birds at night.[3] Owls were thought to make their homes in ruins and other desolate abodes,[4] and because of their wickedness were attacked during the day by other birds. Benesch and De Tolnay associated the Rotterdam drawing with the proverb "Het is een regt uilennest" (This is a real owls' nest),[5] meaning, as paraphrased by Bax, "This is a dark and decayed place."[6] This idea is particularly appropriate if we consider not only the owls, but also the distant killing ground as designating the location as evil and "dark."

Rosenberg's interpretation, based in part on a German woodcut of an owl attacked by day birds, bearing the caption "Der Eulen seyndt alle Vogel neydig und gram" (All birds are envious and hateful of the owl), asserts that the smaller birds are themselves malevolent and, in pecking for insects or hungrily eyeing the spider, are guilty of the sin of gluttony.[7] This represents a shift in meaning, for while the owl is no less a symbol of evil for being attacked, there is no clear-cut triumph of good; in Bosch's pessimistic world corruption is everywhere.

The stylistic characteristics of *The Owls' Nest* are shared by the Berlin and Albertina drawings. Deep shadows are built up through groups of strong, curved strokes, while subtle shadings and cast shadows are formed with parallel hatchings using thinner lines. Bosch's skill and economy in differentiating textures is evident in the contrast of the rough bark of the tree trunk to the smoother wood of the forked branch at the right. Filedt Kok found similarities between the way the birds and the foliage at the left of the Rotterdam drawing are rendered, and in underdrawn details made visible by infrared reflectography in Bosch's painting *The Vagabond* (Museum Boymans-van Beuningen, Rotterdam), another late work.[8] Although such similarities between Bosch's drawings and paintings are useful in establishing a chronology and corroborating authenticity, the precise function of these allegorical drawings—independent of and yet so parallel to the paintings—remains unknown. JOH

1. Baldass 1943, 84-85; Rosenberg 1961, 423, fig.2.
2. Combe 1946, 97, compares the group of riders with those in the background of Bosch's *Epiphany* (Prado, Madrid), while Anzelewsky, in Berlin 1975, 26, cites the group in the center panel of *The Temptation of Saint Anthony* (Museu Nacional de Arte Antiga, Lisbon) and wonders if the drawing is connected with the representation of a saint.
3. Rosenberg 1961, 424, cites specifically the *Dialogus creaturarum*, an edition of which was printed in Gouda in 1480; for negative interpretations of the owl see Schwarz and Plagemann 1973, cols. 284-312.
4. See Psalm 102, 7-9, quoted by Reuterswärd 1970, 96, and Isaiah 34:11.
5. Benesch 1937a, 260, De Tolnay 1937, 49.
6. Bax 1979, 209. Bax himself does not believe the proverb was applicable to the drawing, but rather thinks it represents those who shun the light and, with reference to the place of execution in the background, are punished for their sins.
7. Rosenberg 1961, 425. The only copy of the woodcut accompanied by the text is in the Kupferstichkabinett of the Kunstsammlungen der Veste Coburg; it is catalogued as School of Albrecht Dürer in Detroit 1981-1982, 291-293, no. 162.
8. Filedt Kok 1972-1973, 155, figs. 19-20; the birds in the painting were never executed and exist only in the underdrawing.

HIERONYMUS BOSCH

17 *The Field Has Eyes, the Forest Has Ears.*

Pen and brown ink
(verso: *various sketches*)
202 x 127 (7¹⁵/₁₆ x 5)

Inscribed at top, *Miserrimi quippe est ingenii semper uti inventis et numquam inveniendis*; at bottom, in a later hand, *Jero: Bosch.*

Watermark: fragmentary, perhaps a trefoil

Literature: Eickhoff 1918, cols. 25-26; Friedländer, *ENP*, 5 (1927): 124-125 (5 [1969], 67-68); Bock and Rosenberg 1930, 1, no. 549; Beets 1935, 226; Baldass 1937a, 22; Benesch 1937a, 258-266; De Tolnay 1937, 110-111, no. 6; Roggen 1939-1940, 108; Baldass 1943, 75, 77, 84, 255; Combe 1946, 97; Bax 1949, 158-159 (Bax 1979, 208-209); Boon 1960, 458; Lurker 1960, 23, 67; Baldass 1960, 66, 238-239; Rosenberg 1961, 425-426; De Tolnay 1966, 388, no. 6; Lemmens and Taverne 1967-1968, 85-87; Reuterswärd 1970, 95-98, 281, no. 45; Beuningen 1973, 26; Anzelewsky 1972, 258, no. 179; Vandenbroeck 1981, 178-186

Exhibitions: Rotterdam 1936, no. 12; Amsterdam 1958, no.185; 's-Hertogenbosch 1967, no. 57; Berlin 1975, no. 17

Staatliche Museen Preussischer Kulturbesitz, Kupferstichkabinett, Berlin, inv. no. kdz 549

Bosch's use of proverbs and folklore may be seen as part of a general interest that in northern Europe began in the late fifteenth century.[1] In this, one of Bosch's most symbolically rich and complex drawings, three distinct themes are brought together.

First, the motif of the owl in the dead tree with four day birds (see cat. 16) symbolizes evil, hatred, and envy. Second, the striking occurrence of the seven eyes in the foreground and the large ears refers to a Netherlandish proverb, illustrated in an anonymous woodcut of 1546, "Dat velt heft ogen, dat wolt heft oren, Ick will sien, swijgen ende horen" (The field has eyes, the forest has ears, I will see, be silent, and hear).[2] This is generally taken to mean that as one is constantly being spied upon, the man of experience and wisdom, knowing this, keeps silent and alert.[3] Third, the fox who, as if pretending not to notice, looks away from the rooster next to him refers to proverbs and popular poems such as *Reinaerts Historie*, in which the fox is clever, but also morally reprehensible, treacherous, and deceitful.[4] In the moralized *Physiologus* the fox is equated with the devil who snares his victims through cunning.[5] Like man, the rooster often falls prey to evil through lack of attention, although in certain of Aesop's *Fables*, the rooster, through clever watchfulness, outwits the fox.[6]

The Berlin drawing has resisted a unified interpretation and few authors have dealt with all three themes. What may be called the orthodox readings of De Tolnay, Baldass, Bax, and Rosenberg emphasize the negative aspects of the symbolism, especially of the owl.[7] Benesch, however, interprets the drawing as a disguised self-portrait, noting that the artist's name (Bosch) meant wood or forest (bos).[8] Reuterswärd also considers the Berlin sheet to be a type of self-portrait and a paraphrase of Bosch's painting *The Temptation of Saint Anthony* (Prado, Madrid); both the owl and the hermit saint sit inside a dead tree surrounded by tormentors. The owl, a symbol of wisdom and prudence, at once personifies the artist and the "I" of the proverb, endowed with the virtues of seeing, hearing, and silence.[9]

Finally, intriguing evidence is found in the inscription at the top of the drawing, which may be translated, "Miserable is he that works only with the inventions of others and can think of nothing new himself."[10] The quotation comes from a thirteenth-century tract, *De disciplina scholarium* by Pseudo-Boethius. It occurs in the writings of northern humanists and was paraphrased by Albrecht Dürer.[11]

The inscription is possibly from the hand of Hieronymus Bosch, but no autograph examples of Bosch's handwriting are available for comparison and the physical evidence is inconclusive.[12] If the inscription is by Bosch, then it may be read as self-criticism.[13] It is also important in demonstrating that Bosch knew Latin, and raises tantalizing questions about Bosch's possible association with humanists and humanist thought. If the inscription was added by another hand, it may, as Anzelewsky notes, be intended as praise for the ingenuity of a draftsman who creates, out of traditional motifs, a new image.

As regards the verso, scholars generally agree that only the crippled beggar at the bottom of the page is by Bosch.[14] JOH

1. Vandenbroeck 1981, 165-169.
2. Henkel in Nijhoff 1933-1936, 51-52, pl. 222 was the first to connect the woodcut with the Berlin drawing. Vandenbroeck 1981, 184-186, gives a Middle Latin example of the proverb as well as several examples of its appearance in vernacular literature in the north in the late fifteenth and early sixteenth centuries. He sees in the moral of the proverb a way of escaping evil by passing unnoticed and as a kind of "wisdom"; this may be connected with his earlier discussion, 155-165, of the equation of sin with "foolishness" and virtue with "wisdom." Because of the multiple meanings of the number it is impossible to give a single interpretation of the seven eyes in the drawing; for example, Baldass 1943, 84, associates them with the Seven Deadly Sins, while Lurker 1960, 23, believes the eyes are the seven stars held by Jesus in Revelation 1: 16.
3. Roggen 1939-1940, 108.
4. Benesch 1937a, 262-263, and Berlin 1975, 27, are the most extensive discussions of the motif of the fox and the rooster as they appear in the drawing. For the development of the story of Reynard the Fox in the thirteenth and fourteenth centuries see Best 1983. *Reinaerts Historie* was written about 1380, and editions were published by Gheraert Leeu in 1479 at Gouda and c. 1487 at Antwerp. A drawing of a fox and a rooster appears on the verso of Bosch's *Two Witches* in Rotterdam (De Tolnay 1966, 387, no. 2, repro. 316).
5. Quoted in Varty 1967, 90-91.
6. Noted by Anzelewsky in Berlin 1975, 27.
7. Intriguing yet unproductive are the ideas concerning sexuality and alchemical heresy put forward by Combe 1946, 97. Equally inventive is Lurker 1960, 23, who sees the owl as alluding to the inner man who exists between animals (the fox and the rooster) and God (the birds).
8. Benesch 1937a, 264.
9. Reuterswärd 1970, 95-98, 281, also includes stoic innocence and melancholy as qualities embodied by the owl, and considers as a positive sign the owl's appearance in Lucas Cranach's portrait of the humanist Johannes Cuspinianus of 1502/1503 (Reinhardt collection, Winterthur). He was probaly the first to call attention to the virtual repetition of the tree in the Berlin drawing in the left exterior wing of the *Last Judgment* altarpiece (Akademie der bildenden Künste, Vienna). The triptych is thought to be a reduced copy of the Last Judgment commissioned from Bosch in 1504 by Philip the Fair; it is questioned as an autograph work by De Tolnay, but accepted by Baldass and others. Anzelewsky in Berlin 1975, 28, notes the connection between the painting and the usual dating of the drawing, in the same period.
10. This translation appears in the English edition of 's-Hertogenbosch 1967, no. 57. The correct transcription was made by Boon 1960, 458.
11. Vandenbroeck 1981, 178-184; between 1476/1478 and 1495 there were sixteen printings of *De disciplina scholarium*. That the citation is paraphrased in the prologue to Dürer's *Vier Bücher von menschlicher Proportion* (1528) was first noted by Mielke in Berlin 1975, 27.
12. Berlin 1975, 27, where it is noted that the color of the ink in the inscription is essentially unchanged from that of the drawing. Vandenbroeck 1981, 183, reports a date of shortly after 1500 and very probably before 1510 given by a paleographer as well as the possibility, based on an examination by Anzelewsky, that the inscription was added later.
13. Vandenbroeck 1981, 184, and Reuterswärd 1970, 97-98, both consider it very likely that the inscription is autograph.
14. Berlin 1975, 28; De Tolnay 1966, 388.

Matthijs Bril

1550-1583

Born in Antwerp in 1550, Matthijs probably received his early training from his father. It is likely that he was established in Rome by the mid-1570s, because Van Mander reports that, at the age of twenty, about 1574, his brother Paul left the Netherlands for Lyon and eventually Rome where Matthijs had preceded him. In Rome, Matthijs specialized in landscape painting and participated in projects for fresco decoration. As these were often collaborative ventures, it is difficult to distinguish his part. Van Mander mentions as his work the ten scenes of the translation of the relics of Saint Gregory Nazianzen from Santa Maria in Campo Marzio to Saint Peters, an event that took place on 11 June 1580. These frescoes in the Galeria Geographica of the Vatican palace were commissioned by Pope Gregory XIII. The other documented fresco cycle by Matthijs, in the observatory in the Vatican built by Gregory XIII and known as the Torre dei Venti, was not completed be-

fore his death in 1583 and involved the collaboration of his brother Paul and perhaps others.

Matthijs' drawings are difficult to distinguish from those of his brother Paul, over whose early work he exercised a strong influence. The series of drawings of Roman monuments takes on particular importance, since an inscription by Paul Bril attests to Matthijs' authorship (see cat. 18). The validity of the traditional attribution of other works to Matthijs, notably the designs for two series of landscape prints published by Hendrick Hondius in the early seventeenth century, is more difficult to judge. Matthijs seems to have been particularly interested in the relation of architecture and landscape, and his pen drawings of Roman sites, evidently made available by Paul Bril, influenced the circle of Netherlandish artists in Rome about 1600.

18 The Triumphal Arch of Septimius Severus

Pen and brown ink, added borderline, laid down
207 x 275 (8⅛ x 10¹³/₁₆)

Inscribed on arch in brown ink, *PROPAGAVT/ S.P.Q.R*; on verso at upper left, partially legible from recto, *dit is een van die besste desenne die Ick van matijs mijn broeder nae het leeven hebbe*

Provenance: Paul Bril, Rome; Everhard Jabach (Lugt 2961), inv. vol. 5, no. 142; sold 1671 to Louis XIV, marks of Louvre (Lugt 1899 and 2207)

Literature: Lugt 1949, 1: 16-17, no. 356; Winner 1961, 191; Berlin 1967, 33-34, under no. 16; Florence 1980-1981, 45, under no. 30

Exhibitions: Rome 1972-1973, no. 116; Berlin 1975, no. 19; Paris 1977-1978, no. 132

Musée du Louvre, Cabinet des Dessins, Paris, inv. no. 20.955

The triumphal arch built by Septimius Severus in 203 AD is represented in front of San Adriano, with roads leading off on the left to the temple of Saturn and on the right to the Capitol at the top of the hill. The scene is without human activity, but the scattered stones and carts, the medieval crenellations and tower atop the arch, and the earth piled high within the side arches indicate the still dilapidated state of the monument in the late sixteenth century.

This drawing belongs to a series of views of ancient monuments in and around Rome, eight of which are preserved in the Louvre.[1] These were part of a large and important group of drawings attributed to Paul Bril that belonged to Jabach and was sold to Louis XIV along with the rest of his collection.[2] The drawings of Roman monuments and *The Triumphal Arch of Septimius Severus* in particular provide the key evidence for separating the drawings of Matthijs Bril

from the early drawings of Paul Bril. On the back of this sheet Frits Lugt discovered the inscription, "this is one of the best drawings that I have from my brother Matijs done from life."[3] Lugt characterizes the penwork of the Roman series as more nervous and spirited than that of Paul Bril. In addition, the preference for architectural subjects, together with the rather drastic perspectival diminution and abruptly shifting planes of the drawings, may also be taken as typical of Matthijs' work. Other pen drawings of the Roman monuments from the same series are in the Albertina and Fondation Custodia.[4]

Paul Bril's statement attests not only to Matthijs' authorship, but to the work's status as one of his best drawings, *nae het leeven*. Nevertheless, the drawings of this group appear to be carefully composed, and less immediate records of a scene than the modest pen drawings made by Paul himself about two decades later (see cats. 19 and 20). The existence of replicas apparently from the same hand identified by Lugt, including one in the Louvre of the Forum Nerva with perspective adjustments in black and red chalk, underscores the composed quality of the Roman views.[5] Very likely this manner of describing the triumphal arch implies a contrast with other, purely imaginative landscape or architectural drawings by Matthijs Bril that Paul Bril may also have had in his possession.

That Paul Bril kept the Roman views and made them available to other Netherlandish artists working in Rome is confirmed by the numerous precise copies after the series. At least four early copies of the *Triumphal Arch of Septimius Severus* alone are known, by Jan Brueghel in a drawing at Chatsworth signed and dated 1594,[6] in an anonymous drawing in the Witt collection dated 7 April 1596,[7] by Willem van Nieuwlandt II in a drawing dated 1601 in Amsterdam,[8] and in another anonymous drawing inscribed *In Roma il 20 September 1609*.[9] That several such copies have inscriptions with the precise date and place is noteworthy. It suggests that the documentary value and the connotation of *naer het leven* could be carried over from Matthijs' original to the copy. MW

1. Lugt 1949, 1: 16-19, nos. 356-363, inv. nos. 20.954-20.955, 20.957-20.960, and 20.979-20.980. Of these, cat. no. 360 appears to be an autograph replica of cat. no. 359; see below.
2. Paris 1977-1978, no. 132, noting that ninety-seven drawings were listed as by Paul Bril in the Jabach inventory.
3. The drawing was lifted from its seventeenth-century backing in this corner.
4. Benesch 1928, 31, no. 290, pl. 76, as Aegidius Sadeler, and Florence 1980-1981, no. 30, pl. 103 respectively. Another lost drawing by Matthijs can be presumed on the basis of a copy by Jan Bruegel, see Winner in Brussels 1980, no. 151.
5. Lugt 1949, 1: nos. 359 and 360.
6. No. 846, inscribed *BRVEGHEL/·1594 S.P.Q.R.*; see Berlin 1975, no. 111, fig. 218.
7. No. 679, inscribed on arch *SPQR* and *1595* surmounted by *GP* (?) in monogram and at lower right *1595.4 mai*; see London 1977-1978, no. 23. 8. Rijksprentenkabinet A.184; cited by Lugt 1949, 1: 17, under no. 356. This drawing served as the basis for an engraving by Nieuwlandt, one of four in a series of Roman monuments after Matthijs Bril, Hollstein 6-9.
8. KdZ 3920; see Berlin 1967, no. 16, as circle of Willem van Nieuwlandt II.

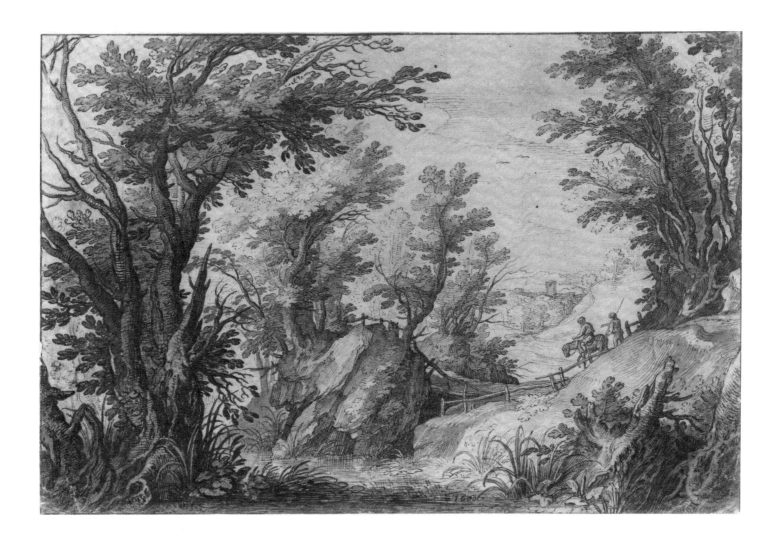

Paul Bril

1554-1626

Born in Antwerp in 1554, Paul Bril received his early training with a painter named Damian Ortelmans. According to Van Mander, he left the Netherlands when he was twenty years old, staying first in Lyon for an unspecified period and then joining his older brother Matthijs who had settled in Rome. He remained in Rome for the remainder of his life. There, before Matthijs' early death in 1583, the brothers collaborated on landscape decorations, notably on the fresco cycles for the Torre dei Venti in the Vatican. Van Mander, Baglione, and Baldinucci enumerate many landscape frescoes that Paul produced after his brother's death, for papal and other patrons. Probably about 1590, he began to make small easel paintings, mostly on copper, as well as designs for prints. His mannerist landscape style, with its active rock and cloud formations, became more relaxed about 1600, in terms of spatial recession.

Throughout his long career, Paul Bril was a key figure for the generations of northern artists who made the pilgrimage to Rome or settled there. Paul Bril's handling of pen and wash was made known in the Netherlands through some of these returning artists, including Jan Brueghel the Elder, with whom he seems to have worked in Rome, and Willem van Nieuwlandt, whom Van Mander mentions as his pupil. He was particularly open to contacts with northerners and may have been influenced by their styles. Thus the arrival of the young Adam Elsheimer coincides with the change in Bril's landscapes to a more open structure and natural tonality, shortly after 1600. Paul Bril's pivotal role for northerners in Rome was such that many of their drawings of Italian subjects have been rather indiscriminately attributed to him.

19 Wooded Landscape with Travelers

Pen and brown ink, brown and gray washes, probably trimmed very slightly at bottom edge
183 x 272 (7³⁄₁₆ x 10¹¹⁄₁₆)

Inscribed in brown ink at center right, *1600;* below and to the right of this, signed with spectacles[1] in brown ink

Provenance: (sale, Sotheby's, London, 15 July 1931, no. 69); (P. & D. Colnaghi, London); C.R. Rudolf, London

Exhibitions: London 1962, no. 90; Washington 1977, no. 1

Maida and George Abrams Collection, Boston, Massachusetts

As a closeup view of a swampy forest, this sheet can be grouped with several other drawings by Paul Bril from the late 1590s, including drawings in Brussels,[2] the Abrams collection, dated 1596 (fig. 1),[3] and Weimar, dated 1597.[4] The low viewpoint and dense vegetation of these drawings is in contrast to most of Bril's

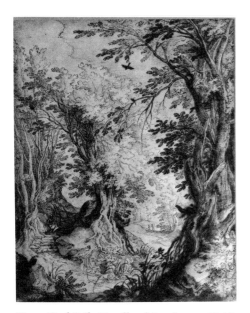

Fig. 1. Paul Bril, *Woodland Landscape*, Maida and George Abrams Collection, Boston

landscape drawings of the 1590s, which are largely views over extensive valleys or coastlines, dramatically set off by trees or hillocks in the foreground. Teréz Gerszi linked several of these drawings, suggesting that they reflect contact with Jan Brueghel the Elder, who was in turn transmitting and transforming the compositions and open, feathery penwork of his father's woodland and swamp drawings.[5] Jan Brueghel, who was Paul Bril's junior by fourteen years, was in Rome by 1592, probably until at least 1595, and he was certainly in touch with Bril.[6] That he had some of his father's early drawings with him or had access to them is demonstrated by his *Trees in a Swamp* in Rotterdam, inscribed *In Milano 13 Gennaro 15(93)*, which can be compared to Pieter Bruegel's *Woodland Landscape with Five Bears* in Prague.[7] Not only the composition of the Rotterdam sheet, but also Jan's use of long, parallel strokes for the airy canopy of leaves makes the debt to his father's early drawings clear. Whether Jan Brueghel, in this and comparable works, actually copied lost landscapes by Pieter Bruegel or simply paraphrased his drawings of this type is still uncertain.[8]

That Bril turned to more modest forest interiors as subjects in the late 1590s, while continuing to produce dramatic panoramic landscapes,[9] probably reflects the mediating effect of Jan Brueghel's work. It is in the upright format and overgrown, tunnel-like paths into space of the 1596 sheet recently acquired by George and Maida Abrams (fig. 1) that this connection is clearest. The more

modest forest subjects do not necessitate a change in his handling of pen and wash.

In the present drawing, a new breadth and ease enter Bril's treatment of the woodland subject. It is achieved through the combination of a low viewpoint and a relatively large opening to a distant town on a plane. A gentle, rhythmic movement into space is created by the paths and hillocks and by the carefully modulated alternation of light and shade. The more classic quality of the Abrams sheet presages another change in Bril's style that occurred shortly after 1600, and that has been ascribed to the influence of the precocious Adam Elsheimer, who arrived in Rome in April of that same year.[10] It may be that in a drawing such as this, and in the rather broadly conceived forms of his frescoes in Santa Cecilia in Trastevere of c. 1599,[11] Bril is already undergoing a stylistic change that will leave him receptive to Elsheimer's vision of the Italian countryside. A thorough investigation of Bril's chronology would help determine the pattern of functions for finished drawings such as this one—whether they served as presentation pieces, print modelli, records of paintings, or preparations for paintings. MW

1. This device is a pun on the artist's name and the Netherlandish word for spectacles, *bril*.
2. Musées Royaux des Beaux-Arts; De Grez collection, no. 502; see Manchester 1967, no. 2, pl. 1.
3. Hamburg 1985, 18-19, no. 8. The date appears to be 1596, altered to read 1597.
4. Staatliches Museum; see Mayer 1910, pl. XLVa.
5. Gerszi 1976, esp. 219-224.
6. For the date of Jan's activity in Rome, as documented by inscriptions on his drawings, see Winner 1972, 122-132, who suggests that he stayed in Rome into 1595. He returned to Antwerp in 1596.
7. For Jan Brueghel's sheet in Rotterdam, see Berlin 1975, no. 50, fig. 72. The last two digits of the date are known from the inscription transcribed on the verso. Pieter Bruegel's drawing in Prague, which is dated 155(4) and served as the basis for Hieronymous Cock's etching of *The Temptation of Christ* (Hollstein 2), is the cornerstone of the attributions of early woodland landscapes to Pieter Bruegel; see Arndt 1966, 207-216, and Arndt 1972, 69-121.
8. See most recently Mielke, 1986, 81-84.
9. See, for example, the drawing in Berlin dated 1599; Berlin 1975, no. 20, fig. 209. This drawing repeats the composition of a 1598 painting in Parma; Faggin 1965, fig. 18.
10. For example, by Mayer 1910, 42-61, and Faggin 1965, 23. See also the account of the learned doctor Johann Faber to whose circle in Rome both Bril and Elsheimer belonged; quoted in Andrews 1977, 153. Andrews 1977, 22, has suggested that the overall chronology of Bril's frescoes, small easel paintings, and drawings must be worked out before it is possible to determine the degree to which Elsheimer inspired this change in Bril's style.
11. Mayer 1910, pls. XVII-XXII. The frescoes nevertheless retain the abrupt spatial transitions of his earlier work.

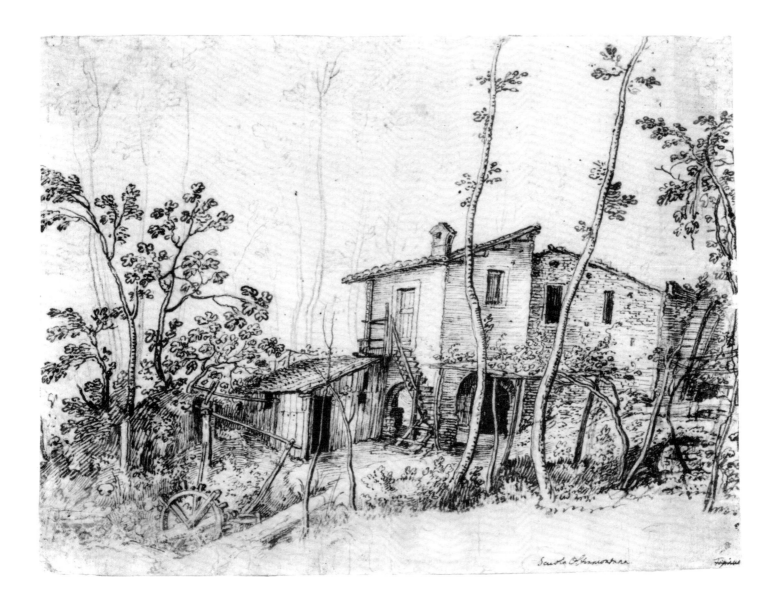

PAUL BRIL
20 *Italian Farmhouse by a Stream*

Pen and brown ink over black chalk, a strip of paper attached at bottom, laid down
205 x 270 (8¹/₁₆ x 10⅝)

Inscribed in dark brown ink at center right, *Scuola oltramontana*; at lower right, *Tiziano*, later crossed out; on verso in brown ink, *P.O.n: 64.*

Provenance: E. Schidlof, Paris, 1948

Literature: Boon 1978, 34, no. 92; Mielke 1980, 43; Boon 1980, 10

Rijksprentenkabinet, Rijksmuseum, Amsterdam, inv. no. 48: 574

This drawing, as a study made apparently from nature, is a rarity in the work of Paul Bril and of his compatriots who stayed in the Netherlands. If and when Bril made studies from nature has been the subject of debate. Lisa Oehler considered four drawings in Kassel to be early nature studies by Bril.[1] Of these, a view

of the Forum inscribed *1595/Paūuels Bril in/Romen ghehooret* (or *gheooūt*) differs from the others, which are loosely structured representations of waterfalls and ruins, executed with angular pen strokes. It is difficult to accept the latter group as Paul Bril's work, and he may have owned, rather than executed, the 1595 *Forum*.[2] The question of attribution is less vexing in the case of the Amsterdam *Italian Farmhouse*. The rounded leaves and even, parallel strokes indicating the swell of the terrain are typical of Paul Bril. As Karel Boon first pointed out, this study is quoted by Willem van Nieuwlandt II in one of his etchings of Italian landscapes after Paul Bril (fig. 1).[3] Van Mander reports in his 1604 *Schilder-boek* that Nieuwlandt, a pupil of Bril's, was then back in Amsterdam. It is likely that Nieuwlandt worked from his own draw-

ing derived from Bril's study, which must have remained in Italy, based on the evidence of its Italian inscriptions.

Other drawings comparable in composition and technique to the Amsterdam *Italian Farmhouse* have been attributed to Bril and were first linked to the Amsterdam sheet by Hans Mielke.[5] These include *The Baths of Diocletian from the Southwest* in Berlin, dated 14 July 1609,[6] and a *Study of Ruins* in the Uffizi.[7] However, its modest, everyday subject makes the Amsterdam *Farmhouse* unique in Bril's known work. All three studies probably date from the first decade of the sixteenth century, when Bril's work underwent a gradual change toward more classic compositions. All three share a planar, horizontal arrangement, with the foreground left open. As with compositional studies by Bril from the same peri-

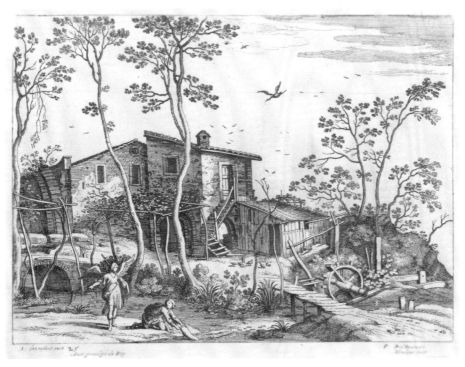

Fig. 1. Willem van Nieuwlandt II after Paul Bril, *Italian Landscape*, Rijksprentenkabinet, Amsterdam

od, the subject is first prepared with black chalk, which imparts a richer tonality to the drawing. Here and in the Berlin sheet, Bril has repositioned or simplified some details in working up the chalk sketch in pen. Thus he chose to omit some of the tall trees around the farmhouse, making its angular silhouette more prominent. Apart from this omission and the empty foreground, Bril's delicate penwork does not seem to intrude a compositional order on the scene. By leaving the foreground in these drawings empty, Bril may have anticipated the use of repoussoir elements introduced later, when the studies were worked up as more finished compositions. MW

1. Oehler 1955, 199-206, figs. 1-3 and 5-7.
2. For the reading of the inscription, see Boon 1980, 7, who accepts all four Kassel drawings as the work of Bril, linking them to the sheet in Amsterdam inscribed *Tiūoli 1606*. However, see also Mielke 1980, 43, who doubts the whole group. The problem of the attribution of the 1595 *Forum* and Bril's possible nature studies of the 1590s is bound up with his relation to Jan Brueghel during these years; see Winner 1972, 129-132, and Brussels 1980, no. 149.
3. Boon 1978, 34.
4. *Schilder-boek*, 2: 302.
5. Mielke 1980, 32.
6. See Berlin 1975, no. 22, fig. 208.
7. See Florence 1964, no. 49, fig. 49, and Boon 1980, 9-10, who also links a drawing formerly in the Perman collection, inscribed *a di 29 Septembr 1620*, to this group.

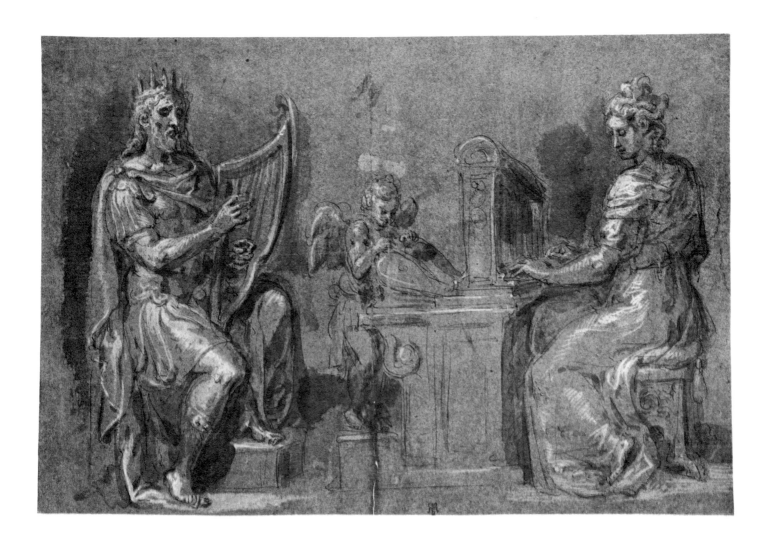

Crispijn van den Broeck

1524-C.1591

Crispijn van den Broeck was born in Mechelen in 1524. Nothing is known about his early years. It has been suggested that Jan van den Broeck, mentioned as a painter in Mechelen in 1551, was his father. In 1551 Crispijn van den Broeck became a master in the painters' guild in Antwerp, but did not acquire citizenship until four years later. His earliest work, a painting of the Last Judgment, *dated 1560 (Musées Royaux des Beaux-Arts, Brussels), contains figures inspired by Frans Floris'* Fall of the Rebel Angels *of 1554, and throughout his career he was heavily influenced by Frans Floris (q.v.). Van Mander reported that Van den Broeck helped to complete several paintings left unfinished at the time of Floris' death in 1570. From 1566 until at least 1589 Van den Broeck worked for Christoph Plantin; along with Pieter van der Borcht he was a major supplier of designs, in the form of drawings, for en-*

graved book illustrations. In 1582 he is recorded as receiving commissions from both the Rederijkers and the magistrate of Antwerp. A document of 6 February 1591 mentions Crispijn van den Broeck's wife as a widow. Van Mander said that he died in Holland, but this is unconfirmed. Van den Broeck was one of the most talented practitioners of Frans Floris' style.

21 *King David and Saint Cecilia*

Pen and brown ink, blue wash, and white heightening on blue prepared paper
209 x 316 (8³⁄₁₆ x 12⁷⁄₁₆)

Inscribed on verso in pen and black ink, *Kaye Dowland/1870/Parmigiano/du Cabinet du Prince de Ligne/411/c;* in pen and brown ink, *parmeganino;* in pencil, SCHOOL OF PALMA C.1550/COLL-PRINCE DE LIGNE/KAY DOWLAND 1870/D29692 AL

Provenance: Prince de Ligne (?); Baron Carl Rolas du Rosey (Lugt 2237); Kaye Dowland (1870); (P. & D. Colnaghi & Co. Ltd., London)

Literature: Haverkamp-Begemann and Logan 1970, 262-263. no. 492; Held 1972, 45; Van de Velde 1975, 90

Yale University Art Gallery, New Haven. Everett Meeks, B.A. 1901, Fund, inv. no. 1967.48.3

Carl van de Velde suggested that this splendid drawing might be a preparatory sketch for the shutters of an organ.[1] Both David and Saint Cecilia, patrons of music

and musicians, are especially associated with liturgical music. David, the supposed author of the Psalms, is shown as a crowned and bearded king playing the harp, the instrument by which he dispelled the madness of Saul. Saint Cecilia, the patron saint of music since the late fifteenth century, is typically depicted playing the organ, in this instance a positive organ. She is assisted by an angel who pumps the bellows. If intended as decoration for an organ case the figures could have been placed on either the inside or the outside of the shutters.[2]

The Yale sheet was attributed by Haverkamp-Begemann and Logan to Frans Floris and dated to the middle 1550s. Subsequently, however, both Held and Van de Velde stated that the drawing was most likely to be from the hand of Crispijn van den Broeck.[3] Although close to the style of his mentor, the Yale drawing reveals Crispijn's own manner of execution and conception of the human figure. In Floris' drawings in a similar technique such as the *Allegory of the Sense of Touch* (Szépmüvészeti Múzeum, Budapest),[4] or the *Group of Men in Antique Clothing* (Staatliche Graphische Sammlung, Munich),[5] there is a greater sense of movement and contrapposto as well as more emphasis on the silhouette. The figures of David and Saint Cecilia are rigid and planar, though endowed with a solidity of form. These figures are built largely out of the blue wash and white heightening, but in contrast to Floris the broken contour lines of the delicate, rapid penwork and the separate strokes of white heightening create an animated, impressionistic surface. The Venetian-inspired technique of wash and white heightening on blue prepared paper seems to have been often used by Crispijn van den Broeck. Although numerous drawings by Van den Broeck exist, and dated and monogrammed examples begin in 1570,[6] his stylistic development has not been studied in enough detail to permit a precise dating of his works. JOH

1. Cited in Haverkamp-Begemann and Logan 1970, 262-263.
2. For reproductions see Wilson 1979. The interior shutters are often decorated with religious scenes such as the Pentecost or the Resurrection and might have been open only at certain times in the liturgical year. For information about organ cases and their decoration I am grateful to John Fesperman, curator, division of musical instruments, Smithsonian Institution.
3. Held 1972, 45; Van de Velde 1975, 90.
4. Washington 1985, 146, no. 65.
5. Van de Velde 1975, 375-376, no. T42, pl. 141.
6. The earliest dated drawing known to the writer is *The Circumcision*, monogrammed and dated 1570, in the British Museum. See Popham 1932, 141, no. 4.

Jan Brueghel the Elder

1568-1625

Born in Brussels in 1568, Jan Brueghel the Elder was the third child of Pieter Bruegel and Mayken Coecke. Van Mander reports that Jan learned to paint in watercolors from his talented grandmother Marie Bessemer, widow of Pieter Coecke van Aelst, but no watercolors by her hand, nor any of Jan's juvenilia, have been identified. We also know nothing of the Pieter Goetkindt who, according to Van Mander, instructed Jan in oil painting. His earliest surviving works, which attest to his contact with Paul Bril, date from Jan's sojourn in Italy. Recorded in Naples in 1590, he may have traveled south as early as 1589. From 1592-1595/ 1596 he resided mainly in Rome, but in 1593 and 1596 he visited Milan, where he stayed with his lifelong patron Cardinal Federico Borromeo. By October 1596 Jan returned to the Netherlands, settled in Antwerp, and married Isabella de Jode in 1599. After her death he married Katharina van Marienburg in 1605. Jan entered the Antwerp Guild of Saint Luke in 1597, served as subdeacon in 1601 and deacon

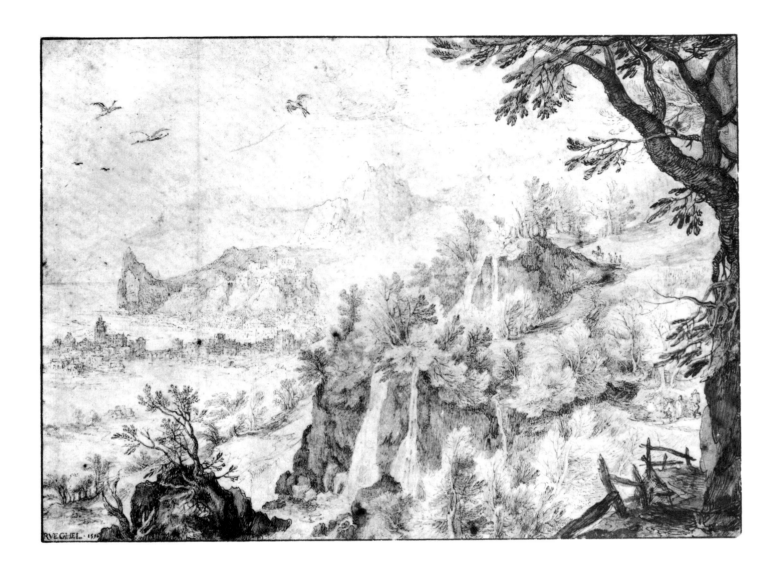

in 1602. During the summer of 1604 he
traveled to Prague, but returned to Ant-
werp by the end of the year. Like his col-
league Peter Paul Rubens, Brueghel en-
joyed a successful career as court painter
to Archduke Albert and Archduchess Is-
abella Clara Eugenia, the Habsburg re-
gents of the Netherlands. He entered
their service in 1606 and retained his po-
sition until his death. About 1613 Jan
traveled to the northern Netherlands in
the company of Rubens and Hendrick
van Balen. He died at Antwerp in 1625.

Jan Brueghel worked as a draftsman
and painter, specializing in exquisitely
executed floral still lifes and various
types of landscapes, including imaginary
mountain panoramas, forest interiors,
villages and country roads, ports, river
views, seascapes, hunting pieces, battles,
and scenes of hell and the underworld.
Many of his landscapes contain numer-
ous figures, either in everyday dress or
enacting biblical, mythological, or alle-
gorical subjects. About 400 paintings by
him are known today.

22 Mountain Landscape with a Harbor City

Pen and brown ink, brown and blue wash; par-
tially incised for transfer
201 x 288 (7⅞ x 11⁵/₁₆)

Signed and dated at lower left in brown ink,
(B) RUEGHEL 1596.

Provenance: F.J.O. Boymans

Literature: Rooses 1902, 97; Van Gelder 1933,
20 n. 4; Winner 1961, 200-201; Franz 1968-
1969, 41; Winner 1972, 134 n. 25, and 136;
Ertz 1979, 133 and 201-204

Exhibitions: Antwerp 1930, no. 369; Berlin
1975, no. 114; Brussels 1980, no. 155

Museum Boymans-van Beuningen, Rotterdam,
inv. no. Jan Brueghel de Oude 5

Many drawings by Jan Brueghel have sur-
vived and they have been studied thor-
oughly by Matthias Winner.[1] Most repre-
sent the various kinds of landscapes fa-
miliar from his paintings, but they also
include a few still lifes and historical
subjects and several charming, vigorously
sketched sheets of studies. He seems to
have drawn exclusively with the pen and

brush, occasionally combining brown and
blue washes in a manner also practiced
by many of his contemporaries, such as
David Vinckboons and Paulus van
Vianen.

Like his father, Jan traveled to Italy as a
young man in his twenties. His stay there
from 1589/1590 to 1596 was a productive
one, and several paintings and drawings
from these years have come down to us.
The drawings consist of views of Naples,
Rome (cat. 23), and Tivoli, copies after
Matthijs Bril's studies of ancient build-
ings (cat. 18), sketches of Roman ruins,
and finished landscapes and coastal
scenes.[2]

*Mountain Landscape with a Harbor
City*, authentically signed and dated
1596, was engraved by Aegidius Sadeler
together with a group of other early draw-
ings by Jan Brueghel (fig. 1).[3] In addition
to this sheet, five studies for these prints
have come to light.[4] One is dated 1595
and was certainly executed in Italy.[5]

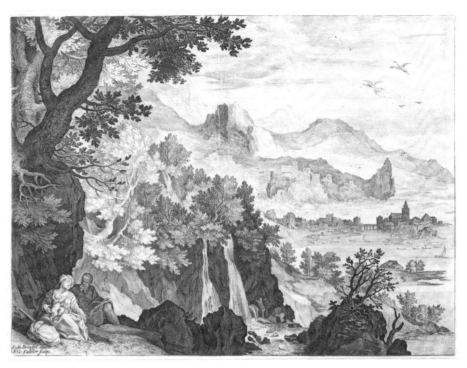

Fig. 1. Aegidius Sadeler after Jan Brueghel the Elder, *Mountain Landscape with a Harbor City*, Rijksprentenkabinet, Amsterdam

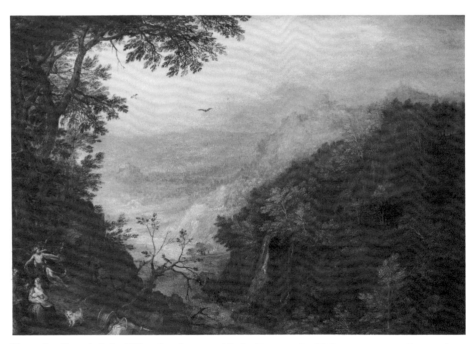

Fig. 2. Jan Brueghel the Elder, *Landscape with the Rest on the Flight into Egypt*, Alan Jacobs Gallery, London

Brueghel left Milan sometime after 30 May 1596 and arrived in Antwerp by 10 October, so we cannot know whether he drew the work exhibited here in Italy or in the Netherlands. The four other drawings are undated, but at least one appears to be later than the mid-1590s.[6] Sadeler, who lived in Prague from 1597 until his death, probably obtained the designs from Brueghel during the latter's visit to the imperial capital in 1604, and produced the prints shortly thereafter.

The engraving reverses the composition and departs from it in several details. Sadeler probably adopted the Holy Family group, which was not Jan's invention, from the work of another artist, perhaps Hans Rottenhammer.[7] In the engraving, large boulders replace the trees between the foreground ledge and the base of the waterfalls.

While the distant mountains and coastal view bring to mind the type of *Welt-landschaft* depicted by Jan's father, the

remainder of the composition reflects his study of recent developments in landscape art in Italy. The hillside in the middle distance with its waterfalls and graceful foliage, and the great rock at the lower left with its tree, clinging roots, and torn branches reveal Brueghel's debt to the drawings of Girolamo Muziano, several of which were reproduced in engravings by Cornelis Cort.[8] Similar details grace the slightly later landscapes by Paul Bril (cat. 19), who also admired Muziano's art. In the imaginary, composite vista of *Mountain Landscape with a Harbor City*, Jan united reminiscences of Muziano's drawings with direct references to the waterfalls at Tivoli, which he sketched from life (see cat. 23, fig. 1).[9]

About the time he made the drawing Brueghel executed a small painting on copper that incorporates, with slight variations, the hill and waterfalls featured in the Rotterdam study (fig. 2).[10] Although this picture represents *The Flight into Egypt*, the figures do not resemble those in Sadeler's engraving. WWR

1. Winner 1961; Winner 1972; Winner in Berlin 1975, nos. 108-128; Winner in Brussels 1980, 209-212 and nos. 148-169. See also Ertz 1979.
2. Winner 1961, 190-202; Winner 1972, 122-136; Ertz 1979, 90-115.
3. For these engravings see Hollstein 208-218, and vol. 22: figs. 208-218. These prints have no title page or date and do not seem to constitute a formal series. The engraving after the drawing exhibited is Hollstein 209 (fig. 1).
4. Apart from the present sheet, the following studies for prints in this group have been identified: *Mountain Landscape with Tobias and the Angel* (Hollstein 208), Szépmüvészeti Múzeum, Budapest, Washington 1985, no. 72; *River Landscape with the Temptation of Christ* (Hollstein 210), Fondation Custodia, Paris, coll. F. Lugt, signed and dated 1595, Berlin 1975, no. 113; *Landscape with Saint Francis Receiving the Stigmata* (Hollstein 212), British Museum, London, Winner 1972, fig. 16; *Village Street with Two Carts* (Hollstein 215), Fitzwilliam Museum, Cambridge, inv. no. PD 210-1963, Rotterdam 1961-1962, no. 25; *Coastal Landscape with Fishermen and Fishermongers* (Hollstein 216), private collection, Augsburg, Berlin 1975, no. 115.
5. *River Landscape with the Temptation of Christ*, see n. 4 above.
6. *Village Street with Two Carts*, see n. 4 above, belongs to a type of composition developed by Jan only after c. 1600, Ertz 1979, 214-218. Winner in Berlin 1975, no. 117, had dated the Budapest *Landscape with Tobias and the Angel* (see n. 4 above) c. 1600, but later changed his mind, Brussels 1980, under no. 156, to agree with Gerszi 1971, 1: no. 30, and Ertz 1979, 146, who dates the sheet 1595-1596.
7. Winner in Berlin 1975, no. 114.
8. Winner 1961, 200-201; Ertz 1979, 201, and 203, fig. 241.
9. See the study of the falls at Tivoli in Leiden (cat. 23, fig. 1), Prentenkabinet der Rijksuniversiteit, Brussels 1980, no. 148, which Brueghel incorporated into *Landscape with Saint Francis Receiving the Stigmata* (see n. 4 above).
10. The painting, which Ertz attributes to Brueghel and dated c. 1595, measures 6½ x 9½ inches. Alan Jacobs Gallery, London, see advertisement in *Art and Antiques* (March 1986), 33 (repr.); not in Ertz 1979.

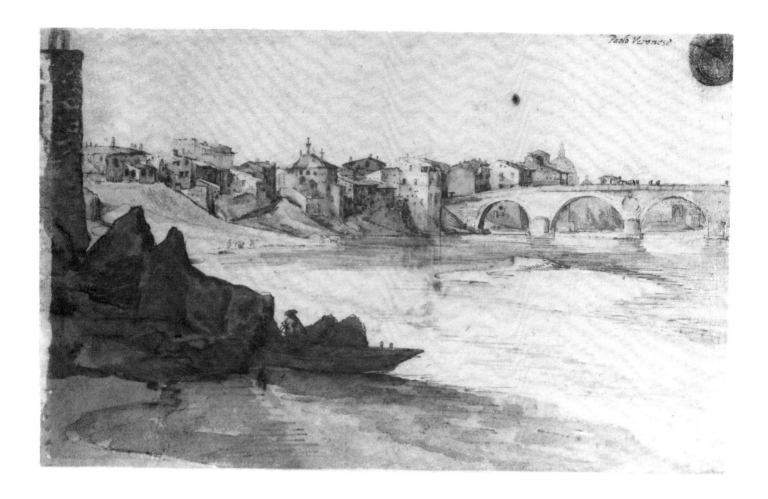

JAN BRUEGHEL THE ELDER

23 *View of the Tiber with the Ponte Sisto and Saint Peter's in the Distance*

Pen and brown ink, brown, blue, and gray
wash
159 x 256 (6¼ x 10¹/₁₆)

Inscribed at upper right in brown ink, *Paolo
Veronese*

Provenance: Unidentified collection (illegible
mark, upper right); (sale, New York, Sotheby's,
3 June 1981, lot 124, as Flemish School, seven-
teenth century)

Literature: Winner 1985, 87-88

Private collection, New York

During his stay in Rome from 1592 to
1595/1596, Jan Brueghel produced several
drawings that document his keen interest
in the ancient and modern architecture of
the Eternal City. He copied Matthijs
Bril's studies of Roman monuments (see
cat. 18), sketched the ruins of the Colos-
seum, the Baths of Caracalla, and the
Campo Vaccino, and made views of the
Tiber with the bridges and buildings
along its banks.[1] These works continue
the distinguished tradition of Roman
topographical drawings by sixteenth-
century Netherlandish artists, which
originated with Gossaert's *View of the
Colosseum* (cat. 63) and was carried on by

others (see cats. 69, 32, 26, 18). Unlike
earlier masters, who concentrated on an-
tique ruins or the more spectacular vis-
tas, Jan included many mundane, domes-
tic structures in his sketches. Some of
the drawings Brueghel made in Italy
served as detail studies for the landscape
backgrounds of his paintings.[2]

View of the Tiber with the Ponte Sisto
is one of three Tiber scenes known to
have been executed by Jan Brueghel. A
drawing of the Castel Sant' Angelo, the
Ponte Sant' Angelo, and Saint Peter's be-
longs to the Hessisches Landesmuseum,
Darmstadt,[3] and a vista of the Isola Tiber-
ina and the Ponte Rotto was in Stuttgart
until the Second World War.[4] Brueghel
sketched the view toward the Ponte Sisto
from a point on the Trastevere bank of
the river near the Isola Tiberina and the
site of the present Ponte Garibaldi. Rising
in the distance, just above the second
span of the bridge, is the dome of Saint
Peter's, which was completed in 1593.
Jan's drawing appears to show scaffolding
on the lantern and cross that surmount
the dome. As the sheet in Darmstadt is
dated November 1594 and the other Ro-

man views by Brueghel bear dates from
1593 to 1595, we may assign the present
work to c. 1594.[5]

As Winner points out, Brueghel applied
the washes to this sheet before the pen-
strokes had dried, blurring the ink. The
swift execution of the study might sug-
gest he made it on the spot, but the dark
repoussoir consisting of a ruined wall and
boat in the left foreground indicates, ac-
cording to Winner, that Jan worked up
the drawing from preliminary sketches
taken from nature.[6] To be sure, the stud-
ies he certainly drew from nature, such as
Falls of the Anio near Tivoli (fig. 1), are
less formally composed.[7] However, other
views of the site confirm that the spit of
land and the ruined wall in the left fore-
ground of Brueghel's drawing did exist
(fig. 2), so their prominence is as much
the result of direct observation as of com-
positional artifice.[8] Whether he sketched
it from life—which seems probable—or
not, Jan described the topography
accurately. WWR

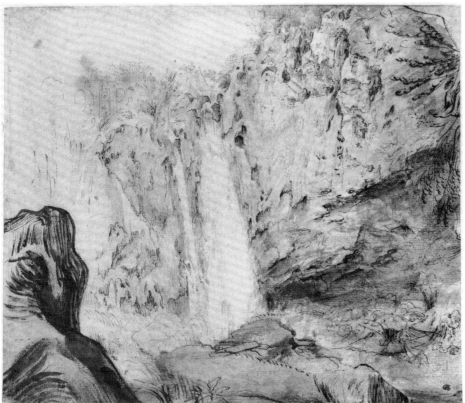

Fig. 1. Jan Brueghel the Elder, *The Falls of the Anio near Tivoli*, Prentenkabinet der Rijksuniversiteit, Leiden

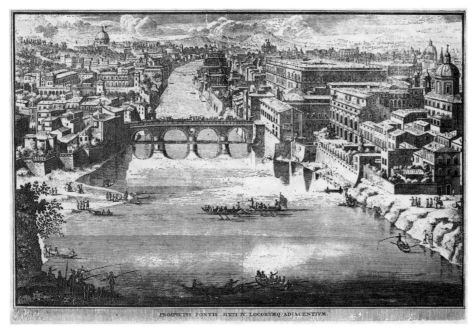

Fig. 2. Lieven Cruyl, *Prospectus Pontis Sixtus*, The Pierpont Morgan Library, New York

1. For Jan Brueghel's Italian drawings, see Winner 1961, 190-204; Winner 1972, 122-136; Berlin 1975, nos. 109-115; Brussels 1980, nos. 148-155.
2. Winner 1972, 192-195; Ertz 1979, 173-178.
3. Brussels 1980, no. 150, with previous literature; Winner 1985, 88-90.
4. Winner 1972, 132-133.
5. For other dated drawings of Roman scenes, see Winner 1961, figs. 2, 3, 4, 5a, and 5c. Winner 1985, 88, dates the drawing exhibited here toward the end of Jan's stay in Rome.
6. Winner 1985, 88-90.
7. Prentenkabinet der Rijksuniversiteit, Leiden, inv. no. AW 1240, Brussels 1980, cat. 148. Winner 1961, figs. 5a and 5c, must also be studied from nature.
8. This engraving by Lieven Cruyl was published in Graevius, *Thesaurus Antiquitatum Romanorum*, Utrecht, 1690 and 1694. See also the painting of the same view by Caspar van Wittel. Both are reproduced in d'Onofrio 1970, figs. 118, 120. I am indebted for reference to Cruyl's print, and for several other observations about the drawing, to Professor E. Haverkamp-Begemann, who was the first to recognize it as the work of Jan Brueghel.

Pieter Bruegel the Elder

c. 1525/1530-1569

The place and date of Bruegel's birth are not documented, but there is good reason to believe he was born at Breda c. 1525/1530. Although Van Mander states that he was a pupil of Pieter Coecke van Aelst, this is not certain. In 1550/1551 Bruegel collaborated on an altarpiece, now lost, in Malines. He joined the Antwerp painters' guild late in 1551 or early in 1552, and shortly thereafter departed for Italy. After visiting Reggio Calabria and probably Naples and Messina in 1552, he lingered in Rome in 1553 and 1554. There he knew the celebrated miniaturist Giulio Clovio, who acquired four paintings from him. Back in Antwerp by 1555, Bruegel began to work for the publisher Hieronymus Cock. During their long association Bruegel produced nearly forty designs representing landscapes, seascapes, religious themes, and secular didactic subjects. In 1563 Bruegel moved to Brussels and married Mayken, the daughter of Pieter Coecke van Aelst. The couple had two sons—Pieter the Younger (1564/1565-1637/1638) and Jan (1568-1626)—both of whom became artists. Bruegel died in Brussels on 9 September 1569.

In addition to the prints after his inventions and a single etching from his own hand, Bruegel's oeuvre consists of some forty paintings and about fifty securely attributed drawings. Most of the latter are from the 1550s and relate to his Italian journey and to his activity as a designer for Antwerp print publishers. The great majority of his paintings, which are cabinet works made for private collectors, date from after 1560.

Among his patrons were the Antwerp merchant and royal official Niclaes Jonghelinck, who owned sixteen of his pictures including the series depicting The Labors of the Months, *and Cardinal Antoine Perrenot de Granvelle, Archbishop of Malines and adviser to the Regent Margaret of Parma. The renowned geographer Abraham Ortelius was Bruegel's friend and the original owner of his grisaille painting* The Death of the Virgin.

Hailed by Ortelius as "the most perfect painter of his century," Bruegel also ranked among the greatest Renaissance draftsmen. Although he had no known pupils, his drawing style influenced all the leading landscapists and genre artists from c. 1560 to c. 1610.

24 *The Wide Valley*

Pen and brown ink over black chalk
104 x 323 (4¹/₁₆ x 12¹¹/₁₆)

Watermark: Crowned shield with lily and letters *WB* (not in Briquet)

Provenance: Acquired in 1723 from the book dealer Moritz G. Weidemann, Leipzig

Literature: Woermann 1896-1898, Mappe 4, no. 131; De Tolnay 1952, no. 11; Münz 1961, no. 8; Berlin 1975, under no. 53; Müller-Hofstede 1979, 108

Exhibitions: Leningrad 1972, no. 7; Prague 1974, no. 12; Washington 1978-1979, no. 587

Staatliche Kunstsammlungen Dresden, Kupferstich-Kabinett, inv. no. C1125

Unlike other sixteenth-century Netherlandish masters who had journeyed to Italy to study the remains of Roman antiquity and the art of the High Renaissance, Pieter Bruegel was the first to travel south primarily to experience the scenery. By the mid-sixteenth century the medieval fear of the Alps had begun to yield to a new scientific and aesthetic interest.[1] The circuitous route of Bruegel's tour attests to his fascination with the mountains: he traveled via Lyons and traversed the Saint Gotthard Pass and Ticino Valley, but he also ventured far to the east, to the region of Innsbruck.[2] That his primary interest lay in landscape and topography is also reflected in the approximately twenty-five drawings from his trip of 1551/1552-1554/1555. One represents a Roman townscape (cat. 26), while the rest depict Alpine views or the Italian countryside.[3]

Most of these works fall into two broad categories. The first consists of finished

presentation drawings (cats. 25, 27, and Münz 1961, nos. 3-5, 15, 25). Bruegel worked up the elaborate compositions in the studio, probably from sketches made outdoors. Some he signed and/or dated. The second group includes more casually composed views ranging in size from small, cursory sketches to large, detailed works hardly distinguishable from the presentation sheets. A few landscapes of this type were probably taken entirely from life, while others were perhaps begun in the mountains and completed in the studio. Because of its spontaneity and informal composition, *The Wide Valley* very likely belongs to the rare sketches that he executed on the spot.[4]

This summary study is one of Bruegel's most personal and freely executed Alpine landscapes. He probably made it in 1552, to judge from its stylistic similarity to the dated drawings of that year (cat. 25, fig. 1) and to the Morgan *Mountain Landscape* and other works which, following Oberhuber's chronology (see cat. 25), belong to the period of his journey to Italy. Over a light sketch in black chalk Bruegel's pen traced delicate, parallel lines that evoke, with admirable economy, the bulk and rhythmic undulations of the mountain range. After adding the sprightly loops that represent trees on the lower slopes, he began to fill in the little wood at the center before abandoning the sketch altogether. (Some of the unworked paper at the bottom of the sheet may have been trimmed off at a later date, giving the sheet its unusually low format.)

Netherlandish artists before Bruegel seldom, if ever, drew landscapes from nature, except for those of topographical or antiquarian interest. This innovation had significant ramifications for Bruegel's own work and for the subsequent history of Netherlandish art. As a storehouse of motives that he later consulted when designing paintings, prints, or finished drawings, his studies of the Alps became the fountainhead of the new naturalism he introduced into the landscape art of the Low Countries. The achievements of the Master of the Small Landscapes (cat. 87) and other exponents of the naturalistic style during the second half of the century were clearly stimulated by Bruegel's practice of drawing from life. WWR

1. Gibson 1977a, 34.

2. A lost painting by Bruegel of the Saint Gotthard Pass, which belonged to Rubens (Jaffé 1979, 37-38), and the drawing by Bruegel of the Martinswand near Innsbruck (Berlin 1975, no. 52), record the only documented stops on Bruegel's Alpine tour(s).

3. Landscape drawings datable or probably datable to Bruegel's Italian journey include: Münz 1961, nos. 1-12, 14-16, 18-23, 26(?); Berlin 1975, nos. 26, 27, 28(?), 29(?), 38, 52; Brussels 1980, no. 11. These constitute nearly the entire corpus of Bruegel's securely attributed landscape drawings. For the small mountain landscapes (Münz 1961, nos. 27-45) and the drawings of the walls of Amsterdam (Münz 1961, nos. 47-49) and the small village landscapes that were formerly given to Bruegel, see cats. 97, 98, and 87. With the removal of these sheets from Bruegel's oeuvre, the works executed during or shortly after the Italian trip are the only remaining securely attributed landscapes.

4. There is little consensus among scholars about the function of Bruegel's landscape drawings, particularly on the issue of which of them he drew from nature. I agree with Mielke (Berlin 1975, under no. 53) that *The Wide Valley* is one of the few studies from nature to have survived, a view also expressed by Münz 1961, no. 8, and in Washington 1978-1979, no. 587. See Müller-Hofstede 1979, 108, for a characterization of the Dresden drawing that is both unclear and debatable. However, Müller-Hofstede's paper is the only systematic attempt to classify Bruegel's landscape drawings according to their function. On this question, see also Oberhuber 1981.

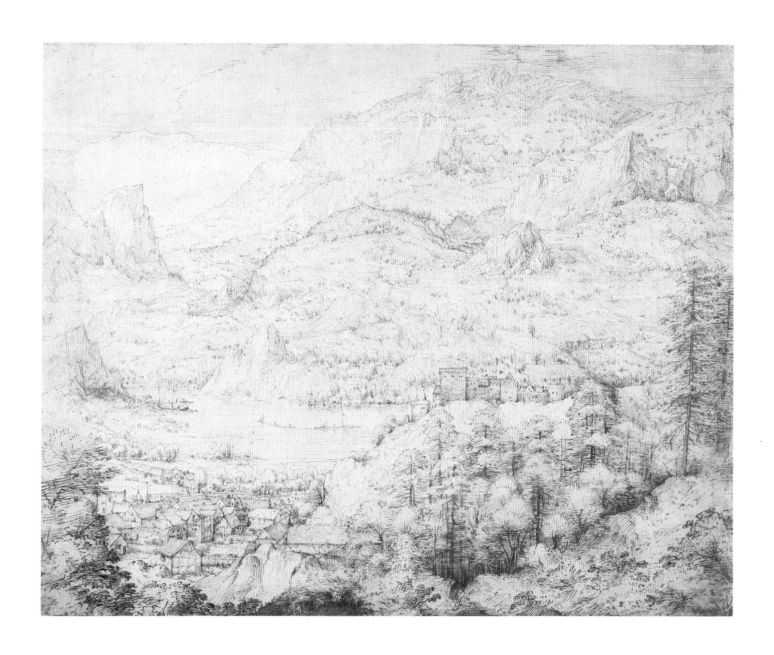

PIETER BRUEGEL THE ELDER

25 *Mountain Landscape with a River, Village, and Castle*

Pen in two brown inks, some brown wash
357 X 443 (14 X 17⅜)

Watermark: Fleur-de-Lis on a crowned shield, illegible countermark

Inscribed at lower right in brown ink, *P. BRE(?)UG(?)EL(?)*. On the verso in brown ink, in an eighteenth-century hand, *Hemskirk* (visible through lining). On verso of lining in graphite, *this drawing comes from a collection formed in 1770 by the Rev^d Thos. Carwardine/of Earls Colne Priory Essex when travelling on the Continent with George Romney/ Romney painted the Rev. and Mr^s. Carwardine with son;* below, in an earlier hand, partially effaced and crossed out, *John Vosterman b. 1643/ J. Savery/ or Dom. Campagnola d. 1540;* below, in a different hand, *M^r. Bensosan Britt has pointed out that/ this drawing is identical in style with the pen & ink/ drawing of Waltersspurg By Pieter Brueghel c. 1554 from Bow-*

doin/ Collection reproduced in The Connoisseur Dec 1947/ Evers/ 20.7.51.; below, in first hand, *Mr. A.E. Popham (British Museum) thought the date was about 1552./ This drawing seems to represent the same piece of country as/drawings No. 172 & 197 in Tolnai 1935*

Provenance: Thomas Carwardine, Earl's Colne Priory, Essex; by descent to Col. Oliver Probert; his sale, London (Christie's, 16 May 1952, lot 41)

Literature: Benesch 1953, 79; Münz 1961, no. 21; Stechow 1969, 34-35; Franz 1969

Exhibitions: Berlin 1975, no. 57; New York 1981, no. 31 (with complete literature and exhibition history)

The Pierpont Morgan Library, New York. Purchased with the assistance of the Fellows, 1952, inv. no. 1952.25

Bruegel's firsthand knowledge of the Alps allowed him to convey the majesty and complexity of the terrain with compelling visual truth as well as imaginative power, far surpassing the grandiose but thoroughly idealized creations of Joachim Patinir, Matthijs Cock, Pieter Cornelisz. Kunst, and Cornelis Massys (cats. 93, 34, 41, and 84). In addition, he transformed the linear pen technique of Massys and Cock into a more pictorial vocabulary of delicate dots, loops, and parallel hatchings that delineate detail and evoke light and atmosphere with unprecedented naturalism. Every major Netherlandish landscape draftsman from the mid-1550s until the early seventeenth century was, to

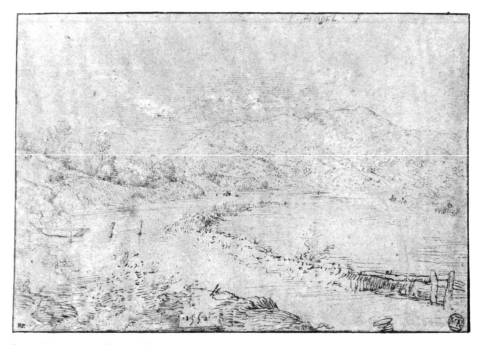

Fig. 1. Pieter Bruegel the Elder, *Bank of a River*, Musée du Louvre, Cabinet des Dessins, Paris (Cliché des Musées Nationaux)

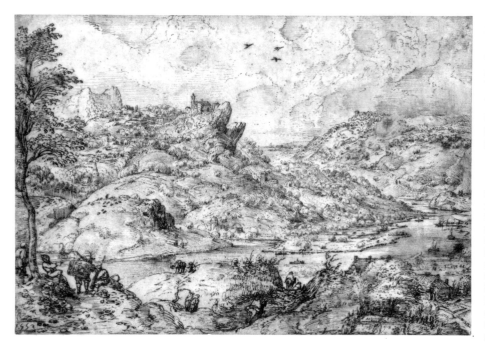

Fig. 2. Pieter Bruegel the Elder, *Landscape with River and Mountains*, The British Museum, London (Courtesy of the Trustees of the British Museum)

closely integrated that he clearly did not labor over the sheet during a protracted period, as he did with some works in the group.[1]

The style of the Morgan drawing closely resembles that of several other undated mountain landscapes (cat. 24 and Münz 1961, nos. 7, 9-12, 17-19). Until recently scholars agreed that Bruegel produced these works during or after his return trip to the Netherlands, assigning them variously to 1553-1554 or 1555-1560. In 1981 Konrad Oberhuber demonstrated that the pen technique of this group has more in common with the delicate touch of the sheets dated 1552 (fig. 1) than with the relatively forceful execution of those dated 1553 (fig. 2, and cat. 27). Further, compared to the Morgan landscape and related works, the drawings dated 1553 display a relatively advanced approach to spatial representation (see cat. 27). These observations led Oberhuber to place the Morgan sheet as early as 1551-1552, during Bruegel's journey to Italy.[2] However, as the complex composition seems more mature in style than the dated works of 1552, it more likely originated late in 1552 or early in 1553.

The Morgan landscape and the scenes depicted in two closely related drawings (Münz 1961, nos. 19 and 20) are perhaps based on the scenery just to the north of the Saint Gotthard Pass, but, as they are composite views, attempts to identify the specific sites are bound to remain inconclusive.[3] WWR

1. See Oberhuber 1981, 146-147.
2. See Oberhuber 1981, 146-151.
3. The Morgan drawing and Münz 1961, nos. 19 and 20, are frequently described as views made in the region of the Vorderrhein, not far to the northeast of the Saint Gotthard Pass. Benesch 1953, 79, tried to identify the Morgan view as the village of Ruis and the Castle of Jörgensberg, between Truns and Ilanz in the Swiss Canton of Graubünden. The location is not far from Waltensburg, supposedly represented in Münz 1961, no. 19; see Brunswick 1985, no. 8. However, as noted by Becker in the Brunswick catalogue, the scant visual evidence that has been presented in support of these specific identifications is inconclusive. The same is true of the photographic material assembled by J.-P. de Bruyn, "Pieter I Bruegel in Graubünden," auction catalogue, Kunstveilingen De Vos, Ghent, 13 December 1982.

some extent, influenced by Bruegel's Alpine and Italian views (cats. 14, 87, 97-100, 101 fig. 1, 116, 19, 22, 50, and 118).

The Morgan Library work is the largest and one of the most finished of these mountain landscapes. Although neither signed nor dated, it is probably a presentation drawing produced in the studio from memory and/or sketches made in the Alps (see cat. 24). The composition teems with minutely described details that create a vivid impression of the height and breadth of the mountains. Bruegel executed the drawing in two distinct brown inks. However, the penwork is consistent in style and the inks so

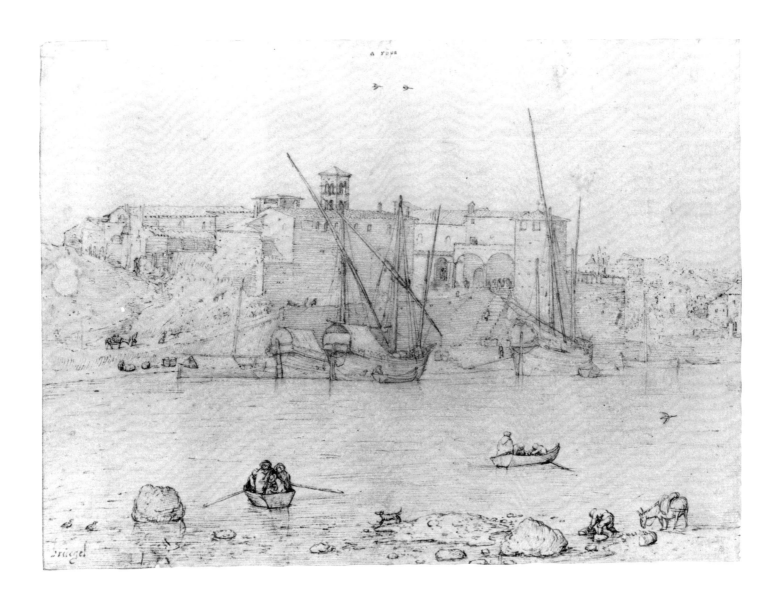

PIETER BRUEGEL THE ELDER
26 *View of the Ripa Grande, Rome*

Pen in two brown inks
208 x 283 (8³/₁₆ x 11⅛)

Inscribed by the artist at upper center, in
brown ink, *a rÿpa,* and by another hand at
lower left, in brown ink, *bruegel;* laid down

Provenance: 2nd Duke of Devonshire, c. 1723 (?);
and by descent

Literature: Egger 1911, 38; *Vasari Society,* 2nd
series, pt. 6 (1925), no. 11; De Tolnay 1952,
no. 4; D'Hulst 1952, 103-106; Münz 1961,
no. A24, as Jan Brueghel the Elder; Haverkamp-
Begemann 1964, 57; Müller-Hofstede 1979, 97-
98; Krautheimer 1980, 239 and 241; Winner
1985, 90-91

Exhibitions: London 1927, no. 527; Washing-
ton 1962-1963, no. 77; Berlin 1975, no. 26

Bruegel's only surviving view of Rome
represents the Ripa Grande (Great Bank)
of the Tiber, a site less remarkable for its
antiquity or architectural character than
for its function as the city's principal har-
bor for seagoing vessels. Bruegel sat at the
base of the Aventine Hill and looked
across the river at the ships moored be-
low the ramp and stairway leading to the
Dogana (del mare) Vecchia (marine cus-
toms house) with its double-arched port-
ico. To the left of the customs house are
the church and campanile of Santa Maria
in Turri, and, to the right, the tower
erected by Pope Leo IV (847-855) to de-
fend the port.[1]

 The Ripa Grande figures in other early
drawings only as a small detail in panora-
mas taken from high on the Aventine.[2]
Bruegel was probably the first draftsman
to isolate the site and depict it from a low
vantage point across the Tiber, a view
that later appealed to Claude Lorrain and
his Dutch followers (fig. 1).[3] Unlike the
Roman views of Jan Gossaert, Maerten
van Heemskerck, or Matthijs Bril (cats.
63, 69, 18,), Bruegel's work does not de-
pict one of the city's ancient precincts or
venerable ruins. Rather, his drawing is an
urban *veduta,* a townscape animated
with everyday activities and enlivened by
the picturesque lines of the masts and
riggings against the austere masonry. Al-
though the autograph inscription is evi-
dence that Bruegel regarded the site as a
notable one, no single feature commands
our attention. On the contrary, the walls
and roofs of the undistinguished medi-
eval buildings, their squat bulk rising
heavily above the river and shimmering

Fig. 1. Isaac de Moucheron, *View of the Tiber*, Musées Royaux des Beaux-Arts de Belgique, Brussels (Copyright A.C.L. Brussels)

Fig. 2. Jan and Lucas Duetecum after Pieter Bruegel the Elder, *Prospectus Tyburtinus*, Museum of Fine Arts, Boston, Helen and Alice Colburn Fund

which the foreground either remained blank (cat. 24) or was completed in a different ink and sometimes in a more advanced style.[4]

The economy of line and the sensitivity of Bruegel's pen to the nuances of light and atmosphere in this scene are unmatched in his oeuvre. Its delicate penwork relates the drawing to dated landscapes of 1552 (cat. 25, fig. 1), but Bruegel's presence in Rome is documented only in 1553 and 1554. If he reached the city in 1552, he might have sketched the Ripa Grande in that year; otherwise, the sheet probably dates from early in 1553.[5] In view of its exceptional quality and stylistic kinship with other early landscapes by Pieter Bruegel, most scholars have rejected Münz's attribution of this drawing to Jan Brueghel.[6]

Although *View of the Ripa Grande* is Bruegel's only known Roman drawing, he must have made other studies, now lost, of the city and its environs. His adaptation of the vaulting of the Colosseum in two paintings of the Tower of Babel may have derived from sketches made on the spot.[7] In addition, *Prospectus Tyburtinus*, one of the large landscapes engraved after his designs in Antwerp c. 1555, represents the falls of the Aniene River (ancient: Tibur) at Tivoli (fig. 2).[8] Bruegel undoubtedly sketched the view from life, like the draftsman in the foreground of the print. His study or studies were probably similar in character to the background of the sheet exhibited here, which exemplifies his manner of drawing from nature. However, when designing the engraving, he combined the sketches in an artfully composed, dramatic panorama with broad, deep space, eddying torrents, and undulating rock formations. WWR

1. Egger 1911, 38; Krautheimer 1980, 239.
2. For example, see the drawing in the Codex Escurialensis, c. 1491, Egger 1911, 38, pl. 69, and the drawing by the Anonymous Fabriczy, c. 1568-1572, Egger 1911, 40, pl. 73.
3. The drawing reproduced in fig. 1 is by Isaac de Moucheron (1667-1744), Musées Royaux des Beaux-Arts, Brussels, de Grez collection, inv. no. 2626, as Frederik de Moucheron; attributed to I. de Moucheron by Zwollo 1973, 43. See also the similar view attributed to Jan Asselijn, De Tolnay 1952, pl. XCII, fig. R4. For drawings of the site by Claude, see Roethlisberger 1968, nos. 280, 286.
4. Münz 1961, nos. 8, 11, 16, 17. See Oberhuber 1981, 148-150.
5. See Biography. *View of the Ripa Grande* has been dated c. 1553 by Winner in Berlin 1975, no. 26; by De Tolnay 1952, no. 4; and by Egger 1911, 38; and 1552-1554 by Winner 1985, 90.
6. The drawing was traditionally ascribed to Jan Brueghel the Elder until Egger 1911, 38, recognized it as the work of Pieter Bruegel. His attribution was accepted by De Tolnay 1952, no. 4. Münz 1961, no. A24, reattributed the work to Jan Brueghel the Elder, and his proposal was accepted by Haverkamp-Bege-

in the sunlight, merge anonymously into each other.

Bruegel began by drawing the scene on the opposite bank from life and noting, *a rÿpa*, in the lighter of the two inks. Later, in his studio, he added the river, the row-

boats, and the foreground bank and staffage in a darker ink. This procedure of starting with the principal motif in the middle ground or distance and finishing the work at a later stage was also followed in several of his Alpine views, in

PIETER BRUEGEL THE ELDER

27 *Landscape with Saint Jerome*

Pen and brown ink
232 x 336 (9⅛ x 13¼)
Signed in brown ink, *BRUEGHEL (UE* and *HE*
in ligature), and dated, *1* (partially cut) *553*

Provenance: Prince of Liechtenstein; Dr. Felix
Somary, Zurich; William S. Schab, New York

Literature: Lugt 1927, 116; De Tolnay 1925,
no. 7; Münz 1961, no. 22; Franz 1969, 160;
Arndt 1972, 85, 87, no. 2; Oberhuber 1981, 151

Exhibitions: Washington 1974, no. 39; Berlin
1975, no. 35

National Gallery of Art, Washington, Ailsa
Mellon Bruce Fund, inv. no. 1972.47.1

mann 1964, 57. Winner in Berlin, 1975, no. 26, and
Winner 1985, 90, and Müller-Hofstede 1979, 97,
strongly defend Pieter's authorship.
7. Winner 1975, no. 26, and Stechow 1969, 82, point
out that the vaults of the Tower of Babel in Bruegel's
paintings in Rotterdam and Vienna, Grossmann
1955, pls. 50-59, were inspired by those of the Colos-
seum and that Bruegel might have made sketches of
the Colosseum during his Roman sojourn.
8. Hollstein 3. For the date of the print series, see
Arndt 1972, 81-82.

Comparison of this drawing and *Moun-
tain Landscape* (cat. 25) underscores the
swift development of Bruegel's style dur-
ing his first two years in Italy. The fine,
detailed penwork of *Mountain Land-
scape*, close to the handling of drawings
dated 1552 (cat. 25, fig. 1), yields here to a
broad, summary technique governed by
forceful, parallel strokes. Even more

striking are differences in the representa-
tion of space. The salient topographical
features in *Mountain Landscape* run par-
allel to each other and to the picture
plane, an approach to composition famil-
iar from the works of Matthijs Cock (cat.
34) and Cornelis Massys (cat. 84). Space is
created by the gradual ascent of these ele-
ments up the sheet, and by a concomi-
tant softening of tone and detail, but the
sense of height impresses more than that
of depth. In *Landscape with Saint Jerome*
Bruegel established the foreground with
the magnificent tree that rises to the top
of the composition, and he organized the
space with emphatic diagonals—the
walls and road at the right, the meander-
ing river, and the suite of hills—that lead
the eye steadily into the distance. The
deep, dynamically constructed landscape
with a high foreground and low horizon
differs fundamentally from the spaces de-
picted in Bruegel's earlier works.[1]

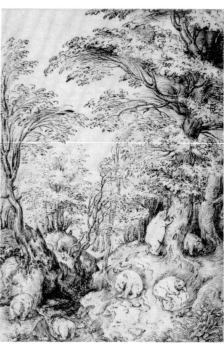

Fig. 1. Pieter Bruegel the Elder, *Forest Landscape with Bears*, Národní Galerie, Prague

Fig. 2. After (?) Pieter Bruegel the Elder, *Landscape with Bears*, The British Museum, London (Courtesy of the Trustees of the British Museum)

The innovations in Bruegel's style resulted primarily from his study of landscapes by Titian and Domenico Campagnola. His admiration for the latter is most eloquently documented by a composition of 1554, which is based on a lost Campagnola drawing,[2] but Venetian influence informed Bruegel's landscapes as early as 1552: The most conspicuous Venetian feature in *Landscape with Saint Jerome*, the sinuous tree that spreads its noble crown over the foreground, already figured in a drawing of that year (cat. 14, fig. 1).[3] However, the principal lesson Bruegel learned from the Venetians, the new approach to spatial representation described above, is first applied in *Landscape with Saint Jerome* and other works of 1553 (cat. 25, fig. 2). These scenes look forward to the vast, complex vistas of the large landscape prints Bruegel designed about 1555 for the Antwerp publisher Hieronymus Cock (cat. 26, fig. 2).[4]

In 1554 Bruegel elaborated the compositional principles and penwork of the Washington sheet in one of his most influential designs, *Forest Landscape with Bears* (fig. 1).[5] Like *Landscape with Saint Jerome*, the work is dominated by a huge tree with a serpentine trunk and spectacular crown described with long parallel strokes enlivened by short hooks to denote foliage. This drawing—or rather the engraving after it, with different staffage, by Hieronymus Cock—and the woodland views mentioned below were the primary

sources for a new type of landscape, the forest interior, which attained enormous popularity in Netherlandish art, especially around 1600 (cats. 19, 116, 118, 119).[6]

Closely related in style and technique to *Forest Landscape with Bears* is a group of woodland scenes of vertical format (fig. 2).[7] All, or nearly all, of these are copies,[8] but one is inscribed by the copyist, *Bruegel inuen. 1554 Roma*, and others bear similar notations that attribute the invention to Bruegel and give the date of the original as 1554. Most scholars accept the reliability of the inscriptions and agree that these sheets record lost drawings by Bruegel made in Rome in 1554.[9]

Landscape with Saint Jerome and other Alpine or Italian views (cats. 25, 26, and Münz 1961, nos. 2-5, 14, 15, 19, 25) are probably presentation drawings. A few of these sheets, including the present example, bear authentic signatures and/or dates that reinforce the likelihood that Bruegel made them to sell or give away.[10] The more casually executed scenes, such as cat. 24, evidently remained in his possession: he adapted motives from some of them (for example, Münz 1961, cats. 6, 7, 11, 12, 16, 17), and undoubtedly from others now lost, for the suite of large landscape prints of c. 1555 mentioned above.

The recently proposed attribution of this sheet to the mediocre Bruegel follower Peeter Baltens can be summarily dismissed.[11] WWR

1. For this discussion of the development of Bruegel's landscape drawings I am indebted to Oberhuber 1981.
2. Arndt 1972, 114-116, figs. 22, 23. Bruegel's drawing is known only through a copy in Berlin, Arndt's fig. 22; Berlin 1975, no. 40.
3. Berlin 1975, no. 27. Large foreground trees occur also in landscapes by earlier Netherlanders, such as Bernard van Orley (cat. 90) and Cornelis Massys (cat. 84), but Bruegel's models were clearly Venetian. Müller-Hofstede 1979, 100-101, assigns greater importance to the influence of Netherlandish precedents on this group of Bruegel's drawings.
4. Oberhuber 1981, 151. For the date of the print series, Hollstein 3-15, see Arndt 1972, 81-82.
5. Národní Galerie, Prague, inv. no. K4493. See Arndt 1972, no. 3, and Brussels 1981, no. 11, with previous literature.
6. Cock's print after Bruegel's drawing is Hollstein 2. Bruegel's influence on the development of the forest interior in the works of Jan Brueghel, Paul Bril, and Gillis van Coninxloo has been studied by Arndt 1972 and Gerszi 1976.
7. British Museum, London, inv. no. 1872. 10. 12.3344, Arndt 1972, no. K1. See Arndt 1972, for the most complete discussion of the group, and Mielke 1986, 81-84 for a recent summary of the problem.
8. Arndt 1972, nos. K1-K5, describes all of them as copies. Müller-Hofstede 1979, 102, accepts as an original by Bruegel the London drawing (fig. 2), Arndt 1972, no. K1, which was also accepted, with reservations, in Berlin 1975, no. 41.
9. See Mielke 1986, 81-84.
10. On presentation drawings see the essay, The Functions of Drawings. Müller-Hofstede 1979, 110-111, also suggests that some of these finished drawings were intended as print modelli, but were never engraved. Although this seems less likely than the possibility that they are presentation drawings, we have no documentary evidence about the function of this group of Bruegel's works.
11. Jung 1985, 52

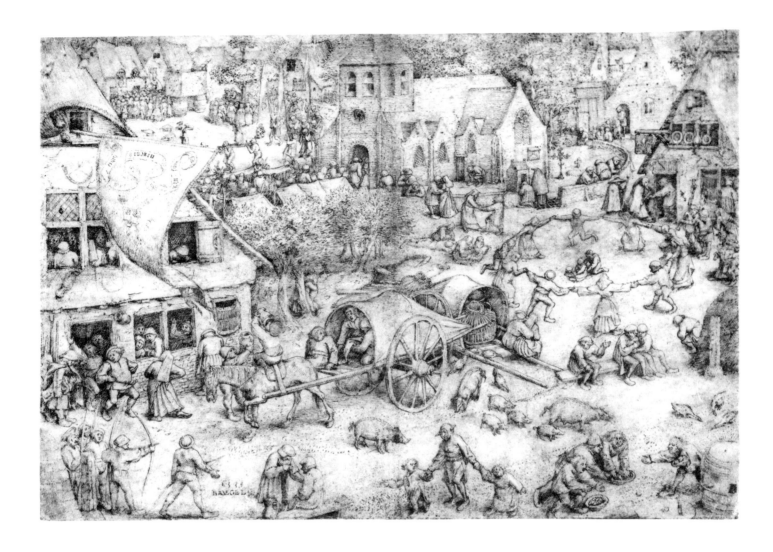

PIETER BRUEGEL THE ELDER

28 *Kermis at Hoboken*

Pen and brown ink on light tan paper, traces of black chalk; indented for transfer
265 x 394 (10⁷/₁₆ x 15½)

Inscribed at lower left, *1559/BRVEGEL*; on banner at upper left, *Glide/. . ./hoboken/. . ./ kan(?). . .*

Watermark: Crossed arrows

Provenance: Sir Kenneth Mackenzie of Gairloch; (sale, Sotheby's, London, 15-16 February 1921, no. 216); Henry Oppenheimer, London; (sale, Christie's, London, 10-14 July 1936, no. 223); (Matthiesen); (Slatter Gallery, London) Lord Lee of Fareham, 1944; acquired by the present owner in 1947

Literature: Vasari Society 1921, 9, no. 12; Tolnai 1925, 73; De Tolnay 1935, 91, no. 36; Glück 1937, 88, under no. 66; Lebeer 1949, 99-103; De Tolnay 1952, 90, no. A20; Münz 1961, 228, no. 141; Lebeer 1969, 90, 92, no. 30; Marlier 1969, 213-215; Monballieu 1974, 139-153; Gibson 1977a, 159; Riggs 1979, 167, 172

Exhibitions: London 1927, no. 526; London 1943-1933, no. 45; Manchester 1965, no. 280; Berlin 1975, no. 68; Brussels 1980, no. 36; London 1983, no. 19; New York 1986, no. 7

Courtauld Institute Galleries, London (Lord Lee of Fareham Collection), inv. no. Lee Inv. 45

This drawing was the model for an engraving by Frans Hogenberg, whose monogram appears on top of the tub at the lower left of the engraving (fig. 1). The print was published without a date by Bartholomeus de Momper. It is one of only two prints made before 1563 not published by Hieronymus Cock.[1] A comparison of the drawing with the print reveals that the drawing has been trimmed on all four sides, but suffered the greatest loss at the top. Monballieu noticed two small differences between the print and the drawing: the cross carried by the procession entering the church is not present in the drawing, while the man kneeling at the head of the procession of crossbowmen, behind the church at the upper left, was omitted from the engraving.[2] Most authorities accept the Courtauld drawing as an autograph work by Pieter Bruegel, but De Tolnay considered it a copy of the period[3] and Lebeer attributed the drawing to Frans Hogenberg, possibly working after a lost Bruegel original.[4]

The kermis, an outdoor village festival usually held on the feast days of local saints, was a popular subject with artists in Germany and the Netherlands throughout the sixteenth and into the seventeenth century. Here, the inscription on the banner over the inn identifies the town as Hoboken, situated south of Antwerp (in the engraving it reads: *Dit is de Gulde van hoboken*).[5] There were two yearly kermises held in Hoboken, but the drawing may represent a third festival, that of the archers' guild, traditionally held on the second day of Pentecost.[6] Prominently displayed on the banner is the Burgundian flint and crossed arrows and beneath it a group of archers shoot at a target. This is Bruegel's earliest representation of a kermis and interestingly, in the year that this drawing was made, Hoboken was sold by William the Silent to Melchior Schetz, member of an Antwerp banking family.[7]

The image of the *Kermis at Hoboken* is subject to multiple interpretations. For the peasant the kermis was both a reli-

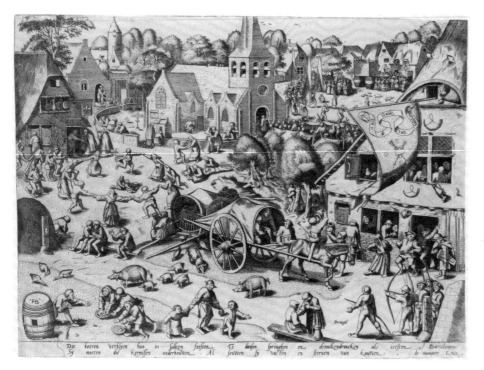

Fig. 1. Frans Hogenberg after Pieter Bruegel the Elder, *The Kermis at Hoboken*, National Gallery of Art, Washington, Rosenwald Collection

gious festival and a chance to escape the harshness of daily labor through sport, dancing, amorous dalliance, and the consumption of great quantities of food and drink. Concerned about the drunkenness and violence that accompanied kermises, the authorities attempted to impose limits on them. The print has been seen as a protest against these measures and as a request to Melchior Schetz, the new lord of Hoboken, to continue to allow the peasants their celebrations.[8] In a slightly later print, the *Saint George's Day Kermis*, published by Hieronymus Cock after Bruegel's design, the words *Laet de boeren haer kermis houuen* (Let the peasants hold their kermis) appear on a banner.[9]

The *Kermis at Hoboken* may also be interpreted as a moralizing exemplum. A starting point lies in the inscription at the bottom of the engraving, which may be translated, "The peasants delight in such feasts,/To dance, caper and get bestially drunk./They would go without food or die of cold/As long as they could have their kermises."[10] The peasant is equated with an animal and, like the pigs who wander the street, those who drink too much are guilty of the sin of gluttony and this, as Renger notes, leads to laziness and stupidity.[11] In the foreground a fool walks with two children, perhaps indicating that foolishness and childishness go hand in hand.[12] A similar inscription appears at the bottom of a print depicting a village kermis by Peter van der Borch,

which is dated to the same year as the Courtauld drawing.[13]

Bruegel recorded the various activities of the kermis from the elevated vantage point comparable to that used for "encyclopedic" paintings, such as the *Battle of Carnival and Lent*, 1559, and the *Children's Games*, 1560 (both Kunsthistorisches Museum, Vienna).[14] Also similar is the way in which the seemingly random placement of figures is actually a carefully composed group of linking configurations, which directs the viewer's glance diagonally across the surface. The composition may also convey a moral message. The wagon with its boisterous occupants is parallel to and juxtaposed to the solemn procession entering the church; in the same manner the circle of men and women dancing is contrasted to the circular wall that surrounds the church. The *Kermis at Hoboken* is thus divided into two zones, one religious and dignified, the other robustly profane. JOH

1. Bastelaer 1908, no. 208. Lebeer 1969, 90, no. 30, lists two other states published by Ioannes (Jan) Galle and Susanna Verbruggen. The other print not published by Cock is the *Doyen de Renaix* (Lebeer 1969, no. 83), which is inscribed *Bruegel Inven 1557*, but whose actual relationship to Bruegel is tenuous. Riggs 1979, 167, points out that these prints have equivalents published by Cock, *The Witch of Malleghem* (Lebeer 1969, no. 28) and the *Saint George's Day Kermis* (Lebeer 1969, no. 52).
2. Monballieu 1974, 145.
3. De Tolnay 1935, 91, no. 36, thought the print was executed after a painting belonging to a cycle of the Amusements of the World; this idea is not repeated in De Tolnay 1952, 90, no. A20.
4. Lebeer 1969, 102-103; Lebeer 1969, 90, 92, no. 30.
5. Monballieu 1974, 148-152, notes that the church and its environs correspond to written descriptions and maps of Hoboken; further, he suggests that the type of cross carried into the church is devotional and refers to the local devotion to the cross, and that the squatting peasants found by the church wall and near the archers' target refer to a scatalogical name for the inhabitants of Hoboken.
6. Monballieu 1974, 144; kermises were held on the Sunday after the feast of the Finding of the Cross (3 May) and the Sunday after the feast of the Birth of the Virgin (8 September).
7. Monballieu 1974, 141.
8. Jans 1969, 105-111, cites as background to the print the regulations put forward in 1550 by the synod of Cambrai, which included Hoboken. These included restrictions on processions, the sale of alcohol on Sundays and feast days during Mass and sermons, and the duration of feasts for church consecrations (a kermis is literally a *kerk-mis* or church-mass), which were intended to correct abuses and scandals. The problem was undoubtedly one of long standing, for an edict of Charles V published in 1531 limited feasts and kermises to one day. The effectiveness of these measures is difficult to judge. Monballieu 1974, 142, notes, however, that in 1562 the excise taxes on beer and wine in Hoboken were reduced to about half of those in Antwerp, bringing an influx of citizens to Hoboken from the neighboring city.
9. Lebeer 1969, 129, no. 52, dates it c. 1561. Riggs 1979, 172, proposes c. 1560 and suggests that the *Kermis at Hoboken* was intended for Cock but was rejected in favor of the *Saint George's Day Kermis*, and that the former was possibly acquired and published by De Momper after 1560.
10. As translated in Miedema 1977, 209. The inscription reads: *Die boeren verblijen hun in sulken feesten/Te dansen springhen en dronckendrincken als beesten/Sij moeten die kermissen onderhouwen/Al souwen sij vasten en steruen van kauwen.*
11. Berlin 1975, 65.
12. For the association of childhood and folly, see Stridbeck 1956, 184-192, and Hindman 1981.
13. Hollstein 467. The inscription as given in Monballieu 1974, 146, is: *De dronckarts verblijen hem in sulken feeste[e]/Kijven en vichten en dronken drincken als beeste[n]/Te kermissen te ghaenne tsij mans oft vrouwen/Daer om[m]e laet de boeren haer kermissen houwen.* Note that the last line corresponds to the inscription on the banner in the *Saint George's Day Kermis*. While there was an increased interest in peasant customs and celebrations in the sixteenth century, contemporary attitudes toward peasants are often ambiguous and there is disagreement over whether representations should be read as moralizing or descriptive; see Alpers 1972-1973, Miedema 1977, and Alpers 1978-1979.
14. Gibson 1977a, figs. 44, 54.

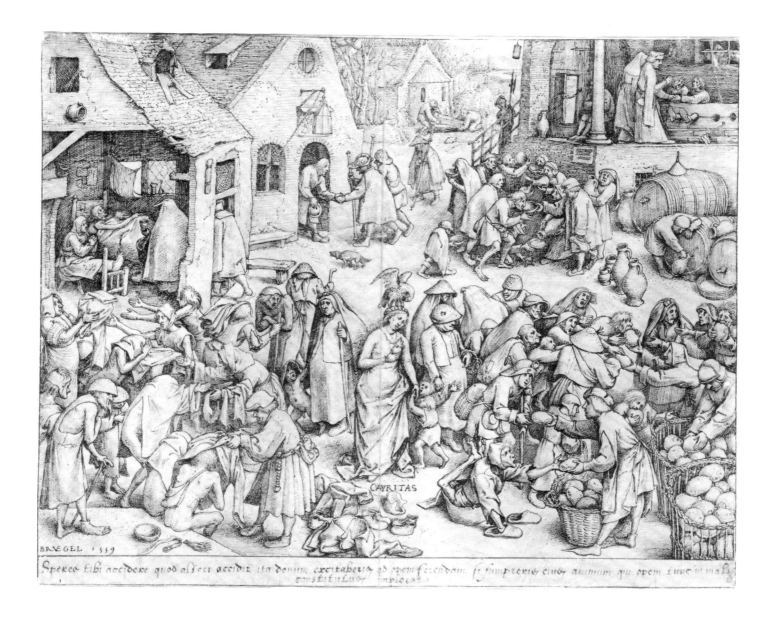

PIETER BRUEGEL THE ELDER

29 *Caritas*

Pen and brown ink, 223 x 294 (8¾ x 11⁹/₁₆)

Inscribed at center, *CAYRITAS*; at lower left, *BRVEGEL 1559*. Written along bottom edge by another hand in light brown ink, *Speres tibi accidere quod alteri accidit ita denum excitaberis ad opem ferendam si sumpseris eius animum qui opem tunc in malis constitutus implorat.*

Provenance: N. Beets; Franz Koenigs by 1925; D.G. van Beuningen, given to the Stichting Museum Boymans 1941

Literature: Tolnai 1925, 90, no. 40a; Michel 1931, 99; De Tolnay 1935, 21; Van Gelder and Borms 1939, 27-29, no. 11; Vanbeselaere 1944, 43-44; De Tolnay 1952, 72, no. 58; Grossmann 1954, 42; Stridbeck 1956, 148-151; Münz 1961, 228, no. 143; Klein 1963, 227-228; Lebeer 1969, 97, 100, no. 33; Gibson 1977a, 62

Exhibitions: London 1927, no. 528; Amsterdam 1929, no. 179; Rotterdam 1934, no. 6; Brussels 1935, no. 459; Rotterdam 1938, no. 243; Rotterdam 1948-1949, no. 12; Paris

1949, no. 50; Brussels 1949, no. 47; Dijon 1950, no. 46; Paris 1952, no. 22; London 1953, no. 539; Rotterdam 1957, no. 8; Brussels 1980, no. 30

Museum Boymans-van Beuningen, Rotterdam, inv. no. N18

This is Bruegel's preparatory design for *Caritas*, from the series depicting the Virtues, most probably engraved by Philip Galle and published by Hieronymus Cock in 1559-1560. In terms of quality and state of preservation it is one of the finest in the series. *Caritas* (fig. 1) is the only dated engraving in the series.[1] The Virtues were preceded by the series of the Seven Deadly Sins, or Vices, engraved by Pieter van der Heyden and published by Cock in 1558.[2]

The individual works in the series of

Virtues and Vices, which occupied Bruegel over a period of four years,[3] are companion pieces and their formats are essentially the same: a female allegorical personification at the center of the composition is surrounded by illustrations of the effects of the individual virtue or sin. The grotesque creatures that inhabit the bizarre landscapes of the Vices are, with the exception of *Fortitudo*, replaced in the Virtues by ordinary people in realistic settings.

The theme of the struggle of virtue to overcome vice goes back to early Christian writings and during the Middle Ages the number of Vices and Virtues was set at seven.[4] The Seven Deadly Sins are: Pride, Envy, Gluttony, Lust, Avarice, Wrath, and Sloth. The seven Virtues are divided into two groups, the three

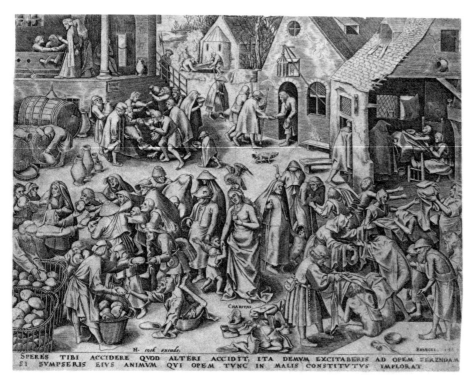

Fig. 1. Probably Philip Galle after Pieter Bruegel the Elder, *Caritas*, National Gallery of Art, Washington, Rosenwald Collection

"Theological" virtues, Faith, Hope, and Charity, and the four "Cardinal" virtues, Justice, Prudence, Fortitude, and Temperance.[5]

In the Rotterdam drawing the central allegorical figures of *Caritas* is a woman with a garland and loose, flowing hair[6] who holds a flaming heart in one hand. Upon her head is a pelican feeding its young with her own blood. The burning heart symbolizes the love of God and the pelican is an emblem of piety and charity. As attributes of Charity these elements are found in the "new" iconography of the Virtues that appeared in French manuscripts of the mid-fifteenth century.[7] The two children next to Charity are also traditional attributes of this virtue and refer to Jesus' words in Luke 9: 48, "Whoever receives this child in my name receives me." Within the series of virtues the figure of Charity is unusual in that she is the only personification standing on the ground and not on a symbolic object.[8]

Surrounding the allegorical figure is a demonstration of the practical effects of Charity, the seven works of mercy. On the right side of the drawing are: feeding the hungry; giving drink to the thirsty; and visiting prisoners. On the left are: clothing the naked; visiting the sick; and giving hospitality to the homeless. These six acts of mercy are described in Matthew 25: 35-40, while the seventh, bury-

ing the dead, is depicted in the background. As noted by Münz, Bruegel would have had a ready model in the representation of the seven works of mercy on the interior wings of Bernard van Orley's *Last Judgment* altarpiece (Koninklijk Museum, Antwerp) which was completed by 1525.[9]

The Virtues and Vices have been interpreted in two fundamentally different ways by De Tolnay and Stridbeck. Both interpretations are based on the realization that Bruegel was part of a circle of humanists and his art reflects an awareness of contemporary religious and philosophic issues. In De Tolnay's view, which is the minority one, both series demonstrate Bruegel's essentially pessimistic and ironic view of man. With specific reference to *Caritas*, the absence of a flaming stove symbolizing the fire of charity, found in earlier manuscripts, was taken as an indication of Bruegel's satiric view of the world upside down. In consequence, all actions are hypocritical and for De Tolnay, the bread given to the hungry is "hard as stones."[10]

On the other hand, Grossmann and Stridbeck stress Bruegel's probable association with the religious belief known as "Libertinism" or "Spiritualism" and the parallels with the writings of its chief spokesman, the engraver and philosopher, Dirck Volckertsz. Coornhert. For Stridbeck, Coornhert's belief that the

passive, theoretical aspect of virtue is incomplete without practical action is mirrored in Bruegel's Virtues.[11] As seen here, charity means service to others, but is motivated by sharing the misfortune of one's fellow man. This is the sentiment found in the Latin inscription at the bottom of the sheet.[12]

At the lower left are a bowl (probably a beggar's bowl), belt, and scourge of twigs (this last object was omitted from the engraving).[13] Stridbeck interpreted them respectively as symbols of poverty and privation, abstinence, and discipline and sorrow, and noted, with reference to the Latin inscription, that Coornhert's definition of "true Charity" involved participating in the pain and privation of others.[14] JOH

1. Bastelaer 1908, no. 134; Lebeer 1969, 97, 100, no. 33.
2. For both sets of engravings see Bastelaer 1908, nos. 125-131 (vices), 132-138 (virtues) and Lebeer 1969, nos. 18-24 (vices), 31-37 (virtues).
3. For the drawings see De Tolnay 1952, nos. 47-53 (vices), 57-63 (virtues) and Münz 1961, nos. 130-136 (vices), 142-148 (virtues). The drawings date between 1556 and 1560; one drawing was made in 1556, six in 1557, five in 1559, and two in 1560.
4. Réau, *Iconographie*, 1 (1955): 175-191; Van Gelder and Borms 1939, 8-9.
5. Stridbeck 1956, 129-130, points out that during the Renaissance the Virtues were not a homogeneous concept, but had a problematic and changeable character.
6. Van Gelder and Borms 1939, 27, and Vanbeselaere 1944, 43, note that the hairstyle gives her the appearance of a bride.
7. Mâle 1925, 311-317, discusses two manuscripts, an *Aristotle* from the second half of the fifteenth century (Bibliothèque, Rouen, Ms. 927), and a history written by Jacques d'Armagnac, duke of Nemours (Bibliothèque Nationale, Paris, Ms. fr. 9186), illuminated around 1470. Tolnai 1925, 63-64, was the first to associate these manuscripts with Bruegel's series of the Virtues.
8. Stridbeck 1956, 149.
9. Münz 1961, 228, no. 143, fig. 26. The altarpiece was commissioned around 1518 by the almoners of Antwerp for their chapel in the Cathedral of Our Lady.
10. De Tolnay 1952, 72, no. 58.
11. Stirdbeck 1956, 130-131; Van Gelder and Borms 1939, 11, also observed that spiritual values were cloaked, as it were, in corporeal acts.
12. Grossmann 1960, col. 647, was inclined to ascribe the wording of the inscription to Coornhert. On the other hand, Nina Serebrennikov, who is preparing a doctoral dissertation on Pieter Bruegel's series of the Virtues and Vices, tends to downplay the importance of Coornhert for Bruegel and observes that several of the inscriptions are actually commonplaces. I am grateful to Ms. Serebrennikov for discussing her work with me and for the following translation of the Latin inscription, "You hope that what happens to others happens to you, so you will at least be driven to bring [him] help, If you should take heed of him who asks for help when then fixed in ills."
13. Noted by Klein 1963, 228.
14. Stridbeck 1956, 150-151; earlier, 148, Coornhert is quoted on true charity, "God's love for man is entirely free of egotistical intention and so must also be the love of man for God and for his neighbors."

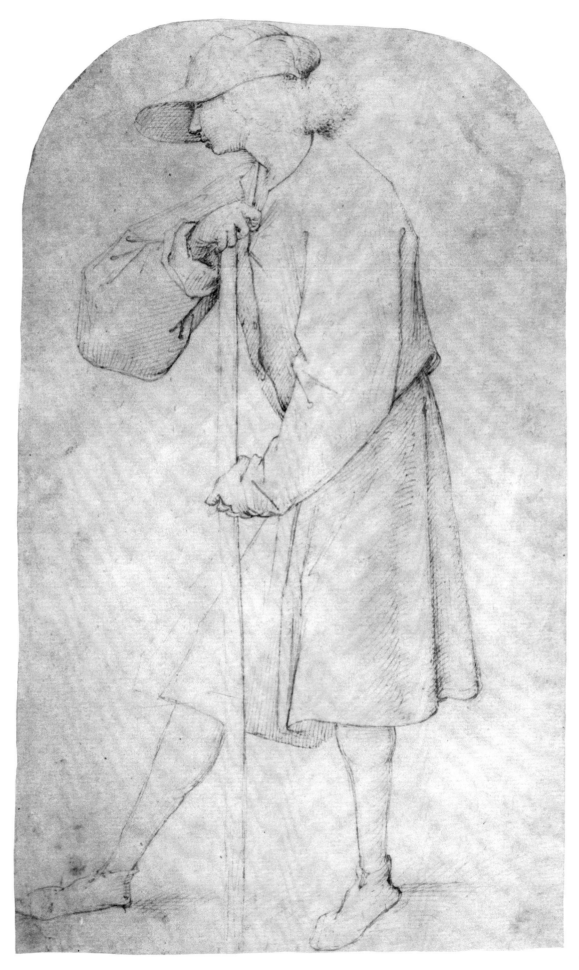

30

PIETER BRUEGEL THE ELDER

30 *Standing Shepherd*

Pen and brown ink, traces of black chalk; upper corners rounded
246 x 148 (9⅝ x 5⅞)

Provenance: Acquired before 1756

Literature: Woermann 1896-1898, Mappe 4, no. 127; Bastelaer and Hulin de Loo 1905-1907, no. 84; Tolnai 1925, 88, no. 81; Benesch 1928, 13, under no. 85; Michel 1931, 106-107; Delen 1944, 71-72; De Tolnay 1952, 85, no. 116; Grossmann 1954, 43-44; Münz 1961, 219, no. 90; Marlier 1969, 159-160, under no. 20; Berlin 1975, 79, under no. 92

Exhibitions: Vienna 1978, no. 62

Staatliche Kunstsammlungen Dresden, Kupferstich-Kabinett, inv. no. C 2128

Pieter Bruegel is universally acknowledged to be one of the greatest and most astute observers of human gesture, movement, and physical type, yet figure drawings by him are extremely rare. The *Standing Shepherd* is one of only three figure drawings that are generally accepted as autograph. The other two are the *Four Men in Conversation* (fig. 1)

Fig. 1. Pieter Bruegel the Elder, *Four Men in Conversation*, Musée du Louvre, Cabinet des Dessins, Paris (Cliché des Musées Nationaux)

(Louvre, Paris)[1] and the *Painter and Connoisseur* (Albertina, Vienna).[2] All three drawings are usually dated around 1565.[3] While the Dresden sheet stands apart by virtue of its extraordinary grace and lyricism, it is technically and stylistically related to the others in the group in its use of a dry but wiry contour line; long, rapidly executed hatching; and occasionally,

in drapery folds, a single stroke ending in a hook. It is closest to the *Four Men in Conversation*; the shepherd's delicate, fluffy hair is similar to the beard of the left-hand figure of the Paris drawing. Pentimenti are visible in the lower edge of the garment and the underside of the hand next to it.

The *Standing Shepherd* is perhaps the only surviving single-figure drawing by Bruegel. A fourth drawing of excellent quality, *The Bagpipe Player* (Woodner Family Collection, New York),[4] must also be taken into account, but is harder to judge because of losses and restoration, and it does not have the same open effect as the drawings in this group. It is also dated c. 1565, but has been related by Goldner to Bruegel's drawings for engravings of *Spring* (1565) and *Summer* (1568).[5]

The pose of the Dresden shepherd is marked by harmonious completeness and balance. As Mielke observes, this artfully constructed figure is a finished study and not a sketch made from nature.[6] Both *The Bagpipe Player* and the *Four Men in Conversation* are also considered finished drawings, but like the Dresden sheet, might have proceeded out of a snapshot-like sketch.[7] Generally regarded as studies for compositions, the exact function and place of these late figure drawings is not fully understood. It is, however, evident that they were admired and copied; several replicas of the *Painter and Connoisseur* are known,[8] a copy of *The Bagpipe Player* is in the Metropolitan Museum of Art,[9] and an exact copy of the *Standing Shepherd* is in the Albertina.[10]

Both of Bruegel's sons used the *Standing Shepherd* in their work. The figure appears as a goose herder in one of a series of six roundels by Pieter Bruegel the Younger depicting proverbs (Koninklijk Museum, Antwerp).[11] The proverb in question, "Who knows why the geese go barefoot?" (there is a reason for everything) was included in Pieter the Elder's *Netherlandish Proverbs* of 1559 (Staatliche Museen, Gemäldegalerie, Berlin) and given Pieter the Younger's penchant for replicating his father's work, the possibility that the Dresden drawing is related to a now lost illustration of the proverb should be considered.[12] Jan Brueghel the Elder included the enchanting shepherd in two paintings of the *Adoration of the Magi* in the National Gallery, London, and the Kunsthistorisches Museum, Vienna.[13] JOH

1. Lugt 1968, 73, no. 273.
2. Washington 1984-1985, 208, no. 25.
3. The Dresden drawing was dated as early as c. 1559/1560 by De Tolnay 1952, 85, no. 116, and c. 1565/1568 by Michel 1931, 106-107, while Münz 1961, 219, no. 90, put it around 1560/1563.
4. First published by De Tolnay 1969, 62-63.
5. Malibu 1983-1984, 118, no. 46.
6. Berlin 1975, 79, no. 92, which is the replica of the *Standing Shepherd* in the Albertina. Mielke considered the Dresden drawing original.
7. Berlin 1975, 80, no. 94; with the assignment of the *Naer het leven* drawings to Roelandt Savery, Mielke regarded the Paris drawing as closest to the immediacy of the *Naer het leven* type.
8. Münz 1961, 224, no. 126, 237, nos. A45-A48.
9. Haverkamp-Begemann 1974, 34, fig. 1.
10. Benesch 1928, 13, no. 85, where it is called workshop; Berlin 1975, 79, no. 92.
11. Marlier 1969, 159-160, fig. 80; two other versions are listed as well.
12. Discussed by Mielke in Berlin 1975, 79, no. 92, who notes that no original by Pieter the Elder exists and that this proverb is absent from the *Twelve Proverbs* (Museum Mayer van den Bergh, Antwerp), generally accepted as by Pieter Bruegel the Elder.
13. Ertz 1979, figs. 506-507.

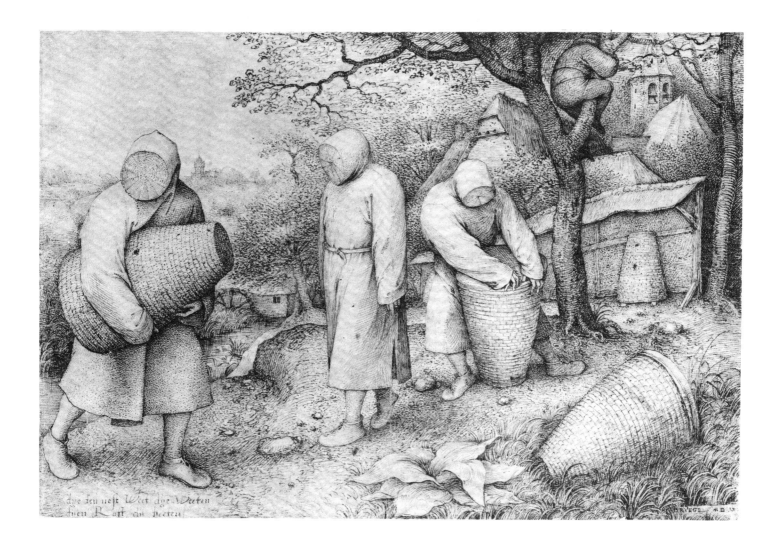

PIETER BRUEGEL THE ELDER

31 *The Beekeepers*

Pen and brown ink; trimmed along the right
margin
203 x 309 (8 x 12⅛)
Signed and dated in the bottom right corner,
BRUEGEL MDLXV . . .; inscribed in bottom
left corner, *dije den nest Weet dije(n?) Weeten
dijen Roft dij heeten* (He who knows where
the nest is, has the knowledge, he who robs it
has the nest)

Provenance: Von Nagler collection (Lugt
2529); acquired by the Kupferstichkabinett
in 1835

Literature: Van Bastelaer and Hulin De Loo
1907, 1: 199, no. 100; Eickhoff, 1918-1919, 30;
Friedländer 1921, 72; Bock and Rosenberg
1930, 18; Glück 1936, 85; Vanbeselaere 1944,
85; Romdahl 1947, 81; Böstrom 1949, 77-80,
85-89; De Tolnay 1952, 76, 77, no. 69; Grauls
1957, 161, 168, 169, 171-173; Münz 1961, 230,
no. 154; Liess 1981, 46, 99

Exhibitions: Berlin 1975, no. 100, fig. 131

Staatliche Museen Preussischer Kulturbesitz,
Kupferstichkabinett, Berlin, inv. no. KdZ 713

Although the date in the lower right cor-
ner is only partially visible, the drawing
style, characterized by finely hatched
lines that are either parallel or cross each
other, and the use of small dotlike
strokes of the pen are similar to the tech-
nique found in Bruegel's signed and dated
1568 *Summer* (Kunsthalle, Hamburg;
fig. 1). Similarities are also found in the
large figures placed close to the fore-
ground plane and, in each case, the bor-
rowing of one figure from Michelangelo.[1]
The stylistic connection between the
Berlin and Hamburg sheets is also evi-
dent in the rendering of the heads. In the
Berlin drawing, there is little or no indi-
cation of a transition between the heads
and the upper torsos. This also occurs in
the figures along the left side of the Ham-
burg drawing where the hat and tray also
become one with the torso and absorb the
heads within their shapes. This lack of
differentiation of the physical parts
causes the heads to become part of an in-

animate object, in the mind of the view-
er. In all of these scenes, the heads are
not clearly depicted, and, in this way,
there is a real sense of ambiguity typical
of the mannerists.[2]

The care with which Bruegel has drawn
in the details for *The Beekeepers* is typi-
cal of his designs for prints, though this
composition was never engraved. Of even
greater interest is the fact that the in-
scription was done in the same ink as the
drawing and is by Bruegel.[3] This is
unique because all of Bruegel's other de-
signs for prints contain inscriptions that
were written in later by others. Not only
is the autograph inscription unusual, but
the subject portrayed is unique in the six-
teenth century.[4]

Bruegel presents the viewer with three
beekeepers at work, dressed in heavy,
protective clothes and woven masks. A
young man, dressed in normal attire, sits
in a tree in the upper right. His presence
has been linked to the Netherlandish

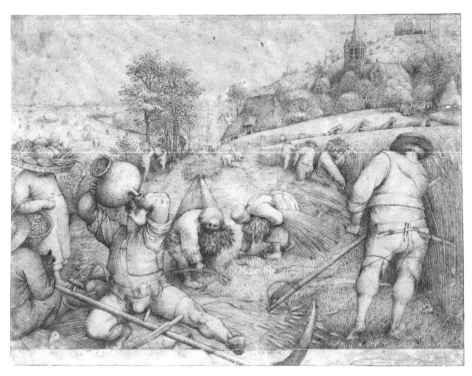

Fig. 1. Pieter Bruegel the Elder, *Summer*, Hamburger Kunsthalle, Kupferstichkabinett, Hamburg
(Copyright Ralph Kleinhempel)

proverb in the bottom left of the drawing: "He who knows where the nest is, has the knowledge, he who robs it has the nest." This axiom was first published, in a collection, by F. Goedthals in 1568, at the same time that Bruegel executed his drawing.[5]

The most convincing interpretation of the Berlin sheet has been made by Böstrom who, following Van Bastelaer and Hulin De Loo,[6] connected the design with the subject of Bruegel's 1568 *Peasant and the Bird Nestor* (Kunsthistorisches Museum, Vienna).[7] Böstrom, however, refers to a 1606 engraving by David Vinckboons which, as in the Vienna picture, depicts the theft of a bird's nest by a young man who is watched by two idlers below.[8] This print contains a text similar to the one on Bruegel's *Beekeepers*. Böstrom draws upon the meaning of the Vienna *Peasant and the Bird Nestor* and the engraving by Vinckboons for his interpretation of *The Beekeepers*. Böstrom believes that the men in the Bruegel design were engaged in seizing the beehives, which the boy in the tree had previously carried away. Further, Böstrom interprets the sheet as containing two completely opposite actions: caution and boldness, distinguished by the difference in clothing. Böstrom points out another symbol in the center foreground where Bruegel has placed a man-

drake plant. According to superstition, this flower grew beneath the gallows and signified a young man on the cross beam.[9] The mandrake is an allusion to the end that awaits the thief in the tree. It is still not clear why Bruegel inscribed the drawing with a text focused upon the nest and the theft of birds in a design representing *The Beekeepers*. Böstrom's idea that the thief in the tree has pilfered a beehive or is about to do so does not explain the obvious contradiction.[10] Perhaps the key to the problem, following Renger, is in the different types of clothes, which could explain the conflict between text and image in the Berlin drawing. Renger has found an illustration in J. Meerman's *Apologi Creaturam* (Antwerp, 1584, fol. 60r., engraved by M. Geraerdts) in which a young man without protective clothes steals three beehives. The print is inscribed "Ut bonis fruaris, toleranda mela" (For good to be pleasurable, one must practice patience). A similar message is also expressed in the Netherlandish proverb: "He who removes the honey, must experience the sting of the bees."[11] When the latter is applied to the Berlin *Beekeepers*, it means that the boy in the tree removes the stingers, but he will possess the spoils. On the other hand, the beekeepers below, dressed in their defensive garments, risk nothing but go away emptyhanded. JRJ

1. In the Berlin drawing, the beekeeper on the left assumes a pose similar to Michelangelo's young man at the right in the *Sacrifice of Noah* (Sistine Chapel, Vatican). In the Hamburg sheet, Bruegel's figure on the right is based upon Michelangelo's on the left in his *Conversion of Saint Paul* (Cappella Paolina, Vatican), De Tolnay 1952, 76, 77. Copies of the Berlin drawing are in the British Museum, London (no. 5236-59) and the Achenbach Foundation for Graphic Arts, The Fine Arts Museums of San Francisco (no. 1978.2.31).

2. This is also present in Bruegel's 1565 drawing of *Spring* (Albertina, Vienna), De Tolnay 1952, no. 67, pl. XLIV, but it does not occur in *The Blind* (cat. 99) where there is a clear transition from the body to the neck to the head. This might be a further argument in favor of Mielke's proposal that the drawing is by Jacques Savery.

3. For doubts about Bruegel as the author of the text see Böstrom 1949, 88.

4. Renger in Berlin 1975, 86, and Renger in Berlin 1975, 86, 87, with which this writer concurs.

5. Renger in Berlin 1975, 86, notes that this adage appeared in a variety of forms, but conveyed the same message, that only active people win. Grauls 1957, 161.

6. Van Bastelaer and De Loo 1907, 1: 277.

7. Böstrom 1949, 77.

8. Böstrom 1949, 80-82, 84, fig. 2, and for Vinckboons' drawing in the Bibliothéque Royale, Brussels, Cabinet des Dessins, inv. no. S.V. 65747. For his 1606 engraving see Berlin 1975, no. 283, fig. 305.

9. Böstrom 1949, 87, 88; for more details see Renger in Berlin 1975, 87.

10. Renger in Berlin 1975, 87.

11. Harrebomè 1858-1870, 1: 56.

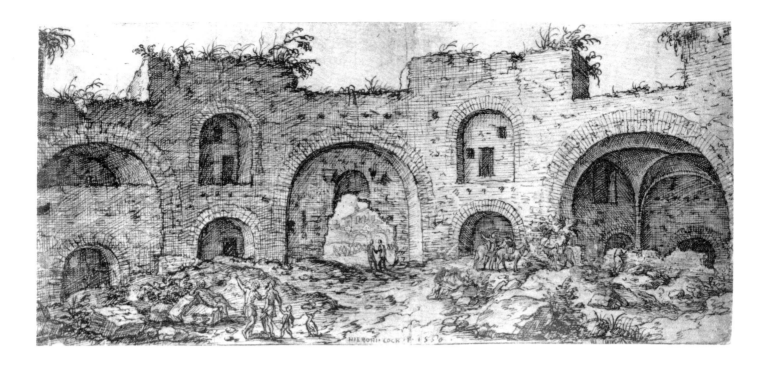

Hieronymous Cock

c. 1510/1520-1570

Hieronymous Cock was born in Antwerp, the son of the painter Jan Wellens de Cock. He presumably received his early training from his father, who died by 1528, or from his elder brother, Matthijs. Though he entered the Antwerp Guild of Saint Luke as a painter, nothing is known about his work in that medium. His importance rests on the print publishing firm Aux Quatre Vents *that he established in Antwerp in 1548, and which from 1550 produced a stream of engravings and etchings after compositions by leading Netherlandish and Italian artists. Whether Cock ever traveled to Italy is unclear, though the fact that Giorgio Ghisi worked for him about 1550 together with the two series of Roman ruins etched by Cock raises this possibility. The few drawings and etchings by Cock, largely landscapes, show a vigorous linear style closely related to that of his brother.*

32 A Ruined Gateway in Rome with Figures in the Foreground

Pen and brown ink on brownish paper
235 x 523 (9¼ x 20⅝)
Inscribed at bottom center,
HIERONI.COCK.F.1550

Provenance: (P. & D. Colnaghi, July 1936); Sir Bruce Ingram (Lugt 1405a)

Literature: Arndt 1966, 211; Lugt 1968, 48, under no. 160; Berlin 1975, 109-110; Riggs 1977, 34-35, 236, no. D-1
The Syndics of the Fitzwilliam Museum, Cambridge, inv. no. PD.242-1963

This drawing is related in technique, subject, and date to three drawings in Edinburgh that are preparations for Cock's series of twenty-four etchings of Roman ruins published in 1551.[1] The Cambridge drawing representing an unidentified ruin was probably also intended as the modello for a print, though it is considerably larger and more emphatically horizontal than the Edinburgh sheets and seems never to have been etched. Like the Edinburgh drawings, its reverse shows signs of having been blackened for transfer.[2] As in the Edinburgh drawings too, the weight of the vigorous, scribbled pen line is varied in a manner that anticipates the variations in the biting of the plate.[3] Thus a more delicate line is used for the view through the central bay of the ruin.

As Timothy Riggs first pointed out, the inclusion of lively figures and rather stereotyped rocky outcroppings indicates that the ruin landscapes were not made directly from nature but were composed on the basis of other records.[4] Whether they are based primarily on material gathered by Cock during a possible trip to Rome is unclear. If Cock did make such a trip, it would presumably have been between 1546, when he joined the Antwerp guild, and 1548, when he began to publish in Antwerp. While one of the etchings is dated 1551 and several are dated 1550, one of the latter also bears the effaced date *154[6?]*.[5] This earlier date is very probably that of the drawing, by Cock himself or by another artist, that served as a basis for the print modello. As Riggs notes, the fact that some sites in the series are incorrectly identified and others left unidentified supports the hypothesis that Hieronymous Cock was working at least in part from material by other artists.[6] Moreover, some of his views are similar to material in the two albums of Roman sketches by Heemskerck and others in Berlin and views in the Codex Escurialensis, though it is not clear that any of these was Cock's model.[7]

Cock's series of etchings of Roman ruins provided a guide to some of the chief monuments of ancient Rome.[8] At the same time, the vigorous linear treatment and lively figures suggest the decay

of these monuments. Regret over the decay of ancient Rome is the theme of Cock's dedicatory lines addressed to Cardinal Granvelle accompanying the 1551 series,[9] and of a recently discovered painting by Hermannus Posthumus, dated 1536, in the Liechtenstein Collection.[10] The grander scale of the Cambridge sheet in relation to the etched series, and the wild strokes delineating the overgrown profile of the ruin make this one of the most evocative and dramatic of Cock's ruin landscapes. MW

1. For the three drawings in Edinburgh, see Riggs 1977, 237-238, D-2, 3, and 4, and Andrews 1985, 19, nos. D 1033-1035, figs. 122-125. Two of the drawings are dated 1550. For the etched series, its title page, and dedication page, see Hollstein 22-46, and Riggs 1977, 256-266, nos. 1-25.
2. Andrews 1985, 19.
3. For Cock's innovative use of variable biting of the plate in the series of Roman ruins, see Riggs 1977, 126-128.
4. Riggs 1977, 30, 41, 263-264.
5. *The Fifth View of the Colosseum*, Riggs 1977, 258, no. 6, fig. 9; the print is also inscribed *H.COCK.FE/ 1550.*
6. Riggs 1977, 264.
7. Riggs 1977, 257-262.
8. Etched copies of Cock's series by Battista Pittoni were used by Veronese for his frescoes at the Villa Maser; see Oberhuber 1968, 207-224.
9. Riggs 1977, 256-257, no. 1a.
10. Dacos 1985, 433-434, fig. 2, and Baumstark in New York 1985, no. 158.

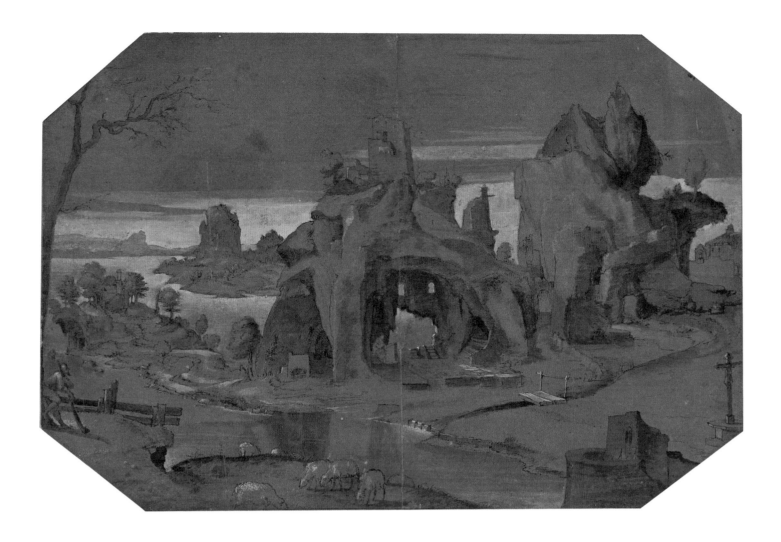

Jan Wellens de Cock

c.1480-before 1527

Very little is known about the life of Jan Wellens de Cock. In 1506 and 1516 he presented pupils to the guild of Saint Luke in Antwerp, and, along with Joos van Cleve, was dean of the guild in 1520. In 1507-1508 he was paid for repairs and additions to a work of art in the Church of Our Lady, Antwerp. His wife, mentioned as a widow, was remarried by 1527. Jan de Cock was the father of Matthijs and Hieronymus Cock. Friedländer identifies him with the "Jan van Leyen" who became a master in Antwerp in 1503, and suggests that "van Leyen" be read as "van Leyden" and that the artist was therefore Dutch.

There are no documented or signed works by Jan Wellens de Cock. The starting point for Friedländer's reconstruction of the artist's oeuvre is the painting Landscape with Saint Christopher *(private collection, Germany). A later engraving reproduces the painting along with the words "Pictum J. Kock" in the inscription. Other authors reject Friedländer's identification and believe, instead, that the artist worked in Leiden and is either Lucas Cornelisz., a son of Cornelis Engebrechtsz., or one of Engebrechtsz.' anonymous workshop assistants.*

ATTRIBUTED TO JAN WELLENS DE COCK

33 *River Landscape with Saint Jerome*

Pen and black ink, gray wash, and white heightening on paper washed with blue body color
275 x 416 ($10^{13}/_{16}$ x $16^{3}/_{8}$); the corners cut

Watermark: Illegible

Provenance: Lagoy (Lugt 1710); E.J. von Dalberg (Lugt Suppl. 1257c-d-e); acquired by the museum in 1812

Literature: Stift and Feder 1930, 27, no. 82-83 (Darmstadt 274-275); Florence 1964, 15-16, no. 7; Ragghianti 1965, 9; Bergsträsser 1979, 54-55, no. 42

Exhibitions: Darmstadt 1964, no. 20; Berlin 1975, no. 138

Hessisches Landesmuseum, Darmstadt, inv. no. AE 436

Saint Jerome, the ostensible subject of this extraordinary drawing, can be found inside the cave seated at his desk. His attribute, the lion, is faintly outlined at the

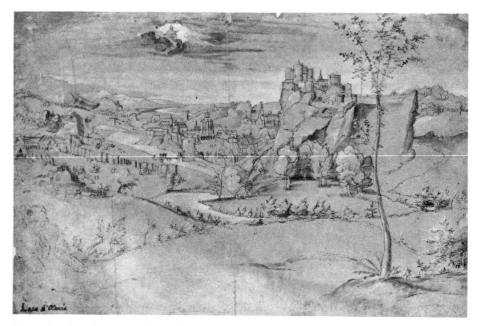

Fig. 1. Attributed to Jan Wellens de Cock, *Landscape with Imaginary City under Siege*, Gabinetto Disegni e Stampe degli Uffizi, Florence (Gabinetto Fotografico, Florence)

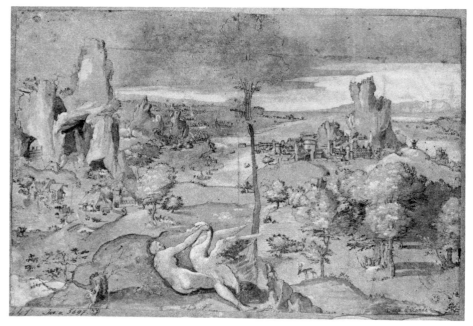

Fig. 2. Attributed to Jan Wellens de Cock, *Landscape with Leda and the Swan*, Gabinetto Disegni e Stampe degli Uffizi, Florence (Gabinetto Fotografico, Florence)

right of the cave's entrance.[1] Jerome's contemplative retreat is set in a bizarre and picturesque landscape. The openings at the back of the cave can be seen as forming a surreal image of two eyes above an irregular, gaping mouth.[2] A pastoral note is added by the sheep in the foreground and the shepherd at the left holding an alpenhorn. The drawing is also marked by an unusually intense blue body color which, in combination with the strong accents of white heightening and gray wash, produces a highly picto-

rial, masterfully worked out composition. While this may be a presentation drawing or a project for a painting, it has also been suggested that it is a finished work of art, an object to be collected.[3]

The Darmstadt sheet is more closely associated with two drawings in the Uffizi that are virtually the same size and executed in the same technique: *Landscape with Imaginary City under Siege*[4] (fig. 1) and *Landscape with Leda and the Swan* (fig. 2).[5] A possible addition to the group is the *Landscape with Saint Chris-*

topher, which was sold in London in 1974 and repeats with minor changes a composition in the Louvre usually attributed to Patinir.[6]

While these drawings have been grouped together under the name of Jan Wellens de Cock, the attribution has no clear basis and can neither be proved nor disproved. The oeuvre of Jan de Cock is highly problematical and a comparison of the Darmstadt sheet with the painting most often given to Cock, the *Landscape with Saint Christopher* (private collection, Germany), yields few similarities.[7] The Uffizi *Landscape with Imaginary City under Siege* has been attributed to a follower of Patinir by Kloek and associated with Lucas Gassel and the Louvre *Landscape with Saint Christopher* by Ragghianti.[8]

If the name of Jan Wellens de Cock is eliminated, then the *River Landscape with Saint Jerome* is best given to an anonymous Antwerp artist working in the style of Patinir. The master is a distinct personality; his manner of rendering deep space stands somewhere between that found in Patinir's middle period paintings[9] and the drawings of Matthijs Cock and Cornelis Massys. In his feeling for the flinty structure and jagged, vigorous power of the fantastic rock forms he is closer to Patinir than Matthijs Cock. The drawing should probably be dated c. 1530/1540. JOH

1. I am indebted to William W. Robinson for pointing out the lion, which apparently had gone unnoticed by previous authors.
2. Berlin 1975, 111-112, no. 138, entry by Lutz Malke.
3. Berlin 1975, no. 138; Bergsträsser 1979, 54.
4. No. 8701S, 269 x 413 mm.
5. No. 5697 Horne, 266 x 410. See Florence 1964, 16, no. 8, fig. 6.
6. Sale, Christie's, London, 26-27 November 1974, no. 151, pl. 51, as Jan Wellens de Cock. At 290 x 434 mm, it is larger than the other sheets. For the Louvre drawing see Lugt 1968, 45-46, no. 151, pl. 72, who considers the Uffizi and Darmstadt drawings slightly later than the Louvre *Landscape with Saint Christopher*.
7. Friedländer, *ENP*, 11 (1974): no. 104, pl. 89. In discussing both the painting and the engraving that reproduces it in reverse, Franz 1969, 115-117, dates the painting after the death of Jan Wellens de Cock and suggests that the inscription "Pictum J. Kock" on the engraving might refer to "Jeronymous," that is, Hieronymous Cock. On the other hand, Gibson 1977, 197-200, gives the painting to the Lamentation Master, a member of Cornelis Engebrechtsz.' workshop and dates it after 1530. The question of which of the many attributions, if any, is by Jan Wellens de Cock and whether these works were produced in Antwerp or in Leiden under Antwerp mannerist influence has not been resolved. For a discussion of the literature see Gibson 1977b, 165, 201-203, and the Editor's Note in Friedländer, *ENP*, 11 (1974): 105.
8. Kloek 1975, no. 170; Ragghianti 1965, 9; the Louvre drawing is dated c. 1530/1540.
9. Compare, for example, Patinir's *Landscape with Saint Jerome* (Louvre, Paris), Friedländer, *ENP*, 9: 2 (1973): no. 245, pl. 238.

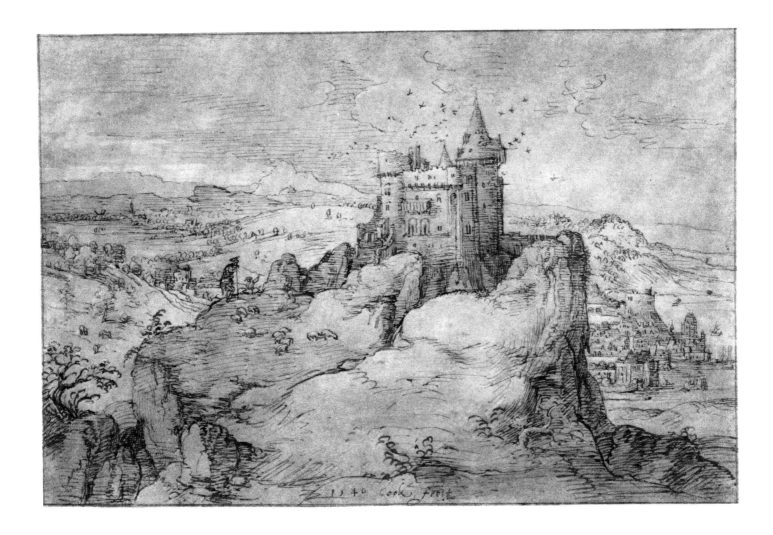

Matthijs Cock

c. 1509-before 1548

Matthijs was the son of Jan Wellens de Cock (q.v.) and the brother of Hieronymus Cock (q.v.). Documents concerning his life are scant. It is reasonable to assume he was first trained by his father. In 1540, Matthijs presented a pupil to the Antwerp guild. Since Hieronymus did not become a master until 1546, it is likely that Matthijs was the elder brother. Matthijs died sometime before 1548. Van Mander, in discussing both brothers, praises Matthijs as an inventive composer and the first to paint landscapes in the "Italian or antique manner."

No signed paintings by Matthijs Cock are known, and there is disagreement over those pictures attributed to him. Greater consensus exists in the area of drawings and approximately fifteen

sheets are given to Matthijs, seven of which are inscribed Cock *(a first name never appears), and which range in date from 1537 to 1544. The complex question of whether some of the drawings might be by Hieronymus or another hand remains open. Matthijs' designs were etched by Hieronymus in the series* Landscapes with Biblical and Mythological Scenes, *published in 1558.*

Matthijs Cock is a key figure for the history of Netherlandish landscape in the first half of the sixteenth century for, in continuing Patinir's vocabulary of panoramic vistas and fantastic rock formations, he is an important link to Pieter Bruegel the Elder. Oberhuber has suggested that Matthijs may have been Bruegel's teacher.

34 *Landscape with Castle above a Harbor*

Pen and brown ink, with gray, pink, and white washes on light brown paper
171 x 260 (6¹¹/₁₆ x 10¼)
Inscribed at bottom center, *1540 Cock fecit*
Inscribed on verso, in graphite, *Cocq*; in black ink, unidentified collector's mark

Watermark: Shield with three fleur-de-lis; similar to Briquet 1788

Provenance: Lord Treowen, Llanover House, Monmouthshire; (sold 26 June 1934); Alfred Jowett, Killinghall; (sale, Christie's, London, 27 November 1973, no. 203); Robert H. Smith, Bethesda, Maryland

Literature: Popham 1938, 136-137; Berlin 1975, 113; Hand and Wolff 1986, 4

National Gallery of Art, Washington. Ailsa Mellon Bruce Fund, inv. no. 1978.19.2

This handsome drawing, the earliest dated work in an album of landscapes, perhaps assembled in the seventeenth or eighteenth century, was first published

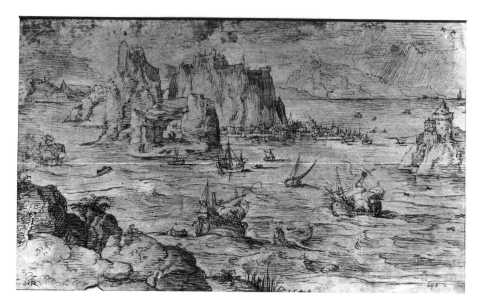

Fig. 1. Matthijs Cock, *Coastal Scene*, Victoria and Albert Museum, London

and attributed to Matthijs Cock by Popham. It is unrelated to any extant painting or print and its precise function is unknown.

In style and technique the *Landscape with Castle above a Harbor* can be readily associated with other drawings in the Matthijs Cock group, and, what is perhaps the closest comparison, to the *Coastal Scene* (fig. 1; Victoria and Albert Museum, London), signed and dated the same year, 1540.[1] Both drawings exhibit the same rapid pen work, system of cross hatching, and the soft, almost malleable appearance of the rocks that is a characteristic of the Matthijs group. In the Washington drawing, however, the middle ground is virtually nonexistent; the rocky promontory rises up from the bottom of the page and is dramatically juxtaposed to the distant hills and valleys. A somewhat similar composition is found in an undated brush drawing in the Louvre where the center of the page is dominated by a vertical rock formation and a wooded hill.[2]

The *Landscape with Castle above a Harbor* is situated at the approximate midpoint of Matthijs Cock's landscapes. The earliest dated works, the *Landscape with Watermill* of 1537 (Rijksprentenkabinet, Amsterdam)[3] and the *Rocky Landscape with Harbor* of 1538 (Staatliche Graphische Sammlung, Munich)[4] are more modest, open compositions and more restrained in their depiction of deep space. The drawings that follow the Washington sheet, such as the *Landscape with Saint Jerome* of 1541 (Staatliche

Museen, Berlin, Kupferstichkabinett)[5] and the *Christ at the Sea of Galilee* of 1544 (British Museum, London)[6] are compositionally and spatially more complex. The views are more panoramic and pen and wash combine to form denser, richer textures. Matthijs Cock's landscapes preserve the Patinir tradition and add to it Italianate elements.[7] The result is a more focused, spatially coherent style that is the logical precursor to the panoramic vistas created by Pieter Bruegel approximately a decade later. Matthijs is a prime subject for further study; at times his drawing style is extremely close to that of his brother Hieronymus[8] and to this author there are drawings that appear to be by other hands. JOH

1. Muchall-Viebrook 1931, 29-30. Also dated 1540 is the *Landscape with a Town Set in a River Valley* belonging to the British Railway Trust; see Austin 1982, 12, no. 6.
2. Lugt 1968, 48-49, no. 162.
3. Boon 1978, no. 131. A second, nearly identical, but indistinctly dated, drawing is in the Kupferstich-Kabinett, Staatlichen Kunstsammlungen, Dresden. Zwollo accepts the Amsterdam sheet as by Cock while Boon believes it is a copy.
4. Wegner 1973, 14-15, no. 33.
5. Berlin 1975, 114, no. 141.
6. Baldass 1927/1928, 92, repro. 93.
7. Zwollo 1965, 44, notes the influence of Venetian woodcuts from the circle of Titian and Campagnola on Matthijs' later works. More prominent and Italianate figures are seen in the 1541 *Rape of Europa* in the Louvre (Lugt 1968, 48, no. 160).
8. A case in point is the *Landscape with the Rape of Helen* (British Museum, London), which contains figures copied from a Marcantonio engraving. It was generally attributed to Matthijs, but after seeing it in the 1975 Berlin exhibition (no. 143), Riggs (1977, 412), thinks it is by Hieronymus.

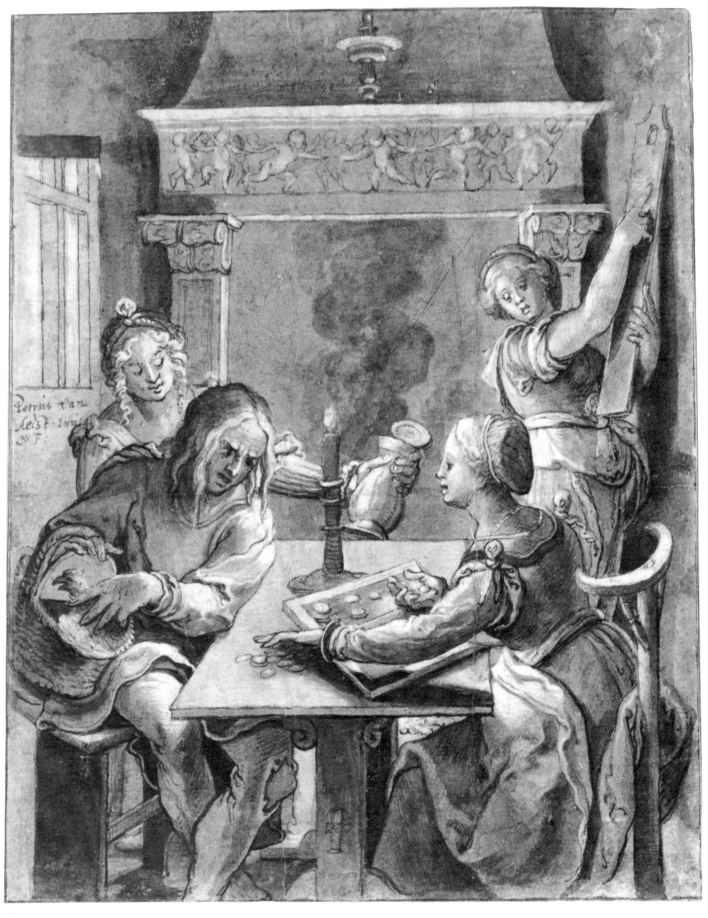

35

Pieter Coecke van Aelst

1502-1550

Pieter Coecke van Aelst was born on 14 August 1502, in the town of Aelst where his father, Jan Coecke, was the Deputy Mayor. From the documents, there is no mention of his activities prior to 1527 when he entered the Guild of Saint Luke in Antwerp. Van Mander writes that Pieter Coecke studied with Bernard van Orley which, if it is true, must have been in Brussels. Boon (1980-1981, 76) has suggested that Pieter Coecke first began his studies with his father-in-law, Jan Dornicke, in Antwerp sometime before 3 December 1526. Van Mander also writes that Pieter Coecke went to Italy, including Rome, and made drawings of sculpture and architecture. This trip most likely occurred sometime prior to his entry into the Guild of Saint Luke in 1527. In 1529, he had two students, Willem van Breda and Willem Key. Pieter Coecke was in Constantinople in 1533-1534 where he executed drawings that were later made into the woodcut series entitled Moeurs et fachon de faire Turcz, *published in 1553 by his second wife and then widow, Maeyken Verhulst. In 1534, Pieter Coecke created a design for the image of the great* Giant of Antwerp. *Three years later, he was named Dean of the Guild of Saint Luke in Antwerp. By 1550, Pieter Coecke had become Painter to the Emperor Charles V.*

Pieter Coecke was a prolific artist. He made numerous paintings, drawings, and designs for tapestries and stained glass windows. In 1541-1542, he introduced the painting of tapestry cartoons to Antwerp. He was also a sculptor and architect. Pieter Coecke translated parts of Vitruvius' De Architectura *into Flemish in 1539. Of even greater importance were his translations of Serlio into Flemish and French, beginning in 1539 with Book IV, with publication continuing past his death until 1553. In 1546, Pieter Coecke moved to Brussels, where he died on 6 December 1550.*

35 *Allegorical Genre Scene*

Pen and brown ink with brown wash and white heightening
201 x 161 (7⅞ x 6⁵/₁₆)
Signed by the artist along the center-left margin, *Petrus van/ Aelst inu / & F.* Inscribed on the verso in brown ink by Ploos van Amstel, *Petrus Koeke van Aelst f 1529 / geb. 1496 te Aelst./ Discipel van Bern. van Orley geb. te Brussel 1484/ Discipel van Rafael Urbinus*

Provenance: Ploos van Amstel, Amsterdam; D. Vis Blokhuyzn (sale, Rotterdam, 23 October 1871, no. 1); acquired by the museum in 1871

Literature: Friedländer 1917, 85; Muchall-Viebrook 1928, 205; Benesch 1928, 9; Van Gelder 1929, 135; Benesch 1937, 17; Delen 1944, 63, 64; Marlier 1966, 88-90, 314; De Jongh 1968-1969, 45, n. 50; Judson 1970, 56; Shubert 1973, 217; Friedländer, *ENP*, 12 (1935): 58 (12 [1975]: 34-35, no. 1); Gibson 1978, 679; Wayment 1980, 44

Exhibitions: Antwerp 1930, no. 387; Brussels 1963, no. 283; Berlin 1975, no. 144

Museum Boymans-van Beuningen, Rotterdam, inv. no. P. Coecke no. 2

Pieter Coecke's drawing has always been entitled *The Prodigal Son*, from Luke 15: 13, which describes how a man's son wasted his patrimony. In fact, this does not seem to be the subject because in all other representations of this episode, the son wears elegant clothes and not the tattered and torn rags worn by the figure on the left in Pieter Coecke's drawing. Further, there are too many details taken from a number of traditional "wastrel" themes to tie this representation to one specific subject. In fact, the picture bears a striking resemblance to illustration number three in Jacob Matham's four representations of Drunkenness.[1] In the text accompanying that image, wine is said to be the cause for unchaste behavior, gaming, and cheating.[2] That Pieter Coecke's drawing should be read as an allegory on lewdness or promiscuous living brought on by too much wine is further emphasized by the conspicuous placement of the jug, symbol of Gluttony; by the woman on the right adding another drink to the bill; and the board game, associated since medieval times, with "emptiness," laziness, time wasting, and carelessness.[3] The immoral message of this sheet is made even clearer by the man on the left who reaches into his basket to pull out a live cock as an offering to the girl on the right. In the Dutch language, as De Jongh has demonstrated, the

bird or cock was closely associated with copulation since the beginning of the sixteenth century.[4]

Pieter Coecke's drawing was probably executed early in his career. The sheet was inscribed on the verso in the eighteenth century by Ploos van Amstel with a date of 1529, which has generally been accepted. Further, the women are similar to those found in Pieter Coecke's c. 1534 tapestry design representing *Saint Paul Preaching to the Macedonian Women Outside of Philippi* (cat. 36). The early date of this sheet indicates that Pieter Coecke created a new setting for this type of allegory. He introduced candlelight, which was used later, in the 1540s, by the Braunschweig Monogrammist in his *Allegorical Card Playing Scene in an Inn* (art market, Berlin 1924)[5] and later become very popular in the seventeenth century, especially in Utrecht.

Pieter Coecke's drawing style is innovative in the stress upon a variety of tonal variations in the wash. Prior to Pieter Coecke, Netherlandish artists produced chiaroscuro effects with a single-toned wash set against the white of the paper. This new manner of drawing may very well have been inspired by Italian chiaroscuro woodcuts executed in Rome around 1518 by artists such as Ugo da Carpi. Pieter Coecke's use of at least three different shades of wash to establish areas of shadow was further developed by the next generation in the works of the Master of the Liechtenstein Adoration (cat. 86) and Dirck Barendsz. (cat. 9).[6]

The chiaroscuro effects achieved by Pieter Coecke are overly decorative; gestures are exaggerated and anatomical details are accompanied by an unclear space. In contrast to this mannerist work is a more realistic representation of the *Money Changers (Vanitas)* (Albertina, Vienna), which is also an interior scene but in the tradition of Jan van Eyck.[7] JRJ

1. Hollstein 314.
2. Renger 1970, 82, fig. 55.
3. Renger 1970, 81, figs. 50, 52.
4. De Jongh 1970, 23-45.
5. For the date of these allegories by the Braunschweig Monogrammist, see Renger 1970, 97, and for an ill. of the lost Berlin *Allegory*, see Renger 1970, fig. 68, or Winkler 1924, 309, fig. 183.
6. Judson 1979, 56.
7. Benesch 1928, no. 50, pl. 15.

PIETER COECKE VAN AELST

36 Saint Paul Preaching to the Macedonian Women Outside of Philippi

Pen, brown ink, brown wash, and heightened with white body color on brown paper
254 x 485 (10 x 19⅛)

Provenance: Acquired in 1927 from the Munich art market

Literature: Wescher 1928, 29; Muchall-Viebrook 1928, 203-209; Steinbart 1933, 34-36; Krönig 1936, 87, 88; Marlier 1966, 313, 314; Wegner 1973, I: 15, no. 35; Friedländer, *ENP*, 12 (1935): 59 (12 [1975]: 35, no. 1; Halbturn 1981, under no. 4

Staatliche Graphische Sammlung, Munich, inv. no. 1927:79

This drawing is part of a series executed by Pieter Coecke van Aelst for nine tapestries illustrating scenes from the life of the apostle Paul.[1] The tapestries contain the following subjects: *The Stoning of Saint Stephen*,[2] *The Conversion of Saint Paul*,[3] *The Sacrifice at Lystra, The Preaching of Paul at Philippi, The Burning of the Books at Ephesus, The Taking of Saint Paul, Saint Paul before Agrippa*,[4] *Saint Paul Bitten by the Snake at Malta*,[5] and *The Beheading of Saint Paul*.[6]

The design for *Saint Paul Preaching* includes several episodes from Acts 16 that led to the conversion and baptism of Lydia who sits in the left foreground with arms crossed. In the right background, the vision of the Macedonian appearing

to Paul is depicted (Acts 16:9) while in the center, behind Lydia and Paul, the Macedonian women are seen (Acts 16:3). Along the river in the distant left, Paul baptizes Lydia (Acts 16:15). Pieter Coecke arranged the main figures in a modified triangle[7] that brings to mind Bernard van Orley's earlier designs for tapestries such as his 1524 *Romulus as the Supreme Judge*, Staatliche Graphische Sammlung, Munich.[8] The latter is clearly based upon the arrangement of the figures in Raphael's tapestry cartoons for *Elymas Struck with Blindness* and *The Death of Ananias*, which were in Brussels late in 1516 or early 1517 (Victoria and Albert Museum, London).[9] Pieter Coecke borrowed not only from Raphael's tapestries but also from his *Triumph of Galatea* (Villa Farnesina, Rome). The boy in front of Lydia repeats the position of the putto in the foreground of the Villa Farnesina painting.[10]

In general, Pieter Coecke's figures are mannered in their proportions, poses, gestures, and the illogical space they occupy. However, there is one figure, the woman standing on the left in front of the tree, who is rendered realistically.

The Munich drawing, and for that matter the entire series, very likely dates

from around 1534.[11] This early date is reinforced by the close affinity of the female facial types with those on the right in Pieter Coecke's 1529 *Allegorical Genre Scene* in Rotterdam (cat. 35).[12] In both drawings, the facial features were built with a mixture of pen lines with wash. The mannered poses in the *Saint Paul Preaching* are similar to those in the 1531 drawings for the tapestries of the *History of David* (British Museum, London).[13] However, the space in the *Saint Paul Preaching* has become more open than the confined arrangement of the figures in the drawings for the earlier *History of David*. This compositional change, with the participants seen from below along with new and more unimpeded views into the distance, is similar to Pieter Coecke's 1533 woodcuts representing the *Manners and Customs of the Turks*.[14]

There is a second drawing of *Saint Paul Preaching to the Macedonian Women at Philippi* in the R. de Cérenville collection, Lausanne, which Frits Lugt thinks could be an original.[15] JRJ

1. A complete set is to be found in Munich but divided between the Residenzmuseum where there are four, including *The Preaching of Paul at Philippi*, and the Bayerische Nationalmuseum, which owns

PIETER COECKE VAN AELST

37 *Design for a Triptych with Scenes from the Life of Saint John the Baptist*

the other five. There is also an incomplete set of five in Madrid—for details see Tormo and Sánchez Cantón, 1919. For an illustration of the Munich *Saint Paul*, see Muchall-Viebrook 1928, fig. 2.
2. For the drawing in Darmstadt, see Marlier 1966, fig. 251.
3. For the drawing, see Marlier 1966, fig. 254.
4. For the drawing, see Benesch 1928, 9, no. 53, pl. 16.
5. See Marlier 1966, fig. 250.
6. See Berlin 1975, no. 147, fig. 42.
7. Muchall-Viebrook 1928, 205.
8. Wegner 1973, 2: no. 89, pl. 13.
9. Krönig 1936, 41, 88, 125.
10. Krönig 1936, 88.
11. For the date of 1549, see Berlin 1975, 117.
12. Marlier 1966, 314.
13. Popham 1932, 22, 23, nos. 3-5, pls. VI, VII.
14. For details concerning the woodcuts, see Marlier 1966, 55-74.
15. Lugt studied this drawing on 5 July 1968. He wrote, on the mount of the photograph of the Munich drawing in the R.K.D., The Hague, that the Lausanne sheet could be an original. He also stated that it was drawn in light brown ink, which has been gone over in black ink by a later hand.

Pen and brown ink and brown wash, frame in black oil
Center: 209 x 160 (8 3/16 x 6 5/16); wings: 209 x 79 (8 3/16 x 3 1/8)

Provenance: L. Woodburn (his sale, 1854, no. 1168)

Literature: Baldass 1915, 228, n. 4; Wescher 1928, 31; Popham 1932, 22, 24, no. 2; Marlier 1966, 291, 292

Trustees of the British Museum, London, inv. no. 1854.6.28.38

Exhibited in Washington only

Karel van Mander writes that Pieter Coecke van Aelst executed many altarpieces,[1] and this sketch in London records one of them, which was probably destroyed during the iconoclastic riots that swept the Netherlands in the 1560s. The inside of the triptych illustrated the *Baptism of Christ* on the center panel, *Saint John the Baptist Preaching in the Wilderness* on the left wing and the

Dance of Salomé on the opposite wing. When the altarpiece was closed, the exterior panels displayed the *Birth of Saint John the Baptist* on the left and the *Martyrdom of Saint John the Baptist* on the right. The panels do not connect with each other and are to be read separately.

Pieter Coecke's figures stand in an ambiguous space close to the foreground. They are elongated and posed in an exaggerated and artificial manner. It is difficult to know whose limbs belong to whom in the left interior wing and in the background of the central panel. In short, this triptych is governed by a mannerist formula that Pieter Coecke must have learned from his teacher Bernard van Orley and further enhanced during his sojourn in Rome in the early 1530s. Pieter Coecke did not use precisely identifiable Italian models, but the general arrangement of the figures and their contorted positions suggest a knowledge of the Ra-

phael School and the decorative style of Parmigianino. It is also possible that the famous antique sculpture of the *Spinario* was in Pieter Coecke's mind when he drew the woman seated just behind Christ and to his right in the *Baptism*.

The abrupt space and the arrangement of the figures close to the foreground in artificial poses is similar to what one finds in Pieter Coecke's c. 1540 *Descent from the Cross* (Museu Nacional de Arte Antiga, Lisbon).[2] The style of the drawing, where the figures are outlined with long continuous contours, the light application of the wash and the treatment of the trees, is close to Pieter Coecke's *Incident in the Legend of Saint Christopher* (British Museum, London, inv. no. 5214-240),[3] which also probably dates from c. 1540. JRJ

1. Van Mander, *Schilder-boek*, 1: 156-157.
2. See Marlier 1966, 75-80, figs. 16-18.
3. Popham 1932, 23, 24, no. 8.

ATTRIBUTED TO PIETER COECKE VAN AELST

38 *The Parable of Dives and Lazarus*

Pen and black ink, gray wash, and white heightening on gray prepared paper
386 x 540 (15¼ x 21¼)
Backed. The upper corners have been damaged and made up; there are made up losses above at the upper right and the left; probably trimmed along the right edge. At bottom right is a blind stamp in the form of a flower, not in Lugt

Provenance: Sir George Clausen

Literature: Friedländer 1909, 92; Popham 1926a, 16, 34, no. 64; Friedländer, *ENP*, 8 (1930): 107-108 (8 [1972]: 66-67); Popham 1932, 34-35, no. 1; Baldass 1944, 171; Farmer 1981, 128-130, 275, 344, no. D12; Wayment 1982, 146

Trustees of the British Museum, London, inv. no. 1899.7.13.216

Exhibited in Washington only

Until very recently, Bernard van Orley's authorship of *The Parable of Dives and Lazarus* has never been disputed. However, the precise relationship of the drawing to Van Orley's *Vertu de Patience* altarpiece of 1521 (Musées Royaux des Beaux-Arts, Brussels)[1] troubles all who write about it. The parable, recounted in Luke 16: 19-31, is depicted on the exterior wings of the altarpiece (fig. 1). The interior shows scenes from the Book of Job. The figures of Lazarus and Dives are on the left and right sides of the British Museum drawing while the center shows the rich man and his companions banqueting in front of his palace.

Friedländer thinks that the drawing not only deviates strongly from the painting, but also lacks its power and expressive-

Fig. 1. Bernard van Orley, Exterior wings of the *Vertu de Patience* altarpiece, Musées Royaux des Beaux-Arts de Belgique, Brussels (Copyright A.C.L. Brussels)

ness, and concludes that it is an earlier design for the picture.[2] Popham, too, does not find a close correspondence between the two works, but hypothesizes that the drawing is a rejected design for the central panel.[3] Baldass feels that the drawing came after the painting and is probably a design for a tapestry.[4] Farmer considers it possibly a presentation sheet for a tapestry or painting, to be dated c. 1517 on stylistic grounds.[5] None of these explanations is wholly satisfactory.

Wayment's proposal that the *Parable of Dives and Lazarus* is actually by Pieter Coecke van Aelst merits serious consideration. He sees as typical of Pieter Coecke the greater fluidity and accomplishment of the drawing as compared to the painting. The figure of Lazarus at the left is seen as anticipating that of Saint Paul in Coecke's tapestry cartoon, c. 1535, showing the beheading of the saint (Hôtel de Ville, Brussels).[6]

The most telling comparison, however, is with Pieter Coecke's *Allegorical Genre Scene* (cat. 35) in the Museum Boymans-van Beuningen, Rotterdam. The long

arms and weak hands with poorly articulated fingers and something of the profile of the woman seated at the right in the Rotterdam drawing may be recognized in the woman seated at the left in the British Museum sheet.[7] There are further similarities in the broad hand with heavy, triangular fingers and the way white heightening is used to define the long, thin nose and eyebrows of the man in the Rotterdam drawing and the rich man at the center of the British Museum drawing.[8] The Rotterdam drawing, one of the cornerstones of Coecke's art, is prominently signed and the date of 1529 given by Ploos van Amstel is accepted as generally correct.

The "indolent grace" that Friedländer[9] observes in the women in the British Museum drawing is more a characteristic of Pieter Coecke's style than Bernard van Orley's. In Van Orley's drawings such as *A Company of Ladies and Gentlemen in a Garden* (British Museum, London)[10] or the three splendid drawings of landscapes with figures (Louvre, Paris),[11] there is not the same elegance and delicacy of pose

and movement. Van Orley's figures tend to be slightly heavier and his women have stronger jawlines than seen here or in Coecke's usual feminine types, as, for example, in *Paul Preaching to the Women of Philippi* (Staatliche Graphische Sammlung, Munich, cat. 36).

If, as suggested, *The Parable of Dives and Lazarus* is by Pieter Coecke, then a date sometime in the 1520s is most likely. In style and technique it is closest to the *Allegorical Genre Scene* of c. 1529 in Rotterdam, while the adaptation of motifs from the *Vertu de Patience* altarpiece puts it around or, more likely, after 1521. Unfortunately, there are no early drawings for comparison and Coecke's career is undocumented until 1527 when he became a master in Antwerp. On the basis of Van Mander's report it is believed that Coecke apprenticed with Van Orley in Brussels before going to Italy.[12] Certainly his later work as a tapestry designer owes much to Van Orley. The attribution of the British Museum drawing to Coecke raises, but does not answer, tantalizing questions about Coecke's possible presence in Van Orley's workshop and the relationship of the two artists.

The function of the drawing is unknown, although it is conceivably a design for a tapestry or possibly a painting. Representations of the parable occur with some frequency in the north. The focus is usually upon the rejection of Lazarus and the rich man's banquet.[13] Christ's parable may be interpreted on several levels: as an admonition to charity, a reference to the Last Judgment, and an illustration of the idea, common in the Gospels, that the first shall be last.[14] JOH

1. For a discussion of the altarpiece, thought to have been commissioned by Margaret of Austria for her quarters in the castle of the Count of Hoogstraeten, see Farmer 1981, 123-144.
2. Friedländer 1909, 92.
3. Popham 1932, 34-35, no. 1.
4. Baldass 1944, 171, also notes that the architecture in the drawing is less stocky than that in the painting and that the figures of Abraham and the angel at the top of the drawing are represented with greater plasticity and movement.
5. Farmer 1981, 128-130; he assumes that the portions of the triptych devoted to the parable of Dives and Lazarus were not originally intended for it, but were adapted and added because of the importance of the commission and the parallels with Job's suffering and patience. There are no secure drawing attributions to Van Orley from this period.
6. Wayment 1982, 146. The cartoon, repro. Marlier 1966, 319, is for the last tapestry in a series of the life of the apostle Paul, dated 1535/1540. The tapestry is in the Kunsthistorisches Museum, Vienna; see Halbturn 1981, 37-54, esp. 51-53, no. 9, pl. 28; see also cat. 36.
7. Compare also the long arms and hands in Coecke's drawing of a *Moneychanger and His Wife* (Albertina, Vienna), repro. Marlier 1966, 296, fig. 236. See Benesch 1928, 9, no. 50.
8. As Wayment 1982, 146, observes, the rich man's

facial type with its long, thin nose and relatively close-set eyes is one that recurs in Coecke's work. Also, the broad hand with splayed fingers, a characteristic of Coecke's commented on by Friedländer, *ENP*, 12 (1975): 34, may be compared with the hand of the man grasping the column at the distant left of the British Museum drawing.

9. See n. 2 above.

10. Popham 1932, 35, no. 3; repro. Friedländer 1909, facing 162.

11. Lugt 1968, 52, nos. 175-177, pls. 82-83.

12. Van Mander, *Schilder-boek*, 1:152-153. Marlier 1966, 309, puts Coecke's apprenticeship with Van Orley c. 1517/1518. However, Boon, in Florence 1980-1981, 76, finds it less probable that Coecke was in Van Orley's atelier before 1527.

13. The subject was treated by Cornelis Anthonisz. in a woodcut dated 1545 (Wurzbach 3), and in drawings by Marten de Vos (Delacre collection, Ghent), Jan Swart (Rijksprentenkabinet, Amsterdam, no. A.2825) and Ambrosius Franken (art market, Amsterdam, 1967); repros. in the D.I.A.L. index.

14. Réau, *Iconographie*, 2, part 2 (1957): 348-352.

Cornelis Cornelisz. van Haarlem

1562-1638

Cornelis Cornelisz. was born into a wealthy Haarlem family in 1562. He studied with Pieter Pietersz. in his native town before 1579, when he sailed for France. Turned back by the plague at Rouen, he went to Antwerp, where he worked briefly with Gillis Coignet. In 1580/1581 he settled in Haarlem. With his close friends Hendrick Goltzius and Karel van Mander he led the artistic revival that followed the iconoclasm and the Spanish occupation of Haarlem. Cornelis lived the life of a comfortable and distinguished citizen, marrying the daughter of a burgomaster and serving as regent of the Old Men's Home from 1613 to 1619. He died 11 November 1638.

Cornelis inherited the role of Maerten van Heemskerck as the premier painter in Haarlem, a major artistic center. Some 250 of his pictures have survived. The earliest is from 1583, and a steady succession of dated examples from 1587 to 1633 has come down to us. His oeuvre includes a few portraits as well as paintings of historical subjects. Many are large, multifigured compositions, some of which were commissioned to decorate Haarlem municipal institutions, such as the headquarters of the civic guard company, the Prinsenhof, the Heilige Geesthuis hospital, and the Sint Maarten's Hofje. Between 1588 and 1602, twenty-two of Cornelis' paintings and drawings were engraved by Goltzius, Jan Muller, and others. Like Goltzius, Cornelis worked initially in a sophisticated, late mannerist style derived from the drawings of Bartholomeus Spranger. During the 1590s he gradually adopted a classicizing mode based on Dürer and High Renaissance models.

Gerrit Pietersz. (cats. 94, 95) was his most important pupil.

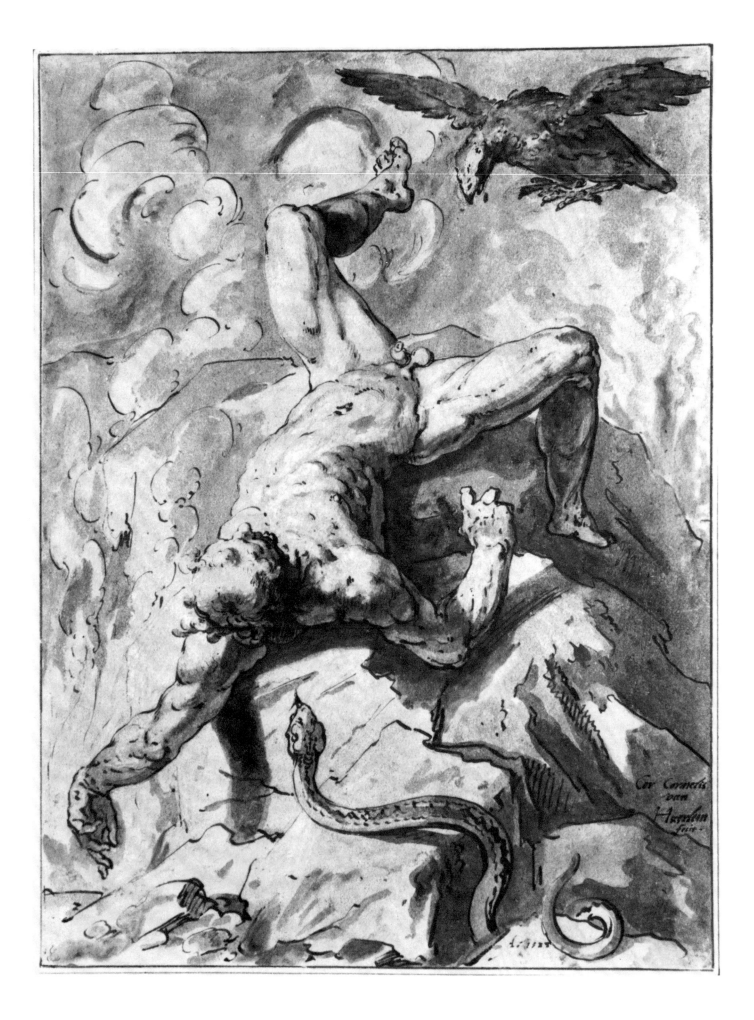

CORNELIS VAN HAARLEM

39 *Tityus*

Pen and brown ink and rose-brown and gray
wash, heightened with white body color over
traces of black chalk; laid down
360 x 268 (14⅛ x 10⁹⁄₁₆)
Signed and dated, in brown ink, at lower right,
Cor Cornelis/ van/ Haerlem/ fecit/ Ao 1588

Literature: Schönbrunner and Meder 1896-
1908, 10: no. 1102; Benesch 1928, no. 367,
pl. 95; Welcker 1947, 66; Reznicek-Buriks
1956, 166, fig. 6; Reznicek 1956, under no. 14;
Bernt 1957, 1: pl. 157; Reznicek 1961, 1: 159,
n. 49, 160; Van Thiel 1965, 127-128, 137,
no. 19, pl. 2; Judson 1970, pl. 151; Lowenthal
1983, 152-153

Graphische Sammlung Albertina, Vienna, inv.
no. 8101

Van Mander reports that his friends nick-
named Cornelis van Haarlem "the Paint-
er," and, from his day to ours, he has
rightly been regarded as the most gifted
and productive painter among the Haar-
lem mannerists.[1]

In contrast to the approximately 250
pictures that have survived, only about
twenty drawings have come to light.[2]
This paltry number does not, however,
reflect the high priority Cornelis assigned
to the practice of drawing. According to
Van Mander, he was a diligent draftsman
who often copied from casts of the best
antique statues. Moreover, the inventory
of his estate lists thirty-eight lots of
drawings, each comprising an unspecified
number. They consisted of studies of
male and female nudes, as well as details
of heads, legs, arms, hands, and draperies,
many described as "done from life" in red
chalk. All that remains of what must
have been hundreds of sheets is one bril-
liant life study in red chalk of a male
nude, which Cornelis transcribed into
various paintings.[3]

Tityus, a mythological giant, suffered
eternal torture for attempting to rape
Leto, mother of Apollo and Artemis. The
gods bound him to the ground in Tarta-
rus—a vast, putrid chasm far beneath the
earth's surface, shrouded in darkness and
racked by cyclones—where two vultures
pecked constantly at his liver. As the an-
cients believed that sexual desire origi-
nated in the liver, the punishment fit the
crime.

Cornelis' magnificent drawing is un-
doubtedly a complete work of art, as its
prominent signature and date, large size,
fully resolved design, and elaborately pic-
torial execution all attest. His choice of a
colored ground for the finished composi-
tion follows a venerable tradition in
Netherlandish draftsmanship, which is
documented by several examples in this
exhibition (cats. 6, 7, 9, 11, 65, 72). An

Fig. 1. Martino Rota after Titian, *Tityus*, The
British Museum, London (Courtesy of the Trustees of
the British Museum)

engraving by Martino Rota after Titian's
painting of the same subject must have
served as Cornelis' point of departure (fig.
1).[4] As in Titian's work, the giant sprawls
over a great rock, and a menacing snake
and clouds of vapors evoke the unsavory
environment of Tartarus. However, the
tense, muscular, and stunningly fore-
shortened figure reflects the most recent
innovations in the expressive late man-
nerist style inspired by the drawings of
Spranger and developed by Cornelis and
Goltzius during the second half of the
1580s. The vigorous modeling with
strongly contrasting passages of dark
wash and white body color, combined
with short, spirited penstrokes to stress
the straining muscles, recalls the tech-
nique of Spranger and Goltzius, which
profoundly affected Cornelis' early draw-
ing style.[5]

In the 1580s and early 1590s Cornelis
delighted in depicting athletic nudes in
attitudes of extreme physical and mental
agitation that reflect their perilous cir-
cumstances. In addition to *Tityus*, he
drew or painted a *Titanomachy*, *The
Dragon Devouring the Companions of
Cadmus*, *The Massacre of the Inno-
cents*,[6] and *Two Wrestlers*[7] during this
period. Perhaps the most sensational of
these works is the series, *The Four Dis-
gracers*, which Goltzius engraved in 1588
after paintings by his friend.[8] Like Tityus,
the protagonists of this suite, Ixion, Tan-
talus, Phaeton, and Icarus, all suffered
horrible fates because of their pride and
presumptuousness. Cornelis represented
them tumbling helplessly through the
air, their ignominious descents vividly
embodying the proverbial fall of those

Fig. 2. Hendrick Goltzius after Cornelis van
Haarlem, *The Fall of Phaeton*, The Art
Museum, Princeton University, Princeton,
N.J., Junius S. Morgan Collection

whose ambitions exceed their abilities.
The eccentric, strongly foreshortened at-
titude of Phaeton (fig. 2) resembles the
pose of Tityus as well as that of Cacus in
Goltzius' woodcut *Hercules Slaying Ca-
cus*, also of 1588.[9]

Cornelis' invention won the admira-
tion of his colleagues. A copy of the
drawing, perhaps by Jan Muller, is pre-
served at Brussels.[10] Figures in the same
position appear in Muller's *The Brazen
Serpent* (cat. 88) and in *After the Flood*, a
drawing by a follower of Cornelis,[11] and
in Gerrit Pietersz' *Odysseus and Teire-
sias* (cat. 94). A study of Tityus by Bloe-
maert seems to reflect Cornelis' design as
well as the prints after Titian.[12] Goltzius'
Tityus painting of 1613, on the other
hand, shows the giant in an attitude
derived directly from Rota's engraving
(fig. 1).[13] WWR

1. Van Thiel 1965, 123.
2. See Van Thiel 1965, where twenty drawings are
catalogued as authentic works by Cornelis. A few of
these attributions, as Van Thiel notes, are not abso-
lutely certain. Several drawings by, or plausibly at-
tributed to Cornelis, have come to light since Van
Thiel's publication. They include: *The Angel Appear-
ing to the Centurion Cornelis*, Washington 1974, no.
44; *The Brazen Serpent*, sale, New York, Sotheby's,
20 January 1982, lot 72, now Ian Duncan, London;
two sheets with studies of figures for a representation
of *The Flood*, private collection, Amsterdam, see
New Brunswick 1983, no. 30, for one of these; *Man
and Child (Jupiter and Ganymede(?)*, sale, Paris,
Hôtel Drouot, 15 February 1984, lot 37, now J. Paul
Getty Museum, Malibu.
3. Van Thiel 1965, 123-124 and no. 11. Cornelis used
the male nude in a painting at Mainz, Van Thiel
1965, fig. 7, and in a *Baptism* at Dessau (photo:
R.K.D.), and in a painting monogrammed and dated
1600 (photo: D.I.A.L. 71B 31.2). Lowenthal 1977, 15,
related the drawing to *The Israelites Crossing the
Red Sea* of 1594.

4. Cornelis could have consulted the engraving of 1566 by Cornelis Cort, Hollstein 192, incorrectly as *Prometheus*, or the engraving after Cort's print by Martino Rota of 1570, Bartsch 106, incorrectly as *Prometheus*. Cornelis' drawing is in the same direction as Rota's engraving (fig. 1). Prints after Titian were listed in the inventory of Cornelis' estate, Van Thiel 1965, 128.

5. Reznicek 1961, 159 points out that Cornelis imitated such Goltzius drawings as Reznicek 1961, 2: pls. 90-93.

6. Van Thiel 1985, figs. 3, 4, 8.

7. Berlin 1979, no. 10.

8. Lowenthal 1983, with earlier literature. For Goltzius' engravings, see Strauss 1977, 2: nos. 257-260.

9. For Goltzius' *Hercules and Cacus*, see Strauss 1977 2: no. 403.

10. Collection de Grez, Músée des Beaux-Arts, inv. no. 2664. Inscribed, *J. Muller/ Ao 1588*, Reznicek 1956, no. 14, as "not certainly by Muller"; Van Thiel 1965, n. 19.

11. Berlin 1975, no. 30, as Cornelis van Haarlem. Judging from the reproduction, this drawing is by a close follower of Cornelis, perhaps Muller.

12. For Bloemaert's drawing see Benesch 1928, no. 442.

13. Biesboer 1983, fig. 24. I am grateful to Mr. Lawrence Nichols for confirming the date and calling my attention to reproductions of the painting.

Pieter Cornelisz. Kunst

1489/1490-1560/1561

Pieter Cornelisz. was born around 1489/ 1490 in Leiden. His father was the famous Leiden artist Cornelis Engebrechtsz. with whom he studied. Pieter Cornelisz. was strongly influenced by Lucas van Leyden who was also a fellow pupil at the same time. Pieter Cornelisz. Kunst is cited in the Leiden archives in 1514, 1519, and 1523. In 1530, he went to live with his brother Cornelis Cornelisz. in Bruges and two years later in 1532 he worked on a project for the pulpit in the Church of Saint Peter's, Leiden. He died sometime between 31 October 1560 and the first week in July of 1561. Pieter Cornelisz. Kunst, according to Van Mander, was a designer of stained glass windows, the earliest from 1516. He also made paintings and designs for maps and furniture. Pieter Cornelisz. Kunst did not sign his work with the monogram PC as has always been thought. According to J.D. Bangs' recent discovery in the Leiden archives, Pieter Cornelisz. Kunst used an entirely different mark, and the monogram PC probably was used by "Meester Pieter Hugenz. van Cloetinge" whose work is documented during the years 1518-1538 (Bangs 1981, 13. I am thankful to my colleague Wouter Kloek for pointing out this important but obscure publication).

ATTRIBUTED TO MONOGRAMMIST PC

40 *Burial of the Dead*

Pen and brown ink
247 x 19 (9¾ x 7½)
Inscribed in bottom center foreground, *1524*; on the verso, the monograms in ink, *LC or CL* joined together

Provenance: Possibly C. Ploos van Amstel (sale, Amsterdam, 3 March 1800, Kunstboek BBB, no. 39, as Lucas van Leyden); Benoît Coster (sale, Amsterdam, 18-19 March 1875, no. 50)

Literature: Beets 1909, 11; Beets 1911, 246, 247; Baldass 1915, 25, 28; Bock and Rosenberg 1930, 27; Henkel 1931, 98; Beets 1935, 160, 1; Hoogewerff, *NNS*, 3: 323, 324; Gibson 1966, 37, 1; Judson 1970, 64; Boon 1978, 54, no. 148; Florence 1980-1981, 141

Exhibitions: Utrecht 1913, no. 10

Rijksprentenkabinet, Rijksmuseum, Amsterdam, inv. no. A 7

The *Burial of the Dead* belongs to a series of drawings executed in 1524 representing the *Seven Acts of Mercy*. Six of these designs are preserved: the *Burial of the Dead* and the *Caring for the Dying* in the Rijksprentenkabinet, Amsterdam;[1] the *Feeding of the Hungry* and the *Sheltering of the Pilgrims* (Staatliche Museen, Kupferstichkabinett, Berlin);[2] the *Giving Drink to the Thirsty*, (Fondation Custodia, coll. F Lugt, Paris), inv. no. 5378;[3] and the *Freeing of the Prisoners*, British Museum, London, inv. no. 1921.10.12.5.[4] There is a second group dated 1531 by the same monogrammist PC, of which two of the scenes are preserved: the *Burial of the Dead*, Staatliche Graphische Sammlung, Munich, inv. no. 41054;[5] and the *Feeding of the Hungry*, Museum Boymans-van Beuningen, Rotterdam, inv. no. N. 5. PC executed a third series of this theme in 1532 and three sheets are extant: the *Burial of the Dead* and the *Caring for the Dying*, both in the Staatliche Museen, Kupferstichkabinett, Berlin (fig. 1)[6] and the *Freeing of the Prisoners* (Earl of Leicester collection, Holkam Hall, Norfolk).[7] The *Burial* is the only subject that appears in each series. Earlier writers discussing these drawings believe that they constituted two distinct groups dating from 1524 and 1531-1532,[8] however, this does not appear to be the case because, for example, the compositions of the three *Burial*s are different. In the 1531 Munich composition, the figures are considerably larger and placed closer to the foreground than in the Amsterdam or Berlin drawings. The arrangement of the participants has also been altered in the Munich sheet and the background scene with the figures carrying a coffin has been eliminated. Both the Amsterdam

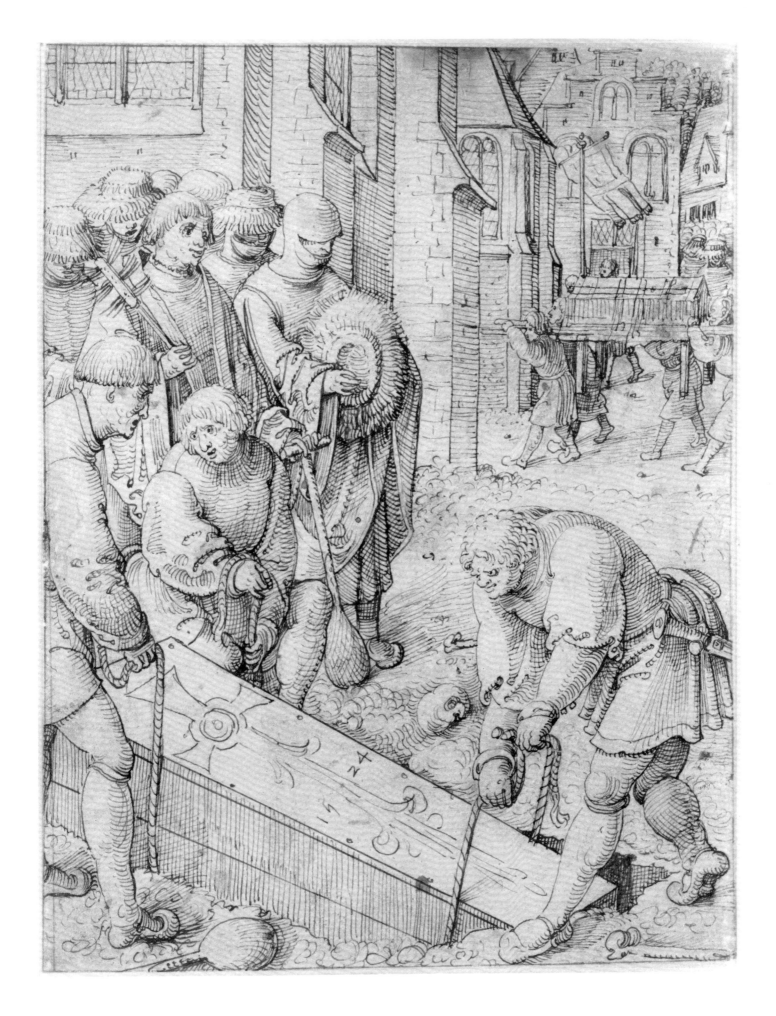

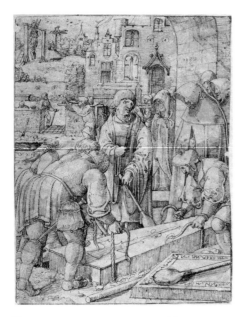

Fig. 1. Monogrammist PC, possibly Pieter Cornelisz. Kunst, *The Burial of the Dead*, Staatliche Museen Preussischer Kulturbesitz, Kupferstichkabinett, KdZ 1190, Berlin
(Jörg P. Anders)

and Munich drawings emphasize the architecture while the Berlin one contains half architecture and half landscape. Although the Berlin composition opens up the city view, the drawing retains, but in reverse, the same general arrangement of the foreground figures. The layout of PC's Berlin design is taken up a few years later by Jan Swart van Groningen in his *Burial of the Dead* (Albertina, Vienna).[9]

PC's Amsterdam drawing was most likely a study for a stained glass window. This was the case with the 1524 *Freeing of the Prisoners* (British Museum, London) from the same series because there is a stained glass in the Louvre that follows it precisely.[10] That Leiden was well known as a center for stained glass design in the early sixteenth century and because the monogrammist PC's drawing style is very close to that in Leiden around 1525,[11] it is most likely that all of the PC drawings of the *Seven Works of Mercy* were made for glass.

The representation of the *Seven Works of Mercy* has a long tradition in the Netherlands. During the early decades of the sixteenth century, the *Burial of the Dead* was combined with the *Last Judgment*.[12] As far as one knows, the monogrammist PC was the first to eliminate holy figures and to place the scene in the realm of everyday action. PC's figures are neither the thin, late Gothic types of the Master of Alkmaar nor the mannered forms of Orley. Heavy-set, realistic, and similar to those of his Leiden contemporary Lucas

van Leyden, they prefigure Pieter Bruegel's.[13] The drawing technique is also closely related to Lucas van Leyden's, with its dependence upon the pen to create clear, parallel hatchings, often with slight curves at their ends, or simply straight and sometimes crossed.[14] This technique, with its reliance upon line to create the shapes, is similar to the *Landscape with the Baptism of Christ*, Maida and George Abrams collection, Boston (cat. 41), but in the latter the contours are thicker and heavier and not as delicate as in the *Burial*. Both sheets use crosshatchings in a similar way, but the application of the pen is more fleeting and lighter in the *Burial*. Because of this, the two drawings do not appear to be by the same hand. JRJ

1. Boon 1978, 53, 54, nos. 147, 148, pl. 63.
2. Bock and Rosenberg 1930, 27, nos. 1191, 1193, pl. 22.
3. Florence 1980-1981, no. 99, pl. 21.
4. Popham 1932, 11, no. 1.
5. Wegner 1973, 16, no. 41; pl. 5.
6. Bock and Rosenberg 1930, 27, nos. 1189, 1190.
7. Dodgson 1924, no. 9.
8. Beets 1935, 160 n. 1, and Florence 1980-1981, 141.
9. Baldass 1915, 25, figs. 1, 2; Benesch 1928, 14, 15, no. 92, pl. 27.
10. Beets 1911, 246, 247, fig. 8 and Hoogewerff, *NNS*, 3: 324, 325, figs. 159, 170.
11. Compare cats. 78-81.
12. Compare, for example, the central panel of the Master of Alkmaar's 1504 *Seven Works of Mercy*, Rijksmuseum, Amsterdam, Hoogewerff, *NNS*, 3, 347, fig. 166, and Van Thiel, 1976, 627, 628, no. A 2815. In the *Burial of the Dead*, Christ, seated on a rainbow and flanked on the right and left by the Virgin and Saint John, looks down upon the *Burial*. Still another example closer in time to the monogrammist PC is Bernard van Orley's 1525 *Altarpiece of the Last Judgment and the Seven Works of Mercy*, Koninklijk Museum, Antwerp. Here the central panel also includes the *Burial of the Dead* surrounded by nude figures representing the elect and the damned while above Christ sits in judgment; see Friedländer, *ENP*, 8 (1972): 69, 70, no. 87, pls. 84, 85.
13. Compare Lucas van Leyden's *Musical Couple*, Bartsch 155, the 1524 *Surgeon*, Bartsch 156, or the *Dentist*, 1523, Bartsch 157—for repros. see Amsterdam 1978, 136, 137.
14. Compare Lucas van Leyden's *Jael Killing Sisera* (cat. 79).

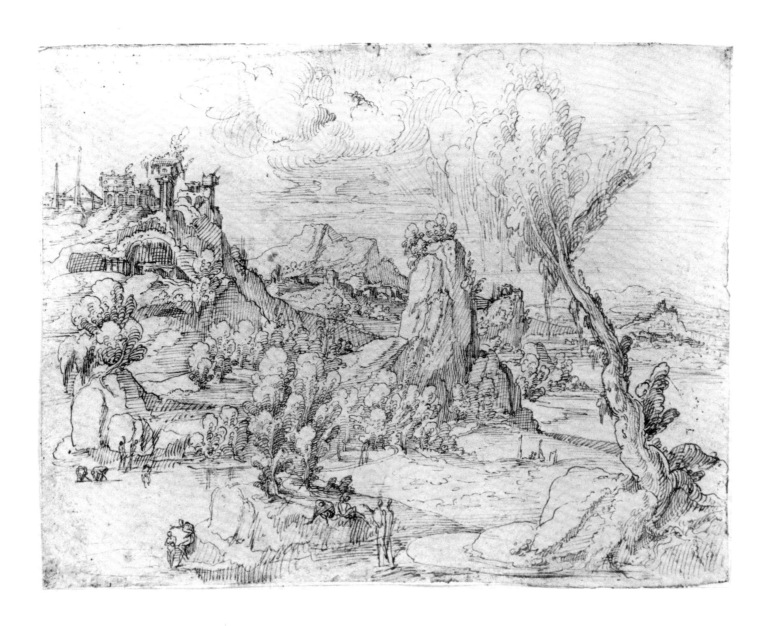

ATTRIBUTED TO
MONOGRAMMIST PC

41 *Landscape with Baptism of Christ*

Pen and brown ink
190 x 252 (7⁷⁄₁₆ x 9¹⁵⁄₁₆)

Provenance: Lord Milford; Sir John Philipps, B.J.; C.R. Rudolf

Literature: Florence 1980-1981, 143

Exhibitions: Royal Academy, London, 1953, no. 250; London, 1962, no. 95, pl. 15

Maida and George Abrams Collection, Boston, Massachusetts

This drawing bears a strong resemblance to early sixteenth-century prints because the artist created forms with a variety of strong pen lines placed in contrast to the paper. The mixture of vertical, horizontal and diagonal lines that are sometimes curved at the ends, or crisscross each

other, is similar to the drawing style of Leiden and, in particular, to such an artist as Aertgen van Leyden.[1] Because of these shared affinities, this design and several others, such as the *River Landscape with Classical Buildings* (Fondation Custodia, coll. F. Lugt, Paris);[2] the *Flight into Egypt* (E.B. Crocker Gallery, Sacramento, inv. no. 98); and *The Soldiers in a Cornfield* (Fitzwilliam Museum, Cambridge, inv. no. 2961), have been attributed to the same hand and specifically to Pieter Cornelisz. Kunst.[3] However, as Boon correctly points out, it is difficult to establish a connection between these landscapes and the style of the drawings signed *PC*. It is on the basis

of this monogram that a group of drawings has been attributed to Pieter Cornelisz. Kunst.[4] However, we now know, thanks to the archival work of J. D. Bangs, that Pieter Cornelisz. Kunst did not sign his work with the monogram *PC* and that the artist may have been "Meester Pieter Hugenz. van Cloetinge," whose work is documented from 1518-1538.[5]

The Abrams drawing contains a number of classical fragments and town views drawn with strong pen lines in the background, which bear a resemblance to the way in which Jan van Scorel populated his distant views.[6] This connection with Scorel is also present in the hastily outlined figures in the foreground. This is es-

pecially clear in the pair of figures in the bottom left that suggest that the Abrams landscape was a setting for the *Baptism of Christ*.[7]

The draftsman of the Abrams sheet was well aware of the drawing styles in Leiden and Utrecht in the 1520s and could have worked in either city. In any case, the artist was not Pieter Cornelisz. Kunst whose landscape and figurative styles remain a mystery. JRJ

1. Compare, for example, the *Temptation and Death of Saint Anthony*, Rijksuniversiteit te Leiden (cat. 1).
2. Florence 1980-1981, 143, 144, no. 101, pl. 22.
3. Florence 1980-1981, 143.
4. Compare, for example, the drawing depicting the *Assisting of the Dying*, Rijksprentenkabinet, Amsterdam, Boon 1978, 53, 54, no. 147, repro., and for a dated but unsigned sheet belonging to this group see cat. 40, fig. 1.
5. Bangs 1981, 12, 13.
6. Compare Jan van Scorel's *Tower of Babel*, Fondation Custodia, coll. F. Lugt, Paris, repro. Florence 1980-1981, pl. 23.
7. Compare the Abrams figures with those in the Lugt drawing and those in the British Museum sheet, cat. 5, fig. 2.

Jacob Cornelisz. van Oostsanen

c. 1492-c. 1533

Jacob Cornelisz. was born around 1472 in Oostsanen, just north of Amsterdam. Van Mander, the only biographical source for the artist, tells us nothing of Jacob's early training. However, through stylistic analysis, Jane Carroll suggests that he began studying with a goldsmith or a woodcut artist and then changed to a painter's atelier. The latter may very well have been grounded in the Haarlem and Utrecht traditions of the late fifteenth century. Jacob Cornelisz. must have experienced some success by 1500 because in that year he purchased a house on the fashionable Kalverstraat in Amsterdam. His earliest dated works are from the year 1507—the Kassel Noli me Tangere *and the woodcut series of the* Life of the Virgin. *In 1512, Jan van Scorel came to study and work with the master until 1517. During his lifetime, Jacob Cornelisz. received numerous commissions for paintings, book illustrations, woodcuts, and stained glass windows.*

He had many patrons, including the clergy and the established families in Amsterdam. His wife, Anna, who lived until at least 1546, had three children by him, Annetje, Dirck Jacobsz. and Cornelisz. Jacobsz. Of the three, Dirck became the most famous as a portraitist while Cornelisz.' oeuvre has yet to be established. Jacob Cornelisz. died sometime prior to 18 October 1533, the date of the inventory listing his possessions at death.

Jacob's drawing style is difficult to define as there are very few of his designs still extant. However, the surviving sheets suggest a manner of drawing that is closely allied with the woodcut tradition. The forms are created through long, continuous contours that are straight or slightly curved, suggesting the shapes, while the shadows are produced through parallel hatchings, often crossed, of various sizes.

42 *Allegory of the Sacrifice of the Mass*

Pen and brown ink
367 x 205 (14½ x 8¹/₁₆)
Inscribed in the bottom left corner by a later hand, *L 1519*; on the verso, a sketch of the missing part of the vault that is cut off on the recto

Provenance: A. Coster, Brussels; A. Boreel and others; (sale, Amsterdam, Frederik Muller & Co., 15-18 June 1908, no. 136)

Literature: Friedländer 1908-1909, 50, 51; Lippmann 1918, 2: no. 225; Steinbart 1922, 162; Steinbart 1929, 214; Bock and Rosenberg 1930, 26, no. 4404; Henkel 1931, 10

Exhibitions: Rotterdam 1936, no. 28; Amsterdam 1958, no. 195

Staatliche Museen Preussischer Kulturbesitz, Kupferstichkabinett, Berlin, inv. no. KdZ 4404

The foreground figures are placed in an open hall and are grouped around an altar. Two priests offer communion while a third, to the left of center, lays his right hand on the head of another to grant absolution. In the background, Christ, weighed down by the cross, stands in a winepress. The beam of the cross is secured to the press and acts as a handle to work the machinery. Two figures to the right and left of the Savior, perhaps apostles, feed grapes into the press. The liquid flows out into a large barrel where a

monk and a figure, possibly wearing the papal tiara, transfer the wine into a vat. The juice of the grape, as a traditional symbol for the blood of Christ, is based upon Isaiah 63:3, "I have trodden the winepress alone," and upon Saint Augustine. The latter interpreted the grapes carried upon a staff by the spies who were sent to Canaan and Hebron[1] as an image of Christ: "He (Christ) is the bunch of grapes, that hung from the tree (from the cross)."[2]

The representation of *Christ in the Winepress* became popular in the Netherlands at the end of the fifteenth and during the sixteenth centuries when it became a standard symbol for the Eucharist.[3]

The figures in the foreground resemble donor portraits of the type found in Cornelisz.' altarpieces dating after 1510. The priest in the center and the benefactor in the right foreground are characterized by sharply outlined heads that are similar to the kneeling donor on the left in Jacob Cornelisz.' 1512 *Adoration of the Christ Child* (Museo e Gallerie Nazionali di Capodimonte, Naples), and to the priest in the center of *The Mass of Pope Gregory* (private collection, Zurich).[4] The ar-

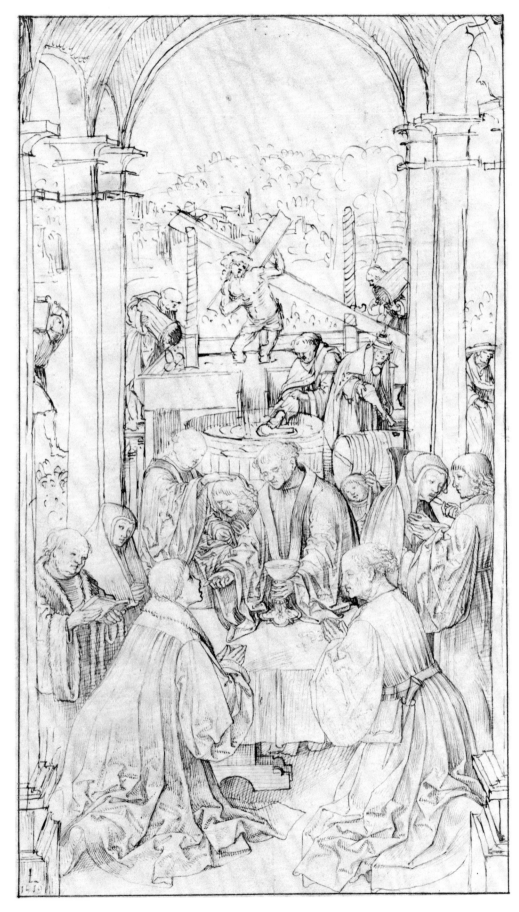

chitecture also brings to mind, but without the decoration, the sort used by Cornelisz. in the Naples *Adoration*.[5]

In this drawing, the artist has carefully worked out the details of the foreground figures, but drew those in the background less precisely. The long, continuous pen lines that sometimes cross are interspersed with shorter strokes to delineate the drapery, while the facial features are rendered in a summary fashion. This meticulous style is similar to Cornelisz.' woodcut style, which contrasts with the freer and more spontaneous penwork that merely suggests the forms in the background.

Because Jacob Cornelisz. included donors in this vertical and self-contained composition, it seems most likely, as first suggested by Friedländer,[6] that the drawing was originally conceived as a study for a single-paneled altarpiece, like the Naples *Adoration*, which also included donors. The stylistic similarities that exist between the drawing and paintings by Cornelisz. executed around 1513 suggest a date from that time for the *Allegory*. JRJ

1. Numbers 13: 17-26.
2. Timmers 1974, 93, 96, nos. 207, 217. For a later image that contains all of these elements see the 1607 print by Jerome Wierix, Knipping 1974, 1: pl. 182, of *The Old and the New Covenants*.
3. Timmers 1974, 93, no. 207.
4. These comparisons were first brought to my attention by Jane Carroll in her dissertation (in progress) on Jacob Cornelisz.
5. Amsterdam 1958, 149.
6. Friedländer 1908-1909, 50.

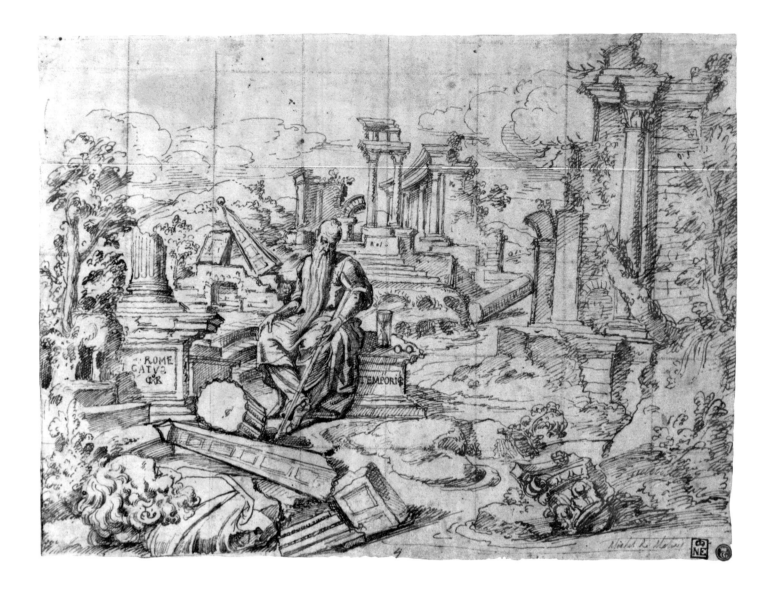

Michiel Coxcie

1499-1592

Michiel Coxcie was born in 1499 in Mechelen and studied with Bernard van Orley. Coxcie traveled to Rome around 1530, where he was strongly influenced by Raphael. Vasari tells us that Coxcie worked for many years on the frescoes in the Church of Santa Maria dell' Anima, Rome, and that he executed some fine prints. Coxcie's work in Rome, which also included frescoes for Saint Peter's, was so highly regarded that he became a member of the Accademia di San Luca. He must have returned to Mechelen sometime in or before 1539 because he was inscribed in that year in that city's

painters' Guild of Saint Luke. In 1543, Coxcie is cited in the archives as being a citizen of Brussels. After he made a copy of Hubert and Jan van Eyck's Ghent Altarpiece *for Philip II, the latter was so pleased that he gave Coxcie the title of Painter to the King. Coxcie died in 1592 in Antwerp.*

Coxcie was most important for his importation and dissemination of Raphael's style. He combined the latter's ideals with those of his teacher, Van Orley, to create a refined form of Flemish mannerism.

43 *The Triumph of Time*

Pen and reddish-brown ink, squared with red chalk
263 x 360 (10⁵/₁₆ x 14⅛)
Signed with Coxcie's monogram to the left of center; above monogram, *CATVS* and *ROME*; and to the right of figure, *TEMPORIS*; signed in bottom right corner in later hand, *Michel de Malines*

Provenance: Gelozzi (Lugt 543); Esterházy (Lugt 1965)

Literature: Hoffmann 1929, 89-93; Steinmann 1930, 80, no. 136; Van Puyvelde 1962, 460, n. 761; Dacos 1964, 28, 29; Gerszi 1971, 38, no. 60

Exhibitions: Budapest 1967, no. 35; Berlin 1975, no. 153, fig. 43

Szépmüvészeti Múzeum, Budapest, inv. no. 1332

Michiel Coxcie's *The Triumph of Time* is one of a series of five drawings based upon the Petrarch's Trionfi.[1] The Coxcie group includes *The Triumph of Love, The Triumph of Chastity, The Triumph of Death, The Triumph of Fame,* and *The Triumph of Time.*[2] Coxcie did not include the usual sixth episode, *The Triumph of Eternity.* Teréz Gerszi convincingly argues that the Budapest set is complete because the composition of *The Triumph of Time* is different from the others.[3] Saturn, symbol of time, sits quietly, suggesting the end of the series.

The concept of Saturn as the personification of time, which developed out of the illustrations of Petrarch's *Triomphi,* is based partly on classical and medieval traditions.[4] Father Time can be read as either a "Destroyer" or a "Revealer."[5] In the case of the Coxcie, he is a "Destroyer." He sits amid the ruins of Rome and holds one of his attributes, the crutch, while two others, an hourglass and spectacles, are placed to his left. Father Time is flanked by inscriptions that further emphasize his destructive character. On his right, one reads *ROME* and the strange word *CATUS*, and to the left, *TEMPORIS.* It is quite possible that Coxcie might have made a mistake in the usage of *CATUS* and really meant *CASUS*, the decay, the fall, the destruction, or the end of time.[6] It is also likely, following Mielke, that Coxcie included *ROME* to signify the destruction of the ancient city. The image itself reinforces Mielke's notion as the

setting appears to be an imaginary reconstruction of the Roman Forum. The fallen architectural fragments, the remnants of ancient temples, and the antique bust in the left foreground all suggest the ravages of time.[7] Coxcie's scene appears to be a close variation of Herman Posthumus' 1536 *Archeological Fantasy* (Liechtenstein collection, Vaduz) which Coxcie might have seen during his years in Rome. Posthumus' painting is inscribed in the bottom center, *TEMPVS EDAX RE/ RVM TVQUE INVI/ DIOSA VETVSTAS/O(MN)IA DESTRVITIS.*[8]

The carefully worked out details, the inclusion of the grid, and most important, the monumental character of this sheet and the other four in Budapest suggest that they were made as preliminary designs for tapestries. We know that Coxcie probably executed tapestry designs a few years after his return from Rome, and upon his move to Brussels in 1543. JRJ

1. Panofsky 1939, 79-81; Gerszi 1971, 37, 38.
2. All of these drawings are in Budapest. For a discussion and illustrations, see Gerszi 1971, 37, 38, nos. 56-60; pls. 55-59.
3. Gerszi 1971, 38.
4. Panofsky 1939, 74-82.
5. Panofsky 1939, 82.
6. Berlin 1975, 121.
7. See Hoffmann 1929, 90, and Steinmann 1930, 80, for the not-too-convincing idea that it is a portrait of Michelangelo.
8. Rubinstein 1985, 425-433. The translation of the above from Ovid, *Metamorphosis* 15: 234-236, reads: "Time devourer of things, and you envious age destroy all."

Gerard David

c. 1460-1523

Gerard David was born in Oudewater, near Gouda. Just when he emigrated to Bruges, or how much of his training he received there, is unclear, but in January 1484 he was admitted as a master to the painters' guild. On three occasions between 1487 and 1498 he was an officer of the guild and was dean in 1501. It is generally agreed that David was a member of the Antwerp guild in 1515, although the duration and purpose of his membership is not known. Gerard David died in Bruges on 13 August 1523.

Two panels illustrating the Judgment of Cambyses *(Groeningemuseum, Bruges) are in all likelihood the works commissioned from David for the town hall in Bruges. The documents run from 1487 to 1498/1499 and one of the panels is dated 1498. The one securely documented painting by David is the* Virgo inter Virgines *(Musée des Beaux-Arts, Rouen), which by 1509 was on the high altar of the Carmelite monastery of Sion, in Bruges. The earliest works show a certain amount of north Netherlandish character, but this was soon replaced by the influence of his older contemporary, Hans Memling, and other Bruges artists. David's influence continued well into the mid-sixteenth century in both manuscript illumination and panel painting. The archaizing tendencies in his art, the conscious quotation from the works of Jan van Eyck and Rogier van der Weyden, are offset by progressive tendencies in the areas of iconography, spatial construction, and landscape.*

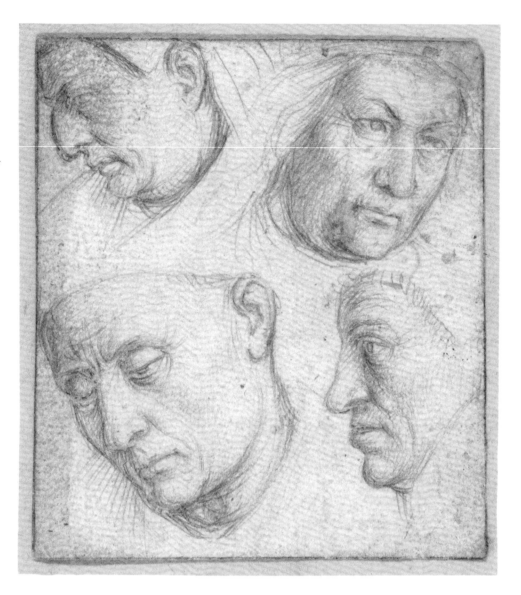

44 Four Heads

Metalpoint on cream-colored prepared paper
72 x 63 (2¹³/₁₆ x 2⁷/₁₆)
Inscribed on the verso in pen and black ink, *xxi* (visible under ultraviolet light)

Provenance: Louis Corot (Lugt Suppl. 1718, on verso); Emile Wauters (Lugt 911, on verso); (sale, Amsterdam, Frederick Muller, 18 June 1926, no. 113, as Memling); Frits Lugt (Lugt 1028, on verso); (P.&D. Colnaghi & Co., London, by 1956); acquired by the museum in 1958

Literature: Lees 1913, 61, 63; Popham and Fenwick 1965, 87-88, no. 126; Mundy 1980a, 60

Exhibitions: London 1956, no. 28; Toronto 1968, no. 1; London 1969, no. 19; Florence 1969, no. 16; Paris 1969-1970, no. 22

National Gallery of Canada, Ottawa/Musée des beaux-arts du Canada, Ottawa, inv. no. 6986

This drawing reproduces four heads from what is perhaps the greatest monument of Netherlandish painting, *The Ghent Altarpiece* of 1432 (Cathedral of Saint Bavo, Ghent), identified by inscription as the work of Jan and Hubert van Eyck. The heads are found in the center panel, *The Adoration of the Lamb*, in the group of clergy at the right foreground (fig. 1). The head at the top left of the drawing corresponds to the foremost pope; the face in profile at bottom right can be found above and to the right of the first pope; at bottom left is the head of the topmost pope at left; and the head at the top right of the drawing is that of the man at the far right facing away from the group.[1] The four heads are accurately copied and arranged symmetrically on the page. What interested the artist were

Fig. 1. Jan van Eyck, *The Adoration of the Lamb*, detail, Cathedral of Saint Bavo, Ghent (Copyright A.C.L. Brussels)

the varied physiognomies and expressions of the figures; headgear and other costume details have been omitted.

Almost certainly a page from a sketchbook, the Ottawa drawing is virtually unanimously attributed to Gerard David.[2] Both the subject matter and the technique of this sheet are tangible expressions of David's archaism. Details of Van Eyck's famous painting were preserved for future reference and use by the artist and his workshop. While the four heads apparently did not make their way into a painting, David's quotation of earlier masters is frequent. In the altarpiece of the *Virgin Enthroned* (Louvre, Paris),[3] for example, there are references to Jan van Eyck's *Madonna of Canon Van der Paele* (Groeningemuseum, Bruges) and to the Adam and Eve on the Ghent Altarpiece. The metalpoint technique, with its fine, unalterable strokes, also recalls the usage of fifteenth-century artists, but as Benesch notes, when compared with drawings from the orbit of Jan van Eyck or Rogier van der Weyden, Gerard David's use of the medium results in a more fluid, less definite articulation of form and more delicate transitions.[4] Compared to the forthright, almost severe character of the figures in Van Eyck's painting, the expressions in the Ottawa drawing appear softened and subdued, and individual lines are often rather free and calligraphic.

Winkler proposes that a group of metalpoint drawings in various public and private collections originally belonged to a single sketchbook by Gerard David.[5] Winkler's argument is for the most part convincing. Popham and Fenwick think it conceivable that the Ottawa *Four Heads* was also from the same sketchbook.[6] Mundy cautiously accepts their suggestion and finds points of comparison with individual drawings in the sketchbook group.[7] There is not, however, sufficient physical or stylistic evidence to link the Ottawa drawing with the others, and it is likely that David had more than one sketchbook.

The *Four Heads* in Ottawa is the only drawing firmly attributed to Gerard David that copies a known work of art and as such is vitally important for our understanding of this artist in relation to workshop practice and archaism in early sixteenth-century Bruges.[8] JOH

1. Popham and Fenwick 1965, 87-88, identify this last head as the foremost of the Just Judges from the outermost left wing of the altarpiece (this panel was stolen in 1934 and replaced with a copy). Careful comparison, however, indicates that this head corresponds to that on the center panel.

2. Lees 1913, 61, 63, gives the drawing to Memling.

3. Friedländer, *ENP*, 6: 2 (1971), no. 165, pls. 175-176.

4. Benesch 1957, 12-13.

5. Winkler 1913, 273-274, and more fully in Winkler 1929, 271-275. Six drawings are discussed as coming from the sketchbook: *Four Heads of Young Girls and Two Hands* (Louvre); *Seated Young Woman* (Louvre, Paris); *Standing Woman* (Edmond de Rothschild collection, Louvre, Paris); *Head of a Woman, Head of a Man* (Städelsches Kunstinstitut, Frankfurt); *Studies of Heads and Hands* (formerly Liechtenstein collection, Vienna); and *Studies of Heads* (formerly private collection, Vienna). Some of the drawings are first published in Conway 1908, 155. Friedländer 1937, 14-18, attributes all the drawings to an English follower of Gerard David. This view is not generally accepted; see Lugt 1968, 20, no. 57.

6. Popham and Fenwick 1965, 88, note that some of the sketchbook pages were damaged by water and suggest this might have been the reason that the Ottawa drawing was cut. They also associate the number *xxi*, visible in ultraviolet light on the verso, with the numerals found on the recto of the *Four Heads of Young Girls* and also on the Rothschild *Standing Woman*. The possible connection with the sketchbook is mentioned in London 1956, no. 28.

7. Mundy 1980a, 55-60; he finds the Ottawa drawing stylistically close to the two sheets of heads and hands (formerly private collection and Liechtenstein collection, Vienna). Because the verso of the Frankfurt sheet contains a study for David's painting, the *Arrest of the Unjust Judge*, dated 1498, Mundy dates the sketchbook around 1497/1498-1500. He has added to the sketchbook the drawing of *Three Female Heads* in the National Museum, Krakow (Czartoryski collection). The Krakow drawing bears a numeral, *xiii*, on the verso.

8. In a paper presented at the colloquium *Dessin sous-jacent et autres techniques graphiques*, held at Louvain-la-Neuve, 29-30 September—1 October 1983, Maryan Ainsworth attributes to Gerard David the pen drawing in Berlin (Bock and Rosenberg 1930, no. 579), which copies Van Eyck's *Madonna of the Fountain*. The attribution is based in part on the similarity to the underdrawing revealed by infrared reflectography in the *Madonna and Child* in the Metropolitan Museum of Art (Wrightsman collection). The drawing has so much of the character of a copy that I find it hard to discern David's hand.

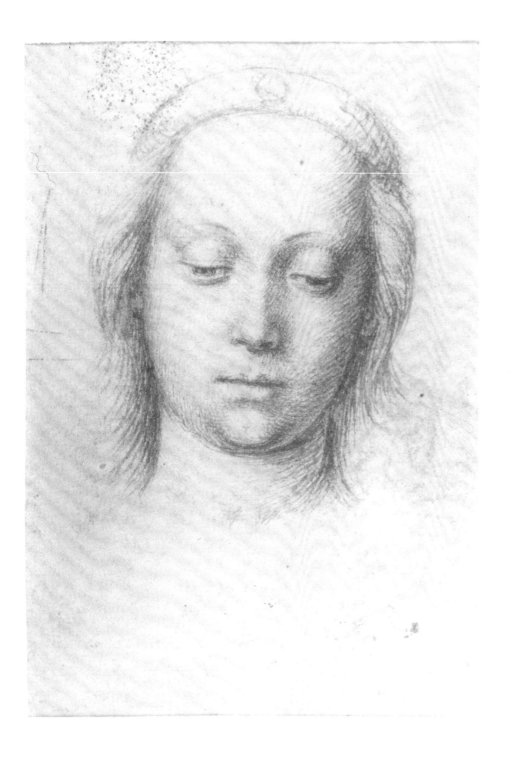

GERARD DAVID

45 *Head of a Girl*

Brush and black ink with traces of black chalk, and touches of white body color
(verso: *head of a man; study of a tree*, fig. 1; silverpoint on prepared paper)
142 x 102 (5 ⅝ x 4)

Provenance: Bequest of E. G. Harzen, Hamburg, 1863

Literature: Pauli 1924, 1: no. 1; Winkler 1929, 274, n.1; Lugt 1968, 20, no. 57; Mundy 1980a, 60-61

Hamburger Kunsthalle, Kupferstichkabinett, Hamburg, inv. no. 21575

This drawing is seldom discussed, even within the already meager literature on Gerard David's drawings. The *Head of a Girl* has unjustly suffered from critical neglect and doubt. Pauli thinks that the head was overdrawn in ink at a later date, while Winkler raises the possibility that it was by another, coarser hand than David's. The silverpoint drawing on the verso was accepted as autograph by Pauli, Winkler, and Mundy.

There can be very little doubt, how-ever, that the *Head of a Girl* is from the hand of Gerard David. The heavily lidded eyes and oval face with pointed, slightly dimpled chin are features of the idealized type of woman used by David for Madonnas and female saints. Although the head does not correspond exactly to that in any extant painting, it is closest to the face of the Virgin in paintings of the *Rest on the Flight into Egypt*.[1] The precise function of the Hamburg sheet is unknown; it might have been used for a

132

Fig. 1. Cat. 45, verso

specific project or have served as a model
for general use by David and his atelier.

The *Head of a Girl* illustrates Gerard
David's quiet virtuosity. Almost all of
David's extant drawings were done in sil-
verpoint and here we see him using the
point of the brush in the manner of a
metal stylus. Long, parallel strokes and
dense networks of intersecting lines build
up the volume and roundness of the head.
The multiple strokes and absence of defi-
nite contours create the softness typical
of David's drawings.

The silverpoint drawing on the verso
appears to have been done from nature,
recording the features of an individual.
Attention is focused on the face, while
the hair is summarily rendered in a few
light strokes. The verso may be compared
to the studies of men's heads (formerly
private collection, Vienna) included by
Winkler in his reconstructed sketch-
book.[2] There is no evidence that the
Hamburg sheet was part of this
sketchbook.[3] JOH

1. Specifically, the paintings in the Prado, Madrid,
Museum Boymans-van Beuningen, Rotterdam, and
National Gallery of Art, Washington, Friedländer,
ENP 6: 2 (1971): nos. 212-214, pls. 215-217.
2. Repro. Winkler 1929, 272.
3. Mundy 1980a, 61, does not believe the drawing
was part of the sketchbook, though Lugt 1968, 20, in-
cludes it in his discussion of the sheet of girls' heads
and hands in the Louvre.

Cornelis Engebrechtsz.

c.1465-1527

*Our knowledge of the life and career of
Cornelis Engebrechtsz. is quite limited
and based in large part on Van Mander's
brief account in* Het Schilder-boek. *Van
Mander states that the artist was born in
1468, but a slightly earlier date has been
suggested. There is no indication of
where and with whom Engebrechtsz.
first studied. We do know that, by 1487,
he was married and living in Leiden.
Housing income records and lists from
the various archers' guilds indicate that
Engebrechtsz. spent his life in Leiden,
though he may have traveled for short
periods. There are no dated or docu-
mented paintings. Bangs has established
that Engebrechtsz. died sometime be-
tween 11 February and 26 August 1527.*

*Of the four paintings mentioned by
Van Mander, two have survived intact,
the* Lamentation *and* Crucifixion *altar-
pieces; originally done for the Augustin-
ian convent at Marienpoel outside Lei-
den, both are now in the Stedelijk Mu-
seum "De Lakenhal" in Leiden. In the
same museum are the wings, depicting
donors, from a triptych that hung in the
Pieterskerk, Leiden, and cited by Van
Mander as belonging to the Lochorst
family of Utrecht. The* Lamentation *al-
tarpiece of c. 1508 demonstrates an
awareness of art in Brussels, while the*
Crucifixion *altarpiece, c. 1517/1522,
shows strong affinities with the work of
the Antwerp mannerists.*

*Cornelis Engebrechtsz. was the first
major painter in Leiden and the head of
a large workshop. His three sons, Pieter
Cornelisz. (Kunst), Cornelis Cornelisz.
(Kunst), and Lucas Cornelisz. (Cock),
were painters. His pupils included Aert
Claesz., called Aertgen van Leyden, and
Lucas van Leyden.*

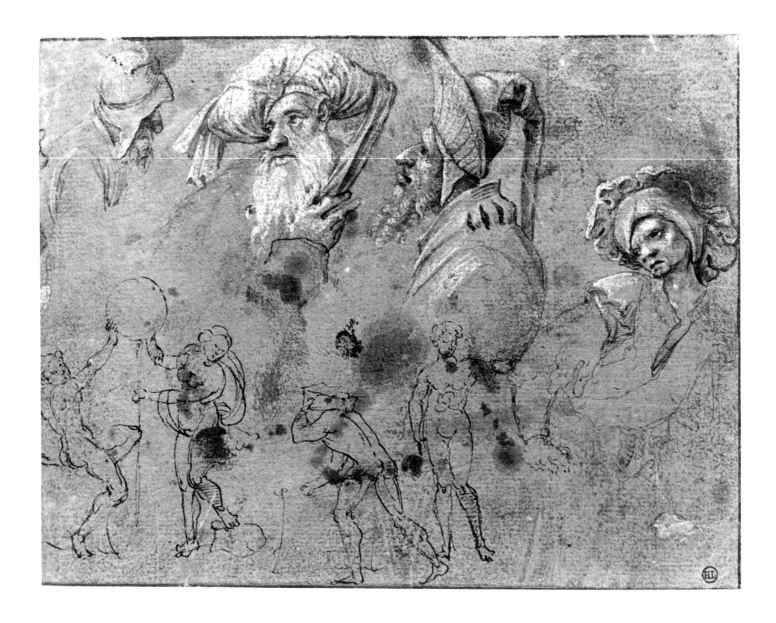

CORNELIS ENGEBRECHTSZ.

46 *Study Sheet with Four Heads*

Brush, pen, and gray and brown ink, with white heightening on blue-gray prepared paper
121 x 160 (4¾ x 6⁵⁄₁₆)
(verso: drapery study)

Provenance: His de la Salle (Lugt 1333); acquired by museum 1894

Literature: Gerszi 1960, 233-236; Gerszi 1971, 40-41, no. 69 a-b; Kloek 1974, 107; Gerszi 1976, no. 1; Gibson 1977b, 113, 244, no. 26, 264, under no. 82

Exhibitions: Budapest 1932, no. 6; Budapest 1967, no. 6; Washington 1985, no. 63

Szépmüvészeti Múzeum, Budapest, inv. no. 1413

The small size of this sheet and the use of the verso for a drapery study indicate that this was almost certainly a page from a sketchbook. The four heads at the top of the drawing were first given to Cornelis Engebrechtsz. by Gerszi[1] and subsequently, this attribution has found general though not unanimous acceptance.[2] The nude figures at the bottom of the page are by another hand; Oberhuber has observed that they were copied from an engraving by Marcantonio Raimondi.[3]

Modeled primarily in white heightening in a painterly manner, these heads are remarkable for their expressiveness and immediacy of characterization. In the center are two old men with Semitic features; one wears an orientalizing turban, the other a tall, extravagant hat. At the right is a younger man with an obviously malevolent visage. These are distinct "types" whose exaggerated features probably owe more to imagination than observation.

Boon first observed that these four heads were used in a *Crucifixion* altarpiece in the Národní Galerie, Prague.[4] The two center heads were used for the Pharisees who witness the Crucifixion on the center panel, while the beardless man on the right appears as one of Christ's tormentors in the scene of Christ Carrying the Cross on the interior left wing. Gibson assigns the Prague triptych to Engebrechtsz.' workshop and dates it after 1520.[5] The heads in the painting resemble those in the drawing, thus indicating that the drawing was available in the atelier, but one also wonders if the painting replicates a now lost original.

Fig. 1. Cornelis Engebrechtsz., *Salome with the Head of John the Baptist*, private collection (Courtesy of Christie, Manson & Woods, London)

The absence of dated or datable pictures has led to differing opinions on the chronology of Engebrechtsz.' work.[6] Gibson, who has perhaps established the most viable sequence for Engebrechtsz.' paintings, dates the Budapest sheet in the same period as the *Crucifixion* altarpiece in Leiden, c. 1517/1522, and sees it as close to another *Crucifixion* altarpiece (Öffentliche Kunstsammlung, Basel) which he dates around 1515.[7] This dating is further strengthened by the associations of these works with the style known as Antwerp mannerism. In the drawing it is mainly expressed in the elaborate headgear worn by the two center figures. Although contacts between Leiden and Antwerp must have been

close, defining the precise relationship between Engebrechtsz., his atelier, and the Antwerp mannerists is a vexing and unresolved problem. Engebrechtsz. may have visited Antwerp or members of his shop could have received their training there.[8]

The *Study Sheet with Four Heads* occupies a particularly important place in Engebrechtsz.' oeuvre as one of the only two drawings that are considered autograph. The second drawing, *Salome with the Head of John the Baptist* (fig. 1), recently at auction, has been compared to Engebrechtsz.' earliest paintings and dated around 1490.[9] Even though it is different in function and style, there is a bond with the Budapest drawing in its painterly use of white heightening to model form. JOH

1. Gerszi 1960, 233-236.
2. Boon, as cited by Gerszi 1971, 41, believes the drawing was a copy by an Antwerp mannerist after an Engebrechtsz. painting. Kloek 1973, 107, calls it a copy after Engebrechtsz.
3. Cited by Gerszi 1971, 41; repro. *The Illustrated Bartsch*, 356.
4. Gerszi 1971, fig. 8.
5. Gibson 1977b, 264-265, no. 82.
6. See the discussion in the Editor's Notes in Friedländer, *ENP*, 10 (1973): 92-93.
7. Gibson 1977b, 113; the Leiden and Basel *Crucifixions* are reproduced in Friedländer, *ENP*, 10 (1973): no. 71, pls. 60-62, and no. 73, pl. 63.
8. Gibson 1977b, 4-6, and in his discussion of the Leiden *Crucifixion*, 103-106, touches on this problem. He thinks, for example, that the middle ground figures of the Basel *Crucifixion* were executed by an artist trained in Antwerp. The possibility that this artist might be one of Engebrechtsz.' sons, Lucas or Cornelis, is not excluded. This problem becomes more pronounced in the attempts to determine whether a group of pictures was painted by the Antwerp artist Jan Wellens de Cock or by a member of Engebrechtsz.' entourage.
9. Sale, Christie's, London, 12-13 December 1985, no. 329; Gibson 1977b, 33, 41, 244, no. 25.

Frans Floris

1519/1520-1570

Born in Antwerp, Frans Floris was the second of four sons of a stone carver, Cornelis de Vrient, also named Floris. All four sons became artists; the eldest, Cornelis Floris II, was an eminent sculptor and architect. Less is known about Jan, a potter, and Jacob, a glass painter. Although probably first trained as a sculptor, in 1539 Frans studied painting in Liège with Lambert Lombard, who had just returned from Italy. He did not stay long and in 1540 was inscribed as a master in the painters' guild in Antwerp.

Frans Floris was probably in Italy from 1541 until 1547. In Rome he made sketches after antique sculpture and figures in Michelangelo's Sistine ceiling and also, according to Van Mander, made studies of Michelangelo's recently completed Last Judgment in the Sistine Chapel. Although no drawings survive he must have also studied the paintings from Raphael's school in the Loggia of the Vatican, for motifs from them appear later in his paintings. In Mantua Floris made drawings after Giulio Romano's frescoes and also visited Genoa and, quite probably, Venice. The artist is recorded as being in Antwerp on 29 October 1547, the date of his marriage to Clara Boudewijns. His earliest signed and dated work, the Mars and Venus Surprised by Vulcan (present location unknown) was executed the same year.

From the 1550s until his death on 1 October 1570, Frans Floris was a dominant figure in Antwerp. Both Guicciardini and Vasari praise him as the preeminent living painter in the Netherlands.

Highly successful and productive, he was the head of a large atelier and owned a splendid house. Floris' figures of the 1550s are marked by a monumentality and sculptural energy that is indebted to Michelangelo. This is particularly evident in the muscular, twisting bodies in The Fall of the Rebel Angels (Koninklijk Museum, Antwerp), painted in 1554 for the altar of the swordsmen's guild in the Cathedral of Our Lady, Antwerp. In addition to numerous altarpieces done for churches in Delft, Zoutleeuw, and Brussels, as well as Antwerp, Floris was equally adept at mythological compositions such as The Banquet of the Gods of 1550 (Koninklijk Museum, Antwerp) or the series, The Labors of Hercules (now known only through engravings), which decorated the house of the rich merchant Nicolaas Jongelinck. In the 1560s Floris' style became more painterly and there is a greater breadth of composition. He was also an outstanding portraitist whose works are notable for their incisive characterization.

Many of Floris' drawings survive; they are executed in a variety of media and include quick sketches and more finished compositional studies for paintings. He also produced numerous designs for prints engraved by Cornelis Cort, Frans Menton, and others. This, coupled with the great number of assistants and pupils who passed through the studio, helped to ensure the popularity of the "Floris style" that was practiced in Antwerp until the end of the century.

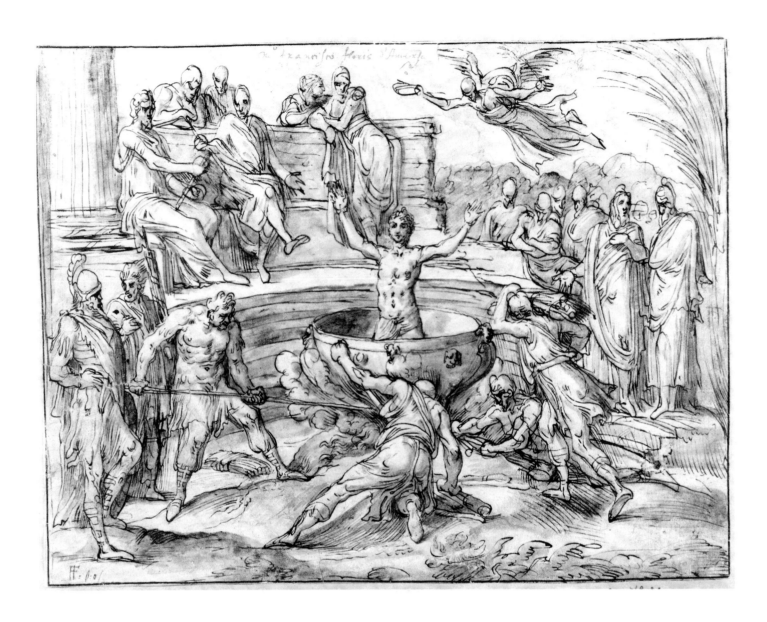

FRANS FLORIS

47 *Saint John the Evangelist in Boiling Oil*

Pen and brown ink, reddish-brown wash,
traces of black chalk; backed
233 X 305 (9³⁄₁₆ X 12)
Inscribed at lower left in brown ink, *FFipio*; at
top center in brown ink, *m° francisco floris
d'Anversa*; on the verso, in graphite, *Franc
Floris*

Provenance: Baron Adalbert von Lanna (d.
1909); (sale, Gutekunst, Stuttgart, 6-11 May
1910, no. 587); Jean de Grez, Brussels (d. 1910);
given by his widow to the Belgian State in
1913

Literature: Bastelaer 1913, no. 2; Delen 1944,
83; Van de Velde 1969, 261-263; Van de Velde
1975, 365-366, no. T30; Boon 1977, 510

Exhibitions: Atlanta 1980, no. 15

Musées Royaux des Beaux-Arts de Belgique,
Brussels, inv. no. 3940

This important drawing depicts an epi-
sode from the legend of John the Evangel-
ist. John was preaching in Ephesus when
he was arrested and, on the order of the
Emperor Domitian, brought to Rome.
There, he was ordered to be publicly exe-
cuted by being plunged into a cauldron of
boiling oil. Although celebrated as a mar-
tyr by the church, John was unharmed by
the experience and is shown here raising
his arms in triumph over his tormentors.
The Emperor Domitian, who is probably
one of the seated figures at the upper left
holding a baton, subsequently exiled John
to the island of Patmos.

Because of his ability to survive intense
heat and boiling oil, several professions,
including armorers and candlemakers,
claimed John the Evangelist as a patron

saint.[1] The Brussels sheet is evidently a
compositional sketch, most probably for
a painting, and while no work survives, it
is not inconceivable that the drawing is
related to a project for a guild altarpiece.
One of Frans Floris' earliest works, the
drawing is dated c. 1547 by Van de Velde
and was probably made just after the
artist's return from Italy.[2] The closest
comparison is with several drawings (Öf-
fentliche Kunstsammlungen, Basel, Kup-
ferstich-Kabinett) from a sketchbook
from the Roman period. There, in pen,
brown ink, and brown wash, Floris re-
corded antique sculpture, accessories, and
decorative elements from the Column of
Trajan, and figures from Michelangelo's
Sistine ceiling.[3] Despite the obvious dif-
ference in function, the figures in the

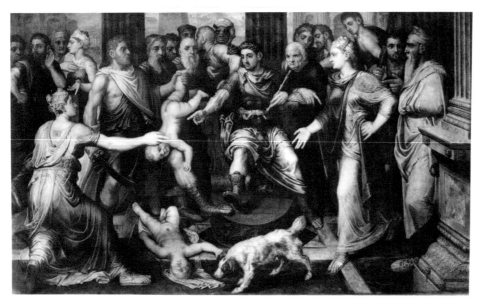

Fig. 1. Frans Floris, *The Judgment of Solomon*, Koninklijk Museum voor Schone Kunsten, Antwerp (Copyright A.C.L. Brussels)

Basel and Brussels drawings are similar in their slim, elongated bodies, small heads often rendered as ovals, and large feet. These characteristics are also present in a compositional sketch, *The Beheading of John the Baptist* (Staatliche Kunstsammlungen, Kupferstich-Kabinett, Dresden) which is dated somewhat later, around 1550.[4]

Floris' early style, as seen here and also in his paintings, is notable for its frequent quotation from the antique. The angel who hovers over John the Evangelist, holding a wreath and the palm branch of martyrdom, is clearly a winged Victory such as those found on sarcophagi. The artist's copies of antique sculpture also provided him with details of costume and ornament such as the helmet on the figure at the extreme left or the togas of the two men standing at the right. Although mannerist in their elongation and contrapposto—note particularly the kneeling figure in front of John—Floris' figures have not acquired the Michelangelesque fullness and muscularity of the 1550s; they are somewhat stiff and in places anatomically incorrect.

The strength of this drawing lies rather in its composition for, like his Italian counterparts, Floris was essentially concerned with the pose and arrangement of the human figure. Within the rather shallow space formed by the ruins of a semicircular temple, the artist created a basically symmetrical and balanced composition. Through the careful calibration of posture and gesture, attention is directed toward the focal point of John the Evangelist whose pose generally recalls that of

the same saint in Quentin Massys' *Lamentation* altarpiece (Koninklijk Museum, Antwerp).[5]

Several of the figures in *Saint John the Evangelist in Boiling Oil* were used by Floris in his painting of *The Judgment of Solomon* (fig. 1, Koninklijk Museum, Antwerp), which dates from the same period, for as observed by Van de Velde, in the painting the man at the right wearing a toga corresponds to the figure at the far right of the drawing, while the striding pose of the executioner holding the infant echoes that of the man stoking the fire.[6] This same figure also recurs in Philip Galle's engraving after Floris of *The Building of the Temple of Solomon.*[7] While the Brussels sheet may be the direct source, it is equally likely these figures were part of a model or sketchbook kept in the studio. JOH

1. Réau, *Iconographie*, 3:2, (1958) 710-711.
2. Van de Velde 1975, 365-366, no. T30.
3. For a discussion of the problems surrounding the sketchbook, which is incomplete, and contains copies after Floris' drawings, see Van de Velde 1969 and Van de Velde 1975, 335-361, nos. T1-25.
4. Van de Velde 1975, 367-368, no T33, fig. 131.
5. Friedländer, *ENP*, 7 (1971): no. 1, pl. 3. Massys' altarpiece, completed in 1511, was installed in the chapel of the joiners' guild in the Cathedral of Our Lady, Antwerp.
6. Van de Velde 1969, 262-263, and 1975, 365, sees, in addition, a relationship between the pose of the man at the center of the Brussels drawings and the kneeling figure of the true mother at the left of the painting.
7. Van de Velde 1975, fig. 171. The figure carrying wood on his shoulder at the right foreground of the drawing has become a wood carrier in the engraving. Even though the engraving is dated 1558, Van de Velde 1969, 263, and 1975, 158, believes that it may reflect a lost painting that belonged with the Antwerp *Judgment of Solomon* as part of a series.

Jacques de Gheyn II

1565-1629

Jacques de Gheyn II was born at Antwerp in 1565. His father and first teacher, Jacques de Gheyn I, was a glass painter, miniaturist, and designer of prints. Although little of Jacques I's work survives, Van Mander reports that he executed important windows in Antwerp and Amsterdam churches. After his father died in 1581, Jacques II emigrated to the North. About 1585 he joined the workshop of Hendrick Goltzius in Haarlem. We do not know the precise nature of their professional relationship, but De Gheyn's early drawings and engravings attest to the profound influence of Goltzius' art on his development. After two years with Goltzius, De Gheyn established his own printmaking business, first in Haarlem, then in Amsterdam, where he settled by April 1591. His marriage in 1595 to Eva Stalpaert van der Wiele, who belonged to a wealthy and prominent family, brought him financial independence. Shortly after the wedding, the couple moved to the university town of Leiden, where De Gheyn befriended some of the leading humanists and scientists of the period. By 1603 they moved to the The Hague and Jacques remained

there until he died in 1629. In The Hague, he enjoyed the patronage of the Stadholder Prince Maurits and his court. Maurits commissioned the influential weapons manual, Wapenhandelinghe (Maniement d'armes), illustrated with 117 engravings after drawings by De Gheyn, which appeared in 1607. Emperor Rudolf II also collected De Gheyn's work around 1600. The artist's pupils included several engravers and his son Jacques III.

Like Goltzius, De Gheyn took up painting c. 1600, and shortly thereafter ceased engraving. About twenty works in oil have come down to us. But it is thanks to the hundreds of surviving drawings that De Gheyn ranks among the greatest Netherlandish masters and as the most important transitional figure between the late Renaissance and the art of seventeenth-century Holland. While some works, including his religious compositions, witchcraft scenes, and many of the landscapes, continue earlier traditions, his portraits, figure studies, scenes from daily life, and delicate renderings of plants and animals are characterized by the empirical outlook and realistic style of Dutch baroque art.

48 Three Studies of a Dragonfly

Pen and brown ink over traces of black chalk
152 x 189 (6 x 7⁷/₁₆)

Provenance: (sale, London, Christie's, 3 May 1979, lot 46)

Literature: Van Regteren Altena 1983, 2: no. 2-900a; Paris 1985 (De Gheyn), under no. 9, 32, 12; Rotterdam 1985-1986, under no. 81

Maida and George Abrams Collection, Boston, Massachusetts

About 1630 Constantijn Huygens, the cultivated son of the stadholder's secretary, described the thrill of his first look through a primitive microscope. He lamented that his recently deceased neighbor in The Hague, Jacques de Gheyn, had not survived to draw the previously invisible microorganisms with his fine brush. De Gheyn's studies, he wrote, could have been engraved and published in a book entitled *The New World*.[1] Huygens' remarks attest that De Gheyn's contemporaries considered him the peerless draftsman of small creatures.

Although a few of De Gheyn's animal drawings evoke the violence and tragedy of death, or present grotesque fantasies reminiscent of his witchcraft subjects (cat. 53), most aspire to preserve an objective record of a specimen. *Three Studies of a Dragonfly*, which shows frontal, rear, and lateral views of the insect, exemplifies his close adherence to the principles of scientific illustration.[2] Over preliminary notations in black chalk, De Gheyn employed a medley of penstrokes to distinguish the different components of the dragonfly's anatomy. Gentle stippling describes the grainy translucence of the wings in the lateral view, while short, parallel strokes from a heavily charged pen convey the hairy surfaces of the thorax and legs and the dark glossiness of the eyes. In company with the better-known sheets that depict various views of a mouse, a frog (fig. 1), a blowfish, a turtle, and a fly, this drawing testifies to De Gheyn's readiness to use his talents as a draftsman to probe and analyze the natural world.[3] Like those works, *Three Studies of a Dragonfly* displays not only mimetic skills, but a delicacy and subtlety that transcend mere illustration.

De Gheyn developed his pen technique and his capacity to achieve an accurate likeness on a tiny scale in the miniature portraits he executed in ink or metalpoint during the early years of his career, when the work of Goltzius greatly influenced his style. Only after he settled in

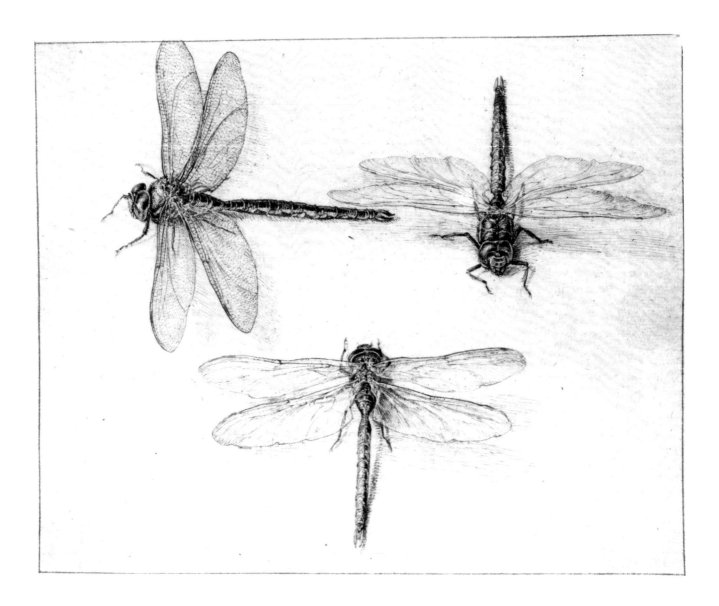

Leiden, with its university, scholars, botanical garden, and collections of *naturalia*, did he turn his attention to portraying animals and plants. During his residence there c. 1596-1601/1602, De Gheyn met the renowned botanist Carolus Clusius (1526-1609), who came to Leiden in 1593 to supervise the creation of the *Hortus Botanicus* for the new university. De Gheyn engraved his portrait in 1600 and designed the title page for Clusius' *Rariorum plantarum historia*, which appeared in Antwerp in 1601.[4]

Contact with Clusius and other scientists must have stimulated De Gheyn, shortly before the turn of the century, to scrutinize the natural world. A lost "flower-piece with insects, finely painted in watercolors . . . on vellum" and dated 1598, is his earliest recorded work of this type.[5] It probably resembled a page in an album of watercolors he executed be-

tween 1600 and 1604. Twenty-two leaves from this volume, which must be the "little book" described by Van Mander and acquired in 1604 by Emperor Rudolf II, have survived, and they constitute one of the seminal masterpieces of Dutch still-life art.[6] One page includes, among other insects, a dragonfly that closely resembles the one at the upper right of the sheet exhibited (fig. 2). To render the wings in watercolor; De Gheyn used a more elaborate variation on the stipple technique he employed at the upper left in the drawing. Despite minor differences between the dragonflies in the two works, De Gheyn may have referred to the study when executing the watercolor. If so, the drawing must date from 1600— the year inscribed on the finished work— or earlier, making it one of his first essays in the representation of small *naturalia*.[7]

De Gheyn also depicted a dragonfly, which is not directly related to any of these studies, on a sheet with various animals in a New York private collection.[8]

WWR

1. Alpers 1983, 6-8; Van Regteren Altena 1983, 1: 137. Huygens' remarks on De Gheyn appear in the fragment of his autobiography, which remained in manuscript until the late nineteenth century. He began to write it in 1629, not long after he attended De Gheyn's deathbed.
2. See Judson 1973, 15-16, for a discussion of De Gheyn's understanding of anatomical procedures. To my knowledge, De Gheyn's position in the history of botanical and zoological illustration has not been thoroughly studied.
3. Van Regteren Altena 1983, 2: nos. 865, 866, 887, 888, 896, 888-900.
4. For Clusius and his relationship to De Gheyn, see Van Regteren Altena 1983, 1: 66-69; Paris 1985 (De Gheyn), nos. 48, 52.
5. Van Regteren Altena 1983, 2: no. 932. The watercolor was recorded in the sale of the W. Y. Ottley collection in 1814.

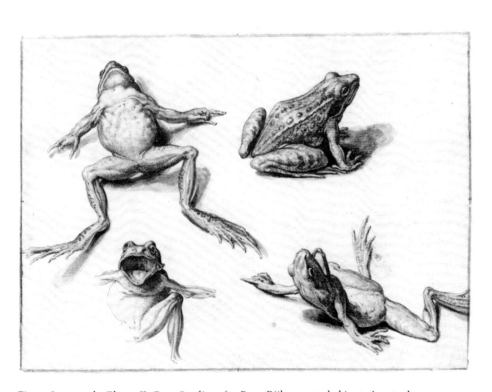

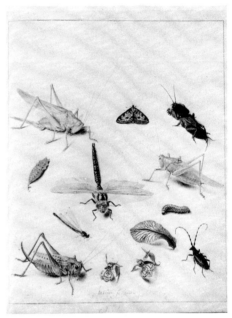

Fig. 1. Jacques de Gheyn II, *Four Studies of a Frog*, Rijksprentenkabinet, Amsterdam

Fig. 2. Jacques de Gheyn II, *Study Sheet with Insects and Flowers*, Fondation Custodia (Coll. F. Lugt), Institut Néerlandais, Paris

6. The album is in the Fondation Custodia, coll. F. Lugt, Paris. See Van Regteren Altena 1983, 2: nos. 909-930, and Paris 1985 (De Gheyn), no. 9.
7. Paris 1985 (De Gheyn), under no. 9, 32, n. 12, where Carlos van Hasselt suggests that the drawing is probably a study for the dragonfly on folio 11 of the Lugt album (here fig. 2).
8. Van Regteren Altena 1983, 2: no. 508; Rotterdam 1985-1986, no. 81.

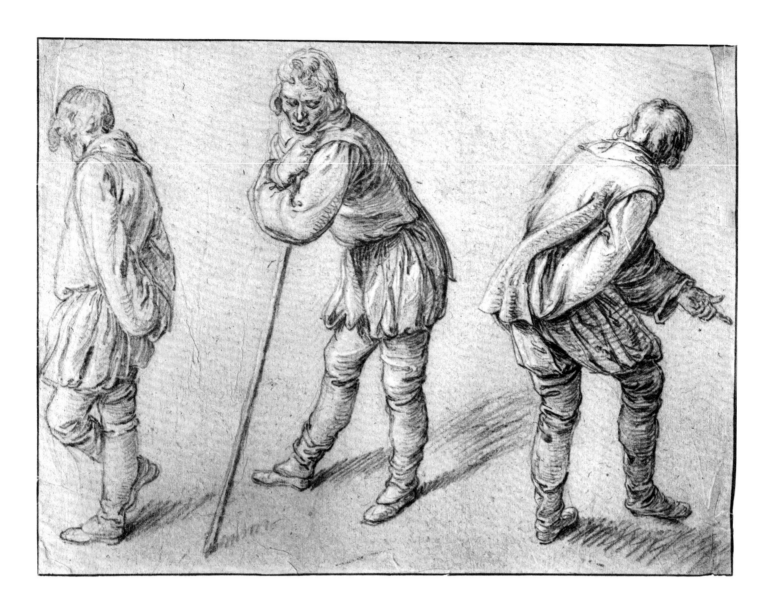

JACQUES DE GHEYN II

49 *Three Studies of a Standing Man*

Black chalk heightened with white body color
256 x 342 (10¹/₁₆ x 13½)

Watermark: Hand (Briquet 11321)

Provenance: Purchased by the Rijksmuseum,
Amsterdam, from Frederik Muller, Amster-
dam, 1885

Literature: Van Regteren Altena 1936, 46; Jud-
son 1973, pl. 78; Boon 1978, 1: 75-76, no. 216,
Van Regteren Altena 1983, 1: 82, 93, and 2: no.
2-30, and 3: pl. 245; Rotterdam 1985-1986, un-
der no. 93

Exhibitions: Amsterdam 1978, no. 56; Amster-
dam 1981-1982, no. 52, 36

Rijksprentenkabinet, Rijksmuseum, Amster-
dam, inv. no. A 473

With the odd exception, such as Lambert
van Noort (cat. 89), Netherlandish artists
did not make figure studies from live
models until the 1590s, when Hendrick
Goltzius (cat. 60), Cornelis van Haarlem,
and Karel van Mander occasionally drew
from the nude.[1] Around 1599 De Gheyn
began to sketch people he encountered on
his daily rounds, and somewhat later he
started to work regularly from studio
models. Like the *naer het leven* drawings
Roelandt Savery produced after arriving
in Bohemia in 1603 (cat. 102), De
Gheyn's studies from life introduce the
realistic style and the approach to figure
drawing characteristic of the seventeenth
century.

Three Studies of a Standing Man epito-
mizes both the new style and De Gheyn's

practice of working from the model. Here
he used black chalk heightened with a
little white body color on a grainy oat-
meal paper, while on other occasions he
chose pen and ink or a combination of
ink and black chalk (fig. 1 and cat. 52) for
his figure studies.[2] De Gheyn applied the
chalk with a stunning range of strokes,
from the spontaneous, loose scribbles
that evoke the hair and clothing in the
study at the left, to the tight coils of long
zigzags—vestiges of the mannerists' de-
light in linear display—that model the
leggings and jerkin of the figure at the
center.

Comparison with the imposing female
nude by Goltzius (cat. 60) illustrates the
originality of De Gheyn's approach.
Goltzius' elegantly posed nude retains a

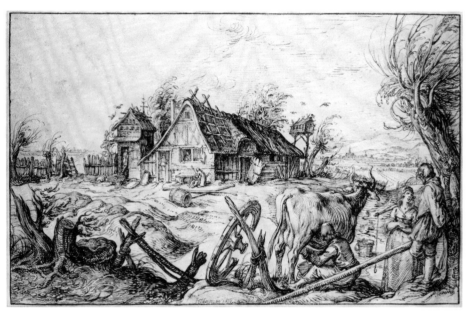

Fig. 1. Jacques de Gheyn II, *A Kneeling Shepherd*, Collection I.Q. van Regteren Altena Heirs, Amsterdam (Courtesy Kunsthistorisch Instituut, University of Amsterdam)

Fig. 2. Jacques de Gheyn II, *Landscape with Farmhouses*, Rijksprentenkabinet, Amsterdam

measure of the idealization dictated by his reverence for the canons of beauty established in classical sculpture. The modeling of her body recalls equally the sensuousness of flesh and the smooth suppleness of polished marble. In De Gheyn's studies, the unrefined proportions, plebeian face, and natural stance of the figure unite with the meticulous description of the rough textures of his clothes. The result is a vivid impression of actuality that places this sheet among the early masterpieces of seventeenth-century Dutch realism.

This drawing relates to two others showing the same young man as a kneeling shepherd (fig. 1), which suggested to Van Regteren Altena that De Gheyn made the studies in preparation for a painting of The Adoration of the Shepherds.[3] Although his supposition is entirely plausible, we have no record of such a picture by the artist. In any event, De Gheyn did use the figure at the left in a drawing that depicts a youth chatting idly with a milkmaid in a ramshackle farmyard (fig. 2). This finished landscape composition is signed and dated 1603, which provides an approximate date for *Three Studies of a Standing Shepherd*.[4] Hans Mielke has interpreted the farmyard scene as an allegory of sloth and its consequences.[5] W W R

1. See cats. 89 and 60 for nude studies by Lambert van Noort and Goltzius.
2. See, for example, Van Regteren Altena 1983, 2: nos. 2-551, -559, -634, -639, and -800 through -808.
3. Van Regteren Altena 1983, 1: 82, and 2: no. 2-30. The two related studies are Van Regteren Altena 1983, 2: nos. 2-31 and 2-32 (here fig. 1). The figures at the center and the left were copied by Hendrick Goudt and grouped as they might have been in an Adoration of the Shepherds; Van Regteren Altena 1983, 1: 156, fig. 117. However, there is no evidence that they were copied from any work other than the drawing exhibited here. See also Amsterdam 1981-1982, no. 52, where Schatborn notes that the sleeping youth in De Gheyn's *Landscape with the Devil Sowing Tares* (Van Regteren Altena 1983, 2: no. 2-50), also of 1603, wears the same clothing as the young man in these five studies.
4. Van Regteren Altena 1983, 2: no. 2-950; Rotterdam 1985-1986, no. 93.
5. Mielke 1980, 46.

JACQUES DE GHEYN II

50 *Landscape with Bandits*

Pen and brown ink, over traces of black chalk; laid down
237 X 391 (9⁵⁄₁₆ X 15³⁄₈)
Signed at lower right, in brown ink, *IDG* (in ligature) *heijn.in.1603*

Provenance: Elector Karl Theodor von der Pfalz, Mannheim

Literature: Grosse 1925, 8; Van Gelder 1933, 21, no. 2; Reznicek 1961, 171-172; Judson 1973, 21, 25, 43; Wegner 1973, no. 576; Van Regteren Altena 1983, 2: no. 2-959, 3: pl. 259; Rotterdam 1985-1986, under no. 97

Exhibitions: Frankfurt 1966-1967, no. 238; Munich 1983-1984, no. 59

Staatliche Graphische Sammlung, Munich, inv. no. 1080

The astonishing diversity displayed in Jacques de Gheyn's landscape drawings reflects his broad interest in earlier artistic traditions, his capacious imagination, and his curiosity about the natural world. They range from realistic scenes of the Dutch coast and countryside (fig. 1) to encompassing panoramas as fantastic as any Bruegelian *Weltlandschaft*. His imaginary vistas abound with the precipitous mountains, vast bays, natural bridges, and picturesque castles that crop up consistently in sixteenth-century landscapes. De Gheyn, like Goltzius, imitated the works of his renowned predecessors, and occasionally paid conspicuous homage to them: one spectacular sheet derives directly from a painting by Patinir or one of his followers, while others adopt the styles and compositional motifs of Bruegel, the Master of the Small Landscapes, and more recent artists such as Paul Bril and Goltzius.[1]

De Gheyn not only invented or mastered several modes of representation, but he practiced them more or less simultaneously. His development by no means traces a linear progression from archaizing fantasies to the intimate views of the Dutch scene that inaugurate the landscape art of the new century. In 1602, for example, he made a study from life of fishermen and their boats on a beach that ranks alongside Goltzius' sketches of 1600 and 1603 as one of the crucial incunabula of Dutch realism (fig. 1).[2] The following year, 1603, De Gheyn produced the signed and dated work exhibited here, which was not drawn from nature, but composed in the studio, and has little to do with the nascent realistic style.

Many of De Gheyn's finished landscapes follow a respected sixteenth-century convention, and the present sheet is no exception.[3] Here he emulated the Venetian tradition of Titian and Domenico Campagnola as mediated through the work of Goltzius. In his didactic poem of 1604, Karel van Mander urged Netherlandish landscapists to study woodcuts after Titian, and the work of Titian and Campagnola certainly influenced such drawings by Goltzius as *Landscape with Mercury* of 1596 (fig. 2).[4] De Gheyn imitated Goltzius' vigorous touch, executing his drawing with forceful strokes of a pen heavily charged with ink, and modeling the swelling banks of earth—a characteristic element of the Venetian prints—with dense combinations of parallel, zigzag, and crosshatched lines. De Gheyn's composition, like Goltzius', achieves an impressive effect of space through the pronounced diagonal movement from one corner of the

Fig. 1. Jacques de Gheyn II, *Fishermen on the Shore*, Städelsches Kunstinstitut, Frankfurt

Fig. 2. Hendrick Goltzius, *Landscape with Mercury*, Musée des Beaux-Arts et d'Archéologie, Besançon

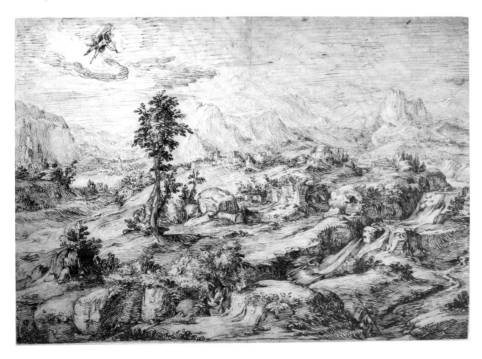

foreground toward the opposite corner of the distance. In contrast to the mountainous terrain represented by Goltzius, which closely resembles the backgrounds of Campagnola's landscapes, De Gheyn invented an extensive, bleak plain, where only the wavy banks and the trees at the left recall the Venetian precedents.

Bandits or soldiers plundering merchants, travelers, or peasants appear frequently in Netherlandish landscapes of the early seventeenth century, for example, in the works of Sebastian Vrancx and Esaias van de Velde.[5] In De Gheyn's unusually terrifying treatment of the subject, the isolation of the place and the agitation of the bulging ground heighten the drama of the ambush scene. Only a solitary rabbit witnesses the anguish of the woman grieving over her slain husband. WWR

1. For the drawing based on a painting by Patinir or a member of his circle, see Van Regteren Altena 1983, 1: 62-63; 2: no. 2-1045; 3: pl. 159. For drawings in the styles of various other landscapists, see Van Regteren Altena 1983, 1: 60-61; and 2: nos. 2-941 (Bruegel), 2-499 (Small Landscapes), 2-963, 2-977 (Bril).
2. For a discussion of his pivotal drawing, see Van Regteren Altena 1983, 1: 76-83; 2: no. 2-940, and Stechow 1966, 122. For Goltzius' drawings of 1600 and 1603 and their importance for the history of Dutch landscape art, see Stechow 1966, 17, 34-35.
3. See nn. 1-2, and Van Regteren Altena 1983, 2: nos. 2-941, 2-961, 2-964, 2-965, 2-972, 2-973, 2-1045, and 2-1049 for De Gheyn's adherence to sixteenth-century types in his finished landscape drawings.
4. Reznicek 1961, 109, 172-173, and no. 393.
5. See Fishman 1982 and Keyes 1984.

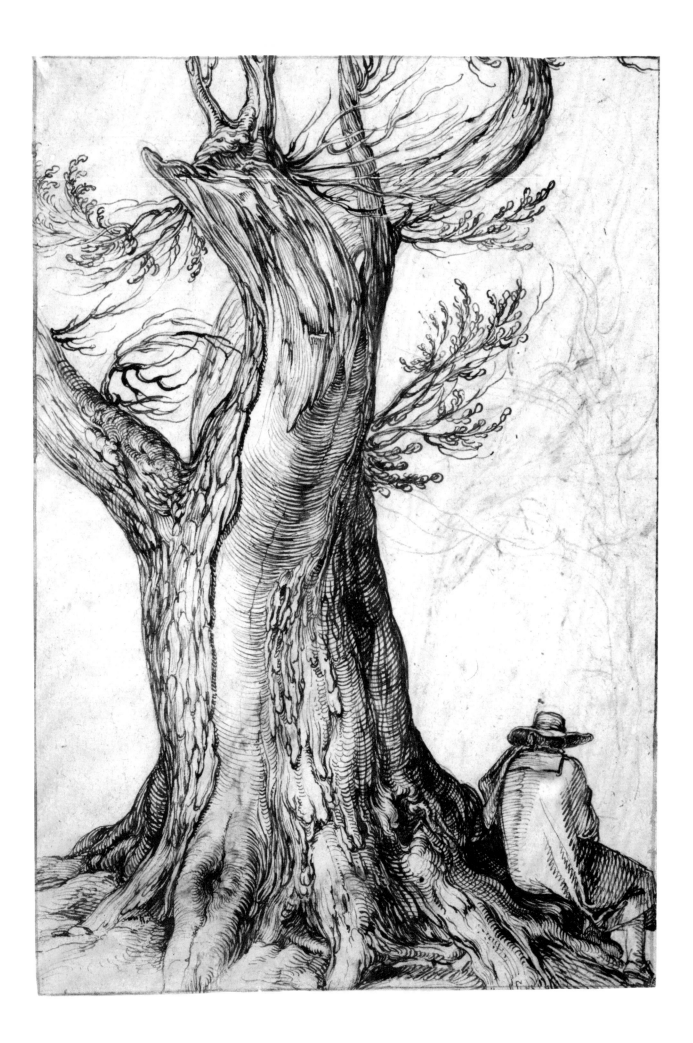

51 *The Trunk of an Old Tree with a Man Seated on the Roots*

Pen and brown ink over black chalk
(verso: *another view of the same tree*, fig. 1,
pen and brown ink)
363 x 250 (14¼ x 9¹³⁄₁₆)

Provenance: N. Nieuhoff; (his sale, Amsterdam, 14 April 1777, lot 251); purchased for the Rijksprentenkabinet, Amsterdam, through W.A. Bruin, 1922

Literature: Van Regteren Altena 1936, 53, 94; Judson 1973, 26-27, 30; Boon 1978, 82, no. 235, pl. 235; Van Regteren Altena 1983, 1: 92; 2: no. 11-998, 3: pl. 304 (recto), 305 (verso); Paris 1985 (De Gheyn), under no. 26; Rotterdam 1985-1986, under no. 87

Exhibitions: Brussels 1961, no. 5

Rijksprentenkabinet, Rijksmuseum, Amsterdam, inv. no. 22:42

The tree in this drawing has been called an elm, an oak, or a chestnut, but it cannot be identified with certainty.[1]

De Gheyn initially sketched in black chalk the contours of the great trunk, the seated figure, and the smaller tree to the right. While the latter remained an undeveloped outline, he worked up the foreground with the pen, describing the exposed wood with long, concentric strokes and the bark with tight coils of short arcs. The close view of the blasted tree and its huge scale, especially compared to the small seated figure, endow the study with a commanding visual presence. Its impact is enhanced by the energetic ductus of the lines, the bold modeling with strong contrasts of light and shade, the dynamic patterns of the bark, and the rhythmic meanderings of the branches, which De Gheyn has probably exaggerated to heighten the expressive effect.

The drawing on the verso (fig. 1) evidently shows the same tree viewed from a greater distance and from a point one quarter of the way around to the right, so that the large, broken branch, seen from directly below and strongly foreshortened on the recto, stretches diagonally out to the left on the verso. Some details finished with the pen on the recto are indicated only in chalk on the reverse.

These two drawings belong to a small group of similar studies by De Gheyn of the lower trunks and gnarled roots of venerable trees (fig. 2).[2] All of them combine an imposing scale with a startling attention to detail. Like De Gheyn's studies of common animals (cat. 48), they demonstrate his practice of using drawing to analyze natural phenomena. De Gheyn consulted these sheets and adapted the tree from the recto of the one exhibited here—or a very similar study that has not survived—in the magnificent finished de-

Fig. 1. Cat. 51, verso

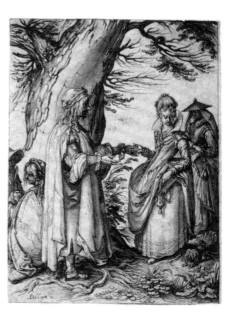

Fig. 3. Jacques de Gheyn II, *The Gypsy Fortune Teller*, Herzog Anton Ulrich-Museum, Braunschweig (B.P. Keiser)

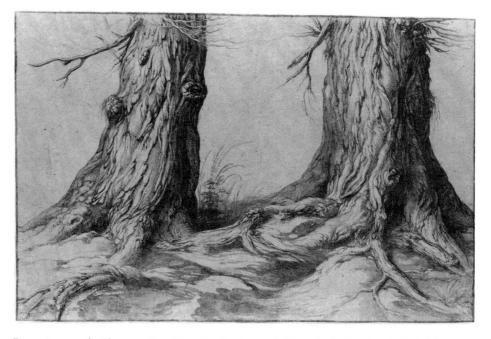

Fig. 2. Jacques de Gheyn II, *Two Tree Trunks*, Prentenkabinet der Rijksuniversiteit, Leiden

sign for the engraving *The Gypsy Fortune Teller* (fig. 3). Van Regteren Altena dated *The Gypsy Fortune Teller* to 1608 at the latest, which provides a *terminus ante quem* for the tree studies.[3]

Around 1600 several Netherlandish artists made drawings of isolated trees. The

majestic work by Goltzius in this exhibition (cat. 62) ranks among the earliest examples. It is an independent, naturalistic rendering of the type of massive, sinuous trunk, originally propagated in the art of such Italian masters as Titian and Girolamo Muziano, that Goltzius had intro-

duced into the landscape settings of his engravings and drawings of the 1590s (cat. 56).[4] De Gheyn sketched a similar diagonal view of a single tree about 1600.[5] A large sheet with an isolated tree, executed in Italy c. 1600, is attributed to Paul Bril.[6] The powerful studies produced by Roelandt Savery in Bohemia and the Tirol, c. 1606-1610, and the delicate ones of c. 1601-1603 by Paulus van Vianen are discussed under cat. 101 and 116. Among these works De Gheyn's drawing stands out by virtue of its grand scale, its intense scrutiny of the subject, and the expressive vigor of its execution. WWR

1. Van Regteren Altena 1936, 94, identifies it as an elm, while Van Regteren Altena 1983, 2: no. II-998, calls it an oak. Boon 1978, no. 235, labels it as a chestnut. I am grateful to Dr. Peter Ashton of the Arnold Arboretum of Harvard University, who points out in a letter that the tree cannot be identified from the evidence presented in the drawing.
2. Van Regteren Altena 1983, 2: nos. II-998 to II-1002; 3: pls. 283-285 and 303-305. The drawing reproduced in fig. 2 is Van Regteren Altena 1983, 2: no. II-999; 3: pl. 285.
3. Van Regteren Altena 1983, 2: nos. 2-534 and 2-998. Boon's dating of 1603 is evidently based on a misreading of Van Regteren Altena 1936, 94.
4. Van Regteren Altena 1983, 1: 92, fig. 69; Reznicek 1961, pls. 122, 123, 125, 126, 224, 251.
5. Van Regteren Altena 1983, 2: no. 2-988, pl. 48.
6. Popham 1932, 137, no. 3, pl. XLV.

JACQUES DE GHEYN II

52 *Sheet of Studies*

Pen and brown ink, black chalk, touches of red and white chalk.
381 x 248 (15 x 9¾)

Literature: Stift und Feder 1930, no. 235; Van Regteren Altena 1936, 96; Möhle 1966, 62; Judson 1973, 20-21; Paris 1974, under no. 38; Kuznetsov 1975, under text for pl. 30; Bergsträsser 1979, no. 50; Van Regteren Altena 1983, 2: no. 2-505, 3: pl. 282; Paris 1985 (De Gheyn), under no. 12, n. 10

Exhibitions: Darmstadt 1964, no. 35; Paris 1971, no. 49

Hessisches Landesmuseum, Darmstadt, inv. no. AE 408

When executing the studies on this sheet of c. 1603, De Gheyn began with a rough sketch in black chalk of the seated woman. He worked up her figure in pen and brown ink, although he did not follow his preliminary indications for her drapery at the right. The other studies in ink were filled in around her. At the top of the sheet De Gheyn drew a finely rendered pair of hands in black chalk and a pair of feet in black chalk with touches of red and white chalk. Although none of these sketches is repeated in another of the artist's works, the hands recall a small sheet with studies of several pairs of folded hands, which are similarly executed in black chalk.[1] The mysterious confrontation of the exotic couple at the bottom, the two children intently examining an object invisible to us at the upper right, and the incongruous juxtaposition of the melancholic woman draining milk from her breast with the nervous figure—apparently Athena—to her right combine to give the entire work an enigmatic air.[2]

The numerous sheets of studies constitute one of the most original features of De Gheyn's oeuvre. They vary considerably in character and function. Some bear sketches from life executed in preparation for another project (cat. 49).[3] Others are pure exercises in life drawing made for the artist's own instruction or pleasure.[4] Still others—including perhaps the Darmstadt example—display an artful arrangement of studies on the page that suggests De Gheyn conceived of them as complete works of art; that one of these virtuoso performances even carries his signature and the date 1604 strengthens this assumption (fig. 1).[5] While some sheets are filled with various drawings of a single motive, a few combine sketches of assorted figures, animals, plants, landscapes, or other details. There are pages with studies from nature (fig. 1), and sheets that unite drawings executed *naer*

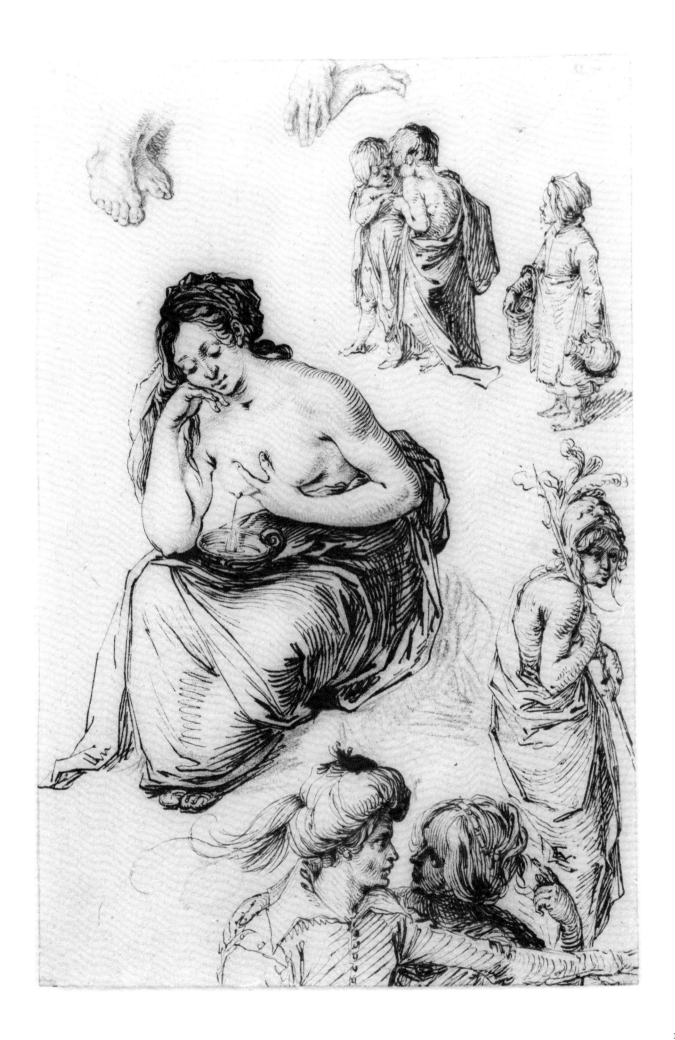

149

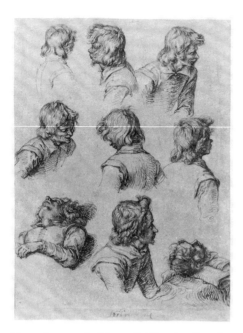

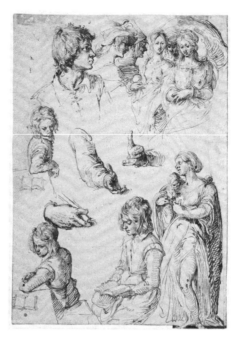

Fig. 1. Jacques de Gheyn II, *Nine Studies of the Head of a Young Man*, Staatliche Museen Preussischer Kulturbesitz, Kupferstichkabinett, KDZ 2456, Berlin
(Jörg P. Anders)

Fig. 2. Jacques de Gheyn II, *Study Sheet*, Rijksprentenkabinet, Amsterdam

het leven with sketches of figures invented by the artist (fig. 2). In the work exhibited here, Athena and the couple at the bottom are obviously imaginary, while the other studies may have been recorded from life.[6]

De Gheyn's sheets of studies are descendents of the model page, exemplified here by cats. 11, 44, 45, 46, which assembles heads, figures, animals, landscapes, and other details copied from disparate works of art.[7] A few drawings of this type have been attributed tentatively to De Gheyn,[8] but in most of his study sheets he departed from the model page tradition by taking his motives from nature rather than from art. For instance, in *Nine Studies of the Head of a Young Man* (fig. 1), the disposition of the heads recalls a model sheet, but the drawings were clearly made from life. Judging from the dated or datable examples of 1600, 1602, and 1604,[9] De Gheyn's sheets of studies belong to the first years of the seventeenth century and include some of the earliest figural sketches from life made in the Netherlands. WWR

1. Van Regteren Altena 1983, 2: no. II-793. Van Regteren Altena dates this sheet c. 1589, while Judson 1973, 18-19, dates it c. 1603, the approximate date of the study sheet exhibited here.
2. Only the figure with the plumed helmet and spear may be identified, cautiously, as Minerva. Bergsträsser 1979, no. 50, tentatively suggests that the woman draining her breast might be Natura or a muse, but this seems unlikely.
3. In addition to cat. 49, other examples include the studies connected with the engraving *The Land-Yacht*, Van Regteren Altena 1983, 1: 77-81; 2: nos. II-507, -514, -556, -557, -940.
4. For example, the studies of nudes, Van Regteren Altena 1983, 2: nos. II-797, II-800-808.
5. Others showing a deliberate and attractive arrangement, which perhaps indicates that De Gheyn made them as finished works of art, include Van Regteren Altena 1983, 2: nos. II-499, -504, -514 recto, -634, -774, -738, -748.
6. The woman draining her breast, as suggested by Bergsträsser 1979, no. 50, may be the same model who posed for the nude studies, Van Regteren Altena 1983, 2: nos. II-800, -803, and -804, but this is not certain.
7. See the essay The Function of Drawings in the Netherlands in the Sixteenth Century for a discussion of the model page.
8. Van Regteren Altena 1983, 2: nos. II-1040-1042.
9. The dated or datable examples are, in addition to fig. 1, Van Regteren Altena 1983, 2: nos. II-495, -507, -514, -556, -557, -940.

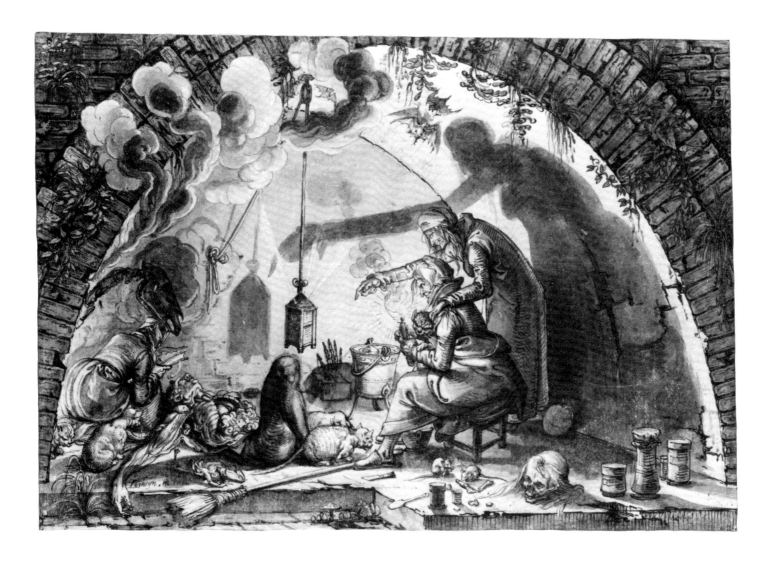

JACQUES DE GHEYN II

53 *Preparations for a Witches' Sabbath*

Pen and brown ink and gray-brown wash
280 x 408 (11¹¹/₁₆ x 16)
Signed and dated, at lower left, in brown ink,
DG (in ligature)*heijn in 160(4?)*

Provenance: Francis Douce, by whom be-
queathed to the University of Oxford, 1834

Literature: Van Regteren Altena 1936, 45-46
and 69-70; Parker 1938, 1: 17, no. 37; Bernt
1957, 1: no. 254; Judson 1973, 209; Judson
1973, 31; Van Regteren Altena 1983, 1: 87-88;
2: no. II-523; 3: pl. 273; Rotterdam 1985-1986,
14 and under no. 68

Exhibitions: New Brunswick 1982-1983,
no. 34

Lent by the Visitors of the Ashmolean Mu-
seum, Oxford

De Gheyn's dramatic witchcraft scenes
consummate a Netherlandish tradition of
diabolical fantasies that reaches back
through Bruegel to Hieronymus Bosch.
The earliest of his nine drawings repre-
senting preparations for the witches' sab-
bath is a tiny sheet of 1603.[1] It was fol-
lowed by the work exhibited here and by
a similarly elaborate drawing (fig. 1), both
probably dated 1604.[2] The most ambi-
tious composition served as the model for
an exceptionally large engraving.[3] De
Gheyn also made several studies, most of
them from life, of old hags (fig. 2), young
sirens, skulls, frogs, mice, lizards, and
necromantic implements that he con-
sulted when executing these elaborate
compositions.[4]

As Judson has shown, the drawings at-
test to De Gheyn's familiarity with the
literature on sorcery, and many of their

features can be clarified by reference to
these treatises.[5] Accompanied by their fa-
vorite cats, mice, and bats, the witches in
the Oxford work prepare to cook the po-
tion that, when smeared on their bodies
and broomsticks, will enable them to fly
to the sabbath. Other drawings show
them already entranced and airborne
aboard goats or brooms wafted by the ris-
ing vapors of the noxious elixir (fig. 1).
Seated beneath a skeletal horse, one
woman reads the recipe for the brew from
the witches' indispensable manual, *The
Black Book*. Remains of victims sacri-
ficed to obtain ingredients litter the dank
chamber: the corpse of a man, clearly re-
membered from a dissection De Gheyn
witnessed in the Leyden Anatomy Thea-
ter; two skulls; some tiny bones gnawed
by the mice; and a frog, staked to the
floor and disemboweled, which he tran-

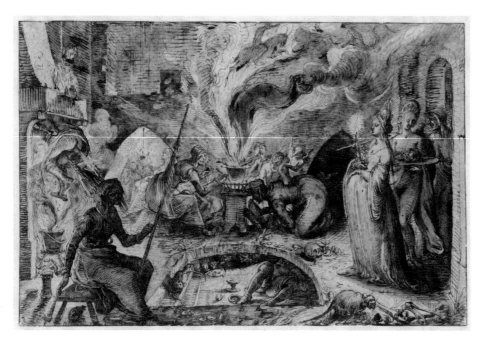

Fig. 1. Jacques de Gheyn II, *A Witches' Sabbath*, Staatliche Museen Preussicher Kulturbesitz, Kupferstichkabinett, KdZ 3205, Berlin (Jörg P. Anders)

Fig. 2. Jacques de Gheyn II, *A Seated Old Woman with a Distaff*, private collection

scribed from a study of a frog prepared for dissection (cat. 48, fig. 1). The bony hand propped against the rear wall is the "hand of glory," which could cast spells and paralyze the uninitiated.[6]

That De Gheyn steeped himself in the lore of witchcraft is certain, but the intellectual basis of his inquiry remains unclear. Noting that early seventeenth-century scholars rarely distinguished empirical knowledge from the pseudo-sciences of magic and alchemy, Judson interprets the interests revealed in De Gheyn's drawings as an extension of his curiosity about the natural world. His conceptions mingled fantasy with the latest scientific hypothesis that linked witches' trances to physical or mental illnesses or the use of drugs.[7] Van Regteren Altena, on the other hand, stresses that some of De Gheyn's acquaintances opposed the persecution of witches and denied the existence of sorcerers. He proposes that the artist's overcharged representations debunked current notions about witchcraft and the supernatural.[8] Indeed, given the satirical tradition to

which these compositions belong, their exaggerated ghoulishness, and their comic treatment of the witches' alleged sexual proclivities and methods of propulsion, it is quite likely that they constitute a farcical critique of the credulous views De Gheyn's contemporaries held about magic and sorcery.

De Gheyn invented an expressive mode of execution that brilliantly conveys both the nocturnal atmosphere and the orgiastic exuberance of the witches' celebrations. In the Oxford drawing the bold washes that render the vapors and the spectral shadow of the pointing woman create a particularly eerie impression. There is a notable pentimento in the legs of the dead man: in the initial black chalk sketch both knees were raised, while in the finished version the truncated left leg is extended. Other sheets are rendered with extraordinarily loose and agitated penwork that enhances the frenzied rhythms of the roiling clouds of smoke and the diabolical abandon of the entranced women. WWR

1. The nine finished compositions depicting preparations for the witches' sabbath are: Van Regteren Altena 1983, 2: nos. II-517 to II-524, and Add. 4. Van Regteren Altena 1983, no. II-521 is dated 1603.
2. The date on the drawing exhibited here has been read as 1600 and 1604. Van Regteren Altena's reading of 1604 seems the more likely one. The date on the drawing in Berlin (fig. 1), Van Regteren Altena 1983, no. II-522, is also unclear and has been deciphered as 1608 and 1604. Van Regteren Altena accepts the date of 1604, based on an earlier reading by Ludwig Burchard.
3. Van Regteren Altena 1983, 2: no. II-519. For the engraving, see Boston 1980-1981, no. 23.
4. Some detail studies relate directly to the finished drawings, while others do not. See Van Regteren Altena 1983, 2: nos. II-528, -529, -538 recto, -539 recto, -743, -815, -888, -892. The work illustrated in fig. 2 is Van Regteren Altena 1983, 2: no. II-539, recto. It was used for the figure at the left in the Berlin composition (fig. 1).
5. Judson 1973, 26-34, for information on the various tools and attributes in De Gheyn's witchcraft scenes.
6. Judson 1973, 26: Rotterdam 1985-1986, 71, under no. 67.
7. Judson 1973, 26-34.
8. Van Regteren Altena 1983, 1: 86-88.

Hendrick Goltzius

1558-1617

Hendrick Gols or Goltz, latinized to Goltzius, was born in the Lower Rhenish town of Mühlbracht (now Bracht). When he was still a small child his family moved to Duisberg where his father was active as a glass painter. About 1574 he was apprenticed to the engraver and publisher Dirck Volckertsz. Coornhert, then living in exile in nearby Xanten. When Coornhert returned to Haarlem following the Pacification of Ghent in 1576, Goltzius joined him. He settled there, marrying in 1579, and producing numerous engravings, many for the Antwerp publisher Philip Galle, based on designs by Maerten de Vos, Antonis Blocklandt, and Stradanus, as well as on his own designs. In 1582 he set up as a publisher in Haarlem. Karel van Mander (q.v.), who settled in Haarlem in 1583, was the means of introducing Goltzius to the drawings of Bartholomeus Spranger (q.v.). The imperial court painter's virtuoso pen style and elegant, contorted figures exercised a strong influence on Goltzius, felt from 1585 on in paraphrases such as the engraving Mars and Venus, *1585 (see also cat. 54) and in engravings after his designs, the most masterly being the* Marriage of Cupid and Psyche, *1587. By the late 1580s this influence had moderated in favor of stiller figures and a greater interest in effects of space and light.*

According to Van Mander, who was undoubtedly precisely informed by his friend, Goltzius departed for Italy in October 1590, reaching Rome by way of Munich, Venice, Bologna, and Florence on 10 January 1591. Goltzius remained in Rome, apart from a brief trip to Naples, until early August, using his time expeditiously in copying antique monuments (see cat. 58) and Renaissance fresco decorations of Raphael and Polidoro da Caravaggio. He also produced a remarkable series of chalk portraits of contemporary artists. Although his health, always precarious, suffered upon his return to Haarlem, he began to work material gathered in Italy into engravings, publishing a series of copies of Roman frescos and beginning a series after antique sculpture. With his series of the Life of the Virgin, bearing dates of 1593 and 1594, the Pietà *of 1596, and* Passion *of 1596-1598 he gave the fullest evidence of his ability to imitate the graphic style and compositions of other artists, notably Lucas van Leyden and Albrecht Dürer. In the mid-1590s he also began to expand his virtuoso pen drawings in imitation of the engraving technique into large, highly finished compositions on parchment and then on grounded linen, finally adding paint for the flesh tones. While such works may have formed a transition to painting, Van Mander reports that Goltzius did not begin to paint until 1600. He gave up engraving at about the same time, only rarely producing designs to be engraved by others. He died in Haarlem on 1 January 1617.*

Goltzius enjoyed an international reputation. Rudolf II granted him imperial privilege for his engravings in 1595, and his patrons included the dukes of Bavaria, the Fuggers, and the archbishop of Milan, as well as the emperor. His influence spread through his widely available prints, the artists belonging to his Haarlem circle, and through others, such as Jacques de Gheyn II, who trained in his engraving shop.

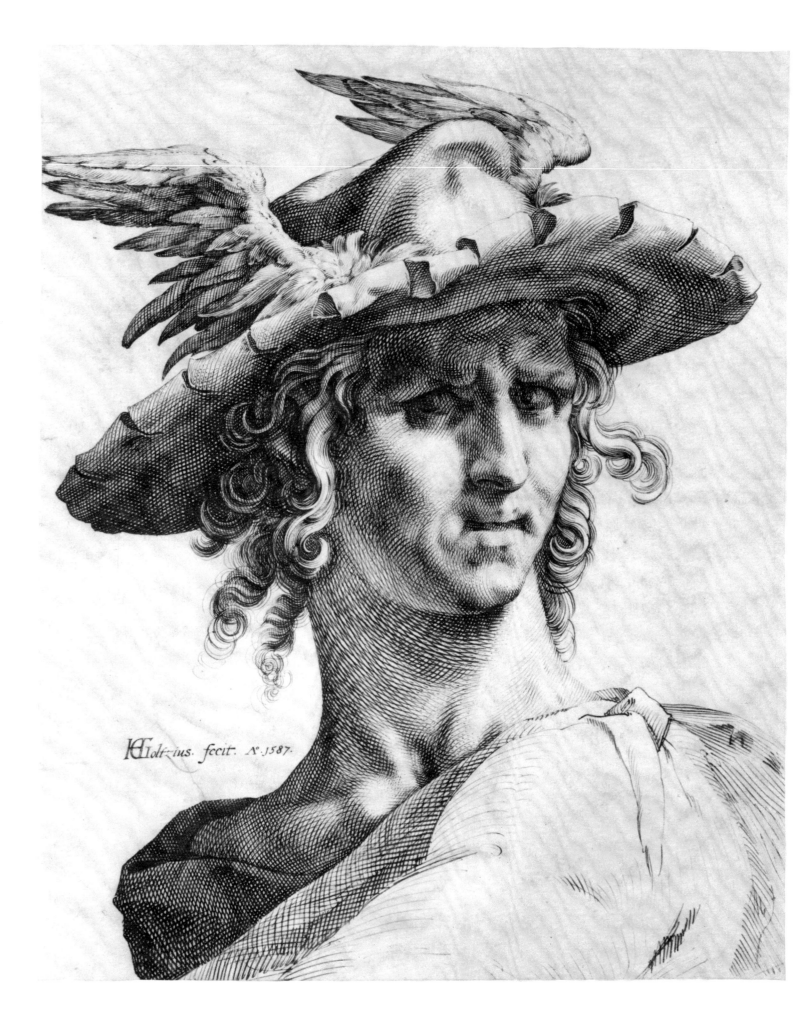

HGoltzius. fecit. Aº. 1587.

154

HENDRICK GOLTZIUS

54 *Head of Mercury*

Pen and dark brown ink; laid down
445 x 365 (17½ x 14⅜)
Inscribed in dark brown ink at left center,
HGoltzius.fecit.A°.1587
Watermark: Close to Briquet 6097[1]

Provenance: Probably Emperor Rudolf II,
Prague (d. 1612), inv. 1621, no. 1115; probably
Queen Christina of Sweden, inv. 1648, no.
362, and 1652, no. 156; Hugh Howard (his sale
12-20 December 1873, no. 621); Mrs. E.F. Dods-
worth; (sale, Sotheby's, London, 31 July 1946,
no. 5f); purchased 1954

Literature: Parker 1954, 60; Reznicek 1961, 79,
280, 305, 356, 406, no. 119; New Brunswick
1983, 31-32

Exhibitions: Rotterdam 1958, no. 110; New
Brunswick 1982-1983, no. 31

Lent by the Visitors of the Ashmolean Mu-
seum, Oxford

The Ashmolean *Mercury* is a relatively
early example of a type of drawing that is
associated particularly with Goltzius—
the virtuoso pen drawing in engraving
technique. The precise hatchings of en-
gravings produced for publishers like Hier-
onymous Cock or Philip Galle served as
the basis for presentation drawings in pen
by artists who worked as reproductive
engravers, such as members of the Wierix
family and the young Goltzius.

When, in the mid-1580s, Goltzius de-
veloped his engraving technique to ac-
commodate the active, foreshortened
forms of Bartholomeus Spranger's designs
as well as his own exaggerations of this
style, his pen drawings in engraving tech-
nique took on a corresponding virtuoso
character.[2] In his engravings after Spran-
ger, such as the 1585 *Holy Family*, and in
the series of Roman heroes after his own
designs of the following year, he used
longer, more widely spaced hatching
lines that swell and taper to model em-
phatically rounded forms.[3] The 1586
Marcus Curtius in Copenhagen appears
to be Goltzius' earliest surviving pen
drawing imitating this new engraving
technique, and it also depends directly in
composition and form on his plate for the
Roman heroes series.[4] In contrast, the
Ashmolean *Mercury* has a more direct
impact as an independent display of pen-
work. Its powerful effect results from the
combination of a scale and direct gaze
that are appropriate to a picture, with the
discipline of the engraving technique and
the immediacy of the line drawn on the
paper. In addition to the system of swell-
ing lines and subordinate dots and flecks
found in engravings like the *Roman He-
roes* or the *Disgracers*,[5] the crisp curves
of the hair recall the burinwork of Dürer
and Lucas van Leyden. At the same time

the looser strokes of the sunlit shoulder
and cloak convey a more personal flour-
ish. A similar relaxation into personal
penwork occurs in the portrait of Goltz-
ius' printer *Gillis van Breen* of 1590 in
Haarlem,[6] while later drawings in engrav-
ing technique such as the London *Sine
Cere et Baccho friget Venus* and the
monumental version of the same subject
in Leningrad are more consistently
worked up and feature extraordinarily
refined effects of texture and light.[7]

Since Mercury was considered the in-
ventor of the arts, the choice of subject
for this ideal head is emblematic of
Goltzius' artistry.[8] It is noteworthy in
this context that in two other pen draw-
ings in engraving technique close in date
to the *Mercury*, Goltzius chose to repre-
sent his own crippled right hand.[9] As
Reznicek observes, the hand, rendered
with remarkable plastic effect in these
two drawings, is an emblem of Goltzius'
mastery of his art and perhaps also his
ability to overcome adversity.[10] It can be
assumed that these self-conscious dis-
plays of skill were eagerly sought after by
the collectors of the day, and Reznicek
has shown that the Ashmolean drawing
is probably identical with the "Mercury
drawn with the pen" recorded in the 1621
inventory of the Emperor Rudolf II's
collection.[11] MW

1. See Christopher Lloyd in New Brunswick 1982-
1983, no. 31.
2. For pen drawings in imitation of engravings and
Goltzius' development of this type of drawing, see
Reznicek 1961, 76-79, 101-105, and 128-130.
3. The change in Goltzius' engraving style is dis-
cussed by Hirschmann 1919, 38-57. For the *Holy
Family* and the Roman heroes, see Strauss 1977, 1:
360-361, no. 219, repro., and 384-403, nos. 230-239,
repro. respectively.
4. For the engraving of *Marcus Curtius*, the fourth
plate in the Roman heroes series, see Strauss 1977, 1:
392-393, no. 234. Reznicek considered that, despite
the correspondence of print and drawing, which ex-
tends to the direction of the image, the inscription,
and plate number, the Copenhagen drawing was an
autograph presentation piece in imitation of the en-
graving. Reznicek 1961, 295, no. 142, pl. 74.
5. After Cornelis Cornelisz. van Haarlem, dated 1588;
Strauss 1977, 2: 444-451, nos. 257-260, repro.
6. Teylers Museum; Reznicek 1961, 356, no. 265,
pl. 131.
7. For the drawing in the British Museum on parch-
ment, dated 1593, see Reznicek 1961, no. 129, pl.
224-226; for the 1604 work on prepared canvas in the
Hermitage, see Reznicek 1961, no. 128, pl. 387.
8. See Reznicek 1961, 280, and Miedema 1973, 2:
393. In the series of the planets engraved by Saenre-
dam after Goltzius, Mercury is the protector of rhet-
oric, the fine arts, and trade; Bartsch 78.
9. In the Teylers Museum and the Van Regteren Al-
tena collection, the former signed and dated 1588;
Reznicek 1961, nos. 165 and 166, pls. 86 and 87
respectively.
10. Reznicek 1961, 305-306.
11. See Zimmerman 1904, 44, no. 1115, and Reznicek
1961, 280 and 286.

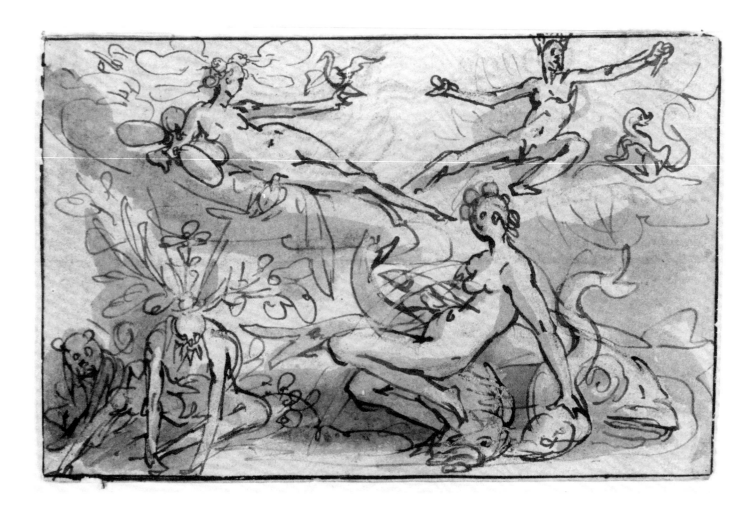

HENDRICK GOLTZIUS

55 *Sketch for the Four Elements*

Pen and brown ink over black chalk, gray
wash and white body color, partially oxidized,
on gray paper
97 X 150 (38¼ X 5¹⁵/₁₆)
Inscribed on verso in brown ink in Goltzius'
hand, *in plats van dit, eene vrouwe/Thetis—is
die godinne der zee*; immediately below these
two lines in red chalk in Goltzius' hand, *met
de erde van voren*; in brown ink, *6*; in red
chalk to right, *6*

Watermark: Lily (close to Briquet 7210)

Provenance: A. Chariatte, London (Lugt Suppl.
88a); N. Beets; (sale, Mensing, Amsterdam, 5-8
November 1940, no. 564); A. Welcker, Amster-
dam (Lugt Suppl. 2793c)

Literature: Welcker 1947, 67-69, 72; Reznicek
1956, 85; Reznicek 1961, 81-82, 158-159, 235-
236, no. 100

Exhibitions: Amsterdam 1956, no. 44; Rotter-
dam 1958, no. 19

Prentenkabinet der Rijksuniversiteit te Leiden,
Leiden, inv. no. A.W. 1015

Until recently, this rapid compositional
drawing was thought to be one of eight
surviving sketches for the series of round
engravings of the Seven Days of Creation
designed by Goltzius and engraved by Jan
Muller in 1589.[1] Like the other sketches
in the group of eight, all now in Leiden
and sharing a common provenance,[2] it is
drawn with a few cursory strokes of the
pen, with wash very summarily indicat-
ing shadow and spatial relationships, and
with white body color added for accents
and to suppress unwanted details. How-
ever, Hélène Mazur-Contamine has dem-
onstrated that this is in fact a first sketch
for the engraving of *The Four Elements*,
the first plate of Goltzius' series of Myth-
ological and Allegorical Subjects en-
graved by Jacob Matham and published in
1588 (fig. 1).[3] Rather than presenting a
narrative like the creation, this series of
eight plates in a vertical format is de-
voted to various animating forces or cate-
gories in nature.[4] The sketch for *The Four
Elements* is in the same direction as the
final engraving. The survival of such first

sketches by Goltzius is extremely rare,
and the re-interpretation of this sheet
sheds further light on his working
method and the interrelationship of de-
signs during a particularly productive pe-
riod when Spranger's influence gave way
to greater naturalism.

The briefly sketched personifications
were previously identified as representing
earth and water from the third day of cre-
ation in the lower register, and the birds
and beasts from the fifth day of creation
in the upper register.[5] However, Mazur-
Contamine notes the following corre-
spondences between Matham's engraving
and the sketch in Leiden: at the upper
right a personification of Fire, wearing a
fiery crown and accompanied by a sala-
mander, is shown striking flints; at the
upper left a personification of Air sitting
on balloonlike clouds and with puffs of
clouds for hair, holds a bird that in the
print has been changed to a chameleon, a
creature believed to live on air. The
changes in the figures of Earth and Water
are more complicated. The direction of

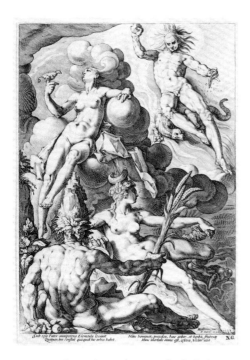

Fig. 1. Jacob Matham after Hendrick Goltzius, *The Four Elements*, Prentenkabinet der Rijksuniversiteit, Leiden

Fig. 3. Hendrick Goltzius, *Sketch for the Third Day of Creation (?)*, Prentenkabinet der Rijksuniversiteit, Leiden

Fig. 2. Jan Muller after Hendrick Goltzius, *The Third Day of Creation*, Rijksprentenkabinet, Amsterdam

the woman personifying Water has been changed in the print, and she wears a crown of shells topped by a boat. The personification of Earth has been moved into the foreground and turned around so that he serves as a repoussoir figure. He wears a fantastic leafy, rocky crown in the print. As Mazur-Contamine notes, when Goltzius transposed the design into a vertical format, he clarified it by lengthening the poses of the two upper figures and swinging their legs in the opposite direction.[6]

That the sketch for *The Four Elements* has been taken for part of the creation series is an indication of Goltzius' fertile and flexible working method. His creation series is conceived in terms of classical personifications or deities embodying principles of nature, so it is appropriate that poses and attributes are shared with *The Four Elements* and other plates of the *Mythological and Allegorical Subjects*. Thus the muscular figure of Earth seen from behind is present in both *The Four Elements* and *The Third Day of Creation* (figs. 1 and 2). It is not clear whether another of the Leiden sketches, with three personifications aligned across the page (fig. 3), is part of the Creation series or relates to the genesis of the *Mythological and Allegorical Subjects*. Its composition is less active than the other creation sketches, and it lacks the spirit of God separating the different constituent parts of nature. Moreover, the woman with a basket is quite close to the personification of Taste in *The Five Senses*,[7] although the two male figures of the sketch do not fit any of the categories of the mythological series. Within the mythological series there is an evolution away from the active intertwined figures influenced by Spranger, such as *The Seven Virtues* and *The Three Fates*, toward stiller groupings like *Apollo and Minerva* in which texture and shadow are carefully observed.[8] The engraving of *The Four Elements* occupies a midpoint in this development. It may be quite close in date to the sketches of the creation series, making it even more likely that the invention of poses would be linked.

Although the hypothesis of three sketches for the engraving of *The Third Day of Creation* is no longer tenable, it is clear that Goltzius worked through numerous adjustments with such rapid sketches (see also *The Judgment of Midas*, cat. 56). This contrasts with the preponderance of finished preparatory drawings or figure and head studies in his surviving work and with the implication of Van Mander's admiring statement about his friend, that he didn't think anyone was so firm and sure in drawing with the pen an image or even a whole scene so perfectly, so completely, or with such spirit without sketching before-hand.[9] The process of adjustment is evident in this sketch in the change of format, in the white body color that corrects the water gushing from the sea goddess' breasts and other details, and in the inscription on the verso. Goltzius there noted in ink, "in place of this a woman Thetis—the goddess of the sea"; later he jotted a further thought in red chalk, "with the earth in front" [or from the front]. As Mazur-Contamine suggests, this probably refers to adjustments to this sketch that are carried out in the finished engraving.[10] The shifting of Earth into the foreground would then be an afterthought noted separately in red chalk. MW

1. Bartsch 35-41, diameter c. 263 mm.

2. Reznicek 1961, 233-237, no. 1-3. The drawings were all together in the Chariatte collection. The sketch for the first day of creation, what has been considered the sketch for the third day, and the present sketch were acquired by Beets and then by Welcker (Welcker 1947, 61-82; Reznicek 1961, nos. 1, 4, and 5). The other five drawings, then in the Reitlinger collection and unknown to Welcker, were first linked to the series by Reznicek 1956, 85-86.

3. Hélène Mazur-Contamine of Iconclass, Rijksuniversiteit te Leiden, very generously provided a note summarizing her conclusions, which are part of a larger study she is preparing on aspects of Goltzius' neo-Stoic imagery.

4. Bartsch 278-285, Hollstein 237-244, 288 x 207 mm. The surviving modelli, in the opposite direction to the engravings, are *The Seven Virtues* in pen and wash with white highlighting, and *The Three Graces* and *Apollo and Minerva* in red chalk (Reznicek nos. 81, 133, and 134, pls. 78, 79, and 80) and *The Alliance of Venus, Ceres and Bacchus*, also a working modello, recently identified in the Ashmolean (Shoaf and Turner 1984, 267-270, fig. 148). The choice of red chalk for some of the modelli may be part of this evolution.

5. Reznicek 1961, 235-236, identified three of the Leiden sketches as preparations for the third day, the sketch which is closest to the final engraving having appeared with the Reitlinger drawings. No preparation for *The Fifth Day of Creation* is known.

6. I am indebted to Hélène Mazur-Contamine for the observations in this paragraph; note of 26 June 1985.

7. Bartsch 279; repro. *The Illustrated Bartsch*, 4: 256.

8. Repro. *The Illustrated Bartsch*, 4: 259, 261, and 258 respectively. Reznicek 1961, 217-218 and 290, suggests that the greater naturalism of the red chalk modello for *Apollo and Minerva* signals a break with Spranger's vocabulary and a concomitant interest in the study of anatomy under the influence of Van Mander.

9. *Ick acht niet, dat yemant soo vast en veerdigh is: een beeldt, jae een gantsche Historie, uyt der handt, sonder yet te bootsen, te trecken ten eersten met de Pen, met sulcken volcomenheyt, en suyverlijck te voldoen, en met soo grooten gheest*, Van Mander, *Schilder-boek*, 2: 250.

10. Note cited above. Reznicek 1961, 235-236, interprets the inscription as referring to adjustments in relation to the preceding sketch with three personifications in Leiden (fig. 3). However, it is difficult to interpret the inscription without knowing how Goltzius arranged these rapid sketches—either scattered over larger sheets or on pages of a small sketchbook. The latter possibility may find some support in the fact that four of the eight sheets in Leiden have segments of the same watermark close to Briquet 7210 in the upper left corner (inv. nos. 58.02, 58.03, and 58.04, and AW 1015, which is the exhibited drawing).

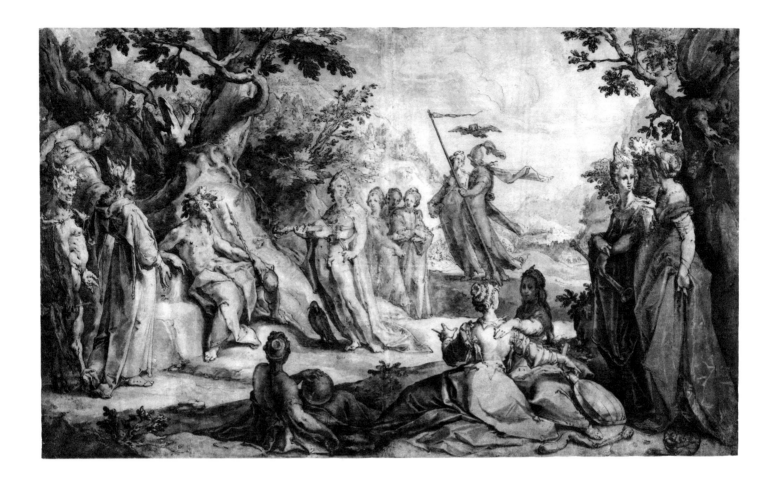

HENDRICK GOLTZIUS

56 *The Judgment of Midas*

Pen and brown ink, rose-brown, brown and
gray washes, green and white body color; laid
down
400 x 681 (15¾ x 26¾)
Inscribed at lower right in dark brown ink,
HG./Fecit/A°1590 (initials in ligature); at cen-
ter left in brown ink, 90

Provenance: John MacGowan (sale, London, T.
Philipe, 26 January-1 February 1804, no. 266);
William Young Ottley; Sir Thomas Lawrence,
d. 1830; Samuel Woodburn (Lawrence-Wood-
burn sale, Christie's, London, 4-8 June 1860,
no. 435); Dr. John Percy (Lugt 1504) (sale,
Christie's, London, 15-18 and 22-24 April
1890, no. 1462); Charles Fairfax Murray; J.
Pierpont Morgan

Literature: Fairfax Murray 1905-1912, 1:no.
228; Parker 1938-1956, 1: 22-23; Reznicek
1961, 19, 74-75, 147, 194, 273-274, no. 107;
Shearman 1967, 192, no. 7; Vienna 1967/1968,
210, under no. 307; Judson 1970, 92-93;
Strauss 1977, 2:504; Shoaf and Turner 1984,
270-271

Exhibitions: New York 1957, no. 88; Rotter-
dam 1958, no. 12; Paris 1979-1980, no. 36
(with complete literature); New York 1981,
no. 69

The Pierpont Morgan Library, New York, inv.
no. I, 228

In this full-scale modello for his engrav-
ing of 1590 (fig. 1),[1] Goltzius illustrates
the musical competition between Apollo
and Pan as described in Ovid's *Metamor-
phoses*.[2] According to Ovid, the satyr-god
Pan considered his pipes superior to
Apollo's lyre and entered into a competi-
tion in which the mountain god Tmolus
served as judge. Tmolus ruled in favor of
Apollo, but this judgment was challenged
by Midas, king of Phrygia and an enthu-
siastic follower of Dionysius and Pan,
who was present at the competition. As
punishment, Apollo turned Midas' ears
into those of an ass.

Goltzius' representation of the main
elements of the story follows Ovid
closely. The scene is set on Tmolus'
mountain, and the mountain god is
seated as judge wearing an oak crown.
Pan stands at the extreme left of the
drawing holding his flute, while his satyr
followers form a lively group in the
branches of the tree. Next to Pan and ges-
turing toward him is King Midas, identi-
fied by his crown and by the ass' ears that
he has already grown even though Apollo

is still playing. Apollo in the center wears
only the laurel crown and full-length
mantle described by Ovid.[3]

Not included in Ovid's account are Mi-
nerva and the nine Muses who are here
arrayed in dignified and varied poses
around Apollo. At the right in a vivid
green dress stands Urania, muse of As-
tronomy, with an armillary sphere at her
feet; next to her is Euterpe, muse of mu-
sic and lyric poetry, holding a flute.
Seated on the ground are, from right to
left: Thalia, muse of comedy; Terpsic-
hore, muse of dancing and song; and Era-
to, muse of lyric and love poetry. They
are identified by a fool's staff, lute, and
sphere and calipers, respectively. In the
distance, Minerva, goddess of wisdom,
identified by her armor, spear, and owl,
walks with Clio, muse of history, who
holds a book. The three muses behind
Apollo include Calliope, muse of epic po-
etry, holding a scroll; and Polyhymnia,
muse of sacred song and rhetoric, with a
caduceus. This leaves Melpomene, muse
of tragedy, indicated only as a downcast
head between these two.[4] The Muses are

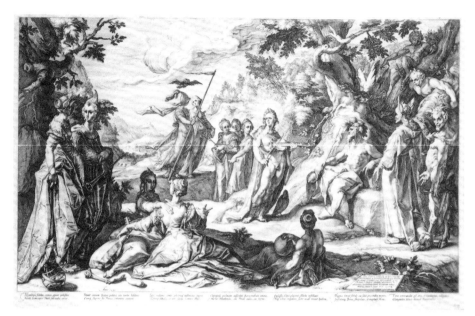

Fig. 1. Hendrick Goltzius, *The Judgment of Midas*, Rijksprentenkabinet, Amsterdam

Fig. 2. Hendrick Goltzius, *The Judgment of Midas*, private collection, England

included as judges in some versions of the story of Marsyas, another flute-playing satyr who challenged Apollo to a musical competition and whose story was often conflated with that of Pan and Apollo.[5] While Goltzius may have included Minerva and the Muses on the basis of such literary sources, it is possible too that they are an interpolation on his part, perhaps inspired by Van Mander's

treatment of the same subject in an engraving published in 1589.[6] In any case, by including Minerva and the Muses as Apollo's retinue, Goltzius emphasizes the refined and learned quality of Apollo's art at the expense of Pan's rude music, a dichotomy that is explicit in the engraving's inscription.

In this context, a recently discovered compositional sketch relating to the

Morgan drawing now in a British private collection (fig. 2)[7] may take on added meaning. Shoaf and Turner have suggested that this sketch was originally intended as part of the three series of scenes from the *Metamorphoses*, making a total of fifty-two engravings whose design occupied Goltzius about 1589.[8] The rapid pen sketch, scored for transfer, is approximately the same size as these engraved Ovidian subjects and features a more exaggerated torsion in the figures, especially Midas and the foreground listeners. The sketch, though rough, presents a coherent composition. In it the satyrs occupy a more prominent foreground position and the female listeners are not specifically characterized or as numerous as in the Morgan drawing. They do not appear to be the Muses, but form a more general audience of nymphs and satyrs. This would tie the scene more specifically to Ovid's account and underscore the hypothesis that it was conceived as part of the earlier narrative series. In any case, the Morgan drawing and the engraving after it are the culmination of Goltzius' involvement with Ovidian subjects and transform their narrative into an allegory of the refining quality of art.

As Reznicek points out, Goltzius' composition is in accord with the principles later enunciated by Van Mander in "Den Grondt der Edel vry Schilder-Const. . . ."[9] He advocated placing standing figures at the sides and seated figures in the center foreground, leaving a view to an open space in the middle ground, here occupied by the protagonist, Apollo. In its exceptional scale and the breadth of its multi-figured composition, *The Judgment of Midas* comes close to Goltzius' 1587 engraving of *The Marriage of Cupid and Psyche* after Bartholomeus Spranger's design,[10] but it can also be seen as a revision of this design. The various planes of the composition are clearly marked out by groups of figures and by alternating areas of shadow and sunlight. The figures' calmer poses and their larger scale in relation to the setting make for a more legible composition. Reznicek notes that *The Judgment of Midas* marks the endpoint of Goltzius' adaptation of Spranger's style, which is no longer pushed to the point of exaggeration, but is still evident in the swaying posture of Apollo and Midas and in Midas' foreshortened gesture.[11] Spranger's influence is still evident too in the nervous swelling and tapering pen contour, which is, however, balanced by the coloristic and corporeal effect of wash.

The drawing and the print after it ap-

160

pear to sum up Goltzius' achievement just prior to his departure for Italy. The addition of the intense green color accent for the satin dress of Urania is difficult to explain in view of the fact that Goltzius himself engraved the plate, though it points to the emphasis he placed on light and texture in this design. The engraving's impact is evident from the number of copies after it, most significant among them a signed copy by Spranger, painted on marble and now in the Kunsthistorisches Museum, Vienna.[12] MW

1. Bartsch 140, Hollstein 132, 418 x 666 mm, dated 1590 at lower left and with a dedication to the amateur Floris Schoterbusch on the tablet at lower right. Inscribed, *Thymbraeis fidibus cannas aequare palustres Arcas Semicaper Tmolo sub indice certat. Stant circum Satyri pedibus cita turba bisulcis, Cumque stupore sui Panos certamina cernunt. Stat radiante coma, plectroque instructus eburno Latonae soboles; circum Sacra numina Musae. Capripedi plamam adscribit Berecynthius amens, Tmolus phoebe tibi, cui Pindi cura, cui Haemi. Insulsis delira placent, selecta refellunt, Atque ultra crepidam sutor male taxat Apellem. Magna tonat stolidae cui sunt preacordia mentis, Inscitiaque Bavi strepitas, et ineptule Mevi. Vera veracunda est ars, et taciturna, relegans Clangentes lituos tumidi blateronibus oris. Franco Estius.* The poet Franco Estius also provided the inscriptions for Goltzius' three series of scenes from the *Metamorphoses*, among other prints, see below.
2. Book XI, ll. 147-180.
3. "Apollo's hair, golden, was wreathed with laurel of Parnassus, his mantle, dipped in Tyrian crimson, swept along the ground," Ovid, *Metamorphoses*, trans. Rolfe Humphries (Bloomington, Indiana, 1958), 264.
4. For the attributes of the Muses, see Goltzius' 1592 series of engravings, Bartsch 146-154, repro. Strauss 1977, 2: 536-553, nos. 299-307, and Felice Stampfle in Paris 1979-1980, no. 36.
5. Minerva and the Muses are not included in the account of the story of Marsyas in Ovid's *Fasti*, VI, ll. 697-710, as stated by Reznicek 1961, 274, but are named as judges between Apollo and Marsyas in Apuleius *Florida* i.3. Hyginus, *Fabulae* 165 cites the Muses as judges in the contest. For the conflation of the two musical contests, see Fehl 1968, 1390-1391.
6. Engraved by Claes Jansz. Clock, Hollstein 4, 267 x 490 mm; see Franz 1969, 1: fig. 22.
7. Shoaf and Turner 1984, 267-271, figs. 150 and 151; 162 x 213 mm; sold Christie's, Amsterdam, 15 November 1983, no. 27, repro. The recto shows various figure studies including Mercury and Andromeda, executed in pen and black ink with gray wash, partially incised for transfer. The verso with the Judgment of Midas is in pen and brown ink over black chalk, incised for transfer.
8. Shoaf and Turner 1984, 270, esp. n. 12. For the three series of anonymous engravings after Goltzius' designs, Bartsch 31-82, 168 x 250-254 mm, see *The Illustrated Bartsch*, 3: 313-338. Neither Midas nor Marsyas is included in the engraved series.
9. Reznicek 1961, 19, 274, pointing to Chapter V, verse 12 of "Den Grondt"; for Van Mander's text, see Miedema 1973, 1: 130-131 and 2: 468.
10. Bartsch 277, Hollstein 322, 436 x 854, printed from three plates.
11. Reznicek 1961, 74-75.
12. For Spranger's copy, see Kaufmann 1985, 303, no. 20-52, repro. Other copies are listed by Reznicek 1961, 274, to which can be added a 1646 painting by Raphael Sadeler in the Heimatmuseum, Baden-Baden; see Kopp 1974, fig. 4.

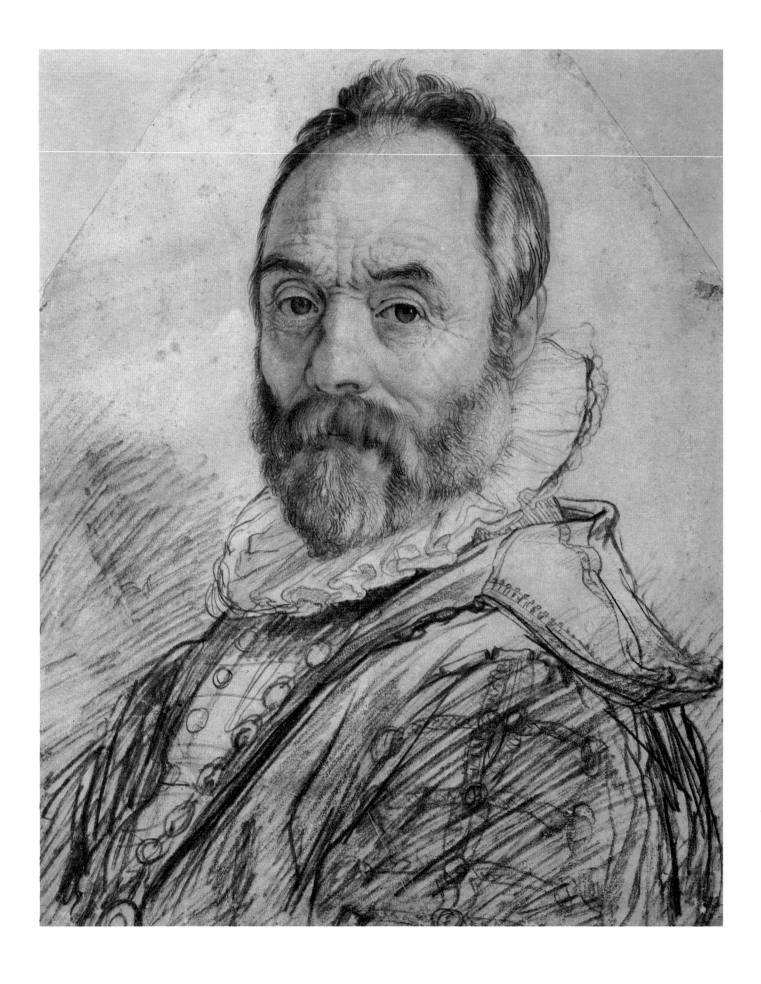

162

HENDRICK GOLTZIUS

57 *Portrait of Giovanni Bologna*

Red and black chalk, slightly washed with
brown in places; laid down
370 x 299 (14⅝ x 11¾)
Inscribed, *Giovan de Bolonia Beelthouwer tot
florence. . /Gheconterf. . . H. Goltzius 1591* on
verso in brown ink

Provenance: Emperor Rudolf II (?); Queen
Christina of Sweden; Cardinal Azzolino, by
descent to his nephew; Dukes of Bracciano;
acquired for Teylers Museum in Rome 1790
(Lugt 2392)

Literature: Hirschmann 1916, 18; Dhanens
1956, 86; Reznicek 1961, 84-89, 355, no. 263;
Bruyn 1961, 136-139; Florence 1980-1981,
113-114

Exhibitions: London 1929, no. 521; Amster-
dam 1934, no. 118; Brussels 1937-1938, no. 21;
Rotterdam 1958, no. 43; Edinburgh 1978-1979,
no. 213

Teylers Museum, Haarlem

This magnificent study belongs to a se-
ries of large chalk portraits made by
Goltzius during his trip to Italy in 1590/
1591. The sitter is identified both by the
inscription on the verso and by the simi-
larity of the features to other almost con-
temporary portraits of Giovanni Bologna.[1]
The chain he wears may be the one sent
to the sculptor by the Elector Christian I
of Saxony in 1587 in gratitude for a statu-
ette of Mars.[2] As the inscription on the
verso states, Goltzius made the portrait
in Florence, presumably at the same time
as the chalk portraits of Pietro Franca-
villa and Stradanus, other Flemish-born
artists active at the Medici court.[3]

Although Van Mander reports that
Goltzius passed through Florence on his
rapid journey to Rome, where he arrived
on 10 January 1591, it is more likely that
the portrait was made on the return jour-
ney in August of 1591. As Reznicek
points out, the increased plasticity and
sureness of the Florentine portraits, in
comparison to the portrait of Dirck de
Vries executed in Venice in 1590, presup-
poses Goltzius' intensive use of black and
red chalk for the studies of antique sculp-
ture that occupied him in Rome (see also
cat. 58).[4] Van Regteren Altena and Rezni-
cek see the influence of Federico Zuccaro
in this mastery of black and red chalk
technique.[5] That Goltzius knew Zuccaro
in Rome is attested by Van Mander.[6]
However, in the conception of the por-
trait—the rather formal presentation of
the sitter in three-quarter view with pre-
cisely observed head and cool, direct
gaze—Goltzius' chalk drawings do not
relate to Zuccaro's portraits. Rather, as
Boon notes,[7] they are allied to a northern
tradition of court portraits in chalk, espe-
cially as practiced by François Clouet and
his followers.

The identifiable sitters from the Italian
trip are all artists and the sizes of the
drawings are very similar, suggesting that
Goltzius intended them as a series; per-
haps for publication as prints. In this they
anticipate Van Dyck's *Iconography.*
Other chalk portraits on the same scale
include the 1588 portrait of Goltzius' stu-
dent and printer Gillis van Breen in
Frankfurt, the 1592 portrait of Jacob Ma-
tham in Vienna, and the self-portrait in
Stockholm.[8] That Goltzius may have in-
tended the drawing as the basis for a print
series seems more probable when the
scale and format of his engraving of Dirck
Coornhert is considered. The drawn
model for this engraving may have been a
large chalk study, presumably made
shortly before Goltzius' Italian trip.[9] The
portrait of Giovanni Bologna is outstand-
ing within the series because of the sub-
tle range of coloristic effects achieved in
the head and the sense of an immediate,
magisterial presence, conveyed through
the slashing strokes of black chalk in the
body. As Reznicek notes, this is the only
one of the portrait drawings made on the
Italian trip in which head and body ap-
pear to have been conceived together.
The greater unity and spontaneity of this
drawing results in part from changes in
the body made during the course of work.
Thus Goltzius repositioned the ruff, first
drawn almost in profile, but then par-
tially redrawn with a tilt to follow the
twist of the head. The repeated, slashing
lines at either shoulder also appear to
correct the position of the body, reducing
its profile aspect and bringing the sitter's
right shoulder forward. MW

1. Compare the portrait type repeated in a painting in
Douai variously attributed to Jacopo Bassano and
Hans von Aachen, a drawing in black and red chalk
by Joseph Heintz in the National Gallery, and an en-
graving of 1589 by Gijsbrecht van Veen; see An der
Heiden 1970, 221-222, fig. 191, and Princeton 1982-
1983, no. 55.
2. This suggestion is made by Keutner in Edinburgh
1978-1979, under no. 43. Reznicek 1961, 355, previ-
ously suggested that the Emperor Rudolf II might
have made Giovanni Bologna a present of such a
chain when he raised him to the nobility in 1588.
3. In the Rijksprentenkabinet and the Institut Néer-
landais respectively; Reznicek 1961, nos. 271 and
286, pls. 203 and 198.
4. Reznicek 1961, 85-86. The portrait of De Vries is
also in the Teylers Museum; Reznicek 1961, no. 287,
pl. 140. For Goltzius' Italian itinerary see Van Man-
der, *Schilder-boek*, 2: 231-239.
5. Van Regteren Altena 1936, 60, and Reznicek
1961, 86.
6. Van Mander, *Schilder-boek*, 2: 185, in his biog-
raphy of Holbein, citing Zuccaro's praise of Holbein
in conversation with Goltzius.
7. In Florence 1980-1981, 114, in connection with the
portrait of Stradanus.
8. Reznicek 1961, nos. 264, 255, and 279, pls. 88, 205,
and 223.
9. Strauss 1977, 2: 510-511, repro.; the dimensions of
the portrait oval are 425 x 321 mm. Coornhert died in
October 1590. Oberhuber in Vienna 1967-1968, no.
313, notes a stylistic relation between the Coornhert
and the chalk series.

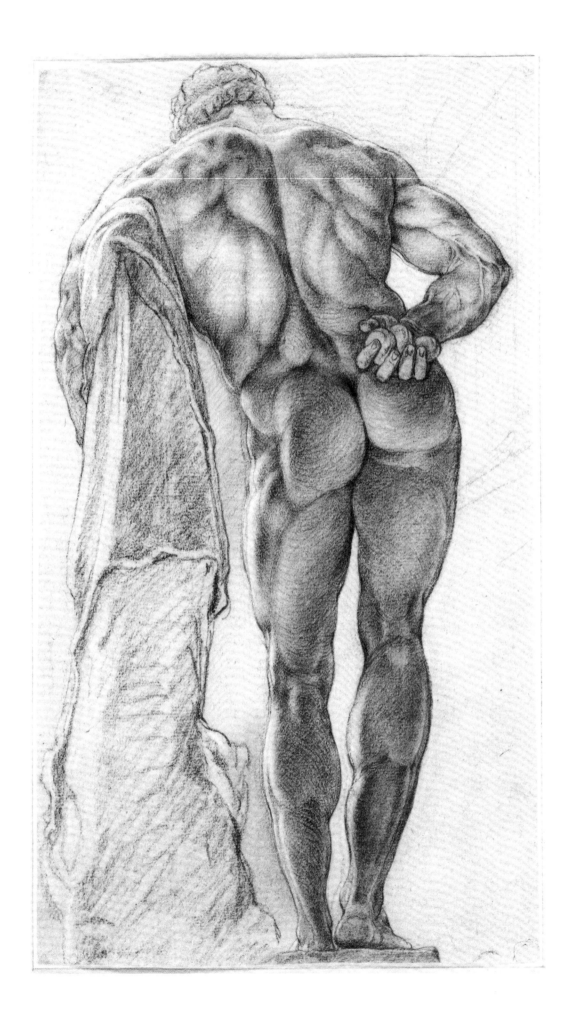

HENDRICK GOLTZIUS

58 *Hercules Farnese from the Back*

Black and white chalk on blue paper; contours indented
362 x 209 (14¼ x 8³⁄₁₆)
Provenance: Probably Emperor Rudolf II, before 1612; Queen Christina of Sweden (inv. 1656; Denucé 1932, 179); Cardinal Azzolino, by descent to his nephew; Dukes of Bracciano; acquired in Rome by the museum in 1790 (Lugt 2392)

Literature: Hirschmann 1919, 61, 166; Reznicek 1961, 336-337, no. 226; Miedema 1969, 76-77; Strauss 1977, 562

Teylers Museum, Haarlem, inv. no. K.III 30

This is one of a group of studies of antique sculpture executed by Goltzius during his stay in Rome in 1591 and evidently intended as preparation for a series of engravings of ancient monuments.[1] Only three engravings by Goltzius himself resulted from this project, the *Hercules Farnese* for which this was the first study, the so-called *Emperor Commodus* (Hercules and Telephos), and the *Apollo Belvedere,* all published posthumously in 1617,[2] yet the systematic preparation of the drawings makes it clear that Goltzius planned an extensive series. The surviving drawings, preserved together in the Teylers Museum, show two stages of preparation.[3] First Goltzius made a sketch in black chalk on blue paper to define the contours, proportions, and lighting of the sculpture from a distance sufficient to avoid perspective distortion. He then transferred the contours to another sheet of white paper and moved closer to his model to produce a highly finished red chalk study of details of texture and light. The red chalk study was in turn transferred to the copperplate through an intermediate transfer onto a sheet of blackened paper, permitting the design to be reversed twice so that the final print was in the same direction as the original.[4]

The Hercules Farnese, a copy inscribed with the name of Glykon after a lost original by Lysippos, was discovered in the Baths of Caracalla in 1546. The missing legs and left arm were restored by Guglielmo della Porta, though the original legs were later unearthed on the grounds of the Villa Borghese.[5] Goltzius saw the colossal statue in the arcade of the courtyard of the Palazzo Farnese. A drawing in Frankfurt shows the height of the statue in relation to the arcade and its position in the shadow of the arch (fig. 1). As Hirschmann first observed, the brighter illumination of the head and shoulders and the play of reflected light over the

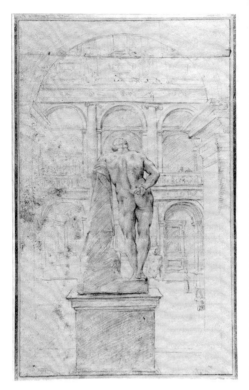

Fig. 1. Hendrick Goltzius, *The Courtyard of the Palazzo Farnese,* Städelsches Kunstinstitut, Frankfurt

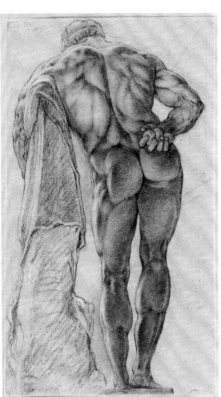

Fig. 2. Hendrick Goltzius, *Hercules Farnese from the Back,* Teylers Museum, Haarlem

muscles of the back in Goltzius' drawing were dictated by this position.[6] The arches of the courtyard, lightly indicated in this sketch, were not incised for transfer to his red chalk study, also preserved in Haarlem (fig. 2). Clouds replace the architectural setting in the engraving (fig. 3). The omission of summarily indicated settings from the red chalk studies is evident in several other cases where both stages of the preparatory process survive.[7] In the black chalk version of the *Farnese Hercules from the Back,* the incised contours make the forms slightly broader than the drawn outline in some places, for example, the left side of the left leg. The greater effect of massiveness in the red chalk studies is also due to Goltzius' extraordinarily precise recording of surfaces, which, however, conveys the quality of flesh and fabric rather than stone.

In the painstaking preparation of the series and in the documentary quality of the fully-worked up red chalk studies, Goltzius seems to have intended a series of authoritative models for his contemporaries. The process of absorbing the poses and expressions into his own work is less evident. The surviving drawings copy twenty-nine sculptures, but, in striking contrast to Rubens' practice a decade later,[8] include only four pieces re-

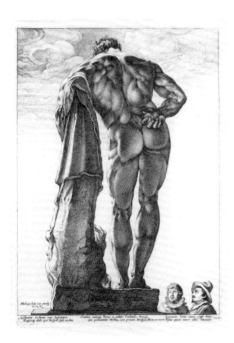

Fig. 3. Hendrick Goltzius, *Hercules Farnese from the Back,* Rijksprentenkabinet, Amsterdam

peated from more than one vantage point, the Farnese Hercules, the so-called Commodus as Gladiator, the Belvedere Torso, and the "Trofei di Mario." The specific quotation of these models in Goltzius'

own work is difficult to trace. Yet the series is among his most fully realized drawings, *naer het leven*, and the intensity of his confrontation with these antique monuments undoubtedly increased the tendency toward balance and naturalism already present in his work by the late 1580s. MW

1. Van Mander reports that Goltzius also copied antique sculpture on a side trip to Naples, *Schilderboek*, 2: 238-239. It is not possible to confirm this from the surviving drawings; see Reznicek 1961, 84.
2. All three with the address of Herman Adolfz., Haarlem and the date 1617. Strauss 1977, 562-569, nos. 312-315, repro. Hirschmann 1919, 123-125, considers these engravings to be late works, since Van Mander does not mention the project. The suggestion put forward by Reznicek 1961, 337, 419, that the plates were engraved shortly after Goltzius' Italian trip, but not published by him because he had not completed the series, has found general acceptance. If Goltzius sold his drawings after antique sculpture to Rudolf II in 1595 as Reznicek 1978/1979, 205, suggests, then he must have given up the intention of completing the series. A fourth print, *Hercules with the Apples of the Hesperides*, is based on a drawing by Goltzius (Reznicek no. 222), but was not engraved by him. It reverses the direction of the drawing; see Strauss 1977, 560-561, no. 311, ill.
3. Hirschmann 1919, 166, considers the black chalk drawings to be by another hand.
4. See Miedema 1969, 76-77, who analyzes this process in detail. It should be noted that in some of the black chalk drawings, surfaces are observed with a precision more characteristic of the red chalk studies, which are not known in these instances (see, for example, Reznicek 1961, nos. 225, 230, 231, 222, and 214, the latter two not indented for transfer). Goltzius may have economized on his working procedure.
5. Now in the Museo Nazionale, Naples. The head was apparently discovered in Trastevere earlier than the body; see Hübner 1912, 96 and Haskell and Penny 1981, 229-232, no. 46, fig. 118.
6. Hirschmann 1919, 61-62.
7. For example, the Farnese Flora, Reznicek 1961, nos. 228, 229, pls. 172 and 173. However, the black chalk sketch after Michelangelo's *Moses*, the only Renaissance sculpture included in this canonical group, is incised to indicate more of the setting than is drawn; see Reznicek 1961, no. 232, pl. 185.
8. Reznicek 1961, nos. 201-202, 225-227, and 230-231, pls. 156-157, 176-179, and 174-175 respectively. For Rubens' drawings after antique sculpture, see Fubini and Held 1964, 123-141.

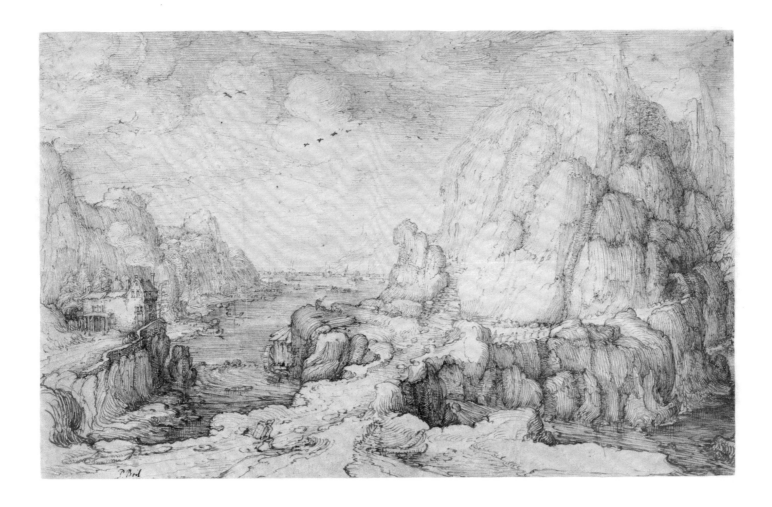

HENDRICK GOLTZIUS
59 *Mountainous Coastal Landscape*

Pen and brown ink over traces of black chalk
235 x 383 (9¼ x 15⅛)

Watermark: Shield with monogram, *FMO*
(close to Heawood 3196)
Inscribed at lower left in dark brown ink,
P Bril; on verso, in center in pencil, *P. Bril*;
at lower left in brown ink, *8*

Provenance: Count Karl Lanckoronski,
Vienna; Countess Adelheid Lanckoronska;
(sale, Christie's, London, 30 March 1971, no.
97); R. M. Light and Co., Boston

Literature: Schönbrunner and Meder 1896-
1908, 6: no. 666; Van Gelder 1933, 20; Van
Regteren Altena 1936, 88; Lugt 1949, 1: 22;
under no. 385; Reznicek 1961, 110, 433, no.
408; Stechow 1966, 133; Haverkamp-Bege-
mann 1973, 32; Keyes 1979, 21-23, 37, no. 42;
Andrews 1985, 32, under no. RSA 75

Exhibitions: New York 1974, no. 38; Los
Angeles 1976, no. 184; Paris 1979-1980, no. 37

The Pierpont Morgan Library, New York. Gift
of the Fellows with the special assistance of
the Lore and Rudolf Heineman Foundation,
1971, inv. no. 1971.3

Before his trip to Italy in 1590-1591,
Goltzius scarcely made any independent
landscape drawings.[1] Yet the experience
of two trips over the Alps and of the work
of practitioners of landscape in Italy, both
past and present, evidently inspired him
to experiment with nature as the subject
for virtuoso pen drawings in the 1590s.
The Morgan drawing, like the others of
this period, is a fantastic rather than an
observed scene, and the mood suggested
by the landscape elements is more impor-
tant than literal description. The cloud-
shrouded peak, mountain torrent, and
rock bridge have an energy that engulfs
the tiny signs of human activity such as
the traveler in the foreground, the figures
leaning on the wall at the left, or the dis-
tant boats.

As the old attribution inscribed at the
lower left attests, Goltzius makes refer-
ence here to the mannerist landscapes of
the brothers Matthijs and Paul Bril. This
is evident in the steep paths and the river
conducting the eye from the immediate

foreground to the distance, devices found
in the early work of Paul Bril (fig. 1). In
general, the highly charged, emotional
quality of the natural forms is reminis-
cent of the Brils' work.[2]

Only a few of Goltzius' landscape
drawings of the 1590s are dated or readily
datable. In drawings dated 1593 in Lisbon
and Chatsworth (fig. 2), the landscape
setting takes on a dominant role and the
dashing penwork imitates Venetian
drawings and woodcuts from Titian's cir-
cle.[3] In two grandiose mountain land-
scapes in Haarlem and Orléans dated
1594, Goltzius seems to consciously imi-
tate Pieter Bruegel's Alpine landscapes in
both subject and technique.[4] A drawing
in Dresden dated 1595 also makes refer-
ence to Bruegel, but the extensive pano-
rama is ordered by rhythmic curving
lines that again recall the sytle of Titian's
circle.[5] Reznicek considered that this lat-
ter tendency was more explicit in the
Landscape with Mercury in Besançon
from which a date of 1596 has been par-

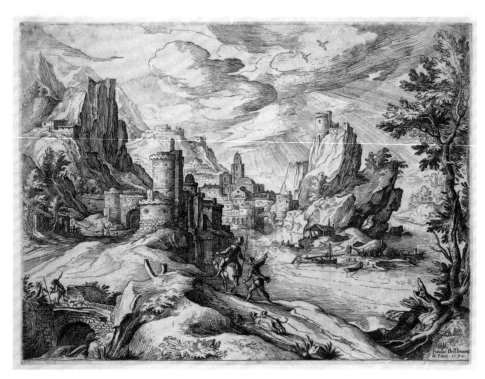

Fig. 1. Paul Bril, *River Landscape with Travelers*, National Gallery of Art, Washington, Andrew W. Mellon Purchase Fund

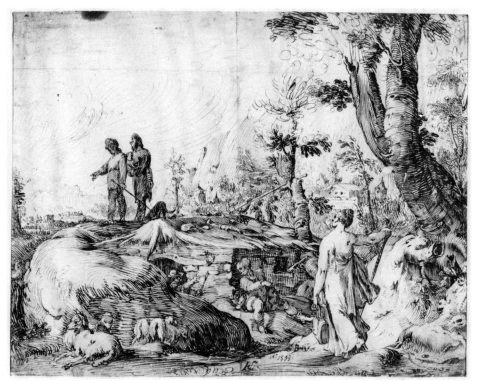

Fig. 2. Hendrick Goltzius, *Pastoral Landscape*, The Duke of Devonshire Collection and the Chatsworth Settlement Trustees, Chatsworth (Courtauld Institute of Arts)

The Morgan drawing has generally been dated after the Dresden *Panorama*.[9] However, it is similar in several respects to the two sheets dated 1594 in Haarlem and Orléans and to a freer, undated sketch in Braunschweig.[10] These share the steep cloud-shrouded mountain and the rather carefully differentiated effects in the sky. Though long curving strokes create the main forms in the Morgan drawing, the use of short flecked strokes or frilly contours to make the transition between rock masses also bears comparison to this early group. Hence a date of 1595 or earlier is possible for the Morgan sheet.

Goltzius' pen landscapes were highly influential for Dutch draftsmen around 1600, particularly Jacques de Gheyn (see cat. 51). Recently George Keyes has included the Morgan drawing in a group of works he attributes to the Haarlem marine painter Cornelis Claesz. van Wieringen, whose drawings show the impact of Goltzius.[11] However, neither the execution nor the more modest subjects of Van Wieringen's few secure graphic works support such an attribution.[12] MW

1. An exception is the panoramic landscape in Rotterdam, which was, however, made in preparation for the background of Goltzius' 1587 engraving of *The Marriage of Cupid and Psyche* after Spranger; Reznicek 1961, 429-430, no. 403, pl. 72. The backgrounds of some of Goltzius' pen drawings in engraving technique, such as the *Venus and Cupid* of 1590 also in Rotterdam, are precedents for his landscapes after the Italian trip; see Reznicek 1961, 108, 281, no. 121, pl. 133.
2. Reznicek 1961, 110, and 433 and Stampfle in Paris 1979-1980, no. 37, point to the influence of Paul Bril. Lugt 1949, 1: 22 refers to the drawing as by Paul Bril.
3. For this type of pen drawing, see Reznicek 1961, 113. For the *Woman with an Angel in a Landscape* in Lisbon, see Reznicek 1961, 454, no. 437, pl. 232. The Chatsworth *Pastoral Scene* is not in Reznicek.
4. Reznicek 1961, 100, 426-427, nos. 396 and 399, pls. 239 and 238 respectively.
5. Reznicek 1961, 108-109, 425, no. 395, pls. 242-244.
6. Reznicek 1961, 109, 424, no. 393, pl. 252. It is unclear whether the monogram and date formerly prominently placed in the sky were autograph: see also Foucart in Paris 1965-1966, no. 154.
7. Reznicek 1961, 110-111, 426-428, 431-432, nos. 398, 401, and 406, pls. 310-312. For the chiaroscuro landscapes that can be given to Goltzius, see Clifford Ackley in Boston 1980-1981, nos. 14 and 15.
8. Van Mander, *Schilder-boek*, 2: 246 compares Goltzius to Proteus or Vertumus in his ability to imitate different styles. See also Reznicek 1961, 114, in relation to his use of different landscape styles.
9. Van Regteren Altena 1936, 88, and Reznicek 1961, 433; Van Gelder 1933, 20, suggests that this sheet might have been drawn on Goltzius' return trip over the Alps.
10. See n. 4 above and Reznicek 1961, 109, 425, no. 394, pl. 237.
11. Keyes 1979, 21-23.
12. See also Andrews 1985, 32, fig. 217.

tially erased.[6] He compared the dramatically lit and roughly executed, undated drawings in Stockholm, Hamburg, and the Lugt collection to the chiaroscuro woodcuts of landscape subjects, placing them at the end of the group of landscape drawings from the 1590s.[7]

The landscape drawings of the 1590s show Goltzius' protean ability to imitate the work of other masters, an ability also displayed in the so-called *Meisterstiche* in the same years, imitating Dürer and Lucas van Leyden.[8] In consequence, the undated landscapes are difficult to place.

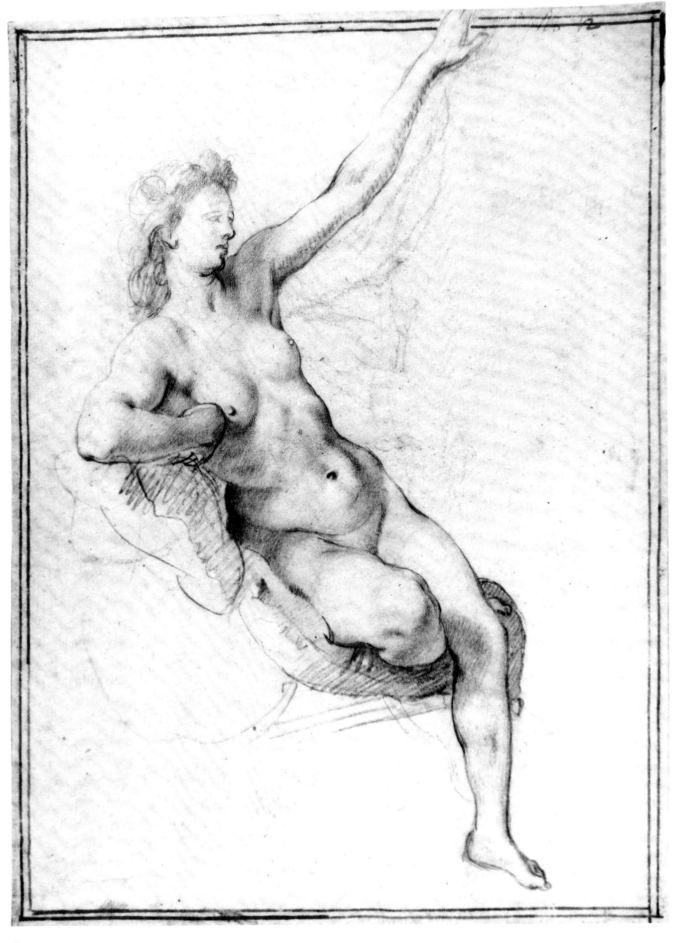

60

HENDRICK GOLTZIUS

60 *Study of a Nude Woman*

Black chalk, added border lines in brown ink
389 x 289 (15¼ x 11⅜)
Inscribed at upper right in brown ink, *no 12*

Provenance: N. Beets, Amsterdam; J. Theodore
Cremer, New York (his sale, Sotheby Mak van
Waay, Amsterdam, 17 November 1980, no.
46); C.G. Boerner, Düsseldorf

Literature: Reznicek 1961, 134-135, 219, 458-
459, no. 446; Van Thiel 1965, 134-135, 147;
Miedema 1976, 263, 265

Maida and George Abrams Collection, Boston,
Massachusetts

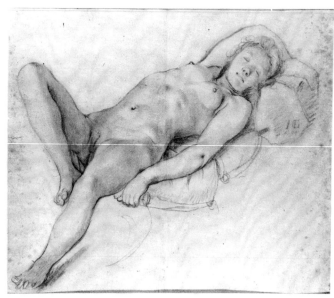

Fig. 1. Hendrick Goltzius,
Sleeping Girl, private
collection, New York

This study in black chalk is one of the
very few known drawings by Goltzius ap-
parently based on observation of a nude
model. The others are the *Sleeping Girl*
in black chalk in an American private
collection (fig. 1), monogrammed and
dated 1594,[1] and the red chalk *Seated
Nude* in the Teylers Museum (fig. 2),
monogrammed and dated 1599.[2] In the
choice of the chalk technique to describe
precise contours and volumes these
drawings are connected with a larger
group of studies in black or red chalk
after antique or Renaissance sculpture
made in Rome in 1590/1591 (see cat. 58),
and with a few closeup studies of animals
and hands made shortly before this trip,
but reminiscent of an earlier model book
tradition in their *mise en page*.[3]

The three known studies presumably
drawn from a nude model show succes-
sive variations in the degree of idealiza-
tion; in this sequence the Abrams draw-
ing occupies a middle point. In the
smaller Haarlem drawing the body is less
specifically modeled and is dominated by
a twisting movement in which the ovoid
head is also subsumed. Both pose and
generalized features express a hesitant
and cringing action so that the figure ap-
proaches Goltzius' imaginative inven-
tions.[4] In the Abrams drawing Goltzius
treats the flesh as a luminous surface,
giving particular emphasis to the project-
ing elbow and knee through subtle grada-
tions of stumped chalk. At the same
time, the pose is conceived as a grand
gesture expressed in one long, undulating
contour, and the barely indicated features
and raised hand apparently supported on
an invisible ledge[5] give the figure an ab-
stract quality. The *Sleeping Girl* goes fur-
thest in the objective recording of form
and light, which plays with equal speci-
ficity and voluptuousness over face and
body.

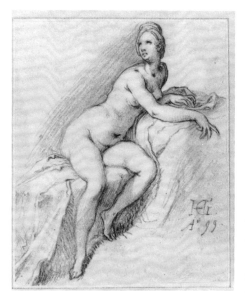

Fig. 2. Hendrick Goltzius, *Seated Nude*,
Teylers Museum, Haarlem

The function of the chalk studies from
the live model is unclear. Despite the fact
that the paintings Goltzius made from
the turn of the century on presuppose
close observation of the live model, these
drawings seem not to be preparations for
specific paintings or prints. Though Rez-
nicek links the Haarlem study to a series
of engravings of classical figures pub-
lished by Matham after Goltzius' death,
these show only a general similarity to
the chalk drawings.[6] The drawings from
the live model may instead have been
drawings for practice, with the figures
cast in poses of a more or less general al-
legorical usefulness. In the Abrams draw-

ing the pose is that of a personification or
deity holding an attribute, with the raised
arm first sketched lightly at several dif-
ferent angles. Miedema argues that the
pose of the 1594 study was that of a
sleeping nymph or bacchante and would
carry classical associations.[7] Related to
the function of the drawings is the ques-
tion of their possible origin in the prac-
tice of the so-called Haarlem Academy.
In 1618 the anonymous biographer of Van
Mander mentioned that shortly after Van
Mander met Goltzius and Cornelis van
Haarlem, the three of them formed an
Academie in order to make studies from
life.[8] The intensive interchange of ideas
between the three artists dates from
about 1588, though they may not have
made drawings from live models until
about 1590 or later.[9] The Abrams draw-
ing should be dated after 1590/1591, be-
cause of the more classic proportions of
the figure, presupposing the Italian trip,
the precedent of the Italian chalk studies,
and the similarity in technique to the
1594 *Sleeping Girl*.

As Miedema and Schatborn note,
Goltzius' drawings after sculpture and
after the live model form a group, with
both being considered studies from life.[10]
Thus Karel van Mander praises Cornelis
van Haarlem for his diligence in drawing
"from life, seeking out the best and most
beautiful, moving and lively antique stat-
ues of which a sufficient number were
available in the Netherlands."[11] It is the
studies after antique and Renaissance
sculpture in black chalk on blue paper
(see cat. 58) that provide the closest par-
allel to the studies from the live model in
the way Goltzius finds and emphasizes
undulating contour, rapidly indicates the

rudiments of spatial setting, and models broad areas of shadow. In contrast, his red chalk drawings made in Italy have more the character of highly finished print modelli. MW

1. See Reznicek 1975, 106, fig. 1; suggesting that the date was autograph, but the monogram was not. Miedema 1976, 263-266, argues that both are autograph and that Goltzius signed his inventions, but not necessarily his life studies, which might be signed or not, depending on their function.
2. Reznicek 1961, 453, no. 434.
3. For example, the study of his own right hand in black and red chalk in Frankfurt, the *Camel* in the British Museum, and the "*Cruyckvis,*" dated 1589, in the Bibliothèque Royale, Brussels; Reznicek 1961, nos. 432, 416, and 418, pls. 89, 116, and 117 respectively.
4. Compare, for example, the chalk drawings gone over in pen representing Atalanta and Daphne in Rotterdam and Munich; Reznicek 1961, nos. 113 and 112, pls. 341, and 315 respectively. See also n. 1 above.
5. Reznicek 1961, 219, points out that this is typical of a studio pose.
6. Reznicek 1961, 453. For the Matham series, Bartsch 286-293, see *The Illustrated Bartsch,* 4: 263-270.
7. Miedema 1976, 263-266.
8. ". . . quam korts daer nae aen kennisse van *Goltsius,* en *Mr. Kornelis,* hielden en maeckten onder haer dryen een *Academie,* om nae't leven te studeeren, *Karel* wees haer de Italiaenische maniere, ghelijck't aen den *Ovidius van Goltzius* wel te sien en te mercken is . . ."; see Miedema 1973, 2: 303-304.
9. See Reznicek 1961, 216-220; Van Thiel 1965, 128-130, 134-135; and Miedema 1973, 2: 303-304. Before the 1594 *Sleeping Girl* came to light, Reznicek dated the Abrams drawing after 1600; Reznicek 1961, 219.
10. Miedema 1976, 263-264, and Schatborn in Amsterdam 1981-1982, 34, 137, no. 54.
11. ". . . te teyckenen nae't leven, daer toe uytsoeckende van de beste en schoonste roerende en levende Antijcke beelden, die wy hier ghenoegh binnens Landts hebben . . . ," Van Mander, *Schilder-boek,* 2: 310.

61 *Venus, Ceres, and Bacchus*

Brush and monochrome oil paint over black chalk on paper, varnished
431 X 320 (17 X 12⅝)
Inscribed at lower right, *HGoltzius. fecit./ A°.1599.* (initials in ligature)

Provenance: V. Röver, Delft, inv. vol. 2, 8, no. 15 (d. 1739); his widow; J. Goll van Franckenstein, Amsterdam (d. 1785); by descent to Pieter Hendrick Goll van Franckenstein (d. 1832); (his sale, July 1833, album N, no. 8, to Brondgeest); Baron J.G. Verstolk van Soelen, The Hague (d. 1845) (his sale, March 1847, album E, no. 181, to Brondgeest); T.H. Hawkins, London; (Colnaghi); purchased by the museum 1861

Literature: Hirschmann 1919, 142; Stechow 1927-1928, 57-58; Popham 1932, 161, no. 8; Bernt 1957, 1: no. 260; Reznicek 1961, 101, 129, 284, 287-288, no. 130; Berlin 1979, 31, under no. 15

Exhibited in Washington only

Though Van Mander mentions a large decorative grisaille of Mucius Scaevola that Goltzius executed in oil in the 1580s, he states that he did not begin to paint in oil until 1600.[1] This highly finished grisaille, dated 1599, can be seen both as presaging Goltzius' work as a painter and as a continuation of the tradition of monochrome oil modelli for prints as practiced by Barendsz., Blocklandt, and others (see cat. 9). The grisaille was the immediate model for the engraving of 1600 by Jan Saenredam (1565-1607), which follows the details of design, texture, and light very faithfully (fig. 1).[2] The modello was itself preceded by a preparatory drawing in the De Grez Collection, Brussels (fig . 2).[3] As Reznicek points out, the working drawing in Brussels, indented for transfer throughout, functioned as a cartoon for the modello.[4] Goltzius' handling of red and black chalk, gray and brown wash, and white, pink, yellow, and blue body color in the Brussels drawing also shows an attraction to painterly effects as well as an effort to clarify the contours of the linked figures and set them off from the shadowed bed. In tracing the elements of the Brussels drawing Goltzius freely drew in further changes, which were retained in the modello—the angle of Bacchus' arm holding the wine glass, the angle of the table, and the harpylike decoration that forms the corner of the bed. In the modello itself he raised and turned the head of Venus, a change that, together with the more generalized facial type given to her and to Bacchus, subtly abstracts the character of their interaction.[5]

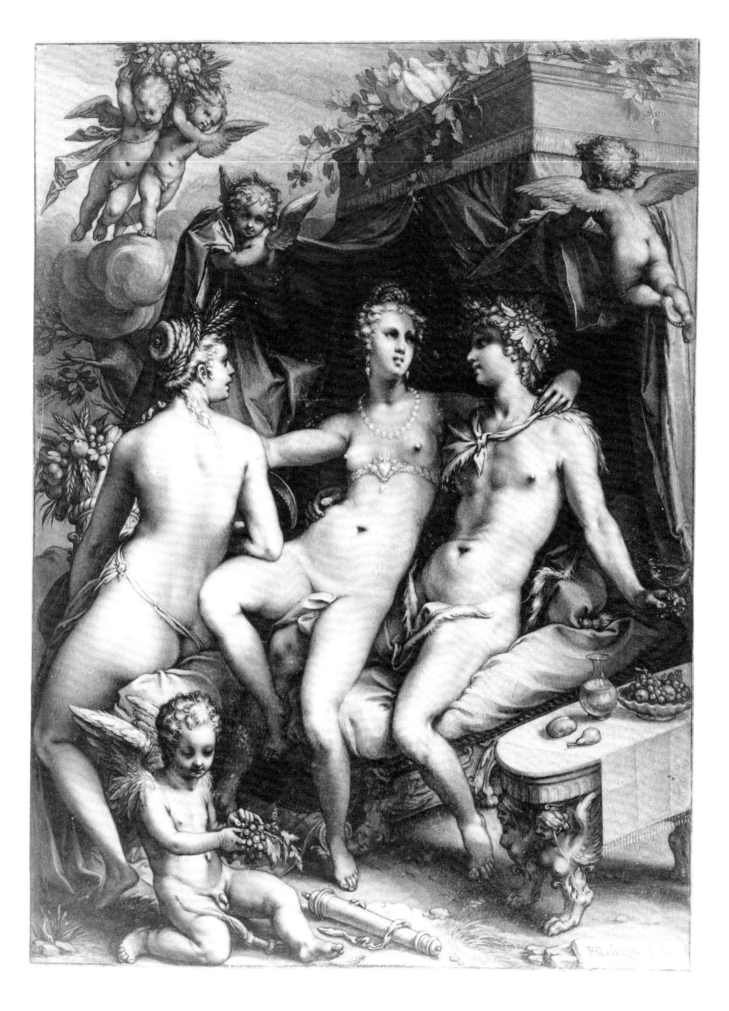

172

In the case of the monochrome *Venus, Ceres, and Bacchus*, the choice of the oil medium and the refined surface textures achieved thereby seem to reflect a harmony between the designer's aims and the engraver's capabilities. The information conveyed in Goltzius' modello is certainly appropriate to Saenredam's engraving style, with its silvery tonality and smooth, dimpled forms. The degree to which engraver and designer worked together toward this goal is unclear, though in his biography of Bloemart, Van Mander reports that Saenredam took great pleasure in Bloemart's drawings and made the utmost effort to make beautiful reproductions of them. Van Mander is here speaking of Bloemart's oil grisailles ("gheteyckent met de Pen, en daer nae met wit en swart, van Oly-werwe gheschildert").[6] An example of this type is his *Vanitas* in Dresden, which corresponds to Saenredam's engraving,[7] but is freer in its depiction of surfaces than Goltzius' oil grisaille.

The rich surface effects of the London grisaille are also suited to the luxuriant mood of the subject, a variation on the maxim "Sine Cerere et Baccho friget Venus." (Without Ceres and Bacchus, personifying food and drink, Venus freezes.) The maxim first occurs in Terence's comedy *Eunuchus* and was frequently given visual expression by Netherlandish artists around 1600. Konrad Renger analyzes the moralizing nature of this theme, which is sometimes underscored by the introduction of a figure in contemporary dress. Renger also notes the ambivalence with which it could be treated.[8] In this image Goltzius omits the glowing fire that both warms Venus and symbolizes the heat of lust in the drawing in engraving technique in London, dated 1593, and in his engraving of 1595.[9] Instead the three figures are presented as abstract, interdependent personifications, almost as general principles of fecundity. Nevertheless, danger is implied by Cupid's fascination with the bunch of grapes and by the close connection of Venus and Bacchus, whose poses echo each other. MW

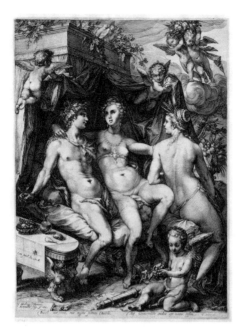

Fig. 1. Jan Saenredam after Hendrick Goltzius, *Venus, Ceres and Bacchus*, Rijksprentenkabinet, Amsterdam

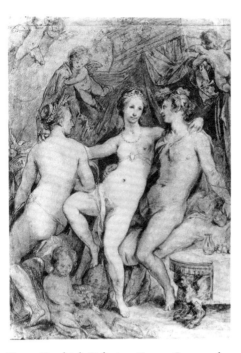

Fig. 2. Hendrick Goltzius, *Venus, Ceres and Bacchus*, Musées Royaux des Beaux-Arts de Belgique, Brussels (Copyright A.C.L. Brussels)

1. From Van Mander's description, this grisaille painting and other large grisailles in greasy charcoal or black chalk also of classical subjects seem to have been designed for particular architectural settings. He reports that he saw them on first coming to Haarlem, hence c. 1583; see *Schilder-boek*, 2: 242. Van Mander's statement that Goltzius did not begin to paint until 1600 is corroborated by the report of Johann Tilmans, agent for the Count of Lippe; see Hirschmann 1916, 35-37.

2. Bartsch 69, Hollstein 76, 431 x 316 mm. Inscribed with imperial privileges and *HGoltzius Inuentor,/ ISaenredam Scup.A° 1600.* and *Bacche meae vires, mea magna potentia Bacche, Tuque Ceres; vestro quidvis ego numine possum. C. Schonaeus.*

3. Musées Royaux des Beaux-Arts, De Grez Collection, inv. no. 1362, 402 x 287 mm, on cream paper; Reznicek 1961, 284, no. 127. The drawing has been cut slightly on all sides.

4. Reznicek 1961, 284.

5. The changes in the angle of the head are not indented.

6. *Schilder-boek*, 2: 360; Van Mander notes that Bloemart's oil grisailles were engraved by Jan Muller, and, more frequently, by Saenredam.

7. Dittrich 1976-1977, 93-95, figs. 3 and 4. Saenredam's engraving is inscribed *ABloemart Pinx* and is in the same direction as the grisaille.

8. Renger 1976-1978, 190-203.

9. For the meaning of the youth blowing on the fire, see Renger 1976-1978, 196-198. For the 1593 drawing in London, see Reznicek 1961, 286-287, no. 129, pls. 224-226. For the engraving, see Strauss 1977, 2: 594-595, no. 325, repro.

10. Stechow 1927-1928, 57-58, notes the allegorical tenor of Goltzius' design as expressed in the arrangement of the figures.

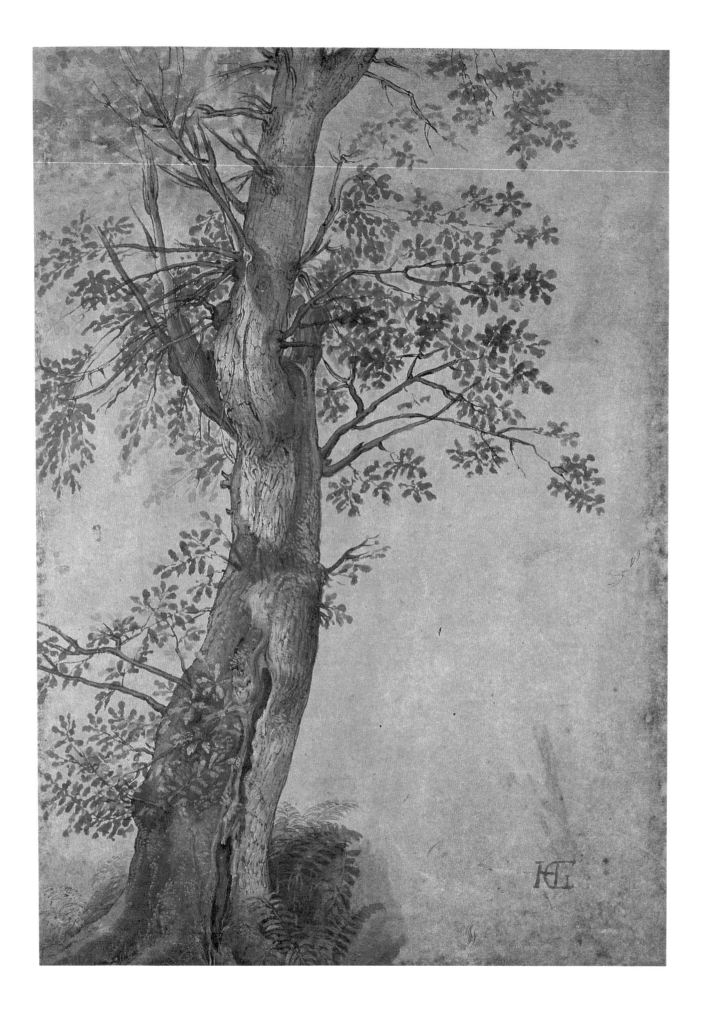

HENDRICK GOLTZIUS

62 *Tree Study*

Pen and dark brown ink, brush and watercolor
and blue, green, yellow, and white body color
on blue prepared paper
424 X 290 (16⅝ x 11⁷⁄₁₆)
Inscribed in gray watercolor at lower right, *HG*
(in ligature)

Provenance: (Colnaghi 1934); Francis Falconer
Madan (d. 1962)

Exhibitions: London 1934; London 1953, no.
267; Rotterdam 1958, no. 95; London 1962, no.
49; New Brunswick 1982-1983, no. 32

Literature: Dodgson 1935, 66; Van Regteren
Altena 1936, 90; Haverkamp-Begemann 1959,
38, Reznicek 1961, 111-112, 276, 429, 437, no.
410; Wegner 1969, 92; New York 1977-1978,
74, under no. 51

Lent by the Visitors of the Ashmolean Mu-
seum, Oxford

This portraitlike study of the texture and
form of a single tree trunk is unique in
Goltzius' known oeuvre. As a closeup
study in nature, rather than a panorama,
and in the coloristic use of wash and
body color on blue paper, this sheet is
closest to two drawings showing trees in
a wood in Hamburg and the Fondation
Custodia.[1] Although none of these works
is dated, all have generally been placed in
the years shortly before 1600.[2] Reznicek
notes their relation to other works, simi-
larly undated, but usually placed at the
end of the 1590s when Goltzius was ex-
perimenting with coloristic effects. These
include a series of four small woodcuts of
landscapes, printed on blue paper with
highlights added in white body color as
well as in chiaroscuro versions, and sev-
eral pen drawings of fantastic landscapes
on brown or gray paper with highlights in
white body color.[3] Further, the free use of
body color in the Ashmolean *Tree Study*
recalls figure drawings from these years,
such as the Brussels *Venus, Ceres, and
Bacchus*, datable to 1599, and like them
probably anticipates or coincides with
Goltzius' first activity as a painter.[4] Fi-
nally, the gnarled trunk sprouting short,
feathery branches is quite similar to the
closeup tree trunk in Goltzius' 1597
friendship portrait of *Frederick de Vries*
(fig. 1).[5] In both the engraving and draw-
ing Goltzius dwells on the play of light
on contrasting textures of rough bark and
shifting leaves.

Goltzius' various experiments with
coloristic effects in landscape raise the
question of possible Italian influences.
His woodcut and pen landscapes on col-
ored paper are indebted to Venetian
woodcuts after Titian and his school, a
type of landscape that Van Mander rec-
ommended as a model for Netherlandish
artists.[6] The comparison that Reznicek

Fig. 1. Hendrick Goltzius, *Frederick de Vries*,
The Art Institute of Chicago, Stanley Field
Collection (Copyright The Art Institute of Chicago, all
rights reserved)

makes between the painterly technique
of the Ashmolean, Hamburg, and Lugt
drawings and the landscape studies of
Federico Barocci is telling.[7] Apart from
the question of the landscape studies,
Goltzius' response to Barocci's art is evi-
dent not only in the 1593 engraving of
the *Holy Family* from the Life of the Vir-
gin series, but also in his use of colored
chalks for softly modeled head studies
beginning in the mid-1590s.[8] Goltzius
may have had access to some of the land-
scape studies of the Urbino painter,
though the large number included in the
inventory taken after Barocci's death in
1612 suggests that they remained in his
possession.[9] However, the comparison of
the Ashmolean *Tree Study* to one of Ba-
rocci's studies (fig. 2) also serves to point
up the elegant linear structure that un-
derlies Goltzius' observations of surface
and light. Among the Netherlandish ar-
tists who turned their attention to the
structure and surface of natural forms
seen from closeup in the years around
1600, Goltzius was not the only one to
use body color in a painterly manner, as a
drawing in Coburg, signed and dated 1602
by Martin van Valckenborch the Elder,
attests.[10]

The appearance of similar gnarled trees
in various works by Goltzius, including
the friendship portrait (fig. 1), the 1593
engraving of the *Holy Family*, and *The
Birth of Adonis* in the Rijksprentenkabi-
net,[11] suggests that he may have made
many more studies in nature. On the

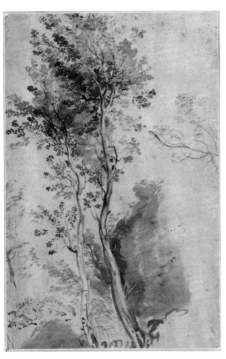

Fig. 2. Federico Barocci, *Tree Study*,
Fondation Custodia (Coll. F. Lugt), Institut
Néerlandais, Paris

other hand, it seems possible, based on
the use of these and of the few surviving
studies of nudes and of antique and Ren-
aissance sculpture,[12] that Goltzius
adapted rather than transposed such life
studies into his finished prints and
paintings.[12] MW

1. Reznicek 1961, nos. 397 and 402, pls. 347 and 348
respectively.
2. Van Gelder 1933, 18 (with reference to the Ham-
burg and Lugt drawings on blue paper), Van Regteren
Altena 1936, 90, and Haverkamp-Begemann 1959, 38.
3. Reznicek 1961, 111-112. For the date of the wood-
cuts, see Clifford Ackley in Boston 1980-1981, nos.
14 and 15, figs. 14 and 15; for the related pen land-
scapes in Hamburg, the Fondation Custodia, and
Stockholm, see Reznicek 1961, nos. 398, 401, and
406, pls. 312, 311, and 310 respectively.
4. Reznicek 1961, no. 127, pl. 337, and fig. 2 under
cat. 61.
5. Bartsch 190; see Boston 1980-1981, no. 13.
6. *Den Grondt . . .* , chap. 8, verse 24; see Miedema
1973, 1: 210-211.
7. Reznicek 1961, 111, 429, and 437.
8. See Reznicek 1961, 96, and 100-101, for Goltzius'
debt to Barocci's chalk technique. For the *Holy Fami-
ly*, which makes reference to Barocci's *Madonna del
Gatto*, see Strauss 1977, 2: 574-575, no. 317, repro.
9. Olsen 1965, 26-32, and Cleveland 1978, no. 32.
10. Wegner 1969, 91-92, and fig. 6.
11. Reznicek 1961, 111, pl. 376, who compares
the large tree in this drawing to the Ashmolean
study. This type of gnarled tree has a Venetian deri-
vation, though it is ubiquitous in the work of Nether-
landish artists c. 1600; see cats. 51, 101, and 116.
12. Radcliffe 1985, 97-108, traces some adaptations
by Goltzius from contemporary Netherlandish sculp-
ture. However, a case in which elements are trans-
posed from known life studies is the emblematic
friendship portrait of *Frederick de Vries* (fig. 1); see
Reznicek 1961, 439-440, no. 415, for a study of the
dog's head and a lost study of the boy's hand holding
the dove.

Jan Gossaert

c. 1478-1532

Jan Gossaert, also known as Mabuse, was born in Maubeuge, in the region of Hainaut, sometime around 1478. His whereabouts are unknown prior to his entry into the Antwerp Guild of Saint Luke in 1503 as a free master under the name of Jennyn van Henegouwe. In 1505 his first pupil, Hennen Mertens, was inscribed in the Antwerp Guild records and two years later Machiel int Swaenken began his apprenticeship with the master. The following year, 1508, Gossaert was employed by Philip of Burgundy, and in October of that year journeyed to Rome with Philip in order to make drawings after ancient sculptures. Gossaert very likely returned to the north in July of 1509, several months after his patron. He rejoined Philip at his residence, the Castle Souburg in Middelburg, which Philip was decorating. In 1516, Gossaert accompanied Philip to Brussels for the funeral of Ferdinand the Catholic and executed decorations for the latter's procession. Sometime in the next year, Philip was named Bishop of Utrecht and moved to the Bishop's Palace at Wijk-bij-Duurstede, fifteen miles south of Utrecht. Gossaert continued to work for Philip and very likely accompanied him to his new post. It was at this time, around 1518, that Jan van Scorel must have studied with Gossaert. In 1520-1521, Gossaert rented a studio close to the Utrecht Cathedral while he designed the new choir stalls. In 1522, he went to Utrecht to make a grille for the Altar of Saint Martin in the Cathedral. The following year, Gossaert traveled to Mechelen to restore paintings owned by the Regent, Margaret of Austria. He received forty livres in payment and lived with the sculptor Conrad Meit. On 9 April 1524, Philip of Burgundy died and Gossaert returned to Middelburg where he entered the service of Adolph of Burgundy, the Marquis of Veere. At this time, Adolph had granted political asylum to the King of Denmark, for whom Gossaert also worked. During his last years, Gossaert had several other patrons, including Mencía de Mendoza, the third wife of Henry III of Nassau-Breda. In 1532, she granted the artist a pension of one hundred guilders a year. However, this ended with a final payment to Gossaert's widow on 13 October 1532.

Gossaert was not only influenced by the antique but also by Luca Signorelli, by Jacopo de' Barbari and, even more important, by Albrecht Dürer. Gossaert introduced the mannerist style into the Netherlands, and his contemporaries, like Bernard van Orley and Lucas van Leyden, felt the impact of Gossaert's innovation as did younger artists, such as Jan van Scorel, Lambert Lombard, the Master of the Female Half-Lengths, Pieter Coecke van Aelst, and Jan van Hemessen.

63 View of the Colosseum in Rome

Pen and brown ink
201 x 264 (7⅞ x 10⅜)
Inscribed at top right in a contemporary hand and in another ink, Jennin Mabusen eghenen/handt Contrafetet in Roma/Coloseus

Provenance: General Andréossy; collection E. Rodrigues (sale, Paris [Hôtel Drouot], 23 May 1928, no. 63); acquired by the present owner in 1928

Literature: Bock and Rosenberg 1930, 36, no. 12918; Friedländer 1931, 183; Krönig 1936, 132; Van Gelder 1942, 4; Glück 1945, 128; Wescher 1949, 263; Folie 1951, 82, 88, 89, no. 6; Marlier 1954, 48; Osten 1961, 454; Dacos 1964, 117, 118; Börsch-Supan 1965, 199; Herzog 1968, 42, 48, 49, 50, 392, 393, 394, 720, no. D. 7; Friedländer, ENP, 8 (1930): 67, no. 26 (8[1972]:43, no. 26); Grosshans 1980, 207; Winner 1985, 91

Exhibitions: Rotterdam 1936, no. 45; Leiden 1954, no. 23; Mechelen 1958, no. 180; Brussels 1963, no. 287; Rotterdam 1965, no. 46; Berlin 1967, no. 25

Staatliche Museen Preussischer Kulturbesitz, Kupferstichkabinett, Berlin, inv. no. 12918

This sheet is the earliest known Netherlandish drawing of the Colosseum in Rome. The erection of this monument began sometime between 70 and 76 A.D., during the reign of the Emperor Vespasian. It was completed by his son Titus in 80 A.D. The history of this extraordinary building during the late antique and medieval periods is most depressing. There are reports of restorations, damage from earthquakes, family struggles over its ownership, and the theft of the stone to build new edifices. By the fourteenth century, it was a ruin comparable in size to what we see today. This destruction reached its worst point during the reign of Nicholas V (1447-1455) when, apparently, the limestone kilns could be seen burning brightly from the marble slabs of the Colosseum.[1] Consequently, when Gossaert made his rendering of the building in 1509 for Philip of Burgundy, the Colosseum was a ruin. Gossaert drew the west side of the amphitheater, viewed from the right of the ancient temple of Venus and Rome at the foot of the Palatine Hill and near the old entrance to the garden of the Maffei family.[2]

As in his other drawings after the antique,[3] Gossaert employs the minutely detailed style of his late Gothic pre-Italian years. He loses the sense of enormity and plasticity of the building through his preoccupation with minutiae; however, he is topographically accu-

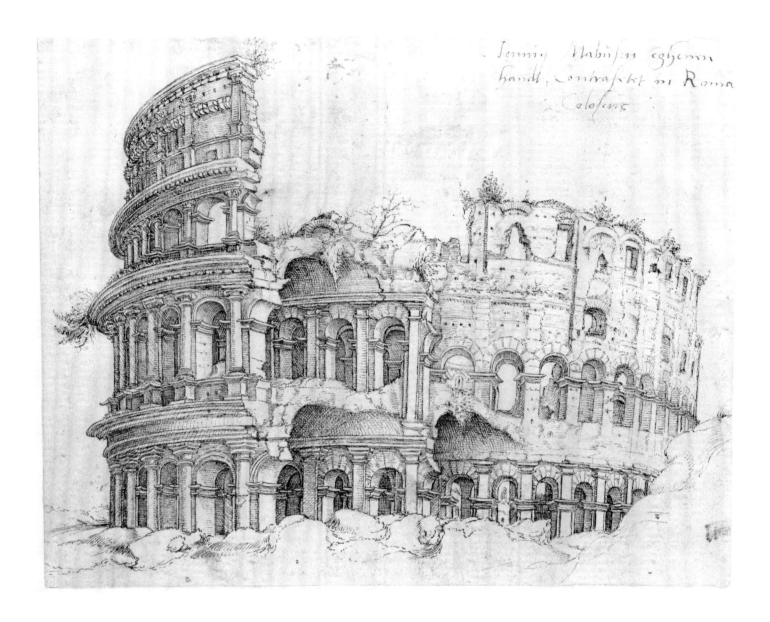

rate in his rendering of the columns, capitals and details of each level and in his observation of the projections and recesses of the cornices. This sheet was probably part of a large sketchbook of major Roman antiquities which Gossaert executed for his patron, Philip. Because it is the same size and drawn in a similar technique as Gossaert's *Spinario* (Prentenkabinet der Rijksuniversiteit, Leiden; fig. 1), they might have been part of the same volume executed in 1509.

The Colosseum was drawn and painted by numerous subsequent artists, the most important being Maerten van Heemskerck. He drew it from the west, but this time looking down upon the ruin.[4] In his later works, Heemskerck used the building for allegorical and moralizing purposes in, for example, his 1553 *Self Portrait* (Fitzwilliam Museum, Cambridge), where the Colosseum becomes a "memento mori."[5] JRJ

1. See Winner in Berlin 1967, 44.
2. See Winner in Berlin 1967, 44.
3. For an example see cat. 64.
4. Compare the Berlin Sketchbook, i Fol. 11r., in Hülsen and Egger 1975, 2: pl. 12
5. Grosshans 1980, 207. For other Heemskerck representations, see his drawing in Louvre, Cabinet des Dessins, Paris, inv. no. R.F. 36729, pen and ink: 207 x 267 mm, which was engraved by Philip Galle as one of the *Eight Wonders of the World*, Hollstein 364, and the 1552 *Battle of the Bulls*, Musée des Beaux-Arts, Lille, Grosshans 1980, fig. 111.

Fig. 1. Jan Gossaert, *Spinario*, Prentenkabinet der Rijksuniversiteit, Leiden

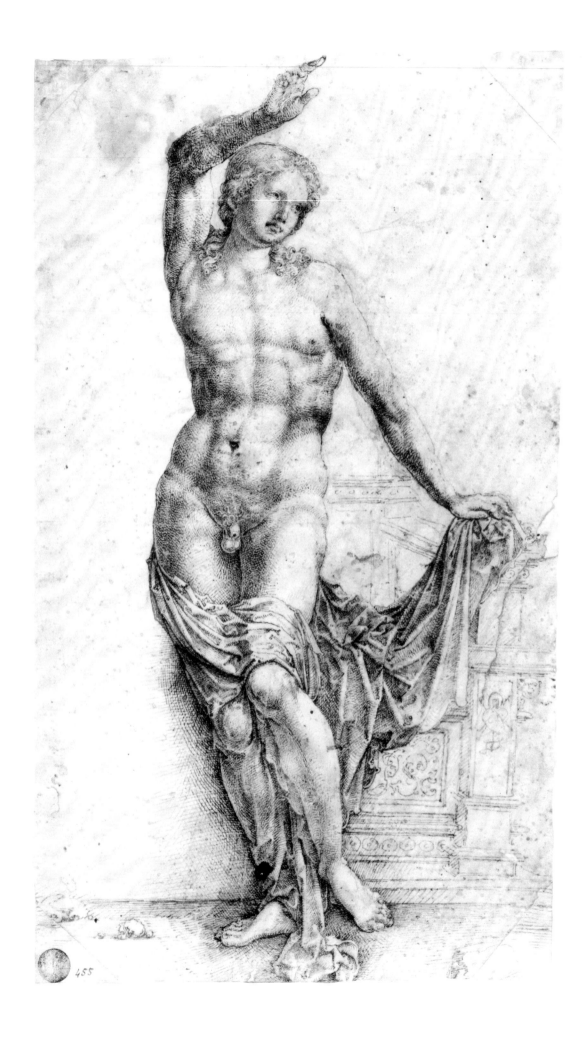

455

JAN GOSSAERT

64 Apollo

Pen and brown ink
305 x 175 (12 x 6⅞)

Provenance: G. Bossi, Milan; Luigi Celotti;
presented to the Accademia in Venice by Franz
I of Austria in 1822

Literature: Fogolari 1913, no. 89; Winkler
1921, 9; Held 1931, 118; Krönig 1936, 131,
132; Glück 1945, 128, 129, 131; Benesch 1945,
80; Folie 1951, 90, no. 9; Marlier 1954, 34;
Friedländer 1956, 96; Bober 1957, 71; Dacos
1964, 20; Herzog 1968, 42, 46-48, 391, 392, no.
D. 6; Friedländer, *ENP*, 8 (1930): 32-33, 67, no.
27 (8[1972]: 23-24, 40, 43, no. 27); Judson 1981,
337; Judson 1985a, 16, 18; Judson 1985b, 50

Exhibitions: Rotterdam 1965, no. 48

Galleria dell' Accademia, Venice, inv. no. 455

Jan Gossaert executed the *Apollo* in 1509,
during his sojourn in Italy with Philip of
Burgundy, who specifically employed the
artist to make copies after ancient sculp-
ture.[1] This drawing was made after a
Roman copy in basalt of a Hellenistic
Apollo Citharodeus, at that time in the
Casa Sassi, Rome.[2] The copy is now in
the Museo Nazionale, Naples.[3] Gossaert
manipulated the arms and the feet of the
original sculpture in order to give greater
elegance to the pose.[4] He also replaced
the classical drapery with a more de-
tailed, decorative, and linear type charac-
teristic of the late Gothic style of the
Netherlands in the fifteenth and early
sixteenth centuries.

Gossaert's elongated *Apollo*, with its
ornamental curves and muscles, creating
attractive, decorative surface patterns,
bears a strong resemblance to Marcanto-
nio Raimondi's engraving (Bartsch 334)
after Raphael's *Apollo* in the *School of
Athens*, which must have been engraved
several years after the Gossaert.

Gossaert used this *Apollo* later, in an
even more exaggerated form, in his 1516
Neptune and Amphitrite (Staatliche Mu-
seen, Kupferstichkabinett, Berlin; see Jan
Gossaert and the New Aesthetic, fig. 4).

JRJ

1. Geldenhauer 1529.
2. The sculpture originally stood at the entrance of
the courtyard opposite a statue of *Mercury*, Aldroandi
1556, 155.
3. Van Gelder 1942, 4, 6; Rotterdam 1965, 255.
4. For other sixteenth-century drawings after the
Apollo, see Amico Aspertini's in the London Sketch-
book dating between c. 1520/1540, Bober 1957, 14, pl.
XXXVIII, fig. 90; Maerten van Heemskerck's in the
Berlin Sketchbook—Hülsen and Egger 1913-1916: I:
fol. 51v.; and those cited in Bober 1957, 71.

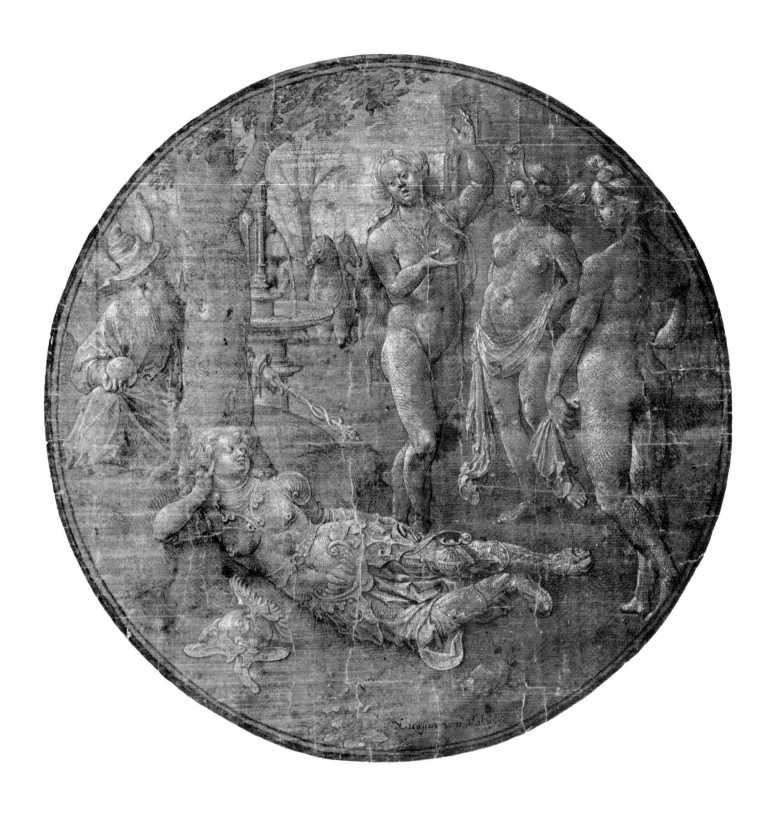

180

JAN GOSSAERT

65 *The Judgment of Paris*

Pen and ink, heightened with body color on
dark gray prepared paper
Diameter 235 (9¼)
Inscribed at bottom right center, *Nicasius van
Mabuyse*

Provenance: David Laing; Royal Scottish
Academy; transferred to National Gallery of
Scotland, Edinburgh, in 1910

Literature: *Vasari Society* 1911-1912, 17; Van
Gelder 1942, 10; Folie 1951, 96, 14; Andrews
1961, no. 10; Van Hasselt 1961, 43; Van
Gelder 1963, 656-658; Herzog 1969, 399,
400, no. D. 11; Andrews 1985, 33, no. D 652

Exhibitions: London 1953, no. 251; London
1953-1954, no. 502; Manchester 1965, no. 317;
Rotterdam 1965, no. 56

National Galleries of Scotland, Edinburgh,
inv. no. D 652

Gossaert's representation of this theme is
taken from Dio Chrysostrom where Paris
sleeps beneath a tree and dreams the ad-
venture.[1] This subject became particu-
larly popular in German drama and is as-
sociated with the story of *Hercules at the
Crossroads* where the choice between the
pure and the sensual is also suggested.[2]
Mercury, who is usually depicted by
northern artists disguised as a bearded
and elderly man,[3] sits behind the tree on
the left.

The Edinburgh drawing has been at-
tributed to Gossaert, along with several
others of the same shape and technique.[4]
However, there are stylistic differences
between them that make it difficult to
accept them all as having been executed
by the same hand. For example, the ren-
dering and highlighting of the drapery in
this drawing is different from the signed
Gossaert sheet representing *The Behead-
ing of Saint John the Baptist* (Ecole des
Beaux-Arts, Paris).[5] However, the helmet
in the left foreground of *The Judgment of
Paris* is similar to the one in the top cen-
ter of Gossaert's *Spinario* (cat. 63, fig. 1).[6]
Furthermore, the posture of the three
nude goddesses also strongly suggests
Gossaert's hand and closely resembles

the nudes in the *Women's Bath* (Print
Room, British Museum, London).[7] Simi-
larly, the central nude in Edinburgh, with
her arm raised, recalls the *Apollo* (cat. 64,
Galleria dell' Accademia, Venice), whose
posture is also reflected in the two
women on the right.[8] Although the fig-
ures in the Edinburgh sheet lack the
monumentality of the 1509 *Apollo*,
which was executed directly after the an-
tique, the similarity of the poses suggests
that either Gossaert or a close follower
executed the Edinburgh sheet. The round
shape and the emphasis upon chiaroscuro
effects suggest that the design was proba-
bly a study for a stained glass roundel.[9]
JRJ

1. Andrews 1985, I: 33.
2. See n.1 above.
3. For examples see Andrews 1985.
4. See the drawings exhibited in Rotterdam 1965,
nos. 54-59, and the drawing in the Fitzwilliam Mu-
seum, Cambridge, formerly collection Sir Bruce In-
gram, Van Hasselt 1961, no. 92, fig. 1. The inscrip-
tion on the Edinburgh sheet, *Nicasius van Mabuyse*,
is not the signature of the artist but that of his broth-
er, an architect, who probably owned the drawing.
5. Rotterdam 1965, no. 54.
6. Rotterdam 1965, 287.
7. See Folie 1951, 91, no. 16, fig. 8.
8. Rotterdam 1965, 287.
9. Herzog 1969, 400.

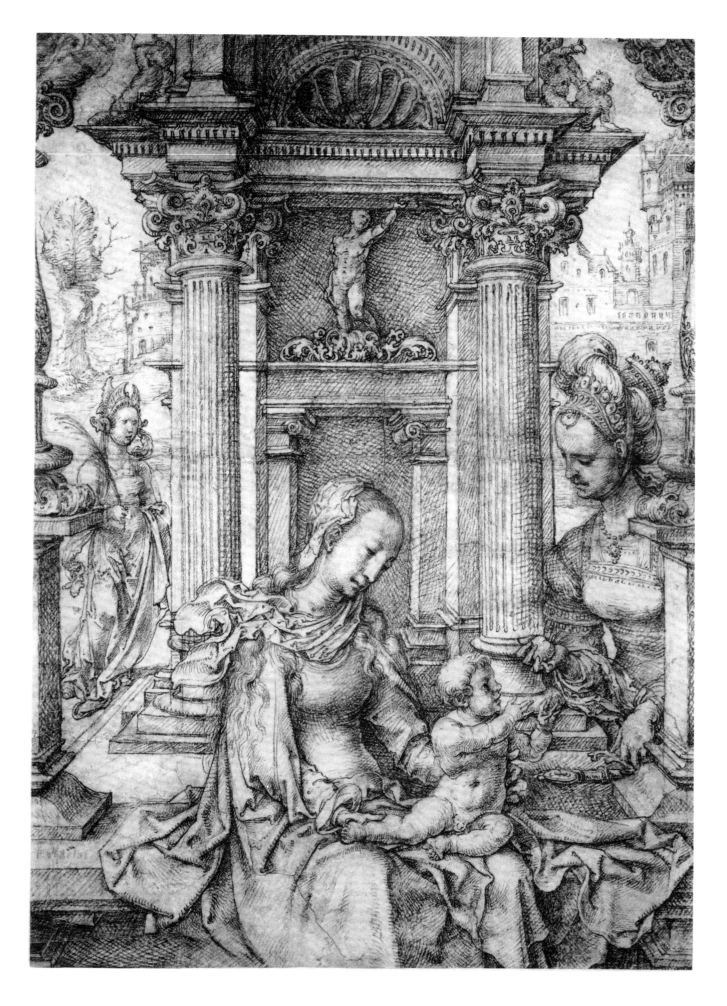

JAN GOSSAERT

66 *Madonna and Child with Saints Barbara and Catherine(?)*

Black chalk; additions at upper left corner, damages around Virgin's cloak, trimmed along sides and bottom margin
422 x 309 (16⅝ x 12⅛)
Inscribed in reddish-brown ink by a later hand on the base of the fantastic column in the left foreground, *P.v.Aelst*; and on the verso in light brown ink, *PETER.VAN.AELST*

Provenance: P. Baderou, Paris; (art dealer N. Beets, Amsterdam); acquired by the present owner in 1949

Literature: Folie 1951, 84, 91, no. 12; Boon 1953, 65-71; Winkler 1962, 145, 152; Marlier 1966, 304; Herzog 1968, 37-39, 43, 44, 397-399, no. D10, Friedländer, *ENP*, 8 (1972): 118, 119, Add. 31; Boon 1978, 101, no. 285

Exhibitions: Antwerp 1954, no. 314; Washington 1958-1959, no. 12; Brussels 1963, no. 288, fig. 274; Rotterdam 1965, no. 49

Rijksprentenkabinet, Rijksmuseum, Amsterdam, inv. no. 49:488

To the right of the Virgin and Child, there is a woman wearing a fantastic late Gothic crown and holding an apple in her right hand, while the other rests on an object that can be read as a sword handle.[1] Because of these attributes, it has been suggested that she could be Saint Catherine. This identification is further supported by the presence of the woman holding a martyr's palm, standing to the left of the Virgin and in front of a tower, which suggests that she is Saint Barbara.[2] These female martyrs have long been associated with each other and represent the active (Saint Barbara) and the contemplative (Saint Catherine) lives.[3] This is the only chalk drawing that can be attributed with certainty to Gossaert.[4] Black chalk began to be used at this time in the Netherlands, very likely through the influence of Albrecht Dürer.[5] As a result of using black chalk, Gossaert's drawing style changed from a more detailed and decorative technique to one that relied upon simple contours and rounded hatchings, which may also have been inspired by Albrecht Dürer's woodcut style. Black chalk made it easier to create subtle nuances of light and shadow and to make alterations (the head of Saint Catherine has been reworked and moved back and up in the design and the left arm of Saint Barbara has also been changed).[6] This technique also made it possible for Gossaert to construct his forms in a more plastic and substantial manner and, consequently, to translate the monumental, antique forms that he studied in Italy into his drawings.[7] Along with this change in the treatment of the

figures and drapery, Gossaert introduced a new type of architecture. Rather than using strange combinations of ancient, Romanesque, and Gothic vocabulary, as found earlier, he created a fantasy based exclusively on the antique. For the first time, Gossaert included fluted columns capped by imaginative capitals decorated with dolphins. They come from Giovanni Bellini's earlier *Virgin and Child with Saints* (Accademia, Venice).[8] Gossaert used these fluted columns again in his 1516 *Neptune and Amphitrite* (fig. 4 in Jan Gossaert and the New Aesthetic); and in the 1519 *Venus and Armor* (Musées Royaux des Beaux-Arts, Brussels) and the capitals reappeared in the c. 1513 *Saint Luke Painting the Virgin* (Národní Galerie, Prague). Still another reference to the antique can be found in the standing nude just beneath the scallop shell. Herzog has suggested that it was executed after an antique sculpture of Bacchus.[9]

Because of the new, robust, and simple rendering of the forms, combined with the antique in a highly imaginative manner, the drawing very likely dates from after Gossaert's return from Italy, that is, sometime around 1511.[10] JRJ

1. For numerous earlier examples of the Child being offered an apple, see the oeuvre of Hans Memling as illustrated in Friedländer, *ENP*, 6a (1971): pls. 36, 37, 52, 98, 100, 104, 105. However, Memling depicts Christ receiving the apple from either the Virgin or an angel. The apple, when associated with Christ, is the symbol of victory over sin (Timmers 1974, 216, 217, no. 611).
 The general position of Christ's torso and legs also might be an adaptation from Memling, in reverse, but with a new sense of solidity (see Friedländer, *ENP* 6a (1971): pls. 32, 33, 52, 66, 104 (no. 60).
2. For Gossaert's earlier inclusion of these two Saints with the Virgin and Child see his *Altarpiece of the Holy Family*, Museu Nacional de Arte Antiqua, Lisbon, Friedländer, *ENP* 8 (1972): pl. 1.
3. Timmers 1974, 238, 275.
4. This author agrees with Bruyn 1965a, 464, who writes that the chalk drawing of *Adam and Eve*, Museum of Art, Rhode Island School of Design, Providence, is too weak to be accepted as an original and is probably a copy after a lost painting.
5. For other Netherlandish examples see Lucas van Leyden's c. 1510 *Standing Boy with a Sword*, Rijksprentenkabinet, Amsterdam (cat. 78, fig. 1) or the *Standing Young Man* (cat. 78).
6. For details see Boon 1953, 69-71.
7. For Gossaert's earlier delicate and decorative style see the *Marriage of Saint Catherine*, Statens Museum for Kunst, Kobberstiksamling, Copenhagen, Rotterdam 1965, no. 43, or the *Madonna and Child with Saints*, Albertina, Vienna, ill. in Benesch 1928, no. 35. Both of these designs are executed in pen and are very precise in rendering the details of the forms.
8. Herzog 1969, 38.
9. Herzog 1969, 44.
10. For a date of 1511, see Boon 1953, 71.

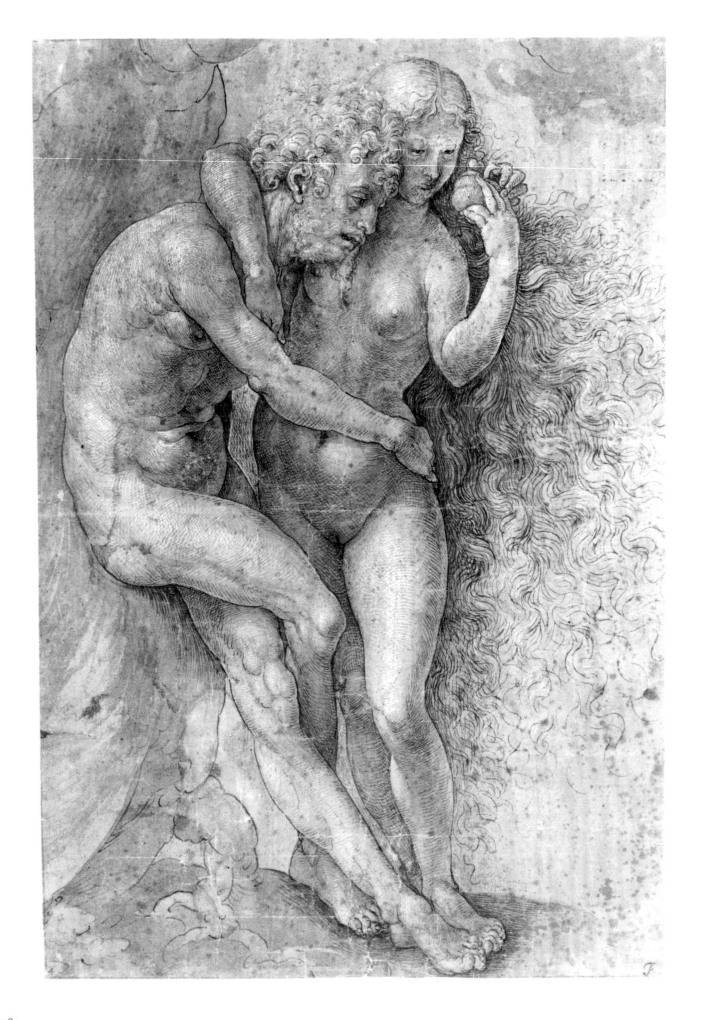

184

JAN GOSSAERT

67 *Adam and Eve*

Pen and black ink with white heightening on
light gray prepared paper
348 x 239 (13¾ x 9⅜)

Provenance: N. A. Flinck; acquired by the sec-
ond Duke of Devonshire in 1723

Literature: Strong 1902, pl. 54; Popham 1926,
no. 63, Chatsworth, *Catalogue,* 1929 (unpub-
lished), no. 935; Krönig 1936, 70, 146; Wescher
1949, 263; Folie 1951, 85, 91, no. 14; Schwarz
1953, 155, 156, 165 n. 29; Osten 1960, 455;
Börsch-Supan 1965, 200; Bruyn 1965, 464;
Herzog 1968, 113, 114, 115, 403, 404, no.
D. 14; Friedländer, *ENP,* 8 (1930): 64, no. 1 (8
[1972]: 40, no. 1)

Exhibitions: Rotterdam 1936, no. 43, fig. 57;
Manchester 1961, no. 82; Washington 1962-
1963, no. 87; Brussels 1963, no. 289; Rotter-
dam 1965, no. 60; London, National Gallery,
1975, no catalogue

The Duke of Devonshire and the Chatsworth
Settlement Trustees, Devonshire

In this drawing, Gossaert continued the
detailed drawing style of his early years.
This is characterized by short, parallel
and curving lines with cross-hatching to
emphasize the shaded areas that are in
opposition to the white highlights. Gos-
saert carried on, albeit in a more decora-
tive way, the style which he had learned
from his contact with Albrecht Dürer's
prints.

Gossaert painted and drew a number of
Adam and Eve representations.[1] The ear-
liest two, dating from c. 1509 and c. 1512,
are based almost entirely upon the com-
positions of Dürer.[2] However, the later
Chatsworth drawing abandoned the con-
cepts in Dürer's *Small Passion* (fig. 1),
with the exception of Eve's long, flowing
hair and the intimate embrace between
the figures in the 1509-1511 *Adam and
Eve.* Gossaert translated the figures into
the erotic, exaggeratedly muscular type
based upon his interpretation of the an-
tique and mannerism and seen in the
1509 drawings of *Hercules* (heirs of Lord
Wharton, fig. 2), the *Spinario* (Prentenka-
binet der Rijksuniversiteit, Leiden; cat.
63, fig. 1) and the *Apollo* (Accademia,
Venice; cat. 64).

The Chatsworth sheet demonstrates
the artist's ability to borrow from a num-
ber of sources in creating a highly origi-
nal and provocative design. His aware-
ness of Italian innovations is evident in
Adam's posture as he rests with legs
crossed against "The Tree of Knowl-
edge," and in the raised position of Eve's
left arm, both drawn from Marcantonio
Raimondi's c. 1512-1514 *Adam and Eve*
(fig. 3).[3] Gossaert repeated the position of
Eve's arm in reverse in his 1516 *Neptune
and Amphitrite* (fig. 4 in Jan Gossaert and

Fig. 1. Albrecht Dürer, *Adam and Eve,*
National Gallery of Art, Washington,
Rosenwald Collection

Fig. 3. Marcantonio Raimondi, *Adam and
Eve,* The Metropolitan Museum of Art, New
York, Purchase, Joseph Pulitzer Bequest 1917

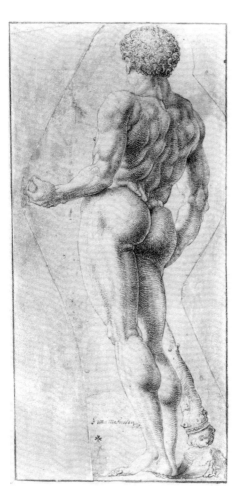

Fig. 2. Jan Gossaert, *Hercules,* Heirs of Lord
Wharton, England (Copyright A.C.L. Brussels)

the New Aesthetic) and placed Neptune's
left arm around Amphitrite in a manner
similar to Adam's in Chatsworth. The
Berlin *Neptune* is also the first dated ex-
ample of Gossaert's translation of the an-
tique into a distorted, mannerist scene as
in the Chatsworth sheet. The erotic in-
tertwining of *Adam and Eve* also began
to be present in Gossaert's paintings at
this time, for example, in the 1517 *Her-
cules and Dejanira* (Barber Institute of
Fine Arts, Birmingham). Because of these
relationships with Gossaert's paintings
from the years 1516 and 1517, one can
suggest a date from that time for the
Chatsworth drawing.

Schwarz' proposal that Adam's head is
a self-portrait in this and several of Gos-
saert's later representations of the theme
is difficult to maintain.[4] JRJ

1. Friedländer, *ENP,* 8 (1972): pls. 6, 18, 19, 64.
2. Compare Gossaert's c. 1509 *Adam and Eve,* Thys-
sen-Bornemisza Collection, Lugano, and the c. 1512
Adam and Eve outer wings, Galleria Nazionale, Pa-
lermo, Schwarz 1953, 147, 148, figs. 1, 2.
3. Folie 1951, 91; Schwarz 1953, 155.
4. Schwarz 1953, 165, 166, 167.

68 *Portrait of Christian II of Denmark*

Pen and brown ink with traces of black chalk; traced for transfer
268 x 216 (10⁹/₁₆ x 8½)

Watermark: Shield crowned with three fleurs-de-lis

Provenance: M. Schneider; (sale, Paris, 6-7 April 1876, no. 63, as Dürer, sold to Fauré Lepage); (sale, Paris, 16 November 1936, no catalogue, together with Lucas van Leyden's *Portrait of Maximilian*, purchased by Fishmann); (Pierre Landry, Paris); acquired by F. Lugt in 1936

Literature: Gonse 1876, 528; Falck 1917, 75-78; Friedländer 1938, 95; Glück 1940, 20-21; Van Gelder 1942, 10; Wescher 1949, 264; Folie 1951, 85, 86, 92, no. 19; Schwarz 1953, 162 n. 24, 162; Amsterdam 1958, 152; Osten 1961, 465; Rostrup Böyesen 1956-1963, 77; Bruyn 1965a, 467; Haverkamp-Begemann 1965, 405; Friedländer, *ENP*, 8 (1972): 114, 119 n. 21, Add. 31; Herzog 1968, 130, 131, 417-419, no. D21; Boon 1976a, 338; Karling 1976, 152; Kai Sass 1976, 166; Kloek 1978, 452, 453; Sterk 1980, 92, 125

Exhibitions: Rotterdam 1938, no. 403; Brussels 1963, no. 290; Rotterdam 1965, no. 65; Copenhagen, Statens Museum for Kunst, Kobberstiksamling, 1975, no catalogue; Florence 1980-1981, no. 87

Fondation Custodia (Coll. F. Lugt), Institut Néerlandais, Paris, inv. no. 5141

Exhibited in New York only

King Christian II is seated before a fantastic arch containing the crowned coats-of-arms of Norway, Denmark, and Sweden, the countries he ruled before he was forced to flee Scandanavia in 1523. Below these main divisions of King Christian's realm, Gossaert has included the devices of his Scandinavian subjects: the Dukes of Holstein, the Counts of Oldenburg, the Kings of Wend, the Dukes of Schleswig and the Dukes of Daneborg (Stormarn). Christian II wears the Order of the Golden Fleece, which was granted to him in 1519 but not presented until 1520.[1] In this instance, he wears the decoration on the end of a ribbon, which, since 1516, had been permissible in combat or on a dangerous voyage.[2]

Shortly after Gossaert executed this design, Jacob Binck used it as a model for his engraving (fig. 1), which carries an inscription on the balustrade, CHRISTIER-NUS. Z. DANORVM. REX. SVETIE. NORVEGIE. ZC.[3] Hollstein dates the print 1529, when Binck may have visited the Netherlands. This late date is problematical because Binck must have been in touch with Christian II by 1525, the year in which he cut the engraved *Portrait of Christian II*.[4] This is a copy, with very slight changes, of Lucas Cranach's woodcut of 1523.[5] Because of this connection with the Cran-

ach woodcut, it is possible that Binck had been in touch with Christian II well before 1529 and executed the engraving after Gossaert's design several years prior to his possible visit to the Netherlands in 1529.[6]

Gossaert's pen makes delicate and finely curved parallel lines, demonstrating his continued debt to Albrecht Dürer. In this sheet, there are two different intensities in the brown ink. As E. Haverkamp-Begemann has demonstrated, the arch was completed first in a lighter ink while the head and topmost section of the fur collar were executed in darker ink and added to the torso and partially drawn on top of it.[7] This method of working suggests that Gossaert had been asked to use a specific type of setting, which he prepared on the sheet before drawing in the head of the sitter. This supposition becomes even more likely when one studies the portraits of Christian II exe-

Fig. 1. Jacob Binck, *Christian II of Denmark*, Rijksprentenkabinet, Amsterdam

cuted in 1523 immediately after he was expelled from Scandanavia. We know that he first went to Wittenberg where Lucas Cranach executed Christian's portrait in oils and at least one woodcut.[8] Cranach's 1523 woodcut (fig. 2) was included in the 1524 edition of the *New Testament*, published in Wittenberg. Here the deposed monarch is rendered in profile but wears the same type of costume as in the Gossaert drawing, and also placed within a highly imaginative arch decorated with the same coats-of-arms.[9] In the same year, 1523, Cranach's atelier

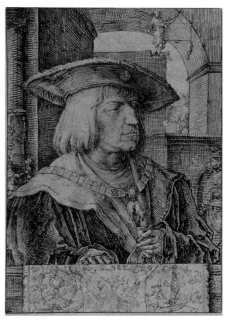

Fig. 2. Lucas van Leyden, *Emperor Maximilian I*, Fondation Custodia (Coll. F. Lugt), Institut Néerlandais, Paris

produced another woodcut of Christian II, which uses, in reverse, the same type of setting, devices, costume, and hair styling as in the Gossaert.[10] Furthermore, the 1523 woodcut made in Cranach's shop is closely related to Albrecht Dürer's 1521 drawing of *Christian II* (British Museum, London), where the sitter also stares out to one side and the rendering of the hat and the hair is similar.[11] Cranach's debt to Dürer is also evident in the use of fanciful architecture to frame the sitter.[12] From all of this, one can suggest that Gossaert was probably requested to use the Cranach model for his *Portrait of King Christian II*, and that this type was based upon a formula initiated by Dürer.[13] It has also been proposed, mistakenly, that Lucas van Leyden's 1520 drawn *Portrait of the Emperor Maximilian* (Fondation Custodia, Paris; fig. 3), and the print after it, are closely related to Gossaert's *Portrait of King Christian II*. This is disproved upon close comparison of the drawing style in both works and the manner in which the figures are presented.[14]

Because Gossaert appears to be strongly dependent upon German models dating from 1523 and because Christian II also arrived in the Netherlands in the same year after having visited Wittenberg, Gossaert's *Portrait of Christian II* cannot date from prior to that time. We also know that Christian II visited Margaret of Austria in Mechelen in 1523, as did

Gossaert. It is not known whether or not the two met there or in 1524 when Christian II took refuge at the Court of Adolph II in Middelburg, whose service Gossaert entered that year. However, it is most likely that Gossaert, using the Cranach models of 1523, made his drawing sometime shortly after he entered Adolph's service, say 1524-1525. JRJ

1. Kai Sass 1976, 163.
2. Kai Sass 1976, 163.
3. 270 X 215 (10⅝ x 8½ mm). For the early bibliography see Hollstein (German) 245, ill.
4. Hollstein (German), 243, ill.; Karling 1976, 152, 153, repro. 155 B.
5. Hollstein (German) 124, ill.; Karling 1976, 152, 153, repro. 155 D.
6. For the 1529 date also see Karling 1976, 152.
7. Haverkamp-Begemann 1965, 405.
8. Friedländer and Rosenberg 1932, no. 27, repro.
9. Karling 1976, ill. on 155 D.
10. This 1523 woodcut was used in a booklet published a year later in Wittenberg, in which Christian II responded to the charges of his enemy, Frederik I, Karling 1976, 152.
11. Kai Sass 1976, 176.
12. Compare, for example, Albrecht Dürer's 1519 woodcut Portrait of Emperor Maximilian I, Bartsch 153; Hollstein 255, repro.
13. For a discussion of Dürer's lost Portrait of Christian II, see Kai Sass 1976, 163-169.
14. For details see Kloek 1978, 452, 453, fig. 19.

Maerten van Heemskerck

1498-1574

Born the son of a farmer in the village of Heemskerck, between Haarlem and Alkmaar, Maerten van Heemskerck studied painting in Haarlem with Cornelis Willemsz. and in Delft with Jan Lucasz. He then returned to Haarlem where he worked with Jan van Scorel (q.v.), who had recently returned from Italy and in 1527-1530 was seeking respite in Haarlem from political unrest in Utrecht. According to Van Mander, who wrote many years later but was presumably well informed through Haarlem sources, Heemskerck was eager to absorb what Scorel had learned in Italy, and succeeded in imitating his painting style very closely. Heemskerck remained in Haarlem until 1532 when he departed for Rome, leaving behind the large altarpiece of Saint Luke Painting the Virgin, *dated 23 May 1532, as a parting gift for the artists' guild and a statement of his skill at that date.*

In Rome, Heemskerck made drawings after antique sculpture and architecture as well as Renaissance painting. Many of these are preserved, together with related material, in two sketchbooks in the Kupferstichkabinett, Berlin. The figures and decorative elements in these drawings served as a resource for the rest of his career. Though Van Mander states that he stayed for three years, it is likely that he remained in Italy into 1536 or early 1537 as he seems to have known the decora-

tion of the Sala di Troja in Mantua, begun from Giulio Romano's designs in 1536. In the autumn of 1537 he must have been back in the Netherlands, as he contracted to provide wings for a Crucifixion *painted by Scorel for the Oude Kerk, Amsterdam. Heemskerck settled in Haarlem, but the important commissions which he received from other cities suggest the extent of his reputation. Following his return from Italy, Heemskerck began to make designs for prints, making numerous drawings that were reproduced, first by Cornelis Bos and later by Dirck Volkertsz. Coornhert and others. As Van Mander declared, his prints "filled the entire world with inventions," and Vasari's descriptions of several series proves that many circulated in Italy by 1568. Heemskerck's work, both paintings and prints, shows a tireless inventiveness in its adaptation of Renaissance forms and subjects, the latter often reflecting the influence of learned advisors such as Coornhert and Hadrianus Junius.*

Heemskerck married twice; his second wife brought him wealth and social standing. He enjoyed a prominent position in Haarlem, serving as church warden of Saint Bavo's from 1553, and being elected deacon of the Guild of Saint Luke in 1554. He died in Haarlem in 1574.

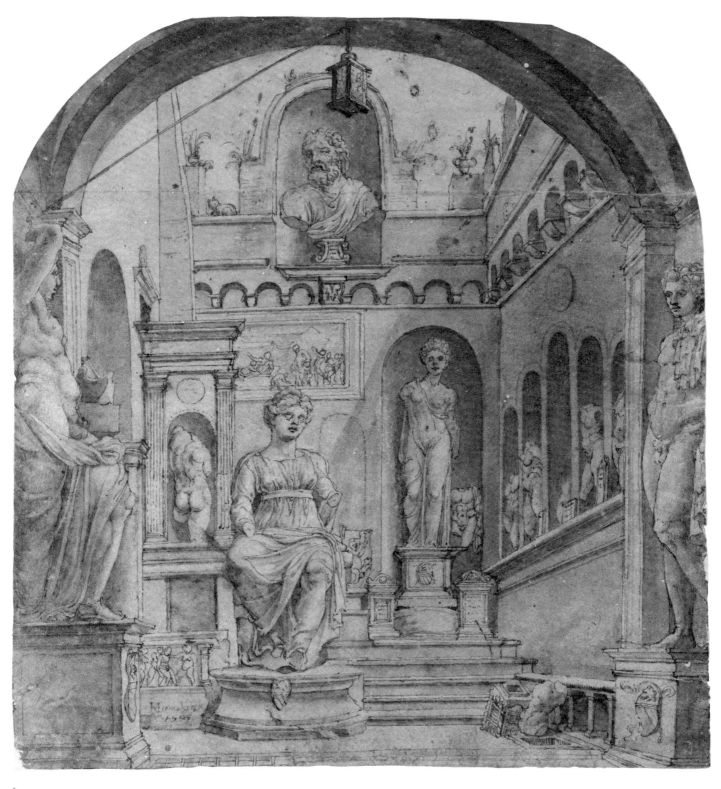

69

69 *Sculpture Court of the Casa Sassi in Rome*

Pen and brown ink with brown wash, trimmed
on all sides and rounded off at top corners; laid
down
230 x 215 (9¹/₁₆ x 8½)
Inscribed in brown ink at lower left, *MVHeems-
kerck/1555* (initials in ligature)

Provenance: Fagan

Literature: Michaelis 1891, 130, 170-172; Prei-
bisz 1911, 36-37, 84, no. 16, 109; Hübner 1912,
54, 114; Hülsen and Egger 1913-1916, 1: 27-28,
42-45; Bock and Rosenberg 1930, 37; Hooge-
werff, *NNS*, 4: 307; Schmitt 1970, 115; Veld-
man 1974, 91; Münster 1976, 120, under no.
95; Grosshans 1980, 196-198, 200

Exhibitions: Berlin 1967, no. 60; Rennes 1974,
no. 88

Staatliche Museen Preussischer Kulturbesitz,
Kupferstichkabinett, Berlin, inv. no. KDZ 2783

Fig. 1. Dirck Volckertsz. Coornhert after
Maerten van Heemskerck, *The Sculpture
Court of the Casa Sassi*, Rijksprentenkabinet,
Amsterdam

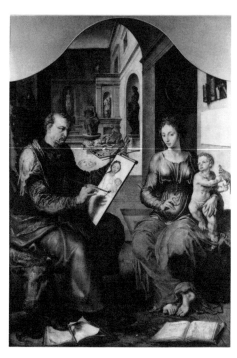

Fig. 2. Maerten van Heemskerck, *Saint Luke
Painting the Virgin*, Musée des Beaux-Arts et
d'Archéologie, Rennes

Throughout his career, Heemskerck
made inventive use of motifs from his
drawings of Roman views and antique
sculpture, now largely preserved in two
albums in Berlin, yet few of these draw-
ings were made accessible to others
through engravings. An exception is this
drawing, in Berlin but not part of the two
albums, which was engraved by Dirck
Volckertsz. Coornhert in 1553 (fig. 1).[1] It
records the courtyard of the house of the
de Sassi family in the Via del Governo
Vecchio in Rome, as it appeared at the
time of Heemskerck's stay in Rome from
1532 to c. 1536/1537. As Hülsen and Eg-
ger first note, a contemporary Italian
drawing at Chatsworth confirms that
Heemskerck recorded the crowded court-
yard accurately.[2] By the time the engrav-
ing was made, the best pieces of the col-
lection of antique sculpture, reliefs, and
inscriptions had been sold by the brothers
Decidio and Fabio de Sassi to Ottavio
Farnese.[3] Hence Coornherts' engraving
was already a historical document.

The drawing of the Casa Sassi differs
from Heemskerck's other Roman views
in its more specific treatment of light and
space and in the inclusion of circumstan-
tial details such as the cat sunning itself
above the courtyard. While his drawings
of the della Valle and Maffei sculpture
collections are comparable in the weight
of the pen contours and the lively nota-
tion of the reliefs, wash is applied with
more variation and details of the sculp-
tures are more legible in the Casa Sassi
drawing.[4] However, the drawing appears
not to have been made as a modello for
an engraving, but should be dated during
Heemskerck's Italian stay. The lack of
exaggeration in the treatment of the clas-
sical statues argues for an early date, and
is in marked contrast to Heemskerck's

reuse of the same elements in the back-
ground of his *Saint Luke Painting the
Virgin*, now in Rennes (fig. 2). Nor did
Coornhert transfer the drawing directly
onto his plate, since the Berlin drawing is
smaller than the corresponding elements
of the engraving.[5] This suggests that an
intermediate drawing may have been
Coornhert's model. In any case, the gene-
sis of the engraving was probably more
complex than the usual transfer from a
pen modello to an engraving of the same
size. The date 1555 on the drawing must
be a later addition.[6]

Heemskerck used the spatial arrange-
ment of the Casa Sassi, with its view
through a vaulted hall into a courtyard,
as well as the major pieces of sculpture,
as the background for his altarpiece of
Saint Luke Painting the Virgin in Rennes
(fig. 2).[7] These elements are reversed in
the Rennes painting, hence Preibisz and
most later scholars assume that Heem-
skerck took Coornhert's engraving as his
immediate source.[8] However, Rainald
Grosshans points out that such reversals
and adaptations are typical of Heems-
kerck's use of models, and that he used
other Roman drawings for some of the
background details. Thus the mask in the
center of the courtyard floor and the
prone statue on which a sculptor works
are taken from his drawings of the old
Palazzo della Valle and the Villa Madama

respectively.[9] The possibility of Heem-
skerck's reliance on his own drawings
rather than the 1553 engraving is relevant
to the dating of the Rennes painting and
the hypothesis that it is identical with
his altarpiece for the Delft Guild of Saint
Luke set up in the New Church in
1550.[10] This connection, while tantaliz-
ing, can neither be proved nor disproved,
because we lack a description of the Delft
painting and because Heemskerck's use
of models is so complex that neither the
drawing nor the engraving can be taken
as the essential source. Thus Heems-
kerck simplifies the space of the court
and increases the scale of architecture
and sculpture, at the same time giving a
new torsion to the antique monuments.
This is especially evident in the elon-
gated proportions and twisting pose of
the central seated statue, understood to
be a female figure and described in the
mid-sixteenth century as "Roma trion-
phante." Moreover, Heemskerck retains
the original coloration of the antique
monuments, which is not indicated in
either the Berlin drawing or Coornhert's
engraving. The seated statue has the red-
dish tone of porphyry, while the black
basalt of the Apollo Citharodeus, in the
sixteenth century taken for a representa-
tion of Hermaphrodite, has also been ac-
curately rendered.[11] MW

1. Hollstein 185, 380 x 295 mm, inscribed on roundel on left wall, *DVC/1553;* below image, *SPECTANTVR HAEC ANTQVITATIS MONVMETA ROMAE. IN AEDIBVS VVLGO DICTIS DE ZASSE.* See also Münster 1976, no. 95. Hieronymus Cock apparently used some of Heemskerck's material for his two series of Roman views of 1551 and 1561; compare, for example, the second plate in the 1561 series, and fol. 55 of the second Berlin sketchbook; see Riggs 1977, 296, no. 98, also 239-240 and 297 under nos. Q-1 and 100, and Veldman 1977a, 110-111. In these cases, Riggs postulates an intermediate drawing, which was the model for the print. A derivation from a lost Heemskerck drawing has been claimed for the view of the sculpture court of the Palazzo Valle-Capranica published by Cock in 1553; Hülsen and Egger 1913-1916, 2: 56-57, pl. 128.

2. Hülsen and Egger 1913-1916, 1: 42, repro. 44, citing also an early nineteenth-century ground plan of the house.

3. The record of sale is dated 26 June 1546; Hülsen and Egger 1913-1916, 1: 42.

4. Fol. 3v in the first album and fol. 20 in the second album; Hülsen and Egger, pls. 3 and 24 respectively.

5. The corresponding elements of the engraving measure approximately 270 x 265 mm; the whole engraved image measures 367 x 287 mm.

6. First suggested by Michaelis 1891, 130 and 170.

7. Grosshans 1980, 195-201. First recorded in the town hall of Nurenberg in 1705.

8. Preibisz 1911, 37, taking the print as a *terminus post quem.*

9. Grosshans 1980, 197-198, figs. 217 and 218; for these sheets, fol. 46 in the first album and fol. 20 in the second; see also Hülsen and Egger 1913-1916, 1: 24-25, pl. 47, and 2: 15-16, pl. 24 respectively.

10. For the recently discovered documents relating to the altarpiece, see Scheller 1972, 42 and 47-48. He and Veldman 1974, 94 and 98, who dates the painting c. 1560, both exclude the possibility that the Rennes painting is identical with the Delft altarpiece. Montias 1982, 24-25, and 31-33, indicates that the record of payment to Heemskerck in the 1551 account of the Delft Guild of Saint Luke relates to expenses incurred in the preceding year. He also publishes the accounts of 1575, shortly after the Alteration when Delft went over to the Protestant side, with records of payments for expenses incurred in disposing of the guild's altar *(die't outer ofde[d]den ende wech deen in den trubel)* and for cleaning and decorating it; these leave the fate of the altarpiece as well as its subject unclear.

11. See Winner in Berlin 1967, 97-99, for the identification and current location of the antique pieces.

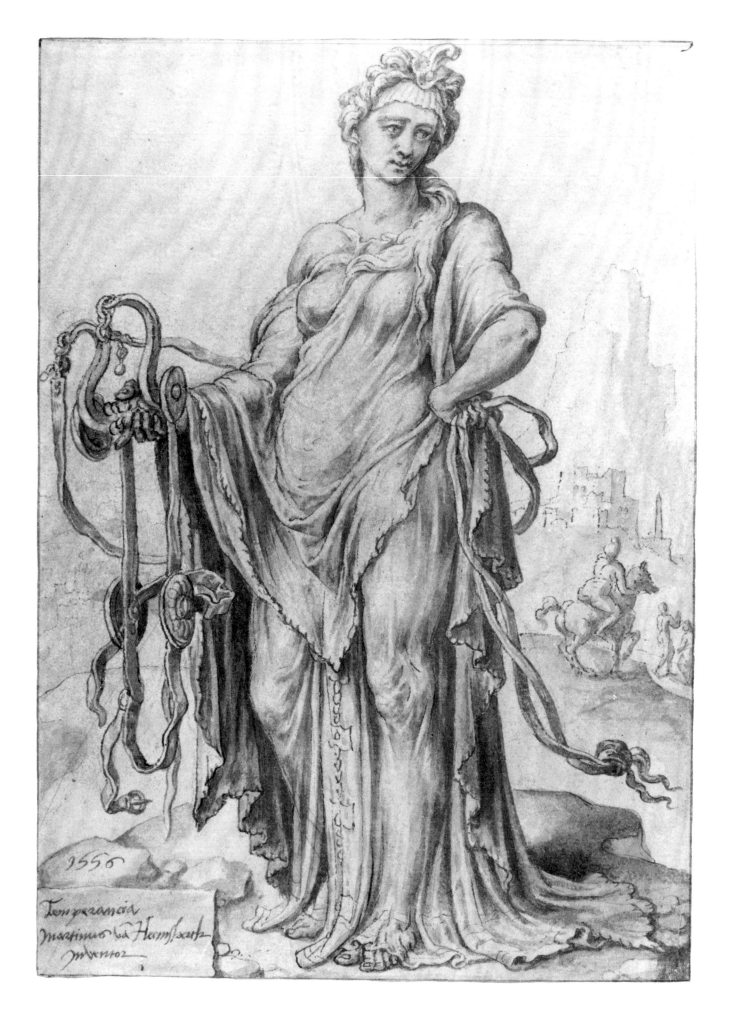

1556

Temperancia
Martinus van Heemskerck
inventor

MAERTEN VAN HEEMSKERCK

70 *Temperance*

Pen and brown ink, brush and brown ink, gray-brown wash, and pink body color over traces of black chalk

297 x 211 (11¹¹/₁₆ x 8⁵/₁₆)

Inscribed in brown ink at lower left on rock, *1556*; on tablet, *Temperancia/Martinus vâ Heemkerck/inventor*

Watermark: Double-headed eagle with crown

Provenance: Simon Meller, Budapest and Munich; Frits Lugt, acquired 4 October 1929 (Lugt 1028)

Literature: Reznicek 1961, 139; Veldman 1973, 117

Exhibitions: Rotterdam 1936, no. 70; Rennes 1974, no. 118; Florence 1980-1981, no. 91

Fondation Custodia (Coll. F. Lugt), Institut Néerlandais, Paris, inv. no. 4140A

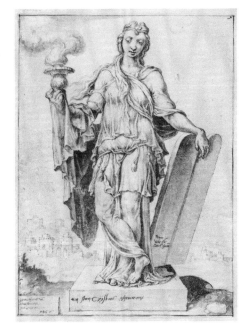

Fig. 1. Maerten van Heemsherck, *Justice*, Städelsches Kunstinstitut, Frankfurt

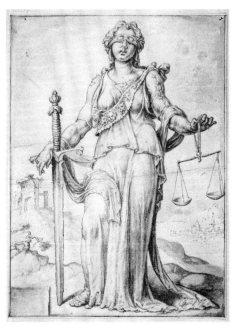

Fig. 2. Maerten van Heemsherck, *Faith*, Städelsches Kunstinstitut, Frankfurt

This representation of Temperance and a drawing of *Fortitude* also in the Lugt collection form a series with two more drawings of *Justice* and *Faith* (figs. 1 and 2), in the Städelsches Kunstinstitut, Frankfurt. The four drawings correspond in dimensions, technique, and inscriptions.[1] Either as single figures or in an allegorical framework, the virtues were an important part of the humanist vocabulary of Heemskerck and his circle. Thus the three theological virtues are incorporated in the device of the *Wijngaardranken* chamber of rhetoric in Haarlem, etched by Coornhert after Heemskerck's design in 1550.[2] The combination of three of the cardinal with one of the theological virtues suggests that the drawings were originally part of a larger series of the seven virtues, though Heemskerck used Charity in combination with three cardinal virtues for his grisailles on the back of the panels of *Venus and Mars Surprised by Vulcan* and *Vulcan Presenting Achilles' Shield to Thetis* in Vienna.[3]

For these statuesque figures of virtues Heemskerck subordinates pen line to subtly modulated wash to give the effect of shimmering fabric, through which the figure is revealed. He uses a broken pen contour for the background elements, thereby dissolving them in light. The wash technique is exceptional in Heemskerck's oeuvre. Two other monochrome brush drawings from the years around 1550 are known, a *Last Supper* dated 1551 in the Prado[4] and a *Last Judgment* in Budapest, which was preparatory to an etching attributed to Cornelis Bos.[5] Boon suggests that the four drawings in the Fondation Custodia and the Städel might be preparations for grisailles or for paintings.[6] Besides the grisailles of virtues on the backs of the Vulcan panels mentioned above, which date from the first

half of the 1540s, Heemskerck painted grisailles of the three theological virtues as a fixed triptych about 1545.[7] However, the figures standing on a little mound, with a label bearing the signature and date set into the corner of the image, are reminiscent of the figures, including several virtues, in the allegorical series entitled *Jacob's Ladder* etched by Coornhert after Heemskerck's designs in 1550.[8] Hence the drawings may be preparations for prints that were never executed, or they may be independent presentation drawings that recall prints in their format and serial character. In any case, Heemskerck's use of the monochrome brush technique does not appear to be reserved for works of a particular subject or function, but, like the very delicate hatching system that Heemskerck developed for his print modelli of the 1550s, reflects an effort to achieve more evanescent effects of light (see cat. 71). MW

1. *Justice*, inv. no. 13753, 299 x 216 mm, and *Faith*, inv. no. 13754, 299 x 217 mm, inscribed on label, *Martinus va/Heemskerck/inventor/1556*; on plinth, *En stan Cristus ghenaemt (?)*; on the tablets, *Dope/vresse/Deo sperä*. All four drawings also have a comma-like mark in the upper right corner.
2. See Veldman 1977, 125-141, fig. 76.
3. Grosshans 1980, 119-126, nos. 21-23, fig. 25, and Veldman 1977, 21-42, fig. 3, who demonstrates that the two wings date from c. 1540/1545. Prudence and Justice are paired on the reverse of *Mars and Venus Surprised by Vulcan*. The grisaille formerly on the back of the other panel represented Temperance and Charity.
4. Grosshans 1980, fig. 194.
5. See Gerszi 1976, no. 4, for drawing and print.
6. In Florence 1980-1981, 131, under no. 92.
7. Grosshans 1980, 162-163, fig. 71. Only the large central panel with *Charity* survives.
8. Hollstein 187-200; for the sequence, see Veldman 1977, 57-62, figs. 25-38.

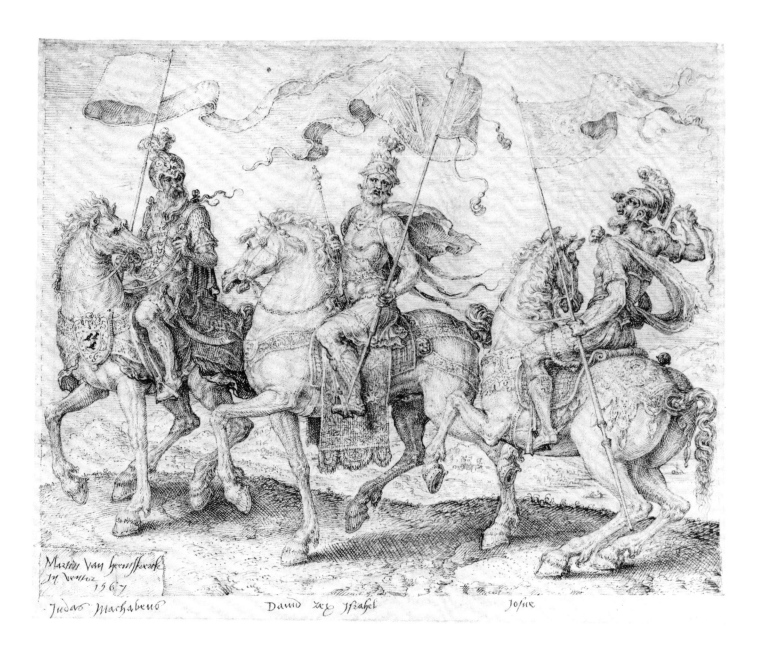

MAERTEN VAN HEEMSKERCK

71 *The Three Jewish Worthies: Joshua, David, and Judas Maccabeus*

Pen and brown ink over traces of black chalk; contours incised
206 x 257 (8⅛ x 10¼)

Signed in brown ink, *Martin van heemskerck/ Inventor/ 1567*; and inscribed, *Judas Machabeus, David rex Israhel, Josue*

Watermark: Crowned shield with letter *B*, surmounted by a flower, a banderole with illegible letters below; similar to Briquet, 8077-8079

Provenance: John MacGowan; Paul J. Sachs

Exhibitions: Tokyo 1979, no. 31

Harvard University Art Museums (Fogg Art Museum), Bequest—Meta and Paul J. Sachs, inv. no. 1965.205

Heemskerck was the first major Netherlandish painter to draw numerous compositions for reproduction by professional printmakers. Thanks to the approximately 700 engravings and etchings after his designs, Heemskerck enjoyed an international reputation during his lifetime.

Hundreds of Heemskerck's finished designs for prints have come down to us. Nearly all, like *The Three Jewish Worthies*, are executed in pen and ink in a technique that resembles the linear vocabulary of the contemporary reproductive engraver. The early works of this type, which date from the late 1530s and the 1540s, are broadly drawn with thick, parallel lines and cross-hatchings (fig. 1). During the 1550s and 1560s, when designs for prints played an increasingly important role in his work, this relatively crude penwork evolved into the delicate handling exemplified in this sheet, with its fine hatchings and stipples that describe intricate details, lively surface textures, and subtle gradations of tone. These qualities of Heemskerck's draftsmanship were already admired in the Netherlands around 1600. The artist, wrote Van Mander, "had a pleasant way

of drawing with the pen, his hatchings were very neat, and he had a light, fine touch."[1]

The Harvard drawing is the model for the first plate in a series of three prints representing the Nine Worthies. Its contours are incised for transfer and the composition is reproduced in reverse in the engraving by Harmen Jansz. Muller, published at Antwerp by Hieronymus Cock.[2] The study for *The Three Pagan Worthies: Julius Caesar, Alexander of Macedon, and Hector of Troy* is in the Gemeente Archief, Haarlem,[3] and the design for *The Three Christian Worthies: Arthur, Charlemagne, and Godfrey of Bouillon* belongs to the Stichting P. & N. de Boer, Amsterdam.[4] All three drawings are dated 1567.

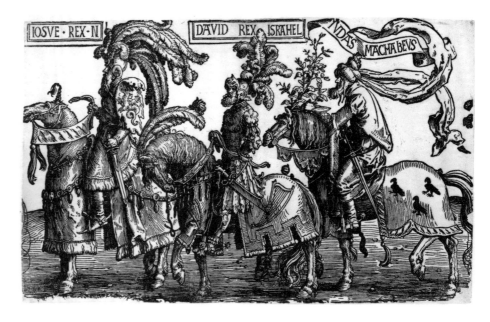

Fig. 2. Lucas van Leyden, *The Three Jewish Worthies*, National Gallery of Art, Washington, Rosenwald Collection

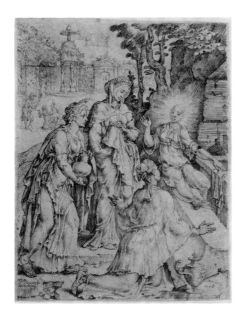

Fig. 1. Maerten van Heemskerck, *The Three Marys at the Tomb*, Statens Museum for Kunst, Kobberstiksamling, Copenhagen (Copyright Hans Petersen)

The theme of the Nine Worthies originated in a chivalric romance, *The Vows of the Peacock*, written by Jacques de Longuyon in 1312-1313. De Longuyon likened his protagonist's prowess in battle to the valor of the greatest Jewish, pagan, and Christian heroes. Due to the poem's popularity, the Nine Worthies became a favorite literary topos as well as the subject of countless works of the visual arts during the fourteenth and fifteenth centuries, but by the later sixteenth century it was rarely depicted.[5] Heemskerck and his contemporaries probably regarded the heroes less as paragons of knightly bravery than as exemplars of the humanist virtue of political and military service to the state.[6]

All three horsemen carry banners;

David's displays a harp, evoking his poetical and musical gifts. Joshua's is emblazoned with a sunburst, which refers to his defeat of the Amorites (Joshua 10: 12-14), when the sun stood still to prolong the day until the Israelites avenged themselves against their enemies. The pennant held by Judas Maccabeus is blank, but the escutcheon attached to his horse's breast features three ravens. Although ravens do not figure in the Biblical history of Judas Maccabeus, they often serve as his attributes in representations of the Nine Worthies, where they allude to speed and bellicosity.[7]

A suite of three woodcuts of c. 1515-1517 by Lucas van Leyden, which also shows the Nine Worthies on horseback, suggested the design of Heemskerck's series (fig. 2).[8] Compared to the rigid frontality of Lucas' parade of Gothic knights, the graceful rhythms of Heemskerck's compositions, the classicizing attitudes of the horses and riders, and the battledress *à l'antique* of the heroes underscore the later master's knowledge of Renaissance art. The horses demonstrate his skillful adaptation of northern as well as Italian models: while David's mount combines elements from Dürer's engravings *Knight, Death, and the Devil* and *The Small Horse*, the rearing animal ridden by Joshua derives from a type found in battle scenes by Leonardo and Raphael.[9] Heemskerck's understanding of Italian art impressed even Vasari, who wrote that one print series was "designed by Martin in a bold, well-practiced, and resolute manner, which is very similar to the Italian."[10] WWR

1. Veldman 1977, 15. A letter from Joris Hoefnagel to the Florentine collector Niccolò Gaddi attests that Heemskerck's drawings were already sought by collectors in 1579; Grosshans 1980, 10.
2. Hollstein 428, 57; Riggs 1971, no. 131. The print is signed, *MVH* (in ligature) *eemskerck. Invet. / Cock excud.* The title below the engraving reads, *JOSUE DUX DAVID REX IUDAS MACHABEUS/ Judeorum hi tres fortissimi fuerunt.*
3. Preibisz 1911, no. 28.
4. (Sale, Amsterdam, Mak van Waay, 29 May 1960, no. 228a.)
5. Schroeder 1971, chap. 3.
6. Schroeder 1971, 327-355 and 373.
7. Schroeder 1971, 231-235.
8. Hollstein 143-145 (as Jacob Cornelisz.). See Washington 1983, no. 54.
9. Dürer's engravings are Bartsch 98 and 96. The type of horse ridden by Joshua appears in copies after Leonardo's *Battle of Anghiari* and in Raphael's *Repulse of Attila* in the Stanza d'Eliodoro.
10. ". . . disegnate da Martino con fierezza e pratica molto risoluta, e molto simile alla maniera italiana," Grosshans 1980, 10.

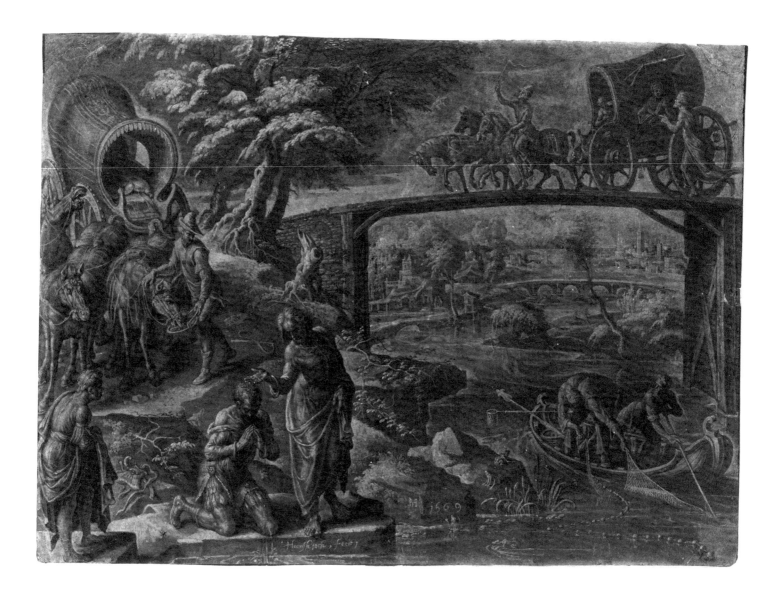

MAERTEN VAN HEEMSKERCK

72 *The Baptism of the Eunuch*

Brush and dark brown ink, gray wash, and
white body color on brown prepared paper;
laid down
191 X 268 (7½ X 10⁹⁄₁₆)
Inscribed in white body color on rock below
Saint Philip *Heem kerckfecit*; on rock at cen-
ter, *MVH 1569* (initials in ligature); in black
ink at lower right corner, *[4] 1932*

Provenance: Nagler; acquired in 1835

Literature: Preibisz 1911, 84, no. 14; Bock and
Rosenberg 1930, 37

Exhibitions: Rome 1972-1973, no. 35

Staatliche Museen Preussischer Kulturbesitz,
Kupferstichkabinett, Berlin, inv. no. KDZ 2779

The vast majority of surviving drawings
by Heemskerck are pen and ink modelli
for prints, perhaps because these draw-
ings were preserved as the property of the
publishers who reproduced them. Never-
theless, it is evident that Heemskerck
made a variety of other kinds of draw-
ings, of which his Roman studies—either
pen drawings of Roman sites, or chalk
copies of sculpture and painting—form
the second largest surviving group.[1] He
also produced study heads,[2] composi-
tional drawings executed in connection
with paintings,[3] and brush drawings that
may be independent works or prepara-
tions for prints or paintings (see *Temper-
ance*, cat. 70). Among the last group, *The
Baptism of the Eunuch* is one of the very
few chiaroscuro drawings.[4]

The Berlin *Baptism of the Eunuch* was
the basis for one plate in Heemskerck's
late print series of the Acts of the Apos-
tles and also has the quality of an inde-
pendent landscape. For the scene of Saint
Philip converting and baptizing the Ethi-
opian eunuch published by Philip Galle
in 1575 (fig. 1), Heemskerck made a pen
modello, dated 1572 and preserved in Co-
penhagen (fig. 2). While the engraving fol-
lows the modello precisely, reversing its
direction, the modello itself is clearly
based on the chiroscuro brush drawing of
1569 in Berlin, repeating the arrangement
and direction of most elements.[5] How-
ever, the scene as developed for the print
is more emphatically a sequential narra-
tive following the gospel account (Acts
8:26-40), with Philip first running after

Fig. 1. Philip Galle after Maerten van Heemskerck, *The Baptism of the Eunuch by Philip*, National Gallery of Art, Washington

Fig. 2. Maerten van Heemskerck, *The Baptism of the Eunuch*, Statens Musem for Kunst, Kobberstiksamling, Copenhagen (Copyright Hans Petersen)

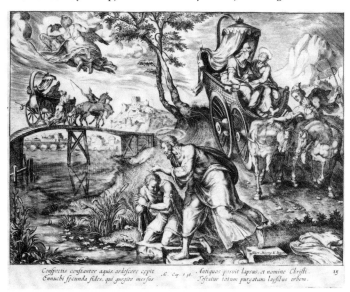

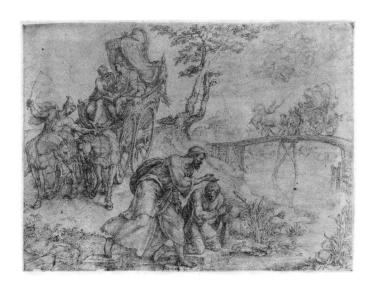

the eunuch's chariot on the bridge, then instructing him in his chariot, and finally baptizing him. The last event gains in prominence in relation to the chiaroscuro drawing, through its central position and the forceful, striding pose of the saint. The Berlin drawing, on the other hand, has a pronounced bucolic character conveyed by the overgrown bank, prominent trees, and activity of the fishermen; the high bridge permits the distant landscape to enter the middle ground. Figures and landscape are intertwined, in part by the inclusion of mundane activities scattered through the scene—the servant feeding the horses, the moorish servant and the fisherman.

The relationship of the Berlin drawing to the print modello is very similar to the relationship that Heemskerck's painting of the *Baptism of Christ* in Braunschweig of 1563 bears to his pen modello for an engraving by Philip Galle of the following year.[6] Here, too, the main action is moved to a central position for the print modello, a sequential narrative added, and subordinate scenes suppressed. By the end of the 1560s, Heemskerck had

virtually stopped painting. His last dated paintings, *Christ on the Sea of Tiberias* at Bowes Castle and the *Allegory of Nature* in the Norton Simon Museum, both from 1567,[7] are essentially landscapes interspersed with vignettes of human activity. The Berlin chiaroscuro should be viewed as an extension of Heemskerck's late paintings, with the subtle gradations achieved by the chiaroscuro technique continuing the refined monochrome effect of such late paintings as the Braunschweig *Baptism* and the Amsterdam *Erythaean Sibyl*.[8] The dignified, internalized emotion of the three foreground figures is characteristic of Heemskerck's very late style. MW

1. Hülsen and Egger 1913-1916, and Veldman 1977a, 106-113.
2. A rare mature study head is the red chalk *Elderly Man* in Berlin, KdZ 8485, 181 x 278 mm; Bock and Rosenberg 1930, 37, pl. 29.
3. For example, a *Crucifixion*, also in Berlin, whose arched format suggests the central section of a triptych, is a working drawing for the *Crucifixion* in Griethausen; KdZ 2780, pen and dark brown ink over black chalk, with some gray and yellow wash, squared in black chalk, signed and dated 1554, 377 x 264 mm; Bock and Rosenberg 1930, 37, pl. 28,

and Grosshans 1980, 210-212, no. 81, figs. 114 and 228. See also a design for a triptych of the Crucifixion in Copenhagen, Mag VI Def/41A under G.B. Franco, pen over black chalk, squared in black chalk, 274 x 422 mm; photo Gernsheim 73250, not included in Garff 1971.
4. Other chiaroscuro drawings include *Pyramus and Thisbe* in the Kupferstichkabinett, East Berlin, which Ilya Veldman kindly informs me is related to Philip Galle's engraving of the same subject, Hollstein 369 (letter of 17 January 1986); and the so-called *The Sacrifice of a Bull* on green prepared paper dated 1555, sold Christie's, Amsterdam, 15 November 1983, no. 1, pl. 1, and now in a British private collection, used for the first plate of the series of the *Parable of the King Who Made a Supper* (Hollstein 99).
5. Hollstein 222, 211 x 272 mm (plate); 193 x 263 mm (image); see Kerrich 1829, 54-58, for the several editions and copies of this series, to which Stradanus also contributed designs. For Heemskerck's modelli, see Garff 1971, nos. 117-134, esp. no. 130, *The Baptism of the Eunuch*, 196-200 x 274 mm. The pose of Saint Philip in the Berlin drawing is very close to that of Saint Peter in the fifth plate of the series, *Peter and John at the Beautiful Gate*.
6. Herzog Anton Ulrich-Museum, dated 1563; Grosshans 1980, 235-237, no. 94, pl. VIII. For the drawing in the British Museum, see Popham 1932, 20, no. 3, pl. V, and Grosshans 1980, fig. 231.
7. Grosshans 1980, 245-246, no. 100, fig. 136, and 246-249, no. 101, fig. 137, respectively.
8. Rijksmuseum, dated 1564; Grosshans 1980, 237-239, no. 95, figs. 130-131.

197

Joris Hoefnagel

1542-1600

Joris (Georg) Hoefnagel was born in Antwerp in 1542. His father was a wealthy diamond merchant, and it was probably assumed that he would pursue a career in business. It is possible that his first journeys, to France in 1561 and Spain between 1563 and 1567, were commercial in nature. He was in England in 1568-1569. In 1570 Hoefnagel returned to Antwerp where, in the following year, he married Susanna van Onsen. It was probably at this time that he studied, according to Van Mander, with Hans Bol, although, in an inscription on a drawing of 1578 in Berlin, Hoefnagel described himself as self-taught ("autodidact"). Probably as a direct result of the Spanish Fury of 1576, Hoefnagel left Antwerp and traveled with the cartographer Abraham Ortelius to Augsburg and Munich, and then on to Venice, Naples, and Rome. Van Mander reports that the artist was offered a position with Cardinal Alessandro Farnese of Rome, but declined because he had promised to work for Duke Albrecht V of Bavaria. By April 1578, Hoefnagel was in Munich working for Albrecht and, after 1579, for Albrecht's successor, Duke Wilhelm V. Between 1582 and 1590 Hoefnagel was engaged in illuminating a missal for Duke Ferdinand of the Tyrol, necessitating trips to Innsbruck. At roughly the same time, he produced views of cities that were published in Georg Braun and Franz Hogenberg's Civitates Orbis Terrarum *(Cologne, 1572-1618). In 1590 Hoefnagel entered the service of Rudolf II and by 1594 had added miniatures to Georg Bocskay's calligraphic masterpiece, the* Schriftmusterbuch. *The artist was living in Frankfurt in 1591, and afterward is reported by Van Mander as living in Vienna. Joris Hoefnagel died on 9 September 1600.*

73 The Four Elements

Four volumes bound in red morocco, containing 277 illustrations in pen, brush, watercolor and body color, framed in gold, on vellum; each illustration bears inscriptions in Latin and is interfoliated with a paper leaf, which also often carries additional inscriptions Approximate page size 143 x 184 (5⅝ x 7¼)

Volume I: *Animalia Rationalia et Insecta (Ignis)*
Title page monogrammed, *GHF*

Volume II: *Animalia Qvadrvpedia et Reptilia (Terra)*
Title page monogrammed, *GHF*

Volume III: *Animalia Aqvatilia et Cochilata (Aqva)*
Title page monogrammed, *GHF*

Volume IV: *Animalia Volatilia et Amphibia (Aier)*

Provenance: Emperor Rudolf II (d. 1612), Prague; Rüpfel, Munich, c. 1830; Bürgermeister Niggl, Tolz, 1842; Carl August von Brentano (sale, R. Weigel, Leipzig, 28 October 1861, no. 2220a-d); F.S. Eliot, London; Henry Huth; J.H. Huth (sale, Sotheby's, London, 2-6 June 1913, no. 3722); C.F.G.R. Schwerdt (sale, Sotheby's, London, 11 March 1946, no. 3722); The Rosenbach Company, Philadelphia; Lessing J. Rosenwald, Jenkintown, Pennsylvania

Literature: Van Mander, *Schilder-boek*, 2:78-79); Sandrart 1925, 169; Chmelarz 1896, 285-286; Killermann 1924, 194; Kris 1927, 247; *The Illustrated London News*, 23 March 1946, 328-329; Schwerdt 1928: 2:335-339; *The Illustrated London News*, 27 April 1946, 467; *The Illustrated London News*, Supplement, 18 February 1961, II-III; Wilberg Vignau-Schuurman 1969, 1: 9; Evans 1973, 172; Berlin 1975, 127-129, under nos. 168-169; Hendrix 1984; Spicer 1984, 326-327; Kaufmann 1985, 116-117, 244-245, no. 9-1

Exhibitions: Washington 1982, no. 57a-d; Princeton 1982-1983, no. 56; Vienna 1985, nos. 38, 44

Promised gift on deposit at the National Gallery of Art, Washington, by Mrs. Lessing J. Rosenwald

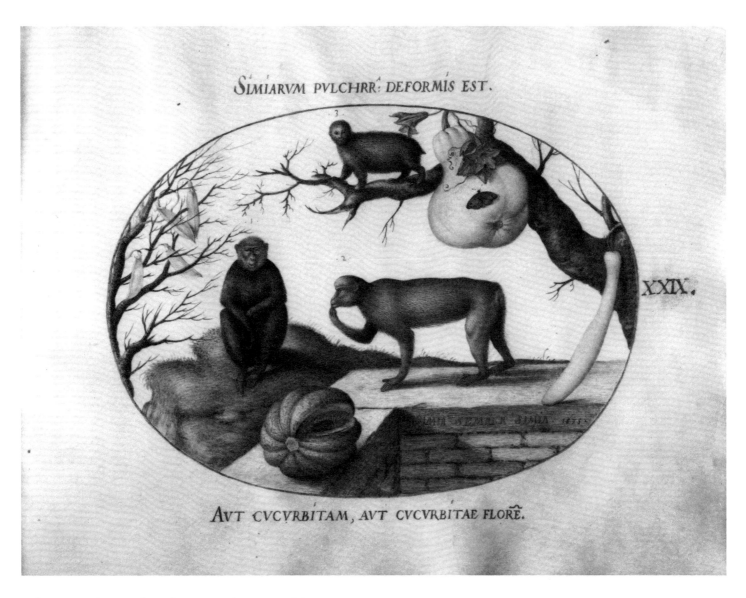

SIMIARVM PVLCHRR: DEFORMIS EST.

XXIX.

AVT CVCVRBITAM, AVT CVCVRBITAE FLORẼ.

Vol. 2, *Animalia Qvadrvpedia et Reptilia (Terra)*, folio 29.

A triumph of late sixteenth-century na-
ture illumination, the full impact of the
astonishing detail and vibrant color found
in the miniatures in these four volumes
can only be absorbed through close and
repeated observation. According to Van
Mander, *The Four Elements* was executed
for Rudolf II, who paid the artist one
thousand gold crowns.[1] The manuscript
has survived largely intact although, for
more than two centuries, the location
and degree of completeness of the vol-
umes were unknown. Some individual
leaves are in public and private
collections.[2]

This encyclopedic presentation of
thousands of living creatures is organized
around the traditional framework of the
four elements. The creatures of the world
are grouped under different elements:
insects and a hirsute "wild man" are

equated with fire (vol. 1, *Ignis*); four-
legged animals and reptiles belong to the
earth (vol. 2, *Terra*); fish and aquatic crea-
tures are associated with water (vol. 3,
Aqua); while birds and other flying crea-
tures are illustrated in the volume on air
(vol. 4, *Aier*). Individual specimens are
often numbered and Kaufmann suggests
that an explanatory text may have been
intended to accompany the volumes.[3]

While *The Four Elements* is a compen-
dium of natural history, it also has the
character of an emblem book. As noted
by Hendrix, the oval shapes of the images
reflect the ovoid or circular shapes often
used in emblem books. Above and/or be-
low the illustrations are Latin inscrip-
tions in colored inks. There are often ad-
ditional inscriptions on the ruled paper
folios facing the images. The quotations
come from a wide variety of sources: the

Bible, the *Adages* of Erasmus, proverbs,
poetry, and the writings of such classical
authors as Lucian and Terence.[4]

Hoefnagel's motto, *Natura sola magis-
tra* (Nature alone is mistress)[5] would at
first glance seem to be borne out in the
vivid characterizations and lifelike quali-
ties of each creature. Yet, most of the
birds, animals, and fish in *The Four Ele-
ments* were not done from life, but were
copied from earlier and contemporary
works. The greatest number of images
were taken from illustrations in the mon-
umental series of books published in the
1550s from the drawings of the Swiss
doctor, naturalist, and humanist Conrad
Gessner (1516-1565).[6] Gessner provided a
further model by including quotations
from classical authors and ancient and
modern proverbs. Hoefnagel's Antwerp
contemporaries were also influential; of

particular importance are three albums of drawings of quadrupeds, birds, and fish by Hans Bol (Kongelige Bibliotek, Copenhagen),[7] as well as animal prints by Adrian Collaert and Abraham de Bruyn. There are several borrowings from Albrecht Dürer as well.[8] For Hoefnagel, fidelity to nature meant copying the illustrations of others and injecting vitality through subtlety and freshness of technique. A possible exception to this approach may have occurred in the first volume, *Ignis*, for, as Hendrix notes, there are no visual precedents for the beautifully wrought insects that adorn the pages; thus it is likely that these miniatures are based on direct observation.[9]

Despite Van Mander's statement, it is not at all certain that *The Four Elements* was commissioned by Rudolf II. Dates of 1575, 1576, 1580, and 1582 appear on various folios. Mielke asserts that Hoefnagel's initial contact with Rudolf II must date from this time and not from 1590, as generally believed. This view is challenged by Hendrix who finds it unlikely that, a year before his coronation as emperor, Rudolf would commission so grand a project from a then nearly unknown artist.[11] Moreover, there are no symbolic references to Rudolf in the manuscript. *The Four Elements* was begun while Hoefnagel was in Antwerp and the combination of inscriptions and dates indicates that work continued in Munich[12]; apart from Van Mander, there is no external documentation and nothing in the manuscript to indicate that it had a patron. It is clear, however, from its influence on the other court artists and Hoefnagel's own work done for Rudolf, that *The Four Elements* accompanied the artist to Prague and Vienna. While it is possible, as Kaufmann suggests, that the volumes were presented to Rudolf shortly after the artist entered his service, the existence of several blank folios leaves open the possibility that Hoefnagel considered the work unfinished and kept it in his possession until his death.[13]

The Four Elements represents the culmination of the Netherlandish manuscript illumination tradition; in its combination of art, science, and emblematics, it also mirrors the distinctive world view of the late sixteenth century.[14] Its influence on central European natural history illustration, still life, and animal painting was decisive. The miniatures were copied by Hoefnagel's son, Jacob, in the engraved series, *Archetypa*, of 1592, and in Aegidius Sadeler's *Theatrum Morum* of 1608, and provided models for the early painted still lifes of Roelandt Savery.[15] JOH

1. Van Mander, *Schilder-boek*, 2: 78-79.
2. In addition to the sixteen sheets in the Staatliche Museen, Kupferstichkabinett, Berlin (KdZ 4805-4820), Hendrix 1984, 126 n. 10, lists two leaves in the Národní Galerie, Prague (R37.382, R37.383), two leaves in the Staatliche Kunstsammlungen, Weimar (KK 122, 123), three leaves in a private collection in Surth, Germany, and three leaves in a private collection, Paris. For a discussion and repro. of two of the Berlin leaves, see Berlin 1975, 128-129, nos. 168-169.
3. Princeton 1982-1983, 156, where the expository text that accompanied the missal done for Archduke Ferdinand of Tyrol (Österreichische Nationalbibliothek, Vienna) is cited for comparison. Hendrix 1984, 11-12, doubts the existence of an explanatory text.
4. Hendrix 1984, Appendix I, 266-332, identifies the sources of many of the inscriptions; approximately one-quarter were from the Bible.
5. The motto appears in *The View of Seville* (Bibliothèque Royale, Brussels) dated 1570 and 1573.
6. Hendrix 1984, 58, 65-66, cites as antecedents Gessner's *Historia Animalium Lib.I* (1551), *Icones Animalium Quadrupedem* (1553), *De avium natura* (1555), and *Historiae Animalium Lib. III qui est de piscium . . .* (1558). In Appendix II, 333-352, she lists Gessner as a pictorial source for more than 295 creatures.
7. Ms. 3471, nos. 1-3. Franz 1970, 228, 230, and Spicer 1979, cited by Hendrix 1984, 40-42, are the first to associate the Bol album with Hoefnagel's miniatures. This also, as noted by Hendrix 1984, 40, tends to confirm Van Mander's assertion that Bol was Hoefnagel's teacher. Hoefnagel was also influenced by the miniatures of the recently discovered artist who signed his work, *Hans Verhaegen den Stommé van Antwerpe*; see Vienna 1985, 130, no. 41, 276.
8. Hoefnagel's borrowings from Dürer are discussed in Vienna 1985, nos. 38, 44.
9. Hendrix 1984, 235-236; in this context it is worth noting that, on folio 54, real insect wings are affixed to the page.
10. Berlin 1975, 127.
11. Hendrix 1984, 40.
12. The inscription facing the depiction of a hirsute "wild man" and his wife on folio 1 of *Ignis* states that it was composed in Munich in 1582.
13. Kaufmann 1985, 245; Hendrix 1984, 65, for the opposing view.
14. Bergström 1963 discusses Hoefnagel in relation to late-fifteenth-century manuscript illumination. For a discussion of Hoefnagel in relation to Rudolfine philosophical and scientific investigation, see Kaufmann 1985, esp. 114-118.
15. Princeton 1982-1983, 157.

200

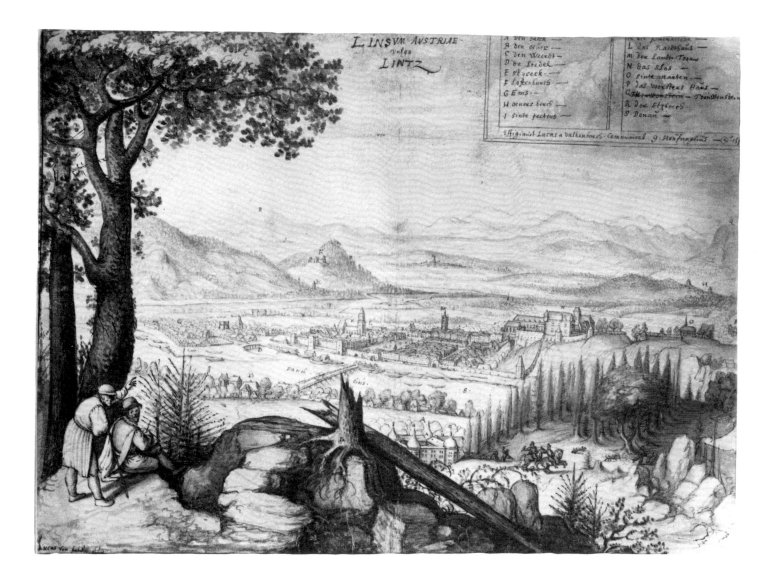

JORIS HOEFNAGEL

74 *View of Linz from the Pöstlingberg*

Pen and brown ink, brown and blue wash, some white body color, traces of preliminary sketch in graphite
350 x 488 (13¾ x 19¼)
Inscribed in brown ink, at upper center, *LIN-SUM AUSTRIAE/ vulgo/ LINTZ*; in tablet at upper right, *A den haeck-/ B den oever-/ C den weendt-/ D den Loede-/ E styreck-/ F Losten-burch-/ G Ems-/ H oevresberch-/ I sinte pee-ters-/ J die pfaerkirche-/ L das Raedthaŭs-/ M den Landtoor-/ N das Slos-/ O sinte marten-/ P das voorstens Haŭs-/ Q Trouwenstein/ R den Etzberch/ S Donaŭ/ Effigiavit Lucas a Valkenburch. Communicab: G: Hoŭfnaglius -@ 1594/*; at lower left, by a later hand, *nach LUCas van falckenburg*

Provenance: Hofbibliothek, Vienna, deposited in the Albertina, 1927

Literature: Benesch 1928, no. 311; Schmidt 1965, 262, no. 11; Wacha 1967, 26; Koschatsky and Haiböck 1970, no. 6; Wied 1971, under no. G17; Paris 1985-1986, under no. 89

Exhibitions: Rome, 1972-1973, no. 82; Berlin, 1975, no. 170

Graphische Sammlung Albertina, Vienna, inv. no. 23476

The second half of the sixteenth century witnessed unprecedented advances in topographical drawing as well as the publication of landmark works in the history of cartography. The most ambitious of these was the first uniform atlas of views and plans of the world's cities, Braun and Hogenberg's *Civitates Orbis Terrarum*. Composed of no fewer than 546 representations of cities in Europe, Asia, Africa, and Mexico, it appeared over the years 1572 to 1598 in five volumes, to which a sixth was added in 1617.[1] Writing in 1581 in the Preface to Book III, Georg Braun

explains the appeal of this successful enterprise to the armchair traveler: "What could be more pleasant than, in one's own home far from all danger, to gaze in these books at the universal form of the earth . . . adorned with the splendor of cities and fortresses and, by looking at the pictures and reading the texts accompanying them, to acquire knowledge which could scarcely be had but by long and difficult journeys?"[2]

Joris Hoefnagel, who traveled extensively, produced topographical drawings as early as 1561, long before his association with Georg Braun and Frans Hogenberg. Once involved in the project, he became the guiding artistic spirit of the *Civitates Orbis Terrarum* and its most consistent contributor, providing about

Fig. 1. Lucas van Valckenborch, *View of Linz from Pöstlingberg*, Ecole Nationale Supérieure des Beaux-Arts, Paris

Fig. 2. After Joris Hoefnagel, *View of Linz from Pöstlingberg*, from *Civitates Orbis Terrarum*, Book V, The Pierpont Morgan Library, New York

Urfahr (B) on the near bank of the Danube, the towers of the Pfarrkirche (K) and the Landhaus (M), the palace (N), and the Danube Valley and the Alps beyond.

Valkenborch's study has survived in two pieces that match when properly aligned (see fig. 1, where alignment is incorrect). Before it was cut and much of the sky and left edge lost, it must have resembled Hoefnagel's copy in most details.[6] The arbitrary truncation of the shrubs and rocks at the bottom and the right side of Valckenborch's drawing indicates that there, too, it has suffered a loss, and that the copy preserves its original appearance. In the copy Hoefnagel sacrificed the pen and watercolor technique he normally employed for topographical studies in favor of Valckenborch's preference for the brush, in some passages following the strokes of his model meticulously. Hoefnagel's characteristic touch is discernible in the penwork of the trees at the lower right.

Hoefnagel sent his drawing to the publishers in Cologne, where it was engraved for Book V of *Civitates Orbis Terrarum*, which appeared in 1597 (fig. 2).[7] The print is in the same direction as the drawing and differs from it only in the slight extension of the composition at the top and bottom and the addition of a few minor details. WWR

1. Tooley and Skelton in Braun and Hogenberg 1965, 1: 5, 7-10, 28-43.
2. Quoted by Skelton in Braun and Hogenberg 1965, 1: 7.
3. Skelton in Braun and Hogenberg 1965 1: 12, and Princeton 1982-1983, 154.
4. Skelton in Braun and Hogenberg 1965, 1: 12, 45.
5. For Valckenborch's drawing (fig. 1), see Paris 1985-1986, no. 89. Valckenborch consulted this sheet when preparing two of his own landscape paintings, one in the Landesmuseum, Oldenburg, the other in the Städelsches Kunstinstitut, Frankfurt. The latter, like the drawing, is dated 1593.
6. See Berlin 1975, no. 170, and Paris 1985-1986, no. 89, for other explanations of the relationship of the two fragments of Valckenborch's drawing.
7. The engraving after Hoefnagel's drawing and the accompanying commentary are no. 52 in Volume 5 of *Civitates Orbis Terrarum*.

sixty original views, based on studies made on the spot, of sites in Southern France, Spain, England, Bavaria, Italy, Austria, Bohemia, and Hungary.[3]

In addition to the original compositions he submitted to Braun and Hogenberg, Hoefnagel solicited studies from other draftsmen and prepared them for publication.[4] The inscription on *View of Linz from the Pöstlingberg* "Lucas van Valckenborch portrayed. Joris Hoefnagel communicated" records that he copied a drawing by the Netherlandish landscape painter and draftsman Lucas van Valckenborch. The original by Valckenborch (fig. 1) dates from 1593, the year he left the service of Archduke Matthias in Linz and settled in Frankfurt.[5] Hoefnagel lived in Frankfurt until the summer of 1594, so he must have obtained Valckenborch's work there. His copy is dated 1594. The most prominent features of the view are Schloss Hagen (A) on the hillside just below the fallen tree trunk, the Village of

Cornelis Ketel

1548-1616

Cornelis Ketel was born in Gouda and first trained there with his uncle Cornelis Jacobsz. Ketel. In 1565 he studied with Anthonis Blocklandt in Delft and the following year journeyed to Fontainebleau and Paris before returning to Gouda, where he stayed for six years. Ketel moved to London in 1573, where he was active as a portraitist. In 1581 he returned to the Netherlands, settling in Amsterdam, where, with the exception of a stay in Gouda in 1593, he lived until his death in 1616.

Ketel's most important contribution was the establishment in the northern Netherlands of the full-length group and single portrait. The portrait of the Company of Captain Dirck Jacobsz. Rosecrans *of 1588 (Rijksmuseum, Amsterdam) is, in its immediacy and topicality, the point of departure for the seventeenth-century group portrait. Ketel's paintings of complex allegories, typical of late mannerism, have not survived, but are described, along with the poems that often accompany them, in Van Mander's long and enthusiastic biography of the artist. Around 1600, Ketel began painting pictures using his fingers and toes instead of brushes, a practice that was defended by Van Mander and attracted commissions. A surviving example of this technique is the* Portrait of a Man, *monogrammed and dated 1601 (Foundation P. & N. de Boer, Amsterdam), whose inscription states that it was painted without brushes.*

75 Allegory of Human Nature

Pen and brown ink, black chalk, and white heightening, on blue paper
(verso: seated woman; black chalk)
515 x 376 (20¼ x 14¾)
Indented for transfer

Watermark: Flower (not identified)

Provenance: Possibly Jacobus Razet, Amsterdam (d. 1608); Valerius Röver (d. 1739), by 1705; (Frederik Muller and Co., Amsterdam); acquired by the present owner 1888

Literature: Van Mander, *Schilder-boek*, 2:192-193; Kauffmann 1923, 200-203; Stechow 1927, 220; Stechow 1927-1928, 59 n. 3; Reznicek 1961, 166 n. 64; Judson 1963, 38-41; Boon 1978, 117, no. 328

Exhibitions: Amsterdam 1955, no. 205; Amsterdam 1978, no. 89

Rijksprentenkabinet, Rijksmuseum, Amsterdam, inv. no. A 1423

This elegant, finished drawing is the design for an engraving (fig. 1) by Jan Saenredam.[1] The subject is an allegory of gratitude and ingratitude, and the title at the top of the engraving, *Naturae sequitur semina quisque suae*, may be translated, "Each follows his own tendencies." Elucidation is provided by the various inscriptions on the engraving as well as from Van Mander's comments in *Het Schilder-boek*, where it is described under the title "The Mirror of Virtue."[2]

In the center of the composition, a young woman, identified as *Beneficentia* (beneficence, charity), offers the sun, symbol of the greatest good, to a man who responds by biting her arm and stabbing her. This figure rests his knee on a skull and two fighting serpents encircle his thigh; he is associated with death, symbolized by the coffin. *Beneficentia* presents the moon, the lesser gift, to a woman who kneels in gratitude. Behind her is an obelisk, symbol of immortality. Also present is a small dog (fidelity?) and a lion who is tied by a rope. The small mouse who chews on the rope may, with reference to Aesop's fable, symbolize gratitude.

The polarities of good and evil are continued in the figures that adorn the elaborate frame. Two groupings on the sides are identified as *Bona indolas* (good nature) and *Malignitas* (ill nature). The woman on the left of the drawings stands on a serpent and gives birth to a child who receives the breath of an evil spirit (possibly Chronos?); the fruit that she picks is labeled poisonous in the engraving. On the right, the child of good nature receives the breath of Apollo, the sun

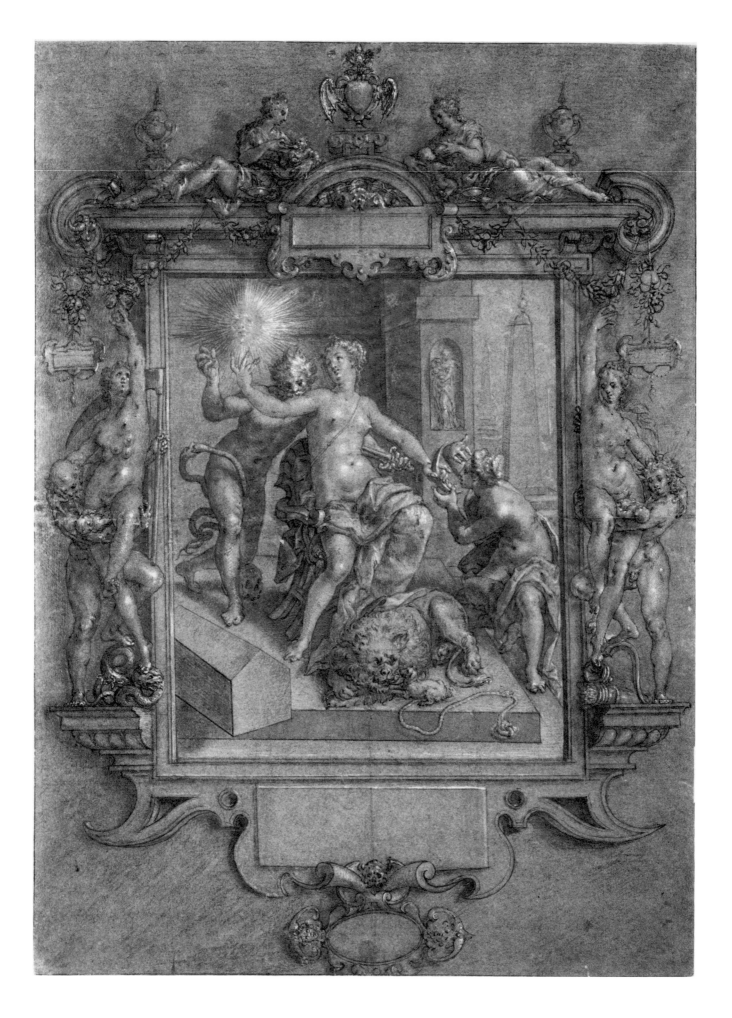

Fig. 1. Jan Saenredam after Cornelis Ketel,
Allegory of Human Nature,
Rijksprentenkabinet, Amsterdam

god. Overhead, the child on the side of gratitude is breast-fed, while the child of ingratitude is fed with a spoon.

The Amsterdam drawing and the engraving that proceeded from it are typical of the complex allegories produced by the mannerists in emulation of Italian models. The strongly literary quality serves to remind us that, like his fellow Amsterdamer Dirk Barendsz., Ketel moved in humanist circles. Van Mander cites several instances of poems composed by Ketel to accompany his paintings.[3] The engraving bears a poem by P. Hogerbeets and, below that, a dedication to Jacobus Razet, notary of Amsterdam. Razet was also a painter, poet, and collector. Van Mander mentions two religious paintings made for Razet by Ketel,[4] and the artist was mentioned as a witness to Razet's will in 1608.[5] Razet published the *Allegory of Human Nature*, and one wonders to what extent he might have had a hand in designing the iconographic program.

Neither the drawing nor the engraving are dated, but Judson connects the sketch on the verso with the *Portrait of a Lady*, dated 1594 (Thyssen-Bornemisza collection, Lugano), and thus suggests a date of 1594 or slightly earlier for the drawing.[6] This accords with the date usually assigned on stylistic grounds.[7]

Cornelis Ketel was one of the most important progressive artists working in the northern Netherlands at the turn of the century. Virtually all of his surviving paintings are portraits, as are three of the five surviving drawings attributed to him.[8] Ketel's mannerist style is visible in the Amsterdam sheet and in a drawing of *The Raising of the Brazen Serpent* (Staatliche Graphische Sammlung, Munich), which is signed and dated 1583.[9] The muscular forms of the Munich sheet may reflect Barendsz.' interest in Michelangelo in the 1580s, seen in prints made from his designs.[10] Further, Reznicek sees in the Munich sheet the influence of the style and manner of composition of Federigo Zuccaro, who was in England in 1574/1575 while Ketel was there. Goltzius and Ketel were acquainted, but both Reznicek and Stechow raise the possibility that Ketel was practicing a mannerist style earlier and independently from Goltzius.[11] Kauffmann sees north Netherlandish mannerism as growing directly out of the School of Fontainebleau and, because he was in Fontainebleau and Paris in 1566, Ketel was considered a pioneer in planting the French style in the north.[12] This approach is firmly rejected, correctly, I believe, by Stechow. Instead Stechow stresses Ketel's independent, personal, and distinctively Dutch character while downplaying dependence on Goltzius or the Spranger style.[13] In the *Allegory of Human Nature*, done about ten years after the Munich drawing, Ketel has arrived at an integrated, fluent, and individual mode of mannerism that, by the 1590s, could have been influenced by Goltzius and Cornelis van Haarlem. A certain resonance is also found in the firm contours and clear gestures of the figures and the approach to decoration, to drawings of Federigo Zuccaro, such as *The Calumny of Apelles* (Hamburger Kunsthalle, Kupferstichkabinett, Hamburg).[14] JOH

1. Hollstein 114 (Bartsch 106).
2. Van Mander, *Schilder-boek*, 2: 192-193.
3. Van Mander, *Schilder-boek*, 2: 176-179, 182-185, 188-189; Van Mander does not state whether the poem that he includes at the end of his description of the *Allegory of Human Nature* was composed by Ketel or someone else.
4. Van Mander, *Schilder-boek*, 2: 202-203.
5. Amsterdam 1955, no. 205.
6. Judson 1963, 40, n. 8; he stresses the painterly character of the portrait sketch and its associations with Venetian art.
7. Kauffmann 1923, 202 n. 9, does not know the drawing, but dates the print in the 1590s; he thinks the print reproduced a painting. Reznicek 1961, 166 n. 64, dates the drawing around 1600.
8. This counts the sketch on the verso of the Amsterdam sheet as a separate item. In addition to the drawings discussed in the text, a sketch of a *Standing Woman* (Q. van Regteren Altena Heirs collection, Amsterdam), Judson 1963, 39, repro. pl. 27, and a drawing for the group portrait of a civic guard (Rijksprentenkabinet, Amsterdam), Boon 1978, 117-118, no. 329, are attributed to Ketel.
9. Wegner 1978, 21, no. 72; Stechow 1927, 270, and Reznicek 1961, 148, note that the drawing was gone over by another hand.
10. Judson 1970, 91; the prints by Jan Sadeler are *The Last Judgment*, no. 87, fig. 62, and *Hell*, no. 89, fig. 64.
11. Reznicek 1961, 147-148. Ketel's drawing is compared specifically to Zuccaro's sketches of 1574 in Vienna and Darmstadt for the frescoes in the cupola of the cathedral of Florence.
12. Kauffmann 1923, esp. 194-204.
13. Stechow 1927, 218-219 and Stechow 1927-1928, 54-64.
14. Stubbe 1967, 26, no. 22, fig. 16. The composition was engraved by Cornelis Cort in 1572. There are also two paintings by Zuccaro in the Howard-Caetani collection, Rome, and at Hampton Court Palace.

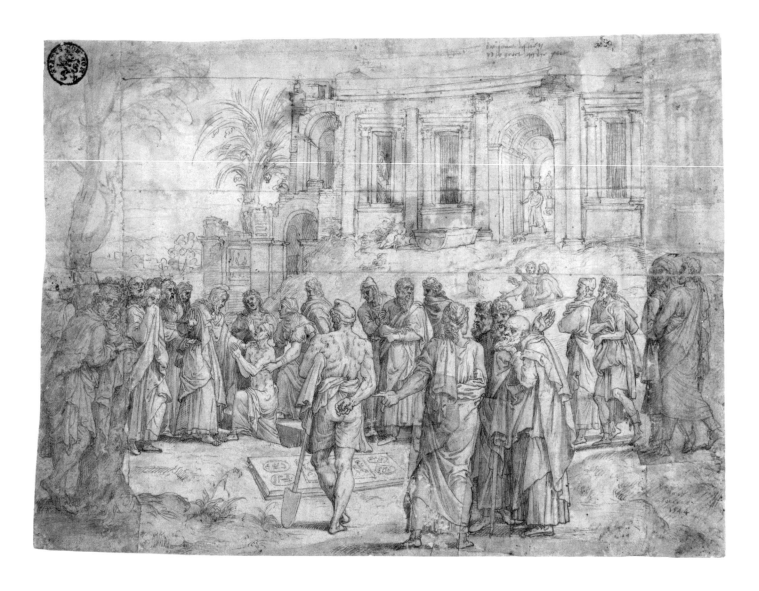

Lambert Lombard

c. 1505/1506-1566

Lambert Lombard, artist and architect, was born in Liège in 1505 or 1506 and died there in 1566. The major source of information is Dominicus Lampsonius' biography, published by Hubert Goltzius in 1565. Lampsonius writes that the artist was with Jan Gossaert, very likely sometime after 1524, and with the Antwerp designer of stained glass windows, Arnold de Beer, after he became a master in 1529. Lombard was back in Liège by 1535, when he entered the service of the Bishop of Liège, Erard de la Marck. In 1537, Lombard joined the English Cardinal Reginald Pole's entourage, traveling to Rome in order to purchase sculpture, painting, and furniture for the Bishop of Liège's palace. Lombard returned to his native city shortly after the latter's death on 16 February 1538. While in Rome, Lombard executed numerous drawings after antique and Italian Renaissance

art. Lampsonius tells us that Lombard believed that Mantegna, Michelangelo, and Baccio Bandinelli were the best Italian artists because they imitated ancient rather than contemporary art. We also know from Karel van Mander's discussion of Lambert Lombard that he studied provincial Roman antiquities and Romanesque fresco painting before he went to Italy. He visited France and Germany, and one sheet still exists that is a copy of the c. 250 A.D. relief on the south base of the Igeler Grave Monument near Trier (Musée de l'Art Wallon, Liège). In addition, there is a drawing copied from frescoes in Schwarzrheindorf, Palazzo Farnesina, Rome, and at least two others, in the Musée de l'Art Wallon, Liège, that cannot be identified. These designs, and the ones pasted into the Arenberg Sketchbook, Musée de l'Art Wallon, Liège, were used by Lambert Lombard

in his academy, which was probably founded shortly after his return from Italy in 1538. This academy, probably the first of its kind in the Netherlands and based upon the Italian prototype, attracted numerous students, who were introduced to the great art of the past through Lombard's drawings.

Lambert Lombard was extremely important for the development in Northern art of a mannered style based upon antique and Renaissance ideals. Lombard and his many pupils were responsible for its spread throughout the Netherlands in the sixteenth century. Among his numerous students can be counted some of the most influential artists of the period: Willem Key, Hubert Goltzius, Lucas de Heere, Dominicus Lampsonius, and Frans Floris. The latter alone had 128 pupils, according to Van Mander.

76 The Raising of Lazarus

Pen, brown ink, gone over partially with red
chalk, brown wash on brown paper
267 x 378 (10½ x 14⅞)
Enlarged along the left and right margins
through the addition of two strips of paper.
Signed at lower right, *Lamb/Lomb/1544*, and
at the upper right of center, *dat quart . . ./to
groot in der Port*

Provenance: Academy of Fine Arts, Düsseldorf

Literature: Helbig 1873, 139; Levin 1883, 154;
Helbig 1892, 436; Goldschmidt 1919, 214, 216,
239, no. 9; Kuntziger 1921, 190, 271; Klapheck
1928, 74; Budde 1930, no. 786; Hollstein; Yer-
naux 1957-1958, 321, 353; Düsseldorf 1962,
no. 626; Hühn-Kemp 1970, no. 15; Kemp 1973,
141, 142, 145, fig. 15; Riggs 1977, 119 n. 23,
349; Boon 1978, 126; Denhaens 1982-1983,
430, no. 8, fig. 462

Exhibitions: Düsseldorf 1958, no. 5; Brussels
1963, no. 293; Liège 1966, no. 169; Düsseldorf
1968, no. 67; Düsseldorf 1969-1970, no. 134

Kunstmuseum Düsseldorf, inv. no. FP4748

Lambert Lombard's drawing for *The Rais-
ing of Lazarus* was published as a print by
Hieronymous Cock. The plate was proba-
bly cut by Hans Collaert who, when
working for Cock, did the majority of his
engravings after drawings by Lambert
Lombard, beginning in 1555.[1] Although
Lombard's sheet is dated 1544, it is most
unlikely that it was made into a print in
that year. The drawing appears to have
undergone considerable changes after
that date and before Collaert made his
engraving. The drawn copy of Lom-
bard in the library, Université, Liège, re-
cords the composition prior to the addi-
tions to the left and right (fig. 1).[2] The
changes in the left margin were added to
the print while the two figures walking
into the scene from the right were not.
The man dressed in classical robes lean-
ing against the tree on the left is similar
to the *Standing Man Resting against a
Tree* (Musée de l'Art Wallon, Liège, for-
merly Arenberg collection)[3] but the lat-
ter's right arm is not raised nor are the
fingers on his left hand bent as they are
in *The Raising of Lazarus*. These details
are, however, present in Lambert Lom-
bard's signed and dated 1552 drawing of a
figure leaning against a tree stump in the
Rijksprentenkabinet, Amsterdam.[4] Be-
cause the Amsterdam sheet is dated 1552
and because the figure is virtually the

same in pose and detail as its counterpart
in *The Raising of Lazarus*, it can be pro-
posed that Lombard used the 1552 Am-
sterdam study for the extension of the
1544 sheet in Düsseldorf. Consequently,
Collaert's engraving must have been exe-
cuted after 1552. Lombard not only used
his Amsterdam design for the finished
drawing, but other figures, and especially
costumes, in the latter are taken from
Lombard's earlier studies found in the
Arenberg Sketchbook and elsewhere.[5]

Lombard's figures are dressed in classi-
cal costumes and are dispersed over the
surface in the almost perfect isocephaly
found in antique reliefs or in the works of
Raphael. The truncated middle-ground
space causes an abrupt transition from
the figures to the ruins behind them. De-
spite Lombard's reverence for ancient and
Italian art, his spatial conventions are
often typically Netherlandish. JRJ

1. Riggs 1977, 85, 86; Hollstein 27.
2. Goldschmidt 1919, 214, 215, fig. 7. A painted copy
was sold Sotheby's, London, 25 February 1952,
no. 119
3. Liège 1963, no. 106, pls. VII-XI.
4. Boon 1978, 125, 126, no. 352; pl. 132, no. 352.
5. Goldschmidt 1919, 216. Also see, for example, the
bearded, fully draped figure who stands to the right
and behind the grave digger in the middle distance.
He is similar to the man standing at the bottom of a
sheet in the Arenberg Sketchbook, known to me
from a photograph (neg. no. 1887, R.K.D.).

Fig. 1. Lambert Lombard, *The Raising of Lazarus*, Collections artistiques de l'Université de Liège

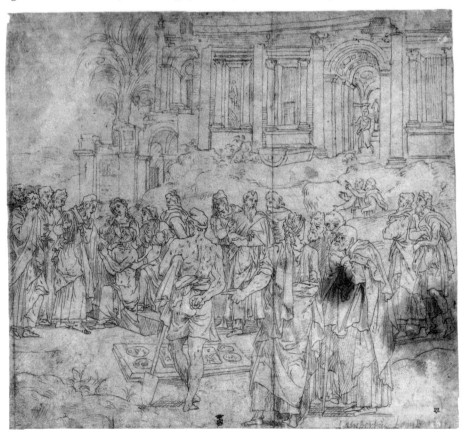

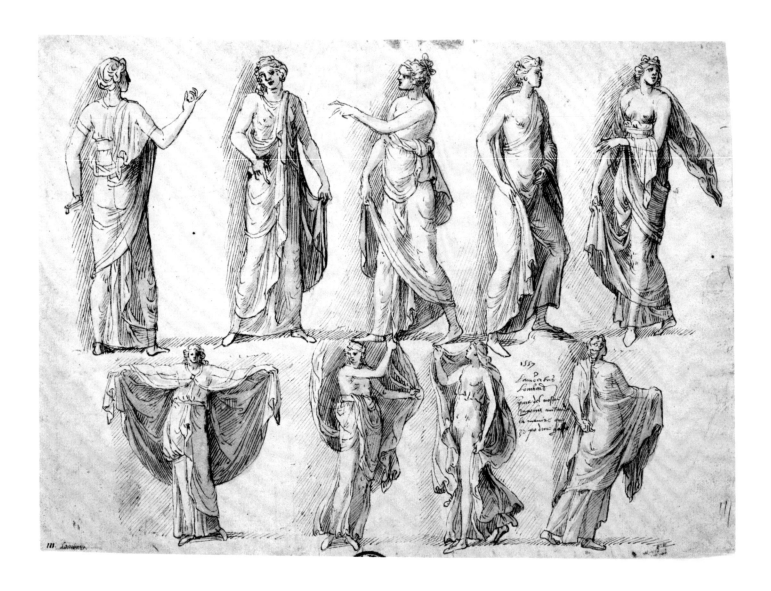

LAMBERT LOMBARD

77 *Nine Female Drapery Studies*

Pen and brown ink, olive-green wash
208 x 287 (8³/₁₆ x 11⁵/₁₆)
Signed between two bottom figures at right,
1557/Lambertus/Lombard/part del nostro/Ingenio imitando/la maniera qua(e)/si po dirre goffa(e); signed in later hand at bottom-left corner, *III. Lambart*

Literature: Helbig 1873, 138; Levin 1883, 154; Helbig 1892, 436; Klapheck 1928, 74; Budde 1930, 115, no. 788; Hühn-Kemp 1970, no. 56; Kemp 1973, 144, 145; Denhaens 1982-1983, 418, 434, no. 31

Exhibitions: Liège 1966, no. 180; Düsseldorf 1968, no. 69

Kunstmuseum Düsseldorf, inv. no. FP 4747

Lambert Lombard's 1557 study presents the viewer with nine thin, elongated forms whose heads are too small for their bodies. The artist has combined medieval figure types with antique drapery to establish a mode of expression suited to contemporary mannerist taste. Unfortunately, the inscription on the sheet gives no clear indication of what Lombard was attempting to do. The drawing appears to be an exercise in the placement of figures in various poses and the way in which the drapery might be used to enhance them. As Kemp points out, the slender, elongated figures dressed in flowing drapery recall fifteenth-century Florentine art.[1] For example, Flora in Botticelli's *Spring* (Uffizi, Florence) compares surprisingly well with the last figure on the right in the top row of Lombard's draw-

ing, while the same can be said for the woman on the far right in the bottom row and Botticelli's draped nymph in his *Birth of Venus* (Uffizi, Florence).[2] Of course, these are not direct and precise adaptations by Lombard but they suggest that the northerner worked, at times, in a style reminiscent of a style practiced seventy-five years earlier in Florence.[3] Although Lombard probably studied fifteenth-century Florentine painting, his figures have different proportions. The relationship between the heads and bodies in Lombard's figures is considerably more out of proportion than those in Florence and is more akin to mannerist ideals.

The figure on the far right in the top row of the Düsseldorf drawing appears again in the Arenberg Sketchbook (Musée de l'Art Wallon, Liège).[4] This single fig-

ure seems to be drawn with less assurance and boldness and with a more labored, repetitive use of the pen, suggesting that it is a copy. If this is true, it adds weight to the idea that Lombard's numerous drawings were used by his students for drawing exercises.[5]

The drawing style of the Düsseldorf sheet was taken up later by Lombard's famous pupil, Frans Floris, in his sketchbook of Roman antiquities (Kupferstich-Kabinett, Basel). Floris used the same thin pen lines and wash to create elongated bodies with small heads that are so close in style to Lombard that the sketchbook was at first attributed to him.[6] JRJ

1. Kemp 1973, 144.
2. See n. 1 above.
3. See n. 1 above.
4. Liège 1963, no. 156, pl. XXII.
5. For other connections between the Düsseldorf sheet, compare the figure in the top row, far left, with a woman seen from behind with her right arm raised in the Arenberg Sketchbook, Denhaens 1982-1983, 418, no. 339a, fig. 431. Compare the second figure from the left in the top row with the sheet in the Arenberg Sketchbook illustrated in Denhaens 1982-1983, 419, no. 339c, fig. 433.
6. For the Floris sketchbook of 1540-1547, see Van de Velde 1975, 335-361, nos. T1-25, figs. 106-121.

Lucas van Leyden

1489/1494-1533

The most reliable source for the particulars of Lucas van Leyden's life is Karel Van Mander's Schilder-boek. *According to Van Mander, Lucas was born in Leiden in 1494, but this date has been questioned by a number of scholars who believe it to be 1489. Lucas first studied with his father, Hugo Jacobsz., and then with Cornelis Engebrechtsz. The young Lucas also trained with an armorer and a goldsmith, and he married a member of the Van Boschuyzen family and had a daughter. Van Mander writes that Lucas never traveled to Italy, but that Albrecht Dürer visited him in Leiden where they exchanged portrait drawings. When Lucas was thirty-three years old, he journeyed to Zeeland, Flanders, and Brabant. On this trip, he visited Jan Gossaert in Middelburg and then they traveled together. Lucas believed that he had been poisoned on this trip and, consequently, for the next six years, until his death in 1533 at the age of thirty-nine, he was frequently sick.*

Lucas van Leyden was first and foremost a draftsman; his drawings, engravings, and woodcuts were very much sought after during his lifetime. Lucas' themes were carefully observed, with a sense for the original texts, and above all he attempted to differentiate between the psychological states of the characters he portrayed. His ability to suggest the mental state of his subjects through facial expressions, gestures, and the positioning of the bodies marks a clear change from his forerunners' idealized types. Lucas' ideas were well received in Italy where they were carried through his engravings to such artists as Marcantonio Raimondi, who in turn influenced Lucas, as well as to Andrea del Sarto, Jacopo da Pontormo, and Bacchiacca. Lucas was also very important for late sixteenth- and early seventeenth-century Dutch art when interest in his work was revived through copies and adaptations. Such artists as Hendrick Goltzius, Jacques de Gheyn II, and Rembrandt were especially touched by him.

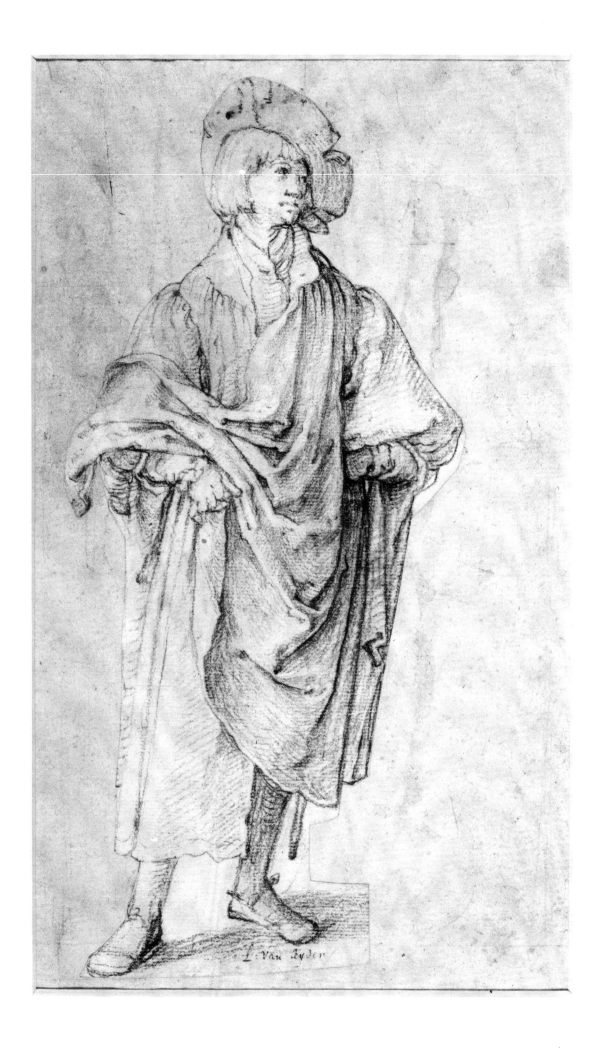

LUCAS VAN LEYDEN

78 *Standing Young Man*

Black chalk; trimmed along the contours and
mounted
300 x 180 (11¹³/₁₆ x 7⅛)
Inscribed at bottom center beneath left foot in
pen and brown ink by a later hand, *L: Van
leyden*

Provenance: Bloxam collection

Literature: Popham ms.; Müller Hofstede
1959, 232; Friedländer 1963, 74 n. 40a;
Reznicek-Buriks 1965, 246; Kuznetsov 1970,
fig. 3; Kloek 1978, 427, 429, 430, 440, no. 4;
Boon 1978, 122; Vos 1978a, 192, no. 217

Exhibitions: Amsterdam 1958, no. 199

Private collection

Stylistically, this design is very close to
the 1510 *Standing Boy with a Sword*
(Rijksprentenkabinet, Amsterdam; fig. 1)[1]
However, this sheet is more accom-
plished in the plastic treatment of form,
which is still awkward in the Amsterdam
drawing. This difference, along with the
greater degree of delicate nuances of light
and shade to model the shapes and give
life to the drapery and physiognomy, sug-
gests that the *Standing Young Man* was
drawn shortly after the *Standing Boy
with a Sword* (fig. 1). Although the draw-
ing bears some resemblance to several
figures in Lucas' engravings from
c. 1510,[2] these similarities are more gen-
eral than specific. The *Standing Young
Man* cannot be seen as a study for a spe-
cific print; neither can it be related to any
of Lucas' extant paintings. Thus the
drawing's specific function is unknown
to us. JRJ

1. Amsterdam 1958, 151.
2. Compare Lucas van Leyden's c. 1510 engraving of
Young Man with Eight Armed Men (Bartsch 142), fig-
ure in the center foreground, Amsterdam 1958, 151;
figure on the right in group in left foreground of the
c. 1510 *Return of the Prodigal Son* (Bartsch 78).
See also Müller Hofstede 1959, 232 n. 13

Fig. 1. Lucas van Leyden, *Standing Boy with
a Sword*, Rijksprentenkabinet, Amsterdam

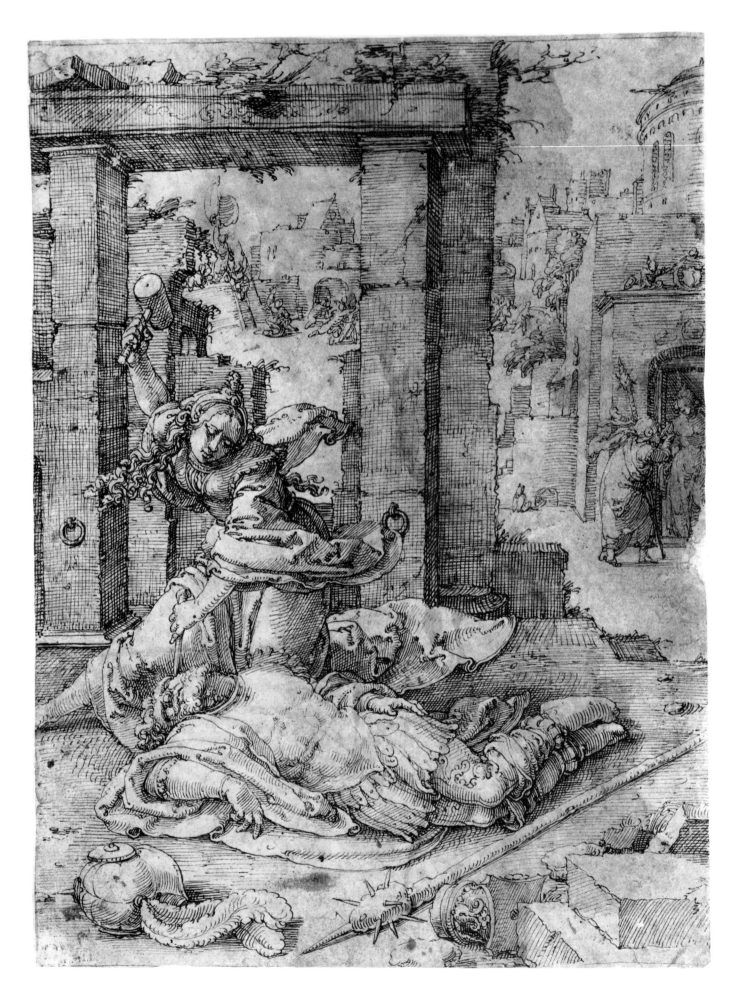

LUCAS VAN LEYDEN

79 *Jael Killing Sisera*

Pen and brown ink. A border line runs along the upper margin. The edges are ragged and damaged
271 x 203 (10⅝ x 8)
At bottom left, a blotted Dürer monogram in brown ink
Watermark: Gothic *P*

Provenance: Thomas Lawrence (Lugt 2445); F. Koenigs, Rotterdam, no. 13; D.G. van Beuningen, Rotterdam, 1940; acquired by the present owner in 1941

Literature: Koomen 1934, 306; Friedländer 1963, 77, no. 33; Hollstein 20; Kloek 1978, 428, 432, 444, 445, 454, no. 10; Vos 1978a, 196, no. 237; Amsterdam 1978, 58, 59; Kloek and Filedt Kok 1983, 9, 16, 88

Exhibitions: Rotterdam 1934, no. 23; Rotterdam 1936, no. 55; Washington 1958-1959, no. 14; Prague 1966, no. 12; Leiden 1978, no. 19

Museum Boymans-van Beuningen, Rotterdam, inv. no. N-13

Lucas van Leyden's drawing illustrates the story in Judges 4: 17-21, and is characterized by the exceptionally sensitive rendering of details with delicate, parallel pen lines similar to those in his engravings. The style is close to Lucas' c. 1520 *Men Pointing and Standing by a Balustrade and Two Children with a Dog* (Musée des Beaux-Arts, Lille)[1] and the *Judith and Holofernes* (British Museum, London).[2] The similarity between Lucas' *Jael and Sisera* and the *Judith and Holofernes* (cat. 81, fig. 1) is evident in the expression as well as in the almost identical format. This suggests that they are pendants, as does the fact that, beginning in the Middle Ages, these two themes were often paired. They illustrate the cunning actions of women triumphing over men. In these two representations, the women are seen as traditional prefigurations of the Virgin's victory over the devil and as Jewish heroines.[3] The heroic aspect of Jael's actions is extolled in the text accompanying Jan Saenredam's c. 1600 engraving (Bartsch 107), cut after the Lucas drawing some eighty years later in Haarlem.[4] This print also places Jael in the same valiant category as Judith.[5] Because of the refined technique used in both the Rotterdam and British Museum sheets and because there are no extant prints made by Lucas after these designs, it is possible that the drawings were made for a series of stained glass windows, the other art form requiring meticulously drawn studies.[6] Van Mander wrote that Lucas executed glass paintings,[7] and it is possible that the Jael and Judith sheets were part of a large glazed series representing wily females.[8]

Lucas van Leyden did not always portray Jael as a heroine; the text in the margin of his c. 1517 woodcut describes her treacherous conduct in breaking the holy laws of hospitality.[9]

There is a copy of the Rotterdam *Jael and Sisera* in the Rijksprentenkabinet, Amsterdam, which is, like the original, in the same direction as Saenredam's c. 1600 engraving.[10] This later repetition and the print are good examples of the strong revival of interest in Lucas van Leyden around 1600 in Haarlem; and later in other cities.[11] JRJ

1. For the connection between the Lille design and Lucas van Leyden's 1526 engraving of *Virgil Suspended in a Basket* (Bartsch 136), which helps to date the former in the early 1520s, see Kloek 1978, 443, 444, repro.
2. Kloek 1978, 445, no. 11, repro.
3. Amsterdam 1978a, 58.
4. Hollstein 18.
5. Saenredam also made an engraving after Lucas' drawing of *Judith and Holoferenes* around 1600 (Bartsch 108); Hollstein 18.
6. Amsterdam 1978, 59.
7. Van Mander 1906, *Schilder-boek*, 1: 112-113, 124-125.
8. Kloek and Filedt Kok 1983, 16, 17.
9. Amsterdam 1978, 58, 141, ill.
10. Boon 1978, no. 339; pen, brown ink: 270 x 202 mm.
11. For Lucas' importance for Goltzius see Reznicek 1961, 113-115, 126, and for De Gheyn see Van Regteren Altena 1983, 49, 102.

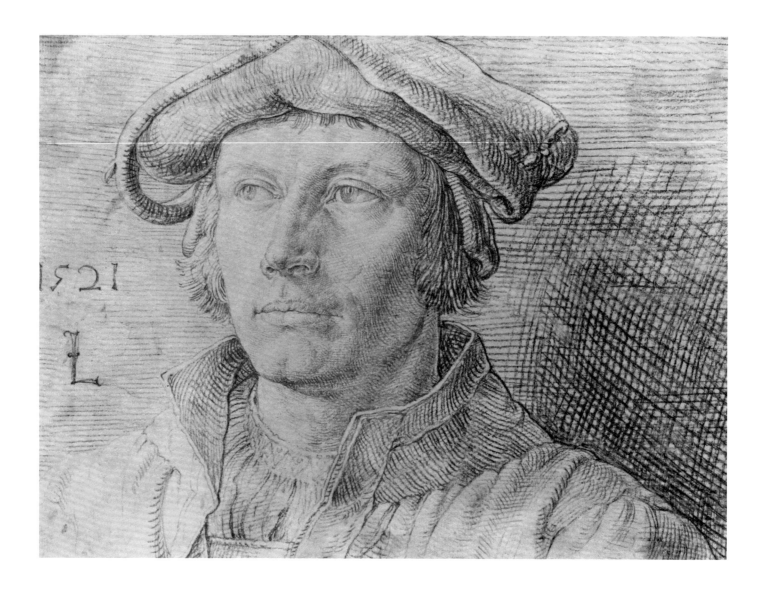

LUCAS VAN LEYDEN

80 *Portrait of a Young Man*

Black chalk; black chalk border line; upper
left-hand corner has been cut and restored; at
center right of bottom margin, a rectangular
form has been cut out and restored; at upper
left and right margins and on bottom right
side, the drawing has been stained; there is a
small hole in the bottom left side; doubled
261 x 352 (10⁵/₁₆ x 13⁷/₈)
Inscribed at left center, *1521/L*

Provenance: Perhaps the drawing described in
the Valerius Röver collection, Delft, 1705-
1731, inv. no. 47; presumably from the collec-
tion N. Tjark and others (sale, 10 November
1762, no. 186, sold to Yver for 1 fl. for J. van
der Marck, Leiden); (possibly sale, 29 Novem-
ber 1773); probably Goll van Franckenstein
collection; (sale, 1 July 1883, no. 12, sold to
Gruyter, as self portrait, for 15¼ gulden); be-
quest of Mr. Ch. M. Dozy, 1901

Literature: Beets 1913, 78; Gleadowe 1922,
178, 179; Glück 1928, 54-56; Henkel 1931, 11,
97; Hoogewerff, *NNS*, 3: 273; Van Gelder
1958, 18; Friedländer 1963, 76, no. 15; Kloek
1978, 431, 432, 446, 447, 449, no. 13; Filedt
Kok 1978a, 166, n. 14; Filedt Kok 1978b, 512,
no. 18; Vos 1978, 194, no. 228; Van Gelder
1979, 61, 62, 101; Leiden 1983, 205, no. 245

Exhibitions: Utrecht 1913, suppl. 62, no. 33;
London 1929, no. 518; Rotterdam 1936, no. 49;
The Hague 1945, no. 131; Brussels 1954-1955,
no. 104; Ghent 1955, no. 181a; Washington
1958-1959, no. 15; Prague 1966, no. 13; Brus-
sels 1977, no. 380; Leiden 1978, no. 18

Stedelijk Museum "De Lakenhal," Leiden

Lucas van Leyden's finished *Portrait of a
Young Man* is one of three chalk portrait
drawings dated 1521. They are drawn
with delicate crosshatching in the face in
contrast with thicker lines used to articu-
late the clothes and the shadows. Two
other undated drawings in the same tech-
nique in the Louvre form a homogeneous
group with the dated sheets.[1] It is likely
that there were more than five portrait
drawings of this type done in 1521, bear-
ing in mind the copy of Lucas' lost
Portrait of a Man, Teylers Museum,
Haarlem.[2]

The physiognomy of the Leiden *Por-
trait* is close stylistically to Lucas van
Leyden's c. 1521 *Portrait of a Man* (Na-
tional Gallery, London; fig. 1). This is es-
pecially evident in the careful outlining
of the lips and in the strong contours that
model the nose, eyelids, and eyebrows.

Filedt Kok points out that the costume is the same in both.[3] Further, in the drawing the construction of the mouth, made up of a single dark line, and the indication of the lips with short, quick strokes compare closely to the underdrawing of the donor's face in the 1522 Munich *Virgin and Child with Saint Mary Magdalene and a Donor*.[4]

Although one can point to stylistic connections between the Leiden drawing and other works by Lucas dating from the years around 1521, the function of these portrait drawings remains a mystery. As far as is known, they were not used as models for his paintings or graphics. It is, however, quite certain that all of these sheets were kept together by Lucas. If

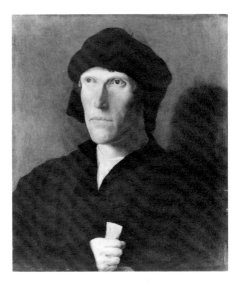

Fig. 1. Lucas van Leyden, *Portrait of a Man*, The National Gallery, London (Reproduced by courtesy of the Trustees, The National Gallery, London)

this was the case, perhaps he drew them for his own personal use.[5] Because three of these sheets carry the date 1521 and because they bear a remarkable resemblance to the charcoal portraits executed by Albrecht Dürer prior to that year, Lucas probably executed these sheets as a result of his meeting in Antwerp with Dürer in June 1521.[6] JRJ

1. For details see Kloek 1978, 428, 429, 446-449, nos. 13-16, 18, fig. 9, repros. on 446-448.
2. Kloek 1978, 429, fig. 11.
3. Filedt Kok 1978a, 166 n. 114. For another point of view concerning the style and date of the London *Portrait* see Bruyn 1969, 44-47, who dates the painting from c. 1515-1517.
4. Filedt Kok 1978a, 53, fig. 53.
5. For a detailed discussion of this question, see Kloek 1978, 431, 432.
6. Compare Dürer's 1520 *Portrait of a Young Man*, Kupferstichkabinett, Berlin, illustrated in Panofsky 1948, 2: fig. 261.

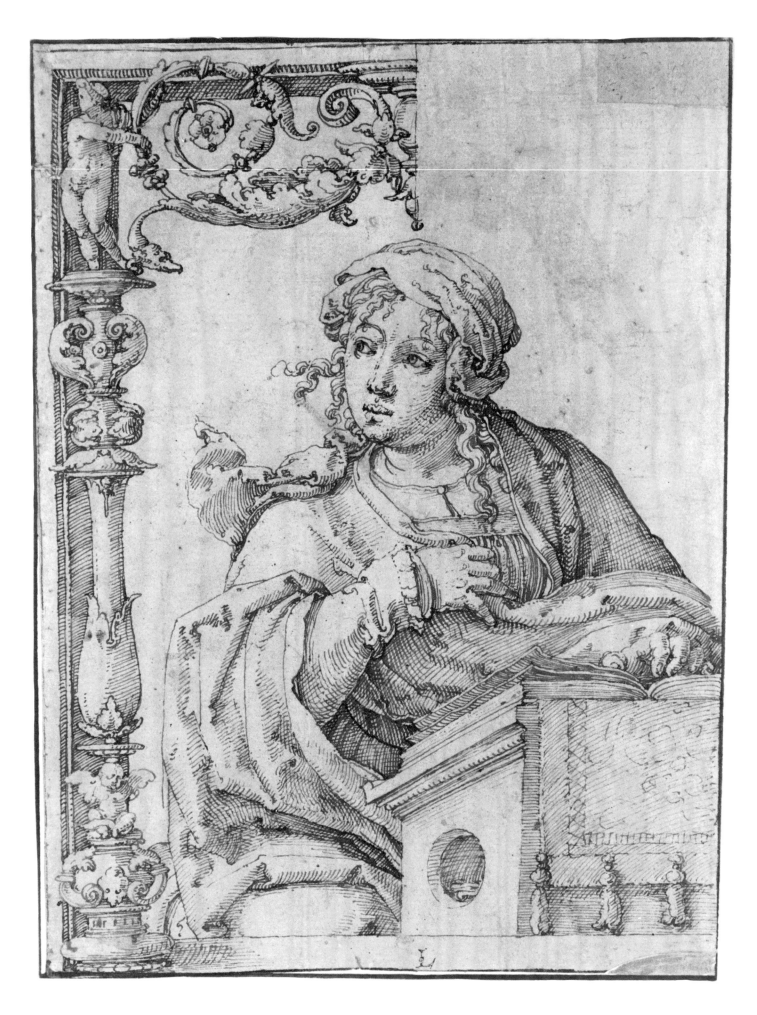

216

LUCAS VAN LEYDEN

81 *Virgin behind a Prayer Stand*

Pen and brown ink; a square piece has been
cut out at the upper right corner, a corner has
been cut at the lower right corner; slightly
damaged at the upper left, stained just above
Virgin's head at right, there is a border line on
the mount and traces along left margin suggest
an original border line executed in pen and
brown ink; perforation along the left margin
suggests that the sheet was once bound in a
book
249 x 180 (9¹³⁄₁₆ x 7⅛)
Inscribed just to the right of center at the bot-
tom margin, *L*

Literature: Bock and Rosenberg 1930, 39, no.
4020; Friedländer 1963, 77, no. 28; Kloek 1978,
426, 430, 441, 450, 453, 454, 455, no. 24; Filedt
Kok 1978a, 55; Filedt Kok 1978b, 512, no. 16;
Vos 1978a, 196, no. 236

Exhibitions: Ghent 1955, no. 181; Amsterdam
1958, no. 207; Leiden 1978, no. 15

Staatliche Museen Preussischer Kulturbesitz,
Kupferstichkabinett, Berlin, inv. no. KdZ 4020

The Virgin looks up and to the left in sur-
prise as if she has just received the mes-
sage from Gabriel announcing the com-
ing birth of Christ. Normally, the angel
would be included either with the Virgin
or in a pendant. Because of the architec-
tural decoration to the left, which frames
Mary and makes eye contact with a pen-
dant impossible, it is most likely that
Lucas intended this to be a single-figured
representation. The purpose for which
this design was made is not known.[1] It is
possible, however, to discern indications
of a frame on the right-hand margin. This
suggests that it has been trimmed and
perhaps originally contained an enfram-
ing ornament similar to the one on the
left.

The date for this design, which reflects
a translation of Lucas' woodcut style into
drawing, is difficult to establish. On the
one hand, the technique is similar to his
works from the early 1520s, such as *Jael
Killing Sisera* (cat. 79), *Judith and Holo-
fernes* (British Museum, London; fig. 1)
and the *Portrait of the Emperor Maximil-
ian*, Fondation Custodia, Coll. F. Lugt,
Paris (cat. 68, fig. 3).[2] However, the treat-
ment of the Virgin's physiognomy is akin
to Lucas' c. 1512 drawing of a *Man Writ-
ing* (Staatliche Museen, Kupferstichkabi-
nett, Berlin, inv. no. KdZ 4021), where
double lines are also used to create the
nose and eyebrows.[3] This manner of de-
fining the nose is also evident in the un-
derdrawing of Saint Mary Magdalene's
face in the 1522 Munich *Virgin and
Child with Saint Mary Magdalene and a
Donor*.[4] Filedt Kok also points out the
similarity in the hatchings used to con-
struct the clothes in both figures of the
Virgin. Consequently, he suggests that

Fig. 1. Lucas van Leyden, *Judith and
Holofernes*, The British Museum, London
(Courtesy of the Trustees of the British Museum)

both the painting and drawing were exe-
cuted at the same time, that is 1522.
Kloek, to the contrary, proposes that the
drawing in Berlin dates from around
1527/1528 because the ornaments on the
left are like those present in Lucas van
Leyden's engravings from late in his ca-
reer (Bartsch 160-162, 164, 165, 167,
171).[5] Kloek also believes, quite rightly,
that the 1522 *Annunciation* in Munich,
originally on the exterior of the diptych
with the *Virgin and Child with Saint
Mary Magdalene and a Donor*, is not as
advanced in concept as the Berlin draw-
ing of the *Virgin behind a Prayer Stand*.[6]
The women in the Munich diptych are
considerably thinner and more ephemeral
than the more substantial Virgin in the
drawing. Her plasticity recalls the types
that appeared in Lucas' work after his
contact with Jan Gossaert and the en-
gravings of Marcantonio Raimondi. The
more rounded forms that turn vigorously
to the right or left in Lucas van Leyden's
1526-1527 *Last Judgment* (Stedelijk Mu-
seum "De Lakenhal," Leiden) are seen in
the Berlin *Virgin behind a Prayer Stand*.

JRJ

1. Friedländer 1963, 77, suggests that it could be a de-
sign for a glass window.
2. Kloek 1978, 454.
3. See n. 2 above.
4. Filedt Kok 1978a, 55, fig. 56.
5. See n. 4 above.
6. Kloek 1978, 454.

Karel van Mander

1548-1606

*The painter, draftsman, poet, and biogra-
pher Karel van Mander was born in May
1548 to an established family at Meule-
beke near Kortrijk. His first teacher was
the Ghent master Lucas de Heere, who,
like Van Mander, was an artist with a
strong literary bent. After De Heere was
banned for his sympathy with the Re-
form, Van Mander studied in 1568-1569
with Pieter Vlerick in Kortrijk and Tour-
nai. He traveled to Italy in 1573, visited
Florence, and spent about three years
(1574/1575-1577) in Rome, where he met
Bartholomeus Spranger and Hans
Speckaert. At Spranger's invitation, he
journeyed to Vienna in 1577 to help dec-
orate a triumphal arch for Rudolf II. He
returned to Meulebeke the same year. In
the early 1580s Van Mander embarked,
like many of his Flemish colleagues, on a
protracted emigration from his war-torn
native province to the relative safety of
the northern Netherlands. He stopped
briefly in Kortrijk and Bruges before set-
tling in Haarlem in 1583. When he
showed some drawings by Spranger to
his new friend Hendrick Goltzius, Van
Mander precipitated the creation of the
Haarlem mannerist style. At a later date
he, Goltzius, and Cornelis Cornelisz.
probably gathered in an informal "acad-
emy" to draw from life. Van Mander
moved to Amsterdam in 1604, and died
there on 2 September 1606.*

*Van Mander's earliest known work
dates from 1582, but his artistic activity
is well documented only from 1587 to c.
1602. In addition to his career as a paint-
er and draftsman, he was a serious and
productive writer, who published trans-
lations of* The Iliad *(posthumously, 1611)
and Virgil's* Georgics *(1597), as well as
original poetical works. His outstanding
literary achievement was* Het Schilder-
boek, *which appeared in 1604.* Het
Schilder-boek *is our single most valuable
source of information about the lives of
fifteenth- and sixteenth-century Nether-
landish artists, and about the theory and
practice of art in the Low Countries
around 1600. It consists of four parts.*
Den grondt der edel vry schilderkunst *is
a long didactic poem that offers various
kinds of instruction to young artists.
Next come the biographies, of which the
most original are the lives of Netherlan-
dish masters from Van Eyck to Van Man-
der's contemporaries.* Wtlegghingh op
den Metamorphis . . . *is the first Dutch
commentary on Ovid's* Metamorphoses,
and Wtbeeldinge der Figueren *is the first
iconographic handbook in the Dutch
language.*

217

KAREL VAN MANDER

82 *Diana and Actaeon*

Pen, brown and black ink, and gray wash,
heightened with white, on pink prepared paper;
laid down
315 x 419 (12⅜ x 16½)

Literature: Keller 1958, 184-185, as Karel van
Mander II; Reznicek 1961, 161-163

Exhibitions: Bremen 1964, no. 28

Kunsthalle Bremen, inv. no. 170

Grandiose in design and sumptuously
pictorial in execution, this magnificent
sheet is the masterpiece of Van Mander,
the draftsman.[1] Although it bears neither
a signature nor any other inscription,
comparison with the artist's signed *Ker-
mis* of 1591 (fig. 1) or with Clock's en-
graving *The Judgment of Midas* of 1589
(fig. 2), which reproduces a Van Mander
composition, confirms both the attribu-
tion and a date of c. 1590.[2] Van Mander
usually employed a combination of draw-
ing media, but no other example is as lav-
ishly fashioned as *Diana and Actaeon*,
with its pink ground and extensive high-
lights in white body color. If not a fin-
ished work produced for a collector, it
might be the model for an unexecuted
engraving.

Although Van Mander introduced his
Haarlem colleagues to the work of Bar-
tholomeus Spranger in 1583, *Diana and
Actaeon* and other drawings reveal that
he succumbed to the magisterial inter-
pretation of Spranger's manner devised c.
1585/1588 by Goltzius.[3] E. K. J. Reznicek,
the first to attribute this sheet to Van
Mander, notes its resemblance to the fig-
ure style and landscapes in Goltzius' de-
signs of 1590 for engravings of scenes
from *The Metamorphoses*, which also
trade on painterly contrasts of dark
washes and liberally applied white body
color.[4] In Van Mander's nudes, the stren-
uous poses and dramatic gestures favored
by Goltzius and Cornelis van Haarlem in
the 1580s are characteristically tempered
with a sinuous grace and breadth of mod-

eling recollected from his expeience of the work of such Italian mannerists as Jacopo Zucchi. Like some Goltzius drawings of 1590 (cat. 56), Van Mander's *Diana and Actaeon* foreshadows the rejection of the excessively contorted and elongated figures of the 1580s in favor of more naturally proportioned bodies and restrained movements. This rejection would distinguish the classicizing style embraced by the Haarlem masters after Goltzius' return from Italy in 1591.[5]

The subject, a popular one among northern artists of the late sixteenth and early seventeenth centuries, comes from Book III of Ovid's *Metamorphoses*. While hunting, Actaeon stumbles by chance upon the place where Diana and her companions are bathing. Although the girls cry out and try to shield their mistress from his view, Actaeon catches a glimpse of the naked goddess. She splashes water in his face, transforming him into a stag, and taunts, "If you can talk, then speak, /

Say that you saw Diana in undress." In the drawing, two of Actaeon's dogs already catch the animal scent: one lifts his head alertly from drinking, and another turns hungrily toward his master. Far in the distance the dogs and his unwitting colleagues hunt Actaeon down.

Renaissance scholars often allegorized and moralized the narrative tales in *The Metamorphoses*. The first and most important Ovid commentator in the Dutch language was none other than Karel van Mander, whose "Wtleggingh op den Metamorphosis Pub. Ovidii Nasonis" appeared in his *Het Schilder-boek* of 1604. Van Mander offers four interpretations of the fable of Diana and Actaeon. As E.-J. Sluijter notes in a recent discussion on this subject in Netherlandish art around 1600, three of his explanations derive from earlier commentators.[6] The fourth, which Van Mander favors, is original. While Ovid ascribes Actaeon's fate to bad luck, Van Mander blames his destruction on his lasciviousness. During the sixteenth and seventeenth centuries, it was agreed that lust was stimulated through the sense of sight, so Actaeon must have been aroused by this brief glimpse of the chaste goddess in the nude. His sensual instincts turned him morally, as well as physically, into a beast. According to Sluijter, a mythological work like Van Mander's *Diana and Actaeon* was intended to delight the viewer with its display of attractive nudes, but might also lead him to contemplate the deadly consequences of lust.[7] WWR

Fig. 1. Karel van Mander, *Kermis*, Ecole Nationale Supérieure des Beaux-Arts, Paris

Fig. 2. Claes Jansz. Clock after Karel van Mander, *The Judgment of Midas*, Rijksprentenkabinet, Amsterdam

1. Singled out as Van Mander's outstanding mannerist drawing by Reznicek 1961, 162.
2. *The Kermis* (fig. 1) is in the Ecole des Beaux-Arts, Paris, inv. no. M, 519, Paris 1985-1986, no. 91. The engraving by Claes Jansz. Clock after a lost *Judgment of Midas* by Van Mander (fig. 2) is Hollstein 4.
3. Van Mander reports in *Het Schilder-boek* that, when he arrived in Haarlem in 1583, he showed to Goltzius drawings by Spranger. Goltzius' first engravings after Spranger appeared in 1585, Reznicek 1961, 8, and 23-24. See Reznicek 1961, 24, and 162-163 for a discussion of the exchange of artistic ideas between Van Mander and Goltzius.
4. Reznicek 1961, 162.
5. Reznicek 1961, 162-163.
6. Sluijter 1985, 65.
7. Sluijter 1985, 65-66.

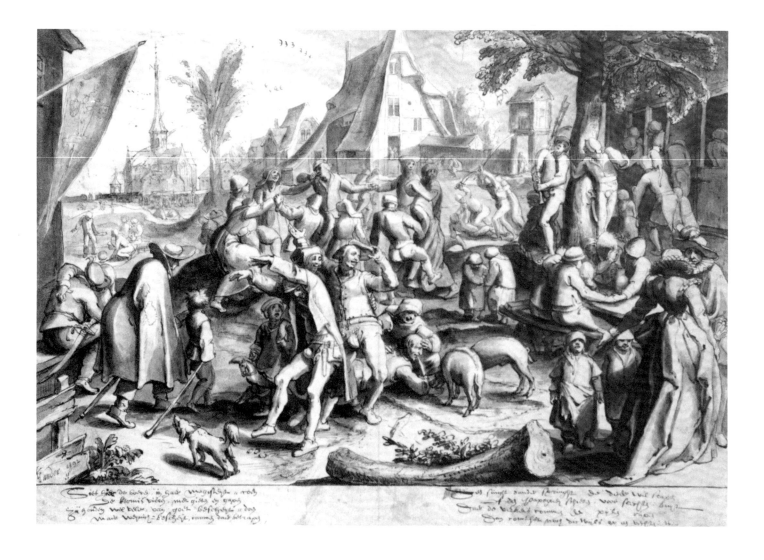

KAREL VAN MANDER

83 *Village Kermis*

Pen, brown ink, and gray wash over traces of black chalk
(verso: *Study of a Head*; pen and brown ink)
284 x 406 (11³⁄₁₆ x 16)
Signed and dated at lower left, in pen and brown ink, *KvM* (in ligature) *ander 1592*
Inscribed by the artist at bottom, in pen and brown ink, *Siet hier de boeren, in haar magesteyt coen/ De kermis vieren, met gieten en gapen/ Zij houden wel vele, van goet bescheyt doen/ maer weinich bescheyt, canmen daer betrapen/ Deen singt dander springht de derde wil slapen/ Of den papegaei schieten, voor slechten : buyt/ Daer de verkens commen de pijlen rapen/ Dan comt het noch dicwijls op een vechten:uit*

Provenance: John, Lord Northwick

Literature: Regteren Altena 1937, 169; Wegner 1967, 206; Alpers 1975-1976, 122-124; Miedema 1977, 212

Exhibitions: The Hague 1952, no. 55; Rotterdam 1976-1977, no. 87, pl. 21

Collection I.Q. van Regteren Altena Heirs, Amsterdam

Juxtaposition of Van Mander's *Diana and Actaeon* (cat. 82) with his *Village Kermis* and other drawings of low-life scenes (fig. 2, and cat. 82, fig. 1) demonstrates that he, like Goltzius, simultaneously explored widely divergent categories of subject matter and modes of representation. While the mythological theme of *Diana and Actaeon* demanded a poetic landscape and graceful, Italianate nudes, the low-life subjects called for boorish Bruegelian rustics and a realistic Netherlandish village setting.

Village Kermis, dated 1592, served as the model for an engraving of 1593 by Claes Jansz. Clock (fig. 1).[1] The drawing is reproduced in reverse in the print, which Clock entitled *Der Bouwren Kermis*.

Kermis, a medieval celebration that honored a local patron saint or commemorated the foundation of a church, became increasingly secularized in the later

sixteenth century, especially in Protestant Holland. The pious processions that figured prominently in Bruegel's *Kermis at Hoboken* (cat. 28) and in a print of the same date after Pieter van der Borcht[2] all but disappeared from the works of Van Mander (cat. 82, fig. 1), Jacques Savery (cat. 100, fig. 2), and David Vinckboons (cat. 118), yielding to the exclusive depiction of the various amusements associated with the holiday. In the present drawing, the celebrants drink, dance, embrace, vomit, brawl, visit hawkers' stalls, and play traditional games. The banner identifies the building at the left as the headquarters of a civic guard company under the patronage of Saint Sebastian.[3]

The verses Van Mander inscribed beneath this study and those appended to contemporary engravings of kermis scenes provide the only direct verbal clues to the interpretation of these images. Almost without exception, the texts

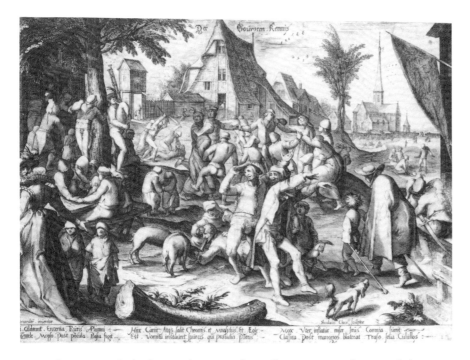

Fig. 1. Claes Jansz. Clock after Karel van Mander, *Village Kermis*, Rijksprentenkabinet, Amsterdam

Fig. 2. Karel van Mander, *Drinkers and Piper*, Graphische Sammlung Albertina, Vienna
(Fonds Albertina)

condemn the behavior of the festive peasants as foolish, intemperate, and self-destructive.[4] For example, the etching of 1559, after Pieter van der Borcht, is accompanied by the lines, "The drunkards delight in such feasts,/Quarreling and brawling and getting drunk as beasts, . . ."[5] An engraving of c. 1603 after a Vinckboons *Kermis* includes the following inscription: "See these peasant folk, see these minions of Bacchus./ One eats, drinks, and fills to the brim, the other/ Vomits on the ground. One sings and dances lustily, the other yells and wants to fight,/ Meanwhile health and money are ebbing away."[6] If less harshly derisive, the lines written beneath Van Mander's drawing also sound a critical note: "See here the peasants in their bold majesty/ Celebrating the kermis with guzzling and gaping/ They think they do much that is wise/ But one can detect little wisdom here/ The one sings, the other jumps, the third wants to sleep/ Or shoot the parrot, for a lousy prize/ There the pigs come to gather up the arrows/ Then it often ends in a brawl." The parrot was the target in the traditional marksmanship contest that often took place during a kermis celebration. Van Mander's reference to the pigs gathering up the arrows is perhaps an ironic comment on the prowess of the drunken sharpshooter

whose vomit provides a meal for the pigs.[7]

The elegant bourgeois woman in the right foreground of the drawing presumably addresses these words to her male companion, stretching out her arm to present the spectacle to him as she speaks. Her gesture, her speech, and their fashionable costumes express their social and moral distance from the rowdy celebration. Although Alpers interprets this scene and the appended verses as merely describing "what peasants will do," without ridiculing or reproving their conduct,[8] Van Mander's work and his poem certainly satirize the bumptious antics, the gross overindulgence in drink, the violence, and the dissipation of the peasants' meager resources. A vivid reminder of the work's admonitory character is the prominence of the two pigs. Foraging swine grace numerous sixteenth- and seventeenth-century scenes of debauchery, and Van Mander's contemporaries would have instantly recognized this earthy image as an allusion to the deadly sin of gluttony.[9]

To be sure, there is a humorous dimension to this and other low-life works that embody a moral warning. We might say of Van Mander's figures what he wrote of Bruegel's, namely, that they comically and naturally convey the peasants' rustic, uncouth bearing in walking, dancing, and

standing.[10] In addition, *Village Kermis* can be likened to a more explicitly humorous design by Van Mander from a series that pillories various human foibles (fig. 2). Showing two drinkers and a piper in a tavern yard, the drawing is illuminated by ironic verses in Van Mander's hand that poke fun at the boors' immoderate attachment to drink: "A head on an idle belly can't comprehend joy, . . ./ The bag must be full before the pipe will sound."[11] Here, as in *Village Kermis*, the admonishment to avoid the evils of inebriation is no less effective for its satirical presentation. WWR

1. Clock's engraving *Der Bouwren Kermis* is Hollstein 11. Van Mander's Dutch verses are replaced in the print by a Latin poem composed by Franco Estius: "See how the children of the country celebrate. After the drinking, Thymele gives one kiss after another to Mopsus, Chromis and Mnasylus and Aegle dance and sing, and the vomit of many celebrants is a feast for the pigs. Soon one will play the bagpipe. The wretched Irus gets ready for a brawl. Traso, having emptied many a jug, repeatedly trumpets the horrible sound of the horn he heard in battle." There is a copy of Clock's engraving by Claes van Breen, Hollstein 60.
2. Pieter van der Borcht IV, Hollstein 467, dated 1559.
3. Giltay in Rotterdam 1976-1977, no. 87. The image of the saint on the banner is easily legible in the print (fig. 1).
4. Miedema 1977, 209-214.
5. See n. 2, and Miedema 1977, 210. See also Moxey 1981-1982, 121-122, fig. 12.
6. Miedema 1977, 212.
7. Giltay in Rotterdam 1976-1977, no. 87. See also

the Latin poem inscribed beneath Clock's engraving (fig. 1), translated in n. 1.

8. Alpers 1975-1976, 124.

9. Renger 1970, 72-73. See also Jan Swart, *Gluttony*, cat. 111.

10. Miedema 1977, 210. Van Mander writes that Bruegel often disguised himself and visited kermises and peasant weddings, taking pleasure in observing the habits of the peasants in drinking, dancing, jumping, and other comical situations ("kodden"), "welke dingen hy dan seer cluchtigh en aerdigh wist met den verwen nae te bootsen . . . en dat Boerigh dom wesen seer natuerlijck aen te wijsen in dansen, gaen, en staen, of ander actien." Miedema points out that Van Mander probably adapted an anecdote told by Lomazzo about Leonardo to underscore the skill and expressiveness with which Bruegel depicted peasant life.

11. Van Mander's *Drinkers and Piper* (fig. 2) is in the Graphische Sammlung Albertina, Vienna, inv. no. 8012, Benesch 1928, no. 362.

Cornelis Massys

1505/1508–c.1557

Cornelis Massys was born around 1505/ 1508 in Antwerp. He was the son of the famous artist Quentin Massys and his first wife, Alyt Tuylt. Cornelis studied with his father and, in 1531, along with his brother, Jan, became a master in the Guild of Saint Luke, Antwerp. Cornelis died sometime after 1557, the year of his last known signed and dated work, a painting of the Destruction of Sodom, *(sale, Countess Ida Roland Coudenhove-Kalergi and others, Fischer, Lucerne, 17 November 1951, no. 2642).*

Massys continued the landscape tradition established by Joachim Patinir. His Weltlandschaft *type is populated, as with the previous generation of Patinir and Matthijs Cock, with mountains, woods, rivers, buildings, people, and animals. However, contrary to earlier practice, Cornelis often concentrated on the rendering of the landscape and eliminated the historical content. In this way, Massys took a major step in the direction of creating pure landscape. The transitions from plane to plane are still abrupt and difficult to read and the various parts of the landscape are not unified but separated by clear boundaries consisting of alternating light and dark areas. These landscapes, although filled with realistic details, are mannered in the unclear construction of space and the separation of the parts. Cornelis Massys' characteristic short, scratchy penstrokes, combined with the exposed paper, beautifully suggest the forms. It is this pen technique, but with a lighter touch, that Pieter Bruegel would use to impart to his late landscape drawings an almost impressionistic effect.*

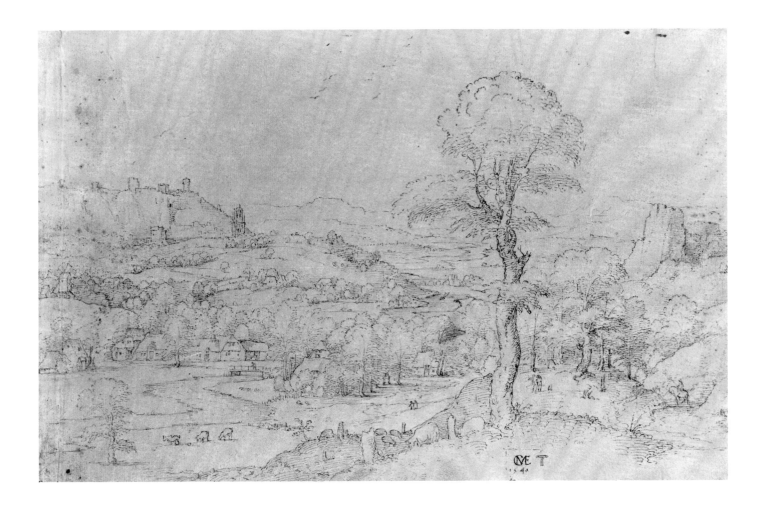

84 Hilly Landscape

Pen and brown ink
199 x 312 (7¹³/₁₆ x 12¼)
Signed at bottom right center, *CME T 1540*;
the *T* is in a lighter ink and was added later by
another hand

Provenance: Marquis de Valori (Lugt 2500); De
Grez, Brussels; presented to the museum in
1912 by the latter's widow

Literature: Brussels 1913, no. 2464; Benesch
1928, 11; Van Puyvelde and Goldschmidt
1936, no. 1; De Tolnay 1943, 133, no. 166; De-
len 1944, 64-65; De Tolnay 1952, 55; Hooge-
werff 1954, 39; Białostocki 1956, 46; Zwollo
1965, 45, 46, 53, 57, 62; Franz 1965, 22, 23;
Franz 1969, 93; Dunbar 1972, 72; Friedländer,
ENP, 13 (1975): 21; Van der Stock 1983, 96-98;
Brussels 1985, 17, 18

Exhibitions: Brussels 1926, no. 173; Rotterdam
1948-1949, no. 52; Brussels 1949, no. 39; Rot-
terdam 1954-1955, no. 1; Antwerp 1956, no.
595; Brussels 1961-1962, no. 76; Brussels 1963,
no. 297, fig. 271; Prague 1966, no. 17; Brussels
1967, no. 31; Brussels 1967-1968, no. 317; Ge-
neva 1969-1970, no. 31; Berlin 1975, no. 173;
Ottawa 1977, no. 16; Atlanta 1980, no. 20

Musées Royaux des Beaux-Arts de Belgique,
Brussels, inv. no. De Grez 2464

Cornelis Massys' landscape, divided into
separate parts, continues in the tradition
of Joachim Patinir (cat. 93), but without
the dramatic geological rock formations.
Massys' vistas encompass a larger area
and the sense of *Weltlandschaft* is pres-
ent here, and will later become important
for Pieter Bruegel.

In this Brussels sheet, it is still not fea-
sible to move logically from plane to
plane. The foreground is elevated and this
compositional arrangement, following
Albrecht Dürer's example, makes it pos-
sible to enjoy the distant view.[1] However,
Massys' horizon line is proportionately
higher, and the tall mountains on the left
block off the view of the horizon. Pieter
Bruegel continued this type of composi-
tion in his "World Landscapes," but he
suggested a sense of space beyond the
mountains through his less precise and
more atmospheric use of line in rendering
the mountains. Massys is also important
for Bruegel in his use of short pen strokes
that simply suggest the shapes of the
trees and the houses. Although Bruegel

used this technique later, his touch is
lighter, more atmospheric, and the ink
blends more with the paper to create an
"impressionistic" array of forms.

Massys' sharply drawn lines, with their
quickly sketched-in quality, the illogical
space, and his new and grander vision of
the world, are all found in his 1540 *Land-
scape* (Hermitage, Leningrad, inv. no.
15297).[2] However, they are less freely
drawn in the 1541 *Landscape* (Staatliche
Museen, Kupferstichkabinett, Berlin, inv.
no. KdZ 6527).[3]

The Brussels sheet is neither a design
for a painting nor for an engraving and
must be seen as an independent work.[4]
The monogram, *CME*, is identical with
that found on eight prints executed by
Massys dating from the years 1539-1544.[5]
JRJ

1. Berlin 1975, 131.
2. Zwolle 1965, fig. 4.
3. Zwolle 1965, fig. 5.
4. Zwolle 1965, 49.
5. Van den Stock in Brussels 1985, 16, 17.

Master of the Good Samaritan

active mid-16th century

This is the name given to the only work-shop assistant, or collaborator, of Jan van Scorel, apart from Maerten van Heems-kerck and Antonis Mor, whose work has been isolated from the production of the workshop. Among the paintings given to this hand are The Good Samaritan in the Rijksmuseum, Amsterdam, dated 1537, David and Goliath, dated 1538, in the Rheinisches Landesmuseum, Bonn, which is a variant of Scorel's painting of the same subject in Dresden, and the

Portrait of David Jorisz. in the Kunstmu-seum, Basel. This hand has sometimes been identified as Cornelis Buys II, but this hypothesis is contradicted by docu-mentary evidence. Two drawings have recently been attributed to this hand. They show the same tendency toward decorative contour and a particularized treatment of chiaroscuro effects. In their subjects and style, these drawings con-firm that the painter's association with Scorel occurred in the years around 1540.

85 The Sacrifice of Isaac

Pen and black-brown ink with gray wash; laid down
215 x 298 (8½ x 11¾)
Provenance: Königlich Bayerische Graphische Sammlung, by 1804 (Lugt 2723)

Literature: Baldass 1937a, 56-57; Hoogewerff, NNS, 4: 208-210; Wegner 1973, 26-27; Faries 1975, 171-175, 219; Boon 1978, 149

Exhibitions: Utrecht 1955, no. 114 (as circle of Scorel); Utrecht 1977, no. 43 (as the Master of the Good Samaritan)

Staatliche Graphische Sammlung, Munich, inv. no. 6848

Fig. 1. Master of the Good Samaritan, *The Good Samaritan*, Rijksmuseum, Amsterdam

Fig. 2. Master of the Good Samaritan, *The Stoning of Saint Stephen*, Rijksprentenkabinet, Amsterdam

In its reliance on decorative, almost frilly contours, this drawing represents a distinctive variation on the style of Jan van Scorel's pen and wash drawings. While it has generally been attributed to Scorel's workshop, Molly Faries' recent proposal to attribute it and one other drawing to the painter of the *Good Samaritan* in the Rijksmuseum (fig. 1) is persuasive.[1]

J.G. van Gelder attributes the Amsterdam *Good Samaritan*, dated 1537, and the *David and Goliath* in Bonn of the following year to the same hand and proposes that this was Cornelis Buys II (d. 1546).[2] Hoogewerff adds several paintings and the drawing of *Joseph Interpreting his Dreams* in Budapest to this group, but names the painter after a monogrammed *Adoration of the Magi* in Valenciennes that appears not to be by his hand.[3] The discovery that the younger Cornelis Buys was working for the Abbey of Egmont as early as 1524 and 1528 eliminated the possibility that the anonymous master was identical with this artist.[4] In connection with her study of underdrawings in the Scorel atelier, Molly Faries is more restrictive than Hoogewerff in the paintings she gives to this artist, but points out correspondences between the Munich drawing and the *Stoning of Saint Stephen* in the Rijksprentenkabinet (fig. 2) and the underdrawing in the Amsterdam and Bonn paintings.[5] These include the treatment of light and shade as distinct areas, as well as morphological features, such as the disproportionately small hands and the treatment of the trees. In comparison to Scorel's own pen and wash composi-

tional studies, especially the Lugt version of the *Stoning of Saint Stephen*, she notes both the absence of Scorel's long curving contour and an avoidance of intersecting contour lines in the Munich and Amsterdam drawings.[6] Indeed, in the *Sacrifice of Isaac*, the reliance on an interrupted contour line with almost no intersection creates a remarkable decorative mosaic, accentuated by the discrete areas of wash.

The works of the Master of the Good Samaritan derive from Scorel, in composition as well as in style, and the Munich *Sacrifice of Isaac* is probably related to one of the two treatments of the subject known to have been commissioned from Scorel, both now lost. Van Mander reports that he painted two sets of wings for a sculpted altarpiece decorating the high altar of the Church of Saint Mary in Utrecht, the better of the two sets being a Sacrifice of Isaac extending across two wings and including a very beautiful landscape.[7] As Faries suggests, this may have been horizontal in format.[8] The 1550 contract for the altarpiece on the high altar of the New Church, Delft, calls for a Sacrifice of Isaac above the altarpiece.[9] Faries thinks it more likely that the Munich drawing is related to the Utrecht commission. She points out that, according to Van Mander, Scorel had this project of the Sacrifice in hand for years, and notes a record of payment from the chapter of Saint Mary's to his servant in 1545/1546 in connection with the painting of two new panels for this altarpiece.[10] However, the nature of the servant's role in the actual painting of the

altarpiece is unclear. Moreover, the function of the Munich drawing in relation to a major commission of Scorel's is problematic. Scorel may have left to this accomplished assistant a particular stage of the preparatory process, perhaps the mapping out of areas of dark and light, or the assistant may have made an individual transcription of a composition by Scorel. In any case, the drawing probably attests to the efficient variations on a theme that was a hallmark of the production of Scorel and his associates. Further, it reflects an important composition in which the prominent figures serve as a type for Christ's sacrifice and an excuse for an extensive landscape background. MW

1. Faries 1975, 171-174, notes that the organizers of the 1955 Utrecht exhibition came to the same conclusion, which was, however, not enunciated in the catalogue. See also Baldass 1937a, 56-57.
2. Van Gelder 1939, 17; see also Utrecht 1955, nos. 55 and 75, with the Amsterdam painting listed under Scorel, though compared in handling to Buys II.
3. Hoogewerff, *NNS*, 4: 214-230, attributes another group of paintings to Buys II and associates the Munich drawing with the latter group.
4. Bruyn 1966, 158-159, nos. 44 and 45, 162, no. 72, and 197-198, notes that there is no evidence that Buys worked outside of Alkmaar after his probable schooling in Amsterdam.
5. Faries 1975, 173 and 217-219. Of the paintings grouped together by Hoogewerff she excludes the *Adoration* in Valenciennes, the *Baptism* from the Hevesy collection, and *Gathering of the Manna* triptych in Utrecht (Hoogewerff, *NNS*, 4: figs. 95, 97, and 98). She omits the Budapest drawing from consideration. Boon 1978, 148-149, under no. 410, attributes the Amsterdam and Munich drawings and the *Martyrdom of Saint Ursula and the 11,000 Virgins*, also in Amsterdam, to a single hand, without associating them with the paintings.

6. Fondation Custodia, Institut Néerlandais, inv. no. 4612, pen and brown ink, gray wash, 298 x 200mm; Florence 1980-1981, no. 127, pl. 25, and Faries 1975, 142-146, fig. 33, suggest that the Lugt drawing is a contract sketch for the Marchiennes polyptych.

7. Van Mander, Schilder-boek, 1: 274-277.

8. Faries 1975, 174-175.

9. Van Bleyswijck 1667, 247-248; see also Utrecht 1977, no. 6.

10. Van Mander states, "D'ander twee deuren [i.e., the better wings with the Sacrifice of Isaac] bleven eenen tijdt van Jaren onder handen," Schilder-boek, 1: 274 and 276. For these records of payments for the high altar, see Faries 1970, 21, no. 47 and Faries 1975, 175. Jacob Nobel received 12 Rhenish guilders for gilding several panels, and a servant of Scorel received 6 Rhenish guilders for unspecified services in connection with the painting of these panels in the next document cited by Faries 1970, 21, no. 48; also for 1545/1546, Scorel is paid 12 guilders for paints applied to the high altar. This work was apparently finished by 1549, since Van Mander states that a version painted in watercolor on linen as a substitute for the unfinished painting was purchased by Philip II of Spain in that year.

Master of the Liechtenstein Adoration

active c. 1550

Not only does the identity of this artist present us with a mystery, but also his place of work. It has been suggested that he was South German because of certain compositional connections with Georg Pencz, Herman tom Ring, and Virgil Solis, and scenery that recalls the Danube School, or that he was one of the many Netherlanders working in Nuremberg during the second half of the sixteenth century, or that he was the young Jan van Scorel and that he was from the southern Netherlands. Of all these possibilities, it is most likely that the Master of the Liechtenstein Adoration, who received his name from a group of eight drawings formerly in the collection of the Prince of Liechtenstein, Vaduz, came from Antwerp or Brussels. His drawing technique relies upon highly decorative and contrasting light effects combined with fantastic figures and architectural forms placed on prepared colored paper. This style suggests a contact with Pieter Coecke van Aelst and Cornelis Floris. Because of this probable dependence upon those artists and the fact that his Adoration of the Shepherds *(Rijksprentenkabinet, Amsterdam) is dated 1549 and the* Judith and Holofernes *(private collection, Munich) is inscribed 1550, one can assume that the master worked around the middle of the century in Antwerp or Brussels.*

86 *The Judgment of Solomon*

Pen, black ink, and gray wash with heightening, on dark rose prepared paper
216 x 318 (8½ x 12½)

Provenance: Liechtenstein Collection, Vaduz, prior to 1950; Mr. and Mrs. Julius Held, New York

Literature: Winkler 1963, 35, 37; Wegner 1970, 265; Florence 1980-1981, 29

Exhibitions: Wesleyan University 1957, no. 41; Binghamton 1970, no. 88

National Gallery of Art, Washington. Julius S. Held Collection, Ailsa Mellon Bruce Fund, inv. no. 1984.3.17

This drawing from c. 1550 is a splendid example of northern mannerism, with its decorative play of light and shadow, exaggerated and overly dramatic poses frozen in space, fantastic juxtapositions of antique architectural vocabulary, and illogical space. The Master of the Liechtenstein Adoration's combination of techniques produced a variety of tonal variations that suggest a connection with chiaroscuro woodcuts. The translation of this medium into drawing began with Pieter Coecke van Aelst's 1529 *Allegorical Genre Scene* (cat. 35), where the figures are also conceived by variations in tone.

The Master of the Liechtenstein Adoration placed *The Judgment of Solomon* in a completely imaginative architectural

setting of strange combinations of an-
tique elements. This manner of using an-
tiquity was also often used in the Nether-
lands by Pieter Coecke and his contem-
poraries, such as Dirk Vellert. However,
the Master of the Liechtenstein Adora-
tion placed all of his participants within a
relatively complete structure when com-
pared with the unfinished ruins of his
forerunners. This mysterious artist also
used Italian motifs that were known in
the Netherlands before 1540. For exam-
ple, the position of the kneeling mother
in the left foreground is a close variation
on the man in the same location in Ra-
phael's tapestry cartoon for the *Death of
Ananias* (now in the Victoria and Albert
Museum, London, but in Brussels by late
1516 or early 1517).[1] Further, the terms
to the right and left of the throne are sim-
ilar to those in Agostino Veneziano's
woodcuts of 1536.[2] These were copied be-

tween 1540 and 1544 by the Antwerp en-
graver Cornelis Bos.[3] However, this type
of term was present earlier in the frontis-
piece of Pieter Coecke's 1539 translation
of Serlio's fourth book from his *Architet-
tura et Prospettiva*.[4] Bos certainly must
have known this kind of term through
the Serlio that he had purchased in 1542
as part of a large consignment for resale
in his Antwerp shop.[5]

Because of the many similarities with
Pieter Coecke in the use of chiaroscuro to
build up his figures, in the strange fu-
sions and distortions of ancient architec-
tural details and in the appearance of ex-
otic Turkish-like headpieces in this and
other drawings by the Master of the Liech-
tenstein Adoration,[6] it is likely that this
master continued to develop Pieter
Coecke's mannerist style[7] around 1550 in
either Brussels or Antwerp.[8] JRJ

1. For Pieter Coecke's connection with the Raphael
tapestries and their importance for the Netherlands,
see Marlier 1966, 309.
2. *The Illustrated Bartsch*, 26: nos. 301, 303.
3. For details, see Schelé 1965, 147, no. 80, pl. 27.
4. For an illustration see Marlier 1966, fig. 335.
5. Schelé 1965, 14, 15. Unfortunately, none of the ar-
chitectural details in the Washington drawing, other
than the term, can be found in Serlio's book.
6. For the Turkish connection with Pieter Coecke,
see Wegner 1970, 264.
7. Winkler 1963, 37.
8. For his possible German origins, see Benesch
1965, 48.

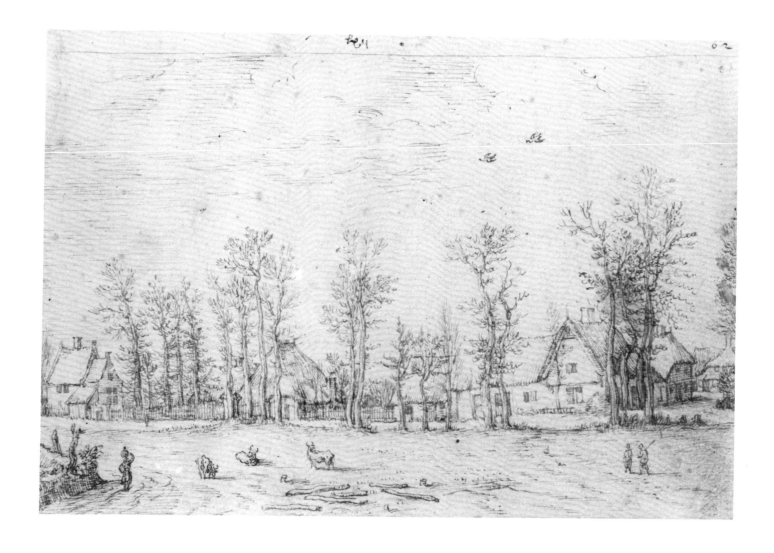

Master of the Small Landscapes

The Master of the Small Landscapes takes his name from two remarkable series of prints published in 1559 and 1561 by Hieronymus Cock. Although the forty-four etchings that make up the two suites have been attributed to Jan or Lucas Duetecum (Vienna 1967-1968, 44), the identity of their designer remains mysterious. He was, after Bruegel, the most original Netherlandish landscapist of the mid-sixteenth century. All his works represent straightforward views of—to quote the title of the earlier print series—"various houses, farms, fields, roads, and such like, arrayed with all sorts of animals. Everything drawn from life, mostly around Antwerp." Except for a couple of isolated paintings and a lost Bruegel drawing of c. 1555, there are no precedents in Netherlandish art for either the mundane, local subjects of

these scenes or their unpretentious, realistic style (Haverkamp-Begemann 1979, 23-24; Berlin 1975, no. 36).

Uncertainty about the master's identity has prevailed since the early seventeenth century: the title-page of a new edition of the Small Landscapes issued in 1601 names the engraver Cornelis Cort as inventor, while Claes Jansz. Visscher designates Pieter Bruegel in his set of etched copies published in 1612. Twentieth-century art historians have proposed Cort, Bruegel, Hans Bol, Cornelis van Dalem, and Hieronymus Cock as the designer of the series (Berlin 1975, 139; Mielke 1986, 84-88).

The only plausible nomination was advanced by Egbert Haverkamp-Begemann, who offered the name of the little-known Joos van Liere. Van Mander writes that Van Liere was a very good

landscape painter and that he also made designs for tapestries. Born in Brussels and still documented there in 1572, Van Liere emigrated to the Protestant settlement at Frankenthal, near Heidelberg, in 1574. He returned to the Netherlands to preach in 1580, and died near Antwerp in 1583. From Van Mander's vita we may conclude that Van Liere gave up painting in 1574, and that his works were already rare c. 1600 (Haverkamp-Begemann 1979, 22).

THE MASTER OF THE SMALL LANDSCAPES

87 *Village behind Trees*

Pen in two brown inks; incised for transfer
134 x 197 (5 5/16 x 7 3/4)
Inscribed at top center, in pen and brown ink,
lxii; at upper right, *62*. Inscribed on verso, in
red ink, *lot 367*

Provenance: Sir Bruce Ingram (Lugt 1405a)

Literature: Riggs 1971, 252, no. R-16a; Mielke
in Berlin 1975, 140, no. 1; Haverkamp-Bege-
mann 1979, 25, App. no. 1; Liess 1979-1980,
13, no. A1, 28-34; Liess 1981, 42-43

Lent by the Syndics of the Fitzwilliam Mu-
seum, Cambridge, inv. no. PD55-1963

Village behind Trees served as the model
for an etching in the first series of Small
Landscapes published by Cock in 1559
(fig. 1; see Biography).[1] Close examina-
tion of the drawing reveals the participa-
tion of two hands. The initial sketch
showed only the trees and the line of
houses. As in Bruegel's nature studies
(cats. 24 and 26), the foreground was left
blank. A second draftsman, presumably
in Cock's workshop, added the sky, the
birds, the staffage, and the foreground
clearing, to make the casual sketch suit-
able for publication in a print. Most of
the drawings used for etchings in the se-
ries underwent similar reworking.[2] The
printmaker introduced further altera-
tions, adding the bank in the left corner
and the clump of grasses to the right of it,
reversing the direction of the light, and
strengthening the shadows.[3]

The original passages preserve the
draftsman's delicate touch and the imme-
diacy of his vision. His pen technique re-
calls that of Bruegel's landscape draw-
ings, especially in the lively rendering of
the trees and the sensitive parallel
strokes that evoke the textures of the
thatched roofs.[4] Before the addition of the
sky and the foreground, the impression of
a direct transcription from nature must
have been even more striking.

We know twelve drawings that were
etched in the two series.[5] Ten or eleven
more studies, although not used for
prints, can be associated with this group.[6]
Reinhard Liess has proposed recently that
the original sketches, that is, before re-
working, are by different artists. Liess
compares two of the studies, which rep-
resent the same site, and notes telling
differences in their execution and quality.
His discovery leads him to assign some
drawings related to the prints to a more
talented draftsman and the rest to a less
gifted imitator. The sheet exhibited ex-
emplifies the hand of the superior
master.[7]

Haverkamp-Begemann proposed to
identify the Master of the Small Land-

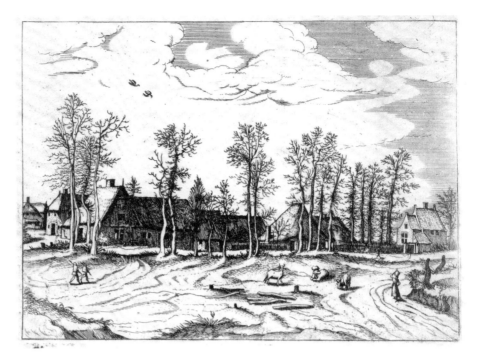

Fig. 1. Jan or Lucas Duetecum (?) after the Master of the Small Landscapes, *Village behind Trees*, National Gallery of Art, Washington, Rosenwald Collection

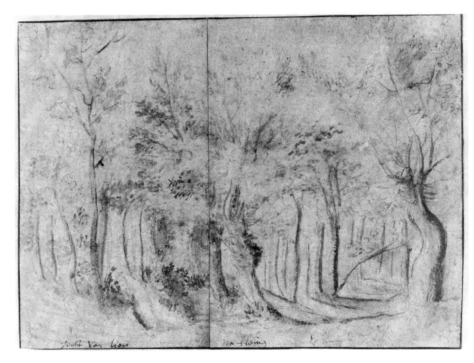

Fig. 2. Joos van Liere, *Forest Landscape*, Staatliche Kunstsammlungen Dresden, Kupferstich-Kabinett

scapes on the basis of the inscription
Joost van Lier . . . on a drawing that, al-
though not reproduced in a print, belongs
to the oeuvre of Liess' prime draftsman.
The secure work of Joos van Liere (see Bi-
ography) comprises a handful of draw-
ings, probably made in the early 1570s,
and a few prints after his designs. While
one of the prints to some extent recalls

the sober realism of the *Small Land-
scapes*, Van Liere's drawings share no
common stylistic ground with them. For
example, his brush study of a forest ex-
hibits not only a different style and
choice of media, but a poetic sensibility
quite alien to the spirit of the print series
(fig. 2). If Van Liere invented the *Small
Landscapes*, we would have to accept

that his art, like Hans Bol's (cat. 15), changed radically over the next decade.[8]

The *Small Landscapes* represent the most advanced expression of the realism that also characterized the drawings of Bruegel and Bol in the 1550s (cats. 24-27, 14). For the rest of the century, this approach was cultivated only by relatively minor figures like Jacob Grimmer. Interest in the *Small Landscapes* revived in Holland after 1600, when the prints exercised a decisive influence on Claes Jansz. Visscher, Esaias van de Velde, and other pioneers of Dutch realism.[9] WWR

1. The drawing is reproduced in reverse in the etching, Bastelaer 1908, no. 20, Liess 1979-1980, no. 12. The series of 1559 comprised fourteen plates; that of 1561; thirty plates; see Liess 1979-1980, pls. I-III for illustrations of all forty-four prints.
2. Liess 1979-1980, 28-29. Mielke, in Berlin 1975, 139-140, first called attention to the reworking of the drawings.
3. Liess 1979-1980, 28-29.
4. Compare the trees in the backgrounds of *Caritas* and *The Kermis at Hoboken* by Bruegel (cats. 29 and 28), as well as in his early landscape drawings, Münz 1961, nos. 3, 4 (cat. 25, fig. 2). See also the illustrations in Liess 1982, pls. 203-205 and 212-214, though he incorrectly concludes from them that Bruegel was the Master of Small Landscapes.
5. See Liess 1979-1980, 13-15, Group A and Group B, where he lists thirteen drawings. His no. A5 was not etched, but was copied in his no. A2, which was. The authorship of A5 is disputed: see Mielke 1986, 85. Liess' B4 has rightly been rejected as a copy; see Mielke in Berlin 1975, 140, and Haverkamp-Begemann 1979, 18 n. 6. The modello for Bastelaer 1908, no. 25; Liess 1979-1980, no. 17, has come to light since the publications of Haverkamp-Begemann and Liess: sale, Amsterdam, Sotheby Mak van Waay, 15 November 1983, lot 249, now in the collection of Ian Woodner.
6. See Liess 1979-1980, 15-16 and 21, Group C and Group E, where he lists nine drawings. His C2 is a copy of a drawing in the collection of Seiden & De Cuevas, Inc., on deposit at the Fogg Art Museum, Harvard University. In my view Liess 1982, 160, errs in continuing to accept his C2 over the Seiden & De Cuevas sheet. Liess' A5, which is not the version etched in the print series, belongs with the sheets in his Group C. A drawing unknown to Liess and Haverkamp-Begemann should be added to this group: C. G. Boerner, Düsseldorf, *Sommerausstellung*, 15 July-8 August 1980, no. 1, repr.
7. Liess 1979-1980, 41, figs. 48, 50. His Group A, 13-14, includes the models for prints that he gives to the superior draftsman, while Group B, 14-15, includes those he ascribes to the imitator. The newly discovered model for Bastelaer 1908, no. 25 (see n. 6) should be added to his Group A.
8. Haverkamp-Begemann 1979, 17-24. On page 23 he argues that the later work of Bol and other artists is as difficult to reconcile with their beginnings as it is to accept the *Small Landscapes* and the secure works of Van Liere as products of the same master's career.
9. On Grimmer, see Franz 1969, 242-248, pls. 341-372. For the influence of the *Small Landscapes* on the early Dutch realists, see Stechow 1966, 16-19.

Jan Harmensz. Muller

1571-1628

The draftsman and engraver Jan Muller was born in Amsterdam, where he spent most of his life. His father and grandfather were book publishers, engravers, and art dealers. Muller probably received his earliest training from his father, and his precocious facility is evident in a drawing dated 1585 that imitates Heemskerck's print modelli. By the late 1580s he had absorbed the late mannerist style of Hendrick Goltzius and Cornelis van Haarlem, whose works he engraved. It is unclear whether his mastery of this style resulted from a period of study in nearby Haarlem or from the exercise of imitating their drawings, such as Cornelis' Tityus (cat. 39), which he is known to have copied. In any case, his drawings from about 1590 employ an elongated figure type and nervous pen line reminiscent of Haarlem artists at the height of Spranger's influence. In the 1590s, Muller engraved the designs of Bartholomeus Spranger and Adriaen de Vries. He may have traveled to Prague to work with these artists, though it is equally possible that they sent their designs to his father's noted publishing house in Amsterdam to be engraved.

About 1594 Muller traveled to Italy where he visited Rome and Naples. By 1602 he was back in Amsterdam working in the family publishing house, the "Vergulde Passer." He remained there for the rest of his career, taking over the firm after his father's death in 1617. In his later drawings, luminous effects, achieved through chalk or wash and white heightening, become more important. His forms become more stable, though he never fully abandoned the late mannerist style.

88 Moses and the Brazen Serpent

Pen and dark brown ink, gray wash, and white body color (oxidized) on paper washed with red chalk
236 x 375 (9 5/16 x 14 3/4)
Inscribed at upper center, *An° 1590*; at lower right, *spranger*; on verso, *M^r Crullier* (?)

Provenance: Ottley; Douce Bequest, 1834

Literature: Parker 1938-1956, 1: 15, no. 34; Reznicek 1961, 166-167, no. 8; Van Thiel 1965, 127, 151; Reznicek 1980, 131, no. 14

Lent by the Visitors of the Ashmolean Museum, Oxford

This incident of the Israelites' rebelliousness, punishment, and forgiveness, as recounted in Numbers 21: 4-9, provided a vehicle for complex, contorted poses beginning with Michelangelo's pendentive from the Sistine ceiling. During the Exodus, the Israelites grumbled to Moses about the rigors of their journey and their diet of manna, whereupon the lord sent serpents to bite and kill them. When the people had repented their rebelliousness, Moses was directed to set a brass serpent on a pole so that those who had been bitten could look at it and be healed. Muller's treatment of the theme is characteristic of Dutch mannerism in the years following the first impact of Spranger's designs. Within an extensive landscape, the central event of the brazen serpent is relegated to the middle distance, while the foreground is filled with athletic figures whose foreshortened poses emphasize the manipulation of the spatial recession.

Fig. 1. Jan Muller, *The Baptism of Christ*, Staatliche Graphische Sammlung, Munich

That the drawing was formerly attributed to Cornelis Cornelisz. van Haarlem[1] demonstrates the young Jan Muller's precocious absorption of the style of the Haarlem mannerists. The attribution to Muller, first made by Van Thiel and reinforced by Reznicek,[2] is fully borne out by

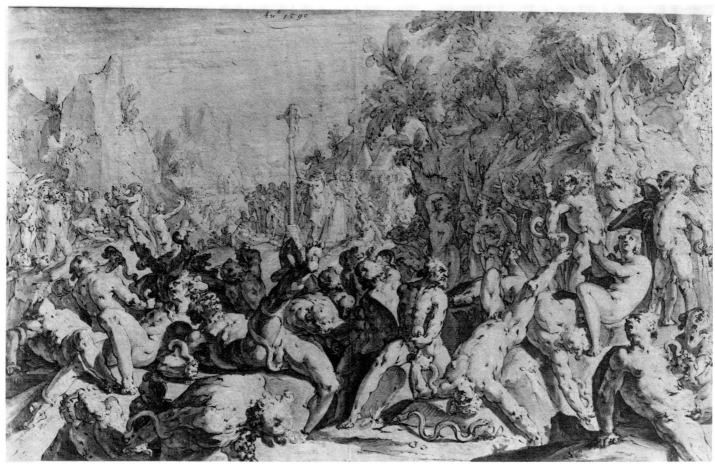

88

a comparison to the drawing in Munich, dated 1590, which was the modello for Muller's engraving of the *Baptism of Christ* (fig. 1).[3] The same nervous flicks of the pen are employed in the Munich drawing, as are the rounded bullet heads. Indeed, these simplified heads thrust

back on stemlike necks are a hallmark of Muller's early work. At the same time, the aggressively foreshortened figures, who seem to struggle against the constraints of the foreground plane, owe a clear debt to Cornelis van Haarlem. Several of Muller's engravings after Cornelis'

designs feature athletic figures breaking through the picture plane, with the *Fortuna* of 1590 (fig. 2) being closest to the scheme of the *Brazen Serpent*.

Individual figures also derive from Cornelis, who was, in the late 1580s, the chief painter in the Haarlem group. Hence the man sprawled on his back to the left of center, whose pose reverses that of the *Ixion* from the *Disgracers*,[4] while the man sprawled headfirst depends on Cornelis' *Tityus* (cat. 39). Whether Muller, who was not yet twenty years old in 1590, absorbed this style through study in Haarlem or through assiduous imitation of the artists whose prints he engraved, is unclear.[5] In any case, the Oxford *Brazen Serpent*, like Muller's copy of Cornelis' *Tityus*,[6] is an important document of the rapid diffusion of the Haarlem style. MW

Fig. 2. Jan Muller after Cornelis van Haarlem, *Fortuna*, Rijksprentenkabinet, Amsterdam

1. Parker 1938-1956, 1:15, no. 34.
2. Van Thiel's opinion is quoted by Reznicek 1961, 166-167.
3. Wegner 1973, 112, no. 800.
4. Strauss 1977, 2:450-451, no. 260.
5. Reznicek 1956, 65-68.
6. For Muller's copy of Cornelis' drawing, see Reznicek 1956, 67-68. The Brussels drawing is illustrated in Reznicek-Buriks 1956, 165-169, fig. 5.

231

Lambert van Noort

c. 1520-1570

A native of Amersfoort, near Utrecht, Van Noort joined the guild of Saint Luke in Antwerp in 1549, becoming a citizen of Antwerp in the following year. Where he received his earliest artistic training is unknown, though he apparently traveled to Italy before settling in Antwerp, since a signed altarpiece of the Assumption *is still in Ferrara. His earliest known dated painting, the* Adoration of the Magi *of 1555 in the Koninklijk Museum voor*

Schone Kunsten, Antwerp, shows connections to this altarpiece, together with the influence of Frans Floris and affinities with the more severe Italianizing work of Pieter Pourbus. Van Noort produced designs and cartoons for windows in the Sint-Janskerk, Gouda, and the high proportion of designs for stained glass among the drawings by him indicates that this was an important part of his activity.

89 *Sheet of Studies*

Red chalk
202 x 270 (7¹⁵⁄₁₆ x 10⁵⁄₈)
Inscribed at center in red chalk, *L.V.N./1553;* above nude at left in brown ink, *23;* at upper right in brown ink, *28.* Inscribed on verso at right center in black ink, *Lambrecht van noort fecit;* at lower left, *Lot 42*

Provenance: Sir Joshua Reynolds (Lugt 2364)

Literature: Müller Hofstede 1967, 119-120; Lugt 1968, 93, under no. 380; Van de Velde 1969, 279; Dacos 1980, 176

Fondation Custodia (Coll. F. Lugt), Institut Néerlandais, Paris, inv. no. 1954

This drawing is exceptional in Van Noort's known oeuvre in that it is a study from life in preparation for a figural composition. The use of the same figure in related poses, the repetition of the leg of the figure on the left, and the specificity of light and musculature all indicate that the studies on the recto were made before a model. The more even hatching and fixed contours of the figure on the verso, together with the way portions of the figures are omitted, suggest that these were copied from another work of art. The only other surviving studies from life by Van Noort, a figure study in the Louvre and a drawing of an elephant in Stockholm occasioned by the arrival of this exotic animal in Antwerp in 1563, are also in red chalk.[1]

The seated man on the right of the Lugt drawing appears, in the dress of a Roman soldier and in reverse, in the foreground of Van Noort's design for the *Annunciation of the Birth of John the Baptist* window in the Sint-Janskerk, Gouda (fig. 1). Though the figure is clothed, the summarily indicated drapery of the drawing is incorporated into the soldier's costume. Van Noort furnished cartoons for several windows in the Sint-Janskerk, whose execution was then left to others. The window with the *Annunciation of the Birth of John the Baptist* was not dedicated until 30 October 1561.[2] The Lugt drawing, a pen and wash drawing in the British Museum setting out the architecture and main figural groups for the window of *Christ among the Doctors*,[3] and the cartoons still in Gouda (fig. 2) indicate that there must have been several stages of preparation for this commission. The time lag between the Lugt drawing and the cartoon for this window, dated 1561, suggests that Van Noort used the drawing as part of a repertory of dramatically posed figures rather than in preparation for this specific composition.

Though very few life studies by Netherlandish artists survive from the sixteenth century, there is evidence that this type of preparation, inspired by Italian practice, was indeed used. Among the drawings by Heemskerck in the Roman albums in Berlin are red chalk studies after antique sculpture and Renaissance paintings, in which the chalk technique is clearly inspired by Italian examples.[4] That Frans Floris made similar studies a decade later during his own sojourn in Italy can be deduced from Van Mander's testimony and from copies by his students in an album formerly belonging to G. Dansaert. These chalk drawings also included figure studies that Floris used in his paintings over a period of years.[5] Jus-

tus Müller Hofstede, who first published the Lugt drawing, argues that the use of chalk studies from life as preparation for figural compositions was common practice among Antwerp artists, in particular during the second half of the sixteenth century.[6] This argument finds support in K.G. Boon's attribution of a variety of preparatory material in two sketchbooks to the Floris follower Bernaert de Rijckere.[7] Whether Van Noort began to make such chalk drawings during his own stay in Italy or whether he was inspired by Floris' example is unclear. However, the Lugt and Louvre drawings must represent a body of studies by Van Noort, which are now lost.
MW

Fig. 1. Lambert van Noort, *Annunciation of the Birth of John the Baptist*, Sint-Janskerk, Gouda

Fig. 2. Lambert van Noort, *Cartoon for the Annunciation of the Birth of John the Baptist*, Sint-Janskerk, Gouda

1. Lugt 1968, 93, no. 380, pl. 40, Nationalmuseum, z 84/1953, inscribed *In anversa Lamberto van Noort/ apres del vivo A° 1563/primo di(e) de october*; see Washington 1985-1986, no. 73.
2. For Van Noort's contribution to the Gouda windows, see Van de Boom 1940, 173, and 180-187, figs. 36-38. The cartoon for the *Annunciation of the Birth of John the Baptist*, is signed and dated 1561 (fig. 2). A drawing of an allegorical subject at Christ Church, Oxford, first attributed to Van Noort by Hans Mielke, also shows Van Noort deriving poses from nude models. In the margin, he sketched nudes corresponding to two of the figures in this composition; see Huvenne 1980, 27-28, and Byam Shaw 1976, no. 1316, pl. 776, as attributed to Pieter Pourbus.
3. Popham 1932, 174, no. 2, pl. LXV.
4. Repro., Hülsen and Egger 1913-1916. Some chalk drawings in these albums seem to derive not only from Michelangelo's frescoes, but also to be indebted to his chalk technique, a supposition that is supported by a red chalk drawing in the Uffizi attributed to Heemskerck after Michelangelo's study for the Libyan Sybil in the Metropolitan Museum; see Steinmann 1901-1905, 601, no. 46, fig. 50.
5. Van Mander, *Schilder-boek*, 1: 300 and 302. For the Dansaert album and the repetition of figures in it, see Van de Velde 1969, 255-256, and Dansaert and Bautier 1911, 319-333.
6. Müller Hofstede 1967, 119-120, and 1973, 237-238.
7. Boon 1977, 109-128, figs. 3, 11, and 12.

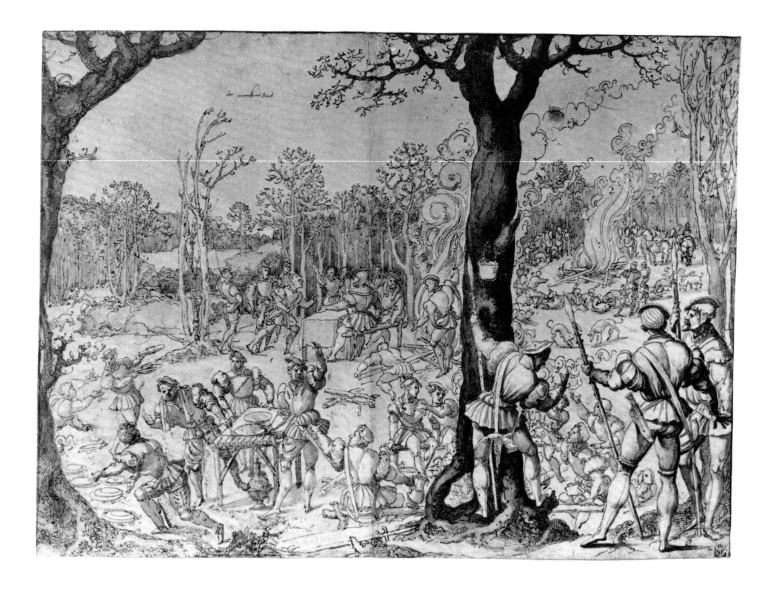

Bernard van Orley

c. 1488-1541

Bernard van Orley was born in Brussels, probably around 1488, and died there on 6 January 1541. Both his father and younger brother were painters, and it is assumed that Bernard was initially taught by his father. In 1518 the artist was appointed painter to the court of Margaret of Austria. He remained in this position until her death in 1530 and continued to work for her successor, Mary of Hungary. It seems unlikely that Van Orley journeyed to Italy, but he was an important "Romanist" whose knowledge of Italian art came from engravings and from direct observation of Raphael's tapestry cartoons for The Acts of the Apostles, *which were in Brussels, where the series was woven, from 1516 onward.*

The earliest dated work is the portrait of Dr. George Zelle *of 1519 (Musées Royaux des Beaux-Arts, Brussels). Possibly commissioned by Margaret of Austria, the* Vertu de Patience *or Job altarpiece of 1521 (Musées Royaux des Beaux-Arts, Brussels) is an important example of Van Orley's dynamic figure style and use of heavily ornamented Italianate architecture. Van Orley's activity as a painter decreased markedly in his later years.*

Van Orley was associated with the art of tapestry throughout most of his career, beginning with the series of c. 1516-1518, The Legend of Notre Dame-du-Sablon *(Musées Royaux d'Art et d'Histoire and Musée Communal, Brussels, and State Hermitage Museum, Leningrad). Almost*

all of his surviving drawings are related to tapestry production. The drawings for the tapestry series The History of Romulus and Remus *(Staatliche Graphische Sammlung, Munich) are monogrammed and dated 1524. Van Orley was also a skilled designer in stained glass, as can be seen in the windows in the Chapel of the Holy Sacrament in Saint Gudule, Brussels, dated between 1537 and 1540. Adept in several media, the head of a large workshop, a court artist whose clients also included the bourgeoisie, Bernard van Orley was a major figure in the creation and dissemination of a High Renaissance style in the Netherlands.*

234

BERNARD VAN ORLEY

90 *November*

Pen and brown ink, brown, blue, light green, and red washes, traces of black chalk on light brown paper; laid down
376 x 577 (14¾ x 22⅝)

Inscribed at upper left, *An mennekens dans*

Provenance: Esterházy collection (Lugt 1965, 1966)

Literature: Lugt 1968, 56, no. 186; Gerszi 1971, 74-75, no. 215; Berlin 1975, 153-154, no. 210; Gerszi 1976, no. 2; Balis 1979/1980, 15-16; Farmer 1981, 287-293; Ainsworth 1982a, 79-80; Schneebalg-Perelman 1982, 167, no. 4

Exhibitions: Budapest 1932, no. 11; Budapest 1967, no. 12; Vienna 1967, no. 69; Washington 1985, no. 64

Szépmüvészeti Múzeum, Budapest, inv. no. 1365

This is a preparatory drawing for a tapestry from one of the great monumental tapestry series of the Renaissance, *The Hunts of Maximilian*, which today hangs in the Louvre. Both tapestries and cartoons are first mentioned by Van Mander in his biography of Bernard van Orley.[1] The series consists of twelve tapestries depicting scenes of hunting, set in the Fôret de Soignes, a large preserve near Brussels. Each tapestry corresponds to a month of the year and the governing sign of the zodiac is found in a cartouche at the top of the border. The commission probably originated with the Emperor Charles V and was possibly intended as remembrance of Charles' grandfather, Maximilian I, who was passionately fond of hunting.[2] The series is usually dated around or after 1525.[3] The tapestries bear the mark of Brussels and hence were woven after 1528.[4]

The Budapest drawing is for the month of November, which inaugurates the season of wild boar hunting. The setting has been identified as the woods of Héron, between Boitsfort and Trois-Fontaine.[5] A meal, possibly breakfast, is underway and groups of men and dogs gather around fires to ward off the autumn chill.

There exist two sets of drawings that are preliminary to *The Hunt of Maximilian*: a complete set of twelve drawings in the Louvre and what appears to be an incomplete set that, in addition to the November sheet, includes drawings for March and September (Prentenkabinet, Rijksuniversiteit, Leiden), June (Kupferstichkabinett, Staatliche Museen, Berlin) and December (Kongelige Kobberstiksamling, Statens Museum, Copenhagen).[6] The unusual occurrence of two nearly identical sets of drawings has caused numerous discussions of the attribution, most based on the assumption that only

Fig. 1. Bernard van Orley, *November*, Musée du Louvre, Cabinet des Dessins, Paris (Cliché des Musées Nationaux)

Fig. 2. Brussels, c. 1528/1540, *November*, Musée du Louvre, Paris (Cliché des Musées Nationaux)

one group can be autograph and that the other must be a copy.[7] However, Ainsworth, Farmer, and Anzelewsky concluded that both sets are from the hand of Van Orley, but represent different preparatory stages.[8] The Budapest/Leiden series, which is more spontaneous and slightly less detailed, probably belongs to the initial design stage.[9] The Louvre drawings would then represent the next, more fin-

235

ished stage of small cartoons (*petits patrons*), which in turn would have been followed by the full-scale cartoons (*patrons*) given to the weaver. It is possible that a royal commission would have required additional stages, and Ainsworth suggests that the tighter, more careful Louvre drawings might have been presented to the patron for approval.[10]

There are only slight differences between the Budapest and Louvre drawings (fig. 1). In the tapestry (fig. 2) the vantage point is lower than in the Budapest drawing and the space more developed and, especially in the two groups at the left, there are some differences in facial types and gestures.

The Budapest drawing is a superb example of Bernard van Orley's mature style and, in its breadth and vigor of execution, may be compared with his signature pieces, the 1524 drawings of *The History of Romulus and Remus* in Munich. Although Van Orley assimilated the harmonious figural groupings and dramatic, somewhat rhetorical gestures of Italian art, his conception of the human figure is essentially decorative and not based on the observation of human anatomy. It is in his working procedures that Van Orley is closest to the Italians.[11] JOH

1. Van Mander, *Schilder-boek*, 1: 104-105. For a general discussion of the tapestries see Alfassa 1920 and d'Hulst 1960, 171-182; the tapestries are reproduced in color in Schneebalg-Perelman 1982.

2. In the December tapestry, Charles' device of the columns of Hercules and a banderole is found on a dog collar and, although there is no real consensus on the identification of royal personages, the central rider in the scene is often thought to be Maximilian, who died in 1519. Balis 1979/1980, 18-19, believes that the initiative for the series came not from Charles but from Erard de la Marck, prince-bishop of Liège. It is more likely that de la Marck owned a second edition of the tapestries; see Steppe and Delmarcel 1974, 40-42.

3. A *terminus post quem* of sorts is provided by the stages of construction of the ducal palace in Brussels, which date after 1521 and between 1525 and 1533; see Alfassa 1920, 137-138.

4. From 1528 onward it was obligatory for tapestries woven in Brussels to display the mark of the city. The tapestries also bear an unidentified atelier mark that Alfassa 1920, 241-242, and d'Hulst 1960, 181, believe is that of Jean Gheteels, a Brussels weaver.

5. D'Hulst 1960, 173. Although the various locales are rendered with great topographical accuracy, Alfassa 1920, 134, notes that caution must be used in identifying settings in open woods, such as those in the months of June, October, November, and December.

6. For the Louvre drawings see Lugt 1968, 52-57, nos. 178-189; for the Leiden drawings Beets 1931a; the Berlin drawing was first discussed in Berlin 1975, 153-154, no. 210 (entry by Fedja Anzelewsky); the Copenhagen drawing is reproduced in Schneebalg-Perelman 1982, 188, fig. 115. As noted by Ainsworth 1982a, 80, these drawings are similar in size, technique, and in the handwriting of inscriptions.

7. Beets 1931a, considered the Leiden drawings original and the Louvre set a copy; Gerszi 1971, 1985, also thought the Louvre drawings are copies. Lugt 1968, 53, held to the contrary opinion.

8. Ainsworth 1982a, 79-87; Farmer 1981, 287-294; Berlin 1975, 153-154. Balis 1979/1980, 15-16, finds the Leiden-Budapest series most defensible as autograph drawings by Van Orley, but believes the Louvre set is possibly by the artist himself and is certainly out of his antelier. The possibility that a landscape specialist named Tons and Pieter Coecke, or unnamed artists, might have assisted in the Louvre series is raised by Friedländer 1909, 162, and others, but not resolved. The most radical suggestion, by Schneebalg-Perelman 1982, 155-185, is that both sets of drawings represent a collaboration between François Borreman for the landscapes and Pieter Coecke for the figures. Her arguments are convincingly refuted in Delmarcel 1980.

9. Ainsworth 1982a, 80-81, and Farmer 1981, 293, reverse the order, believing that the Leiden/Budapest group followed the Louvre set.

10. Ainsworth 1982a, 82-83, also suggests that they might have served as a model for the *cartonnier*, although there may have been further stages in which details, such as portraits, were added. She demonstrates that, in the case of the June tapestry, the *cartonnier* must have known both the Berlin and Louvre drawings.

11. The similarity to the procedures of artists such as Giulio Romano and Raphael is pointed out by Ainsworth 1982a, 81, 87.

BERNARD VAN ORLEY

91 *Count John V of Nassau and His Wife Elizabeth of Hesse*

Pen and brown ink, colored washes, traces of white heightening, and black chalk (verso: *male horseman on recto;* outlined in black chalk)
396 x 528 (15⅝ x 20¾)

Inscribed in cartouche at top, in a sixteenth-century hand, *Johannes comes de Nassou in (?) coniugem habens dominam Elizabeth Henrici lantgravii de Hessen filiam, ex qua inter susceptas proles Henricum et Guilhelmum suscepit. Homo vere christianus et ad amplissiman fortunam natus. sed tranquillitati magis studens reipublicae quam propriis commodis. Obiit anno 1516 sepultus in Siegen*

Provenance: In the collection of the Staatliche Graphische Sammlung since the beginning of the nineteenth century (Lugt 2723)

Literature: Roest van Limburg 1904, 13-14; Friedländer 1909, 160, 162; Friedländer, *ENP*, 8 (1930): 119-120 (8 [1972]: 73); Drossaers 1930, 264-267; Crick-Kuntziger 1943, 86-87; Delen 1944, 61-62; d'Hulst 1960, 144; Cellarius 1961, 58-80; Heldring 1964, 155-163; Steppe 1967, 11; Steppe 1969, 474-475; Fock 1969, 3-4, 11-12; Wegner 1973, 23-24, no. 85; Farmer 1981, 274, 284-285, 345, no. D13; Ainsworth 1982a, 78-79

Exhibitions: Brussels 1935, no. 415; Breda 1952, no. 170; Delft 1960, no. 3; Munich 1983-1984, no. 67; Delft 1984, nos. 2, 10

Staatliche Graphische Sammlung, Munich, inv. no. 20

This magnificent drawing is one of five surviving that are preparatory to the tapestry series known as the Nassau Genealogy, mentioned by Van Mander in his biography of Bernard van Orley.[1] Four of the drawings are in the Staatliche Graphische Sammlung, Munich, and a fifth is in the Musée des Beaux-Arts, Rennes.[2]

The series of eight tapestries was commissioned by Count Henry III of Nassau (1483-1538). Henry was a confidant and trusted advisor to Charles V and a collector and patron of note whose holdings included a hotel in Brussels and a castle in Breda. The tapestries were apparently in

Fig. 1. Netherlandish 16th century, *The Children of Philip the Fair*, Rijksprentenkabinet, Amsterdam

design was not left to the weavers. The border, with its cornucopias, putti, grotesques, and swags, is fully Italianate and quite unlike the floral motifs commonly used.[12] This is also the most complete and attractive drawing of the series. The others bear pentimenti in the form of cut pieces of paper pasted over the original sheet; certain details, such as the overhead garlands, are rendered in a simplified, almost shorthand manner. It seems possible, then, that at some point in the design process this was the drawing shown to the patron for his information and approval.

Taken as a whole, the drawings for the Nassau Genealogy offer fascinating insights into Van Orley's working methods. The sure sense of design and colorful decorative effects, combined with a dignity and grandeur of conception, amply illustrate in this drawing why Bernard van Orley was the preeminent northern tapestry designer of the early sixteenth century. JOH

the process of being woven in 1531 and so the drawings must date sometime before this, probably c. 1528/1530.[3] According to Steppe, the tapestries hung for a time in the Nassau hotel in Brussels.[4] Following Henry's death, the tapestries passed from his son, René de Chalon, to William the Silent of the house of Orange-Nassau. In the eighteenth century they hung in the Nassau castle in Dillenberg until they were destroyed by fire in 1760.[5]

Here and in Van Orley's other four drawings, the ancestral alliances and dynastic continuity of the house of Nassau are presented in a noble and traditional manner. Henry's forebears are arranged in pairs, facing each other, and set against a landscape vista. The males especially are shown in commanding poses and carry symbols of authority such as the baton or scepter and orb. The antecedents for this imagery are to be found in German and Netherlandish equestrian portraits, such as Jacob Cornelisz. van Oostsanen's woodcut series of 1518, The Procession of the Counts and Countesses of Holland,[6] or a Netherlandish woodcut of 1522/1525 (fig. 1) depicting the children of Philip the Fair.[7] This last-named work is compositionally closer in that the figures are in a landscape and facing each other, males on the left. Both the woodcuts and the drawing show women riding mules sidesaddle, for the mule was considered the proper mount for a lady.[8]

This, apparently the last drawing in the series, is different from the others in several important ways. The coats-of-arms and the inscription in the cartouche identify the main riders as Count John V of Nassau (1455-1516) and his wife Elizabeth of Hesse (1466-1523). Unlike the other drawings, this one includes two women on horseback in the middle ground. The escutcheons that flank them are blank and their identities have not been established with certainty, but Cellarius and Heldring agree that the women are members of the families of John and Elizabeth.[9] Their presence may allude to the dispute over inheritance and rights of succession that resulted from Count John V's claim of sovereignty after the male line of the Katzenelnbogen branch died out in 1500.[10] As representatives of the houses of Nassau and Hesse, the women's gestures toward the count have been interpreted as acknowledgment of his right to rule. In the earlier literature, however, and recently by Bevers, the primary figures are identified as Henry III and his wife Mencía de Mendoza, along with his previous wives, Francisca of Savoy and Claudia of Chalon.[11] Since the inscription is a later addition, and the tapestries themselves no longer exist, the earlier identification should not be discounted entirely.

This drawing is also unique in that it is the only instance where Van Orley himself composed the tapestry border and the

1. Van Mander, *Schilder-boek*, 1: 102-105. Van Mander mentioned sixteen cartoons for tapestries depicting members of the house of Nassau, but this number was changed to eight in an appendix.
2. Wegner 1973, 23-24, nos. 82-84; Paris 1972, 38-39, no. 34.
3. Though it is not confirmed absolutely, it is generally believed that the tapestries of the Nassau Genealogy are the subject of a letter of 6 November 1531 from Henry to his brother William in which he states that, unless he receives information from William, probably of a genealogical nature, work on the tapestries will soon stop; see Fock 1969, 2, and Cellarius 1961, 59. Both Fock 1969, 2, and Steppe, in Halbturn 1981, 33-35, believe that the series was woven by Willem Dermoyen of Brussels, but Duverger 1971, 210-212, questions this view.
4. Steppe 1967, 11, also states that the tapestries were taken between 1533/1535 to Henry's castle in Simancas, Spain, but does not publish full documentation.
5. Fock 1969, 14-24; a second series was woven in 1632 for Prince Frederick Henry, who added four tapestries in 1639; three more were added by William III later in the century. The entire series was in the Nassau castle in Breda in 1793, but was presumably sold in 1798 and has disappeared. Van Mander mentions that the cartoons were copied in oil for Prince Maurits by Hans Jordaen of Antwerp (cited as living in Delft), but these works have not survived either; see above n. 1.
6. Cellarius 1961, 60, 72, in addition to Jacob Cornelisz. van Oostsanen, pointed to the influence of German woodcuts by Michael Ostendorfer and Hans Burgkmair. See also Fock 1969, 12-13, fig. 6. For Jacob Cornelisz. van Oostsanen's series see Steinbart 1937, 64-73, nos. 34-47, pls. 9-11, and Washington 1983, 272-273, no. 112.
7. Fock 1969, 13, fig. 9.
8. Interestingly, in the woodcut depicting the children of Philip the Fair, it is only the eldest daughter Eleanore who rides a mule.
9. Cellarius 1961, 76-79, identifies the women as Anna of Nassau, John's sister and wife of Philip of

Katzenelnbogen, and Zimburga, wife of Engelbert of Nassau and John's sister-in-law. This identification is accepted by Wegner 1973, 23. Heldring 1964 sees the figures as Anna of Hesse, John's stepgrandmother, and Mechthild of Hesse, Elizabeth's sister and wife of John of Cleves. In what appears the most sensible solution, Fock 1969, 4, identifies the figure on the left as John's sister, Anna of Nassau, and the woman on the right as Elizabeth's sister, Mechthild.

10. Cellarius 1961, 76-79; Fock 1969, 3-4.

11. For example in Roest van Limburg 1904, 13-14, and Crick-Kuntziger 1943, 86-87. Bevers in Munich 1983-1984, no. 67, makes several interesting observations that challenge the current identification. He notes that the inscription was added later, does not fill out the cartouche, and so may not have been intended for it. The arms also appear to have been added later. The red flower held by the woman riding a mule was identified as a pink and hence alluded to the marriage of Henry III and Mencía de Mendoza, which took place in 1531. Last, Bevers finds it unlikely that the final tapestry in a series would not depict the patron, that is, Henry. I would note that none of the inscriptions really fills out its allotted spaces in the cartouches and, if this inscription is incorrect, then the others may be misplaced as well.

12. Crick-Kuntziger 1943, 86-87, and d'Hulst 1960, 144, stress the differences between this and those borders typical of Brussels tapestries of the period. Both authors see a relationship to the borders of *The Legend of Notre-Dame du Sablon* of c. 1516-1518, generally considered Van Orley's earliest tapestry series. An even closer comparison, for which I am indebted to Guy Delmarcel, is found in the border of a tapestry depicting *Christ on the Mount of Olives* (Musée des Beaux-Arts, Besançon), attributed to Van Orley or his atelier and dated c. 1520; discussed and reproduced in Paris 1965-1966 (Tapisseries), no. 22. I have not found any Italian tapestries with comparable borders, but Van Orley could have learned about Italian grotesque ornament through engravings; for examples from the early sixteenth century by Zoan Andrea and Nicoletto da Modena, see Northampton 1978, nos. 120-122.

92 *The Resurrection*

Charcoal with white heightening, squared in red chalk on three pieces of horizontally joined paper
886 x 479 (34⅞ x 18⅞)

Inscribed at lower right in pen and brown ink, *xx*

Provenance: Robert Lehman, New York, by 1925

Literature: De Tolnay 1943a, 132, no. 162; Haverkamp-Begemann and Logan 1970, 268-271, no. 502; Florence 1980-1981, 165; Farmer 1981, 302

Exhibitions: Cambridge, Massachusetts, 1967 [no catalogue]

Yale University Art Gallery, New Haven. Gift of Robert Lehman, B.A. 1913, inv. no. 1941.302

The Resurrection belongs to a series of drawings depicting the Passion of Christ that most probably are preparatory designs for stained glass windows. Twelve other drawings in public and private collections in Europe are considered part of the series.[1] Some of these drawings, like the Yale sheet, bear numerals that probably indicate the narrative sequence.[2] From the *xx* on the Yale drawing we may surmise that a minimum of twenty scenes was anticipated. The windows themselves have not survived.

Initially attributed to Bernard van Orley by Friedländer and Baldass are three drawings now in East Berlin and three drawings in Brussels (Musées Royaux d'Art et d'Histoire).[3] De Tolnay accepts the Yale drawing as autograph.[4] Now, however, it is generally believed that the drawings are by another hand. Held was the first to question the attribution, observing a resemblance to certain paintings from Van Orley's workshop.[5] As a further refinement, Farmer has brought together a group of paintings and drawings that he believes were made by the same distinct but anonymous personality. He has christened this artist the Master of the Raleigh Ascension and Pentecost after two paintings in the North Carolina Museum of Art. Included in the grouping are *The Resurrection* and the companion drawings in Berlin and Brussels, as well as the panels cited by Held.[6] Although based on Bernard van Orley's works of the 1520s, the Raleigh Master did not fully assimilate Van Orley's Romanism and so the paintings are often chaotically organized and the gestures of the figures confused and awkward. Characteristic of this artist's style are thick, powerful figures with large heads and disproportionately large hands and feet. In

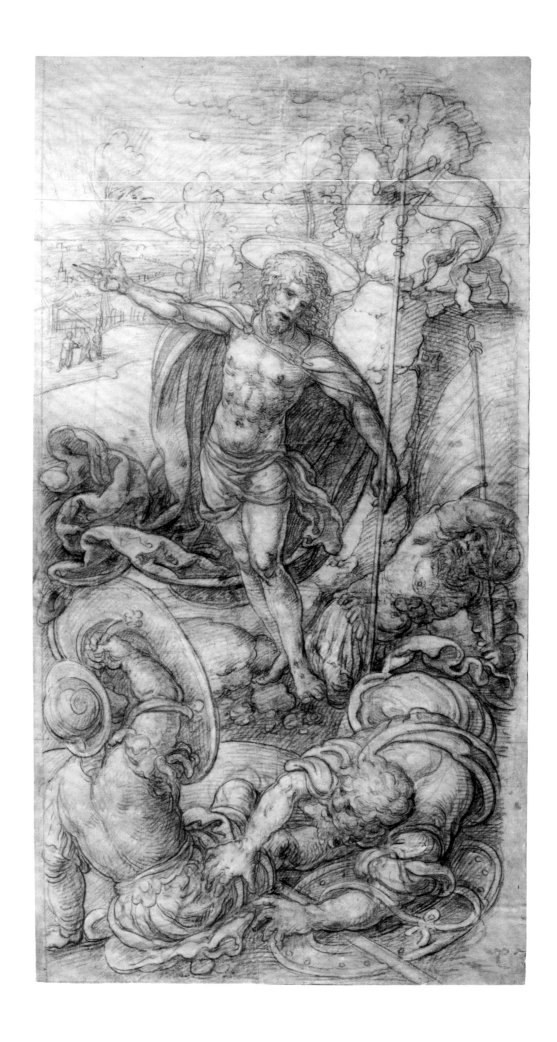

the Yale drawing, the facial type of the soldier at the lower right is virtually identical with that of the kneeling figure at the right of the Raleigh *Ascension* (fig. 1) as well as the apostle in the *Pentecost* panel.

The series of drawings is usually dated around 1525. Boon's observation that a variant of *Pilate Washing His Hands* (private collection, Antwerp) served as the model for a stained glass window, made in 1532, in the church of Saint Peter, Solre-le-Château, France, establishes a *terminus ante quem*.[7] As noted by Held and subsequent writers, the series was influenced by Albrecht Dürer's woodcuts of the small Passion.[8]

The Yale drawing is an important example of a preparatory drawing for stained glass, a type not represented by an autograph work by Van Orley. As noted by Haverkamp-Begemann and Logan as well as by Boon, the master of the Yale *Resurrection* is a better draftsman than he is a painter. A robust energy animates Christ's billowing cloak and the twisting, if ungainly, bodies of the soldiers. Apart from the more spontaneous nature of drawing, the functional requirements of emphatic contours and strongly modeled forms needed for stained glass design, as well as perhaps the closer, more active presence of Van Orley himself during this initial stage, are possible reasons for the greater strength and success of the drawing. JOH

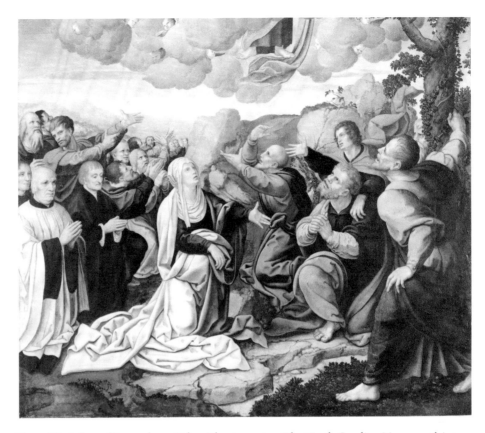

Fig. 1. Workshop of Bernard van Orley, *The Ascension*, The North Carolina Museum of Art, Raleigh

1. The drawings are: *Christ Washing the Disciples' Feet, Christ before Herod, Christ Appearing to the Apostles* (Musées Royaux d'Art et d'Histoire, Brussels, no. 972/986-A, B, C); *Christ Saying Goodbye to His Mother, Christ before Pilate, The Crucifixion* (Staatliche Museen, Kupferstichkabinett, East Berlin); *The Arrest of Christ* (Fondation Custodia [Coll. F. Lugt], Paris, no. 1975-T.20); *Christ before Caiaphus* (private collecton, Belgium); *Pilate Washing His Hands, Descent of the Holy Spirit* (private collection, Antwerp); *Christ Nailed to the Cross, The Elevation of the Cross* (Ecole supérieure des Beaux-Arts, Paris, nos. M.2983, M.2984). The drawings are all approximately the same size and done in the same technique of charcoal or black chalk and squared in red chalk; some have white heightening.
2. *Christ Washing the Disciples' Feet* is marked *ix; Christ Appearing to the Apostles* is marked *x*, and *Christ before Herod* is marked *ii*. I am indebted to Guy Delmarcel and Maarlen van Cauwelaert for making these drawings available to me.
3. Friedländer, *ENP*, 8 (1930): 133 (8 [1972] 80); Baldass 1944, 177, who mentions only the *Christ before Herod* as being in Brussels.

4. De Tolnay 1943a, 132.
5. Held 1931, 108-109. The paintings in question are a pair of shutters with scenes from the life of Saint Anne, dated 1528 (Friedländer, *ENP*, 8 [1972], no. 93, pls. 92-93) and six panels with scenes from the lives of Saint Catherine and Saint Roch (Friedländer, *ENP*, 8 [1972]: no. 98, pl. 100), all in Musées Royaux des Beaux-Arts, Brussels. Friedländer considers these to be workshop pieces. Haverkamp-Begemann and Logan 1970, on page 270 call the drawings School of Bernard van Orley, but suggest Pieter Coecke van Aelst as a possible author. Wayment 1982, 147, suggests that the Brussels and Berlin drawings represent a collaboration between Van Orley and Pieter Coecke.
6. Farmer 1981, 253-258, 301-302. The particular starting point for many of this artist's works is the *Vertu de Patience* altarpiece in Brussels. In addition to the works mentioned here, Farmer includes several drawings and paintings and two tapestry fragments in the master's oeuvre.
7. Florence 1980-1981, 166-167; for the window see Perrot 1978, 247, pl. 32.
8. Held 1931, 109.

241

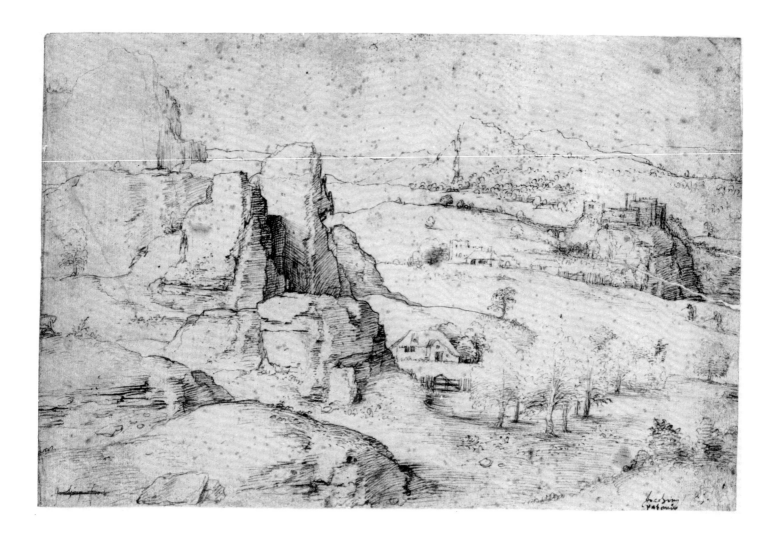

Joachim Patinir

c. 1485-1524

Joachim Patinir was probably born in Bouvignes in southern Belgium. His artistic origins are unknown, but the influence of Hieronymus Bosch is present in the earliest works and some authors see an awareness of Gerard David.

In 1515 he entered the painters' guild in Antwerp, but held no office and presented no pupils. Patinir is mentioned several times in Dürer's diary of his journey to the Netherlands. Dürer presented Patinir with his own drawings and, presumably, some prints by Hans Baldung Grien. Joachim Patinir died sometime before 5 October 1524, when his second wife is mentioned as a widow.

Patinir was the first Netherlandish

artist to specialize in landscape painting. While all of his works contain an identifiable, usually religious theme, their true subject is the panoramic depiction of space. The fantastic rock formations that inhabit the paintings recall those structures found in the region of Patinir's birth, near Dinant and Namur. None of Patinir's paintings is dated and, of the nineteen works considered autograph by Koch, only five bear what appear to be genuine signatures. The vocabulary of landscape created by Patinir is one of the main currents of Netherlandish art and continues through to the end of the sixteenth century.

JOACHIM PATINIR

93 Rocky Landscape

Pen and brown ink; laid down
184 x 282 (17¼ x 11¹¹⁄₁₆)
Inscribed, at lower left, *Joachim fecit* (struck
through); at lower right, *Joachim Patenier*;
a tear at the right

Watermark: Hand with trefoil similar to Bri-
quet no. 11460

Provenance: J.W. Böhler; F. Koenigs (Lugt
Suppl. 1023a on verso); Gift of D.G. van Beu-
ningen 1941

Literature: Benesch 1943, 277-278; Boon
1955b, 216; Białostocki 1955, 235; Van Reg-
teren Altena 1964, 169; Zwollo 1965, 53, 55;
Franz 1969, 47-48

Exhibitions: Rotterdam 1934, no. 29; Rotter-
dam 1938, no. 309; Rotterdam 1948-1949, no.
60; Brussels 1949, no. 32; Paris 1949, no. 34;
Prague 1966, no. 10; Rome 1972-1973, no. 28;
Berlin 1975, no. 211

Museum Boymans-van Beuningen, Rotterdam,
inv. no. N.143

No drawings can be given to Joachim Pa-
tinir with absolute certainty. The *Rocky
Landscape*, however, can lay greatest
claim to being by him. This sheet has
been associated with the name of Patinir
since the late sixteenth century. The
composition was copied in a drawing
dated 1597 and inscribed *Naer Jocham
Patenier* (Muzeum Narodowe, Krakow)
(fig. 1).[1] As Białostocki points out, this
does not confirm Patinir's authorship,
but does indicate that the drawing was
considered representative of his style.

The outstanding quality and distinctive
aspects of both style and conception of
landscape set the Rotterdam sheet apart
from other Patinir attributions: the *Land-
scape with Saint Christopher* in the
Louvre, the *Landscape with Saint Chris-
topher* in Berlin, and two landscapes in
Rotterdam.[2] Drawn only with the pen,
and deftly using large areas of blank pa-
per, the *Rocky Landscape* has an extraor-
dinary spareness and lucidity. As Franz
observes, the artist was more interested
in the overall structure of the landscape
than in differentiating textures or light
effects.[3] Yet the contour lines and hatch-
ings define the rocks, hills, and buildings
with a clarity and solidity of form not
found in other Patinir attributions. The
stronger, darker strokes of the major rock
formation at the left create a composi-
tional focal point that is subtly balanced
by the more distant buildings perched on
a rock at the right. There is no "subject";
with the exception of two small figures at
the far right, there is no human or animal
life to detract from the analysis and con-
templation of the landscape.

The *Rocky Landscape* was first dis-
cussed by Benesch who includes it, along

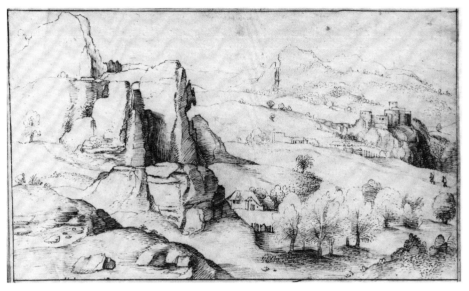

Fig. 1. Aelbrecht tot Vaelerdt (?), *Landscape*, Muzeum Narodowe, Krakow

with the Errera Sketchbook, in the group
that he gives to Hans Vereycke.[4] Boon re-
jects Benesch's proposal without offering
a specific comment of his own.[5] The at-
tribution to Patinir is accepted, with vary-
ing degrees of caution, by Białostocki,
Zwollo, Van Regteren Altena, and Franz.
There is no painting that corresponds to
the Rotterdam drawing, but Mielke notes
that the closest comparison is to the
signed *Landscape with the Flight into
Egypt* (Koninklijk Museum, Antwerp),
dated before 1515 by Koch.[6] The reces-
sion into space and the bizarreness of the
rock formations are more accentuated in
the painting. Interestingly, Van Regteren
Altena dates the Rotterdam drawing
early.[7] The possibility should be ac-
knowledged that the drawing (and the
replica in Krakow) copies a lost, perhaps
early, painting. JOH

1. Białostocki 1955, 235; the full inscription on the
verso is, *Naer Jocham Patinir/aelbrecht tot vae-
lerd[t]/1597*.
2. For the Louvre drawing see Lugt 1968, 45-46, no.
151, pl. 72; for the Berlin drawing, Bock and Rosen-
berg 1930, 47, no. 6698, pl. 42. The landscapes in Rot-
terdam are nos. N14 and N15.
3. Franz 1969, 48.
4. Benesch 1943, 277-278; he considers the *Land-
scape with Saint Christopher* in Berlin (KdZ 6698) to
be by Patinir.
5. Boon 1955, 216, n. 5.
6. Berlin 1975, 154; for the painting see Koch 1968,
22, 24, 71, no. 2, fig. 4.
7. Van Regteren Altena 1964, 169.

Gerrit Pietersz.

1566-before 1616

Gerrit Pietersz., the son of an organist and brother of the great organist and composer Jan Pietersz. Sweelinck, was born in Amsterdam in 1566. He evidently did not adopt the surname Sweelinck, by which his famous brother is known. After completing his initial training with the glass painter Jacob Lenartz in Amsterdam, Gerrit studied in Haarlem, c. 1588-1591, with Cornelis Cornelisz. The presence of his monogram on a painting of 1592, his earliest dated work, indicates that he was an independent master by that time. According to Van Mander, he remained in Haarlem for three or four more years before moving to Antwerp, probably c. 1594. He then traveled to Rome, stayed a few years, and finally settled in Amsterdam by

1600/1601. The date of his death is unknown, but it certainly took place by 1616.

Gerrit Pietersz. was active as a painter, draftsman, and etcher. The style of his early works, produced in Haarlem in 1592-1593, emulates that of the contemporary paintings by Cornelis Cornelisz. Five of his six etchings—which, in both design and execution, are perhaps the most original works in his oeuvre—are dated 1593. Four engravings by the brothers Cornelis and Theodor Galle, after drawings by Gerrit, are the only known products of his brief stay in Antwerp. After his return from Italy, he adopted the classicizing style developed by Goltzius and Cornelis during the 1590s.

94 *Odysseus and Teiresias*

Pen and brown ink, reddish-brown, light brown, and gray-brown washes, heightened with white over black chalk; laid down
246 x 416 (9¹¹⁄₁₆ x 16⅜)
Signed with monogram (?), in brown ink, at lower left, *G* (truncated at bottom)

Provenance: J. Skippe (Lugt Suppl. 1529a-b and 2798; no mark); (sale, London, Christie's, 20-21 November 1958, lot 283B, as B. Spranger); (H.M. Calmann, London); David Rust, Washington

Exhibition: Los Angeles 1976, no. 189

National Gallery of Art, Washington. Ailsa Mellon Bruce Fund, inv. no. 1982.16.1

The rarely illustrated subject comes from Books X and XI of Homer's *Odyssey.*[1] Circe commanded Odysseus to venture into Hades to consult the blind sooth-

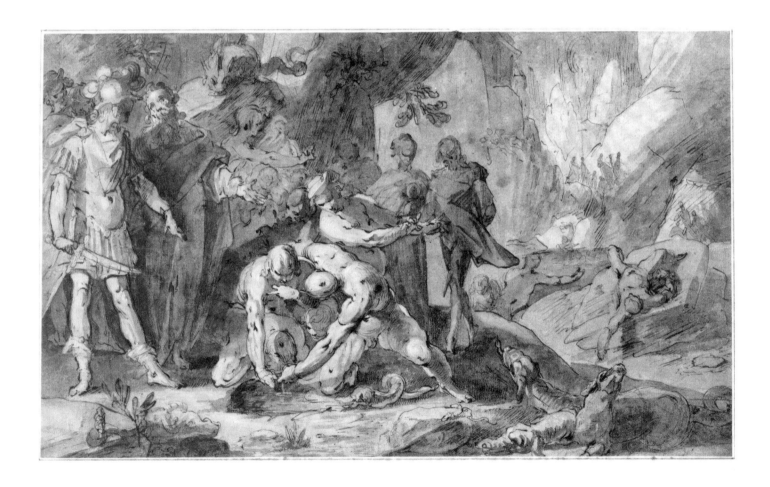

sayer Teiresias. Following Circe's directions, Odysseus dug a pit near a rock at the junction of two roaring rivers and filled it with a libation for the dead. Then he summoned the shades, and sacrificed a ram and a black ewe, adding their blood to the libation. When the spirits, attracted by the blood, gathered around the pit, Odysseus drew his sword to prevent them from approaching until he inquired after Teiresias. The seer then appeared and foretold Odysseus' return to Ithaca. His prophecy completed, he revealed to Odysseus that he could speak with any of the dead whom he permitted to drink the libation. The hero called, in turn, his mother, the wives and daughters of Greek chieftains, Alcinous, Agamemnon, Achilles, and others. He also saw other denizens of the underworld, including Tityus, Tantalus, and Sisyphus.

Gerrit Pietersz.' drawing does not represent a particular moment in the narrative, but encapsulates the entire episode. Odysseus stands at the left, his sword drawn, talking to Teiresias. At their feet lies the lifeless head of the sacrificed ram. Teiresias gestures toward the muscular male spirits—perhaps those of Agamemnon, Achilles, and other heroes raised by Odysseus—that lean over the pit, while a crowd of disembodied shades hovers behind. In the lower right corner, the three-headed dog Cerberus guards the underworld. Behind Cerberus, the giant Tityus, the figure quoted from Cornelis van Haarlem's drawing (cat. 39), stretches out on a rock, while to his left Tantalus reaches vainly for food.

Odysseus and Teiresias can be dated on the basis of style to c. 1592-1593 and belongs, with *Mercury* (cat. 95), to the earliest surviving works by the artist. Its execution and figure style depend primarily on the example of Cornelis van Haarlem, but also recall drawings by other masters active in Haarlem and Amsterdam during the early 1590s, such as Jan Muller and Abraham Bloemaert.[2] The composition—with the figures arrayed across the foreground and the abrupt transition into a deep, craggy space beyond—bears a general resemblance to the designs of Gerrit's painting *The Flood* of 1592 and his etching *Saint John the Baptist Preaching* of 1593 (fig. 1).[3] Moreover, the pose of the Baptist in this print is nearly identical to that of the draped figure standing in the shadow to the right of center in *Odysseus and Teiresias*. Finally, the head of one of the spirits bending over the pit recurs in three of the etchings of 1593 (for example, fig. 2).[4]

Although we cannot be certain about the drawing's function, the elaborate and sumptuous combination of three tones of brown wash with white body color and the presence of what is almost certainly a truncated monogram beneath the ram's head suggest that, despite its free execution, *Odysseus and Teiresias* is a finished work of art. WWR

1. The subject was identified by P. J. J. van Thiel who, in a letter to David Rust, also attributes the drawing to Gerrit Pietersz.
2. Compare, for example, Cornelis' paintings, Van Thiel 1963, fig. 3 and Van Thiel 1985, figs. 3 and 8, and his drawing *Olympic Games*, Van Thiel 1965, no. 20, as well as Muller's *The Brazen Serpent* (cat. 88), and Bloemaert's earliest drawings, such as *Acis and Galatea*, Vienna 1986, no. 58. Although the question of the chronology of these undated drawings is difficult to resolve precisely, Gerrit Pietersz. may have learned from Bloemaert the use of long, parallel arcs of the pen to model the legs and torsoes of nude figures. Van Thiel 1963, 68, notes the influence on Gerrit Pietersz. of such works by Muller as cat. 88.
3. For Gerrit Pietersz.' painting *The Flood*, see Van Thiel 1963, figs. 1-2. For the etching *Saint John the Baptist Preaching*, see *The Illustrated Bartsch*, 53, 325-327, no. .001.
4. Bartsch 53, 328-329, 332-334, nos. .002, .005, (fig. 2), .006. The head type also occurs in the painting *The Flood* of 1592, Van Thiel 1963, figs. 1-2.

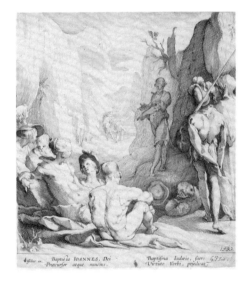

Fig. 1. Gerrit Pietersz., *Saint John the Baptist Preaching*, Graphische Sammlung Albertina, Vienna (Fonds Albertina)

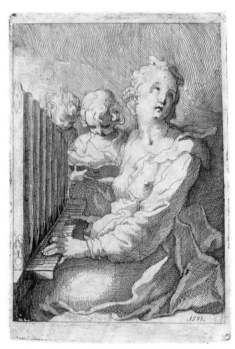

Fig. 2. Gerrit Pietersz., *Saint Cecilia Playing the Organ*, Rijksprentenkabinet, Amsterdam

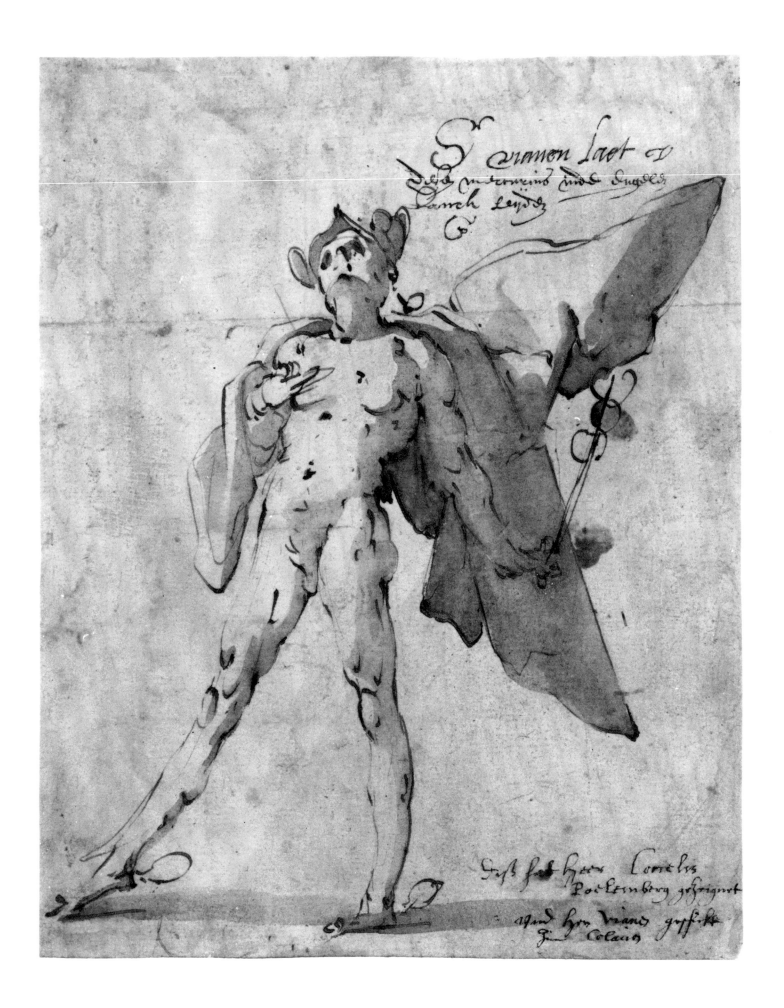

GERRIT PIETERSZ.

95 *Mercury*

Pen and brown ink with brown wash
242 x 196 (9½ x 7¹¹⁄₁₆)
Inscribed by the artist at upper right, in brown ink, *Sr Vianen laet U/ dese mercurius inde Engelen/ Banck Leijden/ GP* (in ligature); at lower right, in brown ink, by a later hand, *Diss hat heer Cornelis/ Poelemburg gezeignet/ und Herr Viane geschickt/ zum Colaūn.* Verso inscribed by the artist, in brown ink, *Aen de Eersamen Jongman/ Adam van Vianen tot/ Utrecht* (fig. 1)

Provenance: E.J. Otto, Berlin, 1956; (P. & D. Colnaghi, London, 1960); (sale, Amsterdam, Mak van Waay, 10 June 1975, lot 9)

Literature: Ter Molen 1979, 484; Ter Molen 1984, 1:31

Exhibitions: London 1960, no. 77; New Brunswick 1983, no. 98; Utrecht 1984-1985, no. 128

Museum Boymans-van Beuningen, Rotterdam, inv. no. MB 1975/T28

This lively sketch and the autograph inscription, "Mr. Vianen, may this Mercury lead you into the company of angels," constitute a greeting directed to the Utrecht silversmith Adam van Vianen (1568/1569-1627), brother of Paulus (cats. 116, 117). (The inscription in German, which mistakenly attributes the drawing to Cornelis van Poelenburgh, is by another hand.) On the verso of the sheet Gerrit Pietersz. addressed the missive "To the honorable bachelor Adam van Vianen at Utrecht" (fig. 1). While the presence of Mercury, messenger of the gods and patron deity of artists, is especially appropriate in a letter to a fellow artist, the precise significance of "the company of angels" eludes us. Perhaps it refers to creative inspiration or, as Mer-

Fig. 1. Cat. 95, verso

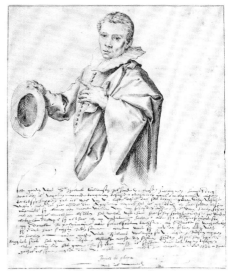

Fig. 2. Jacques de Gheyn II, *Portrait of Matheus Jansz. Hyc*, Staatliche Museen Preussischer Kulturbesitz, Kupferstichkabinett, KdZ 4006, Berlin (Jörg P. Anders)

cury was also bringer of luck and protector of travelers, to an imminent journey or some other event in Van Vianen's life. In any case, this sheet is a rare example of a letter (or part of one) decorated with a drawing by a distinguished sixteenth-century Netherlandish master. Another example is the letter of 3 March 1592 written by Jacques de Gheyn II (fig. 2).[1] It includes a drawing of a young man who, as the text reveals, delivered the message but could neither introduce himself nor offer his services, because he was deaf and dumb. Gerrit Pietersz.' rapid sketch, accompanied by a witty salutation, also recalls the type of drawing commonly entered into an *album amicorum* (see the essay, The Function of Drawings in the Netherlands in the Sixteenth Century).

Mercury, as Ter Molen notes, must date from 1593 or earlier, because in that year Adam van Vianen married and would not have been addressed as "Jongman" (bachelor) thereafter.[2] Stylistic evidence, too, suggests a date of c. 1592/1593. The leggy, muscular figure of the god and his balletic stance derive from works by Gerrit's teacher, Cornelis van Haarlem, such as *The Titanomachy* of 1588 and *The Flood* of 1592. The execution, combining loose washes and short, hooked penstrokes to denote anatomical features, recalls drawings of c. 1590 by Cornelis and Jan Muller (cat. 88).[3] *Mercury* also bears a general stylistic resemblance to Gerrit's earliest dated work, the painting *The Flood* of 1592.[4] WWR

1. For De Gheyn's drawing and letter, see Rotterdam 1985-1986, no. 6.
2. Utrecht 1985, no. 128.
3. For Cornelis' *Titanomachy*, see Van Thiel 1985, fig. 3; for *The Flood*, Van Thiel 1963, fig. 3.
4. Van Thiel 1963, figs. 1-2.

Pieter Pourbus

1523/1524-1584

According to Van Mander, Pieter Pourbus was born in Gouda and came to Bruges at an early age. In 1543 he became a master in the Bruges painters' guild and, in the following year, joined the crossbowmen's guild. Around this time he married Anne, the youngest daughter of Lancelot Blondeel. We are ignorant of his initial training, but it is highly likely that Pourbus studied and collaborated with Blondeel. Around 1547 he painted his only surviving profane subject, the Allegory of Love *(Wallace Collection, London). In 1549 Pourbus was asked by the magistrates of Bruges to work on the decorations for the Joyous Entry of Charles V and his son Philip; the same year marks the beginning of his cartographic activities, which continued throughout his career. His earliest dated paintings are from the year 1551: the portraits of Jan van Eyewerve and his wife and a* Last Judgment *(both Groeningemuseum, Bruges). There is no*

evidence that he ever went to Italy. Rather, he seems to have worked within the confines of Bruges, producing portraits of the prosperous bourgeoisie and religious works, commissioned by the city's confraternities and religious institutions. Pourbus was the leading artist in Bruges in the second half of the sixteenth century and, after Blondeel's death in 1561, was without serious competition. While Pourbus was aware of the work of his contemporaries in Antwerp and of Italian art, he was content to continue in the tradition of his predecessors. His cool, unemotional style was ideally suited to the conservative climate of Bruges. About a dozen drawings are attributed to Pourbus and several are related to extant paintings. Pieter Pourbus died in Bruges on 30 January 1584 at the age of sixty-one. Both his son Frans (1545/1546-1581) and grandson Frans Pourbus the Younger (1569-1622) were painters.

96 The Virgin and Child Enthroned between Saints Luke and Eligius

Pen and brown ink, brown wash, with traces of black chalk; laid down
300 x 260 (11¹³/₁₆ x 10¼)

Watermark: Pot with single handle, bands, letters, and trefoil (variant of Briquet 12631, 12632, or 12724)

Inscribed at base of throne, *1552*

Provenance: Sir Charles Robinson; Charles Fairfax Murray; J. Pierpont Morgan

Literature: Weale 1908-1909, 166; Hymans 1910, 135; Pierpont Morgan 1910, no. 78; Faggin 1968, 42, 44; Huvenne 1980, 25

Exhibitions: Bruges 1984, no. 31

The Pierpont Morgan Library, New York, inv. no. I, 227A

This handsome drawing calls to question the nature of the relationship between Pieter Pourbus and his father-in-law, Lancelot Blondeel. In 1545 Blondeel produced for the Bruges Corporation of Painters and Saddle Makers a banner, now in the church of Saint Salvator, Bruges, that depicts the Madonna and Child seated on an elevated throne and flanked by Luke, patron saint of painters, and Eligius, patron saint of saddle makers (fig. 1).[1] The Morgan Library drawing so clearly owes its inspiration to the banner that it was attributed to Blondeel by Weale and Faggin. Recently, however, Huvenne has convincingly attributed the drawing to Pourbus.[2] A comparison with Pourbus' secure drawings, such as *The Last Judgment* (present location unknown), the *Notre-Dame-des-Sept-Douleurs* (Ecole Supérieure des Beaux-Arts, Paris; see the essay The Functions of Drawings, fig. 1), both related to extant paintings, or the *Descent of the Holy Spirit* (Herzog Anton-Ulrich-Museum, Braunschweig)[3] yields numerous points of congruence. In addition to the large, poorly articulated hands and distinctive manner of rendering eyes, one finds the same calm, uninflected contour lines and use of parallel hatching, particularly in the architecture. The triangular face of the Virgin in the Morgan Library sheet is also a characteristic of Pourbus' manner of drawing.

Our knowledge of Lancelot Blondeel as a draftsman is much less extensive. The most secure work is a painterly study of ruins, monogrammed and dated 1557 (Staatliche Kunstsammlungen, Weimar), done in brush over black chalk with white heightening.[4] Those figure draw-

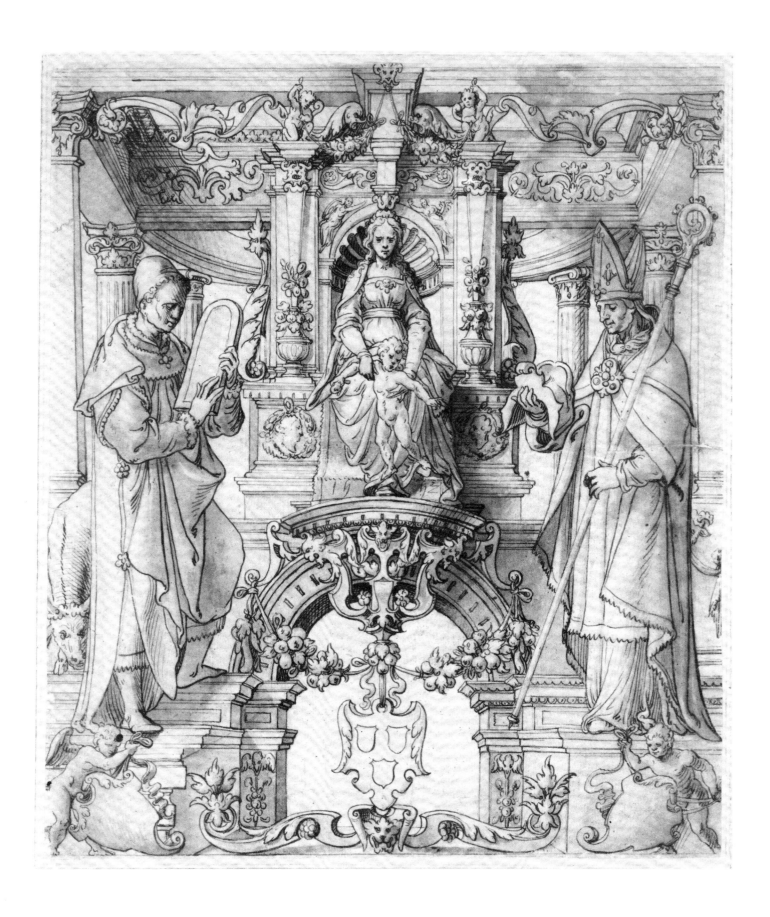

Fig. 1. Lancelot Blondeel, *The Virgin and Child Enthroned between Saints Luke and Eligius*, Saint Salvator, Bruges (Copyright A.C.L. Brussels)

ings attributed to Blondeel by Faggin and Boon are closer in style and spirit to Jan van Scorel or Pieter Coecke than Pourbus.[5]

Both the banner and the drawing show a type of composition derived from Venetian painting. The extravagant use of Italianate ornament characteristic of Blondeel's style, too, is in evidence here. These elements are also found in Pourbus' earliest painting of c. 1545, *The Seven Joys of Mary* (Cathédral Notre-Dame, Tournai).[6] It is likely that both men borrowed architectural details from Serlio's treatise on architecture, which was available in Pieter Coecke's Netherlandish translation from 1539 onward.[7]

Although Pourbus' drawing derives from Blondeel's banner, the seven-year difference in date between the two works and the drawing's purpose have not been satisfactorily explained. Certainly the two men worked closely together on various projects. In 1552, the same year as the Morgan Library drawing, Pourbus, working from designs supplied by Blondeel, prepared cartoons (now lost) for the stained glass in the church of the Annunciate, near Bruges.[8] Huvenne's suggestion that because the guild wanted to renew the banner, Pourbus drew a version more adapted to the manner of the period, merits consideration.[9] If this drawing is a project for a new banner, and not a free copy from the extant one, then it reflects another facet of the essential conservatism of artistic patronage in Bruges. JOH

1. Weale 1908-1909, 160; in the same year he painted a banner of *Saint Luke Painting the Virgin* for the painters' guild (Groeningemuseum, Bruges), Friedländer, *ENP*, 11 (1974): pl. 188, no. 299.
2. Huvenne 1980, 25; Bruges 1984, no. 31.
3. Bruges 1984, no. 2, fig. 61 (The Last Judgment); no. 5, fig. 70 (Van Belle triptych); and no. 30, fig. 116.
4. Boon 1976b, fig. B. Closely related in style and technique is the *Landscape with Burning Buildings* in the Metropolitan Museum of Art, New York, no. 61.167.7, Faggin 1968, fig. 13.
5. Both Faggin 1968, 50, fig. 2, and Boon 1976, 116-117, fig. 117A, attribute to Blondeel a drawing in the Kupferstichkabinett, Berlin, of *The Destruction of Dacian, Proconsul of Capadocia* (KdZ 11921). Boon also attributes to Blondeel the *Martyrdom of Saint George* in the British Museum (no. 1863.1.10.3), the *Design for a Cope with the Rescue of Saint Donatian*, and the *Design for a Sepulchral Monument for Margaret of Austria*, both Rijksprentenkabinet, Amsterdam. See Boon 1978, 27-29, nos. 75-76. For comments on Blondeel's style as seen in these attributions, see Bruges 1984, no. 31.
6. Bruges 1984, no. 1. The painting is given to Pourbus by Huvenne; previously it was generally, but cautiously, attributed to Blondeel.
7. Weale 1908-1909, 166; Bruges 1984, 74, 121.
8. Bruges 1984, 307.
9. Bruges 1984, no. 31.

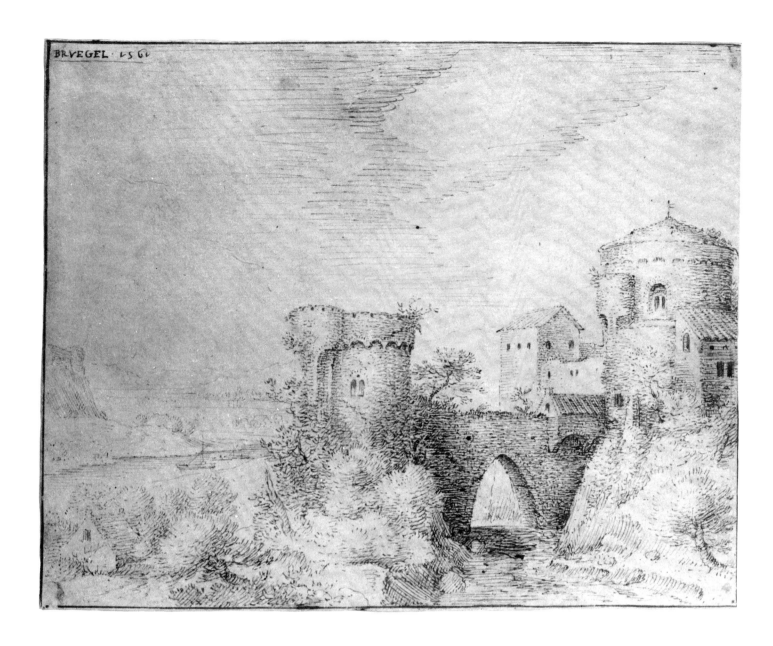

Jacques Savery

c. 1565–1603

Jacques (or Jacob) Savery, the older brother of Roelandt, was born in Courtrai (Kortrijk) about 1565. During the first half of the 1580s, the Savery family, fleeing the civil and religious disturbances in the south, made their way via Antwerp to the northern Netherlands. Jacques studied with Hans Bol, probably in Antwerp before 1584, but perhaps in Dordrecht c. 1584-1586. Van Mander mentioned Savery as Bol's best pupil, adding that he was a diligent worker. Like his teacher, Savery produced miniatures, etchings, drawings, and a few oil paintings. He received payment for a picture in Haarlem in 1585, and joined the guild there in 1587 before taking up residence in Amsterdam, where he became a citizen in 1591. According to Van Man-

der, he died there from the plague in 1602, but, as one of his drawings is dated 1603 (cat. 100), he must have lived until that year. His brother Roelandt was his pupil.

Savery was one of the most influential intermediaries between the flourishing landscape tradition of the southern Netherlands, in particular the art of Bruegel, and the new developments that took place in Holland after 1600. His career deserves further study. Most of his miniatures were apparently produced, under Bol's influence, in the 1580s, while his etchings (fewer than ten) and the majority of his rare oil paintings date from the 1590s. Dated drawings from 1586 to 1603 have come down to us.

97 Landscape with a Castle

Pen and brown ink over black chalk; laid down
145 X 189 (5 11/16 X 7 7/16)
Inscribed at upper left, in brown ink, BRUE-GEL . 1561

Provenance: A. von Beckerath (Lugt 2504)

Literature: Bastelaer and Hulin de Loo 1905-1907, no. 26; Tolnai 1925, no. 23; Bock and Rosenberg 1930, 21, no. 5765; De Tolnay 1952, no. 36; Münz 1961, no. 38; Zwollo 1979 204

Exhibitions: Berlin 1975, no. 79

Staatliche Museen Preussicher Kulturbesitz, Kupferstichkabinett, Berlin, inv. no. 5765

Landscape with a Castle belongs to a group of stylistically related pen drawings that includes some twenty small mountain and village scenes, The Blind (cat.

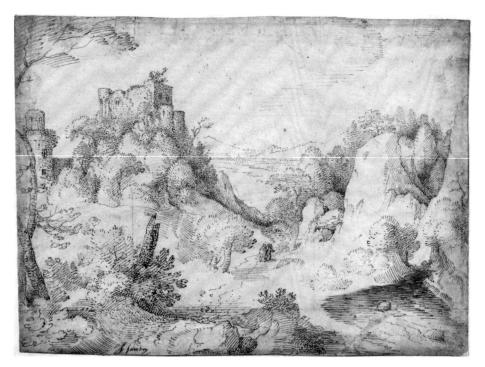

Fig. 1. Jacques Savery, *Landscape with a Castle*, The Pierpont Morgan Library, New York

Fig. 2. Jacques de Gheyn II after Jacques Savery, *Landscape with a Castle*, Rijksprentenkabinet, Amsterdam

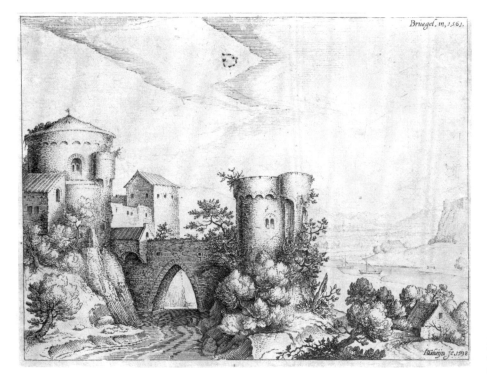

99), and the three views of the walls and gates of Amsterdam (cat. 98).[1] Nearly all the sheets are inscribed with Bruegel's name and dates ranging from 1559 to 1562. Although scholars have questioned individual works in this group, most pass as genuine drawings by Pieter Bruegel. As Hans Mielke has recently argued, though all of them are by the same hand, they do not fit logically within Bruegel's development as a draftsman, nor do they satisfy the standard of quality we expect from his drawings.[2] Their style, as Mielke has shown, suggests an attribution to Jacques Savery.

The composition of *Landscape with a Castle* recalls two signed drawings by Savery (fig. 1 and cat. 100).[3] In the Morgan Library work (fig. 1), the principal features of the landscape are massed in the foreground and middle ground. Beyond, we glimpse an abrupt transition to the distance, which is barely indicated in outline. The same approach informs *Landscape with a Castle* and several of the related sheets.[4] However, Bruegel's works of c. 1560, such as the etching *The Rabbit Hunters*, never exhibit such quirky disjunctions in scale or precipitous spatial recessions.[5]

To model foliage, Savery favored a combination of dots and zigzag strokes that resemble a corkscrew. These spiral lines appear in his two signed drawings and in *Landscape with a Castle*, as well as *The Blind*, and *Walls, Towers, and Gates of Amsterdam* (cats. 98-99). Close comparison of the details in all five drawings leaves no doubt that they are by the same draftsman. Savery's airy, delicate modeling differs perceptibly from Bruegel's dense penwork which, in the *Kermis at Hoboken*, *Caritas*, and *The Beekeepers* (cats. 28, 29, 31) imparts far greater weight and volume to the trees and architecture.[6]

The ruined fortresses with round towers and bridges, which dominate *Landscape with a Castle* and several other sheets in the group, occur frequently in the drawings, etchings, and miniatures of Jacques Savery (cat. 100).[7] In one or two instances, the correspondence between one of the drawings

252

wrongly ascribed to Bruegel and a documented work by Savery is very close, as in the case of *Landscape with a Castle* and a miniature of c. 1585, where an almost identical structure appears in reverse.[8] Three sketches of castles, executed in a freer variation on the style of the "Bruegel" group, were given to Jacques Savery long ago.[9]

Scholars have retained these drawings in Bruegel's oeuvre for so long partly because of their signatures—written either in a calligraphic script (cat. 99) or in block capitals—and their plausible dates. Mielke has analyzed the signatures and finds them inconsistent with those on genuine Bruegel drawings.[10]

Bruegel's name and the date 1561 on *Landscape with a Castle* were already there when Jacques de Gheyn II made an engraving after it in 1598 (fig. 2), and the signatures and dates on the other sheets are probably also original.[11] Mielke concludes from this that Savery produced the drawings, presumably in the 1590s, as deliberate forgeries.[12] Whether De Gheyn consciously abetted the enterprise is unknown. In any event, to put Savery's counterfeit—if that is what it was—in its proper context, we should recall that, at about the same time, Hendrick Goltzius made drawings and prints in the styles of celebrated artists, including Bruegel. Van Mander reports that, for a time, Goltzius even passed off two of his engravings as unknown plates by Dürer and Lucas van Leyden.[13] Perhaps Savery, too, drew his "Bruegel" landscapes as virtuoso emulations of the work of a famous old master.
WWR

1. The mountain and village landscapes are Münz 1961, nos. 27-45, and App. 3. Another is Seilern 1969, no. 317, pl. XXX, and another was published by De Tolnay 1973, 326-327, fig. 3. A copy of this latter drawing, almost certainly by Roelandt Savery, is Münz 1961, no. A19; Spicer Durham 1979, 2: no. C1 F2.
2. The three drawings of the walls and gates of Amsterdam were doubted as early as 1935; see cat. 98 and Florence 1980-1981, under no. 43. See also Mielke 1986, 76-81; for his attribution to Savery and a discussion of the whole issue.
3. The drawing reproduced in fig. 1 was sold in Amsterdam, Sotheby Mak van Waay, 18 November 1985, lot 8, and is now in the Pierpont Morgan Library, inv. no. 1985.101. De Tolnay 1952, no. 24, attributes it to Bruegel. Münz 1961, no. A8, accepts the signature and gives it to Jacques Savery. Although the cursive signature *JSavery* bears no resemblance to the signature in block capitals on cat. 100, it is in the same ink as the drawing and is certainly genuine. As Mielke pointed out in conversation, the identical cursive inscription of the surname appears on a typical Savery drawing in the British Museum, inv. no. 1946-7-13-133, which is fully signed, *Jacques Savery inventor*.
4. Compare, for example, Münz 1961, nos. 27, 28, 32, 39, 40, 41, 42.
5. Hollstein 1.
6. Mielke 1986, 78-81.
7. Zwollo 1979, figs. 11-16. Münz 1961, nos. 27, 30, 33, 38, 39, 43. Compare also the background of the etching Hollstein 3 and the drawing Münz 1961, no. 44.
8. Zwollo 1979, 209 and fig. 1.
9. The sketchier studies, which Münz and Zwollo give to Savery, include Münz 1961, nos. A12, A15, and Zwollo 1979, figs. 12, 15.
10. The engraving, Hollstein 338, is in reverse and the same size as the drawing. The signature, *Bruegel in. 1561*, differs slightly from the drawing, but is in the same place.
11. Mielke 1986, 77-78.
12. Mielke 1986, 81.
13. Reznicek 1961, 9-10. It should also be remembered that Bruegel's early designs, *The Temptation of Saint Anthony* and *Big Fish Eat Little Fish*, Hollstein 119, 139, were published by Cock as inventions of Bosch.

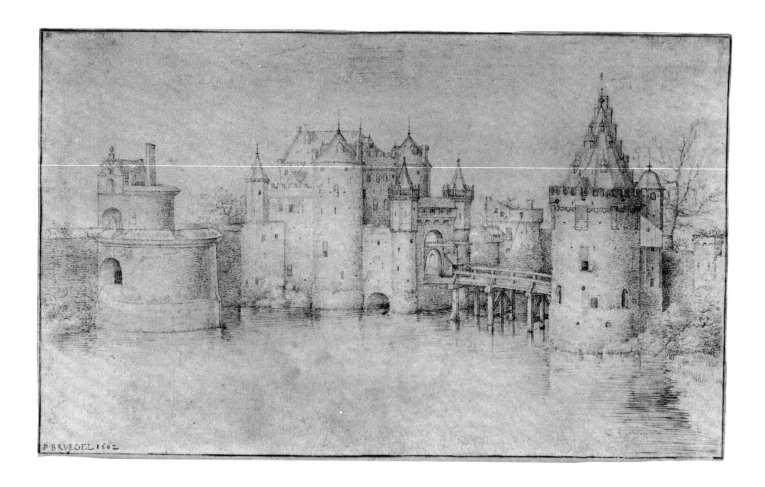

JACQUES SAVERY

98 *Walls, Towers, and Gates of Amsterdam*

Pen in two brown inks over black chalk
185 x 307 (7¼ x 12¹/₁₆)
Inscribed at lower left, in brown ink, *P BRUE-GEL 1562*

Provenance: W. Argoutinsky-Dolgoroukoff
(Lugt 2602d)

Literature: De Tolnay 1925, no. 43; Eeghen 1935; De Tolnay 1952, no. 43; Münz 1961, no. 49; Berlin 1975, under no. 86; Müller-Hofstede 1979, 97; Spicer-Durham 1979, I: 117

Exhibitions: Brussels 1980, no. 19

Museum of Fine Arts, Boston. Louis Curtis Fund 1938, inv. no. 38.769

This is one of three closely related sheets, all inscribed with Bruegel's name and the date 1562, that depict the walls, towers, and gates of Amsterdam (figs. 1, 2).[1] They belong to a group of pen drawings in the same style that includes *The Blind* (cat. 99), *Landscape with a Castle* (cat. 97), and some twenty other land-scapes. Most were accepted as works by Pieter Bruegel until Hans Mielke tenta-tively, but convincingly, attributed the whole lot to Jacques Savery (see cat. 97).

Mielke is not the first to question Bruegel's authorship of the drawings of the Amsterdam fortifications. In 1935, a Dutch scholar noted that the other two views (figs. 1, 2) show trees growing at the base of the Rondeel, the large, semi-circular bastion left of center in fig. 1.[2] These are first documented only in 1597, and they presumably did not yet exist during Bruegel's lifetime. The observa-tion is significant because the draftsman reproduced the details of the individual buildings with notable accuracy.

We have no evidence that Bruegel ever visited Amsterdam, apart from the du-bious authority of these three sheets. Jacques Savery, on the other hand, lived there from 1591 until his death in 1603. Moreover, comparison of the rendering of trees, water, and masonry in Savery's documented drawings (cat. 100, and cat. 97, fig. 1), with analogous passages in *Walls, Towers, and Gates of Amsterdam* confirms the attribution to him. In the Boston work, foliage is described with Savery's characteristic filigree of dots and spirals, while the still surface of the canal, evoked with long, light, parallel lines interspersed with shorter, darker strokes, clearly resembles the handling of water in cat. 100. Savery's loose, grainy representation of the surfaces and vol-umes of the ramparts, which also relates this drawing to cat. 100, contrasts with the more substantial modeling of the ar-chitectural forms in Bruegel's works of c. 1560, such as the *Kermis at Hoboken*, *Caritas* (cats. 28, 29), and *Skaters outside Saint George's Gate, Antwerp*.[3]

Roy Perkinson, conservator of works on paper at the Museum of Fine Arts, Boston, pointed out that the drawing was

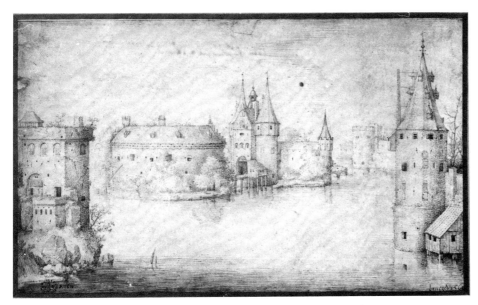

Fig. 1. Jacques Savery, *Walls, Towers, and Gates of Amsterdam*, Musée des Beaux-Arts et d'Archéologie, Besançon

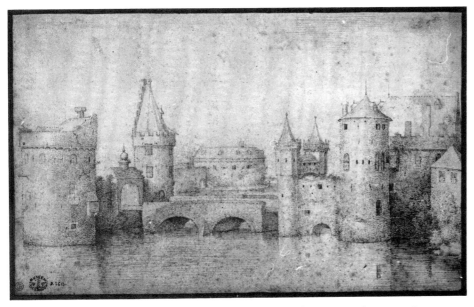

Fig. 2. Jacques Savery, *Walls, Towers, and Gates of Amsterdam*, Musée des Beaux-Arts et d'Archéologie, Besançon

executed in two inks. The draftsman re-
lied on the darker ink primarily to lay in
the principal contours of the architecture,
following his preliminary black chalk
outlines. The lighter ink was used for
modeling the forms. Perkinson also noted
that the inscription *P BRUEGEL 1562*
was written in a third brown ink that is
cooler and grayer than those utilized for
the drawing.[4]

As noted above, the artist faithfully re-
produced the details of the towers and
gates in the three drawings. However, he
arranged the structures in picturesque *ca-
pricci* that take considerable liberties
with the topographical truth, placing in
close proximity components of the fif-

teenth- and sixteenth-century city walls
that in reality stood far apart. The Sint
Anthoniespoort (built 1488), the large
gate at the center of the Boston sheet,
was the principal portal on the city's east
side. The Tower Swych Utrecht (built
1481-1482), detached at the right of the
drawing, actually formed part of the same
wall as the Sint Anthoniespoort and,
moreover, was located far to the south.
In one of the related views (fig. 2), the
Tower Swych Utrecht is similarly juxta-
posed with another of the city's gates, the
Regulierspoort.[5] WWR

1. Both other works are in the Musée des Beaux-Arts,
Besançon. The sheet reproduced in fig. 1 is inv. no.
2614, Münz 1961, no. 47; that in fig. 2 is inv. no.
2613, Münz 1961, no. 48.
2. Van Eeghen 1935. See the perceptive remarks of
Spicer-Durham 1979, 1: 117 and n. 90. Boon, in Flor-
ence 1980-1981, no. 43, assigns the Besançon draw-
ings of the walls and gates of Amsterdam to Jacques
Savery, but he bases his conclusion on the mistaken
belief that the paper used for the drawings had a wa-
termark datable c. 1590. Mielke 1986, 76-79, while
he also ascribes the drawings to Savery, points out
that the paper with the late watermark was used only
for the backing, not for the drawings. Several other
works in the group attributed by Mielke to Savery are
laid down on sheets with this same watermark;
Mielke 1986, 76-79.
3. Münz 1961, no. 140.
4. Letter to the author, 15 July 1985.
5. Van Eeghen 1935; Brussels 1980, no. 19.

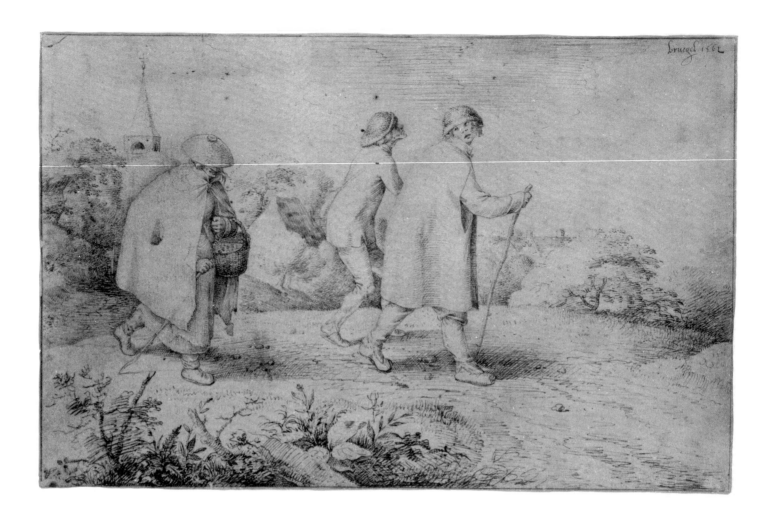

JACQUES SAVERY

99 The Blind

Pen in light brown ink over black chalk; some contours incised
192 x 310 (7⁹⁄₁₆ x 12³⁄₁₆)
Inscribed at upper right, in brown ink, *bruegel 1562*

Provenance: Acquired by the Berlin Museums in 1881

Literature: Van Bastelaer and Hulin de Loo 1905-1907, no. 97; De Tolnay 1925, no. 46; Bock and Rosenberg 1930, 18; De Tolnay 1952, no. 65; Münz 1961, no. 46; Spicer 1970, 6; Spicer-Durham 1979, 1: 197; Mielke 1986, 77-81

Exhibitions: Berlin 1975, no. 84

Staatliche Museen Preussischer Kulturbesitz, Kupferstichkabinett, Berlin, inv. no. KDZ 1376

Like *Walls, Towers, and Gates of Amsterdam* (cat. 98) and *Landscape with a Castle* (cat. 97), *The Blind* belongs to a group of some twenty-six drawings usually associated with Pieter Bruegel but recently ascribed by Hans Mielke to Jacques Savery.[1] See cat. 97 for a discussion of these works.

Mielke stresses weaknesses in the execution of *The Blind* that rule out an attribution to Bruegel. For example, the figures appear awkward and stiffly modeled when compared to the bulky peasant types, often striking complicated poses, in Bruegel's drawings of the late 1550s and 1560s, such as *The Alchemist, Elck, Spring, Summer,*[2] and *The Beekeepers* (cat. 31). We cannot tell, without glancing at the feet, whether the man in front has his right or left leg forward. In addition, the plants and branches in the foreground lack the impressive mass and clarity of analogous details in *Spring, Summer, The Beekeepers,* and *The*

Alchemist.[3] Finally, there is no mistaking the similarity, both in type and execution, of the figures in *The Blind* to those on the rare study sheets by Savery (fig. 1).[4]

The landscape in *The Blind* recalls one of the village scenes in the same group, which is similarly inscribed *bruegel 1562* (fig. 2).[5] The execution of this latter work, specifically the handling of the water, the foliage, and the lightly sketched distance, relates it especially clearly to two signed drawings by Savery (cat. 100 and cat. 97, fig. 1).

The figures may allude to the Biblical passage, "Let them alone; they are blind leaders of the blind. And if the blind lead the blind, both shall fall into the ditch" (Matthew 15:14). Christ's words, with which he assailed the spiritual blindness of the Pharisees, inspired several sixteenth-century Netherlandish works of art, including a print, perhaps designed by Bosch, and a painting by Bruegel.[6] The

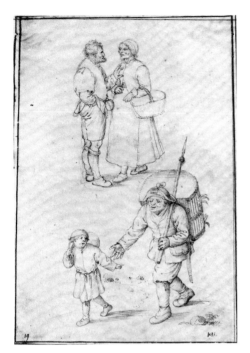

Fig. 1. Jacques Savery, *Study Sheet with Peasants and a Child*, Musée des Beaux-Arts et d'Archéologie, Rennes

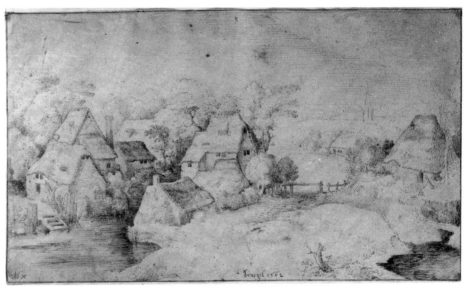

Fig. 2. Jacques Savery, *Farmhouses by a Stream*, Herzog Anton Ulrich-Museum, Braunschweig (B.P. Keiser)

Berlin drawing differs from the other examples, which feature a teetering procession of blind men lurching headlong into a ditch. Here, as Mielke notes, the artist contrasts the steady stride and directed downward glance of the woman with the tentative gait of the blind men and the sightless gaze of the one who turns his head.[7] But whether the drawing refers to the biblical saying, or has any deeper meaning at all, is uncertain.

The indentation of some contours with a stylus suggests that, at one time, an artist began to transfer the composition to a copper plate. However, no print after this drawing has come to light.

The deletion of *The Blind* and the related drawings from Bruegel's oeuvre does not detract from the imaginative compositions of the mountain landscapes and the views of the Amsterdam walls, the charm of the village scenes, or the lively penwork of the whole group, which have led generations of scholars to accept them as genuine works by the great Flemish master. Together with many paintings and drawings by Roelandt Savery, Jan Brueghel, Jacques de Gheyn, Paul Bril, and David Vinckboons, these sheets attest to the serious revival of interest in Bruegel's art that took place from c. 1595-1610. WWR

1. Mielke 1986, 76-81.
2. Münz 1961, nos. 138, 139, 151, and 152.
3. Mielke 1986, 79-81.
4. For the figure studies by Jacques Savery in Rennes and Lund, see Spicer-Durham 1979, 1: 198-199, and Rennes 1973, nos. 40, 41 (inv. no. 794.4.2540, here fig. 1).
5. Münz 1961, no. 45. Mielke in Berlin 1975, no. 83, already emphasizes the close stylistic relationship to *The Blind*.
6. See Berlin 1975, no. 84, for reference to other sixteenth-century Netherlandish works that represent *The Blind Leading the Blind*.
7. Mielke in Berlin 1975, no. 84.

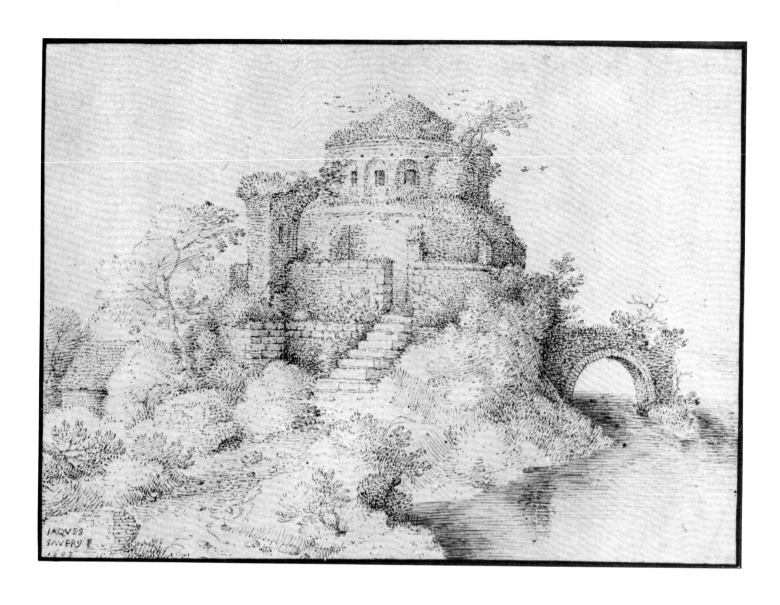

JACQUES SAVERY

100 A Ruined Circular Bastion and Bridge.

Pen and brown ink
155 x 211 (6¹/₁₆ x 8⁵/₁₆)
Signed and dated, at lower left, in pen and
brown ink, *IAQUES/ SAVERY F/ 1603*. (*F*
added later)

Provenance: C. Fairfax Murray; (his sale, Lon-
don, Christie's, 30 January 1920, lot 89); Frits
Lugt

Literature: Murray 1913, V, reproduced in fac-
simile; Lugt 1931 (Louvre), 29; Münz 1961, no.
A11; De Tolnay 1969, 62; Berlin 1975, under
no. 215; Zwollo 1979, 209

Exhibitions: Brussels 1926, no. 274; Brussels
1968-1969, no. 136; Florence 1980-1981,
no. 118

Fondation Custodia (Coll. F. Lugt), Institut
Néerlandais, Paris. inv. no. 484A

Exhibited in New York only

We can trace the development of Jacques
Savery's drawing style in dated sheets
from the mid-1580s until the year of his
death.¹ The works of 1586-1590 remain
very close to those of his teacher Hans
Bol.² Three village landscapes of 1595,
which he executed entirely in blue wash,
represent the labors associated with June,
December, and January, and probably be-
longed to a series of the months. The De-
cember scene (fig. 1), although still remi-
niscent of Bol (cat. 15), exhibits an inti-
macy of scale and a feeling for everyday
details that are quite original.³ During
the second half of the 1590s, Savery's art
underwent a sudden transformation in-
spired by his intense study of the work
of Pieter Bruegel. The large watercolor
Kermis of 1598 (fig. 2) is based closely on

the two influential prints of village fairs
Bruegel designed c. 1560 (cat. 28).⁴ About
the same time, Savery probably fashioned
the pen drawings in which he so success-
fully imitated Bruegel's style and tech-
nique that scholars still debate their at-
tribution (cats. 97-99). One of these com-
positions was engraved by Jacques de
Gheyn in 1598 (cat. 99, fig. 1), which pro-
vides an approximate date for the whole
group.

A Ruined Circular Bastion and Bridge
of 1603, Savery's latest surviving work,
dates from the final year of his life (see
Biography). Tumbledown medieval build-
ings appear frequently in his documented
prints and drawings, and even more
prominently in the landscapes he drew in
the style of Bruegel (cat. 97).⁵ Here, the

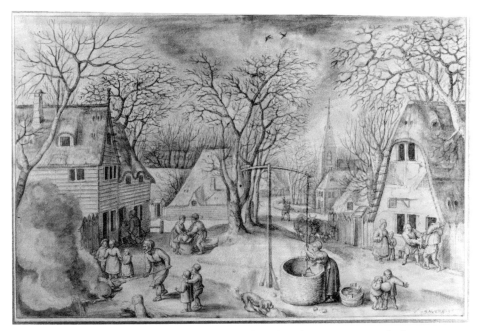

Fig. 1. Jacques Savery, *A Village Scene: Winter*, The Ashmolean Museum, Oxford

Fig. 2. Jacques Savery, *Kermis*, The Victoria and Albert Museum, London

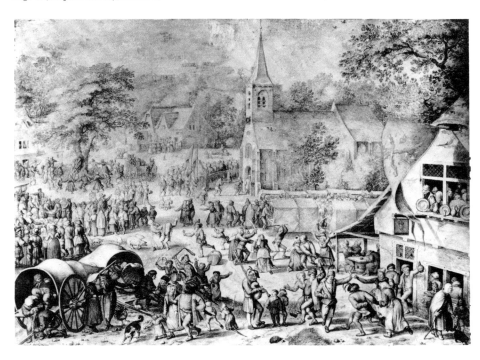

penwork embodies Savery's ultimate re-
finement of the technique he derived
from Bruegel. He executed the ruined
masonry entirely with dots and short
dashes, bestowing on the timeworn walls
a woolly texture barely distinguished
from the shrubs that encircle and invade
them. The modeling of the stonework
and foliage is even looser and less sub-
stantial than in the sheets inscribed with
Bruegel's name. As in those composi-
tions, the subject is concentrated in the

foreground and middle ground, with only
the slightest indication of the distance or
even the continuity of space behind the
bastion.

With its full signature and date, *A
Ruined Circular Bastion and Bridge* is
probably a finished work of art. This
sheet, or another representation of a sim-
ilar subject, inspired one of Roelandt
Savery's earliest drawings.[6] WWR

1. Zwollo 1979, 206-211.
2. Zwollo 1979, figs. 4, 6, 18, 19. Benesch 1928,
no. 276.
3. See Florence 1980-1981, no. 117; Parker 1938, 1:
nos. 69 (here, fig. 1), 70. The former drawing may also
show the influence of Gillis van Coninxloo, who ar-
rived in Amsterdam about 1595; compare the trees in
Coninxloo's early painting, Franz 1969, 2: fig. 411.
4. Hollstein 207, 208. Zwollo 1979, 206-207.
5. Zwollo 1979, figs. 13, 14, 16, 20; Franz 1969, 296,
fig. 25; Hollstein 8, 3.

Roelandt Savery

1576-1639

Roelandt Savery was born at Kortrijk (Courtrai) in 1576. In the early 1580s his family began a protracted emigration to the northern Netherlands, which led, via Antwerp, and perhaps Dordrecht and/or Haarlem, to Amsterdam. His brother and teacher Jacques Savery (cats. 97-100) became an Amsterdam citizen in 1591, and Roelandt, too, must have settled there by that year. A few paintings can be assigned to Roelandt's early years in Amsterdam. In the autumn of 1603 he traveled to Prague, where he embarked on the most productive and creative period of his career, especially of his activity as a draftsman. Nearly all the datable drawings and about sixty paintings belong to the years 1603-1613/1614, which he spent in central Europe. Although there is no documentary evidence of his status at the Imperial court before 1613, he must have entered the employ of Rudolf II at an early date. The emperor sent him on a trip, probably in 1606/1607, to the Tirolean Alps to make drawings of "their marvels of nature." After Rudolf's death in 1612, Savery remained briefly in the service of his successor Matthias. In 1613 or 1614 he traveled to the Netherlands, evidently intending to return to the imperial court. However, he stayed in Amsterdam until 1619, when he moved to Utrecht. He died there in 1639.

More than 250 drawings and a large number of paintings by Roelandt Savery have come down to us. Numerous prints were executed by professional engravers from his designs, but he made only two or three etchings himself. His paintings and drawings of lowlife scenes and mountain landscapes and his studies naer het leven *of Bohemian peasants belong to the most important transitional works between the Flemish tradition of Pieter Bruegel and the art of seventeenth-century Holland. He also produced floral still lifes and cattle pieces that are among the seminal masterpieces in those categories of Dutch painting. Savery's other specialities included forest landscapes, military subjects, and biblical or mythological themes, such as* The Garden of Eden *and* Orpheus Taming the Animals, *in which he could flaunt his extraordinary talent as an* animalier.

101 Study of a Tree

Black, oily black, blue-green and red chalk, stumped in places
482 x 370 (19 x 14½)
Inscribed at lower right, in black chalk, *R. Sav.*; on verso, in red chalk, *R. Savry*

Watermark: Shield (see Spicer-Durham 1979, 1: 388)

Provenance: K. E. von Liphart; (probably his sale, Leipzig, Boerner, 26 April 1898, lot 538); E. Parsons and Co., London; C. Hofstede de Groot

Literature: Van Gelder 1938-1939, pl. IV; Van Gelder 1958, no. 23; Spicer-Durham 1979, 1: 85-86, 2: no. C 57 F 59, and under no. C 229; Gerszi 1982, under no. 45

Exhibitions: The Hague 1930, no. 106; Brussels 1937-1938, no. 36; Rotterdam 1938, no. 353; Ghent 1954, no. 155; Dordrecht 1955, no. 219; Washington 1958-1959, no. 39; Rotterdam 1976-1977, no. 120

Collection I. Q. van Regteren Altena Heirs, Amsterdam

Among the landscape drawings Savery produced in central Europe during the years 1603-1609 are some that brilliantly adapt the pen technique and compositional models of Pieter Bruegel the Elder to the depiction of different kinds of terrain, and others that, like the woodland scenes of Paulus van Vianen (cat. 116), are precocious examples of the informally designed and spontaneously executed nature studies characteristic of seventeenth-century art. The range of subjects and motifs depicted in Savery's drawings are unparalleled in the work of earlier Netherlandish landscapists. They represent forest interiors, trees, rock formations, panoramas of the Bohemian countryside, village scenes with peasant cottages, Prague townscapes, and mountain views with precipitous cliffs (fig. 1), huge firs, waterfalls, and streambeds clogged with fallen timber (fig. 2). Also unprecedented in his skillful use, often in harmonious combination, of a variety of drawing media, including pen and ink, black, oily black, red, white, yellow, and blue chalks, gouache, and washes of blue, brown, gray, green, yellow, and rose.

Roelandt's earliest landscapes closely imitate the drawings of his brother Jacques (cats. 97-100), and thus belong to the revival of Bruegel's style that took place around 1600.[1] *Limestone Cliffs* of 1605/1606 spectacularly exemplifies his synthesis of a Bruegelian composition and technique with impressions of the scenery he experienced in Bohemia (fig. 1).[2] The emulation of Bruegel and the preference for pen and ink in this and

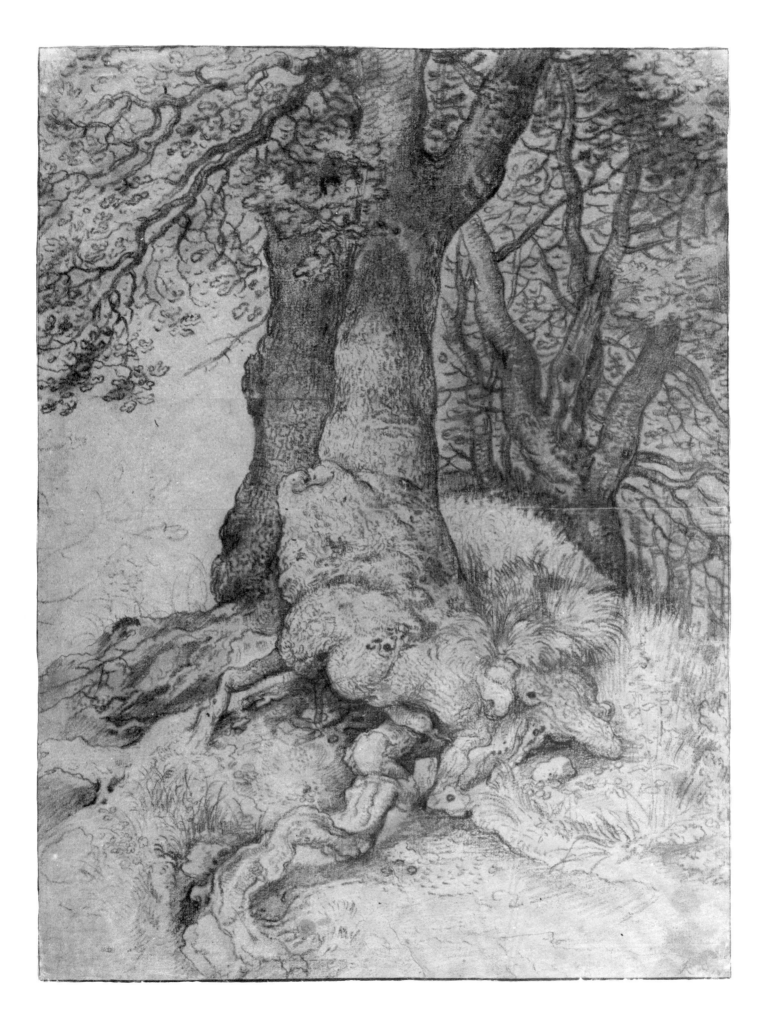

261

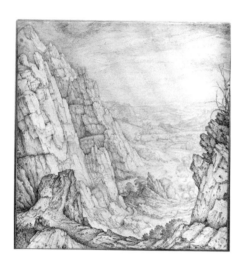

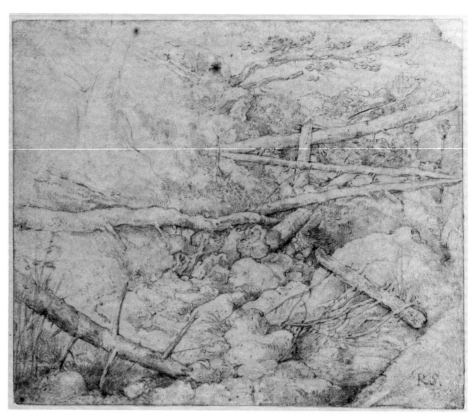

Fig. 1. Roelandt Savery, *Limestone Cliffs*, Musée du Louvre, Cabinet des Dessins, Paris (Cliché des Musées Nationaux)

Fig. 2. Roelandt Savery, *Stream Bed with Fallen Timber*, Staatliche Museen Preussischer Kulturbesitz, Kupferstichkabinett, KDZ 3231, Berlin (Jörg P. Anders)

other drawings of 1603-1606 give way during the succeeding period, when he traveled in the Alps, to a predilection for chalk and a greater immediacy in the representation of nature.

In 1675, Joachim von Sandrart wrote that Savery displayed such talent in the depiction of cliffs, rocks, mountains, and waterfalls that Emperor Rudolf II sent him to Tirol in order to seek out the "rare marvels of nature" there. "So he drew diligently for two years all the most beautiful and admirable mountains and valleys of this area with the pen, the great trees with charcoal, and the wide vistas with watercolor in a large book, which proved very useful when he produced his later landscapes."[3] Savery's two-year Alpine tour, which led him as far west as Schaffhausen, probably took place in 1606/1607. As Sandrart realized, some of the drawings he made then served as studies for paintings executed after his return to the Netherlands.[4]

Sandrart's references to "great trees [drawn] with charcoal" must refer to such studies as the one shown here, although at a distance of many years, the German art historian not surprisingly mistook for charcoal the oily black chalk Savery used in works of this type. Large in size and

scale and profoundly expressive in its close concentration on the gnarled, zoomorphic roots, the bulbous burls and knots, and the furrowed bark of the venerable trunk, this study conveys an unforgettable impression of organic vitality and the process of persistent growth over time. Savery evoked the life cycle of the forest in several drawings of this period, whether they represent a single tree, an impenetrable swamp, a waterfall, or a jumble of logs deposited by a torrent long since gone dry (fig. 2).[5] His choice of oily black chalk applied in irregular clusters of crumbly dots and dashes on a rough paper exactingly captures the rough textures of the bark.

Although the winter scenes of his brother Jacques include a few vigorously characterized trees, Roelandt's awe of the grandeur and drama of the woods must reflect his admiration for the works of Gillis van Coninxloo, the outstanding landscapist in Amsterdam from c. 1595 until his death in 1606. However, no drawings or paintings of single trees by Coninxloo have come to light.[6] Savery also certainly knew the drawing of forest interiors by Van Vianen (cat. 116), which exercised a visible influence on his delicate pen and wash views of 1603-1606.

Van Vianen's chalk studies of individual trees, on the other hand, postdate Savery's Alpine journey and attest to an exchange of artistic ideas between the two draftsmen.[7] WWR

1. A drawing possibly by the young Roelandt Savery is a copy after one of Jacques Savery's pen landscapes in the manner of Bruegel; see Münz 1961, no. A19, pl. 170, and Spicer-Durham 1979, 1: 47-49, and 2: no. C1 F2. Roelandt's drawing *A Round Tower* closely imitates Jacques' drawing of 1603 of a similar edifice, cat. 100; see Spicer-Durham 1979, 1: 49-50, and 2: no. C3 F4, and Mielke 1986, 80-81.
2. The drawing reproduced in fig. 1 is in the Cabinet des Dessins, Musée du Louvre, Paris, inv. no. 20.721, Spicer-Durham 1979, 1: 53-54, 55-56; 2: no. C17 F17.
3. See Spicer-Durham 1979, 1: 360-361, for the passage about Savery's Alpine journey in J. von Sandrart, *Teutsche Academie*, Nuremberg, 1675, Sandrart 1925, 175-176.
4. For the date of Savery's Alpine excursion, see Spicer-Durham 1979, 1: 62, 69-70.
5. For the drawing illustrated in fig. 2, Staatliche Museen Preussischer Kulturbesitz, Kupferstichkabinett, Berlin, inv. no. KdZ 3231, see Spicer-Durham 1979, no. C54 F56.
6. For the influence of Jacques Savery and Coninxloo on Roelandt's drawings of trees, see Spicer-Durham 1979, 1: 83-84.
7. Spicer-Durham 1979, 1: 101-102; Gerszi 1982, no. 45.

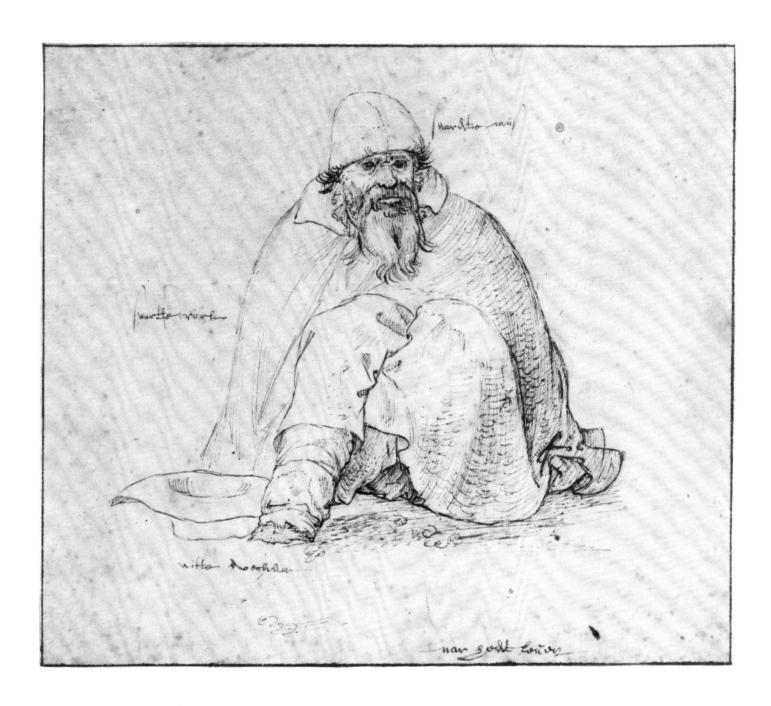

ROELANDT SAVERY

102 *A Seated Beggar Looking Out*

Pen and brown ink over graphite
153 X 175 (6 x 6⅞)
Inscribed by the artist in brown ink, *swardte mūs/ swartte rock/ witte doeckker/ nar hedt leūen.*

Watermark: Fragment of an eagle

Provenance: Adolf Friedrich Albert Reinicke (1753-1838); by descent to Martin Reinicke, Darmstadt; (his sale, Amsterdam, Sotheby Mak van Waay, 15 November 1983, lot 144)

Literature: Spicer-Durham 1979, 2: no. C 227

Exhibition: Berlin 1975, no. 238

The J. Paul Getty Museum, Malibu, inv. no. 83.GA.382

A Seated Beggar Looking Out belongs to a group of eighty sheets of figure studies datable to 1603-1609, when Savery worked in Prague. These works are known collectively as the *naer het leven* drawings from the Dutch phrase meaning "from the life," inscribed by the artist on many of them, including the present example.[1] Long accepted as works by Pieter Bruegel the Elder, they were attributed conclusively to Savery in the late 1960s by Spicer and Van Leeuwen.[2] While the studies exhibit no binding connection to Bruegel's work, there is abun-

dant evidence of Savery's authorship. The sketches are above all costume studies, and those costumes that can be identified are Bohemian and datable c. 1600. The handwriting on the sheets closely resembles that on drawings certainly by Savery, and the watermarks, too, relate them to Savery's oeuvre, rather than to Bruegel's. Most significantly, Savery reproduced many of the figures in paintings or finished drawings (see cat. 103).[3]

The *naer het leven* studies record a motley assortment of everyday types whom Savery encountered on the streets

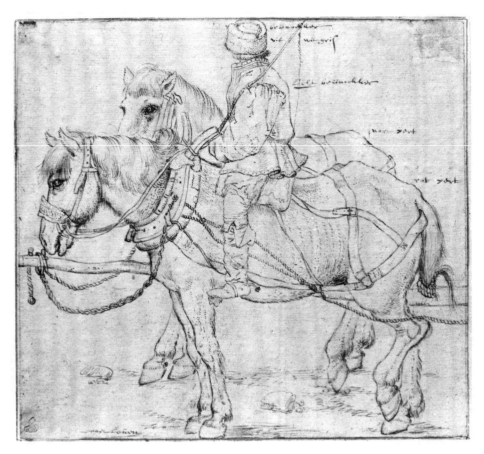

Fig. 1. Roelandt Savery, *A Team of Horses*, Graphische Sammlung Albertina, Vienna
(Fonds Albertina)

of Prague and probably elsewhere on his wanderings in central Europe. They include peasants, beggars, market women, woodcutters, a peasant bride, a pilgrim, Hungarian cavalrymen, Jews, a mule, and a team of horses (fig. 1).[4] Terse annotations that describe the items of clothing and their colors accompany the majority of the sketches. On most sheets these inscriptions, like the figures themselves, were initially jotted down in graphite and then worked up with the pen, although in some instances the graphite sketch and color notes remain unelaborated. Touches of watercolor enliven the costumes in a few studies. Many sheets show a single figure, while others depict two or three. Although he rarely indicated the setting, Savery must have executed the majority of these sketches outdoors. The small but arresting study exhibited here is representative of the *naer het leven* group. Savery's laconic notations describe the beggar's "black cap," "black cloak," and the "white rag" over his right foot. According to Spicer's chronology of the drawings, it is a late example, datable c. 1608, characterized by the substantial volumes of the clothing rendered with pliant networks of parallel

and cross hatchings punctuated by short hooks for the deeper shadows.[5] As far as we know, the figure does not appear in any other work by the artist.

This kind of life study is extremely rare in Netherlandish art before the 1590s. About 1599, Jacques de Gheyn began to sketch people in everyday situations, and a few figure drawings of the late 1590s by Jacques Savery, which probably provided the stimulus for Roelandt's works, have come to light (cat. 99, fig. 1).[6] However, the large size and the programmatic consistency of the *naer het leven* group are unprecedented. By recording the Bohemian street types from life, and later adapting his studies for finished compositions, Roelandt introduced the practice of figure drawing followed by seventeenth-century genre painters.

Although the attribution of the *naer het leven* sheets to Bruegel must be dismissed, we should not lose sight of their debt to the tradition he founded. The style of Savery's squat, ample, but vital figures, as well as his pen technique, derive directly, or by way of Jacques' work, from Bruegel's paintings, drawings, and prints. Indeed, at least one of the studies was not taken from life, but copied from

a picture by the great Flemish master, which belonged to Rudolf II's collection in Prague.[7] Finally, the peasant themes of Savery's paintings, for which many of these sketches served as studies, were first formulated by Bruegel and still identified with him in the early seventeenth century. WWR

1. See Spicer-Durham 1979, 1: chap. 4 for the *naer het leven* group.
2. Van Leeuwen 1967, 1970, and 1971; Spicer 1970.
3. See Spicer 1970 for the most complete discussion of the attribution, and Spicer-Durham 1979, 1: 300, for Savery's use of the drawings in finished works.
4. The drawing is in the Städelsches Kunstinstitut, Frankfurt, inv. no. 769, Spicer-Durham 1979, 2: no. C224 F218. The work illustrated in fig. 1 is in the Graphische Sammlung Albertina, Vienna, inv. no. 7867, Spicer-Durham 1979, 2: no. C164 F162. For the other subjects of the *naer het leven* drawings, see Spicer-Durham 1979, 2: nos. C148-C227.
5. Spicer-Durham 1979, 1: 217-222 for the chronology of the *naer het leven* drawings.
6. Spicer-Durham 1979, 1: 197-199.
7. Spicer-Durham 1979, 1: 197-198 and no. C216.

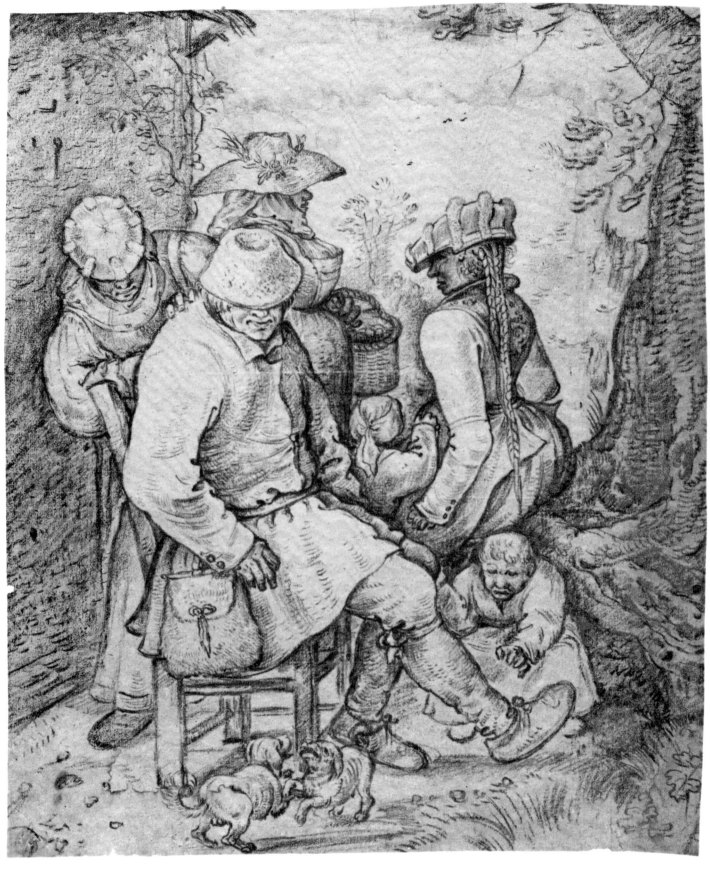

103

ROELANDT SAVERY

103 *Peasants with Scuffling Dogs*

Black chalk, traces of red chalk, some white body color
426 x 360 (16¾ x 14⅛)

Provenance: Purchased from Erich Dehmel, Weinböhla/Dresden

Literature: Spicer 1970, 25; Spicer-Durham 1979, 1: 229, 231, 2: no. C229 F220

Staatliche Kunstsammlungen Dresden, Kupferstich-Kabinett, inv. no. 1911-22.

Like David Vinckboons (cat. 118), Roelandt Savery helped to transmit to seventeenth-century Holland the tradition of lowlife painting founded by Pieter Bruegel. His sojourn in Prague played an important part in this development. Not only was he able to study the collection of Bruegel's pictures assembled there by Rudolf II, but it was in central Europe that he made the life studies of peasants and other picturesque types that he used in his paintings and drawings of lowlife subjects (see cat. 102).

Three elaborate drawings of lowlife scenes by Roelandt Savery have come down to us. The watercolor and gouache *Kermis* of 1606, which unites dozens of figures in a composition reminiscent of Bruegel's *kermis* prints and the paintings and drawings of peasant festivals by Jacques Savery, has the dimensions (470 x 757 mm) and the finish of a painting.[1] The other two works, *Six Peasants Merrymaking* (fig. 1) and the sheet exhibited here, are intimately related in style

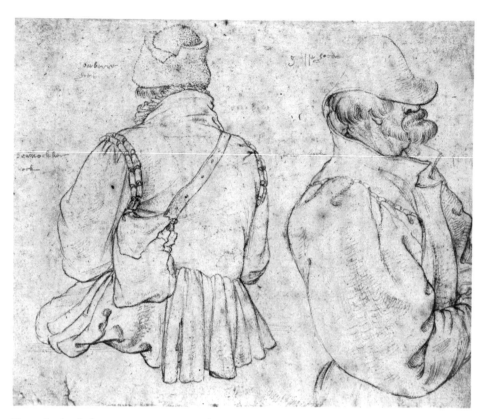

Fig. 2. Roelandt Savery, *Two Peasants*, The Cleveland Museum of Art, Purchase from the J.H. Wade Fund

Fig. 1. Roelandt Savery, *Six Peasants Merrymaking*, private collection, England

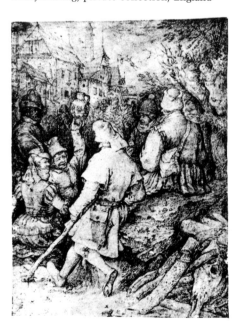

and technique, and both date from about 1608 or shortly thereafter.[2] Savery transcribed the seated man at the far right of *Six Peasants Merrymaking* from a surviving *naer het leven* study (fig. 2), and it is quite likely that one or more figures in the present work were originally recorded in lost sketches from life and subsequently incorporated into this composition.[3] As the woman holding a basket closely resembles a fruitseller in a painting by Savery of 1609, both figures probably derive from the same *naer het leven* drawing, which has not come to light.[4] The literal translation of life studies into the finished work would account in part for the stiff, additive character of the design and for the unconnected glances and poses of the two women at the rear. An aggregation of mostly unrelated figure sketches, the drawing has no recognizable subject; the scuffling dogs serving only as a focus for the attention of the man, woman, and child in the foreground.

However ungainly the composition, the individual protagonists memorably exemplify Savery's veneration for Bruegel's figure style and his abiding interest in the variety of central European costume. The weighty form of the seated man—his countenance rendered anony-

mous by the low brim of the cap and the woolly textures of his clothes skillfully evoked by Savery's broad application of the black chalk—and the stocky woman with the basket recall peasant types created by Bruegel.[5] As Spicer notes, the singular hats worn by the women at the far right and left belong to the costume of the Rheinpfalz, attesting to Savery's curiosity about the local dress of regions outside the imperial domains.[6] WWR

1. Spicer-Durham 1979, 2: no. C228 F219, reproduced also in Spicer 1970, pl. 17.
2. *Six Peasants Merrymaking* (fig. 1), private collection, Great Britain, Spicer 1970, pl. 4; Spicer-Durham 1979, 1: 229, 231-233, and 2: no. C230 F221, where she compares the drawings to the painting *Peasants before an Inn* of 1608 in Brussels and to the *Study of a Tree* (cat. 101).
3. Spicer-Durham 1979, under no. C229. The *naer het leven* drawing reproduced in fig. 2 is in the Cleveland Museum of Art, inv. no. 45.114. Spicer 1970, 6, points out that it served as a study for *Six Peasants Merrymaking*.
4. Spicer-Durham 1979, under no. C229.
5. Compare, for example, the male types in Bruegel's paintings *The Wedding Dance, Peasant Wedding, The Peasant Dance, The Peasant and the Birdnester,* Grossmann 1955, pls. 121, 134, 141, and in several of the prints after Bruegel's designs. The woman with the basket recalls the woman at the left in Bruegel's drawing *Summer*, Münz 1961, no. 152, which was reproduced in a print, Bastelaer 1908, no. 202.
6. Spicer-Durham 1979, 2: under no. C229.

Jan van Scorel

1495-1562

Jan van Scorel was born on 1 August 1495, in Scorel (Schoorl) near Alkmaar. He was the son of a minister and attended the Latin School in Alkmaar. Upon completion of his studies at the age of fourteen in 1509, Scorel was apprenticed to Cornelisz Willemsz. in Haarlem. In 1512, Scorel began to work in Amsterdam with Jacob Cornelisz. van Oostsanen, with whom he remained until 1517 when he moved to Utrecht and came into contact with Jan Gossaert. The following year Scorel went to study and work in Germany and Austria. By 1520, he was in Venice from whence he traveled to the Holy Land; he was back in Italy by 1522. In 1523, he was named curator of the papal collections under Pope Adrian VI and, with the latter's death in 1523, Scorel returned to Utrecht shortly after 26 May 1524. Because of the political troubles in Utrecht, Scorel fled to Haarlem in 1527 and stayed there for three years. In 1528, while in Haarlem, Scorel was appointed Canon of Saint Mary's Church in Utrecht and rented a house on the church's property. By 1532-1533, he was working in Breda and very likely in Mechelen but was back in Utrecht by the close of 1533. Six years later, he made a diplomatic trip to Ysselstein and in 1540 he journeyed to France, very likely to paint the great altarpiece for the Abbey of Marchiennes. He re-

mained there until 1542 when he returned to Utrecht where he was involved with numerous artistic and scientific projects. Scorel died on 6 December 1562 in Utrecht where he was buried in the Church of Saint Mary.

Jan van Scorel was the first northern Netherlander to study in Italy and to bring back the new Italian styles to his homeland. He not only studied Michelangelo and Raphael while in Rome but also introduced antique vocabulary into Dutch art along with a more painterly Venetian approach to the rendering of landscape. His drawings clearly demonstrate a move away from the more precise linear style of his contemporaries and forerunners toward a broader and freer use of wash combined with fewer lines. Scorel was also very important for the development of Dutch group portraiture, especially the type that later became famous in Amsterdam. He had two pupils of renown. Maerten van Heemskerck was both his student and assistant around 1527/1529 and carried on Scorel's study of ancient Roman art and Italian art, and his master's portrait style. Antonis Mor, Scorel's second great disciple, continued the latter's portrait style and became one of the most distinguished artists of this genre in the Netherlands.

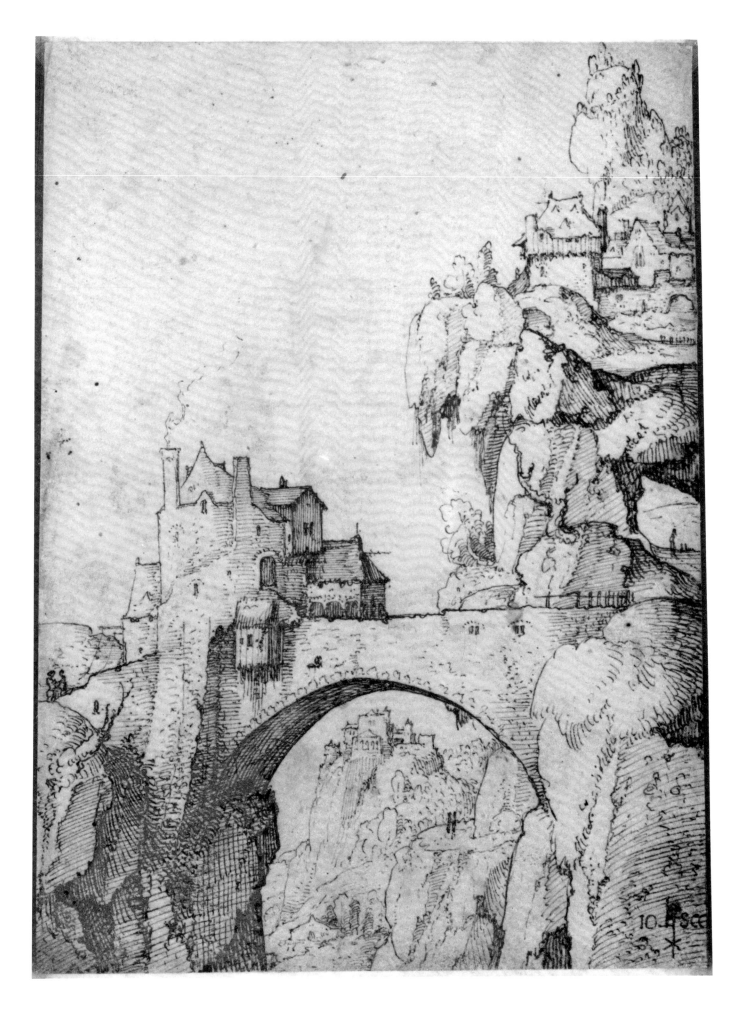

JAN VAN SCOREL

104 *Fantastic Mountain Landscape with a Bridge*

Pen and brown ink
(verso: *castle on the rocks*)

207 X 152 (8⅛ x 6)
Inscribed at lower right corner, *IO SCO*,
divided by a housemark

Provenance: Obach and Co., 1908; acquired by
the museum in 1909

Literature: C. Dodgson, *Vasari Society*, 1910-
1911, First Series, Part 6, no. 17; Baldass 1916,
4; Hoogewerff 1923, 143; Winkler 1926, 15 n.
1; Winkler 1930, 35, 36, 40; Popham 1932, 39,
no. 1; Hoogewerff, *NNS*, 4: 45, 46; Boon 1955,
208, 209; Haverkamp-Begemann 1957, 9; Van
Gelder 1958, 18, 93, no. 14; Brown 1973, 761,
762

Exhibitions: London 1908, no. 51; London
1973, no catalogue

Trustees of the British Museum, London, inv.
no. 1909.1.9.7

Exhibited in Washington only

Both sides of this drawing are executed in
a printmaker's style. There is a strong
emphasis upon line, which contrasts
with the white paper to create the shapes
and light patterns. This technique is sim-
ilar to the woodcut style of Scorel's Am-
sterdam teacher, Jacob Cornelisz. van
Oostsanen, and to that of the Leiden
school around 1520.

The British Museum drawing is part of
a group that Scorel executed during his
trips through the Alps and to the Holy
Land and which includes *View of Bethle-
hem* (British Museum, London),[1] the
Tower of Babel (Fondation Custodia, coll.
F. Lugt, Paris),[2] and the *View of a Town
in a Valley* (Museum Boymans-van Beu-
ningen, Rotterdam).[3] It is possible that
the views on the recto and verso of the
British Museum drawing and the *View of
a Town in a Valley* may have been exe-
cuted during Scorel's return to Utrecht in
1524 via north Italy and the Alps. These
sheets appear to be more advanced than
the others because of their more imagina-
tive, lively, and varied pen strokes, which
suggest a more mature hand. The tech-
nique and rendering of the buildings,
trees, rocks, terrain, and figures are close
to several landscape drawings attributed
to the Leiden school, that is, the follow-
ers of Cornelis Engebrechtsz. These simi-
larities intimate a close relationship be-
tween Utrecht and Leiden in the 1520s.

In the right background of the recto of
the British Museum design, Scorel has
drawn a dramatic overhang and, to the
right, a rock formation with a natural
opening. This ensemble, with minor
changes, was repeated by the master in
his *Portrait of a Man* (Gemäldegalerie,
Staatlichen Museen, Berlin) while only
the overhang was used in the left back-
ground of Scorel's *Saint Mary Magdalene*
(Rijksmuseum, Amsterdam)[4] and, with
slight alterations, in the upper right land-
scape of the Scorel atelier wing represent-
ing the *Martydom of Saint Ursula and
the Eleven Thousand Virgins* (Musée de
la Chartreuse, Douai, inv. no. 2856).[5]
These copies make it clear that the recto
of the British Museum drawing was not a
study for a specific painting but most
likely an imaginary reproduction of na-
ture recreated by Scorel from various de-
tails that he had observed in the Alps,
while the verso might very well be
topographical.[6] JRJ

1. Popham 1932, 39, 40, no. 2.
2. Florence 1980-1981, 184, no. 126, pl. 23.
3. First identified as Scorel by De Tolnay. See Utrecht
1955, no. 120, fig. 118.
4. *Vasari Society* 1910-1911, Part 6, no. 17.
5. Utrecht 1977, fig. 57.
6. Popham 1932, 39.

269

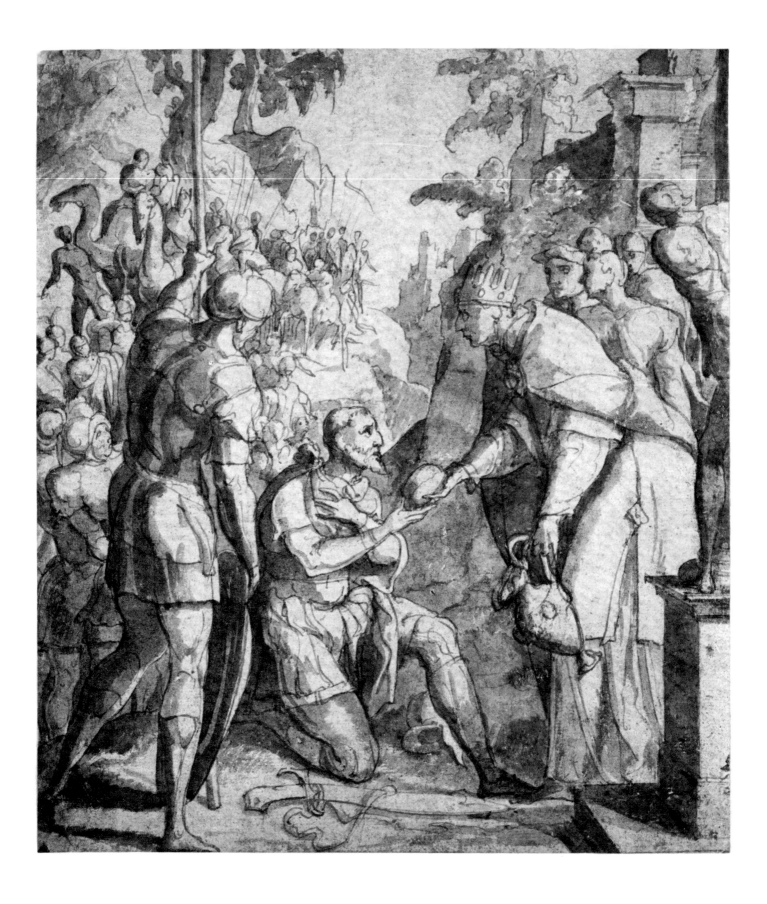

JAN VAN SCOREL

105 Abraham and Melchizedek

Pen, brown ink, and gray wash
218 x 193 (8⁹⁄₁₆ x 7⁹⁄₁₆)

Provenance: Beets, Amsterdam; acquired by P. de Boer in 1941

Literature: Faries 1975, 155-158, 160, 161

Exhibitions: Utrecht 1955, no. 101, Utrecht 1977, no. 38

Fondation P. & N. De Boer, Amsterdam, inv. no. 237

Jan van Scorel's *Abraham and Melchizedek* is different in style from his c. 1524 mountain scenes. The latter contain no wash and rely entirely upon line and paper to conceive the forms. The Scorel *Abraham and Melchizedek* continues to use pen and line and now adds wash in a variety of tones. This drawing can be dated around 1540 because of its similarity in style to the documented c. 1540 design of *The Stoning of Saint Stephen* (Fondation Custodia, coll. F. Lugt, Paris), for the central panel of the *Polyptich of Saint Stephen* (Musée de La Chartreuse, Douai).[1] These are the first known drawings in which Scorel used wash with a diversity of shades to work out the light patterns and indicated the boundaries of the various parts of the anatomy with long and continuous contours. The figures are elongated and exaggerated in their poses, and Scorel placed a repoussoir figure in the right and left corners of each composition to help direct attention to the main action. This fully developed mannerist style is also evident, but with fewer gradations of shading, in Scorel's c. 1540 design of *Ignoto Deo* (Fondation Custodia, coll. F. Lugt, Paris).[2]

In these drawings, executed during the years around 1540, Scorel employed a technique not seen earlier in his preserved oeuvre. However, because his close followers Maerten van Heemskerck (cats. 69-72) and Jan Swart van Groningen (cats. 110 and 111) were making drawings that combined pen and wash in the early 1530s, it is conceivable that Scorel introduced this technique to them.[3] Unfortunately, there is no evidence for this in either his known drawings or in the underdrawings for his panel paintings.[4] It is most likely, following Molly Faries, that Scorel made these wash drawings as supplements to the underdrawings which, in the works around 1540, did not contain a tonal layer. Scorel probably worked out the chiaroscuro effects in these designs, which explains the sudden appearance of wash in his drawings at this time.

The De Boer sheet cannot be connected with a surviving Scorel painting, but it might have been a design for one of the wings of his lost *Altarpiece of the Last Supper* mentioned by Van Mander.[5] Iconographically, the theme of *Abraham and Melchizedek*, with its emphasis upon the bread and wine, belongs to such an ensemble as exists, for example, in Dirck Bouts, *Altarpiece of The Holy Sacrament* (Collegiate Church of Saint Peter, Louvain).[6] JRJ

1. For the documentation see Faries 1975, 132-146, pls. 32, 33; Utrecht 1977, 86-94, figs. 50, 56, and Florence 1980-1981, no. 127, pl. 25.
2. See Faries 1975, 155, 156, fig. 37; Utrecht 1977, no. 37, fig. 69, and Florence 1980-1981, no. 128, pl. 24.
3. For a discussion of this technique and the possible source for this style in German woodcuts of the late fifteenth and early sixteenth centuries, see Judson 1979, 48.
4. I am very thankful to Molly Faries for her generous help concerning this question.
5. Van Mander, *Schilder-boek*, 1: 276-277.
6. Friedländer, *ENP*, 3 (1968): no. 18, pl. 28.

Hans Speckaert

died c. 1577

What little is known about the life of Hans Speckaert derives largely from the testimony of Van Mander, who evidently knew him in Rome. In his life of De Weerdt, Van Mander reported that during his own time in Rome, the outstanding young painter Speckaert was also active there. He noted that he was from Brussels, the son of a braidmaker, and that he died about 1577. By 1575 he was sufficiently established to be painting frescoes in Roman churches, as is indicated by a record of difficulties he and Anthonis van Santvoort encountered with the Guild of Saint Luke. Another document of 1575 refers to him as recently paralyzed. Hence he must have arrived in Rome several years before this date, a supposition that is borne out by his influence on Bartholomeus Spranger.

Speckaert's portrait of the engraver Cornelis Cort in Vienna is the only known painting certainly by his hand. His designs are known from engravings by Cort, Crispijn van de Passe, and others, yet the scarcity of drawn preparations for these prints has made it difficult to attribute drawings securely to him. Moreover, his drawings were frequently copied, and his fluid, elegant style influenced several northern artists in Rome in the 1570s and 1580s, notably Hans van Aachen.

106 Battle of Nude Men

259 x 427 (10³⁄₁₆ x 16³⁄₄)
Pen and brown ink with brown and gray wash on blue paper
Inscribed at lower right, *J.G.E.*

Provenance: C. Molinier (Lugt 2917); J.G.E. (not in Lugt); sale, Christie's, London, 16 May 1978, no. 81

Literature: Amsterdam 1979, 32
Rijksprentenkabinet, Rijksmuseum, Amsterdam, inv. no. 1978: 38

Speckaert's importance as a transmitter of Roman late mannerism to northern artists in the last quarter of the sixteenth century is now recognized.[1] However, the boundaries of his oeuvre have proved difficult to define. A drawing of *The Triumph of David* now at Oberlin, which is copied in reverse in an anonymous engraving bearing his name, and, to a lesser extent, several drawings inscribed with his name are the basis for the attribution of drawings to him.[2] The recently discovered Amsterdam *Battle of Nude Men* shares the friezelike arrangement of active figures with the Oberlin drawing and other related works. As in the Oberlin sheet, the figures are arranged across a foreground stage that drops off at the side to suggest a limited spatial recession. Their foreshortened poses and doughy muscles recall the Düsseldorf *Brazen Serpent* (fig. 1). In these works Speckaert uses wash and open parallel hatching strokes not so much to model form as to lay in broad areas of shadow and to separate figures and groups from the overall mass of bodies.

While nervous pen lines and repeated contours are characteristic of Speckaert, the *Battle of Nude Men* shows to an ex-

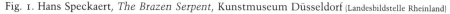

Fig. 1. Hans Speckaert, *The Brazen Serpent*, Kunstmuseum Düsseldorf (Landesbildstelle Rheinland)

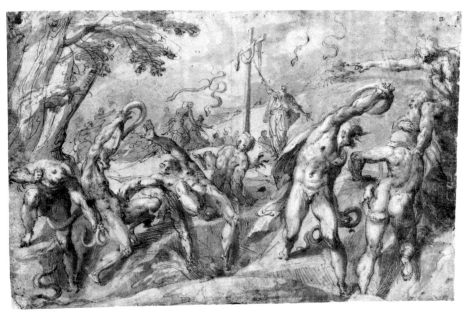

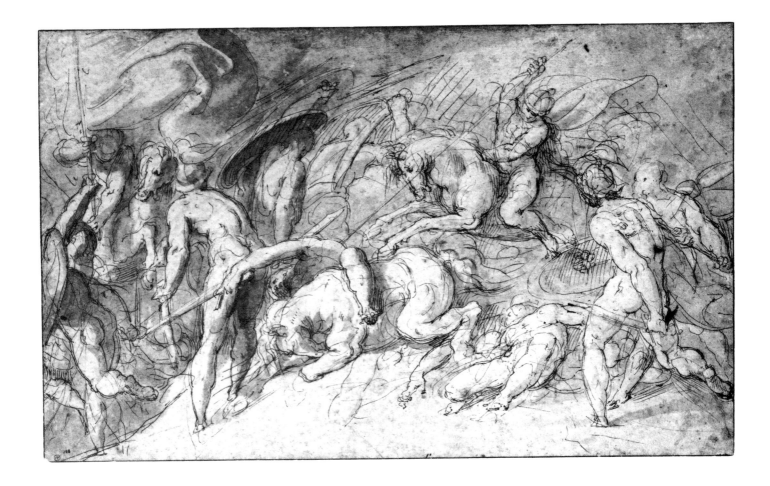

ceptional degree the experimental, prob-
ing quality of his draftsmanship. Figures
were first very lightly drawn in pen and
the angle of limbs or the position of fig-
ures then adjusted and the contours clari-
fied with repeated lines. This process is
readily apparent in the figure moving to-
ward the left, in the mounted horseman
wielding a spear, or in the fallen horse-
man, whose foot was drawn with more
than one angle of foreshortening. Speck-
aert's concern with placement and ges-
ture here is close to that in the stage of
the brazen serpent composition recorded
in drawings in the Albertina and the
Kunstmuseum, Basel, as opposed to the
more fully composed and worked-up
Düsseldorf sheet.[3]

The type of work for which the battle
scene is a study remains unclear. In addi-
tion to making frescoes and designs for

prints, Speckaert, like Spranger, probably
produced easel paintings for collectors.
Several such works have recently been
attributed to him.[4] The precise subject of
the Amsterdam sheet is also unknown,
though the piled up melée of nude figures
recalls Raphael's design for the fresco of
the Battle of Constantine in the Vatican.
Speckaert is known to have made a draw-
ing for this composition that served as a
model for Cornelis Cort's large, unfin-
ished engraving.[5] In particular, the group
of the fallen horse and rider and the foot-
soldier drawing his sword are reminiscent
of figures in the center of the left portion
of Cort's engraving. Raphael's battle
scene may have been a point of departure
for the scene in which other influences,
notably those of Parmigianino and Feder-
ico Zuccaro, combine to produce a rhym-
ically surging mass of figures. MW

1. Valentiner 1932, 163-171.
2. For the Oberlin drawing, formerly in the Liechten-
stein collection, and the anonymous engraving after
it, see Valentiner 1932, 166, and Stechow 1962, 110-
114, repro. For the most recent information on the
problem of attributions to Speckaert, see Kloek 1974,
108.
3. Béguin 1973, 11, figs. 10 and 11. Both the Vienna
and Basel sheets seem to me to be copies after
Speckaert.
4. Béguin 1973, 9-13. *The Conversion of Saint Paul*
cited by Béguin, fig. 8, was sold at Christie's, London,
on 10 July 1981, no. 80.
5. The drawing is mentioned in the inventory of
Cort's estate; Bierens de Haan 1948, 177-178 and 227.
For Cort's engraving, see Bierens de Haan 1948,
fig. 49.

Bartholomeus Spranger

1546-1611

Spranger was born in Antwerp, the son of a merchant. According to Van Mander, he studied first with the landscape painters Jan Mandyn, Gillis Mostaert, and Cornelis van Dalem in Antwerp. In March 1565 he left for Paris, where he stayed briefly, working with the miniature painter Marc Duval before moving on to Italy. After a brief sojourn in Milan and another in Parma, where he worked for Bernardino Gatti on the decoration of the cupola of Santa Maria della Steccata, Spranger arrived in Rome in 1566. There his small landscapes apparently brought him to the attention of Giulio Clovio and Cardinal Alessandro Farnese. From 1570 to 1572 he was in the service of Pope Pius V, painting small easel paintings. After Pius V's death in 1572, Spranger worked independently in Rome, producing some larger religious works of which only the Martyrdom of Saint John the Evangelist *in San Giovanni a Porta Latina survives.*

In 1575 Spranger and the sculptor Hans Mont were called to the court of the Emperor Maximilian II in Vienna through the recommendation of Giovanni Bologna. He continued to work in Vienna following the emperor's death in October 1576, and together with Hans Mont and Karel van Mander (q.v.) produced a triumphal arch for the entry of the new emperor Rudolf II in 1577. In 1580 he joined Rudolf's court in Prague where he painted a series of large mythological canvases of erotic subjects as well as palace decorations for the emperor. He married early in 1582 and was ennobled in 1588. He remained in Prague for the rest of his life, with the exception of brief trips to Augsburg and Vienna and, in 1602, to the Netherlands where he was fêted by his old friend Van Mander and the circle of Haarlem artists whose work he had profoundly influenced.

Spranger's virtuoso drawing style and his tense, artificial figural combinations exercised an immense influence on his Dutch contemporaries, primarily through the intermediary of Van Mander and through the engravings made after his drawings by Hendrick Goltzius (q.v.) beginning in 1585 and, later, by Jan Muller (q.v.) and others.

BARTHOLOMEUS SPRANGER

107 *The Repentant Magdalene*

Pen and dark brown ink, brown wash, and white body color on coarse yellow-brown paper; laid down
255 x 143 (10 x 5⅝)

Provenance: Jean-Francois Gigoux, d. 1894

Literature: Niederstein 1931, 28, no. 38; Oberhuber 1958, 246, 262, no. 9; Reznicek 1961, 68-69, 154; Strauss 1977, I: 362

Exhibitions: Besançon 1950, no. 5; Paris 1957, no. 187; Stuttgart 1979-1980, no. B 10

Musées des Beaux-Arts et d'Archéologie, Besançon, inv. no. D.282

Exhibited in Washington only

Saint Mary Magdalene is represented as a hermit in the wilderness, half-kneeling and half-hovering before a crucifix lying on the ground at the lower left, toward which she directs her gaze. The book in her right hand and the emphatic gesture with which she points to the skull at the bottom right are further indications of her repentant state. The contrast between these attributes of penitence and her exaggerated hip-slung posture and extremely scanty clothing gives the drawing great impact. The drawing's effect is further intensified by Spranger's virtuoso technique as, with a few deft strokes of wash and white heightening, he establishes the unstable, swaying pose.[1] The drawing is essentially a chiaroscuro, with the yellow-brown paper providing a middle tone. The paper's coarse texture accentuates the luminous effect of the thickly applied white heightening.

Reznicek points out that the drawing served Goltzius as the source for his 1585 engraving of the *Repentant Magdalene* (fig. 1),[2] and this may be the only surviving example from the group of drawings by Spranger that Karel van Mander reported having shown to Goltzius upon settling in Haarlem in 1583.[3] While there is a clear connection between the two figures in the emphatic thrust of the hip and the hovering pose, particularly the trailing right foot, Goltzius does not here copy Spranger, nor has he fully absorbed his style. In contrast to the *Adam and Eve* or the *Holy Family* of the same year, Goltzius, not Spranger, is named as the inventor.[4] Moreover, as Oberhuber notes in the case of Goltzius' *Mars and Venus Surprised by Vulcan*, also dated 1585, the influence of the form of mannerism practiced by Antonis van Blocklandt is still present.[5] This is evident in the careful definition of the long curving contours of the limbs and in the rather contained quality of the pose which, despite the

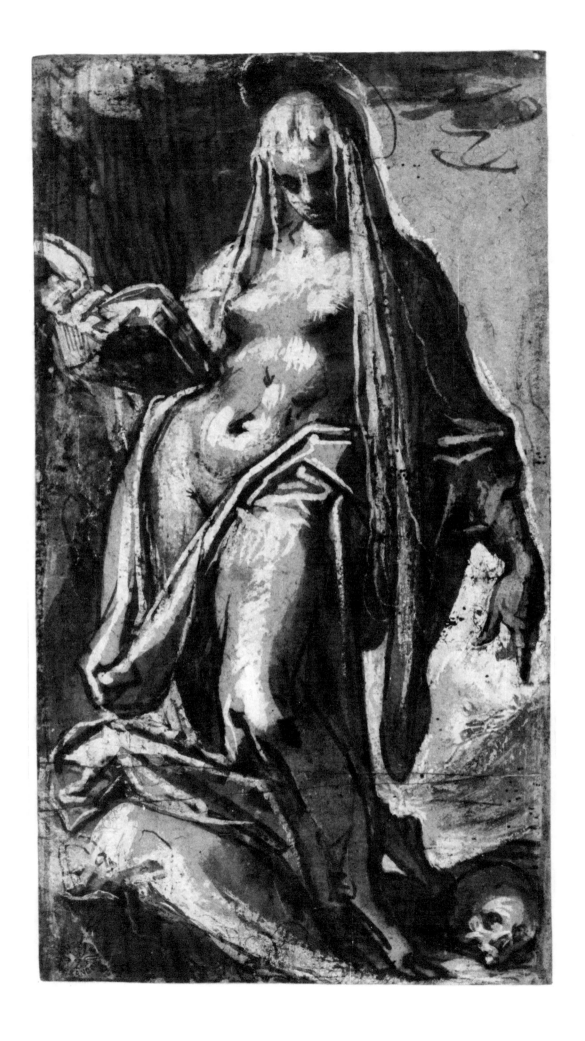

275

Fig. 1. Hendrick Goltzius, *The Repentant Magdalene*, Rijksprentenkabinet, Amsterdam

Fig. 2. Bartholomeus Spranger, *Saint Luke Painting the Virgin*, Alte Pinakothek, Munich

outward-thrusting hip, does not really break out of a single plane. The spherical head and delicate arched eyebrows refer more to Goltzius' own earlier types of the Magdalene than to Spranger's facial type.[6] The engraving based on this drawing, or on a very similar work by Spranger, must therefore be one of Goltzius' earlier efforts at a paraphrase of his style.

Oberhuber and Reznicek assume that the drawings by Spranger that Van Mander made available to Goltzius could be dated no later than 1577, when Spranger and Van Mander worked together on the decorations for the entry of Rudolf II into Vienna.[7] Very few works survive from this period of Spranger's activity in Vienna. The only drawing that can be linked to documented activity of this period is a study in the Albertina, apparently for a ceiling in the *Neugebäude*, Vienna.[8] However, more recently Oberhuber and Kaufmann have come to the conclusion that these influential drawings could have been executed somewhat later.[9] Indeed, in the case of the Besançon drawing, the kinship to the rounded forms of the Vienna sheet is not particularly strong, but the flickering effect of dark into light recalls a grisaille oil sketch dated 1582 in the Alte Pinakothek, Munich (fig. 2).[10] In pose, the Magdalene is very similar to a three-quarter-length *Saint Catherine* in the Gemäldegalerie, Berlin, dated by Kaufmann c. 1583-1585, though the saint is reversed and more effectively draped.[11] MW

1. White body color is also used to correct the pointing hand and the arm holding the book; an earlier pen contour of this arm is visible through the book.
2. Reznicek 1961, 68-69; Bartsch 58, Hollstein 53, 277 x 198 mm. Inscribed, *HGoltzius inuen. et Sculptor/excudebat.* and *A° 1585*.
3. Van Mander, *Schilder-boek*, 2: 240.
4. Bartsch 271 and 274, respectively; Strauss 1977, 1: 356-357 and 360-361, nos. 217 and 219, repro.
5. Oberhuber 1958, 84-85. The *Mars and Venus* (Bartsch 139; Strauss 1977, 1: 354, no. 216, repro.) is likewise in Spranger's style, rather than a reproduction of his invention.
6. Compare his 1582 engraving of the *Magdalene*; Bartsch 57, Strauss 1977, 1: 262-263, no. 155, repro.
7. Oberhuber 1958, 83-84 and Reznicek 1961, 152.
8. Inv. no. 15114; see Benesch 1928, 30, no. 278, pl. 73, who first links the drawing, evidently a design for a cupola, to the lost fresco decorations for the *Neugebäude*.
9. Oberhuber's opinion is cited in Kaufmann 1985, 296-297. See also Kaufmann in Princeton 1982-1983, 142, under no. 49.
10. See An der Heiden 1976, 34-37.
11. Kaufmann 1985, 296-297, no. 20-28, repro.

BARTHOLOMEUS SPRANGER

108 Sheet of Studies for 'Fame Conducting the Arts to Olympus'

Red chalk with white body color, partially oxidized, on brown paper
(verso: *design for a lunette*)
257 X 429 (10⅛ X 16⅞)

Provenance: Elector Carl Theodor of the Palatinate; Königlich Bayerische Graphische Sammlung (Lugt 2723)

Literature: Weihrauch 1937-1938, 7-8; Oberhuber 1958, 80, 170-171, 252, 290, no. 37; Schnackenburg 1970, 151-152, 159; Wegner 1973, 28, no. 109

Exhibitions: Munich 1983-1984, no. 85

Staatliche Graphische Sammlung, Munich, inv. no. 2195

Spranger's influence as a draftsman was based in part on the apparently effortless fluency of his pen and wash drawings, yet this sheet is evidence that his compositions sometimes went through several stages of preparation. The Munich drawing, one of very few sheets of figure studies identified as Spranger's work, includes several motifs for *Fame Conducting the Arts to Olympus*, the large engraving made by Jan Muller in 1597 after Spranger's design (fig. 1).[1] The print unites themes of imperial patronage of the arts and the Turkish threat to Christendom, both common in the work of Spranger and his fellow court artists in Prague during the period of the Turkish wars (1593-1606).[2] The page of studies, together with the rough compositional sketch, probably a battle scene, on the verso (fig. 2), affords a glimpse of Spranger's working method.

As would have been the case with the lost modello, the poses of the figures on the Munich sheet are in the opposite direction from Muller's print. On the left are the intertwined figures of the arts of painting, sculpture, and architecture, which dominate the engraving. In the center is the *amorino* who appears holding the arms of Antwerp to the right of the inscription, while the figure of Neptune, seated in the heavens to the left of Zeus, is drawn twice in varied poses. Spranger must have studied the figures for the arts flourishing under the protec-

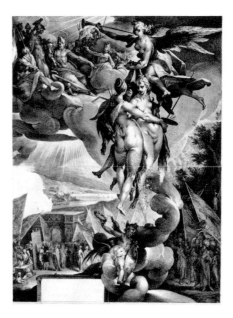

Fig. 1. Jan Muller after Bartholomeus Spranger, *Fame Conducting the Arts to Olympus*, Rijksprentenkabinet, Amsterdam

Fig. 2. Cat. 108, verso

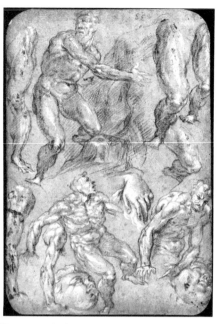

Fig. 3. Bartholomeus Spranger, *Study Sheet*, Fitzwilliam Museum, Cambridge

tion of the emperor, the subordinate scene in the background of Muller's engraving, with equal care. The torso in the bottom right corner of the Munich sheet appears to be that of the artist working at his easel, though Weihrauch identified this figure with the statue of a river god being carved by the sculptor.[3] Weihrauch considered the half-crouching man in the upper right corner to be a study for the pointing figure of Mercury to the right of Zeus in the engraving.[4] However, this pose is the same as that of a man crouching or running beside a rock in a sheet of studies in the Fitzwilliam Museum, Cambridge, attributed to Spranger by David Scrase who notes the resemblance to the Munich studies (fig. 3).[5] This figure does not appear in *Fame Conducting the Arts to Olympus*, nor do the two other crouching or cowering men on the Fitzwilliam sheet, one of which is also studied on the Munich drawing.[6] Hence, Spranger scattered sketches for several complex figural compositions across more than one sheet.

As Konrad Renger notes, the studies are not drawn from life, but from memory, to work out placement and lighting for figures whose general interrelationship was already laid out in a compositional sketch, possibly similar in type to the one on the verso of this sheet.[7] Figures are drawn without drapery and, for the most part, without indication of their support in space. Spranger was evidently concerned with the corporeal effect of each element of his design, yet the liberal

touches of white heightening often remain discrete islands. Also tending to contradict the effort at corporeality is the almost obsessive repetition of body parts, which are often neatly truncated or violently foreshortened. The Munich and Cambridge sheets must have been executed about 1596/1597, a period when Spranger was strongly influenced by Hans von Aachen.[8] According to Van Mander, Spranger credited contact with von Aachen and Joseph Heintz with reawakening his interest in coloristic effects after years of working in relative isolation in Prague.[9] A comparison with von Aachen's chalk figure studies from the same period (fig. 4) reveals a possible stimulus for making this type of drawing, while at the same time underscoring Spranger's urge to particularize and exaggerate the figure.

The compositional sketch on the verso may be for a wall painting, since it has the form of a lunette. There is some evidence that Spranger was involved in the decoration of rooms added to Prague castle in the late 1590s.[10] Although the subject of this composition is unclear, it is possible that both this melée of figures, some wielding pikes or swords, and the repeated, rather schematic horses and riders on the verso of the Cambridge drawing also relate to the Turkish wars. MW

Fig. 4. Hans von Aachen, *Seated Female with Putti*, The University of Michigan Museum of Art, Ann Arbor, Michigan, Gift of H.M. Calmann

1. See Weihrauch 1937-1939, VI-IX, for two other studies of female figures, also in Munich, inv. no. 13696 and 13764, in black chalk with white heightening on blue paper; Wegner 1973, nos. 110 and 111, pl. 41.

2. Bartsch 76, Hollstein 72, 680 x 505 mm, printed from two plates and dedicated to the consuls and senators of Antwerp; for the interpretation of the print and Spranger's probable intention of flattering the Antwerp city fathers, see Hans Mielke in Berlin 1979, no. 20.

3. Weihrauch 1937-1938, VIII.

4. Weihrauch 1937-1938, VIII.

5. Inv. no. 3018, formerly attributed to Tintoretto. On the verso are studies of horses and riders and a putto; inscribed on recto, *88* in upper right corner, on verso in upper left corner, *Palma*. I am most grateful to David Scrase for bringing this drawing to my attention.

6. Compare the man at the bottom right to the head and torso visible between the two sketches for Neptune on the Munich sheet.

7. In Munich 1983-1984, 73.

8. Oberhuber 1958, 170, dates the lost modello shortly before the execution of Muller's engraving, though Diez 1909-1910, 132, and Niederstein 1931, 18, dated it 1592-1593. Von Aachen settled in Prague in 1596, but visited intermittently at Rudolf II's invitation in the preceding years. Von Aachen's influence is evident in the sweeping conception of space in *Fame Conducting the Arts to Olympus.*

9. Van Mander, *Schilder-boek*, 2: 164-166. Oberhuber 1958, 171, observes that it may not be accidental that the surviving chalk figure studies by Spranger are either early, hence in proximity to his Italian years (the two drawings in Munich cited in n. 1 above), or under the influence of renewed contact with Italian art, transmitted by von Aachen and Heintz.

10. See Princeton 1982-1983, no. 52.

11. See Kaufmann 1978, 22-23.

BARTHOLOMEUS SPRANGER

109 *Allegory of Time*

Pen and brown ink, gray wash, and white body color (partially oxidized)

322 x 239 (12¹¹⁄₁₆ x 9⅜)

Inscribed at lower left in white body color, ·*1597*·

Provenance: Dukes of Braunschweig, seventeenth century

Literature: Flechsig 1923, 2: no. 55; Niederstein 1931, 13-14, 25, no. 15; Niederstein 1937, 405; De Tolnay 1943, 132, no. 163; Delen 1944, 83-84; Benesch 1945, 152, 182; Oberhuber 1958, 190-191, 247, 251, 265, no. Z 14

Exhibitions: Paris 1948-1949, no. 64 (no. 67 in Paris catalogue); Nuremberg 1952, no. W. 128; Amsterdam 1955, no. 256

Herzog Anton Ulrich Museum, Branschweig, inv. no. Z 245

Long recognized as an outstanding example of the draftsmanship of Spranger's later years, this sheet has been difficult to date because of Spranger's tendency to employ different drawing styles as it suited his purpose for works of the same period. Niederstein places the drawing about 1590.[1] Oberhuber dates it about 1605, linking it to a sketch of *Fame* of that year in an album in Schloss Ottenstein.[2] Until now, the date 1597 inscribed in slightly oxidized white body color in the shadow to the left of the putto's foot has gone unnoticed. Indeed, the *Allegory of Time* can be linked to other works from the late 1590s when Spranger was influenced by the pictorial effects of his fellow court artists at Prague, Hans von Aachen and Joseph Heintz. The slashing pen line, which reduces features and joints to an almost geometric essence, is comparable to the *Mars and Venus* dated 1596 in Frankfurt and repeated in a replica apparently by Spranger dated 1597 at Smith College.[3] At the same time, wash and body color applied with hatching strokes give the figures a corporeality that balances the decorative line of these drawings. The slender, serpentine form of the female figure in the *Allegory* recalls Venus in the painting of *Venus and Adonis* in the Kunsthistorisches Museum, which Oberhuber dates about 1597.[4] The preparatory drawing for this painting, as reflected in a copy in Karlsruhe, presents further parallels to the Braunschweig drawing in the morphology of the figures (fig. 1).[5]

A drawing now in Wrocław has generally been related to the *Allegory* since it combines two winged personifications of Time with a prancing horse. However, it lacks the energy of the Braunschweig sheet either in the arrangement of the fig-

Fig. 1. After Bartholomeus Spranger, *Venus and Adonis*, Staatliche Kunsthalle, Karlsruhe

ures or in the quality of line, hence it seems unlikely that it is a preparation by Spranger for the same project.[6]

The function of the Braunschweig drawing is unclear. Oberhuber suggests that it is a first sketch, executed with such freedom that it rises to the level of an independent drawing.[7] The way in which the boundaries of the composition are indicated with wash and these boundaries respected by the linear pattern may point to a preparatory study for a painting or an autograph repetition of such a study. The precise significance of the figures and the degree to which they form a legible allegory is also unclear. The female figure is not specifically characterized, but the putto with a scythe evidently represents Time. The winged horse Pegasus is associated with fame and also with fleeting time. Pegasus also appears in scenes of the muses, for example Spranger's drawing of *Minerva and the Muses* in the Albertina, and it is possible that the subject is an allegory of the arts, a common theme in Spranger's work.[8] MW

1. Niederstein 1931, 13-14.
2. Oberhuber 1958, 190-191. For the drawing of *Fame*, see *Osterreichische Kunsttopographie*, 8; 1 (1911): 125, fig. 100.
3. Städelsches Kunstinstitut, inv. no. 14458, dated to the left of the helmet, and Smith College Museum of Art, inv. no. 1963.52, dated on the window ledge; Oberhuber 1970, 221-223, figs. 12 and 13, noting that Spranger repeated his drawings. The inscription, *·B·/ Sprangers/Inventor*, formerly above the date on the Smith drawing, an area now cut out and patched, is still visible in Reznicek 1961, pl. XIV.
4. Oberhuber 1958, 166-167 and 234, no. 60, and Kaufmann 1985, 306, no. 20-62, repro.
5. In an early seventeenth-century album containing various copies, including four after lost drawings by Spranger; see Oberhuber 1958, 166-167, 260-261, nos. Z 79-82.
6. Biblioteka Zakład Narodowy im. Ossolińskich, formerly in Lemberg (now Lvov), inv. no. 8402; Niederstein 1931, 13-14, no. 14, fig. 5. The style of this drawing and the conception of the allegorical figures seems more closely allied to two drawings by a follower of Spranger in the Akademie der bildenden Künste, Vienna, *Allegory of Time*, inv. no. 4296, and *Saturn Devouring His Children*, inv. no. 4295.
7. Oberhuber 1958, 191.
8. For allegories of the arts by Spranger and other Rudolfinian artists, see Kaufmann 1982, 119-148. For Spranger's drawing of *Minerva and the Muses*, see Benesch 1928, 31, no. 281, repro., and Oberhuber 1958, 257, no. 61. Compare also Wtewael's *Parnassus* formerly in Dresden (Lindeman 1929, pl. 1), the date of which has been read as 1594 by Lowenthal 1975, 151-154, no. A-2. Spranger also included Pegasus among the elements of a decorative scheme preserved in a drawing in Munich that Kaufmann believes to be a plan for the sculptural decoration of the Neuer Saal of Prague castle; see Kaufmann 1978, 22-23, fig. 2.

Jan Swart

c. 1500-after 1558

The main source of information for Jan Swart is Karel van Mander's Schilderboek, *which tells us that the artist was born in Groningen, that he worked in Gouda around 1522-1523, and that he painted landscapes, nudes, and figures very much like Jan van Scorel's, especially in his later years. Van Mander goes on to say that Jan Swart traveled to Italy and lived for some time in Venice. The date for this trip is open to question, but it is most likely that he went south early in his career and not after 1530. It is also most probable that Jan Swart journeyed from Venice to Constantinople sometime before executing his 1526 woodcut of Süleyman the Magnificent. Van Mander writes that he knew of no paintings by Jan Swart, but several "excellent" woodcuts. The latter's evolution as a woodcut artist began around 1520 and continued without interruption until 1533, when he also began to etch. His success as a woodcut artist placed him in contact with book publishers in Antwerp, where he lived and worked from about 1524 until about 1528.*

As a draftsman, Jan Swart started in the style of the Antwerp mannerists and later came closer to Dirk Vellert and the mannerism of Pieter Coecke van Aelst. Jan Swart was also touched by Albrecht Dürer and early Roman mannerism.

Jan Swart was not only important as a printmaker, but also as a designer of stained glass windows. His work was of special significance for the Crabeth brothers in Gouda and his most famous pupil was Adriaen Pietersz. Crabeth, who studied with Jan Swart around 1522/1523.

There are no exact dates for Jan Swart's birth and death, but it is most likely that he was born around 1500 and died after 1558 in Gouda.

JAN SWART VAN GRONINGEN

110 *The Schoolmaster of Falerii*

Pen, black ink and gray wash over black chalk
350 x 215 (13¾ x 8⁷⁄₁₆)

Provenance: Gautier; Hone (Lugt 2793); J.F. Keane (sale, Sotheby's, London, 3 December, 1947, no. 35a); purchased by the museum in 1949

Exhibitions: (P. & D. Colnaghi & Co., London, 1924, no. 88)

Lent by the Visitors of the Ashmolean Museum, Oxford, inv. no. 1949

The subject, *The Schoolmaster of Falerii*, is exceptionally rare, and the only other examples known to me are by the seventeenth-century artists Bartolomeus Breenbergh[1] and Nicolas Poussin.[2] This theme, a grand example of Roman virtue (*exemplum virtutis*), is found in Livy V, 27, in Plutarch's *Life of Camillus*, X, and in Valerius Maximus VI, 5.1. In this story of Roman justice, the children of the principal families of Falerii all had the same teacher, who was the outstanding scholar of the city. It was his custom to take the boys outside the city walls to exercise, continuing this practice during the Roman siege. On some days, he remained close to the city gate and on others he went farther away, entertaining the children with games and stories. One day, he went a greater distance than usual and took this chance to hand the children over to the enemy outpost. They were brought to the Roman general, Camillus. The schoolmaster addressed Camillus saying that, by having handed over the children whose fathers ruled the besieged city, he was presenting Falerii to the Romans. Camillus rejected the offer and, in a fury, responded to this terrible act by having the schoolmaster stripped naked and his hands tied behind his back. The children were given rods to beat the traitor back to Falerii. A large crowd watched this extraordinary event from the main gate of the city. The people of Falerii were so impressed by the honesty of the Romans and the justice of Camillus that they surrendered.

In the foreground of the drawing, Jan Swart depicts the children beating the traitorous schoolmaster as they approach the main gate of Falerii. In the left background, the Romans, including the robed Camillus, observe the action from in front of their tents.[2]

During the fifteenth and sixteenth centuries, "Justice Pictures" decorated many town halls in the Netherlands. This design by Jan Swart and the sheet in the Staatliche Kunstsammlungen, Dresden (inv. no. 673),[3] of *The Justice of Cambyses*[4] are similar in size and style. The dimensions are typical of drawings that served as designs for stained glass windows. Consequently, it is more than likely that these two sheets were part of a series showing examples of Roman justice, to be placed in a courtroom of a town hall for those in power to emulate.

Jan Swart's *Schoolmaster of Falerii* is similar to his woodcuts of the late 1520s in the thin trees, the vaguely indicated birds, and the use of clear and continuous contours as well as single-toned wash in contrast with the large areas of white paper.[5] However, in the Oxford design, the figures are more substantial and move with greater ease than in the woodcuts and drawings of the late 1520s, such as the *Four Incidents from the Book of Joshua* (British Museum, London).[6] Jan Swart's more plastic forms are also present in the c. 1530 *Banquet of Esther and Ahasuerus* (Rijksprentenkabinet, Amsterdam).[7] Because of these similarities with the Amsterdam sheet and with landscape details in the designs in London, the Oxford drawing possibly dates from c. 1530.

JRJ

1. Roethlisberger 1980, 65, 66, no. 157, repro.
2. Friedlaender 1964, 22, 31, 36, 39, 52, 140, fig. 27, and Blunt 1966, 102-105, nos. 142-143, ill., for Poussin's pictures done in 1634-1637.
3. Pen, black ink, gray wash, 351 x 211 mm; Baldass 1918, 18, no. 21.
4. For details concerning this subject and its use in the Netherlands as an example of Roman justice, see Van de Waal 1952, 2: 124, under 261 n. 6.
5. Beets 1914, figs. 2-4.
6. Popham 1932, 42, 43, nos. 2-5, pl. XVI.
7. Boon 1978, 162, no. 441; 168, no. 441, repro.

JAN SWART VAN GRONINGEN

111 *Gluttony*

Pen, brown ink, and gray wash
244 X 190 (9⁹⁄₁₆ X 7⁷⁄₁₆)

Literature: Baldass 1918, 14, 19, no. 45;
Popham 1932, 45, no. 13; Renger 1970, 73

Trustees of the British Museum, London, inv.
no. 1872-10.12.3311.13

Exhibited in Washington only

Jan Swart's *Gluttony* (*Gula*) is one of
three extant drawings that must have
been part of a series representing the
Seven Vices. The three, *Gluttony, Pride,*
and *Anger,* are preserved in the British
Museum, London, along with one of the
Seven Virtues, *Temperance.*[1] Unfortu-
nately, the drawings for *Vanity, Avarice,
Luxury,* and *Envy,* the remaining vices,
have been lost, as have six of the Virtues:
Faith, Hope, Charity, Justice, Prudence,
and *Fortitude.*

 Gluttony contains the attributes tradi-
tionally associated with this vice. Since
medieval times, the personification has
been shown drinking from a vessel and
accompanied by a pig.[2] Jan Swart has
added a loaf of bread in the drinker's left
hand and a tablespoon in his hat, symbol
of a wastrel.[3] However, this illustration
showing a figure astride a pig is unusual;
more often the figure, drinking from a
mug, would be standing beside the pig.[4]
Jan Swart's configuration appears later in
Pieter Bruegel's *Gula* of 1557, where the
drinker faces the pigs' back end.[5]
Whether or not Jan Swart's design was
known to Bruegel is impossible to say,
but he does continue Swart's image.

 Because this sheet contains consider-
ably denser areas of shade, because the
landscape is modeled with more subtle
gradations of wash and because the back-
ground is made up of small figures and
antique monuments reminiscent of Jan
van Scorel, the London drawing might
date from shortly after 1540.[6] JRJ

1. Popham 1932, 45, nos. 13-15.
2. Renger 1970, 73.
3. Renger 1970, 73.
4. Compare Cornelis Anthoniszoon's c. 1544 *Gula,*
from his series of the *Seven Vices;* Dubiez 1969, 41,
100, no. 4, fig. 15.
5. For the Bruegel drawing, see De Tolnay 1952,
no. 48.
6. For a date in the 1520s, see Baldass 1918, 14.

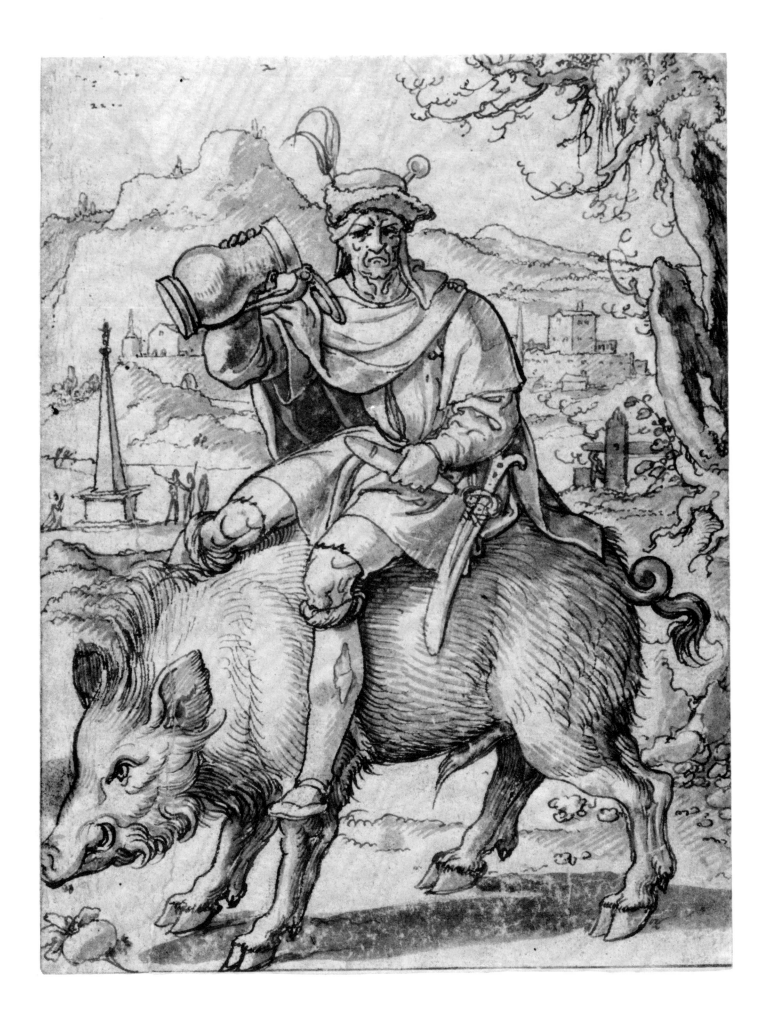

285

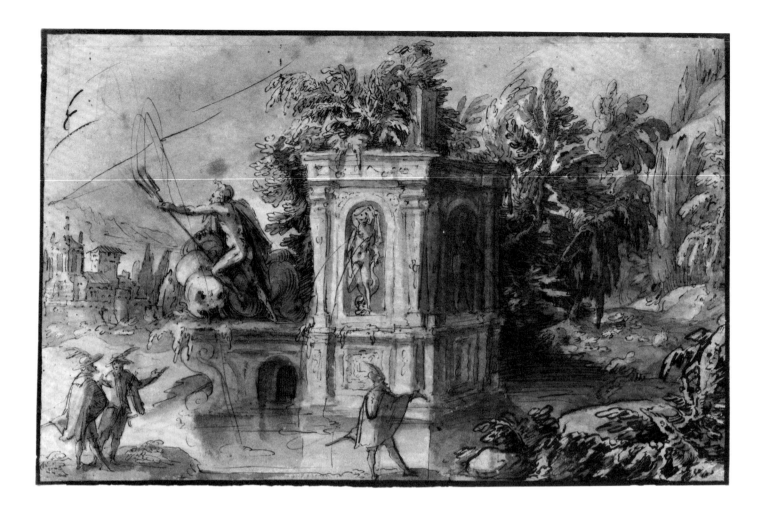

Lodewijck Toeput

c. 1550-c. 1604

Lodewijck Toeput, whose surname means "closed well," was known in Italy as Lodovico Pozzoserrato. We know nothing about him prior to his arrival in Venice c. 1573, except that he was born in Mechelen around the middle of the century. According to Ridolfi's Le maraviglie dell' Arte (1648), he worked in Tintoretto's shop, and painted a picture of the fire that damaged the Doge's Palace in 1577. A drawing of Roman ruins dated 1581 documents a visit to the Eternal City. Perhaps on the same journey to central Italy he sketched a view of Aquapendente near the Lake of Bolsena, which was copied by Joris Hoefnagel and reproduced in Braun and Hogenberg's Civitates Orbis Terrarum (vol. 5, 1598) together with Toeput's panorama of Treviso, the town where he settled by February 1582. Toeput married in Treviso in 1601 and died there c. 1604.

Toeput specialized in imaginary landscapes and biblical scenes. His paintings include decorative frescoes, altarpieces for Treviso churches, and religious canvases for the Monte di Pietà in Treviso, as well as easel pictures. Like his Flemish colleagues Marten de Vos and Pauwels Franck, he executed landscape backgrounds in Tintoretto's paintings before establishing himself as an independent master. With Franck and Jan Soens, Toeput practiced a distinctive style that combines Flemish and Venetian elements: while his broken colors, mannered figures, and spirited brushwork recall his firsthand experience of the paintings of Tintoretto and Veronese, the compositions of his innovative panoramic landscapes attest to his Flemish heritage, occasionally borrowing directly from Bruegel's works.

112 Figures by a Neptune Fountain

Pen and black ink, gray wash
212 x 335 (8⁵/₁₆ x 13⅛)

Watermark: Coat of Arms with the letter H (similar to Briquet 1971)

Provenance: Acquired by the museum before 1756

Staatliche Kunstsammlungen, Kupferstich-Kabinett, Dresden, inv. no. C1970-29

One of Toeput's liveliest and most elaborate drawings, this brilliant *capriccio* is published here for the first time. It was ascribed to Toeput by An Zwollo in 1962, and comparison with securely attributed works by the artist confirms his authorship.[1] Particularly characteristic of Toeput's draftsmanship are the looping contours, some shaded with a delicate wash, that describe the gracefully windblown foliage (fig. 1).[2] The figure types, with their mannered stances and oversized hands, also occur elsewhere in his oeuvre.[3] In addition, the thick, vertically oriented arcs that model the dolphin's flanks closely resemble the strokes used for the identical purpose in *Venus and Amoretti on a Dolphin* (fig. 2), which is signed with Toeput's monogram.[4]

Dated paintings and drawings by Toeput are few and far between, and his chronology difficult to establish. The earliest surviving works, a study of Roman ruins of 1581 and an oil *Landscape with the Tower of Babel* of 1583 or 1587, recall his Flemish origins.[5] The penwork of the drawing brings to mind the technique of Matthijs Bril's Roman views (cat. 18), raising the possibility that Toeput made contact with Bril in Rome. A sketch of a crumbling stele inscribed with a poem in Italian and Dutch is dated 1597,[6] while a trio of landscapes, which were engraved by Jan Sadeler, can be assigned to 1598/1599.[7] These late landscapes miss the deft touch, the linear exuberance, and the free application of the wash that distinguish *Figures by a Neptune Fountain*, and, moreover, they all represent diligently composed panoramic vistas seen from a high viewpoint. The date of the Dresden sheet is perhaps closer to that of *Venus and Amoretti on a Dolphin* (fig. 2), with which, as noted above, it shares certain stylistic features. Judging from the inscription, *hans bruegel In Rooma 1592*, on the verso of *Venus and Amoretti on a Dolphin*, Jan Brueghel must have acquired Toeput's monogrammed drawing in Rome in 1592.[8] Toeput probably executed the study shortly before it came into Brueghel's hands. In the absence of more precise evidence for dating *Figures by a Neptune Fountain*, it, too, should be assigned to the period around 1590.

Toeput executed virtually all his landscape drawings in the pen and wash technique employed in *Figures by a Neptune Fountain*. Except for the early view of Roman ruins discussed above, the landscapes bear witness to his intimate study of the works of Titian, Paolo Veronese, and other Venetian draftsmen. Here, the influence of Veronese's drawings emerges unmistakably in the graphic conventions used to evoke clusters of swaying and drooping foliage, while a few studies with more prominent figures betray a debt to Titian's penwork.[9] These observations apply equally to the drawings of Pauwels Franck, the Flemish master who, like Toeput, worked in Tintoretto's studio and later painted landscapes of a pronounced Venetian character.[10]

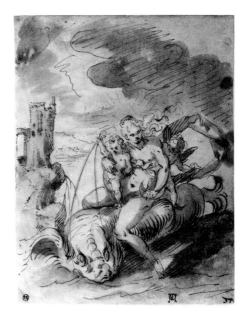

Fig. 2. Lodewijck Toeput, *Venus and Amoretti on a Dolphin*, Nationalmuseum, Stockholm

The Dresden drawing is a delightful fantasy that features an elegant, if overgrown and slightly dilapidated, fountain with whimsical jets of water and over-life-size figures, which appears like an oasis in a poetic landscape on the outskirts of a town. The invention is consistent with the subject matter of other paintings and drawings by Toeput that represent imaginary panoramas with capriciously sited classical ruins or aristocratic gatherings in a refined architectural or garden setting. As far as we know, the drawing was not engraved, nor did it serve as a study for a painting. It may well be an autonomous work of art. WWR

1. Information communicated by Dr. Christian Dittrich, Dresden, whose assistance is gratefully acknowledged.
2. *Landscape with Saint John on Patmos* (fig. 1), the Pierpont Morgan Library, New York, inv. no. 1954.8. See Paris 1979-1980, no. 1.
3. Menegazzi 1957, figs. 51, 70; Haverkamp-Begemann and Logan 1970, nos. 507, 508; Wegner 1963, pl. 20.
4. *Venus and Amoretti on a Dolphin* (fig. 2), Nationalmuseum, Stockholm, inv. no. 1347-1868. See Wegner 1961, 111, fig. 124; Stockholm 1984, no. 296.
5. Franz 1969, 304-305; figs. 450-451.
6. Schapelhouman 1979, no. 75.
7. Franz 1969, 307; figs. 454-456.
8. For a reproduction of the inscription on the verso, see Winner 1961, 191, fig. 1.
9. For the handling of the foliage, compare Veronese's drawings, Cocke 1984, nos. 36, 41. For the figures, compare Toeput's work, Wegner 1963, pl. 20, and Titian's drawing, Venice 1976, no. 34. A Venetian drawing assigned by H. Tietze and E. Tietze-Conrat 1944, no. 2204, to Carletto Caliari is especially close to Toeput's style, both in the figures and in the rendering of the foliage.
10. On Franck's drawings, see Haverkamp-Begemann 1962, 68-75.

Fig. 1. Lodewijck Toeput, *Landscape with Saint John on Patmos*, The Pierpont Morgan Library, New York

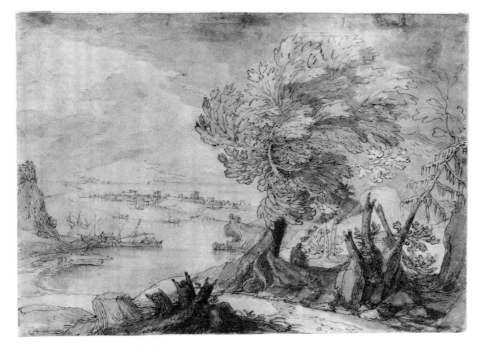

Dirk Vellert

active c. 1511-1547

Dirk Jacobsz. Vellert is first mentioned in 1511 when he became a master in the guild of Saint Luke in Antwerp. He was dean of the guild in 1518 and 1526, and, between 1512 and 1530, regularly presented pupils to the guild. Dürer mentioned Vellert three times in his diary; the last reference was to a banquet given for the German artist by Vellert on 12 May 1521. In 1539/1540 Vellert's assistants were mentioned as being paid drinckgeld *for work on a stained glass window in the Church of Our Lady, Antwerp. Vellert was still alive in December of 1547 when he granted power of attorney to two Amsterdam lawyers. Vellert was unknown to critics of succeeding centuries until 1901 when Glück identified him as the author of a group of works signed D☆V.*

Vellert was proficient in a variety of media: stained glass, etching, engraving, and woodcut, as well as painting and drawing. Almost all of his drawings are for stained glass roundels or windows, and his most important surviving works in this medium are several windows at King's College Chapel, Cambridge. Vellert's earliest work is the stained glass roundel, The Triumph of Time *(Musées Royaux d'Art et d'Histoire, Brussels), dated 21 April 1517, while the latest is the 1544 engraving,* The Flood. *Many of his etchings, engravings, and drawings are dated to the day and month, as well as the year. Vellert's style reflects the diversity of influences possible in Antwerp in the early sixteenth century: Mantegna and Marcantonio Raimondi, Lucas van Leyden and Albrecht Dürer, as well as the Antwerp mannerists, Quentin Massys and Jan Gossaert. The influence of Bernard van Orley and Pieter Coecke has also been noted in Vellert's later work.*

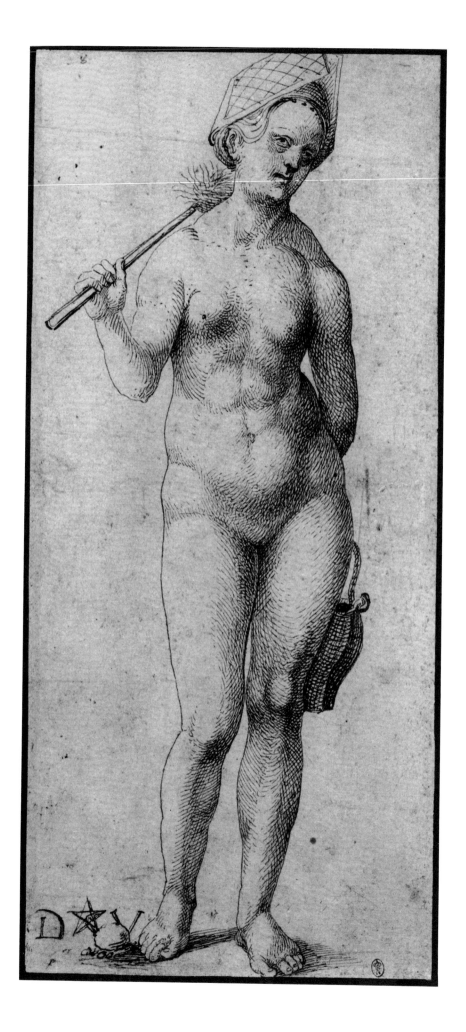

DIRK VELLERT

113 *Bather*

Pen and black ink; laid down

280 x 125 (11 x 4¹⁵⁄₁₆)

Watermark: At right edge center, illegible

Inscribed at lower left, *D☆V*

Provenance: Probably Paul Bourgevin Vialart, Count of Saint Morys; entered the Louvre during the French Revolution (Lugt 1955)

Literature: Glück 1901, 25-26 (1933, 116); Rooses 1902, 169-170; Meder 1919, 397; Popham 1925a, 210; Popham 1925b, 350; Popham 1926a, 32, no. 56; Held 1931, 92-94; Popham 1932, 19; Delen 1944, 59-60; Lugt 1968, 35, no. 107

Exhibitions: Brussels 1977, no. 356

Cabinet des Dessins du Musée du Louvre, Paris, inv. no. 18.804

An outstanding example of Vellert's draftsmanship, the *Bather* is unique in Vellert's oeuvre as the only drawing not directly related to a project in another medium, such as stained glass or engraving. Several authors have assumed this is a study from nature, which, if true, would be Vellert's only life study and the sole example of its type in early Netherlandish art.[1]

Held, however, demonstrates that the Louvre sheet is copied from one of Albrecht Dürer's proportion studies, most probably one now in the British Museum (fig. 1).[2] The woman depicted on the verso of Dürer's drawing, monogrammed and dated 1500, corresponds closely in pose, body type, and even coiffure, with Vellert's figure. The left leg in Vellert's drawing deviates from Dürer's, but is quite similar to the alternate position of the right leg on the recto (fig. 2) of the British Museum drawing. The attributes of a bather, or more likely a bathhouse attendant, were thus added to provide a context, for, as Held observes, it is hard to imagine the arm held behind the back reaching the bucket. Vellert also emulated Dürer's technique of modeling by means of short strokes and groups of curving parallel lines that intersect to form areas of shading. In Vellert's hands the effect is denser and the line more brittle and engraving-like. Ames thinks the contour line might have been traced.[3]

Exactly how Vellert came by Dürer's drawing is not known. The two men were acquainted. In January, 1521, Dürer presented Vellert with the Apocalypse series and six Knots, and on 12 May of the same year Vellert gave a banquet for the German artist.[4] Only Held discusses the date of the Louvre *Bather*, placing it in the early 1520s.[5] It was conceivably executed at the time of, or after, Dürer's vis-

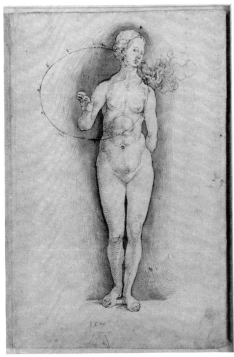

Fig. 1. Albrecht Dürer, *Proportion Study*, verso, The British Museum, London (Courtesy of the Trustees of The British Museum)

Fig. 2. Albrecht Dürer, *Proportion Study*, recto, The British Museum, London (Courtesy of the Trustees of The British Museum)

its to Antwerp. Dürer's profound influence on Vellert is well known, but here one wonders if the Antwerp master copied a proportion study in an effort to understand the theoretical basis of Dürer's art.

The brush, bucket, and curious headgear, which functioned like a shower cap, identify this woman as a bather or bathhouse attendant. Bathing was an integral part of life in the Middle Ages and Renaissance, but subject to differing moral interpretations. On the one hand, bathing was considered beneficial and therapeutic, and in the sixteenth century the sexually segregated bathhouse was the respectable norm, witness Dürer's 1496 drawing of a women's bath (formerly Kunsthalle, Bremen) and his woodcut of a men's bath.[6] On the other, mixed bathing and the eating, drinking, and music-making that accompanied it were an invitation to licentious behavior. The public bathhouse was often synonymous with the brothel, and the bathhouse attendant barely a step removed from a prostitute.[7]

For the artist, the bathhouse was a source of nude models and, conversely, provided the rationale for depicting male and female nudes in a contemporary setting.[8] In this regard, it is interesting that the only other early Netherlandish drawing of bathers, the large sheet in the British Museum attributed to Gossaert, is not a nature study but a gathering of figural quotations from antique and contemporary art.[9] For both Vellert and Gossaert the bath provided a suitable and justifiable context for representing the female nude. JOH

1. Delen 1944, 59-60; Lugt 1968, 35, no. 107; Glück 1901, 25-26, also suggests that it might be a preparatory study for a Bathsheba.
2. Held 1931, 92-94. For Dürer's drawing see Panofsky 1948, 2: 152-153, nos. 1627-1628; Strauss 1974, 2: 548-551.
3. Meder-Ames 1978, 2: 70.
4. Goris and Marlier 1971, 66-67, 81, 89. Vellert is first mentioned in Dürer's diary in September 1520, when he sent Dürer some red color in brick form.
5. Held 1931, 93, compares the form of the monogram, particularly the irregularly shaped *D*, with those on the first engraving, dated 1522. Ellen Konowitz, who is preparing a doctoral dissertation on Vellert, also dates the drawing after Dürer's visit to Antwerp. I am grateful to Ms. Konowitz for discussing her work with me.
6. Washington 1971, 161-162, no. 84.
7. See Cologne 1976, for the social history of baths and bathing in northern Europe in the fifteenth and sixteenth centuries.
8. This point is emphasized by Meder 1919, 394-397; Delen 1944, 59-60; and Lugt 1968, 35. An early example is the drawing in Berlin, attributed to Pisanello, repro. Meder 1919, 395.
9. Popham 1932, 18-19, no. 2; Folie 1951, repro. 93, noted such diverse sources for poses as the *Spinario*, Raphael, Jacopo de'Barbari and Dürer. Herzog 1968, 426-427, no. D26, assigns the drawing to Gossaert's atelier and dates it to the 1520s or later.

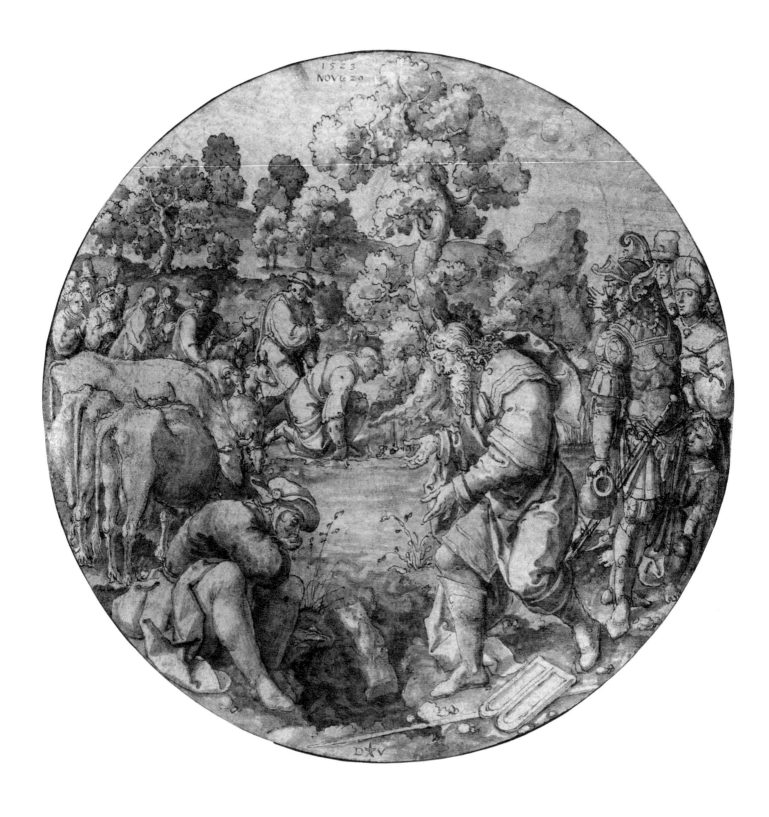

DIRK VELLERT

114 *Moses Sweetening the Waters at Marah*

Pen and brown ink, gray wash, traces of black
chalk; laid down
Diameter 285 (11³⁄₁₆)
Inscribed at top, *1523/ NOVE 29*; at bottom,
D☆V

Provenance: E.G. Harzen, Hamburg (Lugt
1241, no mark)

Literature: Beets 1912, 144; Boon 1964, 156

Hamburger Kunsthalle, Kupferstichkabinett,
Hamburg, inv. no. 22546

Seldom depicted in Netherlandish art,
the subject of this drawing is found in the
Book of Exodus, 15: 22-25.[1] Having passed
through the Red Sea, Moses led the Israel-
ites into the wilderness where, after three
days without water, they arrived at the
waters of Marah, which were, however,
too bitter to drink. At the lord's behest
Moses threw a tree into the waters, which
rendered them sweet. Here, Moses ap-
pears to have thrown a log into the pool.

Illustrating Vellert's as yet unexplained
penchant for putting the day and the
month as well as the year on many of his
drawings and prints, the Hamburg draw-
ing is a preparatory design for a stained
glass roundel. Ellen Konowitz believes
that this drawing belongs to a previously
unrecognized cycle of roundels that jux-
taposed one or two Old Testament scenes
to a New Testament scene. Thus, the
Hamburg drawing would have been
paired with its typological counterpart
from the New Testament, *The Marriage
Feast at Cana* (fig. 1; British Museum,
London), which is dated four days earlier,
to 25 November 1523.[2]

The series appears to have been exten-
sive; in addition to the drawings men-
tioned above, another ten drawings of
Old and New Testament scenes date
from the same year.[3] The roundels them-
selves are not extant. If surviving works
are any indication, this was a very pro-
ductive year for Vellert, for an additional
five etchings and engravings are dated to
1523.[4]

Along with Aerdt Ortkens, Dirk Vellert
was the foremost stained glass designer
in the Netherlands in the sixteenth cen-
tury and *Moses Sweetening the Waters of
Marah* is typical of his work in this me-
dium in the early 1520s. Vellert was thor-
oughly at ease with the compositional re-
strictions of a circular format. Here, by
opening up the center of the composition,
Vellert created a visual link between
Moses' act of throwing the tree into the
water and its consequences, the figure
filling his jug at center. The execution is

Fig. 1. Dirk Vellert, *The Marriage Feast at
Cana*, The British Museum, London (Courtesy of
the Trustees of the British Museum)

marked by a certain speed and assurance
in handling pen and wash, and the draw-
ing as a whole is more tonal and less
graphic than Vellert's work of the 1530s
(see *Abraham and Pharaoh [?]*, cat. 115).

Like that of such contemporaries as Jan
Gossaert and Bernard van Orley, Vellert's
figure style blends southern and northern
elements. The rounded, muscular figure
in the left foreground drinking from his
cupped hand appears Italianate, while the
angular, slightly awkward pose of Moses
is more indigenously northern. This lat-
ter posture was a favorite of Vellert's
and was used for protagonists in several
drawings and prints, but here, since it
is the inner leg that is thrust forward,
there is a greater contrapposto in the
lower body.[5] JOH

1. Beets 1912, 144, identified the subject. This theme
appears on the interior left wing of Joos van Ghent's
Crucifixion altarpiece of c. 1465 (Cathedral of Saint
Bavo, Ghent), Friedländer, *ENP*, 3 (1968): no. 100, pl.
104. Réau, *Iconographie*, 2: part 1 (1956), 200, lists, in
addition, only a stained glass window in the church
of Saint Catherine at Oppenheim and a miniature in
Les antiquités judaïques in the Bibliothèque Nation-
ale, Paris, Ms.fr.247, fol. 49.
2. I am very grateful to Ms. Konowitz, who is prepar-
ing an article on Vellert's drawings of 1523, for shar-
ing her ideas with me in a letter of 27 March 1986.
For the British Museum drawing see Popham 1932,
no. 4.
3. *Moses and the Burning Bush*, dated 31 March, *Gid-
eon in Prayer* (Staatliche Museen, Kupferstichkabi-
nett, Berlin), *The Passage of the Jews through the
Red Sea, Moses Showing the Tablets of the Law*,
dated 25 November, *The Sermon on the Mount*,
dated 25 November, *Christ and the Man of Caper-
naum*, dated 29 November, the same day as the Ham-
burg roundel (Staatliche Kunstsammlungen, Wei-
mar); *David's Escape out of a Window* (Albertina,
Vienna); *The Flight into Egypt*, dated 11 July, *The
Massacre of the Innocents, Naaman Bathing in the
Jordan*, dated 26 November (British Museum,
London).
4. *Jesus Calling Saints Peter and Andrew*, dated 30
May (Bartsch 3); *The Temptation of Christ*, dated 11
April (Bartsch 5); *Christ and the Samarian Woman*
(Bartsch 6); *A Sleeping Man*, dated 10 October
(Bartsch 15); and *A Drummer and a Boy*, dated 14
October (Bartsch 17). For Vellert's graphic work see
Popham 1925b, and Washington 1983, 318-325.
5. For instance, in the drawings of the *Temptation of
Christ* and *Christ and the Man of Capernaum* in
Weimar and the engraving *The Temptation of Christ*
cited above.

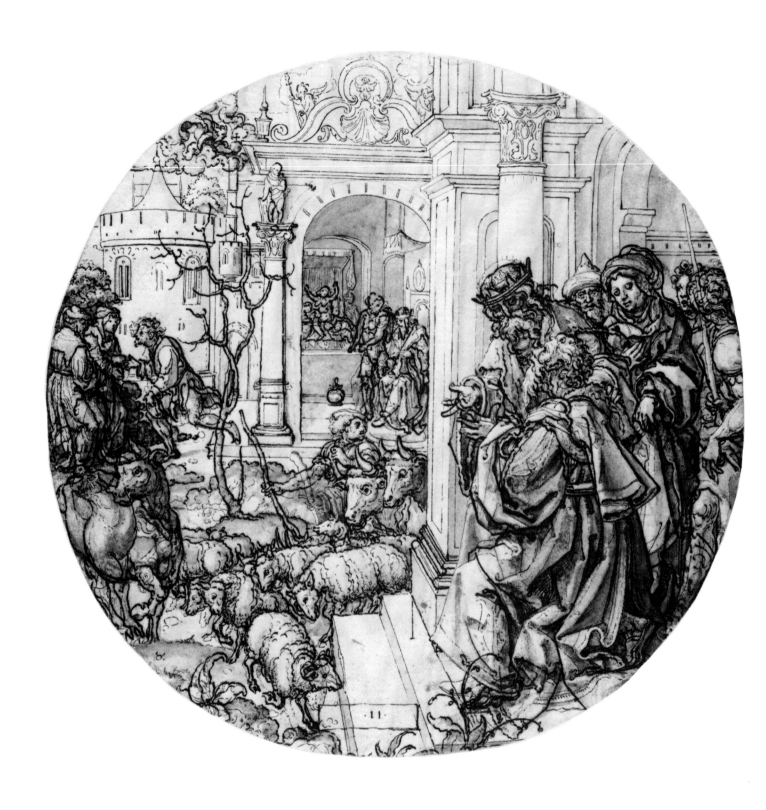

DIRK VELLERT

115 *Abraham and Pharaoh (?)*

Pen and black ink with gray wash over traces
of black chalk
Diameter 274 (10¾)

Watermark: Small crowned jug, similar to Bri-
quet 12629

Inscribed, at bottom center, ·*11*·; at lower left, ♉
Inscribed on verso, *teckening antijck 5
schellingen*

Provenance: Earl of Essex, Cassiobury Park
(sale, Hodgson's, 24 November 1922, no. 875)

Literature: Popham 1925a, 206-208; Popham
1932, 51-52, no. 8; Wayment 1972, 19-20

Trustees of the British Museum, London, inv.
no. 1923.4.17.1

Exhibited in Washington only

The radiant beauty of stained glass was available to the well-to-do in northern Europe in the form of roundels. Popular in the fifteenth and sixteenth centuries, roundels were set into the windows of domestic interiors, and narratives, such as biblical subjects, were sometimes arranged horizontally or vertically in series.[1]

This drawing is a preparatory study for a stained glass roundel. The subject has not been identified with complete certainty, but most probably illustrates events from the twelfth chapter of Genesis. Fearful that he will be killed by the Egyptians because of his beautiful wife, Sarah, Abraham asked Sarah to pretend to be his sister. Attracting Pharaoh's attention, Sarah was brought into Pharaoh's harem and because of this Abraham prospered. In the right foreground, Pharaoh presents the kneeling Abraham with sheep, oxen, and a herdsman. The woman standing behind Pharaoh is probably Sarah. In the background the woman in bed before Pharaoh and the person next to the enthroned Pharaoh is probably Sarah as well. When Pharaoh found that Sarah was married to Abraham he expelled both, but let Abraham keep his possessions.

A second drawing in the British Museum depicts episodes from the eighteenth chapter of Genesis: the lord appearing to Abraham, and Abraham entertaining the angels.[2] Both drawings are from a series of roundels on the history of Abraham. Since the incidents shown on this drawing are seldom represented, it is possible that the series was rather extensive. A stained glass roundel by Vellert, *Abraham Prostrating Himself before the Lord* (Rijksmuseum, Amsterdam; fig. 1) is possibly an extant work from the series, or related to it.[3]

Abraham and Pharaoh (?) is especially interesting for the insights it offers into the working methods of one of the finest glass designers of the period. Over an outline drawing done in a very fine, even line, the artist reworked and modified the composition using a thicker, bolder line and darker washes. The architectural setting was, for the most part, left intact, but in the figures and animals there are numerous alterations and refinements. Abraham's robe is changed, the sheep have been repositioned, and, in the background, the figures of Sarah and Abraham have been modified and strengthened. The addition of the leafless tree at the left helps to define the middle-ground space.

It is likely that, in Vellert's shop, a composition went through several stages of revision before being finally executed

Fig. 1. Dirk Vellert, *Abraham Prostrating Himself before the Lord*, Rijksmuseum, Amsterdam

in glass; the exact process, however, is not known to us. Popham suggested that the fine line drawing was a tracing of an earlier composition of the same subject.[4] This portion of the drawing is quite possibly a tracing; not only would it save the artist from having to redraft large portions of the scene, but it is the kind of work that could be relegated to an assistant. The British Museum sheet is not pricked, and one assumes that the revised composition was again traced or copied in some manner before a final design was achieved.

Abraham and Pharaoh (?) and its companion piece are dated late in Vellert's career. On the basis of their similarity to the 1532 drawing of *The Adoration of the Magi* (fig. 2) (Albertina, Vienna) and others apparently from the same series,[5] Popham dates the British Museum drawings c. 1532. Wayment believes that around 1535/1540 Vellert reworked designs done fifteen or twenty years earlier.[6] Although Vellert's style does not change radically, *Abraham and Pharaoh (?)* and other late works are marked by a greater richness and density of spatial and figural composition, some of this due to the influence of Bernard van Orley and Pieter Coecke van Aelst.[7]

The precise purpose and meaning of the markings on the drawing is not known. The astrological symbol for Taurus, ♉, is similar to the symbols found on other drawings from the collection of the Earl of Essex.[8] What appears as a figure eleven inside a tablet might refer, incorrectly, to the eleventh chapter of Genesis or the position of the drawing in the series. JOH

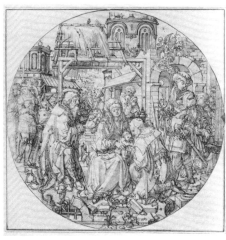

Fig. 2. Dirk Vellert, *The Adoration of the Magi*, Graphische Sammlung Albertina, Vienna (Fonds Albertina)

1. Hans Memling's 1487 diptych of the *Virgin and Child and Martin van Nieuwenhove* (Hospital of Saint John, Bruges; repro. Friedländer, *ENP*, 6: 1 [1971]: no. 14, pls. 52-53) is an often-cited depiction of an interior containing stained glass roundels. For a discussion of domestic stained glass in the Netherlands see Popham 1928, Rackham 1936, 103-112, and Gibson 1970.
2. Popham 1932, 52, no. 2; repro. Wayment 1972, pl. 6.3.
3. No. N.M. 3154, diameter 280 mm, signed *D☆V*; discussed by Popham 1929, 156, and Beets 1925, 119-120. A variant of this roundel, with a different architectural setting, is in the Victoria and Albert Museum, London; see Rackham 1936, 110, pl. 47A.
4. Popham 1932, 52, states that the model was probably an old glass roundel, but it might also have been a drawing.
5. Benesch 1928, 7, no. 41; other drawings associated with the series are the *Birth of the Virgin* and the *Birth of Christ* (Staatlichen Kunstsammlungen, Weimar), and the *Presentation in the Temple* and the *Marriage of the Virgin* (British Museum, London).
6. Wayment 1972, 19-20. I see nothing in the style of the initial line drawing that would confirm or deny this assertion.
7. See Wayment 1958, 99-101; Wayment 1972, 20; Boon 1964, 156. The dating of several of Vellert's drawings is still a matter under discussion; the *vidimus* for the windows at King's College Chapel, Cambridge (Bowdoin College Museum of Art, Brunswick, Maine) is dated c. 1523 by Boon 1964, 156, and c. 1538 by Wayment 1972, 20.
8. In addition to the drawings by Vellert in the British Museum mentioned above in n. 5, and catalogued in Popham 1932, 51, nos. 6-7, an Antwerp mannerist drawing, *The Virgin Ascending the Steps of the Temple*, also from the collection of the Earl of Essex, is marked with an arrow and crescent; see Popham 1932, 71, no. 27.

Paulus van Vianen

c. 1570-1613

Paulus van Vianen was born about 1570 into a Utrecht family that produced several silversmiths, including his brother Adam (see cat. 117). At the age of ten, Paulus began a four-year apprenticeship with the Utrecht silversmith Bruno Ellardsz. van Leydenberch. He completed his training with Bruno's brother, Cornelis, before embarking on a journey to France, Germany, and Italy. By 1596 he was in Munich, where he became a citizen in 1598 and a master in the goldsmith's guild in 1599. In Munich he enjoyed the patronage of Duke Maximilian. Van Vianen moved to Salzburg by 1601, entering the service of the great Maecenas Archbishop Wolf Dietrich von Raitenau, who was particularly fond of luxury objects executed in precious metals.

In December 1603, Van Vianen became court goldsmith to the Emperor Rudolf II in Prague. He remained there until his death in 1613.

Van Vianen created a large oeuvre of tazze, ewers, dishes, plaquettes, and medals in gold, silver, lead, and bronze. The reliefs on these objects usually depict biblical and mythological subjects. While his earliest works, produced in Munich, recall sixteenth-century Nuremburg metalwork, around 1600 he developed a highy refined variant of the Netherlandish late mannerist style exemplified in the works of Goltzius. After about 1605 he began to imitate High Renaissance models, particularly works by Raphael and Dürer.

116 *Forest Scene*

Pen and brown ink, gray wash; laid down
193 x 281 (7⁹⁄₁₆ x 11¹⁄₁₆)
Inscribed at lower right, in brown ink, *N. 32*

Provenance: Miklós Esterházy (Lugt 1965)

Literature: Gerszi 1970, 266, 269; Gerszi 1971, no. 303; Gerszi 1982, no. 28; Ter Molen 1984, 2: 59, no. 243 (PDa)

Exhibitions: Budapest 1932, no. 55; Budapest 1967, no. 66; Salzburg 1983, no. 30

Szépmüvészeti Múzeum, Budapest, inv. no. 1399

Paulus van Vianen is best known as one of the most brilliant mannerist silversmiths, whose exquisitely chased reliefs on plaquettes and luxury vessels captivated his aristocratic patrons at the courts of Munich, Salzburg, and Prague. Less celebrated, but scarcely less momentous, are his sensitively rendered landscapes, which are among the earliest nature studies of their kind in Netherlandish art.

About eighty-five drawings by Van Vianen have come down to us.[1] Of the sixteen that depict biblical or mythological subjects, several served as compositional or detail studies for reliefs in gold, silver, or bronze (see cat. 117).[2] More than sixty sheets represent landscapes or topographical views.[3] The largest and most notable group dates from 1601-1603 and features scenery in and around Salzburg. Gerszi has partially reconstructed two of the sketchbooks Van Vianen used during his Salzburg sojourn. The drawing exhibited here once belonged to the larger of these volumes, many pages of which are preserved in the museums in Budapest and Berlin.[4]

Although a couple of the Salzburg drawings include Roman ruins translated incongruously into an alpine setting, most are realistic, topographically accurate panoramas of the city and the surrounding mountains, or forest scenes with rocky outcroppings, rugged stream beds, and eroded banks. A few studies focus on individual trees (fig. 1), and one fascinating sheet shows a pair of draftsmen sketching diligently in the woods (fig. 2).[5]

The Budapest *Forest Scene* epitomizes the immediacy of these studies as well as the delicate and luminous technique in which they were executed. With the exception of the Small Landscapes (cat. 87) and perhaps a handful of Bruegel's Alpine scenes (cat. 24), the only sixteenth-century Netherlandish views made from nature were topographical drawings of towns and other notable sites. This type of intimate and informal glimpse of the forest interior, unconstrained by the compositional formulas of late sixteenth-century landscape art, is an important innovation in Netherlandish draftsmanship. As precedents for these drawings, Gerszi could cite only the precocious landscape studies by Dürer, which Van Vianen could have seen during his years in Munich.[6]

Van Vianen's technique combines exceptionally fine pen lines, which render details with steely clarity and precision, and broad washes that evoke subtle fluctuations of shadow, light, and atmosphere. While some of the mountain panoramas betray a slight debt to Bruegel's compositions and penwork, the handling of the forest scenes is entirely original. The juxtaposition of carefully finished details with large areas summarily described by a few sketchy lines and passages of wash greatly enhances the spon-

taneity of these sheets. Van Vianen's loose technique and his direct approach to nature inspired similar studies executed in Bohemia and Tirol by Roelandt Savery (see cat. 101) and Pieter Stevens.[7]

His *naer het leven* studies in the Alpine forests contributed significantly to the development of Van Vianen's metal reliefs. The landscape elements in his plaquettes of the 1590s were either invented by him or lifted from German and Netherlandish prints, such as those of Hieronymus Cock. From 1603-1604 onward, he transcribed many of the strikingly naturalistic landscape details in his reliefs from the pages of his Salzburg sketchbooks.[8] WWR

1. Gerszi 1982, catalogues eighty-three works as original drawings by Van Vianen. Her nos. K2 and K3, which she lists as copies after Van Vianen, are originals, as pointed out in the sale catalogue Amsterdam, Sotheby Mak van Waay, 15 November 1983, lots 140, 141. See cat. 117, n. 2.
2. Gerszi 1982, nos. 65, 68, 70, 77, 78.
3. Gerszi 1982, nos. 1-64, 82, 83, K2 K3 (see n. 1 above).
4. Salzburg 1983, gives the most thorough account of the Salzburg sketchbooks.
5. For the study illustrated in fig. 1, see Gerszi 1982, no. 43. The work reproduced in fig. 2 is Gerszi 1982, no. 10.
6. Gerszi 1982, 18-19.
7. Gerszi 1982, 35.
8. Gerszi 1982, 17-18; Ter Molen 1984, 1: 26-27, 52-53.

Fig. 1. Paulus van Vianen, *Tree by a Swamp*, Staatliche Museen Preussischer Kulturbesitz, Kupferstichkabinett, KDZ 13616, Berlin (Jörg P. Anders)

Fig. 2. Paulus van Vianen, *Two Draftsmen in a Forest*, Staatliche Museen Preussischer Kulturbesitz, Kupferstichkabinett, KDZ 13612, Berlin (Jörg P. Anders)

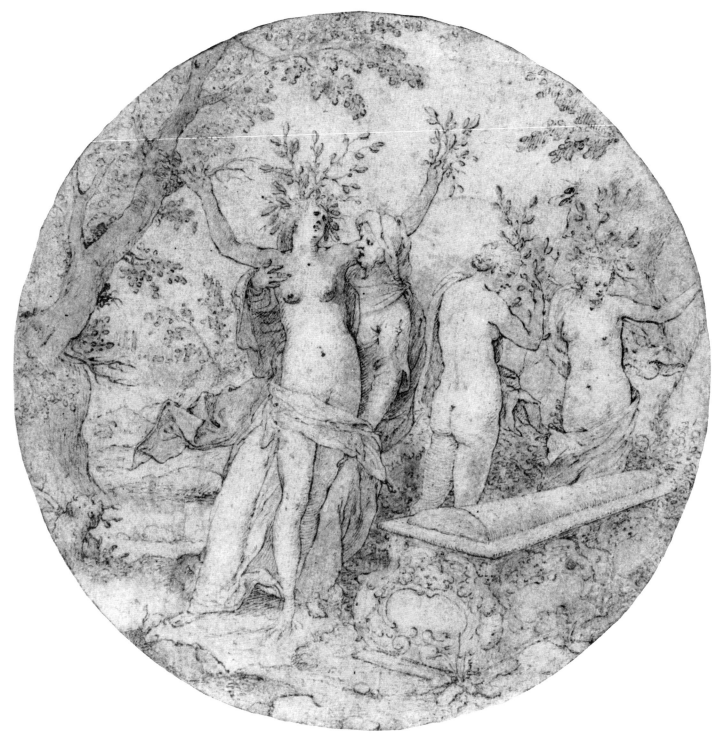

PAULUS VAN VIANEN

117 *The Transformation of the Heliades*

Pen and brown ink, brown wash
Diameter 206 (8⅛)

Provenance: (sale, Christies, London, 6 December 1972, lot 70, as Rottenhammer)

Literature: Gerszi 1982, 31, and no. 68, Ter Molen 1984, 2: no. 289, and under no. 132

Stiftung Ratjen, Vaduz/Ratjen Foundation, Vaduz

The majority of Van Vianen's drawings depict landscapes (cat. 116), and only a

small number relate to the production of the reliefs that decorate his plaquettes and other luxury objects. These few fall into two categories. One group consists of composition studies, such as *The Transformation of the Heliades*, which is the design for a lost silver plaquette known only through a copy in bronze (fig. 1).[1] He drew them in chalk, chalk and wash, and pen and wash. There are also various detail studies. They include land-

scape and figural motives from the Salzburg sketchbooks (see cat. 116), which he incorporated into the backgrounds of his biblical and mythological reliefs, and one powerful study of an old peasant woman, perhaps made from life, for the figure of Saint Elizabeth in a plaquette representing *The Holy Family with Saint John the Baptist and Saints Elisabeth and Joachim* (fig. 2).[2]

In *The Transformation of the Heliades*

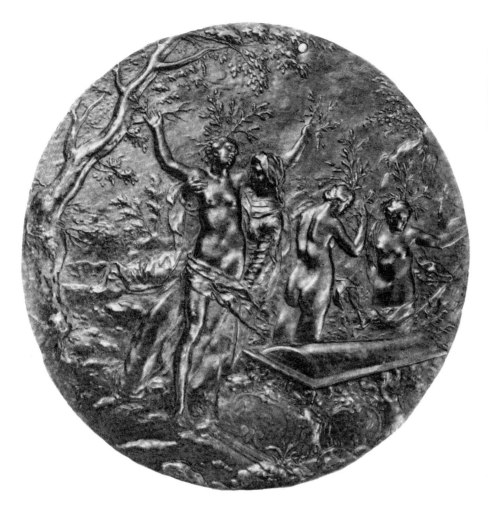

Fig. 1. After Paulus van Vianen, *The Transformation of the Heliades*, private collection (from J.W. Frederiks, *Dutch Silver*, The Hague, vol. 4, 1961, no. 81)

Fig. 2. Paulus van Vianen, *Saint Elizabeth*, Fondation Custodia (Coll. F. Lugt), Institut Néerlandais, Paris

the graceful nudes with ample, elongated torsos and small heads typify the style, based on the works of Haarlem and Utrecht mannerists like Goltzius and Wtewael, that was practiced by the Netherlandish masters who dominated artistic life at the Munich and Prague courts. Van Vianen's exceptionally delicate handling of the pen and wash invests the details with a brittle refinement and decorative contours that anticipate the translation of the design into a metal relief. Neither the drawing nor the plaquette bears a date, but Gerszi has convincingly assigned the study on stylistic grounds to the beginning of the seventeenth century. *The Transformation of the Heliades* documents a transitional phase in Van Vianen's development between the earliest known studies for metalwork of c. 1600-1602, where the figures are even more mannered and precious, and the Raphaelesque forms and composition of *The Judgment of Paris* of 1607.[3] It must date from 1603-1606.

The drawing corresponds in size, and in nearly every detail, to the related pla-

quette, which exists in a single bronze version attributed to one of Van Vianen's assistants (fig. 1). It belongs to a series of circular plaquettes of identical dimensions that represent mythological subjects.[4] A copy of the drawing is in the Kupferstich-Kabinett, Dresden.[5]

The subject comes from Book II of Ovid's *Metamorphoses*.[6] Heliades means "children of the Sun," and the three nude women in Van Vianen's drawing were offspring of Helios (Phoebus Apollo) and Clymene. Their brother, Phaeton, perished in his presumptuous attempt to drive the Sun's chariot across the sky. His sisters, Phaethusa, Lampetia, and another whom Ovid does not name, mourned inconsolably for four months over Phaeton's sarcophagus, which occupies the lower right corner of the drawing. Finally, the gods took pity and transformed them into a row of poplars. Van Vianen depicts the moment after they have begun to grow roots, bark, and branches, when the hysterical Clymene "rushed to press/Each fading pair of lips against her own" before the transforma-

tion was complete. After the metamorphosis they continued to weep for their brother, and the tears they shed hardened in the sun into pieces of amber.

The Transformation of the Heliades was seldom illustrated as an independent subject, but it occasionally occurs in representations of *The Fall of Phaeton*.[7]
WWR

1. For the composition studies for metalwork reliefs, see Gerszi 1982, nos. 65, 66, 68, 70, 75, 77. The drawing exhibited here is the design for a bronze plaquette in a private collection, Ter Molen 1984, 2: no. 132 (PBb); Gerszi 1982, pl. 169.
2. For the landscape studies from the Salzburg sketchbooks that Van Vianen worked into the backgrounds of his reliefs, see Gerszi 1982, 17-18, and her no. K2. Although she designates the latter work a copy, it is an original study used by Van Vianen in a plaquette, *The Muses*, 1604 (Gerszi 1982, 168), as pointed out by Julian Stock in the sale catalogue Amsterdam, Sotheby Mak van Waay, 15 November 1983, lot 142, and Ter Molen 1984, 2: no. 261 (PDa). A sketch of a figure from the Salzburg period that Van Vianen adopted for a relief is Gerszi 1982, no. 22v, Ter Molen 1984, 2: no. 238 (PDa). The study of an old woman illustrated in fig. 2 is Gerszi 1982, no. 78, pl. 85, Ter Molen 1984, 2: no. 301 (PDa); the related plaquette is reproduced by Gerszi 1982, 175.
3. Gerszi 1982, 30-31, and no. 68.
4. For the plaquette, which measures 201 mm, see n. 1 above.
5. Inv. no. 36. See Gerszi 1982, under no. 68.
6. Lines 340-366.
7. *The Fall of Phaeton* and *The Transformation of the Heliades* are represented together in drawings by Hans Bol, Paris 1985-1986, no. 79, and by Crispijn van den Broeck, Wegner 1973, no. 20.

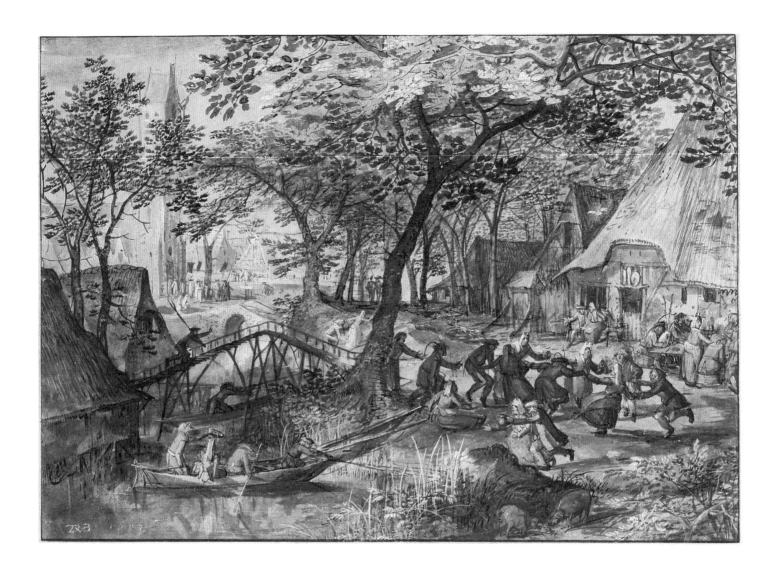

David Vinckboons

1576-1630/1633

Vinckboons was born in Mechelen (Malines) on 13 August 1576. His father, the minor watercolorist Philips Vinckboons, moved his family to Antwerp in 1579. They eventually joined thousands of other Flemish Protestants who fled the war and religious persecution in the south and emigrated to the northern Netherlands. After leaving Antwerp in 1586, the Vinckboons family resided in Middelburgh before settling in Amsterdam by 1591. David married Agnieta van Loon in 1602 in Leeuwarden, but the couple lived in Amsterdam. They had ten children. The date of Vinckboons' death, formerly thought to be 1629, is not documented. He was still living in 1630, but died before January 1633.

Vinckboons was taught by his father to work in watercolors, but none of his juvenilia in this medium, which Van Mander describes, has come down to us. His earliest paintings and drawings so resemble the landscapes of Gillis van Coninxloo, who arrived in Amsterdam c. 1595, that some scholars have assumed Vinckboons studied with him. However, Van Mander mentions no such relationship. Vinckboons produced paintings and drawings, and, in addition to designing numerous compositions for reproduction by professional engravers, executed three prints himself. The early landscapes with tiny staffage yield after c. 1605 to works in which the figures gradually assume greater importance in relation to the setting. Many of the latter are lowlife scenes inspired by Pieter Bruegel or outdoor merry companies, which laid the groundwork for this important category of Dutch genre art.

DAVID VINCKBOONS
118 *Village Kermis*

Pen and black and brown ink, watercolor and
body color in shades of blue, red, and green
206 x 294 (8⅛ x 11⁹⁄₁₆)

Watermark: Illegible
Signed at lower left, in white body color, *DVB*
(in ligature) *1603*. Inscribed on verso at upper
left, in brown ink, in a seventeenth-century
hand, *Davidt Vinckeboons*; in brown ink, in a
later hand, *£50-extra*; at lower left, in graphite,
Collection of the/ Marquis Vindé/ Miss James;
at lower right, in black chalk, *No. 1367* (inv.
no. of the collection of the Vicomte Morel de
Vindé)

Provenance: Paignon Dijonval (1708-1792),
Paris; Charles-Gilbert, Vicomte Morel de
Vindé (according to inscription on verso; no
mark; see Lugt 2520); sold in 1816 to Samuel
Woodburn (no mark; see Lugt 2584) Thomas
Dimsdale (Lugt 2426); Samuel Woodburn; (his
sale, London, Christie's, 22-23 June 1891, lot
171); probably Sir John Charles Robinson (no
mark; see Lugt 1433); Charles Fairfax Murray;
J. Pierpont Morgan

Literature: Bénard 1810, 67, one of three in no.
1367; Fairfax Murray, 1905-1912, 3: no. 164;
Held 1951, 242; Wegner and Pée, 1980, 65-66,
no. 18

Exhibitions: Berlin 1975, no. 281; Paris 1979-
1980, no. 8

The Pierpont Morgan Library, New York, inv.
no. III, 164

Vinckboons ranks among the wittiest and
most accomplished Netherlandish drafts-
men of the seventeenth century. Eighty-
four securely attributed drawings have
been identified.[1] While a few might go
back to c. 1598/1599, the earliest dated
sheet is from 1600.[2] Vinckboons was not
only precocious, but also more produc-
tive at the beginning than at the end of
his career: roughly seven-eighths of the
surviving drawings belong to the decade
1600-1610. A majority—fifty-two of the
eighty-four known works—are studies
for prints executed by professional
engravers.[3]

The monogrammed and dated *Village
Kermis* of 1603 is not a design for a print,
but a finished work destined for a collec-
tor. Although Vinckboons frequently uti-
lized combinations of white body color
and brown, gray or blue washes, this is
his only drawing worked up with several
hues of watercolor and body color. The
choice of body color recalls the minia-
tures of Hans Bol, Jacques Savery, and
others. However, Vinckboons used it here
primarily for heightening, applying the
medium with exceptional freedom.

The Morgan Library work is one of
about a dozen drawings and paintings by
Vinckboons that represent a kermis or
peasant dance. They range in date from
1602 to 1629, but most fall within the
first decade of the century.[4] These and

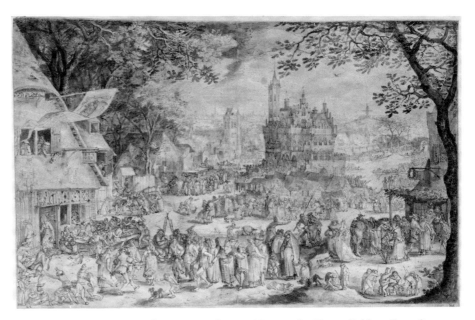

Fig. 1. David Vinckboons, *Village Kermis*, Statens Museum for Kunst, Kobberstiksamling,
Copenhagen (Copyright Hans Petersen)

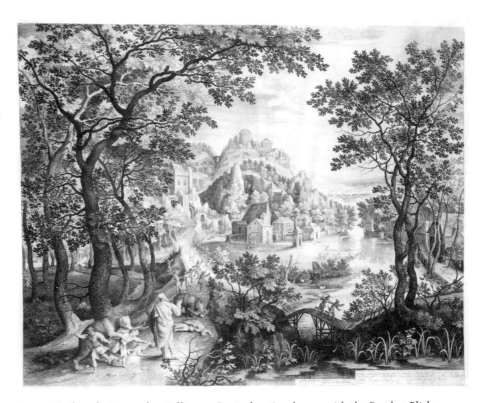

Fig. 2. Nicolaes de Bruyn after Gillis van Coninxloo, *Landscape with the Prophet Elisha*,
Rijksprentenkabinet, Amsterdam

other lowlife subjects by the artist form
an important link between the sixteenth-
century Flemish tradition founded by
Bruegel and the development of peasant
genre in the hands of Adriaen Brouwer,
Adriaen van Ostade, and Jan Steen. Most
of Vinckboons' kermis scenes follow the
same general compositional arrangement,
although within this scheme there is the

widest imaginable variation in the de-
tails: an inn figures prominently in a
foreground corner, groups of revelers
gather along a tree-lined street of a vil-
lage, and a church rises in the back-
ground. The procession that issues from
the portal on the Morgan Library sheet
recalls the origins of the kermis in an ec-
clesiastical holiday commemorating a lo-

cal saint or the foundation of a church. Unlike other kermis scenes by Vinckboons, where huge crowds of merrymakers of all social classes throng the streets (fig. 1), the few peasant revelers here suggest that this is a small village celebration.[5]

Pigs often appear conspicuously in representations of the kermis by Vinckboons and other Netherlandish masters (cats. 28, 83), where they usually allude to the deadly sin of gluttony.[6] It is likely that the swine foraging in the foreground of the present work embody the vice exemplified by the merrymakers. An engraving after a slightly earlier kermis by Vinckboons carries an inscription that explicitly condemns the drunkenness and self-destruction of the festive peasants.[7]

Vinckboons' village festivals and peasant dances belong to the tradition established c. 1560 by Bruegel's *Kermis at Hoboken* and *Saint George's Kermis* (see cat. 28), but the immediate precedents for his compositions should be sought in more recent examples. His paintings and drawings showing enormous crowds of celebrants (fig. 1) relate more directly to works by Jacques Savery than to Bruegel's prototypes (cat. 100, fig. 2).[8] Like many of Vinckboons' early landscape compositions, the design of the Morgan Library drawing—with the roof of foliage that spreads across the top of the sheet, the avenues of space bisected by the large tree at the center, and such details as the foreground bushes and reeds—was suggested by the forest scenes of Gillis van Coninxloo (fig. 2).[9] However, the Morgan drawing is far more intimate in scale than Coninxloo's extensive views. Vinckboons' spontaneous touch animates the entire sheet with a visual exuberance that amplifies the riotous vitality of the dancers and other merrymakers. The vigorous execution is especially evident in the plants, in the lively contours of the thatched roofs, the boats, and the footbridge, in the dramatic fluctuations of light and shade, and in the energetic figures, whose costumes sport the principal accents of color. WWR

1. Wegner and Pée 1980, 48-112, catalogue and illustrate the eighty-three drawings they attribute to Vinckboons. Cat. 119, previously unpublished and not known to Wegner and Pée, brings the number of authentic drawings to eighty-four.
2. Wegner and Pée 1980, nos. 1, 2, and 4.
3. Wegner and Pée 1980, 35. They catalogue fifty-one drawings that are studies for prints; with cat. 119, this number reaches fifty-two. Their nos. 1-53, which comprise more than seventy drawings, all date from before 1611. See Wegner and Pée 1980, 41.
4. For these works see: Goossens 1954, 65-83, and 126-132, figs. 30-41, 69, 70; Goossens 1966, 66-74, figs. 3, 4; Wegner and Pée 1980, nos. 16, 18, 19, 27, 33-35; and Philadelphia 1984, no. 122, where it is stated that the important painting in Dresden (Goossens 1954, fig. 38), may date from 1601, because there is a copy after it with that date. Goossens dates the picture c. 1611.
5. The drawing of 1602 illustrated in fig. 1 is Wegner and Pée 1980, no. 16.
6. See Philadelphia 1984, no. 122.
7. See n. 6 above.
8. In addition to Savery's large drawing of a kermis reproduced in cat. 100, fig. 2, Zwollo 1979, 206-207, see the paintings, Zwollo 1979, fig. 10; and sale, New York, Sotheby's, 21 January 1982, lot 71.
9. For the engraving after Coninxloo illustrated in fig. 2, see Hollstein 12. For Coninxloo's influence on Vinckboons, see Wegner and Pée 1980, 36-39.

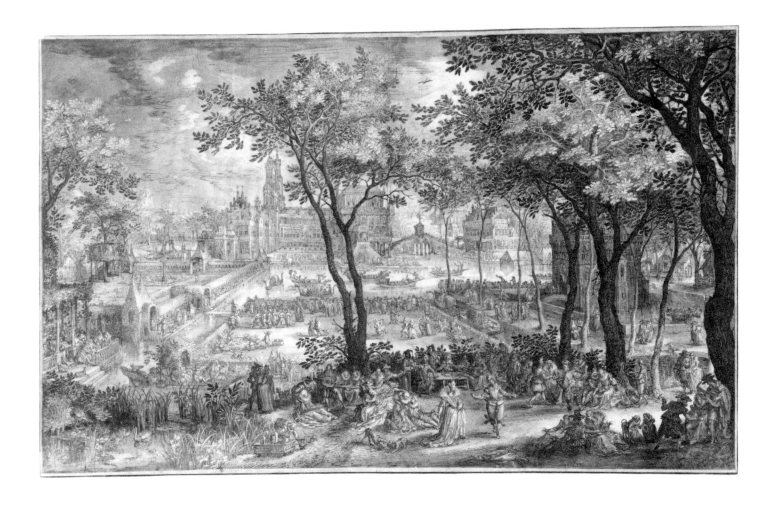

DAVID VINCKBOONS
119 *Fête in a Park*

Pen and brown ink, brown and gray wash, heightened with white body color, over traces of black chalk on two sheets of paper joined vertically. Incised for transfer; laid down 425 X 705 (16¾ X 27¾)

Provenance: (P. & D. Colnaghi, London)

Private collection, U.S.A.

Fête in a Park, published here for the first time, is Vinckboons' largest and most elaborate drawing of an elegant garden party and his most important work to come to light in recent years.

Like the majority of Vinckboons' surviving drawings, it is a detailed, full-scale study for a print. The engraving by Nicolaes de Bruyn (fig. 1) is nearly identical in size and reproduces the composition in reverse with only minute changes in detail. An inscription on the print credits Vinckboons with the invention but does not give a date.[1] On the grounds of style, the drawing may be assigned to the years 1602-1604: while it is clearly more advanced than similar park landscapes of 1601, in drawings of 1605 and later the

figures are almost invariably larger in relation to the background.[2] Wegner and Pée, who did not know the study, date the print to 1604.[3]

Fête in a Park displays, perhaps in greater measure than any other drawing by Vinckboons, the virtuoso draftsman's ability to combine countless charming and deftly delineated details in a vast but coherent design. Surprisingly, we know only a single sheet of sketches that might have served as a preliminary study for one of the huge crowds in such a composition (fig. 2).[4] Although the spectators watching a boating party in this sheet cannot be related directly to the drawing exhibited or to any other finished work, the sketches provide the unique glimpse into the working procedure Vinckboons must have followed when executing these populous scenes.

In *Fête in a Park*, the compositional role of the trees and their elegant contours still recall the leafy landscapes of Gillis van Coninxloo (cat. 118, fig. 2), who exerted a strong influence on the

young Vinckboons.[5] However, the powerful, carefully contrived spatial recession and the enchanting setting—with its splendid castle, neat parterres, shady arbors and gazebos, and gondolas gliding gently over the calm canals—are Vinckboons' own inventions. Despite the realism of many of the details, Vinckboons' compositions remain squarely within the sixteenth-century tradition of the imaginary panoramic landscape.

In addition to the drawing exhibited here, Vinckboons produced at least eight variations on the theme of an elegant company in a landscape or garden. They range in date from c. 1601 to 1610.[6] Van Mander must have had in mind the prints of *Fête in a Park* and of a similar design when he referred to Nicolaes de Bruyn's engravings after Vinckboons as "landscapes with modern figures."[7]

Vinckboons made a crucial contribution to the development of the outdoor merry company theme, and his paintings and drawings inspired Dutch genre painters of the second decade of the cen-

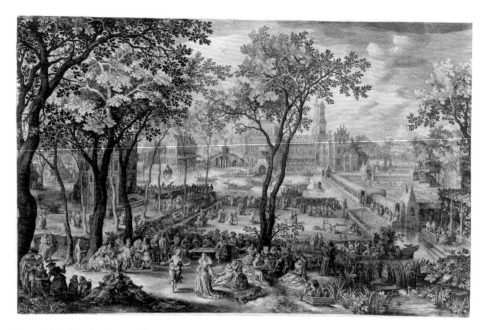

Fig. 1. Nicolaes de Bruyn after David Vinckboons, *Fête in a Park*, The Metropolitan Museum of Art, New York, The Elisha Whittelsey Collection, The Elisha Whittelsey Fund, 1949

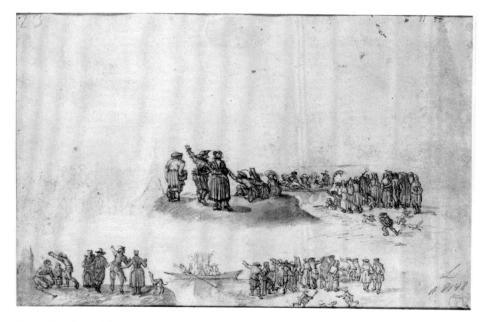

Fig. 2. David Vinckboons, *Figures on a Bank*, Fitzwilliam Museum, Cambridge

tury, such as Dirck Hals, Willem Buytewech, and Esaias van de Velde. These scenes evolved from sixteenth-century representations of love gardens, of the prodigal son wasting his substance, and of spring in cycles of the seasons, all of which feature fashionably dressed couples feasting, dancing, and flirting in a pleasure garden. Drawing on all three iconographic traditions, Vinckboons and other genre specialists made an independent subject of amorous dalliance fostered by agreeable surroundings, music, wine, dance, and elevated conversation. The refined pleasures pursued by the couples, as well as the garden setting, reflect the erotic ideals celebrated in contemporary poetry, songs, courtesy books, and treatises on etiquette.[8] Not to be overlooked, however, is the fool who stands among the revelers in the center foreground. Although he may be merely a costumed entertainer, his presence could imply—as the appearance of jesters occasionally does in sixteenth- and seventeenth-century genre art—an admonition against the folly and vanity of wordly pleasures.[9] WWR

1. In the literature, the data on this print are confused. Hollstein 172 may refer to this engraving, which is catalogued in the Rijksprentenkabinet and the Metropolitan Museum as Hollstein 172. However, Hollstein states that no. 172 is dated 1607 and that it was copied by Bolswert, Hollstein 312, but the copy by Bolswert reproduces another work, namely Hollstein 171, and the engraving after the drawing exhibited here is not dated. Moreover, Hollstein gives an incorrect reading of the inscription on the print after *Fête in a Park*. The correct reading: is *Daviedt Vinckboons Inv..t Nicola de Bruyn Sculptor.* Hollstein's measurements, 425 x 690 mm, are right. Goossens 1954, 11, describes the engraving after this drawing as the earliest work by Vinckboons, though he gives no evidence to support this assertion. Wegner and Pée 1980, under no. 17, date the print to 1604. Although they give no explanation, their date seems correct on stylistic grounds.
2. Wegner and Pée 1980, 40-41.
3. Wegner and Pée 1980, under no. 17, see n. 1 above.
4. Wegner and Pée 1980, no. 17 (here fig. 2).
5. See cat. 118, and Wegner and Pée 1980, 36-39.
6. Goossens 1954, figs. 4, 7, 50, 51, 52; Wegner and Pée 1980, nos. 3, 20, 48. See also Philadelphia 1984, no. 121.
7. Van Mander, *Schilder-boek*, 2:370-371.
8. Philadelphia 1984, no. 121.
9. There is a long tradition in Netherlandish genre art of merry company scenes attended by fools who admonish the viewer to avoid the kind of conduct exemplified by the festive protagonists. See, for example, the woodcuts by Lucas van Leyden, Washington 1983, no. 72; and Monogrammist A.P., Renger 1970, 90-92, fig. 62; and the drawing by Johann Liss, Augsburg 1975 no. B45. See also Philadelphia 1984, no. 67.

Marten de Vos

1532-1603

Marten de Vos was born in the summer of 1532, the son of Anna de Heere and the painter Pieter de Vos. Nothing is known of his youth nor with whom he studied, although it is most likely that he began with his father. Van Mander writes that Marten de Vos traveled to Rome, and it is presumed that he started for Italy with his Antwerp contemporary Pieter Bruegel in the middle of March 1552. When he arrived in Rome or the length of his stay there is not documented. Van Mander also informs us that De Vos was in Venice, and Ridolfi writes that the Fleming worked in Tintoretto's studio as a landscape specialist. There is also evidence that De Vos stopped in Florence. He was back in Antwerp by 1556 when he executed the signed and dated Portrait of an Old Woman, *whereabouts unknown. Two years later he became a master in the Guild of Saint Luke, and, by the end of 1564, De Vos had his first pupil. Shortly after entering the guild, he married Joanna Le Boucq, and they had five daughters and three sons.*

The artist's earliest commission of consequence came from Gillis Hooftman, one of the wealthiest businessmen in Antwerp. De Vos decorated his dining room with scenes from the Acts of the Apostles *that Abraham Ortelius, the famous Antwerp intellectual and geographer, helped him to interpret. This commission brought him fame and esteem so that by 1572 he became the Dean of the Guild of Saint Luke.*

Antwerp's cathedral and churches had been badly damaged by the iconoclasts, especially in 1558 and 1566. With the death of Frans Floris in 1570, Marten de Vos became the most sought-after artist to replace the lost church works as well as to execute paintings for private collectors. Although few of his drawings for paintings are extant, there are numerous drawings for engravings and book illustrations for the Plantin-Moretus press. De Vos' remarkable career ended with his death on 4 December 1603, and he was buried in Saint Luke's Chapel of the Antwerp Cathedral.

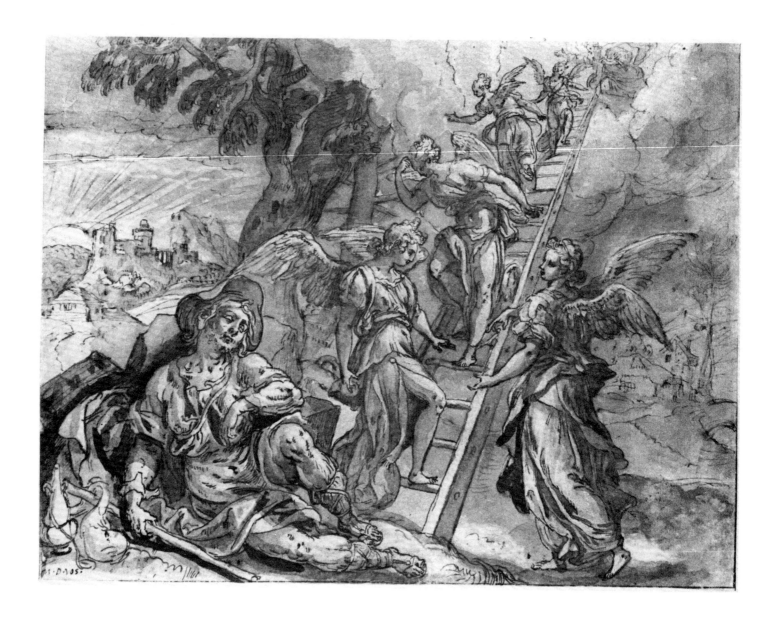

MARTEN DE VOS

120 *The Dream of Jacob*

Pen and brown ink and brown wash height-
ened with white body color over traces of
black chalk; indented for transfer
205 X 275 (8¹/₁₆ X 10 ¹³/₁₆)
Signed in the lower left corner, *M. D. VOS.*

Provenance: Sir Willoughby Rooke; inherited
by Miss Williams, from whom purchased by
Sir Robert Witt in 1926; presented by the lat-
ter to the Courtauld in 1952

Exhibitions: London 1927, no. 550; London
1977-1978, no. 2

Courtauld Institute Galleries, London. Witt
Collection, inv. no. 2257

Marten de Vos executed this drawing
sometime in the 1580s. It was during this
period that he usually placed the focal
point of the theme in the center fore-
ground in front of a tree whose trunk

Fig. 1. Gerard de Jode after Marten de Vos, *The Dream of Jacob*, The Metropolitan Museum of Art, New York, The Elisha Whittelsey Collection, The Elisha Whittelsey Fund, 1951

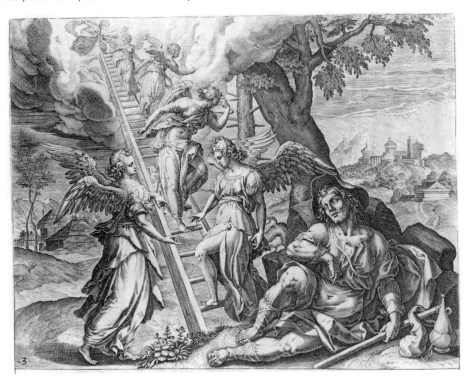

spiraled upward in a decorative way. The foreground, at this time, was often flanked by abrupt views into the distance with no clear transition from foreground to background, a characteristic of mannerist spatial concepts.[1] Jacob sleeps on the ground, assuming the position of an antique river god type,[2] which De Vos knew from his visit to Rome sometime before 1558.[3] Jacob's exaggerated musculature and his contorted position, as well as the angels with small heads and extended bodies placed in unnatural poses, are indicative of mannerism.

This episode from Genesis (28:11-13) has been often represented, and the participants have frequently been associated with stories and meanings other than the *Dream of Jacob*. Although Marten de Vos extends the ladder beyond its usual size for decorative reasons, the fifteen steps

traditionally used symbolize the Virtues.[4] The descending angels represent the active life, and those ascending, the contemplative life. Jacob, who sleeps on the ground resting against a large stone, has been seen as a prefiguration of the young Saint John the Evangelist sleeping against Christ during the Last Supper, dreaming of the secrets of heaven.[5]

This drawing was made into an engraving by an unknown artist and published by Gerard de Jode[6] (fig. 1). It is also possible that the sheet can be connected with a lost painting of this theme cited in the 7 November 1678 inventory of the Antwerp painter Erasmus Quellinus: "Schala Jacob, Italiaens, Marten de Vos" (Ladder of Jacob, Italian, Marten de Vos).[7] JRJ

1. Compare Marten de Vos' design for Jan Wierix' engraving of *Saint John the Evangelist*—Franz 1969, 264, 265, fig. 17; Mauquoy-Hendrickx, 1979, 2:164, 165, no. 839, pl. 118.
2. Compare the *Tigris* and *Nile*, which were often copied in the sixteenth century; Netto-Bol 1976, 39, fol. Vir., pl. 69.
3. Van Mander, *Schilder-boek*, 2: 92, 95.
4. Compare the mid-twelfth-century miniature by Herman van Landsberg in the *Hortus Deliciarum*, Timmers 1974, 15, fig. 4, where the virtuous, shielded by angels, avoid the temptations of the devil and climb to the top of the ladder to receive the crown of life.
5. Réau, *Iconographie*, 2: 1 (1956), 147.
6. The engraving was not part of the series entitled *Thesaurus sacrarum historiarum veteris testamenti* . . ., published in 1585 (see London 1977-1978, 1), but one of a set of four engravings with episodes from the life of Jacob. The engraving published by Gerard de Jode is in the Metropolitan Museum of Art, New York, no. 51.501.1715(3). I am extremely grateful to Miss Nadine Orenstein for checking this material and finding the De Jode print.
7. Denucé 1932, 291; Zweite 1980, 341.

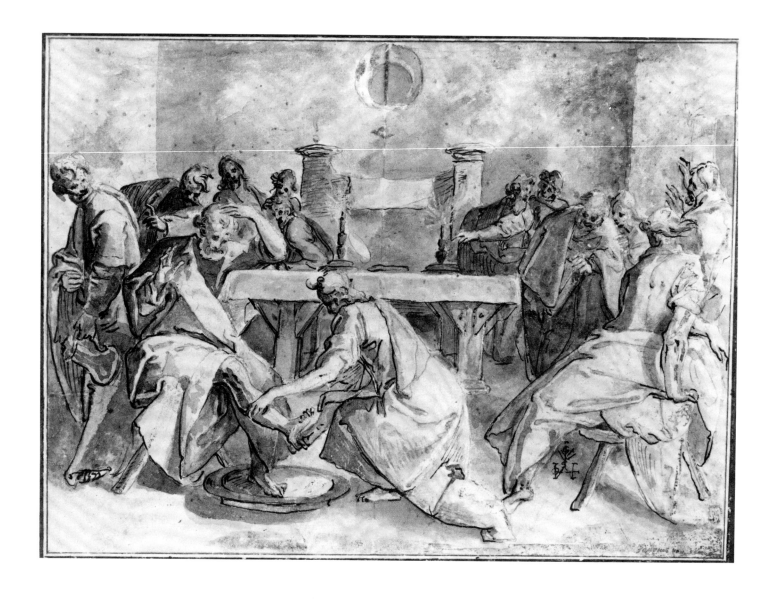

Joos van Winghe

1542/1544-1603

Van Mander gives contradictory information about Van Winghe's birth, stating that he was born in 1544 in Brussels, but that he died in Frankfurt in 1603 at the age of sixty-one. Frankfurt documents confirm that he died in December 1603. Nothing is known of Van Winghe's early training, though Van Mander reports that he spent four years in Rome in the house of a cardinal. Returning to Brussels through France by 1568, he became painter to the Regent Alessandro Farnese. He emigrated to Frankfurt with his family, probably in 1585 or shortly

thereafter. In 1588 he acquired Frankfurt citizenship. That he settled in Frankfurt for religious or political reasons can be deduced from the subject of one of his paintings described by Van Mander, Belgica Freed from Tyranny.

According to Van Mander, Van Winghe's output was not large. A small group of paintings and drawings has been assembled around signed paintings of Samson and Delilah *in Düsseldorf;* two versions of Apelles Painting Campaspe *in Vienna, one of them from the collection of Rudolf II; the drawing of*

Christ Washing the Disciples' Feet *in the Musées Royaux des Beaux-Arts, Brussels (cat. 121) that bears the same monogram as the Düsseldorf painting; and several prints after his work. These can now be supplemented by several drawings previously attributed to his son Jeremias. Joos van Winghe was the most important practitioner of Italianate late mannerism in the southern Netherlands in the last quarter of the sixteenth century. His influence was felt primarily through engravings after his active and light-filled biblical and allegorical scenes.*

JOOS VAN WINGHE

121 *Christ Washing the Disciples' Feet*

Pen and brown ink, lavender, blue, and gray washes, pink and white body color (partially oxidized), over traces of black chalk, reinforced with dark brown ink; laid down
228 x 310 (8¹⁵/₁₆ x 12³/₁₆)
Inscribed at center right in dark brown ink with artist's monogram; at lower right in light brown ink, *Jodocus van Wingen.*

Provenance: Julius Weitzner, New York

Literature: D'Hulst 55, 247-248; Poensgen 1970, 505, 514; Poensgen 1972, 39; Florence 1980-1981, 228, under no. 158

Exhibitions: Stuttgart 1979-1980, no. K6

Musées Royaux des Beaux-Arts de Belgique, Brussels, inv. no. 6737

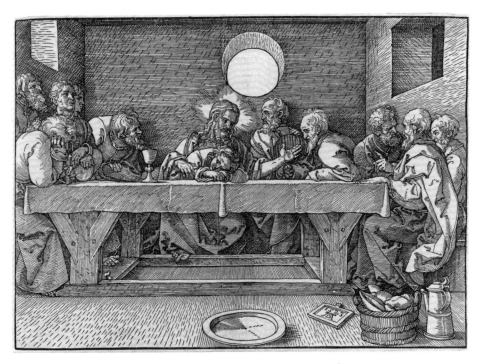

Fig. 1. Albrecht Dürer, *The Last Supper*, National Gallery of Art, Washington, Rosewald Collection

This luminous drawing is a touchstone of Joos van Winghe's work as a draftsman since it is signed with a complex, hall-marklike monogram, very close to the one Van Winghe included in the signature on the painting of *Samson and Delilah* in Düsseldorf.[1] The monogram is in the same dark brown ink with which Van Winghe accented what is essentially a watercolor.

Van Winghe represents the episode of the footwashing after the Last Supper as it is recounted in John 13: 5-11. After the meal, Jesus poured water into a basin and began to wash the disciples' feet. Saint Peter, when it was his turn, protested, saying, "Lord, not my feet only but also my hands and my head." As Heinrich Geissler notes, Saint Peter here acts out the biblical text in his angular gestures.[2] The foreground figures of Peter and Christ and the seated disciples seen from behind dominate the scene through their large scale, broad masses of light drapery, and the alternation of their active poses. Though Van Winghe, together with Blocklandt, Speckaert, and Spranger, transmitted the elegant, attenuated figures of Roman late mannerism to the Netherlands, it is noteworthy that here Dürer is the point of departure for this anticlassical vocabulary. Dürer's 1523 woodcut of *The Last Supper* (fig. 1) is clearly the basis for the composition, providing the oculuslike window, plain walls, and trestle table.[3] However, Dürer's austere classical space, a container for carefully placed, strongly plastic figures and objects, is made irrational and subjective. The boundaries of the room are barely indicated and the middle ground is virtually eliminated so that space is created only through the dramatic diminution in the figures' scale and their foreshortened poses. Thus the disciple who rests his elbow on the table

immediately adjacent to the much larger figure of Saint Peter, presumably seated next to him, has the effect of telescoping the room's space. In Van Winghe's drawing, the oculus, rather than setting off the geometry of monumental forms, is aligned with the altarlike table and the kneeling figure of Christ as the central axis of the pattern of active figures.

Whether *Christ Washing the Disciples' Feet* is a study for a print or painting is unclear. The example of the Dresden and Braunschweig studies for the *Night Banquet* (cat. 122) shows that Van Winghe could prepare a print in terms of rather broad effects of light and movement before making a more precise modello. Poensgen dates the drawing before Van Winghe's departure from Brussels in 1585 or shortly thereafter.[4] However, the lack of datable works earlier than the prints after his designs from the mid-1580s suggests caution on this score. MW

1. Incorporated in the second word of the signature *IODOCVS VAN DE WINGHE.* and read by Poensgen as "Winghensis," Poensgen 1970, 505, fig. 1. Contrary to Poensgen's statement, the hallmark-like monogram on the Brussels drawing is not identical to that on the Düsseldorf painting, since it includes the *O* of his first name. For some of the ways Joos signed his work, see his *Night Banquet*, cat. 122.
2. In Stuttgart 1979-1980, no. K6.
3. Bartsch 53. Panofsky 1955, 221-223, suggested that the centrally placed basin in Dürer's woodcut refers to Luther's teachings on the Mass. Peter Parshall suggests that it relates instead to the episode of the footwashing; see Washington 1983-1984, no. 9.
4. Poensgen 1972, 39.

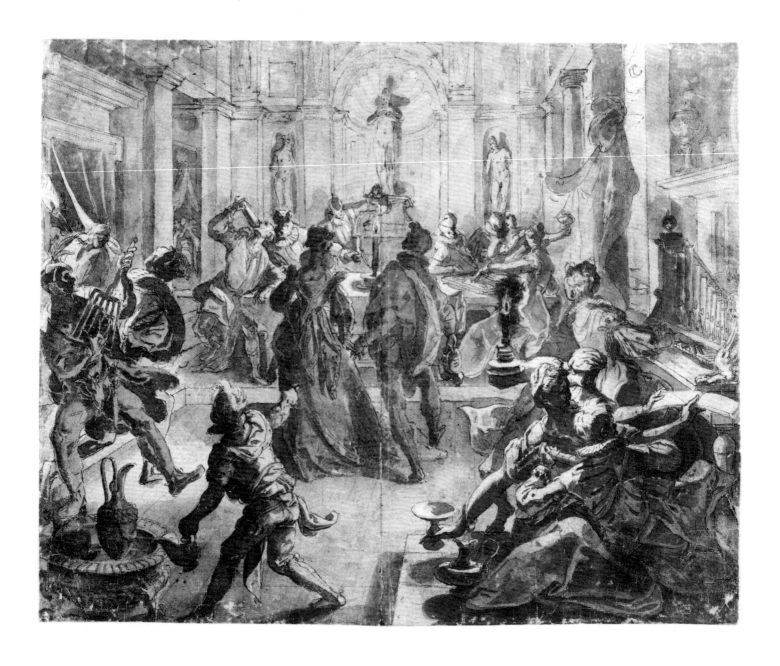

JOOS VAN WINGHE

122 *Night Banquet with Masqueraders*

Pen and brown ink, brown wash, white heightening over black chalk, pricked for transfer
362 x 457 (14¼ x 18)
Provenance: A. von Lanna, Prague (sale, Berlin, Lepke, 23-24 May 1911, no. 170); Consul Palmie; given to museum in 1924

Literature: Poensgen 1925-1926, 324-330; d'Hulst 1955, 243-247; Poensgen 1970, 505, 515; Poensgen 1972, 44; Judson 1972, 37-40; Renger 1972, 161-193

Exhibitions: Dresden 1978, no. 73

Staatliche Kunstsammlungen Dresden, Kupferstich-Kabinett, inv. no. c1924-91

Among the rare works of Van Winghe, Van Mander speaks of prints after his drawings, including *een Nachtbancket, met een Mascarade.*[1] The Dresden drawing has been considered to be the preparatory study for this engraving, which is in the same direction as the drawing, with some variations in the arrangement of the figures and architecture (fig. 1).[2] However, an unpublished drawing in Braunschweig, which is indented, rather than pricked for transfer, must be the modello for the print, since it corresponds closely in design and is in the opposite direction

(fig. 2).[3] There are only a few minor differences in details between the Braunschweig drawing and the print; for example, in the vessels displayed on the buffet behind the organist and the small owl added above the door in the print. The Brunschweig drawing is inscribed *I·V·W*, a type of monogram associated by Poensgen and others with Joos van Winghe's son Jeremias (1578-1645), who is thought to have prepared some of his father's designs for the engraver.[4] However, the two drawings of the *Night Banquet* are clearly by the same hand, suggesting that some

revisions are necessary in our views of Joos' working method and in the distinctions made between father and son.

In the Dresden drawing, the scene of revelry is rendered with great verve, primarily through varied tones of wash and sparkling areas of spared paper. In the Braunschweig modello, on the other hand, the contrasts of light and shade are not as bold, and the figures are more precisely defined through pen line and white body color. This is especially clear in the details of hair and costume and in the more subdued reflected light falling over the seated figures in the foreground. In terms of the events depicted, too, the Braunschweig modello is more explicit, substituting a procuress handing a purse to a young woman who gazes back at the scene of merrymaking for the glimpse of lovers embracing visible through a doorway at the left of the Dresden drawing.[5] Nevertheless, the Braunschweig drawing is executed with the rhythmic sureness of hand characteristic of Joos van Winghe. While it is possible that the Dresden drawing is preparatory to another work, perhaps a painting, it is most likely that it precedes the Braunschweig modello as a study of composition and light.

In view of the monogram, function, and early date of the Braunschweig *Night Banquet*, as established by the print after it, there is no reason to assign to Jeremias van Winghe those drawings with the *I·V·W* monogram, in distinction to the more complex monogram or hallmark on the Brussels *Footwashing* (cat. 121). That these drawings are actually by Joos is confirmed by the *Saints Mary Magdalene, John, and Peter at the Empty Tomb* in Rouen, signed and also monogrammed *I·V·W·F* and executed in the more precious style with lavish use of white heightening, that Poensgen identifies with Jeremias van Winghe.[6] This sheet, indented for transfer, was engraved in reverse by Raphael Sadeler I in 1591, when Jeremias van Winghe was only thirteen.[7] By extension, drawings like the *Calumny of Apelles* in the Bibliothèque Nationale, Paris, and the *Marriage at Cana* in the Ashmolean Museum, Oxford,[8] should be retained as the work of Joos van Winghe, who apparently turned toward more tender expressiveness and more solid three-dimensional form in the 1590s, a development parallel to that of Goltzius and Spranger. His son's style should be reconstructed independently.

Konrad Renger has analyzed the moralizing overtones of the *Night Banquet* as they are conveyed through the inscription on Sadeler's engraving from the Book

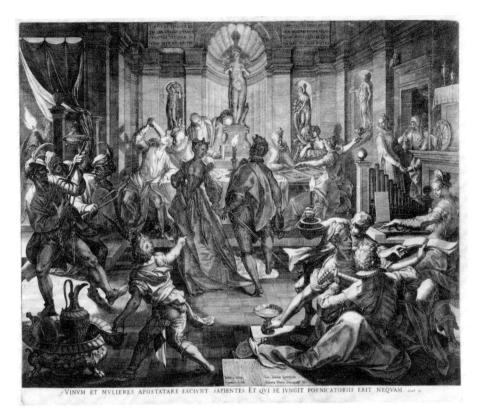

Fig. 1. Jan Sadeler I after Joos van Winghe, *Night Banquet with Masqueraders*, Rijksprentenkabinet, Amsterdam

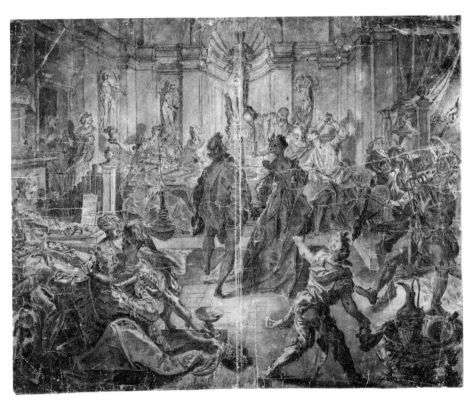

Fig. 2. Joos van Winghe, *Night Banquet with Masqueraders*, Herzog Anton Ulrich-Museum, Braunschweig (B.P. Keiser)

of Sirach, 19: 2-3, which warns of wine and women, and through the associations of the particular activities represented.[9] Thus, wine vessels are prominently displayed, and the revelers drink with exuberance. The masqueraders, with their burlesque musical instruments of bellows and griddle, suggest deception. The central motif of the couple dancing beneath the statue is emphasized by the page's pointing gesture and given an additional sinister twist by the procuress included in the Braunschweig drawing and the print. Like Barendsz.' earlier and more overtly moralizing *Mankind Awaiting the Last Judgment* (see cat. 10), this image of revelers in contemporary dress anticipates seventeenth-century genre painting.[10] MW

1. Van Mander, *Schilder-boek*, 2: 92.
2. Hollstein 559, 379 x 451 mm. For the Dresden drawing as preparatory to the print, see Poensgen 1925-1926, 324-330, and 1972, 44.
3. Inv. no. Z 775, 368 x 456 mm; pen and brown ink, brown wash, and white body color over black chalk on blue paper, indented for transfer. There is no evidence of pouncing on the Braunschweig drawing, which is brittle and creased. Inscribed in brown ink at lower left, *I·V·W*; on the verso at bottom, *Der Nahme original im Kupfer stehet bezeichnet*; and in the center, in black ink, *I. GP, N° 9*; already identified by Preibisz as the modello for the print in the files of the Kupferstichkabinett, Berlin.
4. Poensgen 1970, 504-515, especially 506-507, concludes that Jeremias was authorized to prepare modelli for prints of his father's designs about 1600; see also Florence 1980-1981, no. 158, pl. 84.
5. The embracing lovers are in the background on the left of the Dresden sheet; the door is omitted in the reversed Braunschweig drawing and the procuress added on the other side of the composition.
6. Donation H. and S. Baderou, inv. no. 497, 185 x 138 mm; pen and brown ink with gray wash and white body color on pink prepared paper, indented for transfer. Inscribed in brown ink on lid of tomb, *Jodicus van Wingen·f·*; on the tomb, *I·V·W·F·*; Rouen 1977, unpaginated, repro.
7. Hollstein 42; 211 x 145 mm inscribed below the image, *Jodocus a Winghe inuentor, Raphael Sadeler fecit et excudit 1591*. For Jeremias' date of birth, see Zülch 1935, 481.
8. Lugt and Valery-Rados 1936, no. 194, pl. LVIII, and Parker 1938-1956, 1: 42-43, no. 101, pl. XXI, respectively.
9. Renger 1972, 161-193. The print also includes inscriptions from the Wisdom of Solomon, 2:6 and 9, on the rear wall of the banqueting hall. Renger 1972, 164-165, suggests that these are to be interpreted ironically.
10. For paintings based on the print in Brussels and Amsterdam, see Renger 1972, figs. 3 and 4.

Joachim Anthonisz. Wtewael

1566-1638

The son of a glass painter, Joachim Anthonisz. Wtewael (Uytewael; Wttewael) was born at Utrecht in 1566. Van Mander records that he worked for his father until he reached the age of eighteen. Joachim then took up oil painting, studying with the shadowy Utrecht artist Joos de Beer, who also briefly taught Abraham Bloemaert. After two years with De Beer, Wtewael traveled to Italy in the entourage of Charles de Bourgneuf de Cucé, Bishop of Saint Malo. He spent four years in the bishop's service in Padua and France, and, according to Van Mander, executed many pictures for him. Wtewael returned to Utrecht and entered the Saddlers' Guild there in 1592. When the local painters and sculptors broke away from the Saddlers' Guild to establish a Guild of Saint Luke in 1611, Wtewael was one of the founders of the new organization.

In addition to his activity as an artist, Wtewael was also a flax merchant. Indeed, Van Mander, writing in 1604, chides Joachim for devoting more time to business than to painting. However that may be, Wtewael was a productive painter and draftsman. About 100 pic-

tures, most with crowded compositions and minutely observed details, have come down to us. They range in format from tiny works on copper to very large panels and canvases, and in date from the early 1590s to 1628. The majority depict biblical and mythological subjects, but Wtewael also produced a few portraits and genre scenes.

A patriot and Calvinist, Wtewael also found time for politics, serving on the Utrecht city council in 1610 and 1632-1636. In 1618, he participated in the overthrow of the Remonstrant magistracy and its replacement by an orthodox Calvinist administration loyal to the stadholder. Wtewael expressed his ideas about the political role of the House of Orange in a series of drawings that allegorize the history of the Dutch Revolt. He also designed a great window in the Sint Janskerk at Gouda, commissioned by the city fathers, which represents the Freedom of Conscience.

Wtewael died at Utrecht 1 August 1638. One of his sons, Peter, worked as a painter. Twenty-one pictures can be attributed to him.

JOACHIM WTEWAEL

123 *Design for a Piece of Plate*

Black ink (discolored to brown in places), gray wash, and white body color, a ruled horizontal line in black chalk, on paper prepared with gray wash
356 x 223 (14 x 8¾)
Signed at center, in black ink, *Joachim Wte(?)wael fecit anno 160(8)? (3)?*

Provenance: Sir Thomas Lawrence (Lugt 2445)

Literature: Lindeman 1929, 21 n. 1, 257, no. 2; Popham 1932, 198, no. 1; Thieme-Becker, 36: 286

Exhibited in Washington only

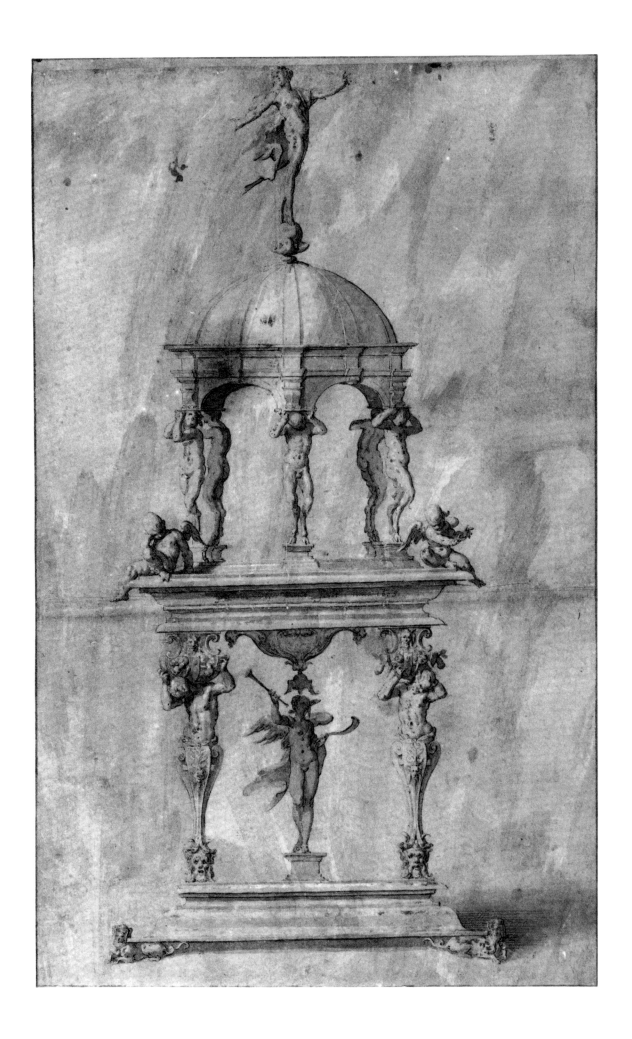

The subject and function of this design are apparently unique in the oeuvre of the Utrecht mannerist best known for his exquisitely wrought paintings of biblical and mythological themes. Although about seventy-five of his drawings have come down to us, no other study by the artist relates to sculpture or metalwork or to the lost sculptures mentioned by Buchelius. Caryatids on tapering bases, somewhat similar to those in the lower story of this object, occur in the design for the title page of Wtewael's print series *Thronus Justitiae*, but the use of such architectural elements is otherwise rare in his art.[1]

The original purpose served by the drawing remains unclear. Lindeman plausibly identifies the object as a centerpiece.[2] Wtewael's native town of Utrecht was the home of the Van Vianen family and other silversmiths, but we do not know whether this design was ever executed in bronze or a precious metal, or, indeed, whether Wtewael intended it to be.

Atop the dome stands the figure of Fortune, balanced precariously on a sphere to symbolize the capriciousness of her blessings.[3] Seated on the moulding beneath the satyr-caryatids who carry the dome are two putti, the one at the left in an attitude denoting sleep, indolence, or melancholy, the other in a more active pose. They might allude to the idea that Fortune favors those of active temperament, while her largesse is inaccessible to those who wait idly until she passes them by, which was the subject of a print of 1590 designed by Cornelis van Haarlem.[4] Flanked by herms in the lower story is the personification of Fame with her attributes, the trumpet and the palm branch, the latter symbolic of the victory of renown over death and time.

If its subject is uncharacteristic, the style of this sheet is typical of Wtewael's fluid and graceful draftsmanship. The suave contours of the figures and the modeling with nervous dots and dashes of the pen, shaded with gray wash and heightened with light touches of white body color, make an impression of extraordinary delicacy against the freely brushed gray ground.

Wtewael's figure style depends upon that of the Haarlem mannerists. Here, he adapted the figure of Fortune from the engraving by Jan Muller after Cornelis van Haarlem mentioned above, which represents *Fortune Distributing Her Gifts*.[5] While Wtewael's drawing technique often resembles that of his Utrecht colleague Abraham Bloemaert, the handling of the figures in this work is closer to the execution of some of Cornelis' rare pen and wash drawings (cat. 39).[6] Wtewael continued to practice the late mannerist style until he ceased to paint at the end of the 1620s, long after the death of Goltzius and even longer after Goltzius, Cornelis, and Bloemaert had turned to more modern modes of representation.
WWR

1. For Buchelius' brief notice of Wtewael's activity as a sculptor, see Lindeman 1929, 21. The study for the titlepage of the series *Thronus Justitiae*, engraved in 1606 by Willem van Swanenburg, Hollstein 49, is reproduced by Lindeman 1929, pl. XLII. Compare also *Susanna and the Elders*, Lindeman 1929, pl. XXVI. datable 1611-1614. I am grateful for Anne Lowenthal's generous help with this entry.
2. Lindeman 1929, 257, no. 2, and Thieme-Becker, 36: 286.
3. See Berlin 1979, no. 13.
4. Berlin 1979, no. 13.
5. Berlin 1979, no. 13.
6. Compare especially Cornelis' drawing *Juno Appearing to Sea Gods*, Van Thiel 1965, pl. 6a.

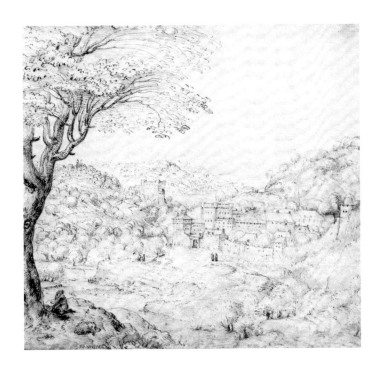

References cited

BOOKS AND ARTICLES

Ainsworth 1982a
Ainsworth, Maryan Wynn. "Bernart van Orley as Designer of Tapestry." Ph.D. diss., Yale University, New Haven, 1982.

Ainsworth 1982b
Ainsworth, Maryan Wynn. "Underdrawings in Paintings by Joos van Cleve at the Metropolitan Museum of Art." *Le Dessin sous-jacent dans la peinture. Colloque IV* (Louvain-La-Neuve, 1982): 161-167.

Alfassa 1920
Alfassa, Paul. "Les tapisseries des 'Chasses de Maximilien'." *Gazette des Beaux-Arts* 1 (1920), 127-140, 233-256.

Alpers 1972-1973
Alpers, Svetlana. "Bruegel's Festive Peasants." *Simiolus* 6 (1972-1973), 163-176.

Alpers 1975-1976
Alpers, Svetlana. "Realism as a Comic Mode: Low Life Painting Seen through Bredero's Eyes." *Simiolus* 8 (1975-1976), 115-144.

Alpers 1978-1979
Alpers, Svetlana. "Taking Pictures Seriously: A Reply to Hessel Miedema." *Simiolus* 10 (1978-1979), 46-50.

Alpers 1983
Alpers, Svetlana. *The Art of Describing. Dutch Art in the Seventeenth Century.* Chicago, 1983.

Ames-Lewis 1981
Ames-Lewis, Francis. *Drawing in Early Renaissance Italy.* New Haven, 1981.

Amsterdam 1979
Anonymous. "Keuze uit de aanwinsten." *Bulletin van het Rijksmuseum* 27 (1979), 30-47.

Andrews 1961
Andrews, Keith. *Fifty Master Drawings in the National Gallery of Scotland.* Edinburgh, 1961.

Andrews 1979
Andrews, Keith. *Adam Elsheimer: Paintings—Drawings—Prints.* Oxford, 1979.

Andrews 1985
Andrews, Keith. *Catalogue of Netherlandish Drawings in the National Gallery of Scotland*. Edinburgh, 1985.

Anonymous 1946a
Anonymous. "Unique Natural History Illustrations: XVIth-Century Miniatures from the Emperor Rudolph's Manuscript." *The Illustrated London News* 208 (23 March 1946), 328-329.

Anonymous 1946b
Anonymous. "Classified by Hoefnagel with Insects: The Mysterious Hairy Folk." *The Illustrated London News* 208 (27 April 1946), 467.

Anonymous 1950
Anonymous. "Meister der Mailänder Anbetung." *Thieme-Becker* 37 (1950), 212.

Anonymous 1961
Anonymous. "An Eye for Nature: Hoefnagel's Exquisite Miniatures for the Emperor Rudolph's Natural History." *The Illustrated London News* Supplement, 238 (19 February 1961), II-III.

Anzelewsky 1972
Anzelewsky, Fedja. "Handzeichnungen und Druckgraphik." *Propyläen Kunstgeschichte. 7. Spätmittelalter und beginnende Neuzeit*. 8 vols. Berlin, 1972.

Arndt 1961
Arndt, Karl. "Gerard Davids *Anbetung der Könige* nach Hugo van der Goes, Ein Beitrag zur Kopienkritik." *Münchner Jahrbuch der bildende Kunst* 3d series, 12 (1961), 153-175.

Arndt 1966
Arndt, Karl. "Unbekannte Zeichnungen von Pieter Bruegel d. A." *Pantheon* 24 (1966), 207-216.

Arndt 1972
Arndt, Karl. "Pieter Bruegel d. A. und die Geschichte der 'Waldlandschaft'." *Jahrbuch der Berliner Museen* 14 (1972), 69-121.

Asperen de Boer 1975
Asperen de Boer, J.R.J. "An Introduction to the Scientific Examination of Paintings." *Nederlands Kunsthistorisch Jaarboek* 26 (1975), 1-40.

Baldass 1915
Baldass, Ludwig. "Eine Komposition Barend van Orleys." *Jahrbuch der königlich preussischen Kunstsammlungen* 36 (1915), 223-230.

Baldass 1916
Baldass, Ludwig. "Notizen zu holländischen Zeichnern des 16. Jahrhunderts: Jan van Scorel." *Mitteilungen der Gesellschaft für Vervielfältigende Kunst* 39 (1916), 4-8.

Baldass 1918
Baldass, Ludwig. "Notizen über holländsche Zeichner des 16. Jahrhunderts. III. Jan Swart van Groningen." *Mitteilungen der Gesellschaft für Vervielfältigende Kunst* 41 (1918), 11-21.

Baldass 1927-1928
Baldass, Ludwig. "Ein Landschaftsbild von Matthys Cock." *Zeitschrift für bildende Kunst* 61 (1927-1928), 90-96.

Baldass 1937a
Baldass, Ludwig. "Die Zeichnung im Schaffen des Hieronymus Bosch und der Frühholländer." *Die graphischen Künste* 2 (1937), 18-26.

Baldass 1937b
Baldass, Ludwig. "Die niederländischen Maler des spätgotischen Stiles." *Jahrbuch der kunsthistorischen Sammlungen in Wien* 11 (1937), 117-138.

Baldass 1943
Baldass, Ludwig. *Hieronymus Bosch*. Vienna, 1943.

Baldass 1944
Baldass, Ludwig. "Die Entwicklung des Bernart van Orley." *Jahrbuch der kunsthistorischen Sammlungen in Wien* 13 (1944), 141-191.

Baldass 1960
Baldass, Ludwig. *Hieronymus Bosch*. New York, 1960.

Balis 1979-1980
Balis, Arnout. "De 'Jachten van Maximilaan', kroonstuk van de hoofse jachticonografie." *Gentse Bijdragen tot de Kunstgeschiedenis* 25 (1979-1980), 14-41.

Bangs 1979
Bangs, Jeremy Dupertuis. *Cornelis Engebrechtsz.'s Leiden. Studies in Cultural History*. Assen, 1979.

Bangs 1981
Bangs, Jeremy Dupertuis. "The Leiden Monogramist PC and Other Artist's Enigmatic Fire Buckets." *Source* 1 (1981), 12-15.

Van Bastelaer 1908
Bastelaer, René van. *Les estampes de Peter Bruegel l'ancien*. Brussels, 1908.

Van Bastelaer 1913
Bastelaer, René van. *Suite de dessins de maîtres tirés de la collection de Grez*. Brussels, 1913.

Van Bastelaer and Hulin de Loo 1905-1907
Bastelaer, René van, and Georges Hulin de Loo. *Pieter Bruegel l'Ancien, son oeuvre et son temps*. Brussels, 1905-1907.

Bauer 1978
Bauer, Linda Freeman. " 'Quanto si disegna, si dipinge ancora': Some Observations on the Development of the Oil Sketch." *Storia dell'arte* 32 (1978), 45-57.

Bax 1949
Bax, Dirk. *Ontcijfering van Jeroen Bosch*. The Hague, 1949. (English trans. *Hieronymus Bosch, His Picture-writing Deciphered*. Rotterdam, 1979).

Bean 1964
Bean, Jacob. *100 European Drawings in the Metropolitan Museum of Art*. New York, 1964.

Beets 1909
Beets, Nicolaas. "Pieter Cornelisz. Kunst als glasschrijver en schilder." *Bulletin van den Nederlandschen Oudheidkundigen Bond* 2 (1909), 10-16.

Beets 1911
Beets, Nicolaas. "Aanwinsten Nederl. Museum voor Geschiedenis en Kunst." *Bulletin van den Nederlandschen Oudheidkundigen Bond* 4 (1911), 243-247.

Beets 1912
Beets, Nicolaas. "Dirick Jacobsz. Vellert, peintre anversois. IV. Dessins postérieurs à 1520." *L'art flamand et hollandais* 18 (1912), 129-148.

Beets 1913
Beets, Nicolaas. *Lucas van Leyde*. Brussels, Paris, 1913.

Beets 1914
Beets, Nicholaas. "Zestiende-eeuwsche Kunstenaars. I. Jan Swart." *Oud Holland* 32 (1914), 1-28.

Beets 1925
Beets, Nicolaas. "Dirick Jacobsz. Vellert, peintre d'Anvers. V. Verres peints." *La revue d'art* 26 (1925), 116-145.

Beets 1931a
Beets, Nicolaas. "Zestiende-eeuwsche Kunstenaars, II. Barent van Orley." *Oud Holland* 48 (1931), 145-171.

Beets 1931b
Beets, Nicolaas. "The 'Small Cartoons' of Barend van Orley for the 'Belles Chasses de Maximilien'." *Old Master Drawings* 6 (1931), 25-28.

Beets 1935
Beets, Nicolaas. "Zestiende-eeuwsche Kunstenaars. IV. Lucas Corneliszoon de Kock. 2. Teekeningen van Lucas Cornelisz en van Pieter Cornelisz." *Oud Holland* 52 (1935), 216-228.

Beets 1936
Beets, Nicolaas. "Zestiende-eeuwsche Kunstenaars. IV. Lucas Cornelisz. de Kock." *Oud Holland* 52 (1936), 55-78.

Beets 1952
Beets, Nicolaas. "Nog eens 'Jan Wellens de Cock' en de zonen van Cornelis Engebrechtsz: Pieter Cornelisz Kunst, Cornelis Cornelisz Kunst, Lucas Cornelisz de Kock." *Oud Holland* 67 (1952), 1-30.

Béguin 1973
Béguin, Sylvie. "Pour Speckaert." In *Album Amicorum J.G. van Gelder* (The Hague, 1973), 11-15.

Benesch 1928
Benesch, Otto. *Beschreibender Katalog der Handzeichnungen in der Graphischen Sammlung Albertina. Die Zeichnungen der niederländischen Schulen des XV. und XVI. Jahrhunderts*. Vienna, 1928.

Benesch 1937a
Benesch, Otto. "Der Wald, der sieht und hört. Zur Erklärung einer Zeichnung von Bosch." *Jahrbuch der preussischen Kunstsammlungen* 58 (1937), 258-266.

Benesch 1937b
Benesch, Otto. "Zu van Regteren-Altenas de Gheyn-Monographie." *Die graphischen Künste* 2 (1937), 143-147.

Benesch 1943
Benesch, Otto. "The Name of the Master of the Half Lengths." *Gazette des Beaux-Arts* 23 (1943), 269-282.

Benesch 1945
Benesch, Otto. *The Art of the Renaissance in Northern Europe: Its Relation to the Contemporary Spiritual and Intellectual Movements*. Cambridge, Mass., 1945.

Benesch 1953
Benesch, Otto. "The Drawings of Pieter Bruegel the Elder." *Kunstchronik* 6 (1953), 76-82.

Benesch 1957
Benesch, Otto. "Die grossen flämischen Maler als Zeichner." *Jahrbuch der kunsthistorischen Sammlungen in Wien* 17 (1957), 19-32.

Benesch 1965
Benesch, Otto. "Once again the Anonymous Liechtenstein Master." *Master Drawings* 3 (1965), 47-48.

Bergsträsser 1979
Bergsträsser, Gisela. *Kataloge des Hessischen Landesmuseum Darmstadt Nr. 10. Niederländischen Zeichnungen 16. Jahrhundert im Hessischen Landesmuseum Darmstadt*. Darmstadt, 1979. (Beiheft zu Heft 18-19 der Zeitschrift Kunst in Hessen und am Mittelrhein).

Bergström 1963
Bergström, Ingvar. "Georg Hoefnagel, le dernier des grands miniaturistes flamands." *L'Oeil* 101 (1963), 2-9, 66.

Bernard 1810
Bernard, Michel. *Cabinet de Paignon Dijonval, état détaillé et raisonné des dessins et estampes dont il est composé*. Paris, 1810.

Bernt 1957-1958
Bernt, Walther. *Die niederländischen Zeichner des 17. Jahrhunderts*. 2 vols. Munich, 1957-1958.

Best 1983
Best, Thomas W. *Reynard the Fox*. Boston, 1983.

Beuningen 1973
Beuningen, Charles van. *The Complete Drawings of Hieronymus Bosch*. London, New York, 1973.

Białostocki 1955
Białostocki, Jan. "Nouvelles notes sur l'album Errera." *Bulletin Musées Royaux des Beaux-Arts de Belgique* 4 (1955), 233-238.

Białostocki 1956
Białostocki, Jan. *Bruegel Pejzazysta*. Poznan, 1956.

Białostocki 1970
Białostocki, Jan. "Two Types of International Mannerism: Italian and Northern." *Umění* 18 (1970), 105-109.

Bierens de Haan 1948
Bierens de Haan, J.C.J. *L'Oeuvre gravé de Cornelis Cort, graveur hollandais 1533-1578*. The Hague, 1948.

Bisboer 1983
Bisboer, P. *Schilderijen voor het stadhuis Haarlem. 16e en 17e eeuwe kunstopdrachten ter verfraaiing*. Haarlem, 1983.

Van Bleyswijck 1667
Bleyswijck, Dirck van. *Beschrijvringe der Stadt Delft*. Delft, 1667.

Blunt 1966
Blunt, Anthony. *The Paintings of Nicolas Poussin. A Critical Catalogue*. London, 1966.

Bober 1957
Bober, Phyllis. *Drawings after the Antique by Amico Aspertini. Sketchbooks in the British Museum*. London, 1957.

Bock and Rosenberg 1930
Bock, Elfried, and Jakob Rosenberg. *Staatliche Museen zu Berlin. Die Zeichnungen alter Meister im Kupferstichkabinett. Die niederländischen Meister. Beschreibendes Verzeichnis sämtlicher Zeichnungen*. Berlin, 1930, Frankfurt-am-Main, 1931.

Börsch-Supan 1965
Börsch-Supan, Helmut. "Jan Gossaert gen. Mabuse. Zur der Ausstellung im Museum Boymans-van Beuningen, Rotterdam, und im Museum Groeningen, Brügge." *Kunstchronik* 18 (1965), 197-202.

Böstrom 1949
Böstrom, Kjell. "Das Sprichwort vom Vogelnest." *Konsthistorisk Tidskrift* 18 (1949), 77-89.

Van der Boom 1940
Boom, Anton van der. *Monumentale Glasschilderkunst in Nederland.* The Hague, 1940.

Boon 1953
Boon, Karel G. "Maria en het Kind en twee Heiligen door Jan Gossaert getekend." *Bulletin van het Rijksmuseum* 1 (1953), 65-71.

Boon 1955a
Boon, Karel G. "Tekeningen van en naar Scorel." *Oud Holland* 70 (1955), 207-218.

Boon 1955b
Boon, Karel G. "De tekenaar van het Errera-Schetsboek." *Bulletin Musées Royaux des Beaux-Arts de Belgique* 4 (1955), 215-229.

Boon 1960
Boon, Karel G. Review of Ludwig Baldass, *Jheronimus Bosch. The Burlington Magazine* 102 (1960), 457-458.

Boon 1964
Boon, Karel G. "Two Designs for Windows by Dierick Vellert." *Master Drawings* 2 (1964), 153-156.

Boon 1976a
Boon, Karel G. "Sixteenth-century Dutch Figure Drawings." *Apollo* 4 (1976), 338-345.

Boon 1976b
Boon, Karel G. "Lancelot Blondeel as a Designer for Sculpture and Textiles." *Hafnia. Copenhagen Papers in the History of Art*, (1976), 113-124.

Boon 1977a
Boon, Karel G. "De Antwerpse Schilder Bernaert de Rijckere en zijn tekeningen-oeuvre." *Oud Holland* 91 (1977), 109-131.

Boon 1977b
Boon, Karel G. Review of Carl van de Velde, *Frans Floris (1519/20-1570). Leven en Werken* 1975. *The Burlington Magazine* 119 (1977), 509-511.

Boon 1978
Boon, Karel G. *Catalogue of the Dutch and Flemish Drawings in the Rijksmuseum. Netherlandish Drawings of the Fifteenth and Sixteenth Centuries.* 2 vols. The Hague, 1978.

Boon 1980
Boon, Karel G. "Paul Bril's 'perfetta imitazione de' veri paesi'." *Relations artistiques entre les Pays-Bas et l'Italie à la Renaissance: études dédiées à Suzanne Sulzberger. (Etudes d'histoire de l'art. L'Institut historique belge de Rome, IV.).* Brussels and Rome (1980), 5-14.

Boon 1983
Boon, Karel G. "Sixteenth-Century Cartoons for Church Windows." *Apollo* 117 (1983), 437-442.

Boon 1985
Boon, Karel G. "Notities bij een houtsnede naar en een voorbeeldenblad van Jan de Beer." *Rubens and His World. Bijdragen opgedragen aan Prof. Dr. Ir. R.-A. d'Hulst* (Antwerp, 1985), 9-16.

Borafull y Sans 1956
Borafull y Sans, Don Francisco de. *Heraldic Watermarks, or La Heráldica en la Filigrana del Papel.* Hilversum, 1956.

Boschloo 1982
Boschloo, A.W.A. "Rudolph II en het Maniërisme." *Leids Kunsthistorisch Jaarboek* 2 (1982), 35-43.

Brandi 1980
Brandi, Karl. *The Emperor Charles V. The Growth and Destiny of a Man and of a World-Empire.* Translation of *Kaiser Karl V. Werden und Schicksal einer Persönlichkeit und eines Weltreiches.* Munich, 1937. Atlantic Highlands, 1980.

Braun and Hogenberg 1965
Braun, Georg, and Franz Hogenberg. *Civitates Orbis Terrarum 1572-1618 (Facsimile).* 6 vols. Amsterdam, 1965.

Briquet
Briquet, Charles Moïse. *Les filigranes. Dictionnaire historique des marques du papier.* Paris, 1907. 4 vols. Ed. Leipzig, 1923.

Brown 1973
Brown, Christopher. "Early Netherlandish Prints and Drawings at the British Museum." *The Burlington Magazine* 115 (1973), 761-762.

Brussels 1913
Brussels, Musées Royaux des Beaux-Arts de Belgique. *Inventaire des dessins et aquarelles donnés à l'état belge. Madame de Grez.* Brussels, 1913.

Bruyn 1955
Bruyn, Josua. "Enige werken van Jan van Scorel uit zijn Haarlemse tijd (1527-1529)." *Bulletin van het Rijksmuseum* 2 (1955), 51-58.

Bruyn 1960
Bruyn, Josua. "Twee St. Antonius-panelen en andere werken van Aertgen van Leyden." *Nederlands Kunsthistorisch Jaarboek* 11 (1960), 37-120.

Bruyn 1961
Bruyn, Josua. "Een portrettekening door Hendrick Goltzius." *Bulletin van het Rijksmuseum* 9 (1961), 135-139.

Bruyn 1965a
Bruyn, Josua. "The Jan Gossaert Exhibition in Rotterdam and Bruges." *The Burlington Magazine* 107 (1965), 462-467.

Bruyn 1965b
Bruyn, Josua. "Some Drawings by Pieter Aertsen." *Master Drawings* 3 (1965), 355-368.

Bruyn 1966
Bruyn, Josua. "De Abdij van Egmond als opdrachtgeefster van kunstwerken in het begin van de zestiende eeuw." *Oud Holland* 81 (1966), 145-172, 197-226.

Bruyn 1969
Bruyn, Josua. "Lucas van Leyden en zijn Leidse tijdgenoten in hun relatie tot Zuid-Nederland." *Miscellanea I.Q. van Regteren Altena* (Amsterdam, 1969), 44-47.

Bruyn 1982
Bruyn, Josua. "Pieter Bruegel in Graubünden." *Kunstveilingen de Vos (auction catalogue)* (13 December 1982).

Buchheit and Oldenbourg 1921
Buchheit, Hans, and Rudolf Oldenbourg. *Das Miniaturenkabinett der Münchner Residenz.* Munich, 1921.

Budde 1930
Budde, Illa. *Beschreibender Katalog der Handzeichnungen in de Staatlichen Kunstakademie Düsseldorf.* Düsseldorf, 1930.

Bull 1985
Bull, Duncan. "London Old Master Drawings Exhibition at P. & D. Colnaghi." *The Burlington Magazine* 127 (1985), 471-472.

Burchard 1913
Burchard, Ludwig. "Pieter Bruegel im Kupferstichkabinett zu Berlin." *Amtliche Berichte aus den königlichen Kunstsammlungen* 34 (1913), 223-234.

Byam Shaw 1968
Byam Shaw, James. "The Collection of Drawings at Christ Church, Oxford." *Master Drawings* 6 (1968), 235-240.

Byam Shaw 1976
Byam Shaw, James. *Drawings by Old Masters at Christ Church, Oxford.* Oxford, 1976.

Cellarius 1961
Cellarius, Helmut. "Die genealogischen Bildteppiche von Breda-Dillenburg. Ein Zeugnis des nassauischen Geschichtsbewusstseins im 16. Jahrhundert." *Verein für nassauische Altertumskunde und Geschichtsforschung. Annalen* 72 (1961), 58-80.

Chmelarz 1896
Chmelarz, Eduard. "Georg und Jakob Hoefnagel." *Jahrbuch der kunsthistorischen Sammlungen des allerhöchsten Kaiserhauses* 17 (1896), 275-290.

Cocke 1984
Cocke, Richard. *Veronese's Drawings: A Catalogue Raisonné.* London, 1984.

Combe 1946
Combe, Jacques. *Jérôme Bosch.* Paris, 1946.

Conway 1908
Conway, Martin. "Drawings by Gerard David." *The Burlington Magazine* 13 (1908), 155.

Conway 1921
Conway, Martin. *The Van Eycks and Their Followers.* London, 1921.

Crick-Kuntziger 1943
Crick-Kuntziger, Marthe. "Bernard van Orley et le décor mural en tapisserie." *Bernard van Orley 1488-1541* (Brussels, 1943), 71-92.

Croft-Murray 1952
Croft-Murray, Edward. "A Leaf from a Flemish Sketchbook of the Early Sixteenth Century." *The British Museum Quarterly* 17 (1952), 8-10.

Cuttler 1968
Cuttler, Charles D. *Northern Painting. From Pucelle to Bruegel.* New York et al., 1968.

Dacos 1964
Dacos, Nicole. *Les peintres belges à Rome au XVIe siècle.* Brussels, 1964.

Dacos 1980
Dacos, Nicole. "Les peintures romanistes. Histoire du terme, perspectives de recherche et example de Lambert van Noort." *Bulletin de l'Institut historique belge de Rome* 50 (1980), 161-186.

Dacos 1985
Dacos, Nicole. "Hermannus Posthumus. Rome. Mantua. Landshut." *The Burlington Magazine* 127 (1985), 433-438.

Dansaert and Bautier 1911
Dansaert, Georges, and Pierre Bautier. "Note sur quelques dessins attribués à Frans Floris et à son école." *Annales de la société d'archéologie de Bruxelles* 25 (1911), 319-333.

Delbanco 1928
Delbanco, Gustav. *Der Maler Abraham Bloemaert.* Studien zur Deutschen Kunstgeschichte, Heft 253. Stuttgart, 1928.

Delen 1924-1935
Delen, Adrien Jean Joseph. *Histoire de la gravure dans les anciens Pays-Bas et dans les provinces belges des origines jusqu'à la fin du XVIIIe siècle.* 3 vols. Paris, 1924-1935.

Delen 1944
Delen, Adrien Jean Joseph. *Teekeningen van Vlaamsche Meesters.* Antwerp, Brussels, Ghent, and Louvain, 1944.

Delmarcel 1984
Delmarcel, Guy. "Les tapisseries des Chasses de Maximilien: rêve et réalité." *Revue belge d'archéologie et d'histoire de l'art* 53 (1984), 119-128.

Demus 1972
Demus, Klaus. *Kunsthistorisches Museum, Wien. Katalog der Gemäldegalerie. Holländische Meister des 15., 16. und 17. Jahrhunderts.* Vienna, 1972.

Denhaens 1982-1983
Denhaens, G. "L'album d'Arenberg. Le language humanist et les intéréts artistiques de Lambert Lombard." Ph.D. diss., Free University, Brussels, 1982-1983.

Denucé 1932
Denucé, Jean. *The Antwerp Art-Galleries: Inventories of the Art-Collections in Antwerp in the 16th and 17th Centuries.* The Hague, 1932.

Dhanens 1956
Dhanens, Elisabeth. *Jean Boulogne-Giovanni Bologna Fiammingo Douai 1529-Florence 1608: Bijdrage tot de studie van de kunstbetrekkingen tussen het Graafschap Vlaanderen en Italië. (Koninklijke Vlaamse Academie voor Wetenschappen Letteren en Schone Kunsten van België).* Klasse der Schone Kunsten, *Verhandeling,* no. 11. Brussels, 1956.

d'Hulst 1952
d'Hulst, Roger-A. "De 'Ripa Grande' te Rome." *Bulletin Musées Royaux des Beaux-Arts de Belgique* 1 (1952), 103-106.

d'Hulst 1955
d'Hulst, Roger-A. "Nieuwe Gegevens omtrent Joos van Winghe als Schilder en Tekenaar." *Bulletin Musées Royaux des Beaux-Arts de Belgique* 4 (1955), 239-248.

d'Hulst 1960
d'Hulst, Roger-A. *Tapisseries flamands du XIV^e au XVIII^e siècle.* Brussels, 1960.

Diez 1909-1910
Diez, Ernst. "Der Hofmaler Bartmolomäus Spranger." *Jahrbuch des allerhöchsten Kaiserhauses* 28 (1909-1910), 93-151.

Dittrich 1976-1977
Dittrich, Christian. "Unbekannte Zeichnungen de Abraham Bloemart: Neubestimmungen und Neuerwerbungenen im Kupferstich-kabinett Dresden." *Jahrbuch der Staatlichen Kunstsammlungen Dresden* (1976-1977), 89-102.

Dodgson 1910-1911
Dodgson, Campbell J. "Jan van Scorel: Mountainous Landscape, British Museum." *Vasari Society* 6 (1910-1911), no. 17.

Dodgson 1926-1927
Dodgson, Campbell J. "Hans Bol." *Old Master Drawings* 1 (1926-1927), 55.

Dodgson 1935
Dodgson, Campbell J. "Hendrick Goltzius (1558-1616)—Study of a Tree." *Old Master Drawings* 9 (1935), 66.

D'Onofrio 1970
D'Onofrio, Cesare. *Il Trevere Roma.* Rome, 1970.

Drossaers 1930
Drossaers, S.W.A. "Inventaris van de meubelen van het Stadhouderlijk kwartier met het Speelhuis en van het Huis in het Noordeinde te 's-Gravenhage." *Oud Holland* 47 (1930), 193-276.

Dubiez 1969
Dubiez, F.J. *Cornelis Anthoniszoon van Amsterdam, zijn leven en werken ca. 1507-1553.* Amsterdam, 1969.

Dunbar 1972
Dunbar, Burton L. "Some Observations on the 'Errera Sketchbook' in Brussels." *Bulletin Musées Royaux des Beaux-Arts de Belgique* 21 (1972), 53-82.

Duverger 1971
Duverger, Erik. "Verder nieuws over de tapijten bekend als de Nassause genealogie." *Artes Textiles* 7 (1971), 210-215.

Van Eeghen 1935
Eeghen, Christiaan Pieter J. van. "Poorten en torens van Amsterdam." *Ochtenblad. Algemeen Handelsblad* (3 December 1935).

Egger 1911
Egger, Hermann. *Romische Veduten. Handzeichnungen aus dem XV.-XVIII Jahrhunderts.* 2 vols. Vienna, Leipzig, 1911.

Eickhoff 1918
Eickhoff, Hermann. "Ausstellung von Handzeichnungen flämischer Meister des XV. bis XVII. Jahrhunderts." *Amtliche Berichte aus den königlichen Kunstsammlungen* 40 (1918), cols. 18-31.

Ertz 1979
Ertz, Klaus. *Jan Brueghel der Altere (1568-1625). Die Gemälde mit kritischem Oeuvrekatalog.* Cologne, 1979.

Evans 1973
Evans, Robert John Weston. *Rudolf II and His World. A Study in Intellectual History 1576-1612.* Oxford, 1973.

Ewing 1978
Ewing, Dan Chalmer. "The Paintings and Drawings of Jan de Beer." 2 vols. Ph.D. diss., The University of Michigan, Ann Arbor, 1978.

Ewing 1980
Ewing, Dan Chalmer. "A New 'Crucifixion' by Jan de Beer." *Jaarboek Koninklijk Museum voor Schone Kunsten Antwerpen* (1980), 37-60.

Faggin 1965
Faggin, Giorgio T. "Per Paolo Bril." *Paragone* 185 (1965), 20-35.

Faggin 1968
Faggin, Giorgio T. "Nuove opere di Lanceloot Blondeel." *Critica d'arte* 95 (1968), 37-54.

Falck 1917
Falck, Gustav. "Samtidige Portraetter af Christian II og Hans Dronning. I Kobberstik og Traesnit." *Kunstmuseets Aarsskrift* 3 (1917), 64-79.

Faries 1970
Faries, Molly. "Jan van Scorel, Additional Documents from the Church Records of Utrecht." *Oud Holland* 85 (1970), 2-24.

Faries 1975
Faries, Molly. "Underdrawings in the Workshop Production of Jan van Scorel—A Study with Infrared Reflectography." *Nederlands Kunsthistorisch Jaarboek* 26 (1975), 89-228.

Faries 1982
Faries, Molly. "Two Additional Panels from Jan van Scorel's Workshop: Comments about Authorship." *Le Dessin sous-jacent dans la peinture. Colloque IV* (Louvain-La-Neuve, 1982), 121-130.

Farmer 1981
Farmer, John David. "Bernard van Orley of Brussels." Ph.D. diss., Princeton University, 1981.

Fehl 1968
Fehl, Philipp P. "Realism and Classicism in the Representation of a Painful Scene: Titian's 'Flaying of Marsyas' in the Archiepiscopal Palace at Kroměríž." *Czechoslovakia Past and Present.* Ed. Marioslav Rechicgl, Jr. 2 vols. (The Hague, 1968), 2: 1387-1415.

Filedt Kok 1972-1973
Filedt Kok, Jan Piet. "Underdrawing and Drawing in the Work of Hieronymus Bosch: A Provisional Survey in Connection with the Paintings by Him in Rotterdam." *Simiolus* 6 (1972-1973), 133-162.

Filedt Kok 1978a
Filedt Kok, Jan Piet. "Underdrawing and Other Technical Aspects in the Paintings of Lucas van Leyden." *Nederlands Kunsthistorisch Jaarboek* 29 (1978), 1-184.

Filedt Kok 1978b
Filedt Kok, Jan Piet. "Lucas van Leyden—Exhibitions and Recent Publications." *Nederlands Kunsthistorisch Jaarboek* 29 (1978), 509-520.

Fishman 1982
Fishman, Janet Susannah. *Boerenverdriet. Violence between Peasants and Soldiers in Early Modern Netherlandish Art.* Ann Arbor, 1982.

Flechsig 1923
Flechsig, Eduard. *Zeichnungen alter Meister im Landes-museum zu Braunschweig. Veröffentlichung der Prestel-Gesellschaft, VII.* 3 vols. Frankfurt-am-Main, 1923.

Fock 1969
Fock, C. Willemijn. "Nieuws over de tapijten, bekend als de Nassause Genealogie." *Oud Holland* 84 (1969), 1-28.

Fogolari 1913
Fogolari, Gino. *Catalogo, Accademia di Venezia.* Venice, 1913.

Folie 1951
Folie, Jacqueline. "Les dessins de Jean Gossart, dit Mabuse." *Gazette des Beaux-Arts* 38 (1951), 77-98.

Foucart 1985
Foucart, Jacques. "De schilderijen die het Louvre in drie jaar heeft verworven." *Tableau* 7 (1985), 38-47.

Foucart and Rosenberg 1978
Foucart, Jacques, and Pierre Rosenberg. "Some 'Modelli' of Religious Scenes by Dirck Barendsz." *The Burlington Magazine* 120 (1978), 198-204.

Franz 1965
Franz, Heinrich Gerhard. "Hans Bol als Landschafts-zeichner." *Jahrbuch des Kunsthistorischen Instituts Graz* 1 (1965), 19-67.

Franz 1968-1969
Franz, Heinrich Gerhard. "Meister des spätmanieris-tischen Landschaftsmalerei in den Niederlanden." *Jahr-buch des kunsthistorischen Institutes der Universität Graz* 3-4 (1968-1969), 21-71.

Franz 1969
Franz, Heinrich Gerhard. *Niederländische Landschafts-malerei im Zeitalter des Manierismus.* Graz, 1969.

Franz 1970
Franz, Heinrich Gerhard. "Niederländische Landschafts-maler im Künstlerkreis Rudolf II." *Umění* 18 (1970), 224-245.

Franz 1979-1980
Franz, Heinrich Gerhard. "Zum Werk des Roelandt Sav-ery." *Kunsthistorisches Jahrbuch Graz* 15-16 (1979-1980), 175-189.

Freedberg 1965
Freedberg, Sydney J. "Observations on the Painting of the Maniera." *The Art Bulletin* 47 (1965), 187-197.

Freedberg 1976a
Freedberg, David. "The Problem of Images in Northern Europe and Its Repercussions in the Netherlands." *Haf-nia. Copenhagen Papers in the History of Art* 1976, 25-45.

Freedberg 1976b
Freedberg, David. "The Representation of Martyrdoms during the Early Counter-Reformation in Antwerp." *The Burlington Magazine* 118 (1976), 128-138.

Freedberg 1982
Freedberg, David. "The Hidden God: Image and Interdic-tion in the Netherlands in the Sixteenth Century." *Art History* 5 (1982), 133-153.

Friedländer 1908-1909
Friedländer, Max J. "Eine Zeichnung Jacobs van Amster-dam." *Amtliche Berichte aus der königliche Kunst-sammlungen* 30 (1908-1909), 49-54.

Friedländer 1909
Friedländer, Max J. "Bernart van Orley. II. Orleys Tätig-keit zwischen 1515 und 1520. III. Orleys Tätigkeit zwischen 1521 und 1525. IV. Orleys Tätigkeit von 1526 bis 1540." *Jahrbuch der königlich preussischen Kunst-sammlungen* 30 (1909), 9-34, 89-107, 155-178.

Friedländer 1915
Friedländer, Max J. "Die Antwerpener Manieristen von 1520." *Jahrbuch der königlich preussischen Kunst-sammlungen* 36 (1915), 65-91.

Friedländer 1917
Friedländer, Max J. "Pieter Coecke van Alost." *Jahrbuch der königlich preussischen Kunstsammlungen* 38 (1917), 73-94.

Friedländer 1921a
Friedländer, Max J. *Pieter Bruegel.* Berlin, 1921.

Friedländer 1921b
Friedländer, Max J. *Die niederländischen Manieristen.* Leipzig, 1921.

Friedländer 1931
Friedländer, Max J. "Uber die Frühzeit Jan Gossaerts." *Mélanges Hulin de Loo.* Brussels, 1931, 182-186.

Friedländer 1937
Friedländer, Max J. "Ein vlämischer Portraitmaler in England." *Gentsche Bijdragen tot de Kunstgeschiedenis* 4 (1937), 5-18.

Friedländer 1938
Friedländer, Max J. "Bildnisse des Dänenkönigs Christian II." *Annuaire Musées Royaux des Beaux-Arts de Belgique* 1 (1938), 89-97.

Friedländer 1956
Friedländer, Max J. *From Van Eyck to Bruegel.* Trans. M. Kay. Ed. Fritz Grossmann. New York, 1956.

Friedländer 1963
Friedländer, Max J. *Lucas van Leyden.* Ed. Friedrich Winkler. Berlin, 1963.

Friedländer, *ENP*
Friedländer, Max J. *Die altniederländische Malerei.* Berlin and Leipzig, 1924-1937. 14 vols. English ed. Brussels and Leiden, 1967-1976. 14 vols. in 16.

Friedlaender 1957
Friedlaender, Walter. *Mannerism and Anti-mannerism in Italian Painting.* New York, 1957.

Friedlaender 1964
Friedlaender, Walter. *Nicolas Poussin, A New Approach.* New York, 1964.

Fubini and Held 1964
Fubini, Giorgio, and Julius S. Held. "Padre Resta's Rubens Drawings after Antique Sculpture." *Master Drawings* 2 (1964), 123-141.

Garff 1971
Garff, Jan. *Copenhagen, Kongelige Kobberstiksamling Tegninger af Maerten van Heemskerck.* Copenhagen, 1971.

Van Gelder 1928
Gelder, Jan Gerrit van. "Twee Teekeningen van Jan de Cock." *Oud Holland* 45 (1928), 241-244.

Van Gelder 1929
Gelder, Jan Geritt van. "Een nieuw Werk van Pieter Coecke van Aelst." *Onze Kunst* 46 (1929), 134-136.

Van Gelder 1933
Gelder, Jan Gerrit van. *Jan van de Velde 1593-1641. Teekenaar-Schilder.* The Hague, 1933.

Van Gelder 1938-1939
Gelder, Jan Gerrit van. "Boomstudies uit vroeger eeuwen." *Beeldende Kunst* 25 (1938-1939), 17-24.

Van Gelder 1939
Gelder, Jan Gerrit van. "Early Work of J.G. Vermeyen and Cornelis Buys II." *XVth International Congress of the History of Art.* London, 1939.

Van Gelder 1942
Gelder, Jan Gerrit van. "Jan Gossaert in Rome 1508-1509." *Oud Holland* 57 (1942), 1-11.

Van Gelder 1958
Gelder, Jan Gerrit van. *Prenten en Tekeningen. De Schoonheid van ons Land.* Amsterdam, 1958.

Van Gelder 1959
Gelder, Jan Gerrit van. *Dutch Drawings and Prints.* New York, 1959.

Van Gelder 1979
Gelder, Jan Gerrit van. "Valerius Röver en Lucas van Leyden." *Bulletin van het Rijksmuseum* 27 (1979), 55-67.

Van Gelder and Borms 1939
Gelder, Jan Gerrit van, and Jan Borms. *Brueghel's zeven deugden en seven hoofdzonden.* Amsterdam and Antwerp, 1939.

Gerszi 1960
Gerszi, Teréz. "Bestimmung einiger niederländischer Zeichnungen des XVI. Jahrhunderts." *Oud Holland* 75 (1960), 229-240.

Gerszi 1970
Gerszi, Teréz. "Die Landschaftkunst von Paulus van Vianen." *Uměmí* 18 (1970), 260-269.

Gerszi 1971
Gerszi, Teréz. *Netherlandish Drawings in the Budapest Museum. Sixteenth-century Drawings.* Amsterdam and New York, 1971.

Gerszi 1976a
Gerszi, Teréz. *Zwei Jahrhunderte niederländischer Zeichenkunst. Ausgewählte Meisterwerke des 16.-17. Jahrhunderts Museum der Bildenden Künste, Budapest.* Budapest, 1976.

Gerszi 1976b
Gerszi, Teréz. "Bruegels Nachwirkung auf die niederländischen Landschaftsmaler um 1600." *Oud Holland* 90 (1976), 201-229.

Gerszi 1982
Gerszi, Teréz. *Paulus van Vianen. Handzeichnungen.* Hanau, 1982.

Gibson 1966-1967
Gibson, Walter S. "Peter Cornelisz. Kunst as a Panel Painter." *Simiolus* I (1966-1967), 37-45.

Gibson 1970
Gibson, Walter S. "Two Painted Glass Panels from the Circle of Lucas van Leyden." *The Bulletin of the Cleveland Museum of Art* 57 (1970), 81-92.

Gibson 1977a
Gibson, Walter S. *Bruegel.* New York and Toronto, 1977.

Gibson 1977b
Gibson, Walter S. *The Paintings of Cornelis Engebrechtsz.* New York and London, 1977.

Gibson 1978
Gibson, Walter S. "Some Flemish Popular Prints from Hieronymus Cock and His Contemporaries." *The Art Bulletin* 60 (1978), 678-681.

Gleadowe 1922
Gleadowe, Reginald Morier Yorke. "A Lucas van Leyden for the National Gallery." *The Burlington Magazine* 40 (1922), 179-180.

Glück 1901
Glück, Gustav. "Beiträge zur Geschichte der Antwerpner Malerei im XVI. Jahrhundert. I. Der Wahre Name des Meisters D☆V." *Jahrbuch der kunsthistorischen Sammlungen des allerhöchsten Kaiserhauses* 22 (1901), 1-34. (Reprinted in Glück 1933, 81-129).

Glück 1928
Glück, Gustav. *Die Kunst der Renaissance in Deutschland, den Niederlanden, Frankreich, etc.* Berlin, 1928.

Glück 1933
Glück, Gustav. "Beiträge zur Geschichte der Antwerpner Malerei im 16. Jahrhundert." *Aus Drei Jahrhunderten europäischer Malerei.* (First published in *Jahrbuch der kunsthistorischen Sammlungen in Wien* 22 [1901], 1-34). Vienna, 1933, 81-129.

Glück 1937
Glück, Gustav. *Bruegels Gemälde.* Vienna, 1937.

Glück 1940
Glück, Gustav. "Portraetter af Christian II og hans hustru Isabella." *Kunstmuseets Aarsskrift* 27 (1940), 1-33.

Glück 1945
Glück, Gustav. "Mabuse and the Development of the Flemish Renaissance." *The Art Quarterly* 8 (1945), 116-138.

Goldschmidt 1919
Goldschmidt, Adolf. "Lambert Lombard." *Jahrbuch der königlich preussischen Kunstsammlungen* 40 (1919), 206-240.

Gombrich 1969
Gombrich, Ernst Hans. "Bosch's 'Garden of Earthly Delights': A Progress Report." *Journal of the Warburg and Courtauld Institutes* 32 (1969), 162-170.

Gonse 1876
Gonse, Louis. "La galerie de M. Schneider." *Gazette des Beaux-Arts* 8 (1876), 511-528.

Goossens 1954
Goossens, Korneel. *David Vinckboons.* Antwerp, 1954.

Goossens 1966
Goossens, Korneel. "Nog meer over David Vinckboons." *Jaarboek Museum voor Schone Kunsten Antwerpen* 1966, 59-106.

Goris and Marlier 1971
Goris, Jan Albert, and Georges Marlier. *Albrecht Dürer. Diary of his Journey to the Netherlands 1520-1521.* Greenwich, 1971.

Graevius 1690-1694
Graevius, Joannes Georgius. *Thesaurus. Antiquitatum Romanorum.* Utrecht, 1690-1694.

Grauls 1957
Grauls, Jan. *Volkstaal en Volksleven in het werk van Pieter Bruegel.* Antwerp and Amsterdam, 1957.

Grosse 1980
Grosse, Rolph. *Die holländische Landschaftskunst 1600-1650.* Berlin, Leipzig, 1925.

Grosshans 1980
Grosshans, Rainald. *Maerten van Heemskerck. Die Gemälde.* Berlin, 1980.

Grossmann 1954
Grossmann, Fritz. "The Drawings of Pieter Bruegel the Elder in the Museum Boymans and Some Problems of Attribution." *Bulletin Museum Boymans Rotterdam* 5 (1954), 41-63, 76-85.

Grossmann 1955
Grossmann, Fritz. *Pieter Bruegel. The Paintings.* London, 1955.

Grossmann 1960
Grossmann, Fritz. "Bruegel, Pieter the Elder." *Encyclopedia of World Art* 2 (1960), cols. 632-651. (16 vols. 1959-1983).

Grossmann 1961
Grossmann, Fritz. "Bruegels Verhältnis zu Raffael und zur Raffael-Nachfolge." *Festschrift Kurt Badt zum Siebzigsten Geburtstage* (Berlin, 1961), 135-143.

Grossmann 1973
Grossmann, Fritz. "Notes on Some Sources of Bruegel's Art." *Album Amicorum J.G. van Gelder* (The Hague, 1973), 147-154.

Gudlaugsson 1959
Gudlaugsson, S.J. "Het Errera-schetsboek en Lucas van Valckenborch." *Oud Holland* 74 (1959), 118-138.

Hand and Wolff 1986
Hand, John Oliver, and Martha Wolff. *Early Netherlandish Painting. The Collections of the National Gallery of Art. Systematic Catalogue.* National Gallery of Art, Washington, 1986.

Harbison 1976
Harbison, Craig. "Reformation Iconography: Problems and Attitudes." *Print Review* 5 (1976), 78-87.

Haskell and Penny 1981
Haskell, Francis, and Nicholas Penny. *Taste and the Antique: The Lure of Classical Sculpture 1500-1900.* New Haven and London, 1981.

Haverkamp-Begemann 1959
Haverkamp-Begemann, Egbert. *Willem Buytewech.* Amsterdam, 1959.

Haverkamp-Begemann 1962
Haverkamp-Begemann, Egbert. "Pauwels Franck-alias Paolo Fiammingo-als tekenaar." *Bulletin van het Rijksmuseum* 10 (1962), 68-75.

Haverkamp-Begemann 1964
Haverkamp-Begemann, Egbert. Review of L. Münz, *Pieter Bruegel. The Complete Edition. Master Drawings* 2 (1964), 55-58.

Haverkamp-Begemann 1965
Haverkamp-Begemann, Egbert. Review of exhibition, *Jan Gossaert genammd Mabuse. Master Drawings* 3 (1965), 403-405.

Haverkamp-Begemann 1973
Haverkamp-Begemann, Egbert. *Hercules Seghers: The Complete Etchings.* Amsterdam and The Hague, 1973.

Haverkamp-Begemann 1974
Haverkamp-Begemann, Egbert. "Dutch and Flemish Figure Drawings from the Collection of Harry G. Sperling." *Master Drawings* 12 (1974), 34-39.

Haverkamp-Begemann 1979
Haverkamp-Begemann, Egbert. "Joos van Liere." *Pieter Bruegel und seine Welt. Eine Colloquium veranstaltet vom Kunsthistorischen Institut der freien Universität Berlin und dem Kupferstichkabinett der Staatliche Museen Preussischer Kulturbesitz am 13. und 14. November 1975* (Berlin, 1979), 17-28.

Haverkamp-Begemann and Logan 1970
Haverkamp-Begemann, Egbert, and Anne-Marie S. Logan. *European Drawings and Watercolors in the Yale University Art Gallery 1500-1900.* New Haven and London, 1970.

an der Heiden 1970
Heiden, Rüdiger an der. "Die Porträtmalerei des Hans von Aachen." *Jahrbuch der Kunsthistorischen Sammlungen in Wien* 30 (1970), 135-226.

an der Heiden 1976
Heiden, Rüdiger an der. "Bartholomäus Sprangers Lukas-Madonna." *Pantheon* 34 (1976), 34-37.

Heinecken 1778-1790
Heinecken, Karl Heinrich von. *Dictionnaire des artistes dont nous avons des estampes.* Leipzig, 1778-1790.

Helbig 1873
Helbig, Jules. *Histoire de la peinture au pays de Liège.* Liège, 1873.

Helbig 1892
Helbig, Jules. *Lambert Lombard, peintre et architecte.* Brussels, 1892.

Held 1931
Held, Julius S. *Dürers Wirkung auf die niederländische Kunst seiner Zeit.* The Hague, 1931.

Held 1933
Held, Julius S. "Notizien zu einem niederländischen Skizzenbuch in Berlin." *Oud Holland* 50 (1933), 273-288.

Held 1951
Held, Julius S. "Notes on David Vinckboons." *Oud Holland* 66 (1951), 241-244.

Held 1963
Held, Julius S. "The Early Appreciation of Drawings." In *Latin American Art, and the Baroque Period in Europe. Studies in Western Art. Acts of the Twentieth International Congress of the History of Art.* Vol. 3. Princeton, 1963.

Held 1972
Held, Julius S. Review of Egbert Haverkamp-Begemann and Anne-Marie S. Logan, *European Drawings and Watercolors in the Yale University Art Gallery, 1500-1900. Master Drawings* 10 (1972), 41-45.

Heldring 1964
 Heldring, H.H. "Een iconografisch raadsel." *Jaarboek Centraal Bureau voor Genealogie* 8 (1964), 155-163.

Hendrix 1984
 Hendrix, Marjorie Lee. "Joris Hoefnagel and the Four Elements: A Study in Sixteenth-Century Nature Painting." Ph.D. diss., Princeton University, 1984.

Henkel 1931
 Henkel, Max Ditmar. *Le dessin hollandais des origines au XVIIᵉ siècle.* Paris, 1931.

Herzog 1968
 Herzog, Sadja. "Jan Gossaert, Called Mabuse (ca. 1478-1532). A Study of His Chronology with a Catalogue of His Works." Ph.D. diss., Bryn Mawr College, 1968.

Hindman 1981
 Hindman, Sandra. "Pieter Bruegel's 'Children's Games,' Folly, and Chance." *The Art Bulletin* 63 (1981), 447-475.

Hirschmann 1916
 Hirschmann, Otto. *Hendrick Goltzius als Maler 1600-1617 (Quellenstudien zur Hollandischen Kunstgeschichte IX).* The Hague, 1916.

Hirschmann 1919
 Hirschmann, Otto. *Hendrick Goltzius. (Meister der Graphik, VII).* Leipzig, 1919.

Hoffmann 1929
 Hoffmann, Edith. "On Some Netherlandish and German Drawings of the Museum of Fine Arts." *Budapest Museum Yearbook* 1929.

Hollstein
 Hollstein, F.W.H. *Dutch and Flemish Etchings, Engravings and Woodcuts ca. 1450-1700.* 21 vols. Amsterdam, 1949-1980.

Hollstein (German)
 Hollstein, F.W.H. *German Engravings, Etchings and Woodcuts, ca. 1400-1700.* 27 vols. Amsterdam, 1954-1980.

Hoogewerff NNS
 Hoogewerff, Godefridus Joannes. *De Noord-Nederlandsche Schilderkunst.* 5 vols. The Hague, 1936-1947.

Hoogewerff 1923
 Hoogewerff, Godefridus Joannes. *Jan van Scorel, peintre de la Renaissance hollandaise.* The Hague, 1923.

Hoogewerff 1954
 Hoogewerff, Godefridus Joannes. *Het landschap van Bosch tot Rubens.* Antwerp, 1954.

Horn 1984
 Horn, Hendrik J. "*The Sack of Tunis* by Jan Cornelisz Vermeyen: A Section of the Preliminary Drawings for his *Conquest of Tunis* Series." *Bulletin van het Rijksmuseum* 32 (1984), 17-24.

Hubaux and Puraye 1949
 Hubaux, J., and J. Puraye. "Dominque Lampson. Lamberti Lombardi . . . Vita. Traduction et notes." *Revue belge d'archéologie et d'histoire de l'art* 18 (1949), 53-77.

Hübner 1912
 Hübner, Paul Gustav. *Le Statue di Roma: Grundlagen für eine geschichte der antiken Monumente in der Renaissance. (Römische Forschungen herausgegeben von der Biblioteca Hertziana, II).* Leipzig, 1912.

Hühn-Kemp 1970
 Hühn-Kemp, E. "Lambert Lombard als Zeichner." Ph.D. diss., University of Munster, 1970.

Hülsen and Egger 1913-1916
 Hülsen, Christian, and Hermann Egger. *Die Römischen Skizzenbücher von Marten van Heemskerck im königlichen Kupferstichkabinett zu Berlin.* 2 vols. Berlin, 1913-1916.

Hulin de Loo 1913
 Hulin de Loo, Georges. "Ein Authentisches Werk von Goosen van der Weyden im Kaiser-Friedrich-Museum. Die gleichzeitigen Gemälde aus Tongerloo und Lier und die Ursprünge der Antwerpen." *Jahrbuch der königlich preussischen Kunstsammlungen* 34 (1913), 59-88.

Huth 1967
 Huth, Hans. *Künstler und Werkstatt der Spätgotik.* 2d ed. Darmstadt, 1967.

Hutter 1966
 Hutter, Heribert. *Drawing. History and Technique.* London, 1966.

Huvenne 1980
 Huvenne, Paul. "Pieter Pourbus als tekenaar, een overzicht." *Oud Holland* 94 (1980), 11-31.

Hymans 1910
 Hymans, Hendrik. "Blondeel, Lancelot." *Thieme-Becker* 4 (1910), 134-135.

Jaffé 1979
 Jaffé, Michael. "Rubens und Bruegel." In *Pieter Bruegel und seine Welt. Eine Colloquium veranstaltet vom Kunsthistorischen Institut der freien Universität Berlin und dem Kupferstichkabinett der Staatliche Museen Preussischer Kulturbesitz am 13. und 14. November 1975* (Berlin, 1979), 37-49.

Jans 1969
 Jans, A. "Enkele grepen uit de kerkelijke wetgeving ten tijde van Pieter Bruegel." In *Jaarboek van het Koninklijk Museum voor Schone Kunsten Antwerpen* (1969), 105-112.

Jenni 1976
 Jenni, Ulrike. *Das Skizzenbuch der Internationalen Gotik in der Uffizien: der Ubergang vom Musterbuch zum Skizzenbuch.* Vienna, 1976.

De Jongh 1968-1969
 Jongh, E. de. "Erotica in vogelperspectief. De dubbelzinnigheid van een reeks 17de eeuwse genrevoorstellingen." *Simiolus* 3 (1968-1969), 22-74.

Jost 1960
 Jost, Ingrid. "Studien zu Anthonis Blocklandt." Ph.D. diss., Universität Köln, 1960.

Jost 1967
 Jost, Ingrid. "Ein unbekannter Altarflügel des Anthonis Blocklandt." *Oud Holland* 82 (1967), 116-127.

Jost 1968
 Jost, Ingrid. "Eine Wohltätigkeitdarstellung Blocklandts." In *Munuscula Discipulorum. Kunsthistorische Studien Hans Kauffmann zum 70. Geburtstag 1966.* Berlin, 1968.

Judson 1962
Judson, J. Richard. "Dirck Barentsen, 'Die . . . des grooten Titiaens boesem heeft ghenoten." *Bulletin Koninklijke Musea voor Schone Kunsten* 11 (1962), 77-122.

Judson 1963
Judson, J. Richard. "A New Insight into Cornelis Ketel's Method of Portraiture." *Master Drawings* I (1963), 38-41.

Judson 1970
Judson, J. Richard. *Dirck Barendsz. 1534-1592*. Amsterdam, 1970.

Judson 1972
Judson, J. Richard. "A New Joos van Winghe Drawing." *Nederlands Kunsthistorisch Jaarboek* 23 (1972), 37-40.

Judson 1973
Judson, J. Richard. *The Drawings of Jacob de Gheyn II*. New York, 1973.

Judson 1981
Judson, J. Richard. "Jan Gossaert's 'Knollenstil'." In *Ars Auro Prior* (Warsaw, 1981), 337-340.

Judson 1985a
Judson, J. Richard. "Jan Gossaert, the Antique and the Origins of Mannerism in the Netherlands." In *Netherlandish Mannerism: Papers Given at a Symposium in Nationalmuseum Stockholm, September 21-22, 1984* (Stockholm, 1985), 14-20.

Judson 1985b
Judson, J. Richard. "Observations on the Use of the Antique in Sixteenth-century Netherlandish Art." In *Rubens and His World* (Antwerp, 1985), 49-59.

Jung 1985
Jung, Roland. "Peeter Baltens, a Forgotten Draughtsman of the Bruegel Circle: His Landscape Drawings." *Nationalmuseum (Stockholm) Bulletin* 9 (1985), 46-58.

Kai Sass 1976
Kai Sass, Else. "A la recherche d'un portrait disparu de Christian II, Roi de Danemark, peint par Albrecht Dürer en 1521." In *Hafnia. Copenhagen Papers in the History of Art* (1976), 163-184.

Karling 1976
Karling, Sten. "Christian II in Stockholm in 1520. 'The Massacre-Picture' in a New Light." In *Hafnia. Copenhagen Papers in the History of Art* (1976), 143-162.

Kauffmann 1923
Kauffmann, Hans. "Der Manierismus in Holland und die Schule von Fontainebleau." *Jahrbuch der preussischen Kunstsammlungen* 44 (1923), 184-204.

Kaufmann 1978
Kaufmann, Thomas Da Costa. "Remarks on the Collections of Rudolf II: the Kunstkammer as a Form of Representation." *Art Journal* 38 (1978), 22-28.

Kaufmann 1982
Kaufmann, Thomas Da Costa. "The Eloquent Artist: Towards an Understanding of the Stylistics of Painting at the Court of Rudolf II." *Leids Kunsthistorisch Jaarboek* 2 (1982), 119-148.

Kaufmann 1985
Kaufmann, Thomas Da Costa. *L'Ecole de Prague. La peinture à la cour de Rodolphe II*. Paris, 1985.

Kemp 1973
Kemp, Ellen and Wolfgang. "Lambert Lombards antiquarische Theorie und Praxis." *Zeitschrift für Kunstgeschichte* 36 (1973), 122-152.

Kerrich 1829
Kerrich, Thomas. *A Catalogue of the Prints, Which Have Been Engraved After Martin Heemskerck; Or Rather, an Essay Towards Such a Catalogue*. Cambridge, 1829.

Keyes 1979
Keyes, George S. "Cornelis Claesz. van Wieringen." *Oud Holland* 93 (1979), 1-46.

Keyes 1982
Keyes, George S. *Hendrick Averkamp 1581-1634: Barent Averkamp 1612-1679. Frozen Silence*. Amsterdam, 1982.

Keyes 1984
Keyes, George S. *Esias van de Velde, 1587-1630*. Doornspijk, 1984.

Kibisch 1955
Kibisch, Christine Ozarowska. "Lucas Cranach's Christ Blessing the Children: A Problem of Lutheran Iconography." *The Art Bulletin* 37 (1955), 196-203.

Killermann 1924
Killermann, Sebastian. "Hoefnagel (Hufnagel), Georg (Joris)." *Thieme-Becker* 17 (1924), 193-196.

Klapheck 1928
Klapheck, Richard. *Die Kunstsammlung der Staatlichen Kunstakademie zu Düsseldorf*. Düsseldorf, 1928.

Klein 1963
Klein, H. Arthur. *Graphic Worlds of Peter Bruegel the Elder*. New York, 1963.

Kloek 1974
Kloek, Wouter Th. Review of Teréz Gerszi, *Netherlandish Drawings in the Budapest Museum: Sixteenth-century Drawings, An Illustrated Catalogue*. Simiolus 7 (1974), 106-108.

Kloek 1975
Kloek, Wouter Th. *Beknopte Catalogus van de Nederlandse Tekeningen in het Prentenkabinet van de Uffizi te Florence*. Utrecht, 1975.

Kloek 1978
Kloek, Wouter Th. "The Drawings of Lucas van Leyden." *Nederlands Kunsthistorisch Jaarboek* 29 (1978), 425-458.

Kloek and Filedt Kok 1983
Kloek, Wouter Th., and Jan Piet Filedt Kok. "De Opstanding van Christus, getekend door Lucas van Leyden." *Bulletin van het Rijksmuseum* 31 (1983), 4-20.

Knipping 1974
Knipping, John B. *Iconography of the Counter Reformation in the Netherlands: Heaven on Earth*. 2 vols. 2d ed. Nieuwkoop-Leiden, 1974.

Koch 1968
Koch, Robert A. *Joachim Patinir*. Princeton, 1968.

Koomen 1934
Koomen, Pieter. "Oud-Nederlandsche Teekeningen." *Maandblad voor beeldende Kunst* 11 (1934), 300-310.

Kopp 1974
Kopp, Peter F. "Der Hausrat des Rathäuser von Baden und Mellingen." *Zeitschrift für Schweizerische Archäologie und Kunstgeschichte* 31 (1974), 171-186.

Koschatzky and Haiböck 1970
Koschatzky, Walter, and L. Haiböck. *Ansichten aus Osterreich*. Vienna, 1970.

Krautheimer 1980
Krautheimer, Richard. *Rome: Profile of a City, 312-1308*. Princeton, 1980.

Kreidl 1972
Kreidl, Detlev. "Die religiöse Malerei Pieter Aertsens als Grundlage seiner Künstlerischen Entwicklung." *Jahrbuch der kunsthistorischen Sammlungen in Wien* 68 (1972), 43-108.

Kris 1927
Kris, Ernst. "Georg Hoefnagel und die wissenschaftliche Naturalismus." In *Festschrift für Julius Schlosser zum 60. Geburtstage* (Zurich, Leipzig, Vienna, 1927), 243-253.

Krönig 1936
Krönig, Wolfgang. *Der italienische Einfluss in der flämischen Malerei im ersten Drittel des 16. Jahrhunderts*. Wurzburg, 1936.

Krönig 1974
Krönig, Wolfgang. "Lambert Lombard-Beiträge zu seinem Werk und zu seiner Kunstauffassung." *Wallraf-Richartz-Jahrbuch* 36 (1974), 105-158.

Kuntziger 1921
Kuntziger, Marthe. "Les dessins de Lambert Lombard." *Gazette des Beaux-Arts* 4 (1921), 185-192.

Kurth 1963
Kurth, Willi (ed.). *The Complete Woodcuts of Albrecht Dürer*. New York, 1963.

Kuznetzov 1970
Kuznetsov, Iurii. *Capolavori fiaminghi e olandesi*. Berlin, 1970.

Kuzentsov 1975
Kuznetsov, Iurii. *Holländische und Flämische Zeichnungen*. Munich, 1975.

Lavelleye 1966
Lavelleye, J. *Lucas van Leyden, Pieter Bruegel l'ancien*. Vienna and Munich, 1966.

Lebeer 1949
Lebeer, Louis. "La Kermesse d'Hoboken." In *Miscellanea Leo van Puyvelde* (1949), 99-103.

Lees 1913
Lees, Frederick. *The Art of the Great Masters*. London, 1913.

Van Leeuwen 1967
Leeuwen, Frans van. "Naar het Leven Figuurstudies van P. Brvegel." Typescript of a seminar paper, University of Amsterdam (April 1967).

Van Leeuwen 1970
Leeuwen, Frans van. "Jets over het handschrift van de 'naar het leven'-tekenaar." *Oud Holland* 85 (1970), 25-32.

Van Leeuwen 1971
Leeuwen, Frans van. "Figuurstudies van 'P. Bruegel'." *Simiolus* 5 (1971), 139-149.

Leiden 1983
Leiden, Stedelijk Museum de Lakenhal. *Catalogus van de schilderijen tekeningen*. M.L. Wurfbain, J.P. Sizoo, and D. Wintgens. Leiden, 1983.

Lemmens and Taverne 1967-1968
Lemmens, G., and Ed Taverne. "Hieronymus Bosch. Naar aanleiding van de expositie in 's Hertogenbosch." *Simiolus* 2 (1967-1968), 71-89.

Levin 1883
Levin, Th. *Repertorium der bei königlichen Kunstakademie zu Düsseldorf aufbewahrten Sammlungen*. Düsseldorf, 1883.

Liess 1979-1980
Liess, Reinhard. "Die kleinen Landschaften Pieter Bruegels d. A. im Lichte seines Gesamtwerkes. (1. Teil)." *Kunsthistorisches Jahrbuch Graz* 15-16 (1979-1980), 1-117.

Liess 1981
Liess, Reinhard. "Die Kleinen Landschaften Pieter Bruegels d. A. im Lichte seines Gesamtwerks (2. Teil)." *Kunsthistorisches Jahrbuch Graz* 17 (1981), 35-150.

Liess 1982
Liess, Reinhard. "Die kleinen Landschaften Pieter Bruegels d. A. im Lichte seines Gesamtwerkes (3. Teil)." *Kunsthistorisches Jahrbuch Graz* 18 (1982), 79-165.

Lindeman 1929
Lindeman, Catherine Marius Anne Alettus. *Joachim Anthonisz. Wtewael*. Utrecht, 1929.

Lippmann 1918
Lippmann, Friedrich. *Zeichnungen alter Meister im Kupferstichkabinett der Koniglichen Museen zu Berlin*. 2 vols. Berlin, 1918.

Lowenthal 1975
Lowenthal, Anne Walter. "The Paintings of Joachim Anthonisz. Wtewael (1566-1638)." Ph.D. diss., Columbia University, New York, 1975.

Lowenthal 1977
Lowenthal, Anne Walter. "Three Dutch Mannerist Paintings." *Record of The Art Museum, Princeton University* 35 (1977), 12-21.

Lugt
Lugt, Frits. *Les marques et collections de dessins et d'estampes*. Amsterdam, 1921; Supplement, The Hague, 1956.

Lugt 1927
Lugt, Frits. "Pieter Bruegel und Italien." In *Festschrift für Max J. Friedländer* (Leipzig, 1927), 111-129.

Lugt 1931
Lugt, Frits. "Beiträge zu dem Katalog der niederländischen Handzeichnungen in Berlin." *Jahrbuch der preussischen Kunstsammlungen* 52 (1931), 36-80.

Lugt 1936
Lugt, Frits. *Bibliothèque Nationale. Inventaire général des dessins des écoles du nord par F. Lugt avec la collaboration de Vallery-Radot*. Paris, 1936.

Lugt 1949
Lugt, Frits. *Musée du Louvre. Inventaire général des dessins des écoles du nord. Ecole flamande*. 2 vols. Paris, 1949.

Lugt 1968
Lugt, Frits. *Musée du Louvre. Inventaire général des dessins des écoles du nord. Maîtres des anciens Pays-Bas nés avant 1550*. Paris, 1968.

Lurker 1960
Lurker, Manfred. *Der Baum in Glauben und Kunst.* Baden-Baden and Strasbourg, 1960.

Mâle 1925
Mâle, Emile. *L'art religieux de la fin du moyen âge en France.* 3d ed. Paris, 1925.

Van Mander, *Schilder-boek*
Mander, Karel van. *Das Leben der niederländischen und deutschen Maler des Carel van Mander.* Trans. by Hanns Floerke. 2 vols. Munich and Leipzig, 1906.

Mariette 1851-1860
Mariette, Jean-Pierre. *Abecedario.* Ed. Ph. de Chennevières and A. de Montaigson. Paris, 1851-1853, 1859-1860.

Marlier 1954
Marlier, Georges. *Erasme et la peinture flamande de son temps.* Damme, 1954.

Marlier 1966
Marlier, Georges. *La Renaissance flamande. Pierre Coeck d'Alost.* Brussels, 1966.

Marlier 1969
Marlier, Georges. *Pierre Brueghel le Jeune.* Brussels, 1969.

Mauquoy-Hendrickx 1978-1979
Mauquoy-Hendrickx, Marie. *Les estampes de Wierix conservées au Cabinet des estampes de la Bibliothèque royale Albert Ier: Catalogue raisonné.* 2 vols. Brussels, 1978-1979.

Mayer 1910
Mayer, Anton. *Das Leben und die Werke des Brüder Matthäus und Paul Bril* (Kunstgeschichtliche Monographien, XIV). Leipzig, 1910.

Mayer-Meintschel, Walther, Marx, and Göpfert 1979
Mayer-Meintschel, Annaliese, Angelo Walther, Harald Marx, and Hans-Jorg Göpfert. *Gemäldegalerie Alte Meister Dresden. Katalog der ausgestellten Werke.* Dresden, 1979.

Meder 1919
Meder, Joseph. *Die Handzeichnung ihre Technik und Entwicklung.* Vienna, 1919.

Meder-Ames 1978
Meder, Joseph. *The Mastery of Drawing.* Trans. and revised by Winslow Ames. 2 vols. New York, 1978.

Menegazzi 1957
Menegazzi, Luigi. "Ludovico Pozzoserrato." In *Saggi e memorie di storia dell'arte* (Venice, 1957).

Michel 1929
Michel, Edouard. "A propos de Blocklandt de Montfort." *Oud Holland* 46 (1929), 140-141.

Michel 1931
Michel, Edouard. *Bruegel.* Paris, 1931.

Miedema 1969
Miedema, Hessel. "Het voorbeeldt niet te by te hebben: Over Hendrik Goltzius' tekeningen naar de antieken." *Miscellanea I.Q. van Regteren Altena.* Amsterdam, 1969, 74-78.

Miedema 1973
Mander, Karel van. *Den grondt der edel vry schilder-const.* Ed. and trans. with commentary by Hessel Miedema. 2 vols. Utrecht, 1973.

Miedema 1976
Miedema, Hessel. "De nimf en de dienstmeid: een realistisch genre?" *Oud Holland* 90 (1976), 262-266.

Miedema 1977
Miedema, Hessel. "Realism and Comic Mode: The Peasant." *Simiolus* 9 (1977), 205-219.

Miedema 1978-1979
Miedema, Hessel. "On Mannerism and Maniera." *Simiolus* 10 (1978-1979), 19-45.

Miedema and Meijer 1979
Miedema, Hessel, and Bert Meijer. "The Introduction of Coloured Ground in Painting and its Influence on Stylistic Development, with Particular Respect to Sixteenth-Century Netherlandish Art." *Storia dell'arte* 35 (1979), 79-98.

Mielke 1980
Mielke, Hans. Review of Karel G. Boon, *Netherlandish Drawings of the Fifteenth and Sixteenth Centuries. Catalogue of the Dutch and Flemish Drawings in the Rijksmuseum. Simiolus* 11 (1980), 39-49.

Mielke 1986
Mielke, Hans. Review of exhibition catalogue by Karel G. Boon, *L'Epoque de Lucas van Leyde et Pierre Bruegel: Dessins des anciens Pays-Bas: Collection Frits Lugt. Master Drawings* 23-24 (1986), 75-90.

Möhle 1966
Möhle, Hans. *Die Zeichnungen Adam Elsheimers.* Berlin, 1966.

Ter Molen 1979
Molen, Johannes Rein ter. "Adam van Vianen's Silverware in Relation to Seventeenth-century Dutch Painting." *Apollo* 110 (1979), 482-489.

Ter Molen 1984
Molen, Johannes Rein ter. *Van Vianen een Utrechtse familie van zilversmeden met een internationale faam.* 2 vols. Leiden, 1984.

Monballieu 1974
Monballieu, A. "De 'Kermis van Hoboken' bij P. Bruegel, J. Grimmer en G. Mostaert." *Jaarboek van het Koninklijk Museum voor Schone Kunsten Antwerpen* (1974), 139-169.

Montias 1982
Montias, John Michael. *Artists and Artisans in Delft: A Socio-Economic Study of the Seventeenth Century.* Princeton, 1982.

Moxey 1981-1982
Moxey, Keith P.F. "Sebald Beham's Church Anniversary Holidays: Festive Peasants as Instruments of Repressive Humor." *Simiolus* 12 (1981-1982), 107-130.

Muchall-Viebrook 1928
Muchall-Viebrook, Thomas. "Ein neuer Gobelinentwurf von Pieter Coecke van Aelst." *Münchner Jahrbuch der bildende Kunst* 5 (1928), 203-209.

Muchall-Viebrook 1931
Muchall-Viebrook, Thomas. "Matthys Cock (d.1548)—A Coast Scene—London, Victoria and Albert Museum." *Old Master Drawings* 6 (1931), 29-30.

Müller-Hofstede 1957
Müller-Hofstede, Justus. "Zum Werke des Otto van Veen 1590-1600." *Bulletin des Musées Royaux des Beaux-Arts de Belgique* 6 (1957), 127-172.

Müller Hofstede 1959
Müller Hofstede, Cornelius. "Das Selbstbildnis des Lucas van Leyden im Herzog Anton-Ulrich-Museum zu Braunschweig." *Festschrift Friedrich Winkler* (Berlin, 1959), 221-238.

Müller Hofstede 1967
Müller Hofstede, Justus. "Aspekte der Entwurfszeichnung bei Rubens." In *Stil und Uberlieferung in der Kunst des Abendlandes. Akten de 21 Internationalen Kongress für Kunstgeschichte in Bonn 1964.* 3 vols. (Berlin, 1967), 3:114-125.

Müller Hofstede 1973
Müller Hofstede, Justus. "Jacques de Backer. Ein vertreter der florentinisch-römischen Maniera in Antwerpen." *Wallraf-Richartz-Jahrbuch* 35 (1973), 227-260.

Müller Hofstede 1979
Müller Hofstede, Justus. "Zur Interpretation von Bruegels Landschaft. Asthetischer Landschaftsbegriff und Stoische Weltbetrachtung." In *Pieter Bruegel und seine Welt. Eine Colloquium veranstaltet vom Kunsthistorischen Institut der freien Universität Berlin und dem Kupferstichkabinett der Staatliche Museen Preussischen Kulturbesitz am 13. und 14. November 1975.* (Berlin and Mann, 1979), 73-143.

Münz 1961
Münz, Ludwig. *Pieter Bruegel, The Drawings.* London, 1961.

Mules 1985
Mules, Helen B. "Dutch Drawings of the Seventeenth Century in the Metropolitan Museum of Art." *The Metropolitan Museum of Art Bulletin* 42, no. 4 (1985).

Mundy 1980a
Mundy, Edwin James III. "Gerard David Studies." Ph.D. diss., Princeton University, 1980.

Mundy 1980b
Mundy, Edwin James III. "A Preparatory Sketch for Gerard David's Justice of Cambyses Panels in Bruges." *The Burlington Magazine* 122 (1980), 122-125.

Murray 1912
Murray, Charles Fairfax. *J. Pierpont Morgan Collection of Drawings.* London, 1912.

Murray 1913
Murray, Charles Fairfax. *Reproductions of Drawings in the Collection of C. Fairfax Murray* (not sold to Mr. J.P. Morgan with the remainder of the collection). Vol. 5. Supplement. London, 1913.

Netto-Bol 1975
Netto-Bol, M.H.L. (Hülsen-Egger 1913-1916). *Die Römischen Skizzenbücher von Marten van Heemskerck im Königlichen Kupferstichkabinett zu Berlin.* Intro. M.H.L. Netto-Bol. 2 vols. Soest, 1975.

Netto-Bol 1976
Netto-Bol, M.H.L. *The So-Called Maarten de Vos Sketchbook of Drawings after the Antique. Kunsthistorische Studiën van het Nederlands Instituut te Rome, Deel IV.* The Hague, 1976.

New Haven 1964
Yale University Art Gallery Bulletin 30, no. 1 (August 1964), 13.

Niederstein 1931
Niederstein, Albrecht. "Das graphische Werk des Bartholomäus Spranger." *Repertorium für Kunstwissenschaft* 52 (1931), 1-33.

Niederstein 1937
Niederstein, Albrecht. "Bartholomaeus Spranger." *Thieme-Becker* 31 (1937), 403-406

Nijhoff 1933-1936
Nijhoff, Wouter. *Nederlandsche Houtsneden 1500-1550.* The Hague, 1933-1936.

Oberhuber 1958
Oberhuber, Konrad. "Die stilistische Entwicklung im Werk Bartholomäus Spranger." Ph.D. diss., Universität Wien, 1958.

Oberhuber 1968
Oberhuber, Konrad. "Hieronymous Cock, Battista Pittoni, und Paolo Veronese in Villa Maser." In *Munuscula Discipulorum: Kunsthistorische Studien Hans Kauffmann zum 70. Geburtstag 1966 gewidinet* (Berlin, 1968), 207-224.

Oberhuber 1970
Oberhuber, Konrad. "Anmerkungen zu Bartholomäus Spranger als Zeichner." *Umění* 18 (1970), 213-223.

Oberhuber 1981
Oberhuber, Konrad "Bruegel's Early Landscape Drawings." *Master Drawings* 19 (1981), 146-156.

Oehler 1955
Oehler, Lisa. "Einige frühe Naturstudien von Paul Bril." *Marburger Jahrbuch für Kunstwissenschaft* 16 (1955), 199-206.

Olsen 1965
Olsen, Harald. "Some Drawings by Federico Barocci." *Artes* 1 (1965), 17-32.

Olszewski 1977
Olszewski, E.J. *Giovanni Battista Armenini, the True Precepts of the Art of Painting.* New York, 1977.

Orth 1980
Orth, Myra Dickman. "Geofroy Tory et l'enluminure. Deux livres d'heures de la collection Doheny." *Revue de l'art* 50 (1980), 40-47.

Orth 1983
Orth, Myra Dickman. "'The Prison of Love': A Medieval Romance in the French Renaissance and Its Illustration (B.N. MS fr. 2150)." *Journal of the Warburg and Courtauld Institutes* 46 (1983), 211-221.

von der Osten 1961
Osten, Gert von der. "Studien zu Jan Gossaert." *De Artibus Opuscula XL. Essays in Honor of Erwin Panofsky* (New York, 1961), 454-475.

von der Osten and Vey 1969
Osten, Gert von der, and Horst Vey. *Painting and Sculpture in Germany and the Netherlands 1500 to 1600.* Harmondsworth, 1969.

Panofsky 1939
Panofsky, Erwin. *Studies in Iconology.* New York, 1939.

Panofsky 1948
Panofsky, Erwin. *Albrecht Dürer.* 2 vols. 3d ed. Princeton, 1948.

Panofsky 1953
Panofsky, Erwin. *Early Netherlandish Painting: Its Origins and Character.* Cambridge, 1953.

Panofsky 1955
Panofsky, Erwin. *The Life and Art of Albrecht Dürer.* 4th ed. Princeton, 1955.

Parker 1938-1956
Parker, Karl Theodore. *Catalogue of the Collection of Drawings in the Ashmolean Museum.* 2 vols. Oxford, 1938-1956.

Parker 1954
Parker, Karl Theodore. "Report of the Keeper of the Department of Fine Art for the Year 1954." *Ashmolean Museum. Report of the Visitors 1954* (Oxford, 1954) 35-67.

Parker 1985
Parker, Geoffrey. *The Dutch Revolt.* Revised edition. Harmondsworth, 1985.

Pauli 1924-1925*
Pauli, Gustav. *Zeichnungen alter Meister in der Kunsthalle zu Hamburg.* 3 vols. Frankfurt-am-Main, 1924-1927.

Perrot 1978
Perrot, Françoise. *Les Vitraux de Paris de la région parisienne de la Picardie et du Nord-Pas-de-Calais. Recensement des vitraux anciens de la France.* Vol. 1. Paris, 1978.

Philippot 1962
Philippot, Paul. "La fin du XVème siècle et les origines d'une nouvelle conception de l'image dans la peinture des Pays-Bas." *Bulletin Musées Royaux des Beaux-Arts* 11 (1962), 3-38.

Pierpont Morgan 1910
Pierpont Morgan Collection. *Collection J. Pierpont Morgan. Drawings by the Old Masters Formed by C. Fairfax Murray.* vol. 2. *Two Lombard Sketch Books in the Collection of C. Fairfax Murray with a Few Drawings Supplementing the Previous Volume.* 4 vols. Privately printed, London, 1910.

Poensgen 1925-1926
Poensgen, Georg. "Ein nächtliches Zedigelage des Jodocus a Winghe." *Zeitschrift für bildende Kunst* 59 (1925-1926), 324-330.

Poensgen 1970
Poensgen, Georg. "Das Werk des Jodocus a Winghe." *Pantheon* 28 (1970), 504-515.

Poensgen 1972
Poensgen, Georg. "Zu den Zeichnungen des Jodocus a Winghe." *Pantheon* 30 (1972), 39-47.

Popham
Popham, Arthur Ewart. "Catalogue of the Drawings at Rugby School." Undated manuscript.

Popham 1925a
Popham, Arthur Ewart. "Teekeningen van de Vlaamsche School onlangs aangeworven in het British Museum." *Onze Kunst* 41 (1925), 205-211.

Popham 1925b
Popham, Arthur Ewart. "The Engravings and Woodcuts of Dirick Vellert." *The Print Collector's Quarterly* 12 (1925), 343-368.

Popham 1926a
Popham, Arthur Ewart. *Drawings of the Early Flemish School.* New York, 1926.

Popham 1926b
Popham, Arthur Ewart. "Antwerp Mannerist 'B'." *Old Master Drawings* 1 (1926), 39-40.

Popham 1926c
Popham, Arthur Ewart. "Dessins de l'école flamand acquis récément par le British Museum." *La Revue de l'art* 27 (1926), 89-91.

Popham 1928
Popham, Arthur Ewart. "Notes on Flemish Domestic Glass Painting—I." *Apollo* 7 (1928), 175-179.

Popham 1929
Popham, Arthur Ewart. "Notes on Flemish Domestic Glass Painting—II." *Apollo* 9 (1929), 152-157.

Popham 1932
Popham, Arthur Ewart. *Catalogue of Drawings by Dutch and Flemish Artists preserved in the Department of Prints and Drawings in the British Museum. vol. V. Dutch and Flemish Drawings of the XV and XVI Centuries.* London, 1932.

Popham 1938
Popham, Arthur Ewart. "Mr. Alfred Jowett's Collection of Drawings at Killinghall." *Apollo* 27 (1938), 133-138.

Popham and Fenwick 1965
Popham, Arthur Ewart, and Kathleen M. Fenwick. *European Drawings (and Two Asian Drawings) in the Collection of the National Gallery of Canada.* Toronto, 1965.

Preibisz 1911
Preibisz, Leon. *Martin Heemskerck. Ein Beitrag zur Geschichte des Romanismus in der niederländischen Malerei des XVI. Jahrhunderts.* Leipzig, 1911.

Van Puyvelde 1960
Puyvelde, Leo van. "Considérations sur les maniéristes flamands." *Revue belge d'archéologie et d'histoire de l'art* 29 (1960), 63-101.

Van Puyvelde 1962
Puyvelde, Leo van. *La peinture flamande au siècle de Bosch et Breughel.* Paris, 1962.

Van Puyvelde and Goldschmidt 1936
Puyvelde, Leo van, and Ernest Goldschmidt. *Dessins de maîtres de la collection des Musées Royaux des Beaux-Arts.* Brussels and Basel, 1937.

Rackham 1936
Rackham, Bernard. *Victoria and Albert Museum. Department of Ceramics. A Guide to the Collections of Stained Glass.* London, 1936.

Radcliffe 1985
Radcliffe, Anthony. "Schardt, Tetrode, and Some Possible Sculptural Sources for Goltzius." In *Netherlandish Mannerism: Papers Given at a Symposium in Nationalmuseum Stockholm, September 21-22, 1985* (Stockholm, 1985), 97-108.

Ragghianti 1965
 Ragghianti, Carlo L. "Disegni Fiamminghi e Olandesi agli
 Uffizi." *Critica d'arte* 12 (1965), 3-14.

Réau, *Iconographie*
 Réau, Louis. *Iconographie de l'art chrétien.* 3 vols. in 6
 parts. Paris, 1955-1959.

Van Regteren Altena 1936
 Regteren Altena, Johan Quirijn van. *The Drawings of
 Jacques de Gheyn.* 2 vols. Amsterdam, 1936.

Van Regteren Altena 1937
 Regteren Altena, Johan Quirijn van. "Carel van Mander."
 Elsevier's geillustreerd Maandschrift 92 (1937), 169.

Van Regteren Altena 1939a
 Regteren Altena, Johan Quirijn van. "Aertgen van Leyden,
 I." *Oud Holland* 56 (1939), 17-25.

Van Regteren Altena 1939b
 Regteren Altena, Johan Quirijn van. "Aertgen van Leyden,
 II." *Oud Holland* 56 (1939), 74-87.

Van Regteren Altena 1964
 Regteren Altena, Johan Quirijn van. "De Sint Pieters abdij
 te Gent. getekend voor 1534." In *Opus Musivum. Een
 bundel studies aangeboden aan Professor Doctor M.D.
 Ozinga ter gelegenheid van zijn zestige verjaardag op 10
 november 1962* (Assen, 1964), 161-173.

Van Regteren Altena 1983
 Regteren Altena, Johan Quirijn van. *Jacques de Gheyn.
 Three Generations.* The Hague, Boston, and London,
 1983.

Renger 1970
 Renger, Konrad. *Lockere Gesellschaft. Zur Ikonographie
 des Verlorenen Sohnes und von Wirtshausszenen in der
 Niederländischen Malerei.* Berlin, 1970.

Renger 1972
 Renger, Konrad. "Joos van Winghes 'Nachtbancket met
 een Mascarade' und verwandte Darstellungen." *Jahrbuch
 der Berliner Museen* 14 (1972), 161-193.

Renger 1976-1978
 Renger, Konrad. "Sine Cerere et Baccho friget Venus."
 Gentse Bijdragen tot de Kunstgeschiedenis 24 (1976-
 1978), 190-203.

Renger 1979
 Renger, Konrad. Review of exhibition *Lucas van Leyden
 Graphik. Kunstchronik* 32 (1979), 57-63.

Reuterswärd 1970
 Reuterswärd, Patrik. *Hieronymus Bosch.* (Acta Universi-
 tatis Upsaliensis, Figura, N.S. 7). Stockholm, 1970.

Reznicek 1956
 Reznicek, Emil Karl Josef. "Jan Harmensz. Muller als tek-
 enaar." *Nederlands Kunsthistorisches Jaarboek* 7 (1956),
 65-120.

Reznicek 1961
 Reznicek, Emil Karl Josef. *Die Zeichnungen von Hen-
 drick Goltzius.* Utrecht, 1961.

Reznicek 1963
 Reznicek, Emil Karl Josef. "Realism as a 'Side Road or
 Byway' in Dutch Art." In *The Renaissance and Manner-
 ism. Studies in Western Art. Acts of the Twentieth Inter-
 national Congress of the History of Art* 2 (Princeton, New
 Jersey, 1963), 247-253.

Reznicek 1975
 Reznicek, Emil Karl Josef. "Het leerdicht van Karel van
 Mander en de acribie van Hessel Miedema." *Oud Holland*
 89 (1975), 102-128.

Reznicek 1978-1979
 Reznicek, Emil Karl Josef. Review of Walter L. Strauss,
 Hendrik Goltzius. Simiolus 10 (1978-1979), 200-206.

Reznicek 1980
 Reznicek, Emil Karl Josef. "Jan Harmensz. Muller as a
 Draughtsman: Addenda." *Master Drawings* 18 (1980),
 115-133.

Reznicek-Buriks 1956
 Reznicek-Buriks, E.I. "Enkele manieristische Tekeningen
 uit de verzameling de Grez." *Oud Holland* 71 (1956), 165-
 169.

Reznicek-Buriks 1979
 Reznicek-Buriks, E.I. "Boekbespreking, Max J. Friedländer,
 'Lucas van Leyden,' herausgegeben von F. Winkler." *Oud
 Holland* 80 (1965), 241-247.

Ridolfi 1648
 Ridolfi, Carlo. *Le maraviglie dell'arte ovvero le vite degli
 illustri pittori veneti e dello stato (1648).* Ed. Detlev
 Freiherr von Hadeln. 2 vols. Rome, 1965.

Riggs 1971
 Riggs, Timothy A. "Hieronymus Cock (1510-70): Print-
 maker and Publisher in Antwerp at the Sign of the Four
 Winds." Ph.D. diss., Yale University, New Haven, 1971.

Riggs 1977
 Riggs, Timothy A. *Hieronymus Cock. Printmaker and
 Publisher.* New York and London, 1977.

Riggs 1979
 Riggs, Timothy A. "Bruegel and His Publisher." In *Pieter
 Bruegel und seine Welt. Eine Colloquium veranstaltet
 vom Kunsthistorischen Institut der freien Universität
 Berlin und dem Kupferstichkabinett der Staatlichen
 Museen Preussischer Kulturbesitz am 13. und 14 Novem-
 ber 1975* (Berlin, 1979), 165-173.

Rijksen 1945
 Rijksen, A.A.J. *Gespiegeld in kerkeglas. Hollands leed en
 vreugd in de Glasschilderingen van de St. Janskerk te
 Gouda.* Lochem, 1945.

Roest van Limburg 1904
 Roest van Limburg, Th. M. "Vier cartons van Barend van
 Orley." *Onze Kunst* 3 (1904), 8-14.

Roethlisberger 1968
 Roethlisberger, Marcel. *Claude Lorrain. The Drawings.*
 Berkeley and Los Angeles, 1968.

Roethlisberger 1980
 Roethlisberger, Marcel. *Bartholomeus Breenbergh: The
 Paintings.* Berlin and New York, 1980.

Rogge 1897
 Rogge, H.C. "Het Album van Emanuel van Meteren."
 Oud Holland 15 (1897), 199-210.

Roggen 1939-1940
 Roggen, D. "J. Bosch: Literatuur en Folklore." *Gentsche
 Bijdragen tot de Kunstgeschiedenis* 6 (1939-1940), 107-
 126.

Romdahl 1947
Romdahl, Axel Ludwig. *Pieter Bruegel d. A.* Stockholm, 1947.

Rooses 1902
Rooses, Max. "De Teekeningen der Vlaamsche Meesters. De Romanisten (Vervolg)." *Onze Kunst* 1 (1902), 168-172.

Rooses 1903
Rooses, Max. "De teekeningen der Vlaamsche meesters. De kleinmeesters der XVIe eeuw." *Onze Kunst* 2 (1903), 93-100.

Rosenberg and Foucart 1978
See Foucart and Rosenberg 1978

Rosenberg 1961
Rosenberg, Jakob. "On the Meaning of a Bosch Drawing." In *De Artibus Opuscula XL. Essays in Honor of Erwin Panofsky* (New York, 1961), 422-426.

Rostrup Böyesen 1956-1963
Rostrup Böyesen, Lars. "Nederlandsk 1514-1518/20 Christian II (1481-1559)." *Kunstmuseets Aarsskrift* 43-50 (1956-1963), 74-77.

Rubinstein 1985
Rubinstein, Ruth Olitsky. " 'Tempus edax rerum': a newly discovered painting by Hermannus Posthumus." *The Burlington Magazine* 127 (1985), 425-433.

Ryan and Ripperger 1941
Ryan, Granger, and Hellmut Ripperger. *The Golden Legend of Jacobus de Voragine.* 2 vols. New York, London, and Toronto, 1941.

Sandrart 1925
Sandrart, Joachim von. *Joachim von Sandrarts Academie der Bau-, Bild- und Mahlerey-Künste von 1675.* Ed. and commentary by A.R. Peltzer. Munich, 1925.

Sanuto 1882
Sanuto, Marino. *I Diarii di Marino Sanuto.* Ed. Rinaldo Fulin. 58 vols. Venice, 1879-1903. (vol. 7, 1882).

Schapelhouman 1979
Schapelhouman, Marijn. *Oude Tekeningen in het bezit van de Gemeentemusea van Amsterdam waaronder de collectie Fodor. Tekeningen van Noord- en Zuidnederlandse kunstenaars geboren voor 1600.* Amsterdam, 1979.

Schéle 1965
Schéle, Sune. *Cornelis Bos. A Study of the Origins of the Netherland Grotesque.* Stockholm, 1965.

Scheller 1972
Scheller, Robert Walter Hans Peter. "Nieuwe gegevens over het St. Lucasgilde te Delft in de zestiende eeuw." *Nederlands Kunsthistorisch Jaarboek* 23 (1972), 41-48.

Schmidt 1965
Schmidt, Justus. *Linz in alten Ansichten.* Salzburg, 1965.

Schnackenburg 1970
Schnackenburg, Bernhard. "Beobachtungen zu einem neuen Bild von Bartholomäus Spranger." *Niederländische Beiträge zur Kunstgeschichte* 9 (1970), 143-160.

Schneebalg-Perelman 1982
Schneebalg-Perelman, Sophie. *Les Chasses de Maximilien. Les énigmes d'un chef-d'oeuvre de la tapisserie.* Brussels, 1982.

Schönbrunner and Meder 1896-1908
Schönbrunner, Josef, and Johannes Meder. *Handzeichnungen alter Meister aus der Albertina und anderen Sammlungen.* 12 vols. Vienna, 1896-1908.

Schoute and Marcq-Verougstrate 1975
Schoute, Roger van, and Hélène Marcq-Verougstraete. "Le dessin de peintre (dessin sousjacent) chez Pierre Bruegel." *Nederlands Kunsthistorisch Jaarboek* 26 (1975), 259-267.

Schroeder 1971
Schroeder, W. *Der Topos der Nine Worthies in Literatur und bildender Kunst.* Göttingen, 1971.

Schwarz 1953
Schwarz, Heinrich. "Jan Gossaert's Adam and Eve Drawings." *Gazette des Beaux-Arts* 42 (1953), 171-194.

Schwarz and Plagemann 1973
Schwarz, Heinrich, and Volker Plagemann. "Eule." *Reallexikon zur deutschen Kunstgeschichte* 6 (1973), cols. 267-322.

Schwerdt 1928
Schwerdt, Charles Francis George Richard. *Hunting, Hawking, Shooting Illustrated in a Catalogue of Books, Manuscripts, Prints and Drawings Collected by C.F.G.R. Schwerdt.* 4 vols. London, 1928.

von Seilern 1969
Seilern, Antoine Graf von. *Flemish Paintings and Drawings at 56 Princes Gate London. Addenda.* London, 1969.

Shearman 1967
Shearman, John. *Mannerism.* Harmondsworth, 1967.

Shoaf and Turner 1984
Shoaf, Jane V., and Nicholas Turner. "Two New Drawings by Goltzius Related to Prints." *Print Quarterly* 1 (1984), 267-271.

Shubert 1973
Shubert, Dietrich. Review of Konrad Renger, *Lockere Gesellschaft. Kunstchronik* 26 (1973), 215-222.

Silver 1984
Silver, Larry. *The Paintings of Quentin Massys.* Montclair, New Jersey, 1984.

Sluijter 1985
Sluijter, Eric Jan. "Some Observations on the Choice of Narrative Mythological Subjects in Late Mannerist Painting in the Northern Netherlands." In *Netherlandish Mannerism: Papers given at a symposium in National Museum Stockholm, September 21-22, 1984* (Stockholm, 1985), 97-108.

Smyth 1962
Smyth, C.H. *Mannerism and Maniera.* New York, 1962.

Snyder 1985
Snyder, James. *Northern Renaissance Art. Painting, Sculpture, The Graphic Arts from 1350 to 1575.* New York, 1985.

Spicer 1970
Spicer, Joaneath Ann. "The 'Naer het Leven' Drawings: by Pieter Bruegel or Roelandt Savery?" *Master Drawings* 8 (1970), 3-30

Spicer 1984
Spicer, Joaneath Ann. Review of Princeton 1982-1983 (See Exhibitions). *Master Drawings* 22 (1984), 320-328.

Spicer-Durham 1979
Spicer-Durham, Joaneath Ann. "The Drawings of Roelandt Savery." Ph.D. diss., Yale University, New Haven, 1979.

Starcky 1981
Starcky, Emmanuel. "A propos d'un dessin maniériste anversois." *La Revue du Louvre et des Musées de France* 31 (1981), 96-102.

Stechow 1927
Stechow, Wolfgang. "Ketel, Cornelis." *Thieme-Becker* 20 (1927), 218-220.

Stechow 1927-1928
Stechow, Wolfgang. Review of Hans Kaufmann, *Der Manierismus in Holland und die Schule von Fontainebleau. Kritische Berichte zur kunstgeschichtlichen Literatur* 1-2 (1927-1928, 1928-1929), 54-64.

Stechow 1962
Stechow, Wolfgang. "The 'Triumph of David' by Hans Speeckert." *Allen Memorial Art Museum Bulletin* 19 (1962), 111-114.

Stechow 1966
Stechow, Wolfgang. *Dutch Landscape Painting of the Seventeenth Century*. London, 1966.

Stechow 1969
Stechow, Wolfgang. *Pieter Bruegel the Elder*. New York, 1969.

Stechow 1972
Stechow, Wolfgang. "Lusuo Laetitiaeque Modus." *The Art Quarterly* 35 (1972), 165-175.

Steinbart 1922
Steinbart, Kurt. *Tafelgemälde des Jacob Cornelisz. van Amsterdam*. Strasbourg, 1922.

Steinbart 1929
Steinbart, Kurt. "Nachlass im Werke des Jacob Cornelisz." *Marburger Jahrbuch* 5 (1929), 213-260.

Steinbart 1932
Steinbart, Kurt. "Unveröffentlichte Zeichnungen und Holzschnitte des Jan van Scorel." *Oud Holland* 49 (1932), 281-288.

Steinbart 1933-1934
Steinbart, Kurt. "Pieter Coecke's Designs for Tapestries." *Old Master Drawings* 8 (1933-1934), 34-36.

Steinbart 1937
Steinbart, Kurt. *Das Holzschnittwerk des Jakob Cornelisz von Amsterdam*. Burg-bei-Main, 1937.

Steinbart 1940
Steinbart, Kurt. *Johann Liss, der Maler aus Holstein*. Berlin, 1940.

Steinmann 1901-1905
Steinmann, Ernst. *Die Sixtinische Kapelle*. 2 vols. Munich, 1901-1905.

Steinmann 1930
Steinmann, Ernst. *Michelangelo im Spiegel seiner Zeit*. Leipzig, 1930.

Steppe 1967
Steppe, Jan-Karel. "Jheronimus Bosch. Bijdrage tot de historische en ikonografische studie van zijn werk." In *Jheronimus Bosch. Bijdragen bij gelegenheid van de herdenkingstentoonstelling te 's-Hertogenbosch 1967* (Eindhoven, 1967).

Steppe 1969
Steppe, Jan-Karel. "Mencía de Mendoza et ses rapports avec Gilles de Busleyden." *Scrinium Erasmianum* 2 (1969), 469-484.

Steppe and Delmarcel 1974
Steppe, Jan-Karel, and Guy Delmarcel. "Les tapisseries du Cardinal Erard de la Marck prince-évêcque de Liège." *Revue de l'art* 25 (1974), 35-54.

Sterk 1980
Sterk, J.J.B. *Philips van Bourgondië (1465-1524) Bisschop van Utrecht als Protagonist van de Renaissance. Zijn leven en maecenaat*. Zutphen, 1980.

Stift and Feder 1930
Stift and Feder. *Zeichnungen aus dem Kupferstichkabinett des Hessisches Landesmuseums zu Darmstadt*. Ed. R. Schrey. Stift and Feder, Frankfurt 1930.

Stock 1983
Stock, J. van der. *Cornelis Matsys Fecit (1510/11-1556). Leven en Werken met Speciale Aandacht voor zijn Graphisch Oeuvre*. Leuven (Licentiaat), 1983.

Strauss 1974
Strauss, Walter L. *The Complete Drawings of Albrecht Dürer*. 6 vols. New York, 1974.

Strauss 1977
Strauss, Walter L. *Hendrik Goltzius 1558-1617: The Complete Engravings and Woodcuts*. 2 vols. New York, 1977.

Stridbeck 1956
Stridbeck, Carl Gustav. *Bruegelstudien. Untersuchungen zu den ikonologischen Problemen bei Pieter Bruegel d. A. sowie dessen Beziehungen zum niederländischen Romanismus*. Stockholm, 1956.

Strong 1902
Strong, Sandford Arthur. *Reproductions in Facsimile of Drawings by Old Masters in the Collection of the Duke of Devonshire*. London, 1902.

Stubbe 1967
Stubbe, Wolf. *Hundert Meisterzeichnungen aus der Hamburger Kunsthalle 1500-1800*. Hamburg, 1967.

Taubert 1956
Taubert, Johannes. "Zur Kunstwissenschaftlichen Auswertung von naturwissenschaftlichen Gemäldeuntersuchungen." Ph.D. diss., Philipps-Universität, Marburg, 1956.

Van Thiel 1963
Thiel, Pieter J.J. van. "Een vroeg schilderij van Gerrit Pietersz. Sweelinck." *Oud Holland* 78 (1963), 67-69.

Van Thiel 1965
Thiel, Pieter J.J. van. "Cornelis Cornelisz van Haarlem as a Draughtsman." *Master Drawings* 3 (1965), 123-154.

Van Thiel 1976
Thiel, Pieter J.J. van, et al. *All the Paintings of the Rijksmuseum in Amsterdam*. Amsterdam and Maarssen, 1976.

Van Thiel 1985
Thiel, Pieter J.J. van. "Cornelis Cornelisz. van Haarlem—His First Ten Years as a Painter, 1582-1592." *Netherlandish Mannerism: Papers given at a symposium in Nationalmuseum, Stockholm, September 21-22, 1984* (Stockholm, 1985), 73-84.

Thieme-Becker
Thieme, Ulrich, and Felix Becker. *Allegemeines Lexikon der bildenden Kunstler von der Antike bis zur Gegenwart*. Leipzig, 1907-1950.

Tietze and Tietze-Conrat 1944
Tietze, Hans, and E. Tietze-Conrat. *The Drawings of the Venetian Painters in the 15th and 16th Centuries*. New York, 1944.

Timmers 1974
Timmers, J.J.M. *Christelijke Symboliek en Iconografie*. Bussum, 1974.

Tolnai 1925
Tolnai, Karl. *Die Zeichnungen Pieter Bruegel*. Munich, 1925.

De Tolnay 1935
Tolnay, Charles de. *Pierre Bruegel l'ancien*. Brussels, 1935.

De Tolnay 1937
Tolnay, Charles de. *Hieronymus Bosch*. Basel, 1937.

De Tolnay 1943a
Tolnay, Charles de. *History and Technique of Old Master Drawings*. New York, 1943.

De Tolnay 1943b
De Tolnay, Charles. *The Youth of Michelangelo*. Princeton, New Jersey, 1943.

De Tolnay 1952
Tolnay, Charles de. *The Drawings of Pieter Bruegel the Elder*. New York, 1952.

De Tolnay 1966
Tolnay, Charles de. *Hieronymus Bosch*. Baden-Baden, 1966.

De Tolnay 1969
Tolnay, Charles de. "A Contribution to Pieter Bruegel the Elder as Draughtsman." In *Miscellanea I.Q. van Regteren Altena* (Amsterdam, 1969), 61-63.

De Tolnay 1973
Tolnay, Charles de. "A Contribution to Bruegel the Elder as Draughtsman." In *Album Amicorum J.G. van Gelder* (The Hague, 1973), 326-327.

Tormo and Sánchez Cantón 1919
Tormo, E., and F. Sánchez Cantón. *Los tapices della casa del Rey*. Madrid, 1919.

Unverfehrt 1980
Unverfehrt, Gerd. *Hieronymus Bosch. Die Rezeption seiner Kunst im frühen 16. Jahrhunderts*. Berlin, 1980.

Urbach 1978
Urbach, Zsuzsa. "Notes on Bruegel's Archaism. His Relation to Early Netherlandish Painting and Other Sources." *Acta Historiae Artium* 24 (1978), 237-256.

Valentiner 1932
Valentiner, Elisabeth. "Hans Speckaert. Ein Beitrag zur Kenntnis der Niederländer in Rom um 1575." *Städel-Jahrbuch* 7-8 (1932), 163-171.

Vanbeselaere 1944
Vanbeselaare, Walther. *Peter Bruegel en het Nederlandsche Manierisme*. Tielt, 1944.

Vandenbroeck 1981
Vandenbroeck, Paul. "Over Jheronimus Bosch. Met een toelichting bij de tekst op tekening KdZ 549 in het Berlijnse Kupferstichkabinett." *Archivum Artis Lovaniense. Bijdragen tot de Geschiedenis van de Kunst der Nederlanden, opgedragen aan Prof. Em. Dr. J.K. Steppe* (Leuven, 1981), 151-188.

Varty 1967
Varty, Kenneth. *Reynard the Fox. A Study of the Fox in Medieval English Art*. Leicester, 1967.

Vasari Society 1911-1912
Vasari Society. *The Vasari Society for the Reproduction of Drawings by Old Masters*. First Series. Part 6. Part 7. Oxford, 1911-1912.

Vasari Society 1921
Vasari Society. *The Vasari Society for the Reproduction of Drawings by Old Masters*. Second Series. Part II. 1921. The Oppenheimer Collection. Oxford, 1921.

Van de Velde 1969
Velde, Carl van de. "A Roman Sketchbook of Frans Floris." *Master Drawings* 7 (1969), 255-286.

Van de Velde 1975
Velde, Carl van de. *Frans Floris (1519/20-1570) Leven en Werken*. Brussels, 1975.

Veldman 1973
Veldman, Ilja Markx. "Het 'Vulcanus-triptiek' van Maarten van Heemskerck." *Oud Holland* 87 (1973), 95-122 (Reprinted in Veldman 1977a, 21-42).

Veldman 1974
Veldman, Ilja Markx. "Maerten van Heemskerck and St. Luke's medical books." *Simiolus* 7 (1974), 91-100 (Reprinted in Veldman 1977a, 114-121).

Veldman 1977a
Veldman, Ilja Markx. *Maarten van Heemskerck and Dutch Humanism in the Sixteenth Century*. Maarssen, 1977.

Veldman 1977b
Veldman, Ilja Markx. Review of Hülsen and Egger, *Die Römischen Skizzenbücher von Marten van Heemskerck*. *Simiolus* 9 (1977), 106-113.

Vervaet 1977
Vervaet, Julien. "Mannerism and the Italian Influence in Sixteenth-century Antwerp." *Apollo* 105 (1977), 168-175.

Voet 1969-1972
Voet, Leon. *The Golden Compasses. A History and Evaluation of the Printing and Publishing Activities of the Officina Plantiniana at Antwerp*. 2 vols. Amsterdam, London, and New York, 1969-1972.

Voet 1973
Voet, Leon. *Antwerp. The Golden Age*. Antwerp, 1973.

Voet 1980-1983
Voet, Leon. *The Plantin Press (1555-1589). A Bibliography of the Works Printed and Published by Christopher Plantin at Antwerp and Leiden*. 6 vols. Amsterdam, 1980-1983.

Vos 1978a
Vos, Rik. *Lucas van Leyden*. Bentveld-Maarssen, 1978.

Vos 1978b
Vos, Rik. "The Life of Lucas van Leyden by Karel van Mander." *Nederlands Kunsthistorisch Jaarboek* 29 (1978), 459-507.

Vuyk 1928
Vuyk, Jadwiga. "Zwei Altarflügel von Anthonie Blocklandt van Montfoort." *Oud Holland* 45 (1928), 159-176.

Van de Waal 1952
Van de Waal, Henri. *Drie Eeuwen vaderlandsche Geschied-Uitbeelding 1500-1800. Een Iconologische Studie.* 2 vols. The Hague, 1952.

Wacha 1967
Wacha, G. "Kunst in Linz." *Kunstjahrbuch der Stadt Linz* (1967), 5-54.

Wayment 1958
Wayment, Hilary G. "Un chef-d'oeuvre anglo-flamand de la première Renaissance. Les vitraux de King's College, Cambridge." *Bulletin des Musées Royaux d'Art et d'Histoire* 30 (1958), 83-101.

Wayment 1972
Wayment, Hilary G. *The Windows of King's College Chapel, Cambridge. (Corpus Vitrearum Medii Aevi. Great Britain. Supplementary vol. 1).* London, 1972.

Wayment 1979
Wayment, Hilary G. "The Great Windows of King's College Chapel and the Meaning of the Word *Vidimus*." *Proceedings of the Cambridge Antiquarian Society* 69 (1979), 365-376.

Wayment 1980
Wayment, Hilary G. "The Stained Glass in the Chapel of the Vyne." *National Trust Studies* 44 (1980), 35-47.

Wayment 1982
Wayment, Hilary G. "The Stained Glass of the Chapel of the Vyne and the Chapel of the Holy Ghost Basingstoke." *Archaeologia* 107 (1982), 142-152.

Wayment 1984
Wayment, Hilary G. "Three Vidimuses for the Windows in King's College Chapel, Cambridge." *Master Drawings* 22 (1984), 43-46.

Weale 1908-1909
Weale, W.H. James. "Lancelot Blondeel." *The Burlington Magazine* 14 (1908-1909), 96-101, 160-166.

Weber 1977
Weber, Bruno. "Die Figur des Zeichner in der Landschaft." *Zeitschrift für Schweizerische Archäologie und Kunstgeschichte* 34 (1977), 44-82.

Wegner 1957
Wegner, Wolfgang. "Ein Bildnis von Hugo Jacobsz. von seinem Sohne Lucas van Leyden." *Mededelingen van het Rijksbureau voor Kunsthistorische Documentatie, Oud Holland* 72 (1957), 191-194.

Wegner 1967
Wegner, Wolfgang. "Zeichnungen von Gillis van Coninxloo und seiner Nachfolge." *Oud Holland* 82 (1967), 203-224.

Wegner 1969
Wegner, Wolfgang. "Bemerkingen zu Zeichnungen niederländischen Künstler um 1600." In *Miscellanea I.Q. van Regteren Altena* (Amsterdam, 1969), 90-92.

Wegner 1970
Wegner, Wolfgang. "Bemerkungen zum Werke des Meisters von Liechtenstein." *Wallraf-Richartz-Jahrbuch* 32 (1970), 263-268

Wegner 1973
Wegner, Wolfgang. *Kataloge der Staatlichen Graphischen Sammlung München. Die niederländischen Handzeichnungen des 15.-18. Jahrhunderts.* 2 vols. Munich, 1973.

Wegner and Pée 1980
Wegner, Wolfgang, and H. Pée. "Die Zeichnungen des David Vinckboons." *Münchner Jahrbuch der bildenden Kunst* 31 (1980), 35-128.

Weihrauch 1937-1938
Weihrauch, Hans R. "Rötel- und kreidezeichnungen Barth. Sprangers." *Münchner Jahrbuch der bildenden Kunst* 12 (1937-1938), vi-ix.

Welcker 1947
Welcker, A. "De schepping van Goltzius' Scheppingsdagen." *Nederlands Kunsthistorisch Jaarboek* 1 (1947), 61-82.

Wescher 1925-1926
Wescher, Paul. "Um Jan de Cock." *Zeitschrift für Bildende Kunst* 59 (1925-1926), 147-154.

Wescher 1928a
Wescher, Paul. "Pieter Coecke als Maler." *Belvedere* 12 (1928), 27-31.

Wescher 1928b
Wescher, Paul. "Holländische Zeichner zur Zeit des Lucas van Leyden." *Oud Holland* 45 (1928), 245-254.

Wescher 1928c
Wescher, Paul. "Zu Antonis Blocklandt." *Oud Holland* 45 (1928), 271-276.

Wescher 1949
Wescher, Paul. "An Unnoticed Drawing by Jan Gossaert in the Morgan Library." *The Art Quarterly* 12 (1949), 262-266.

Wescher and Steinbart 1927
Wescher, Paul, and K. Steinbart. "Vincent Sellaer." *Münchner Jahrbuch der bildenden Kunst* 4 (1927), 356-365.

Wied 1971
Wied, Alexander. "Lucas van Valckenborch." *Jahrbuch der Kunsthistorischen Sammlung Wien* 67 (1971), 119-231.

Wilberg Vignau-Schuurman 1969
Wilberg Vignau-Schuurman, Theodora Alida Gerarda. *Die Emblematischen Elemente im Werke Joris Hoefnagels.* 2 vols. Leiden, 1969.

Wilson 1979
Wilson, Michael I. *Organ Cases of Western Europe.* Montclair, New Jersey, 1979.

Winkler 1913
Winkler, Friedrich. "Gerard David und die Brügger Miniaturmalerei seiner Zeit." *Monatshefte für Kunstwissenschaft* 6 (1913), 271-280.

Winkler 1921
Winkler, Friedrich. "Die Anfänge Jan Gossaerts." *Jahrbuch der königlich Preussischen Kunstsammlungen* 42 (1921), 5-19.

Winkler 1926
 Winkler, Friedrich. "Two Notes on Jan van Scorel as a Draughtsman." *Old Master Drawings* 2 (1926), 15-17.

Winkler 1929
 Winkler, Friedrich. "Das Skizzenbuch Gerard Davids." *Pantheon* 3 (1929), 271-275.

Winkler 1929-1930
 Winkler, Friedrich. "Pieter Cornelisz. Kunst: The Flight into Egypt and the Rest on the Flight; St. George and the Dragon and (reverse) A Pair of Lovers. Nuremberg, Germanisches Museum." *Old Master Drawings* 4 (1929-1930), 27-28.

Winkler 1930
 Winkler, Friedrich. "Biblische Darstellungen Scorels aus seiner italienischen Zeit." *Oud Holland* 47 (1930), 30-42.

Winkler 1948
 Winkler, Friedrich. *Flämische Zeichnungen*. Berlin, 1948.

Winkler 1962
 Winkler, Friedrich. "Aus der ersten Schaffenzeit des Jan Gossaert." *Pantheon* 20 (1962), 145-156.

Winkler 1963
 Winkler, Friedrich. "The Anonymous Liechtenstein Master." *Master Drawings* 1 (1963), 34-38.

Winner 1972
 Winner, Matthias. "Zeichnungen des älteren Jan Brueghel." *Jahrbuch der Berliner Museen* 3 (1961), 190-241.

Winner 1972
 Winner, Matthias. "Neubestimmtes und Unbestimmtes im zeichnerischen Werk von Jan Brueghel d. A." *Jahrbuch der Berliner Museen* 14 (1972), 122-160.

Winner 1985
 Winner, Matthias. "Vedute in Flemish Landscape Drawings of the 16th Century." In *Netherlandish Mannerism. Papers Given at a Symposium in Nationalmuseum, Stockholm, September 21-22, 1984* (Stockholm, 1985), 85-96.

Woermann 1896-1898
 Woermann, Karl. *Handzeichnungen alter Meister im königlichen Kupferstichkabinett zu Dresden*. 10 vols. Munich, 1896-1898.

Wright 1953
 Wright, F. (trans.). *Select Letters of Saint Jerome*. [The Loeb Classical Library]. Cambridge, Mass., 1953.

Yernaux 1957-1958
 Yernaux, Jean. "Lambert Lombard." *Bulletin de l'Institut Archéologie Liègeois* 62 (1957-1958), 267-372.

Zimmermann 1904
 Zimmermann, Heinrich. "Das Inventar der Prager Schatz- und Kunstkammer von 6. Dezember 1621." *Jahrbuch der kunsthistorischen Sammlungen des allerhöchsten Kaiserhauses* 25 (1904), xiii-lxxv.

Zülch 1935
 Zülch, Walther Karl. *Frankfurter Künstler 1223-1700*. Frankfurt-am-Main, 1935, reprinted 1967.

Zweite 1980
 Zweite, Armin. *Marten de Vos als Maler: Ein Beitrag zur Geschichte der Antwerpener Malerei in der zweiten Hälfte des 16. Jahrhunderts*. Berlin, 1980.

Zwollo 1965
 Zwollo, An. "De Landschaptekeningen van Cornelis Massys." *Nederlands Kunsthistorisch Jaarboek* 16 (1965), 43-65.

Zwollo 1969
 Zwollo, An. "Hans Bol, Pieter Stevens en Jacob Savery enige kanttekeningen." *Oud Holland* 84 (1969), 298-302.

Zwollo 1973
 Zwollo, An. *Hollandse en Vlaamse Veduteschilders te Rome*. Assen, 1973.

Zwollo 1979
 Zwollo, An. "Jacob Savery, Nachfolger Pieter Bruegel und Hans Bol." In *Pieter Bruegel und seine Welt. Eine Colloquium veranstaltet vom Kunsthistorischen Institut der freien Universität Berlin und dem Kupferstichkabinett der Staatliche Museen Preussischer Kulturbesitz am 13. und 14. November 1975*. (Berlin 1979), 203-213.

EXHIBITION CATALOGUES

Amsterdam 1929
Oude Kunst. Rijksmuseum, 1929.

Amsterdam 1955
Le triomphe du Maniérisme européen de Michel-ange au Gréco. Rijksmuseum, 1955.

Amsterdam 1956
De Verzameling van Dr. A. Welcker. Rijksprentenkabinet, Rijksmuseum, 1956.

Amsterdam 1958
Middeleeuwse Kunst der Noordelijke Nederlanden. Rijksmuseum, 1958.

Amsterdam 1978a
Netherlandish Drawings 1450-1600. Rijksprentenkabinet, Rijksmuseum, 1978.

Amsterdam 1978b
Lucas van Leyden—Grafiek. Exh. cat. by Jan Piet Filedt Kok. Rijksprentenkabinet, Rijksmuseum, 1978.

Amsterdam 1981-1982
Dutch Figure Drawings from the Seventeenth Century. Rijksprentenkabinet, Rijksmuseum, Amsterdam; National Gallery of Art, Washington, 1981-1982.

Antwerp 1930
Antwerp Trésor de l'art Flamand du moyen âge au XVIIIe siècle. Mémorial de l'exposition d'art flamand ancien à Anvers 1930. Paris, 1932.

Antwerp 1956
Scaldis Tentoonstelling. Stedelijke Feest-Zaal and Provinciaal Veiligheidsinstitut, 1956.

Antwerp 1958
De Madonna in de Kunst. Koninklijke Museum voor Schone Kunsten, 1958.

Atlanta 1980
Flemish Old Master Drawings from the Royal Museums of Fine Arts of Belgium. Exh. cat. by Eliane De Wilde. The High Museum of Art, 1980.

Augsburg 1975
Johan Liss. Rathaus, Augsburg; The Cleveland Museum of Art, 1975.

Austin 1982
Seventeenth-century Dutch Landscape Drawings. Archer M. Huntington Art Gallery, 1982.

Basel 1974
Lukas Cranach: Gemälde, Zeichnungen, Druckgraphik. Exh. cat. by Dieter Koepplin and Tilman Falk. 2 vols. Kunstmuseum, 1974.

Berlin 1967
Zeichner sehen die Antike: Europäischer Handzeichnungen 1450-1800. Exh. cat. by Matthias Winner. Staatliche Museen Preussischer Kulturbesitz, Kupferstichkabinett, 1967.

Berlin 1975a
Pieter Bruegel d. A. als Zeichner. Herkunft und Nachfolge. Staatliche Museen Preussischer Kulturbesitz, Kupferstichkabinett, 1975.

Berlin 1975b
Zeichnungen aus der Ermitage zu Leningrad. Werke XV. bis XIX. Jahrhunderts. National Galerie, 1975.

Berlin 1979
Manierismus in Holland um 1600: Kupferstiche, Holzschnitte und Zeichnungen aus dem Berliner Kupferstichkabinett. Staatliche Museen Preussischer Kulturbesitz, Kupferstichkabinett, 1979.

Besançon 1950
Exposition de dessins allemands, flamands et hollandais. Musée des Beaux-Arts, 1950.

Binghamton 1970
Loan Exhibition. Selections from the Drawing Collection of Mr. and Mrs. Julius S. Held. University Art Gallery, State University of New York at Binghamton; Williams College Museum of Art, Williamstown; Museum of Fine Arts, Houston; Ackland Memorial Art Center, University of North Carolina, Chapel Hill; Art Gallery, University of Notre Dame; Allen Memorial Art Museum, Oberlin College; Vassar College Art Gallery, Poughkeepsie, 1970.

Boston 1980-1981
Printmaking in the Age of Rembrandt. Museum of Fine Arts, Boston; Saint Louis Art Museum, 1980-1981.

Breda 1952
Nassau-Oranje Tentoonstelling. Huis van Brecht, 1952.

Bremen 1964
Die schönsten Handzeichnungen von Dürer bis Picasso. Kunsthalle, 1964.

Bruges 1984
Pierre Pourbus. Peintre brugeois 1524-1584. Exh. cat. by Paul Huvenne. Musée Memling, 1984.

Brunswick 1985
Old Master Drawings at Bowdoin College. Bowdoin College Museum of Art, 1985.

Brussels 1926
Exposition rétrospective de Paysage flamand 16e, 17e, 18e siècles. Musées Royaux des Beaux-Arts de Belgique, 1926.

Brussels 1935
Cinq siècles d'art. Brussels, 1935.

Brussels 1937-1938
De Jérôme Bosch à Rembrandt: Dessins hollandais du XVIe au XVIIe siècle. Palais des Beaux-Arts, 1937-1938.

Brussels 1949
De van Eyck à Rubens. Dessins de maîtres flamands. Palais des Beaux-Arts, 1949.

Brussels 1954-1955
Het Europees Humanisme in de 16de eeuw. Palais van Schone Kunsten, 1954-1955.

Brussels 1961
Dessins hollandais du siècle d'or. Bibliothèque Albert Ier, 1961.

Brussels 1961-1962
L'arbre et la forêt de Patinier à Permeke. Musées Royaux des Beaux-Arts de Belgique, 1961-1962.

Brussels 1963
Le siècle de Bruegel. La peinture en Belgique au XVIe siècle. Musées Royaux des Beaux-Arts de Belgique, 1963.

Brussels 1967
*Cent-vingt dessins flamands et hollandais du 16ᵉ au 18ᵉ
siècle de Collections des Musées Royaux des Beaux-Arts
de Belgique.* Musées Royaux des Beaux-Arts de Belgique,
1967.

Brussels 1967-1968
Un demi-siècle de Mecenat. Musées Royaux des Beaux-
Arts de Belgique, 1967-1968.

Brussels 1968-1969
Dessins des Paysagistes Hollandais du XVIIᵉ siècle. Bib-
liothèque Albert Ier, Brussels; Musée Boymans-van Beu-
ningen, Rotterdam; Institut Néerlandais, Paris; Musée des
Beaux-Arts, Berne, 1968-1969.

Brussels 1977
Albrecht Dürers reis door de Nederlanden, 1520-1521.
Palais van Schone Kunsten, 1977.

Brussels 1980
Bruegel. Une dynastie de peintres. Palais des Beaux-Arts,
1980.

Budapest 1932
Németalföldi rajzok XV-XIX. század. Szépmüvészeti
Múzeum, 1932.

Budapest 1967
Breugeltól Rembrandtig. Szépmüvészeti Múzeum, 1967.

Cleveland 1978
*The Graphic Art of Federico Barocci: Selected Drawings
and Prints.* The Cleveland Museum of Art; Yale Univer-
sity Art Gallery, New Haven, 1978.

Cologne 1976
Bäder, Duft and Seife. Kulturgeschichte der Hygiene.
Kunstgewerbemuseum, 1976.

Copenhagen 1975
*Exposition à l'occasion de la réunion du comité interna-
tional d'histoire de l'art. VIIᵉ colloque international. Les
Pays du Nord et l'Europe. Art et architecture au XVIᵉ siè-
cle.* Statens Museum for Kunst, Den Kongelige Kobber-
stiksamling, 1975.

Darmstadt 1964
*Zeichnungen alter und neuer Meister aus dem Hes-
sischen Landesmuseum in Darmstadt.* Hessischen Lan-
desmuseum, 1964.

Delft 1960
Je Maintiendrai. Stedelijk Museum Het Prinsenhof, 1960.

Delft 1984
Prins Willem van Oranje 1533-1584. Stedelijk Museum
Het Prinsenhof, 1984.

Detroit 1981-1982
*From a Mighty Fortress. Prints, Drawings, and Books in
the Age of Luther 1483-1546.*
Exh. cat. by Christiane Andersson and Charles Talbot.
The Detroit Institute of Arts; The National Gallery of
Canada, Ottawa; Kunstsammlungen der Veste Coburg,
1981-1982.

Dijon 1950
*De Jérôme Bosch à Rembrandt, peintures et dessins du
Musée Boymans de Rotterdam.* Musée de Dijon, 1950.

Dordrecht 1955
Boom, bloem en plant. Dordrechts Museum, 1955.

Düsseldorf 1958
Düsseldorfer Kunstschatze in Villa Hügel. Kunstmuseum,
1958.

Düsseldorf 1962
Eine Auswahl. Kunstmuseum, 1962.

Düsseldorf 1968
Niederländische Handzeichnungen 1500-1800. Kunstmu-
seum, 1968.

Düsseldorf 1969-1970
Meisterzeichnungen der Sammlung Lambert Krahe. Kun-
stmuseum, 1969-1970.

Düsseldorf 1980
Sommeraustellung. C.G. Boerner, 1980.

Edinburgh 1965
*Old Master Drawings from the Collection of Dr. and
Mrs. Francis Springell.* National Gallery of Scotland,
1965.

Edinburgh 1978-1979
Giambologna 1529-1608: Sculptor to the Medici. Ed.
Charles Avery and Anthony Radcliffe. Royal Scottish
Museum, Edinburgh; Victoria and Albert Museum, Lon-
don; Kunsthistorisches Museum, Vienna, 1978-1979.

Florence 1964
Mostra di Disegni Fiamminghi e Olandesi. Gabinetto
Disegni e Stampe degli Uffizi, 1964.

Florence 1969
*Da Dürer a Picasso. Mostra di Disegni della Galleria
Nazionale del Canada.* Gabinetto Disegni e Stampe degli
Uffizi, 1969.

Florence 1980-1981
*L'Epoque de Lucas de Leyde et Pierre Bruegel. Dessins
des anciens Pays-Bas. Collection Frits Lugt. Institut
Néerlandais, Paris.* Exh. cat. by Karel G. Boon. Istituto
Universitario Olandese di Storia dell'Arte, Florence; Insti-
tut Néerlandais, Paris, 1980-1981.

Frankfurt 1956
*Kunst und Kultur von der Reformation bis zur Aufklä-
rung.* Historisches Museum, 1956.

Frankfurt 1966-1967
*Adam Elsheimer. Werk, künstlerische Herkunft und
Nachfolge.* Städelsches Kunstinstitut, 1966-1967.

Geneva 1969-1970
*Dessins flamands et hollandais du XVIᵉ au XVIIᵉ siècle.
Collections des Musées Royaux des Beaux-Arts de Bel-
gique. Cabinet des estampes.* Musée d'Art et d'Histoire,
1969-1970.

Ghent 1954
Roelandt Savery. Musée des Beaux-Arts, 1954.

Ghent 1955
Keizer Karl en zijn tijd. Museum voor Schone Kunsten,
1955.

The Hague 1930
De verzameling Dr. C. Hofstede de Groot III. Gemeente-
museum, 1930.

The Hague 1945
Nederlandsche Kunst van de XVde en XVIde eeuw.
Mauritshuis, 1945.

The Hague 1952
Hollandse tekeningen rond 1600. Rijksbureau voor Kunst-historische Documentatie, 1952.

Halbturn 1981
Tapisserien der Renaissance nach Entwürfen von Pieter Coecke van Aelst. Schloss Halbturn, 1981.

Hamburg 1985
Handzeichnungen alte Meister 1500-1800. Thomas Le Clair Kunsthandel, 1985.

's-Hertogenbosch 1967
Jheronimus Bosch. Noordbrabants Museum, 1967.

Leiden 1954
Nederlanders te Rome. Prentenkabinett van het Universi-teit, 1954.

Leiden 1978
Lucas van Leyden rondom het Laatste Ordeel. Stedelijk Museum de Lakenhal, 1978.

Leningrad 1972
Masterpieces of Drawing from the Collection of the Dres-den Print Room. Hermitage, 1972.

Liège 1966
Lambert Lombard et son temps. Musée de l'Art Wallon, 1966.

London 1908
[Untitled] Obach & Co., 1908.

London 1924
[Untitled] P. & D. Colnaghi & Co., 1924.

London 1927
Exhibition of Flemish and Belgian Art 1300-1900. Royal Academy of Arts, 1927.

London 1929
Exhibition of Dutch Art. Royal Academy of Arts, 1929.

London 1934
Old Master Drawings. P. & D. Colnaghi Co. Ltd., 1934.

London 1943-1944
Pieter Bruegel and His Circle. Slatter Gallery, 1943-1944.

London 1953
Drawings by Old Masters. Royal Academy of Arts, 1953.

London 1956
Exhibition of Old Master Drawings. P. & D. Colnaghi & Co. Ltd., 1956.

London 1960
Exhibition of Old Master Drawings. P. & D. Colnaghi Ltd., 1960.

London 1962a
Memorial Exhibition of Paintings and Drawings from the Collection of Francis Falconer Madan. P. & D. Colnaghi Co. Ltd., 1962.

London 1962b
Old Master Drawings from the Collection of Mr. C. R. Rudolf. Arts Council Gallery, London; Birmingham City Museum and Art Gallery; Leeds City Art Gallery, 1962.

London 1969
European Drawings from the National Gallery of Can-ada, Ottawa. P. & D. Colnaghi & Co. Ltd., 1969.

London 1977-1978
Flemish Drawings from the Witt Collection. Courtauld Institute Galleries, 1977-1978.

London 1983a
Mantegna to Cézanne. Master Drawings from the Cour-tauld. A Fiftieth Anniversary Exhibition. Courtauld Insti-tute Galleries, 1983.

London 1983b
The Genius of Venice 1500-1600. Royal Academy of Arts, 1983.

London 1985
Old Master Drawings. P. & D. Colnaghi Co. Ltd., 1985.

Los Angeles 1976
Old Master Drawings from American Collections. Los Angeles County Museum of Art, 1976.

Malibu 1983-1984
Master Drawings from the Woodner Collection. The J. Paul Getty Museum, Malibu; Kimbell Museum, Fort Worth; National Gallery of Art, Washington, 1983-1984.

Manchester 1961
Drawings from Chatsworth. Manchester City Art Gallery, 1961.

Manchester 1965
Between Renaissance and Baroque. European Art 1520-1600. Manchester City Art Gallery, 1965.

Manchester 1967
Landscape in Flemish and Dutch Drawings of the 17th Century from the Collections of the Musées Royaux des Beaux-Arts de Belgique. Whitworth Art Gallery, Univer-sity of Manchester, 1967.

Mechelen 1958
Margareta van Oostenrijk en haar Hof, Stadhuis en hof van Savoye. Comité stad Mechelen voor Wereldtentoons-telling, 1958.

Middletown 1957
Manuscript Drawings, Prints and Paintings. Davis Art Center, Wesleyan University, 1957.

Munich 1982
Neuerwerbungen. Ankäufe-Geschenke-Dauerleihgaben. München, Staatliche Graphische Sammlung. Neuen Pinakothek, 1982.

Munich 1983-1984
Zeichnungen aus der Sammlung des Kurfürsten Carl Theodor. Ausstellung zum 225 jährigen Bestehen Staa-tlichen Graphischen Sammlung München. Neuen Pinako-thek, 1983-1984.

New Brunswick 1982-1983
Dürer to Cézanne: Northern European Drawings from the Ashmolean Museum. The Jane Voorhees Zimmerli Art Museum, Rutgers University, New Brunswick; The Cleveland Museum of Art, 1982-1983.

New Brunswick 1983
Haarlem: The Seventeenth Century. The Jane Voorhees Zimmerli Art Museum, Rutgers University.

New York 1957
Treasures from the Pierpont Morgan Library: Fiftieth Anniversary Exhibition. The Pierpont Morgan Library, New York; The Cleveland Museum of Art; The Art Insti-tute of Chicago, 1957.

New York 1973
Abraham Bloemaert. Prints and Drawings. The Metro-politan Museum of Art, 1973.

New York 1974
Major Acquisitions of the Pierpont Morgan Library 1924-1974. Drawings. The Pierpont Morgan Library, 1974.

New York 1977-1978
Rembrandt and His Century: Dutch Drawings of the Seventeenth Century. The Pierpont Morgan Library, New York; Institut Néerlandais, Paris, 1977-1978.

New York 1981
European Drawings 1375-1825. The Pierpont Morgan Library, 1981.

New York 1985
Liechtenstein: The Princely Collections. Metropolitan Museum of Art, 1985.

New York 1986
The Northern Landscape. Flemish, Dutch and British Drawings from the Courtauld Collections. The Drawing Center, New York; The Courtauld Institute Galleries, London, 1986.

Northampton 1978
Antiquity in the Renaissance. Exh. cat. by Wendy Stedman Sheard. Smith College Museum of Art, 1978.

Nuremberg 1952
Aufgang der Neuzeit: Deutsche Kunst und Kultur von Dürers Tod bis zum Dreissigjährigen Kriege 1530-1650. Germanisches Nationalmuseum, 1952.

Ottawa 1977
Old Master Drawings from the Royal Museums of Fine Arts of Belgium, Brussels. National Gallery of Canada, 1977.

Paris 1949
De van Eyck à Rubens. Les maîtres du dessin. Bibliothèque Nationale, 1949.

Paris 1952
Dessins du 15e au 19e siècle. Bibliothèque Nationale, 1952.

Paris 1957
Exposition du Musée des Beaux-Arts de Besançon. Musée des Arts Decoratifs, 1957.

Paris 1959
Exposition Lucas de Leyde. Gravures. Institut Néerlandais, 1959.

Paris 1965-1966
Le XVIe siècle européen: peintures et dessins dans les collections publiques françaises. Petit Palais, 1965-1966.

Paris 1969-1970
De Raphaël à Picasso. Dessins de la Galerie nationale du Canada (Ottawa). Cabinet des Dessins. Musée du Louvre, 1969-1970.

Paris 1971
Dessins du Musée de Darmstadt, Landesmuseum. 47e exposition du Cabinet des dessins. Musée du Louvre, 1971.

Paris 1972
Dessins de la Collection du Marquis de Robien conservés au Musée de Rennes. Cabinet des Dessins. Musée du Louvre, 1972.

Paris 1974
Dessins flamands et hollandais du 17e siècle. Collections Musées Royaux des Beaux-Arts de Belgique, Musée Boymans-van Beuningen, Rotterdam, Institut Néerlandais, Paris. Institut Néerlandais, 1974.

Paris 1977-1978
Collections de Louis XIV: dessins, albums, manuscrits. Orangerie des Tuileries, 1977-1978.

Paris 1979-1980
Rubens and Rembrandt in Their Century. Institut Néerlandais, Paris; Koninklijk Museum voor Schone Kunsten, Antwerp; The British Museum, London; The Pierpont Morgan Library, New York, 1979-1980.

Paris 1985
Le Héraut du Dix-Septième Siècle. Dessins et gravures de Jacques de Gheyn II et III. Institut Néerlandais, 1985.

Paris 1985-1986
Rénaissance et Manièrisme dans les Ecoles du Nord. Ecole des Beaux-Arts, Paris; Kunsthalle, Hamburg, 1985-1986.

Philadelphia 1984
Masters of Seventeenth Century Dutch Genre Painting. Museum of Art, Philadelphia; Staatliche Museum Preussischer Kulturbesitz, Berlin; Royal Academy of Arts, London, 1984.

Pittsburgh 1986
Gardens of Earthly Delights. Sixteenth and Seventeenth Century Netherlandish Gardens. The Frick Art Museum, 1986.

Poughkeepsie 1970
Dutch Mannerism; Apogee and Epilogue. Vassar College Art Gallery, 1970.

Prague 1966
Tri Stoleti Nizozemski Kresby 1400-1700. Van Eyck, Bosch, Rubens, Rembrandt. Národní Galerie, 1966.

Prague 1974
Kresby mistrû XVI-XX stoleti ze statnich uméleckých sbírek v Drázdanech. Národní Galerie, 1974.

Princeton 1982-1983
Drawings from the Holy Roman Empire 1540-1680. The Art Museum, Princeton University; National Gallery of Art, Washington; Museum of Art, Carnegie Institute, Pittsburgh, 1982-1983.

Providence 1983
Old Master Drawings from the Museum of Art, Rhode Island School of Design. Exh. cat. by Deborah J. Johnson. Museum of Art, Rhode Island School of Design, 1983.

Rennes 1973
Dessins de la collection Robien. Musée des Beaux-Arts de Rennes, 1973.

Rome 1972-1973
Il paesaggio nel disegno del cinquecento europeo. Accademia di Francia, Villa Medici, 1972-1973.

Rotterdam 1934
Nederlandsche tekeningen uit de 15de, 16de en 17de eeuw, verzameling F. Koenigs. Museum Boymans, 1934.

Rotterdam 1936
Jeroen Bosch—Noord-Nederlandsche Primitieven. Museum Boymans, 1936.

Rotterdam 1938
Meesterwerken uit vier Eeuwen 1400-1800. Tentoonstelling van Schilderijen en Teekeningen uit particuliere verzamelingen in Nederland. Museum Boymans, 1938.

Rotterdam 1948-1949
Tekeningen van Jan van Eyck tot Rubens. Museum Boymans, Rotterdam; Palais des Beaux-Arts, Brussels; Bibliothèque Nationale, Paris, 1948-1949.

Rotterdam 1952
Choix de dessins. Exposition organisée à l'occasion du 17ᵉ Congrès international d'histoire de l'art. Rotterdam, 1952.

Rotterdam 1954-1955
Tekeningen en aquarellen van Vlaamse en Hollandse meesters uit verzameling de Grez in Koninklijk Musea voor Schone Kunsten te Brussels. Museum Boymans, 1954-1955.

Rotterdam 1957
Vijf Eeuwen Tekenkunst. Tekeningen van Europese Meesters in het Museum Boymans te Rotterdam. Museum Boymans, 1957.

Rotterdam 1958
Hendrick Goltzius als Tekenaar. Museum Boymans-van Beuningen, Rotterdam; Teylers Museum, Haarlem, 1958.

Rotterdam 1961-1962
150 Tekeningen uit vier eeuwen uit de verzameling van Sir Bruce en Lady Ingram. Exh. cat. by C. van Hasselt. Museum Boymans-van Beuningen, Rotterdam; Rijksprentenkabinet, Rijksmuseum, Amsterdam, 1961-1962.

Rotterdam 1965
Jan Gossaert genaamd Mabuse. Museum Boymans-van Beuningen, Rotterdam; Groeningenmuseum, Bruges, 1965.

Rotterdam 1969
Erasmus en zijn tijd. Museum Boymans-van Beuningen, 1969.

Rotterdam 1976-1977
Le Cabinet d'un amateur. Dessins Flamands et hollandais des XVIᵉ et XVIIᵉ siècles d'une collection privée d'Amsterdam. Museum Boymans-van Beuningen, Rotterdam; Institut Néerlandais, Paris; Bibliothèque Albert Ier, Brussels, 1976-1977.

Rotterdam 1985-1986
Jacques de Gheyn II als tekenaar 1565-1629. Museum Boymans-van Beuningen, Rotterdam; National Gallery of Art, Washington, 1985-1986.

Rouen 1977
Choix de quelques peintures et dessins de la donation H. & S. Baderou. Musée des Beaux-Arts, 1977.

Salzburg 1983
Die Salzburger Skizzenbücher des Paulus van Vianen. Landschaftszeichnungen und Stadtansichten des Hofgoldschmiedes von Erzbischof Wolf Dietrich von Raitenau. Barockmuseum, 1983.

Stockholm 1984-1985
Bruegels tid. Nederländsk konst 1540-1620. Nationalmuseum, 1984-1985.

Stuttgart 1979-1980
Zeichnung in Deutschland. Deutsche Zeichner 1540-1640. Staatsgalerie Stuttgart, Graphische Sammlung, 1979-1980.

Stuttgart 1984
Zeichnungen des 15. bis 18. Jahrhunderts. Staatsgalerie Stuttgart Graphische, 1984.

Tokyo 1979
European Master Drawings of Six Centuries from the Collection of the Fogg Art Museum. The National Museum of Western Art, 1979.

Toronto 1968
Master Drawings from the Collection of the National Gallery of Canada. Art Gallery of Ontario, 1968.

Utrecht 1913
Tentoonstelling van Noord-Nederlandsche schilderen beeldhouwerkunst voor 1575. Gebouw voor Kunsten and Wetenschap, 1913.

Utrecht 1955
Jan van Scorel. Centraal Museum, 1955.

Utrecht 1977
Jan van Scorel in Utrecht. Centraal Museum, Utrecht; Musée de la Chartreuse, Douai, 1977.

Utrecht 1985
Zeldzaam Zilver uit de Gouden Eeuw. De Utrechtse edelsmeden Van Vianen. Centraal Museum, 1985.

Venice 1976
Disegni di Tiziano e della sua cercha. Fondazione Giorgio Cini, 1976.

Venice 1981
Da Tiziano a El Greco. Per la storia del Manierismo a Venezia. Palazzo Ducale, 1985.

Vienna 1967
Meisterzeichnungen aus dem Museum der Schönen Künste in Budapest. Graphische Sammlung Albertina, 1967.

Vienna 1967-1968
Die Kunst der Graphik IV. Zwischen Renaissance und Barock: Das Zeitalter von Bruegel und Bellange. Exh. cat. by Konrad Oberhuber. Graphische Sammlung Albertina, 1967-1968.

Vienna 1978
Die Albertina und das Dresdner Kupferstich-Kabinett. Meisterzeichnungen aus zwei alten Sammlungen. Graphische Sammlung Albertina, 1978.

Vienna 1985
Albrecht Dürer und die Tier-und Pflanzenstudien der Renaissance. Graphische Sammlung Albertina, 1985.

Vienna 1986
Die Sammlung von Ian Woodner. Graphische Sammlung Albertina, 1986.

Washington 1958-1959
Dutch Drawings from Hieronymus Bosch to Van Gogh. National Gallery of Art, 1958-1959.

Washington 1962-1963
Drawings from Chatsworth. National Gallery of Art, 1962-1963.

Washington 1971
: *Dürer in America. His Graphic Work.* National Gallery of Art, 1971.

Washington 1974
: *Recent Acquisitions and Promised Gifts.* National Gallery of Art, 1974.

Washington 1977
: *Seventeenth Century Dutch Drawings from American Collections.* National Gallery of Art, Washington; Denver Art Museum; Kimbell Art Museum, Fort Worth, 1977.

Washington 1978-1979
: *The Splendor of Dresden. Five Centuries of Art Collecting.* National Gallery of Art, Washington; The Metropolitan Museum of Art, New York; The Fine Arts Museum of San Francisco, California Palace of the Legion of Honor, 1978-1979.

Washington 1980-1981
: *Gods, Saints and Heroes. Dutch Painting in the Age of Rembrandt.* National Gallery of Art, Washington; The Detroit Institute of Art; Rijksmuseum, Amsterdam, 1980-1981.

Washington 1982
: *Lessing J. Rosenwald. Tribute to a Collector.* National Gallery of Art, 1982.

Washington 1983
: *The Prints of Lucas van Leyden and His Contemporaries.* National Gallery of Art, Washington; Museum of Fine Arts, Boston, 1983.

Washington 1983-1984
: *Leonardo's 'Last Supper': Precedents and Reflections.* National Gallery of Art, 1983-1984.

Washington 1984-1985
: *Old Master Drawings from the Albertina.* National Gallery of Art, Washington; The Pierpont Morgan Library, New York, 1984-1985.

Washington 1985
: *Leonardo to Van Gogh. Master Drawings from Budapest.* National Gallery of Art, Washington; The Art Institute of Chicago; Los Angeles County Museum of Art, 1985.

Washington 1985-1986
: *Dürer to Delacroix: Great Master Drawings from Stockholm.* National Gallery of Art, Washington; Kimbell Art Museum, Fort Worth; Fine Arts Museums of San Francisco, 1985-1986.